The Attainment of Delacroix

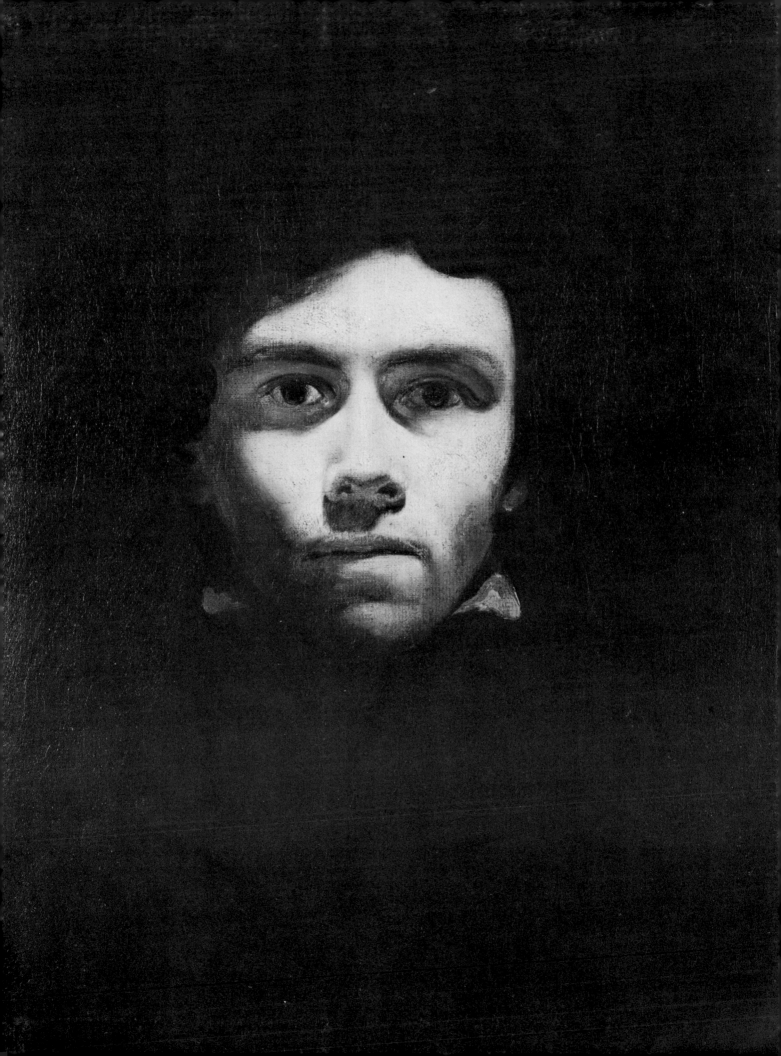

The Attainment of Delacroix

Frank Anderson Trapp

The Johns Hopkins Press *Baltimore and London*

The Johns Hopkins Press, Baltimore, Maryland 21218
The Johns Hopkins Press Ltd., London

Library of Congress Catalog Card Number 70-79728

Standard Book Number 8018-1048-5

Plates I, II, V, VI, VII, VIII, IX, XII, XIII, XVI, XVII, XXI, XXIV, and
XXV were provided through the courtesy of Thames and Hudson
Limited, London, and were printed in England under the
supervision of Thames and Hudson.

Plates III, IV, X, XI, XIV, XV, XVIII, XIX, XX, XXII, and XXIII were
provided through the courtesy of Éditions Cercle d'Art, Paris,
and were printed in France by Imprimerie Union.

To my mother
and to
the memory of my father

Contents

Illustrations

A Note on the Illustrations

Dimensions in the legends accompanying the illustrations are given in meters; height precedes width.

Photographs credited S.D.P. are from the Service de Documentation Photographique de la Réunion des Musées Nationaux of the French government.

Plates I–II, V–IX, XII–XIII, XVI–XVII, XXI, and XXIV–XXV originally appeared in *Delacroix*, by René Huyghe, and were provided by Thames and Hudson Limited, London. Plates III–IV, X–XI, XIV–XV, XVIII–XX, and XXII–XXIII were provided by Éditions Cercle d'Art, Paris.

Unnumbered illustrations throughout the text are from the collection of the Cabinet des Dessins, Louvre, and are reproduced by permission.

The Frontispiece

The attribution of this portrait to Théodore Géricault and even its identification as a portrayal of Delacroix are open to question. Lorenz Eitner indicates that it first appeared at the Andrieu sale on May 6, 1892, listed as No. 210, "attributed to" Géricault. It so strongly recalls a Delacroix self-portrait drawing (Robaut 20), reproduced by Fréderick Villot in an etching of 1847, that the identification, at least, seems tenable. In correspondence, Eitner has further indicated that in his opinion neither the style nor the execution are typical of Géricault, although the fact that he often painted sketches by candlelight in 1818–1819 argues for its association with him. This was the period when Delacroix posed for *Raft of the Medusa* and was much impressed by Géricault. While there is no compelling reason to assign the work to Delacroix himself, and Lee Johnson shares my reluctance to do so, that possible reattribution cannot be ruled out. The portrait is therefore not only an evocative romantic image but also a symbol of the issues that surround the art of the two leading protagonists of the Romantic movement in France. The canvas is now in the Musée Stendhal, Rouen. Photo Giraudon.

Preface

Few painters have left so rich a testament as Eugène Delacroix. The standard French edition of his diary extends to three volumes, his correspondence to five, and miscellaneous letters make up another volume, the *Lettres intimes*. His North African notebooks have also appeared in various forms. Complementing these private records are more formal periodical essays, which have been published as *Oeuvres littéraires*, nor are these isolated instances of his literary ambitions. While still a schoolboy he wrote, apparently for his own amusement, two novels and a play (one of the novels, *Les dangers de la cour*, has recently been published). In later years he planned a dictionary of the fine arts, and although the project never took shape, the *Journal* contains many notes for it.

When we turn to his art, we find among his surviving works several thousand drawings, over a hundred prints, more than nine hundred oil paintings, and another fifteen hundred water colors and pastels.[1] This legacy includes a full complement of major works. The early salon paintings—*Dante and Virgil*, *Massacre at Scio*, *Death of Sardanapalus*, and *Liberty Leading the People*—provided the basis for Delacroix's fame and still readily come to mind at the mention of his name. They bear witness to their maker's early demonstration of his creative powers, but emphasis on them to the detriment of the later works is misleading. It was in his mature work that Delacroix's early genius found its full development. A productive decorator, Delacroix did two mural sequences for the Chamber of Deputies and one for the Senate library at the Luxembourg Palace. A fourth mural program for the Hôtel de Ville was destroyed during the Paris Commune in 1871, but another, and probably finer, example of that period may be seen in the ceiling of the Galerie d'Apollon at the Louvre. Complementing these secular decorations are his religious pieces: first, the *Pietà* in St. Denis-du-Saint-Sacrement, and then the climax of his accomplishment in this genre, the decorations for the Chapel of the Holy Angels in St. Sulpice. Such complex and large-scale paintings as *Entry of the Crusaders into Constantinople*, *Battle of Taillebourg*, and *Justice of Trajan* further indicate the range of his accomplishment.

Paradoxically enough, in spite of this mass of documentation, it is difficult to construct a satisfying portrait of Delacroix. He was the pre-eminent painter of the romantic movement in France, and his early salon entries have often been said to epitomize the reaction of the younger generation against the restraints of an entrenched neoclassical Academy. In the last three salons of the Restoration period—those of 1822, 1824, and 1827—he reiterated the challenge to authority proclaimed by Géricault in his *Raft of the Medusa*, and by 1830, the date often taken to mark the full emergence of the romantic ethos in France, Delacroix was widely recognized as one of its chief exemplars.

However, if the usual generalizations about Delacroix and his period are acceptable at all, it is only with a good deal of qualification. His personality is elusive now, as in his lifetime. The focus of his life was inward, its drama locked inside

1. These numbers must be approximate, for a good deal remains to be done to arrive at a reliable index of Delacroix's *oeuvre*, despite the pioneering efforts of Alfred Robaut and the contributions of later scholars.

his own consciousness, and while he had much in common with his contemporaries of all persuasions, he was essentially an isolated and atypical figure. His individualism reflected his special talent, with all its strengths and limitations, not his rebellion. It was his intention to restore, not destroy, the values he had inherited. The issues that preoccupied him throughout a long and productive career were for the most part familiar ones when he first became active as a painter, and his work now appears more as the climax of an earlier tradition than as the herald of the new.

Yet while Delacroix constantly turned to the art of the past for guidance, he cannot be comfortably relegated to the company of the old masters. His perceptions were too insistently personal, his loyalty to the past too heavily qualified by his sensitivity to the present, for such historical pigeonholing. For most of his career he was as isolated from the conservative as from the radical forces in French art, and the more discerning of his admirers viewed him not as a part of the "new art" but as a brilliant and solitary maverick.

If this book has a bias, it is the belief that the art of Delacroix can best be seen as a product of the interaction of its maker and his times. It is difficult for us to detach ourselves from our assumptions and expectations and confront with a fresh eye the works of another century: knowledge of Delacroix's world and his role in it can aid us to meet that imaginative challenge. If the reader is encouraged to approach the art of Delacroix with respect for the role of the historical imagination, this book will have fulfilled the purpose for which it was conceived. Yet a great artist's contribution, after all, is his art, not his historical significance, however tantalizing that may be. My central purpose, therefore, is to examine the nature and development of Delacroix's creative life and his world as it illuminates that development and that life.

Acknowledgments

My long dormant notion of writing a study on Delacroix was reawakened, some years ago, during a conversation with Professor Earl Latham, whose encouragement and advice have been abundant and valuable throughout the ensuing project. Other colleagues and friends have also been helpful, whether as discerning readers or as listeners tolerant of an author's preoccupation with his own subject. Among them, Professor Christopher Gray of The Johns Hopkins University must be singled out for his detailed review of the entire manuscript at an earlier stage and Mrs. William Calvin Cannon for her help in negotiating some of the hazards of translating from the French. While I alone must accept responsibility for any shortcomings of the book, they and others must be credited for their aid in improving it. Mrs. Perry Thompson showed both forbearance and ingenuity in typing even the most unruly passages of a manuscript which subsequently benefited from the patient efforts of my copy editor, Mrs. Jean Owen.

The matter with which they were confronted could not have been amassed without the good offices of many others, both here and abroad. Special thanks are due Mme Marianne Heumann, who has on many occasions been helpful in obtaining photographs and other information; the reference librarians at Amherst College; M. Jean Adhémar, Mlle Nicole Villa, and the personnel of the Cabinet des Estampes at the Bibliothèque Nationale; Mme Sylvie Béguin of the Services de Documentation and the staff of other facilities at the Louvre; and those elsewhere —scholars, curators, dealers, collectors, and booksellers—who have facilitated my research in a variety of ways. The sabbatical leave granted by the President and Trustees of Amherst College to complete this study and their financial assistance in bringing it to publication are gratefully acknowledged.

The Attainment of Delacroix

Abbreviations

C *Correspondance générale d'Eugène Delacroix*, ed. André Joubin, 5 vols. (Paris: Plon, 1935)

J *Journal de Eugène Delacroix*, ed. André Joubin, new ed., 3 vols. (Paris: Plon, 1932)

J, P *The Journal of Eugène Delacroix*, ed. and trans. Walter Pach (New York: Crown, 1948)

J, W *The Journal of Eugène Delacroix*, ed. Hubert Wellington, trans. Lucy Norton (New York: Oxford University Press, 1951)

L *Lettres intimes: Correspondance inédite*, ed. Alfred Dupont (Paris: Gallimard, 1954)

M *Mémorial de l'exposition Eugène Delacroix*, ed. Maurice Sérullaz (Paris: Éditions des Musées Nationaux, 1963)

O *Oeuvres littéraires*, ed. Élie Faure, 2 vols. (Paris: Crès, 1923)

PM Maurice Sérullaz, *Les peintures murales de Delacroix* (Paris: Les Éditions du Temps, 1963)

R *L'Oeuvre complet d'Eugène Delacroix: Peintures, dessins, gravures, lithographies*, ed. Ernest Chesneau and Alfred Robaut (Paris: Charavay Frères, 1885)

Introduction

Delacroix grew up in the Napoleonic era and the unsettled days of the Bourbon Restoration. This period, in which neoclassical values were of central concern, permanently colored his aims as an artist and his beliefs as a man. Indeed, it might almost be said that most of his career was devoted to resolving to his personal satisfaction the cultural issues which dominated his formative years.

Napoleon reiterated and intensified France's long-standing Latin allegiances, and in a land where authoritarian state patronage had long been traditional, political circumstances—not least of all French involvement in Italian affairs and alienation from the northern countries of Europe—fostered classicist doctrines. Classical models, with their discipline and control, were well suited to reflect the new public morality, in sharp contrast to the mood of the *ancien régime*. With the advent of the Restoration government, however, cultural exchanges with recently hostile Britain and Germany were reopened. French artists and writers were exposed to foreign ideas and forms of expression, and rising French nationalism was tempered by these international contacts. Their effect upon the French intelligentsia was profound.

A respect for German culture that had been nurtured in the circle of Mme de Staël during her long years of exile soon exerted a strong influence in her native land. Although its effects were for the most part literary and philosophical, particularly the introduction of German idealist notions, it had some relevance for artists. Mme de Staël's book *De l'Allemagne* (1810), banned by Napoleon, struck Goethe as the "first breach" in the barrier between French and German culture. Even earlier, in *Corinne* (1807), she wrote the first essay in aesthetic romance outside of German literature. Her insistence on the importance of inner feeling found wide acceptance among those who questioned academic standards of art as normative and descriptive. Jean Jacques Rousseau's anticipation of romantic attitudes—the pastoralism of *La nouvelle Héloïse*, the appreciation of the power of direct, unpremeditated experience in *Émile*—were thus confirmed and extended by Germanic thought. There is considerable evidence of Delacroix's admiration for her and for those who shared or inspired her views. For young French artists and intellectuals who were responsive to those new avenues of philosophical speculation, the complex genius of Goethe assumed considerable importance. For some reason, however, contemporary Germanic ventures in the visual arts—the experiments of the Nazarenes and the picturesque fantasy of Caspar David Friedrich—had little apparent influence in France.

The impact of British culture was even more complicated and far-reaching. Romanticism early assumed a distinctive form in English poetry. Wordsworth published the *Lyrical Ballads* in 1798 and his Preface to the *Ballads* in 1800, and the burst of literary activity in the first decades of the century left its mark in France. Byron's adventurous individualism, both as a man and as a poet, claimed

particular attention, followed shortly after by the picturesque medievalism of Sir Walter Scott. The imagery of Byron and Scott, transmitted through French editions and stage adaptations of their work, had widespread appeal for artists and illustrators. At the same time the great past of English literature was brought to life as never before in France. The genius of Shakespeare was freed from the constrictive standards of the French classical theater, and while not all Frenchmen were prepared to overlook what they considered his aberrations, many of the young responded to the power and depth of his vision. This curiosity extended even to the dramatic incidents of English history, as a host of paintings in the salons of the Restoration testify.

The rehabilitation of the British literary reputation was accompanied by a willingness to view seriously the paintings of a national school the French had not characteristically admired. Although even the most Anglophile of Parisians would not have questioned the pre-eminence of French art, they joined in applauding the virtuosity of Thomas Lawrence. As other English painters, most notably Constable, became known in France, their individual accomplishments within a lively baroque tradition that remained strong had its effect. Delacroix was especially well prepared to profit from the British example. He was responsive to the colorism that English painters had evolved, to their technical innovations, particularly in water color, to their superiority in history painting, and to the grand manner, which was a living tradition in English art.

Although neither Delacroix nor his contemporaries responded strongly to the more extreme individualism of Blake and Fuseli, there were echoes—although muted—of a new visionary sensibility even during the early years of French romanticism. This new tendency found encouragement in the art of Goya. While the paintings of that solitary master were little known, his prints were widely admired in France. Like the English, he had sustained and transformed late baroque traditions. An aging exile in Bordeaux, he was a living reminder of the parochialism of academic values. The bold inventiveness of his imaginary world upset all French notions of propriety, yet the power of his art was undeniable. Its associations with the Spain of Velásquez and Cervantes, the Spain that had taken on a special mysterious, picturesque appeal for the French, gave it an even greater fascination.

The most important single source of foreign influence on artistic developments in France during the first decades of the nineteenth century, however, was the Napoleonic Museum. During the Empire young painters had a singular opportunity to compare the offerings of the old guard in the Paris salons and private ateliers with the masterpieces of the past housed in that collection. Following the example of the Roman conquerors, Napoleon assembled a hoard of artistic trophies to commemorate the success of his campaigns abroad, and his museum presented a panorama of man's accomplishment in painting and sculpture. The Laocoön, the Capitoline Venus, and other classical sculptures thus brought to Paris could only confirm the prestige of the classical tradition as it was interpreted in France and reiterate the values promulgated by the arbiters of contemporary taste.

Michelangelo's Slaves were removed from the Boboli Gardens in Florence to the Galerie d'Apollon in the Louvre, and Raphael's *Transfiguration*, *Vision of Ezekiel*, and portraits of Cardinal Inghiarami and Pope Leo X were further

additions to a collection already rich in Italian treasures from the High Renaissance. Titian's *Martyrdom of St. Peter* and Tintoretto's *Miracle of St. Mark* challenged the dogma of the inferiority of color as an expressive device. As for Northern art, its detractors had to maintain their position in the presence of such masters as Holbein, Dürer, Cranach, Rembrandt, Rubens, and Van Eyck (the *Descent from the Cross* was pillaged from Antwerp and the *Altar of the Mystic Lamb* from Ghent). For those not yet steeped in academic prejudices or committed to practical politics, the collection must have constituted a reproach to mediocrity and a goad to ambition.

This extraordinary juxtaposition of masterpieces was not destined to remain intact for long. Following the Peace of Paris in 1814 most of Napoleon's loot was returned to its owners, although a few pre-empted works remained. For example, Veronese's *Marriage at Cana* and two of Michelangelo's Slaves were so large that the hazards of transport provided a convenient argument for retaining them, and the Italian Primitives were somehow ignored by the diplomats. Furthermore, the adjustments made when the Napoleonic Museum collection was made a part of the Louvre were beneficial in themselves. The Louvre collection remained imposing and was to some extent revitalized by its temporary enlargement. The remaining paintings by Venetian and Northern masters could be seen afresh, and Rubens' Medici series was lent new prominence when transferred from the Luxembourg Palace. For Delacroix and many other young artists, Rubens' series and the *Marriage at Cana* were artistic revelations.

Along with the new visual models and subject matter from abroad, French artists were confronted with distinctively French manifestations of the new romantic sensibility. Anticipated by Rousseau, it was extended by Jacques Henri Bernadin de Saint-Pierre, most notably in *Paul et Virginie* (1789), with its appreciation of human sentiment and natural diversity. After years of anticlericalism, writers had begun to look on Christian themes with a fresh interest, and the image of Milton loomed large in the vision of French epic poets. Chateaubriand's *Le génie du christianisme* (1802) and *Les martyrs* (1809) were notable defections from the neoclassical camp, and the dramatic upsurge of the strength and influence of the Church was both reflected and served by such popular works. History also assumed new meanings. The eighteenth-century notion of the "universality" of human experience gave way to a taste for picturesque diversity, and the Middle Ages became the object of intense curiosity. In 1793 Alexandre Lenoir had opened his Musée des Monuments Français, and in 1805 the Gaelic Academy was founded in Paris. In the following year Tardieu Saint-Michel published his *Charles-Martel, ou la France délivrée*, which anticipated the romantic fascination with Carolingian and Merovingian tales. By this time the Ossianic epics *Fingal* and *Temora* had acquired the stature of Celtic counterparts of the Norse and classical myths, and Napoleon himself greatly admired these products of Macpherson's fancy. The taste for bardic expression and the traditions of troubadour medievalism led to interest in Ariosto, Cervantes, and, eventually, Tasso. As at least one barometer of romantic literary tastes, it is of interest to observe that the favorite books of Delacroix's friend George Sand were reputed to be *Paul et Virginie*, Chateaubriand's *Atala*, and the writings of Tasso.

These new literary interests were not without their influence upon the visual arts, which began to show signs of romantic inspiration. The shift can be seen

even in catalogue listings for the salons held early in the century. Girodet's *Burial of Atala*, showing a scene from Chateaubriand's Indian epic, which had been incorporated in *Le génie du christianisme*, was an excursion into a novel realm of subject matter, exotic in setting and Christian in content. Chateaubriand himself, in the tradition of the classical analogy, called its painter the successor to Apelles. Although Girodet's *Ossian Receiving Napoleon's Generals*, an earlier exploration of new thematic areas, was poorly received at the Salon of 1802, it indicated the appeal of romantic historicism, which had deeper roots than was at first recognized. Ingres painted a dream of Ossian, and his many works in the troubadour manner reflect his interest in medieval and Renaissance subjects treated with an eye to appropriate historical detail. His *Death of Leonardo da Vinci* was not the first painting in which historical "accuracy" of costume and facial type took precedence over strict conformity with classical conventions. The classical view of the depiction of death as a moral exemplum provided a theoretical justification for such subjects and strongly anticipated the necromania of the romantics.

Oriental subjects, often regarded as characteristic of romantic art, became popular in the Napoleonic era. Although such works as the battle scenes and *Pesthouse of Jaffa* of Baron Gros and Girodet's *Revolt at Cairo* were aimed at propagating the Napoleonic legend, they evince a delight in the exotic and picturesque that seems excessive for such patriotic ends. The odalisques of Ingres are

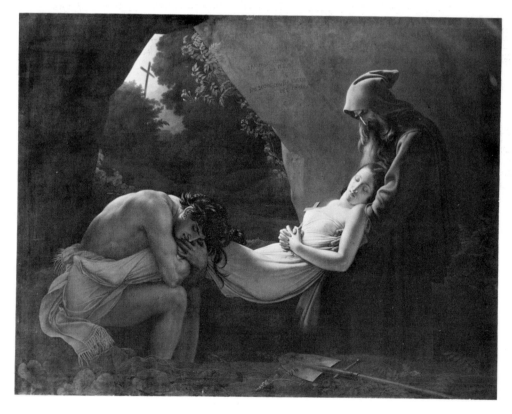

FIGURE 1. A.-L. Girodet-Trioson. *Burial of Atala*. Salon of 1808.
Oil on canvas. 2.07 × 2.86. Louvre. Photo Archives Photographiques, Paris.

FIGURE 2. A.-L. Girodet-Trioson. *Ossian Receiving Napoleon's Generals*. Commissioned 1801.
Oil on canvas. 1.92 × 1.82. Musée de Malmaison, Paris. Photo Bulloz.

FIGURE 3. Jean-Auguste-Dominique Ingres. *Dream of Ossian*. 1812–13.
Oil on canvas. 3.48 × 2.75. Musée Ingres, Montauban. Photo Giraudon.

FIGURE 4. Jean-Auguste-Dominique Ingres. *Death of Leonardo da Vinci*. 1818.
Oil on canvas. Dimensions unknown. Private collection. Photo Bulloz.

devoid of political associations, with the possible exception of their homage to the
formal virtues of neoclassicism. While the taste did not develop as fast or spread
as far as did historical and Christian themes, it was firmly established well before
Delacroix and other painters of the younger generation began to exhibit. Their
contribution to orientalism was therefore more one of reinterpretation than
invention.

The deviations of form and technique espoused by the so-called romantic
generation, however, are apt to be overemphasized, following the example of
the critics of the period, who were highly sensitive to minute departures from
accepted norms. It is true that at the formal and expressive levels French aca-
demic painting was far less orthodox in practice than in precept, that even the
language of romantic academicism is not identical with that of the earlier aca-
demicism, that Ingres' interpretation of neoclassical ideals was markedly at variance
with that of David, and that even in the art of the lesser painters a new awareness
is apparent. The sketches of Delacroix's master, Guérin, are surprisingly free, and
in their cultivation of dramatic, luministic effects Prud'hon and Girodet also
exceeded neoclassical norms.

Yet most artists were respectful of contemporary demands for "finish": con-
tours and interior forms were precisely defined and surfaces carefully elaborated.
The boldly handled sketches of Gros were somewhat exceptional, but it is said

FIGURE 5. A.-L. Girodet-Trioson. *Revolt at Cairo (October 21, 1798)*. Salon of 1810. Oil on canvas. 3.65 × 5.00. Musée de Versailles. Photo S.D.P.

that he was driven to the point of suicide by his inability to reconcile his romantic tastes with his loyalty to Davidian dictates (he apparently did not perceive that even his idol was not invariably consistent). Delacroix was almost alone in his uncompromising pursuit of rich color, open form, and baroque compositional amplitude. Even Géricault's *Raft of the Medusa* shows some retrenchment from the exuberant freedom and brilliant colorism of his earlier salon pieces, and his later canvases suggest Courbet more than French romantic painting. Horace Vernet will serve as an instructive example of a similar ambivalence among the minor painters. He shared many of the thematic interests of Géricault and Delacroix, but he became a prisoner of his own facility and, after a promising beginning, devoted the remainder of his career to the production of the blandly literal works for which he had become popular. The careers of Delaroche, Boulanger, and the brothers Devéria show the same attempt to effect a compromise with conservative opinion and consequent failure to develop their early insights. It must be added that not all the lesser painters of the period can be categorized in this way. Chassériau, for example, occasionally achieved some of Delacroix's fire, particularly in his Oriental subjects, yet the sense of pictorial structure and expressive form characteristic of Delacroix is lacking. As for Fromentin's and Decamps'

FIGURE 6. Théodore Chassériau. *Arab Chiefs Challenging Each Other to Combat*. 1852. Oil on canvas. 0.91 × 1.18. Louvre. Photo Agraci.

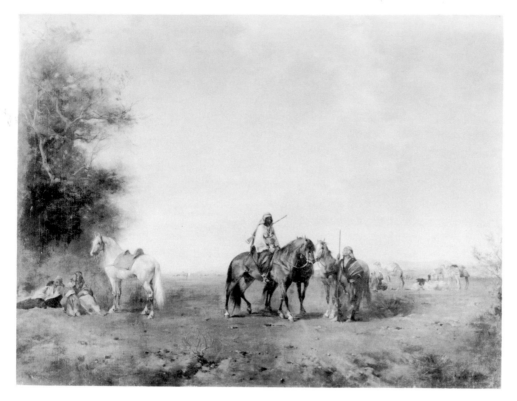

FIGURE 7. Eugène Fromentin. *Arab Riders Resting on a Plain*. N.d.
Oil on canvas. 0.74 × 0.95. Louvre. Photo S.D.P.

ventures into that favorite genre, handsome though they are, they are handicapped
by their obeisance to the popular preference for description. Over all, a survey of
Delacroix's contemporaries makes his development from his early experiments
to his mature expression all the more impressive. While he cannot be conveniently
classified within any index of contemporary taste, he was in a deeper sense
strikingly representative of an age in which aspiration still found its models less
in the future than in the past. That Delacroix could at once so typify and transcend
his historical circumstances is a measure of his greatness and the source of his
appeal to later generations.

The Early Years

1. The thirty-two-page medical report was published at the expense of the government (see A. B. I. Delonnes, *Opération de sarcocèle faite le 27 Fructidor, an V au citoyen Charles Delacroix par le citoyen A. B. Impert Delonnes* [Paris: Imprimerie de la République, 1798]). The account was reprinted in the *Moniteur universel* for April 13, 1798 (see also René Huyghe, *Delacroix* [New York: Abrams, 1963], pp. 51–53, nn. 3–5). Some still argue the case of Delacroix's legitimacy (see P. Loppin, *Charles et Eugène Delacroix* [Paris: Béarn, 1963]).

2. See André Joubin, ed., *Journal de Eugène Delacroix*, new ed., 3 vols. (Paris: Plon, 1932), 1:8–9 (Sept. 12, 1822). Unless otherwise indicated, quotations from the *Journal*, the *Correspondance*, and other French sources will be presented in English with page references to the original French text. References to the Joubin edition will be abbreviated as *J*. The two English-language editions of selections from the *Journal* differ both in their translation and in their choice. These are Walter Pach, ed. and trans., *The Journal of Eugène Delacroix* (New York: Crown, 1948), hereafter cited as *J*, P, and Hubert Wellington, ed. *The Journal of Eugène Delacroix*, trans. Lucy Norton (New York: Oxford University Press, 1951), hereafter cited as *J*, W.

3. This comment appears, for example, in a note on the subject of Delacroix's parentage written in Alfred Robaut's hand on an opening leaf of Delacroix's own copy of Delonnes' medical report, now in the Bibliothèque Nationale. Robaut cites Silvestre as the source of the comment.

The outward facts of Eugène Delacroix's life have none of the biographical luster of David's political adventure, Géricault's mercurial excess, or the pathos of Bonington's brief essay at life. Its most significant events were so private that they are now for the most part unknown, and there are some mysteries of which he himself may well have been unaware.

He was born into the upper-middle-class household of Charles and Victoire Oeben Delacroix at Charenton-Saint-Maurice, near Paris, on April 26, 1798. He was formally accepted as the son of M. Delacroix, a lawyer and civil servant of high rank. Charles Delacroix had been foreign minister under the Directoire and subsequently served as ambassador to Holland, as prefect of Marseille, and, until his death in 1805, was prefect of the Gironde. His public recognition of the child as his own seems, however, to have been a matter of appearance. Six months before Eugène was born, M. Delacroix returned from his post in Holland to undergo a highly unusual and much-publicized operation: the removal of a thirty-two-pound tumor of the left testicle, which in the course of fourteen years had so encumbered its victim as to make him resemble, some said, a pregnant woman. The surgeon claimed complete success and the restoration of his elderly patient's virility, and various friends and relatives bore witness to the legality of Eugène Delacroix's birth, but these claims appear medically improbable.[1] It seems significant that Citizen Delacroix did not return to France in 1798 to attend the birth of this remarkable child of his old age. However, he apparently treated the boy with such kindness that it is uncertain whether he ever questioned the circumstances of his birth. Eugène Delacroix always recalled Charles with affection and respect. He was, moreover, well acquainted with the details of the operation, as one of the earliest entries in the *Journal* makes clear.[2] (At the time of his death a copy of Dr. Delonne's account of it was in his library.)

Romantic commentators impatient with such a mystery have provided a candidate for father in the person of Maurice de Talleyrand, Prince of Benevento. The famous diplomat, who was as well known for his enterprise in the boudoir as in the council chamber, had recently returned to France and knew the Delacroix family. That he replaced the elder Delacroix as minister of state for foreign affairs is taken by these commentators as a public parallel with his replacement of his predecessor in private life. The official publication of the medical report is thus interpreted as having been inspired by the devious Prince as a slight to Charles Delacroix's reputation. Led on by such evidence, some have seen in Delacroix's haughty manner and sallow complexion a resemblance to Talleyrand. They read hidden meanings into the painter's reported comment that he was "raised at the knees of Talleyrand"[3] and offer this as the reason why he never suffered real poverty despite reversals of fortune and official indifference or even hostility toward his work.

To accept Talleyrand as Delacroix's missing parent nonetheless requires a certain credulity. The resemblance between the two men is not especially marked

in the likenesses which survive. Furthermore, to judge by available portraits, Eugène Delacroix no more resembled his mother than he did Charles Delacroix, but it has never been suggested that he was not her son. There is, moreover, no documentary evidence to associate the prince and the painter. Talleyrand was not shy about acknowledging his affairs. In fact, he was careful to mention in his will those to whom he felt some such obligation, and there were many, yet Delacroix's name does not appear there or in the statesman's voluminous memoirs. Such an omission seems strange, in view of the fact that in 1838, when Talleyrand died, Delacroix had attained a considerable reputation.

While present evidence does not permit resolution of these questions, the whole story appears to be romantic fancy. Even in Delacroix's lifetime, efforts were made to attribute to him those special characteristics of personality and circumstance supposed to be peculiar to genius. Early commentators, including Dumas in his *Memoirs*, loved to stress the "predestination" that had spared the infant Delacroix in numerous brushes with danger. (Delacroix himself encouraged such talk and, in fact, was the source of these anecdotes.) Théophile Silvestre's respectful amazement is typical:

Delacroix's infancy was full of accidents; his cradle caught fire while he was sleeping in it; he poisoned himself with verdigris used for cleaning maps; he nearly strangled once from swallowing a bunch of grapes and a second time from playing with the saber belt of his brother, who was a captain in the Chasseurs; and he fell into the harbor of Marseille, from which a sailor pulled him out half dead. "It was a madman who made up my horoscope," he said: "a maid was taking me for a walk when he stopped us; she tried to avoid him, but the fellow held her back, examined me several times attentively feature by feature, and said: '*This child will become a famous man; his life will be full of hard work and anguish and always given to contradiction.*' You see: I work and I am still disputed: that madman was a soothsayer. That's what predestination is!"[4]

In actuality, Delacroix's childhood hardly seems extraordinary. After the death of her husband in 1805, Mme Delacroix took her son to Paris, where they lived with her daughter, Henriette, and son-in-law, Raymond de Verninac. The next October Eugène was enrolled at the Lycée Impérial, later called Louis-le-Grand. Théodore Géricault, who lived next door on the Rue de l'Université, was registered at the Lycée in a higher form a few days later, but the two did not meet until much later. While Géricault did not long survive in this atmosphere of strict academic discipline, Delacroix remained at the Lycée for almost ten years.

By his own description Delacroix was a reasonably good scholar, if not an exceptional one. He won a few academic prizes over the years, including commendations for drawing in 1813 and 1814, while he was in the class of a former winner of the Prix de Rome, Bouillon. Perhaps because of his already delicate health, Delacroix preferred reading to physical exercise and was particularly fond of the classics.[5]

His much-vaunted "universality"[6] cannot be accepted literally. His nine years of formal education did give him a considerable advantage over most of his contemporaries, and throughout his life he remained a voracious, if desultory, reader, but his scholarly inclinations are apt to be exaggerated by his admirers. In spite of his indulgence in such pursuits as writing essays, these were for him peripheral efforts. The essays are of interest today not so much for their literary style or philosophical consistency as for their occasional, if often erratic, brilliance and the insight into Delacroix's art that they provide.

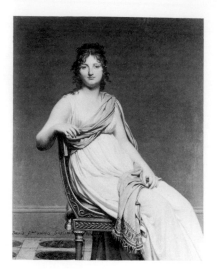

FIGURE 8. Jacques-Louis David. *Mme Henriette de Verninac.* 1799. Oil on canvas. 1.46 × 1.12. Louvre. Photo Giraudon.

4. *Les artistes français*, 4th ed., vol. 1, *Romantiques* (Paris: Crès, 1926), p. 27.

5. A. Piron, *Eugène Delacroix, sa vie et ses oeuvres, d'après les souvenirs inédits du Baron Rivet* (Paris: Claye, 1865), p. 39.

6. The claims of René Huyghe are typical. See, for example, "L'Universalité de Delacroix," in Huyghe *et al.*, *Delacroix* (Paris: Hachette, 1963), pp. 255–72. See also Huyghe, "The Universality of Delacroix," *Formes*, June, 1930, pp. 10–13.

7. André Joubin, ed., *Correspondance générale d'Eugène Delacroix*, 5 vols. (Paris: Plon, 1935), 1:6. Selections from the *Correspondance*, cited as *C*, will be quoted in English while page and volume numbers of the original French text will be given.

8. Reproduced in facsimile in Raymond Escholier, *Delacroix: Peintre, graveur, écrivain*, 3 vols. (Paris: Floury, 1926–29), 1:facing p. 18. The original drawing is now in the library of the Fondation Jacques Doucet, Paris.

9. See Loys Delteil, *Le peintre-graveur illustré (XIXe et XXe siècles)*, vol. 3: *Ingres et Delacroix* (Paris: By the author, 1908), plate 1.

10. See, for example, the letter to his friend Pierret dated October 29, 1819 (*C* 1:61–66).

11. See Jean Marchand, "Eugène Delacroix, homme de lettres, d'après trois oeuvres de jeunesse, inédites," *Le livre et l'estampe*, 19, no. 3 (1959): 3–14. Except for *Les dangers de la cour*, these manuscripts remain unpublished. The summaries of *Alfred* and *Victoria* therefore depend on Marchand's own more detailed synopses.

12. See, *C*, 1:9 Delacroix discussed his impressions of that visit in a letter written on January 10, 1814, to his friend Félix Louvet. This and later visits with the Bataille family at Valmont had deep personal meaning for Delacroix.

13. Delacroix, *Les dangers de la cour, nouvelle inédite publiée d'après le manuscrit autographe par Jean Marchand* (Avignon: Aubanel, 1960).

14. "Delacroix homme de lettres," p. 11.

Apart from his two awards for drawing, there were other minor evidences of his youthful interest in art. In a letter of August 25, 1813, for example, he tells of a visit to the studio of Pierre Guérin, a friend of his uncle, the painter Henri-François Riesener. After discussing what he had seen there, he continued: "I'm sorry to be unable to study with him this year. But when I'm no longer at the Lycée I want to spend some time there in order to develop at least a small amateur talent."[7] To judge by the surviving evidence, Delacroix's ambitions were suitably modest. A school notebook page, including what has been identified as a self-portrait among other pen-and-ink doodles, gives little evidence of genius.[8] His first attempt at print-making, a series of small sketches engraved on the back of a metal saucepan some time in 1814, is another such schoolboy product.[9]

In 1814 Delacroix's mother, to whom he was devoted,[10] died unexpectedly at the age of fifty-six. Left an adolescent in the care of his much older and rather unsympathetic sister, he turned to his school friends for understanding, and throughout his life he remained devoted to them.

His literary efforts of these years seem to show more than a little self-projection. He wrote a play and two short novels, autographed manuscripts of which have recently come to light.[11] Their discoverer, Jean Marchand, has compared them with Victor Hugo's drawings in importance: they tell much about the writer's interests, but their significance is more autobiographical than artistic. Although they are undated, internal evidence led Marchand to place them in 1816, when Delacroix was seventeen. They were apparently concocted simply for the pleasure of their author and his friends.

One novella, *Alfred*, has as its theme love, conflict, and betrayal at the time of William the Conqueror. Its medievalism was doubtless colored, as Marchand suggests, by impressions Delacroix formed on visiting relatives at Valmont. A ruined abbey there conjured up for him a "host of romantic ideas."[12] This bloody tale, marked by a Voltairean anticlericalism, includes a full range of Gothic horrors, especially in its denouement, in which Alfred, the eighteen-year-old hero, unknowingly kills his own father. When the unfortunate Alfred comes to realize the true nature of his deed, he impales himself on his own sword and falls across his victim's corpse.

Les dangers de la cour differs in setting and tone.[13] Its hero, who here narrates his own story, is the son of a country pastor living near Appenzell. In the course of a complicated plot that moves from Switzerland to the Piedmont at Turin, the lad experiences the hazards of living at the Sardinian court. In the end he returns from his life abroad to the simpler, more honest ways of his homeland. Marchand suggests that Delacroix was here inspired by the writings of Jean-Jacques Rousseau and that the final turn of the plot anticipates Delacroix's later love of solitude.

The third of these literary enterprises was a play, *Victoria*. It is, as Marchand puts it, a "somber drama" next to which *Hernani* "cuts a pale figure."[14] Full of the operatic conventions dear to romantic writers, it takes place in Italy and involves a tangled skein of treachery and trauma. The cast is headed by a jealous count, Ariosto, Victoria, his ward, and her lover, Elfredi. In this instance love triumphs in the end and Elfredi escapes Ariosto's traps, while the Count falls victim to his own poison. All of these ventures reflect an uninhibited romantic predisposition that was in the air and a taste that was to be tirelessly exploited in nineteenth-century drama and fiction. A reader of Shakespeare and Sterne, as well as some less Gothic French authors, Delacroix found in the world of fiction and the stage

models of his own feelings about "real" life. Hence, for example, he signed some of his adolescent letters "Yorick," after Sterne's hero.

Some of his amorous escapades with domestics may also have represented heroic poses, such as his brief liaison with Elizabeth Salter, his sister's English maid, whose portrait he painted. Later entries in the *Journal* suggest that this affair, which took place when he was nineteen, made an enduring impression upon him. A series of letters written in faltering, schoolboy English to "dear El" by her "subdued disciple" provide an unusually intimate picture of the young Delacroix—the more touching for their undisguised naïveté.[15] One such letter contains a comment that is peculiarly revealing: "I am not disposed to lose my independence, which is so necessary to an artist." Delacroix never persuaded himself to make that costly sacrifice. He never married, and while many women interested him throughout his life, none of them—not even his mistress of later years, Mme de Forget—ever diverted him from his work for long.[16] At the age of nineteen he had already entered into what proved to be a lasting engagement with his art.

Having left the Lycée in June of 1815, Delacroix was free to follow his earlier artistic inclinations. In March of the following year he enrolled at the École des Beaux-Arts. That decision was doubtless encouraged by his mother's stepbrother, Riesener, who had studied with David. An element of family pride must have

15. See *J,* 1:3 (Sept. 3, 1822), 56 (Mar. 1, 1824), 75 (Apr. 11, 1824); and J. Russell, "That Devilish English Tongue," *Portfolio and Art News Annual,* no. 6 (Autumn, 1962), pp. 74ff. These letters are contained in an old account book used for miscellaneous jottings. This and a group of other related notebooks are now in the library of the Fondation Jacques Doucet, Paris.

16. This subject of Delacroix and women has been treated at length by various authors, chiefly by Raymond Escholier (see *Eugène Delacroix et sa "consolatrice"* [Paris: Librairie Armand Colin, 1932] and his *Delacroix et les femmes* [Paris: Fayard, 1963]).

FIGURE 9. Pierre-Narcisse Guérin. *The Return of Marcus Sextus.* 1798–99 [An. VII]. Oil on canvas. 2.17 × 2.43. Louvre. Photo Bulloz.

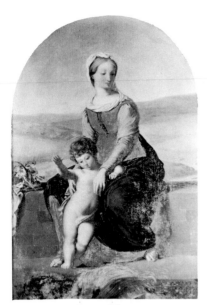

FIGURE 10. *Virgin of the Harvest.* 1819. Oil on canvas. 1.25 × 0.74. Church of Orcemont. Photo S.D.P.

17. Silvestre, *Les artistes français*, 1:52.

18. See *J*, 1:75 (Apr. 11, 1824), n. 4.

19. *Delacroix*, p. 61.

20. See *C*, 1:147, n. 1. Joubin gives the price paid by the state as fifteen hundred francs. Escholier, in *Delacroix*, 1:53, mentions the less likely figure of six thousand francs.

21. *J*, 1:50 (Jan. 27, 1824). Delacroix's feelings about Géricault were ambivalent. At other times he lapsed into a sentimental tone, as in his account of seeing Géricault's death mask at Cogniet's: "Oh, venerable monument! I was tempted to kiss it" (*J*, 1:66 [Apr. 1, 1824]).

22. Silvestre, *Les artistes français*, 1:52.

23. This dreary affair is summarized in Piron, *Delacroix*, pp. 43–44. See also André Joubin, "Documents nouveaux sur Delacroix et sa famille," *Gazette des Beaux-Arts*, 6th ser., 9 (1933):173–86; and Joubin, "Lettres d'Eugène Delacroix à sa soeur Henriette," *Revue des Deux-Mondes*, April 15, 1937; *cf.* related letters in volume 1 of the *Correspondance*. When Raymond de Verninac died, so little was left after his estate was liquidated that his widow had to become a paid companion.

lent conviction to the uncle's promptings. The family names, Riesener and Oeben, had come to stand for a tradition of fine craftsmanship. Delacroix's maternal grandfather, Jean-François Oeben, had been cabinetmaker to the king. In a later generation his own cousin and close friend Léon Riesener also became a painter, if a far less important one. It was therefore natural that a professional friend of Henri-François Riesener, Pierre Guérin, was chosen as Delacroix's master. Guérin enjoyed considerable prestige both as a painter and a teacher, and Delacroix found in his studio not only solid, if orthodox, instruction but a friendly group of fellow students, some of whom later attained at least a modest reputation. Raymond Soulier, Ary Scheffer, and Charles Henri de Champmartin were most prominent among them. It was also there that Delacroix at last met Géricault, a recent graduate of the atelier who returned occasionally to attend the life class.

Delacroix's meeting with Géricault was for himself, at least, momentous. It is unlikely, however, that such an encounter could have had a comparable importance for Géricault, who was seven years older and had already cut something of a public figure as an exhibitor in the salons of 1812 and 1814. The two painters first became acquainted some time in the fall of 1817, before Géricault was absorbed in his *Raft of the Medusa*, which he exhibited at the Salon of 1819. There can be no doubt of the impression that this project made on Delacroix. He was struck not only by Géricault's marked creative gifts but by his air of elegance, sophistication, and charm.[17] He saw the painting while it was in progress and, according to tradition, posed for the nude man seen from the back with left hand extended.[18] His lifelong friend and first biographer, Piron, gives Delacroix's account of the overwhelming impact of the picture on him: "He [Géricault] allowed me to come to see the *Medusa* while he was working on it in a bizarre studio he had near Ternes. I was so overwhelmed by it that after leaving there I ran like a crazy man all the way home to the Rue de la Planche."[19]

Géricault was bitterly disappointed when his ambitious entry was not included among the state purchases from the Salon. It could have been little consolation that, as a sop, Count de Forbin, the Superintendent of Fine Arts, offered him a commission to paint either a triumph of religion or a Sacred Heart of Jesus. Such subjects would have little attraction for one so ardently secular. On the other hand, the payment offered was too handsome to be lightly dismissed.[20] Géricault therefore covertly arranged for Delacroix to paint the picture. Géricault would sign it as his own, and the commission was to be divided between the two.

Delacroix's acceptance of such an arrangement is understandable; he could ill afford to affect Géricault's rather casual attitude toward money—in fact, he came to resent the comparative wealth of his acquaintance ("he was not precisely a friend of mine"[21]) as dangerous to his self-discipline and hence detrimental to his art.[22] Although his own family had been financially comfortable, he had recently been faced with monetary troubles. His sister and her husband were fast squandering Charles Delacroix's legacy in a series of futile lawsuits over the family's claims to lands in Angoumois. By 1822, when the case was finally decided against the claimants, not only had personal relations of the heirs become strained, but there was nothing left of what had once been—on paper, at least— a considerable fortune.[23] Delacroix had not yet established himself professionally and had to take whatever presented itself. His first commissioned painting, a Virgin and Child (*Virgin of the Harvest*) was executed earlier in 1819 for the parish church

of Orcemont, near Rambouillet. It brought him the magnificent sum of fifteen francs. Occasional illustrations, clumsy commercial satires in the manner of Rowlandson and the English caricaturists, also brought in a bit of money from time to time,[24] but he had little claim to financial independence. He therefore agreed to Géricault's proposal, whereby he might earn some money and consolidate his relationship with a person who had taken on a curious blend of meanings for him: teacher, rival, and friend.

Yet as the project took shape, Delacroix seems to have suffered from his own chronic lack of enthusiasm for it. His letters of this period indicate his sense of guilt and his self-recrimination.[25] Work limped along until 1822. Its subject had by then been modified, and it had become *Virgin of the Sacred Heart* (*Consolatrix Afflictorum*). Although intended for the Convent of the Ladies of the Sacred Heart, at Nantes, it was apparently never delivered there. Believed lost for many years and known only from studies, it was identified in 1930 in the Cathedral of Ajaccio. It had been sent there in 1827, presumably as a painting by Géricault.[26] Delacroix never knew its original destination.

It is not difficult to see why this altarpiece remained unidentified among the Cathedral's possessions for so long. It could readily pass for one more example of the nineteenth-century passion for the style of Raphael. The earlier *Virgin of the Harvest* had reflected the gentler model of the *Belle Jardinière*, which was sold in 1822 and which Delacroix once copied,[27] while *Virgin of the Sacred Heart* represents the monumental side of Raphael's art, that of the Sistine Madonna. However, there is much to betray the immaturity of the artist. The composition is faltering and the figures are cramped by the frame. Yet it is only fair to observe that some passages, at least, do reveal an unusual touch. The Virgin has a certain vigorous

24. For a separate discussion of these early works, see J. Laran, "Péchés de jeunesse d'Eugène Delacroix," *Gazette des Beaux-Arts*, 6th ser., 3 (1930): 55–61. Re-evaluation of these works may, however, be considered, for some, such as *Moving House*, here illustrated, are of interest for their signs of technical skill and anticipation of future motifs.

25. See, for example, C, 5:63 (to Mme de Verninac, July 28, 1820); *Lettres intimes: Correspondance inédite*, ed. Alfred Dupont (Paris: Gallimard, 1954), p. 115 (to Guillemardet, October, 1820), hereafter cited as *L*; C, 1:87 (to Pierret, Oct. 20, 1820), 110 (to Soulier, Jan. 26, 1821); 116–17 (to Soulier, Feb. 21, 1821), 123 (to Soulier, Mar. 30, 1821); 5:78–79 (to Mme de Verninac, Apr. 14, 1821), 99 (to Mme de Verninac, Dec. 8, 1821), 104–5 (to Mme de Verninac, Jan. 16, 1822); 1:147 (to Pierret, Aug. 30, 1822).

26. See C, 5:137 (letter of June 28, 1822, and note by Joubin). For further documentation, including reference to the preparatory studies, see Maurice Sérullaz, *Mémorial de l'exposition Eugène Delacroix* (Paris: Editions des Musées Nationaux, 1963), pp. 4–9, hereafter cited as *M*.

27. Throughout his life Delacroix remained an advocate of copying the old masters as a means of enjoyment as well as of learning. This practice and the turn of mind it reflects had deep implications for his art. A close study of one aspect of this larger problem has recently been published: see B. E. White, "Delacroix's Painted Copies after Rubens," *The Art Bulletin*, 49 (March, 1967): 37–51.

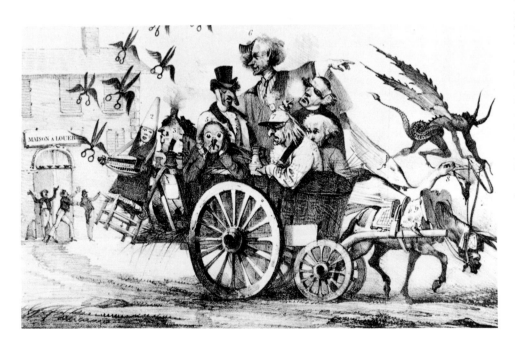

FIGURE 11. *Moving House*. Published 1822. Lithograph. 0.19 × 0.31. Collection of the author. Photo Donald Witkoski.

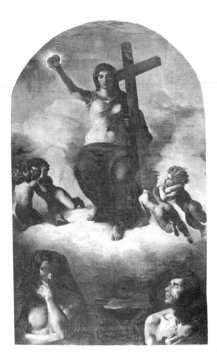

FIGURE 12. *Virgin of the Sacred Heart.*
Completed 1821. Oil on canvas.
2.58 × 1.52. Cathedral of Ajaccio.
Photo Archives Photographiques,
Paris.

28. These works were long thought
to have been executed later, following
Robaut's indications in his catalogue
of the artist's work. See *L'Oeuvre
complet d'Eugène Delacroix*, ed. Ernest
Chesneau and Alfred Robaut (Paris:
Charavay Frères, 1885), hereafter
cited as R. This error has been
corrected and other valuable
clarification of the subject provided
in Lee Johnson, "Delacroix's
Decorations for Talma's Dining
Room," *Burlington Magazine*, 99
(March, 1957):78–89. See also
Johnson, "Four Unknown Paintings
by Delacroix," *Burlington Magazine*,
97 (March, 1955):85, and *cf. M*, pp.
9–14. (A study for the Winter panel
is reproduced in Fig. 13 because
permission to reproduce the panel
itself could not be obtained.)

nobility that suggests the type which later appeared in *Liberty Leading the People*,
and the *putti* are already strikingly similar to those adorning the ceiling of the
Salon du Roi. The two supplicants below, both Davidian in cast, have a sober
dignity and help to offset the signs of eclecticism and inexperience that mark the
picture as a whole.

Another instance, it would seem, of Géricault's intercession on Delacroix's
behalf was a commission to paint a series of decorative panels for the dining room
of François-Joseph Talma.[28] The famous tragedian had just built a new house
at 9 Rue de la Tour des Dames, in the quarter which soon came to be known
as the Nouvelle Athènes. His neighbors there included Géricault and Horace
Vernet. Both appear to have been instrumental in obtaining this modest oppor-
tunity for their unknown friend to try his hand as a muralist. The result of his
efforts was a set of small, lunette-shaped compositions in oil representing the
four seasons, designed to be placed above each of the doors into the room.

The completed panels of the four seasons and a group of related studies have
particular interest because of their classical flavor. It is natural that Delacroix
would have turned to antique precedents. The program at the École des Beaux-
Arts had been calculated to reinforce any latent inclinations in that direction, and
his earlier studies—*Death of Drusus, Son of Germanicus* or *Roman Matrons Giving
Up Their Jewels for Their Country*—recall the repertory of the Prix de Rome
competition subjects assigned in reputable Parisian ateliers. It is therefore hardly
surprising that, quite aside from the possible wishes of his client, he should defer
to tradition.

It was customary to draw, as Delacroix did, from statuary in the Louvre, but
it is significant, as Lee Johnson observes, that he also used as models not the popular
line engravings after Flaxman or "Etruscan" vase paintings but Greco-Roman
wall decorations, with their more "painterly" handling. This aspect of classical
art was known to him through engravings as well as through the Herculanean
examples in the Louvre. In turning to Roman sources and to the related baroque
classicism of France, Delacroix early found a means of reconciling his individual
preferences with his strong respect for tradition. He had arrived at what would
become all but a principle of his mature practice.

For all their associations with earlier art, the Talma decorations are surprisingly
fresh and are possessed of a certain naïve charm. They are, to be sure, rather
self-consciously adjusted to their semicircular format. Even some of the later
pendentives at the Palais Bourbon betray similar formal difficulties. Delacroix's
knowledge of anatomy is not unerring, nor is his drawing always sure. On the
other hand, the characterizations are fairly convincing. *Winter*, a subject perhaps
easier than the others, shows a vigor in the handling which helps compensate
for the heavy execution elsewhere in the series. Although the contours are some-
what harsh and crude, their firm definition of the color masses is effective. The
practice followed in the later murals is anticipated in the introduction of a re-
inforcing line to distinguish form and color areas. The color, however, is un-
exciting throughout the Talma decorations. The tonalities are low-keyed, and
earth tones dominate. Touches of more vivid hues, such as the green wrap of
Winter, the pale blue gown of Spring, or the contrast between the flesh tones and
the purplish background, do not effectively counteract the dun cast of the whole.
The spectator is reminded that this is a student work, and the artist's lack of
experience is as apparent as his talent.

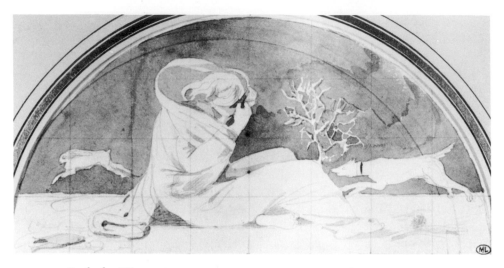

FIGURE 13. Study for *Winter*. 1821.
Water color and pencil. 0.20 × 0.26. Cabinet des Dessins, Louvre. Photo S.D.P.

Despite the false starts and hesitations of these formative years, it is clear that Delacroix's work was gradually acquiring a direction. In 1822 he determined to undertake a project that would test the lessons of his long apprenticeship. As early as July 30, 1821, he was thinking of exhibiting at the next salon. In a letter of that date addressed to his friend Raymond Soulier, then traveling in Italy, he mentioned his decision not to compete for the Prix de Rome but instead to win recognition in the next salon.[29] The following April he again wrote Soulier, apologizing for his neglect of him and explaining that he had been working hard for the last two and a half months on a composition that had taken every moment of his time. His hope was that by "some stroke of luck" his effort would attract favor at the salon and perhaps provide the money he needed to make a trip to Italy.[30] This absorbing project was a painting of Dante and Virgil, the subject he had finally chosen after considering "the recent wars between Turks and Greeks."[31] The latter subject, a premonition of *Massacre at Scio*, his next major effort, reflected his already strong interest in the Greek wars of independence, as well as a general taste for the exotic. In the end, however, he turned to a more literary theme—perhaps to capitalize on the fame of Géricault's *Raft of the Medusa*[32]—and his hopes were at least partially fulfilled. *Dante and Virgil* did attract attention, although not all of it favorable, and it was purchased by the state, but the trip to Italy never materialized.

The handbook of the Salon of 1822 gives the artist's full title for his work: "Dante and Virgil conducted by Phlegyas, crossing the lake which surrounds the walls of the infernal city of Dis. The damned cling to the bark or try to force their way into it. Dante recognizes some Florentines among them." As the description indicates, the canvas represents an episode from Canto VIII of the *Inferno*, in which the two poets are ferried across the broad marsh describing the Fifth Circle of Hell. Although Delacroix modified certain details (Dante's marsh, for example, has here become a stormy lake), he has captured the sense of scene with bold simplicity.

29. *C*, 1:128 (to Soulier, July 30, 1821).

30. *C*, 1:140 (to Soulier, Apr. 15, 1822).

31. Described in another letter to Soulier, dated September 15, 1821 (*C*, 1:132).

32. *Dante and Virgil* is but one of a series of themes involving figures caught in forbidding waters. By 1821 Delacroix had already done a scene of shipwreck in his *Castaways* (Robaut 1473), a subject recurring as late as 1862 in his *Shipwreck on the Coast*. Closely related are the various versions of the shipwreck of Don Juan and of Christ on the Sea of Galilee (see René Huyghe, "Delacroix et la thème de la barque," *La revue du Louvre et des musées de France*, 13, no. 2 [1963]:65–72). For a more general discussion of the romantic theme of the boat, see Lorenz Eitner, "The Open Window and the Storm-Tossed Boat: An Essay in the Iconography of Romanticism," *The Art Bulletin*, 37 (December, 1955); 281–90. It might be noted that Horace Vernet painted his own "storm-tossed boat" in 1822, *Joseph Vernet Tied to a Mast Studying the Effects of a Storm*. The canvas is now in the Musée Calvet, Avignon. See G. Levitine, "*Vernet Tied to a Mast in a Storm*: The Evolution of an Episode in Art Historical Romantic Folklore," *The Art Bulletin*, 49 (June, 1967):92–100. That the symbol of the bark had special meaning for Delacroix is also evident from his references to that image in Michelangelo's late sonnet.

It was, of course, traditional to turn to literature for subject matter, especially for a major effort such as this, and Delacroix characteristically required some such form of external stimulus for his imagination. The *Journal* is filled with references to his search in the world of art for an escape from the commonplace which others sought in mystical visions, drugs, sexual adventures, and alcohol. Unable to accept those forms of pleasure and release, Delacroix preferred the marriage of reason with emotion that poetry and music represented.

Even granting possible exaggerations, Delacroix's account of his youthful susceptibility to the other arts has an authentic ring. The *Journal* states, for example, that "the finest head in my Dante picture was done with dispatch and brio while Pierret read me one of Dante's cantos which I already knew, but to which he gave, by his expression, an energy that electrified me."[33] In an earlier letter written to Pierret he confessed to an even more extreme hypersensitivity. When he read about Tasso's confinement in the madhouse, he said, "You weep for him: you squirm in your chair as you read about that life: your eyes become menacing and you involuntarily clench your teeth with anger."[34] Throughout his life he continued to look to poetry for subjects appropriate to his own sense of the excitement, the mystery, and sometimes the futility of human destiny.[35]

With such a belief in the importance of subject matter, it was natural enough that Delacroix should turn to Dante for inspiration. "No more *Don Quixotes* and

33. See, *J*, 2:136–37 (Dec. 24, 1853). The head to which he refers is that of the figure to the rear who is trying to clamber into the boat, with one arm already thrown over the gunwale. *Cf. J*, 1:265 (Feb. 26, 1849). Delacroix here refers to Piétri, who also read to him from Dante while he was at work on *Dante*.

34. *C*, 1:54 (to Pierret, Sept. 22, 1819); cited by Lucien Rudrauf, *Eugène Delacroix et le problème du romantisme artistique* (Paris: Laurens, 1942), p. 244 (see also p. 309 on poetry and painting).

35. See Juliusz Starzynski, "La pensée orphique du plafond d'Homère de Delacroix," *La revue du Louvre et des musées de France*, 13, no. 2 (1963): 73–82. The author here discusses the very special meaning poetry held for Delacroix and its recurrent importance in providing subjects.

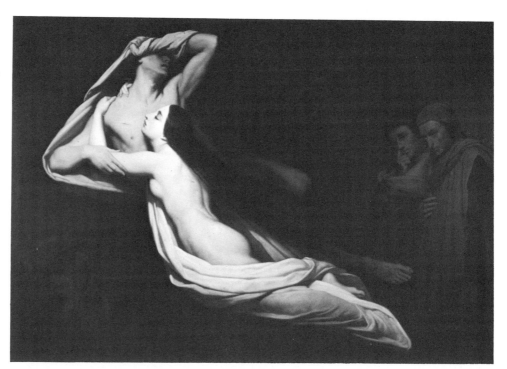

FIGURE 14. Ary Scheffer. *Encounter of Dante and Virgil with Paolo and Francesca* (copy of the painting in the Salon of 1822). 1854. Oil on canvas. 1.14 × 1.63. Amherst College. Photo Donald Witkoski.

things unworthy of you," he wrote. "Concentrate intensely before your painting and think only of Dante. Therein lies what I have always felt in myself."[36] The early pages of the *Journal* are filled with exhortations to himself to fill his mind with the great ideas supplied by the poet and without which, he felt, great painting could not exist. He was not alone in his enthusiasm for Dante. One of his friends and classmates at the Atelier Guérin, Ary Scheffer, also showed a subject from the *Inferno* at the Salon of 1822, *Encounter of Dante and Virgil with Paolo and Francesca.* As friendly competitors, the two men must have been aware of the similarity of their subjects, but Scheffer adopted a theme which had gained acceptance through its treatment by Ingres and Girodet, whose forms he echoed. Delacroix chose to strike out on a more individual path.

36. *J*, P, p. 86 (May 7, 1824).

Dante and Virgil was not, however, as uncompromising a rejection of Davidian standards as is usually supposed. The subject itself was unusual in its emphasis on ignoble anguish and violence at the expense of beauty and elevated, heroic sentiment. But for all its overtones of baroque agitation, its originality lies more in its subject matter than in some mysterious "new" pictorial form. In this respect *Dante and Virgil* has natural affinities with Gros's *Pesthouse of Jaffa* and *Battle of Eylau,* or with Girodet's *Deluge* and Géricault's *Medusa,* none of which represents a wholehearted refutation of academic standards.

To a surprising degree the basic compositional structure of *Dante and Virgil* conforms to neoclassical preferences in its lateral arrangement of figures within a shallow space. Their vigorous curved and diagonal movements are restricted

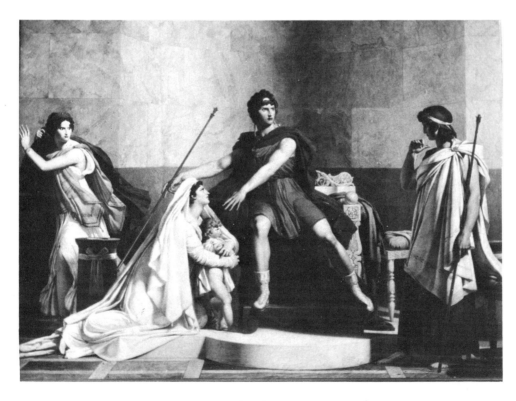

FIGURE 15. Pierre-Narcisse Guérin. *Pyrrhus and Andromache.* N.d. Oil on canvas. 1.31 × 1.76. Musée des Beaux-Arts, Bordeaux. Photo Musée des Beaux-Arts.

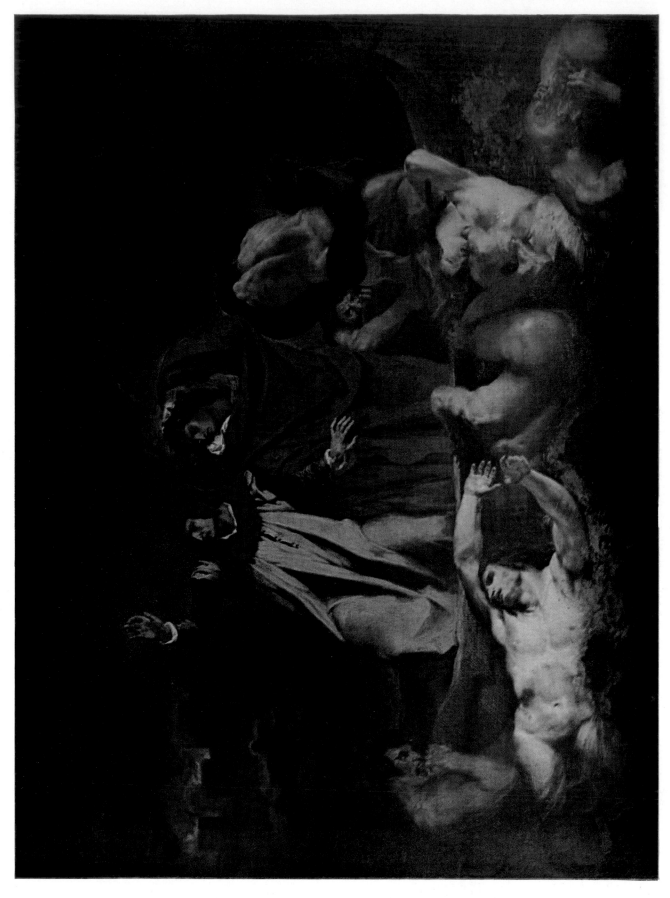

PLATE I. *Dante and Virgil*, 1822. Oil on canvas. 1.89 × 2.46. Louvre.

to the front planes of the picture. The central figure of Virgil stabilizes the movements of Dante and Phlegyas. The emphasis on the profiles of the biting figure at the left and the combatants isolated at the lower right further serves to contain the action within a broadly based and almost symmetrical pyramid. This structure, of course, represents a reworking of the familiar device that had served David for his *Horatii*. It had been confidently recommended by the neoclassicist Mengs, who insisted that every group must form a pyramid and at the same time be as rounded as possible in its relief. What novelty of action Delacroix did attain in his *Dante and Virgil* was accomplished without radical violation of academic rules of composition. Only in the distant focus of Dante's gaze, with its dependence on the viewer to complete its narrative meaning, is there a possible break with the traditional unities of time, place, and action.

In certain other respects the painting leaves prevailing values unchallenged. *Dante and Virgil* is a "history painting," predominantly figural in its emphasis. Its technique stresses plastic qualities of sculptural mass, somewhat at the expense of other possible emphases such as surface texture. Except for the conventional presentations of fire and water (and for all the critics' talk of Delacroix's direct observation of nature, they *are* conventional), there is relatively little appeal to the modern viewer's interest in textural richness. Such textural appeal as the picture has is seen in a formal way in the somewhat broader scale of execution, rather than in any special sensitivity in the treatment of physically varied surfaces. It is not inconceivable, moreover, that the relatively free handling may in fact be the result of the hasty execution of which some of his fellow painters accused him. Delacroix himself remarked upon how little time he had to complete this ambitious project, and it may be that under other circumstances his paint surfaces would have been more "finished."

Intimately associated with the relatively loose execution in *Dante and Virgil* is its rich color, a quality that has attracted critical attention since it was first shown. It should be pointed out, however, that the color range, with its predominantly olive tonality, is hardly more extensive than David's own. The red accents of Dante's cowl and the blue of his sleeves fall within David's palette, as do the rich browns of Virgil's garment. The wide variation in the flesh tones and the strength of the orange lights in the distant fires may push academic preferences to their limits, but even these luministic touches are far from unprecedented, as a glance at the works of Baron Gros will indicate.

Discussion of the precocious "colorism" of *Dante and Virgil* has, moreover, tended to overlook the degree to which the outlines are generally fixed and the color areas firmly bounded. Instead, certain details have been stressed as significant departures from tradition. The touches of dull green in the water droplets on the bodies of the damned, for example, have been taken as evidence of the artist's early interest in the use of complementary hues.[37] The color in this passage is, however, fully within the traditions of baroque painting. Much of the discussion of the painter's colorism, moreover, is heavily dependent upon statements by such informants as Pierre Andrieu and Charles Blanc, who were, it appears, inclined to rewrite history as they sought to interpret the whole of Delacroix's production in the light of his later attitudes. By the time Andrieu became Delacroix's assistant, the master's ideals had, after all, undergone a considerable transformation. So too, unfortunately, had the physical appearance of *Dante* itself. The canvas had, in fact, so deteriorated that in 1857, at Delacroix's own

37. See Lee Johnson, *Delacroix* (London: Weidenfeld and Nicolson, 1963), pp. 18–19 and plate 5.

FIGURE 16. Studies for *Dante and Virgil*. 1820–22.
Conté crayon and pencil. 0.28 × 0.40. Cabinet des Dessins, Louvre. Photo S.D.P.

FIGURE 17. Study for *Dante and Virgil*. 1820–22.
Pen and ink. 0.10 × 0.19. Cabinet des Dessins, Louvre. Photo S.D.P.

request and under his supervision, Andrieu was entrusted with its "restoration."[38] Within the context of nineteenth-century attitudes, it seems highly probable that the painting may actually have been made to conform less to its original look than to Delacroix's recollections of it. The famous drops of water may thus be at best impure evidence. The impasto touches on the surface are less badly cracked than the underlying paint layers, which suggests that they may have been either added or retouched at a later date. Also suspect are the still more intensely "complementary" colors in the minute splashes that appear in a small oil, presumably a study for *Dante*, now in the David-Weill collection in Paris.[39]

38. See Alfred Bruyas, *La galerie Bruyas* (Paris: J. Claye and A. Quantin, 1876), p. 363.

39. See *M*, p. 19.

One's awareness of the degree to which *Dante* is somewhat miscast in the role of a deliberate and total departure from tradition should not, however, be permitted to obscure the genuine artistic power and originality of the work. What is, in fact, one of its most impressive attributes is its early embodiment of Delacroix's characteristic desire to mediate between tradition and innovation. The unity and individualism of his canvas were not obtained without great effort, as the many surviving studies show. These trial sketches include preliminary drawings that trace Delacroix's attempts to define his subject.[40] Another group of vigorously executed studies illustrates the further process of determining the character and pose of individual figures, and still others relate to the problem of inventing an appropriate setting.

An instructive compositional study in pencil, pen and ink, and wash is now in the National Gallery of Canada. Here the basic elements of the final version appear, but in reverse. As in the painting, the main figures assume a pyramidal arrangement, although the formal order is strained and the poses somewhat mechanical. The figure of Phlegyas is all but obscured by those of Dante and Virgil. The damned are fewer and less prominent, except for the pair in the lower right corner. One, probably Dante's Filippo Argenti, stretches out his hand to attract the poet's attention. In this and other respects, the sketch is more literal in its interpretation than the completed work.

40. See *M*, pp. 16, 20–25.

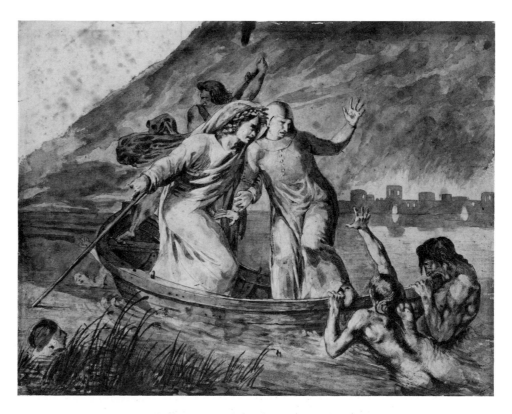

FIGURE 18. Composition study for *Dante and Virgil*. 1820–21?
Pencil, pen and ink, and wash. 0.29 × 0.39.
The National Gallery of Canada, Ottawa, Bequest of Mrs. Ruth Massey Tovell, Toronto, 1961. Photo John Evans.

FIGURE 19. Studies for *Dante and Virgil*. 1820–22.
Pencil, pen and ink. 0.20 × 0.32. Cabinet des Dessins, Louvre. Photo S.D.P.

At the same time, it is notable that certain of the later elements are mirrored in the study, particularly the motif of the burning city and the grotesque creature gnawing at the prow of the boat. A series of drawings of the latter detail show comparatively little change. Whether this indicates the artist's spontaneous invention of a particularly haunting image or a conscious dependence upon a borrowed fragment is difficult to decide. Although Sérullaz's proposal of a drawing of Ugolino ascribed to Géricault as a source has been questioned, one must admit that the resemblance is striking.[41] It is in any case difficult to dismiss the possibility that some prototype (perhaps in the art of Goya) originally suggested the inclusion of this curious gargoyle.

There would have been no inconsistency in such a derivation, for Delacroix was convinced that "what creates men of genius, or, rather, what they create, is not new ideas but the idea, which possesses them, that what has been said has still not been said enough."[42] In later years he even came to see eclecticism as "the French banner in the arts of design and in music."[43] Hence Andrieu's report that the back of Phlegyas, whom he calls Charon, was derived from the Belvedere torso is not surprising.[44] And while, by the same testimony, a model called "Suisse" posed for all the other figures, and a great number of the surviving studies were clearly made from a live model, one must recall that Delacroix was always inclined to regard nature through the medium of art. Attempts to establish specific debts to Michelangelo, Rubens, Goya, Puget, or Flaxman, therefore, have value more as reminders of Delacroix's far-ranging, active memory and his deference to tradition than as definitions of his creative process.[45]

When his long effort was over, Delacroix confidently invited his teacher, Guérin, to approve his work before it was sent to the salon jury. Far from being

41. See Maurice Sérullaz, *Musée du Louvre, les dessins de Delacroix (1817–1827)* (Paris: Morancé, n.d.), pp. 27–28, and *cf.* Lee Johnson, "The Formal Sources of Delacroix's 'Barque de Dante,'" *Burlington Magazine*, 100 (July, 1958):228–32. Johnson rejects both the attribution of the drawing and its introduction as a source. It was, however, a drawing that is presumed to have been available to Delacroix. The artistic merit of the drawing and its attribution do not in themselves either confirm or deny its credibility as a possible source.

42. *J* 1:101 (May 15, 1824).

43. *J*, 3:49–50 (Jan. 25, 1857). His assertion here is similar to statements made by his friend Victor Cousin about philosophy. Cousin considered eclecticism "a doctrine *toute française*" (1850).

44. See René Piot, *Les palettes de Delacroix* (Paris: Librairie de France, 1931), p. 72. This account derives from that contained in Bruyas, *La galerie Bruyas*, p. 362.

45. See, for example, Johnson, "Delacroix's 'Barque de Dante,'" pp. 228ff.; Michel Florisoone, "Comment Delacroix a-t-il connu les 'Caprices' de Goya," *Bulletin de la Société de l'Histoire de l'Art Français*, 31 (1957):131–44; Irène de Vasconcellos, *L'Inspiration dantesque dans l'art romantique française* (Paris: Picart, 1925).

FIGURE 20. Studies after Goya. Ca. 1818–24.
Pencil, pen and ink, and wash. 0.17 × 0.10. Cabinet des Dessins, Louvre. Photo S.D.P.

FIGURE 21. Pierre Puget. Caryatid. 1656.
Stone. Entrance to the Hôtel de Ville,
Toulon. Photo Giraudon.

46. Piron, *Delacroix*, pp. 51–52.

impressed by the result of his student's talent and industry, Guérin tried to discourage him from submitting it. He urged Delacroix to wait until a later competition, when he would be better prepared to put himself before the public. Fortunately, Delacroix was not dissuaded. *Dante* was presented to the jury and accepted for exhibition at the Salon of 1822. At least one of the jurors, Baron Gros, was much impressed with the entry, which he called "Rubens chastened." He himself paid for a suitable frame, which Delacroix could not afford, and as a mark of further favor he received Delacroix in his studio—a privilege he rarely extended—and is reported to have offered to accept him as a student. Delacroix declined the offer, and his account of his visit reflects his wariness of becoming involved with Gros:

He asked me whether there was anything he could do for me. Immediately I requested to be allowed to see his renowned pictures of the Empire, which were for the time being kept in the obscurity of his atelier, as they could not be publicly exhibited at that time because of the nature of their subject matter. He let me stay there for four hours, alone part of the time, or with him amidst his sketches and preliminary works; in brief, he extended the tokens of greatest trust—and Gros was a very uneasy and suspicious man. If some trace of personal motive must be found in such a show of approval, I later sensed bitterness in Gros's behavior towards me, sensed that he had thought of keeping me around him to obtain the Prix de Rome for me while in his school. Ever since, in spite of my naïveté, I charted a different course and declined that protection.[46]

Of more immediate importance for Delacroix's career, however, was the fact that the critics were inclined to share, not Gros's enthusiasm, but Guérin's doubts about the canvas. The influential Étienne Delécluze, for example, dedicated to neoclassicism, referred to *Dante* as a "daub." Others expressed comparable dissatisfaction. The looseness of touch that is now admired then seemed crude. Delacroix's strength as a colorist aroused more criticism than praise. Drawing was associated with moral law and reason and was therefore considered superior to color, with its appeal to sense and emotion, and, at a time when even Rembrandt and Rubens were generally unpopular, the baroque overtones of Delacroix's scene of anguish were unwelcome.

In the midst of adverse comment and quite unexpectedly, an article appeared in the *Constitutionnel* in defense of Delacroix.[47] The piece was written by Adolphe Thiers, a young lawyer from Marseille new both to Paris and to journalism. His review was notable not only for its espousal of Delacroix's cause but for an acumen remarkable in a writer with no background in art criticism. Perhaps his very inexperience permitted Thiers this freedom of opinion. It has since been inferred that his words were his own but that his judgments were borrowed, perhaps from Baron Gérard. Some have gone so far as to discredit Thiers' motives altogether, seeing in the defense of *Dante and Virgil* more political guile than aesthetic perception and postulating some unseen protector (Talleyrand is usually named) at whose urging the painter's reputation was being bolstered.

Whatever Thiers' real intentions may have been, Delacroix was grateful and apparently had no suspicion that he might have had an ulterior motive.[48] He recognized his need of allies, as is made clear in a letter to his sister.[49] He counted Baron Gérard among the "warm partisans" of his picture and supposed, quite plausibly, that the Duke of Orléans himself had been the inspiration for an inquiry he received from Count de Forbin, the Director of Museums, concerning the price of the canvas. In his reply to the Count, Delacroix named a figure of Fr. 2,400, but he made clear his willingness to bargain[50] (he later accepted half his original price for the work).

Early in September Delacroix had the satisfaction of learning that his *Dante* had been installed in the galleries at the Luxembourg Palace. He received this news while visiting his older brother Charles, a former general in the imperial army, then comfortably retired at the village of Le Louroux, where he had a small estate. Somewhat self-satisfied with his current professional success and in good spirits, Delacroix began his *Journal* at Le Louroux on Tuesday, September 3, 1822.[51]

The diary begins a bit self-consciously: "I am carrying out the plan to keep a journal that I have so often formulated. My greatest desire is never to lose sight of the fact that I am writing for myself alone; this will, I hope, keep me truthful and do me a lot of good. These pages will reproach me for my fickleness. I am in a happy frame of mind as I begin."[52] The rest of the talk is of his brother, engravings after Michelangelo, his own painting, and, most of all, of Lisette, a local girl. It seems a little curious that it was not until the second entry, made two days later, that he mentioned having begun his project on the eighth anniversary of his mother's death: "May she be with me in spirit as I write, and may she never have cause to blush for her son."[53]

47. A. Thiers, "Salon de 1822," *Constitutionnel*, May 11, 1822. The "authority" Thiers cites is usually assumed to be Baron Gérard.

48. This is made especially clear in one of the entries of the *Journal* in which Delacroix records his defense of Thiers against what seems to have been the angry accusations of Charles Blanc (see *J*, 3:72 [Mar. 5, 1857]). Thiers is mentioned in one of the last entries in the *Journal* (see *J*, 3:334 [May 4, 1863]).

49. *C*, 5:132 (to Mme de Verninac, June 16 or 17, 1822).

50. *C*, 1:142–43 (to Count de Forbin, June 1, 1822).

51. It was not until 1893 that the *Journal* was finally published. The later edition, edited by Joubin and published in 1932, remains a monument to the editor's dedication in reassembling and collating a mass of long-dispersed material. The present *Journal* shows lapses from 1824 to 1833 and from 1835 to 1843. The year 1845 is lacking, as is 1848, which the author is said to have left in a carriage on his return to Paris from a trip to Champrosay. There is another gap from 1851 to 1854. A few pages remain from 1863, the year of the artist's death. The story of the circumstances surrounding the recovery and reconstruction of the *Journal* is summarized by Wellington (*J*, W, pp. xxviii–xxix).

52. *J*, 1:1.

53. *J*, 1:5.

The *Massacre at Scio* and the Salon of 1824

In spite of the relative success of his first moves toward professional independence, Delacroix hesitated to make a complete break with his student days. When he returned to Paris in late September, he went back to the Atelier Guérin to participate in the competition for placement in the third trimester of the year 1822. He did not remain there long, however. One day, relapsing into schoolboy behavior, he accidentally poured a bucketful of water, intended for his classmate Champmartin, on Pierre Guérin instead. Still smarting from Delacroix's notoriety at the Salon, Guérin summarily expelled him from his studio.

At the advice of his uncle, Riesener, Delacroix set out on his own. For some months he played the man about town and indulged himself in music, parties, and ice cream at the fashionable Tortoni's. Much of his time and attention was devoted to a series of brief amorous liaisons, while his work progressed at a halting pace. A number of studies—portraits, studio interiors, and *académies*—date from this period, but it was not until January of 1824 that he was at last ready to begin work on what would be one of his most famous canvases, *Massacre at Scio*.

A subject which was at once contemporary and exotic, the *Massacre at Scio* was well suited to his interests. The massacre, an episode in the Greek wars of independence, had the same kind of topical and dramatic appeal Géricault had played upon in his *Raft of the Medusa*, but without dangerous political overtones. At the same time, Delacroix's "scenes of massacre" reflected a widespread curiosity about the Moslem lands aroused by Napoleon's near eastern campaigns.

Although Delacroix did not see for himself the wonders of that alien culture until 1832, the East already held personal associations for him. His brother-in-law, Raymond de Verninac, had served as French ambassador to the Sultan of Turkey, and his brother Charles had recently been there. While the rest of the family disapproved of Charles's unconventional behavior, especially his marriage to an innkeeper's daughter, Eugène Delacroix remained devoted to him. The very first entry in the *Journal* indicates their easy and intimate relationship, and one of his ardent letters to Elizabeth Salter suggests that he was an eager listener to Charles's tales of adventure: "Keep those Pastils of Seraglio, wich [*sic*] my brother has carried back of Turkey and given to me."[1]

As early as 1817 Delacroix made two lithographs from Persian miniatures, *The Ambassador of Persia* and *The Ambassador's Favorite Slave* (Delteil 26, 27). At about the same time he painted *Aline the Mulatto* and *Aspasia the Moorish Girl*. These works, handsome in themselves, take on added interest as indications of his growing preoccupation with Oriental subjects. The decision to dedicate a major effort to the specific theme of exotic conflict had been forming in his mind, if vaguely, for some time. It will be recalled that as early as September 15, 1821, he wrote Soulier that he was considering a subject from the Greek wars of independence: "I believe that under the circumstances this will be a way of distinguishing myself, especially if the execution is good. I wish you would send me

1. Quoted in Russell, "That Devilish English Tongue," pp. 117–18.

some drawings of your countryside around Naples, some sketches made after views of the sea or of picturesque mountains. I am sure that this will give me inspiration for the setting of my scene."[2]

For some reason, however, Delacroix changed his mind and instead began his *Dante and Virgil* for the Salon of 1822. The war subject that had at first attracted him was not Scio but the exploits of Marco Bozzaris, the colorful Albanian hero.[3] An entry in the *Journal* for April 12, 1824, well after he had begun work on *Massacre at Scio*, indicates that the former idea still attracted him: "I must make a large sketch of Bozzaris: the Turks, *taken by surprise and throwing themselves all over each other in panic*. Luncheon, 15 sous."[4] He put aside the Bozzaris picture, however, because of his growing involvement with the problems presented by *Scio*.[5] When he finally did return to the idea years later, he never completed the work.

Delacroix's interest in the cause of modern Greece was natural enough. The Turkish rulers of Greece and its neighboring islands had few sympathizers in western Europe, which had traditionally been hostile to their presence on that continent. Such figures as Lord Byron and Marco Bozzaris took on almost legendary stature as tales of Turkish cruelty were issued almost daily by the Philhellenes. Typical of the interest is a fragment in the second entry of Delacroix's *Journal*, deriving, no doubt, from conversations with his brother: "When the Turks find wounded on the battlefield," he wrote, "or even with prisoners, they say to them, 'Nay bos' ('Don't be afraid'), then they strike them in the face with a saber handle to make them hang their heads, and rob them."[6]

During the autumn of 1822, even those Europeans jaded by propaganda and inured to wars and suffering were shocked to hear of the latest Turkish outrage, the sack of Scio, or Chios. The Ottoman fleet, recovered from its recent defeat by the Greeks under Miaoulis at Patras, turned for revenge upon the rich and peaceful island of Scio, whose citizens, ironically, had not fought against them. Ten thousand troops were loosed upon the island, and at the end of a month of massacre and looting, of an estimated population of one hundred thousand, it is reported that only nine hundred survived. Some twenty thousand victims were butchered, while the others, mostly women and children, were carted off to be sold into slavery. In selecting the massacre rather than Marco Bozzaris as his major salon subject, Delacroix chose to dramatize a brutal and pointless sacrifice.

The *Journal* provides valuable insights into Delacroix's state of mind during this period. It is clear from its pages that, for all his resolve to fulfill what he considered his artistic destiny, it was often difficult for him to abandon sensuous temptations. They also indicate a continuing need for external stimulation. He fed his enthusiasm through conversations with people who had actually visited Greece, much as Géricault sought out survivors from the "Medusa." On the morning of January 12, 1824, for example, Delacroix had an appointment with Raymond Verninac (not his brother-in-law, who died in 1822) in order to meet a man named Voutier, who had recently returned from Greece. His appetite for first-hand information had probably been whetted by the *Mémoires de Colonel Voutier sur la guerre actuel des Grecs*, which was published in December, 1823.

His *Journal* entry on the day of the meeting describes Voutier as "good-looking and Greek in appearance."[7] They had a conversation, and Voutier stirred Delacroix with accounts of Hellenic bravery, describing the patriots trampling their oppressors underfoot amid shouts of "*Zito Eleutheria!*"—"Long Live Liberty!"

2. *C*, 1:132.

3. See *C*, 1:132, n. 1. Chief of a picturesque tribe known as the Souliotes, Bozzaris had come down from the hills to fight in the Greek cause. He soon gained fame for an adventurous but brief campaign against the Turks which ended with his death at Karpenisi, where his men defeated a much larger Ottoman force. He was buried at Missolonghi, in the same church in which, soon after, Lord Byron was buried (see Leslie Marchand, *Byron, a Biography* [New York: Knopf, 1957], 3:1235). Other artists of the time were also attracted by tales of the Souliotes. Probably the most ambitious of these representations was the large canvas *Souliote Women*, which Ary Scheffer showed at the Salon of 1827.

4. *J*, 1:76. Joubin suggests (n. 3) that this is No. 1407 in the Robaut catalogue, an unfinished painting sold as No. 99 in the posthumous sale of Delacroix's works. Silvestre refers to it in his notices on the works shown at the sale. It now seems more likely that this is a much later work, dating, as Robaut suggests, from the master's last years. As was characteristic of him, Delacroix returned to a subject that had attracted him. In his annotations of his own catalogue Robaut observes that a dealer cut the canvas into five parts, which fragments were remounted and the backgrounds filled in to make up five separate pictures. One of these and a small canvas showing the intended composition are now in the Jacques Dupont Collection in Paris.

5. It was customary for Delacroix to have more than one project under way at any given time. The demands made by *Scio*, however, made it necessary for him to set aside other, lesser projects, including Tasso.

6. *J*, 1:5 (Sept. 5, 1822).

7. *J*, 1:43–44.

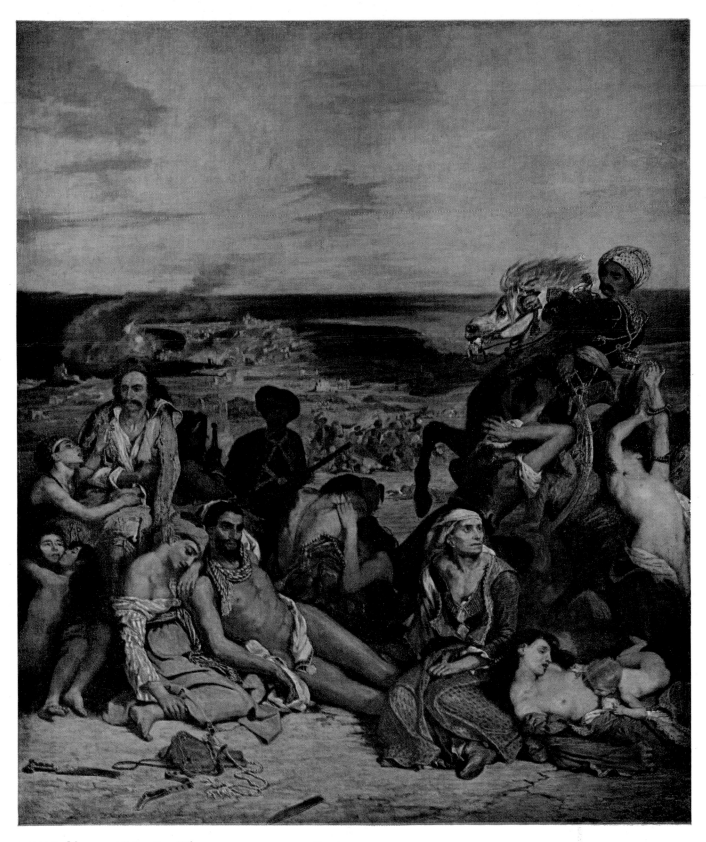

PLATE II. *Massacre at Scio*. 1824. Oil on canvas. 4.17 × 3.54. Louvre,

8. See Voutier's note to p. 251. Michel Florisoone ("La genèse espagnole des Massacres de Scio de Delacroix," *La revue du Louvre et des musées de France*, 13 [1963]:204) points out that this motif was introduced some time after December 30, 1823, as a drawing of that date shows another line of intended development.

9. *J*, 1:45.

10. *J*, 1:53.

11. *J*, 1:60.

(This might be the germ of the motif in *Liberty Leading the People*.) The *Journal* records one more tale of Turkish brutality, but there is no mention of the Colonel's memoirs themselves, which is curious because in them Voutier quotes a witness of the disasters of Scio as saying that "nothing had made a more pathetic impression on his whole being than the sight of the corpse of a young woman whose baby grasps with empty hands at her withered breasts."[8]

After his lunch with Voutier, Delacroix began work on the huge canvas that had been awaiting him at his studio.[9] The *Journal* indicates that only fitful progress was made as, working partly from the model, he attempted to complete the drawing. Soulier, who had recently returned from Italy, helped his friend lay in the first coat for the background areas on February 22[10] (it was not unusual for young painters to lend each other such assistance in beginning large projects they were preparing for the salon). A fortnight later, on Sunday, March 7, Soulier visited Delacroix's studio with their English friend Thalès Fielding, himself an accomplished landscapist. Fielding "arranged" the background for him.[11] Work on the canvas progressed throughout the spring. On May 7 Delacroix wrote, with a curious mixture of sensibility, insight, and braggadocio:

My picture is acquiring a twist, an energetic movement that I must absolutely complete in it. I need that good black, that blessed dirt, and those limbs I know how to paint and few even try to get. The mulatto model will serve my purpose. I must get fullness. If my work loses in naturalness, it will be more beautiful and more fruitful. If it only holds together! O smile of the dying! The look of the mother's eye! Embraces of despair, precious domain of painting! Silent power that at first speaks only to the eyes, and which wins and makes its own all the faculties of the soul! There is the spirit, the real beauty that is proper to you, beautiful painting, so insulted, so misunderstood, delivered up to the blockheads who exploit you. But there are hearts who will still receive you devoutly; souls who will not be satisfied with phrases, any more than with fictions and ingenuities. You have only to appear with your manly and simple vigor, and you will please with a pleasure that is pure and absolute. Admit that I have worked with reason. I do not care for reasonable painting at all. I can see that my turbulent mind needs agitation, needs to free itself, to try a hundred different things before reaching the goal whose tyrannous call everywhere torments me. There is an old leaven, a black depth that demands satisfaction. If I am not quivering like a snake in the hands of Pythoness, I am cold; I must recognize it and submit to it, and to do so is happiness. Everything I have done that is worth while was done this way.[12]

12. *J*, P, pp. 85–86. *Cf. J*, W, p. 38; *J*, 1:96–97.

13. *J*, W, p. 38. *Cf. J*, 1:97.

Two days later he noted that his picture was "beginning to take on a different appearance," with "confusion . . . giving place to somberness."[13]

Delacroix's studio, then located in an "unconsecrated church" near the Place Saint-Michel, seems to have been the meeting place for friends and acquaintances, much like studios in the Quarter even today. The convivial atmosphere suggested in his accounts of his activities contrasts sharply with the isolation he stoically maintained in his studios of later years. The company that gathered there, the parties, the arguments, and the flirtatious engagements with models and *grisettes* pictured in the *Journal* suggest a *vie de bohème* so typical as almost to be suspect but for the fact that Delacroix's description was almost lost and was never meant to be read by any other person. His male friends served as models, while some of the female models were also friends. J. B. Pierret, Delacroix's comrade since his days at Louis-le-Grand, posed for both the studies and the final version of the seated man in the center of *Scio*, and Émilie, Laure, Hélène, and other models provided their professional as well as personal services.

It was often hard for Delacroix to work effectively under these conditions. He sometimes resented the demands of his friends and had to struggle to resist the lures of impromptu parties and to fend off uninvited guests. Then too, not all of his friends shared his artistic convictions or understood the true nature of his ambitions, and many did not realize how unwelcome their criticism could be. Rouget in particular seems to have been unaware of the anger he aroused in Delacroix by his blunt expression of Davidian prejudices. One such occasion is described in the *Journal*:

Today, just as I was starting to work on the woman being dragged by the horse, Riesener, Henri Hugues, and Rouget stopped by for a visit. Just think how they behaved towards *my poor creation*, which they saw in such a messy state that only I could guess what might come of it. "Look here!" I told Édouard, "I must fight against bad luck and a lazy disposition. I have to earn my bread with a little enthusiasm and then buggers like these come around, right into my very lair, nip my inspirations in the bud and look me up and down through their eyeglasses—these fellows who wouldn't wish to be a Rubens!" Thank Heaven I have been blessed, for all my misery, with the *sang-froid* necessary to keep at a respectful distance the doubts which their silly remarks often used to arouse in me. Even Pierret made some observations, but these didn't bother me, since I know what still has to be done. Henri wasn't as difficult as the others.
After they left I got the whole thing off my chest with a broadside of curses at mediocrity. Then I crawled back into my shell.
I was really put off by the praises of M. Rouget, who wouldn't want to be Rubens. He is borrowing the study, meanwhile, and I made a mistake in promising it to him. It might perhaps be useful to me.[14]

Delacroix was coming to regard his work as the only sustaining reality of his life. "What are most real to me," he wrote, "are the illusions I create with my painting. The rest is shifting sand."[15] But he then added, "My health is bad, as capricious as my imagination." His tendency to fits of depression further sapped his creative energy. On March 1 he noted, for example, that he had not worked all day and that he had "spent a sad evening alone in a cafe. Went home at ten o'clock. Re-read some of my old letters, including some of Elizabeth Salter's. How strange it seems after so long."[16] Two days later he exhorted himself, "Work hard at your picture. Meditate on Dante. Read him again. Exert yourself continually to keep your mind on great ideas. How shall I profit from my almost complete solitude if I have nothing but commonplace thoughts?"[17] While Delacroix does not seem to have accepted the traditional notions of immortality, he did cling to the promise of such earthly survival as his creative activity might provide: "Glory is not an empty word with me. I joyfully drink in the sound of praise."[18] The *Massacre at Scio*, therefore, was more than just another picture: it was Delacroix's test of his faith in himself.

In the course of this test he was, however, aware of his own vulnerability. He was haunted by the specter of fleeting time and death, and his "romantic agony" was intensified by the pathetic spectacle of Géricault's lingering, fatal illness. On May 16, 1823, he reminded himself, "Don't forget the allegory of the man of genius at the portals of the tomb."[19] The following January he received word of Géricault's death, and there is a touching reference to it in his *Journal*.[20] Months later Delacroix was still obsessed by intimations of mortality. "Poor Géricault!" he wrote. "I saw you go down into the narrow house, where there are no longer even dreams."[21]

14. *J*, 1:48–49 (Jan. 25, 1824).

15. *J*, P, p. 64 (Feb. 27, 1824).

16. *J*, W, p. 25 (Mar. 1, 1824).

17. *J*, W, pp. 25–26 (Mar. 3, 1825).

18. *J*, 1:88 (Apr. 29, 1824).

19. *J*, P, p. 49. As late as June 14, 1851, he again mentioned his wish to paint an allegory of Glory (see *J*, 1:440).

20. *J*, P, p. 61 (Jan. 27, 1824). See the painting by Ary Scheffer, *The Death of Géricault*, in the Louvre.

21. *J*, P, p. 87 (May 11, 1824).

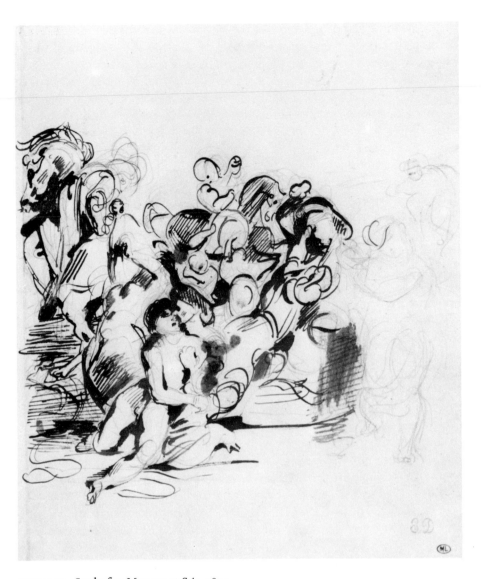

FIGURE 22. Study for *Massacre at Scio*. 1824.
Pencil, pen and ink. 0.23 × 0.38. Cabinet des Dessins, Louvre. Photo S.D.P.

The surviving studies for the *Massacre at Scio* provide some insight into the way in which he developed his theme. Representing a still tentative stage of the evolution of his composition is a small pen-and-ink drawing, now in the Louvre. Only the main masses and movements have been indicated, with very little attention to interior detail, yet this exploratory sketch contains a sense of the final composition. The motif of the rearing horse and its threatening rider is already recognizable, if differently disposed. The struggling female nude also appears to the left center and, except for her placement, is strikingly similar to the final version. The seated male figure, here at the center, also recurs in the completed picture. Even the main lines of the final composition have been anticipated, as the two prevailing diagonals thrust outward from the center to the upper corners. In a variety of ways, therefore, this small sketch, with its heavy line—not unlike Géricault's—contains the seed of the finished work.

A small but elaborate water color of the subject shows *Massacre* at a more developed stage.[22] The device used here of splitting the foreground figures into two main groups to open up the middle distance at the center of the composition was retained. By this point Delacroix had also settled on most of the final groupings, if not the precise details. The embracing couples, the menacing Turk, and the struggling women all assume more or less fixed relationships. This study is also of interest in the derivation of certain details—especially in the horse—from a water-color copy of details from two seventeenth-century Persian miniatures which Delacroix made about 1823.[23]

Certain significant differences may also be noticed. Perhaps as a concession to neoclassical taste, the cowering couple are stripped of their protective cloak in the oil. The revision makes them seem nobler, if perhaps less touching, than their counterparts in the water color. The transformations of the right foreground figures are even more important. The seated woman in the study has been fused with the figure of the older woman who appears just beyond her, and while in the water color the mother is shown seated and staring at her dead baby, in the oil she is slumped in death with her still suckling infant vainly clinging to her.

A more schematic drawing in pencil, now in the Louvre (R.F. 9 201), shows these later revisions. Still other studies rehearse various details in preparation for the full-scale execution. Some of these, such as a page of pencil drawings for the lovely female captive (Louvre R.F. 9 207), appear to have been done from life. In this case it is known that Émilie Robert, who was for a time Delacroix's mistress as well as his model, posed for the figure in the painting and probably for these sketches as well.[24] The *Journal* for this period refers to other models: for example, Mme Clément posed with her baby for the dead mother.[25] The studies of the Turkish horseman are particularly impressive and are, if anything, superior to the finished figure in their air of relentless, domineering energy (Delacroix also made at this time a series of splendid studies of horses).

At this time Delacroix was attempting to master the technical problems of oil painting. His two "finished" canvases, *Orphan Girl in the Cemetery* and *Head of an Old Woman*, were exhibited along with *Scio* at the Salon of 1824. They were listed together as *études*, No. 451 in the exhibition catalogue. Like the related earlier portraits of Aspasia and Aline, these works contain passages of unusual beauty and expressiveness. In *Orphan Girl* the painter has recorded sympathetically the simple dignity and innocence in the frail face of a beggar child he induced to pose for him. Delacroix stated that this girl's head was later reworked into that of the Greek boy at the extreme left of *Scio*.[26] Although the girl's features are more delicate than the boy's and her facial expression more refined, *Orphan Girl* is similar to *Scio* in coloristic character, fluid touch, and, especially, in its landscape, with its generalized, faintly golden light.

As Delacroix experimented with technical problems, he continued to search for documentation that would aid him in his work. With the curiosity which had led him to seek out Colonel Voutier, he gathered the published accounts of travelers who had visited Turkey, Greece, and Egypt, as well as prints and books of illustrations.[27] The *Journal* records his purchase of some wood engravings of Turkish costumes by Scheick, two books, *Habits and Customs of the Turks*, published in 1790 and written by a sculptor named Rosset, and *Letters on Greece and Egypt*, by the eighteenth-century traveler and orientalist Claude-Étienne Savary.[28] These interests had, in fact, become so strong that Delacroix was seriously considering a trip to Egypt, in preparation for which he planned to learn Arabic.[29]

22. It has been suggested that this may be the "composition" referred to in his *Journal* for November 9, 1823 (see Florisoone, "La genèse espagnole," p. 204, and *cf. J*, 1:35).

23. See Lee Johnson, "Two Sources of Oriental Motifs Copied by Delacroix," *Gazette des Beaux-Arts*, 6th ser., 65 (March, 1965):163. The miniatures, representing a cremation scene and a funeral procession, were part of a set made for Shah Abbas II of Persia, acquired by the Bibliothèque Nationale in the first half of the eighteenth century.

24. For a general discussion of Delacroix's models, see André Joubin, "Les modèles de Delacroix," *Gazette des Beaux-Arts*, 15 (1936):345–60.

25. *J*, 1:88 (Apr. 27, 28, 1824).

26. See *J*, 1:52. The painter notes that on February 17, 1824, he paid seven francs "to the beggar who posed for the study in the cemetery." He adds that he "made the young man in the corner after the beggar."

27. At about this time Delacroix finally did borrow some of the sketches Soulier had made during his stay in Naples (see *J*, 1:94 [May 7, 1824], and n. 26 above).

28. *J*, 1:92–93, and n. 2, p. 92.

29. *J*, 1:81 (Apr. 20, 1824).

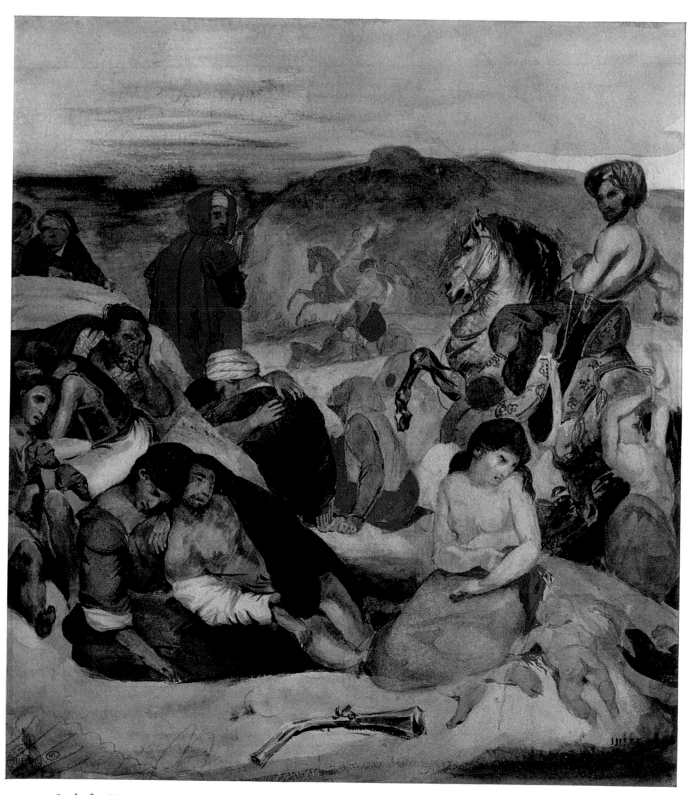

PLATE III. Study for *Massacre at Scio*. 1824. Water color. 0.34 × 0.30. Louvre.

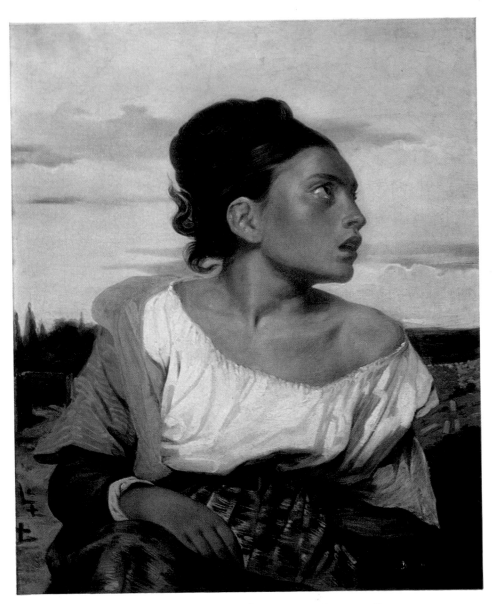

PLATE IV. *Orphan Girl in the Cemetery.* 1824. Oil on canvas. 0.65 × 0.54. Louvre.

30. *J*, 1:72 (Apr. 11, 1824).

31. See *J*, 1:90 (May 1, 1824), and Huyghe, *Delacroix*, p. 517, n. 14. Huyghe discusses Delacroix's relationship with the General and his wife (Delacroix seems to have been on very intimate terms with Mme Coëtlosquet).

32. See Musée de L'Orangerie, *Voyage de Delacroix au Maroc, 1832, et exposition rétrospective du peintre orientaliste, M. Auguste*, intro. André Joubin (Paris: Musées Nationaux, 1933), p. xv. For the most extensive discussion of M. Auguste, see Charles Saunier, "Un artiste romantique oublié, Monsieur Auguste," *Gazette des Beaux-Arts*, 52 (1910), no. 1: 441–60; 2:51–68, 229–42. When Auguste won the first prize, David d'Angers won second.

33. Delacroix was introduced to Auguste by Géricault some time in 1817, not in 1815, as Escholier implies (*Delacroix*, 1:120). Since Delacroix had not yet met Géricault in 1815, nor had he enrolled in the École des Beaux-Arts, that date seems too early. The younger man's aquatint copied after a composition by Auguste, entitled *Hunt (chasse à courre)*, probably dates from that year, not in 1816, as Delteil indicates in his catalogue (no. 5). Delacroix particularly admired his friend's representation of horses, which were of the slender Arabian type Delacroix himself usually preferred for his own compositions (see *J*, 1:116 [June 30, 1824]).

The acquisition of authentic objects which could be used as models for his picture was not without its frustations for one whose desires vastly exceeded his purse. "What a miserable Jew," he complained of a shopkeeper in the Palais Royal known as "the Turk," "with his cloak that he didn't even want to let me see! But however that may be," he added—revealing the sound basis of "the Turk"'s suspicions—"I more or less have its cut."[30] Fortunately, his friends and acquaintances helped. He tells of borrowing Mameluke weapons from General Coëtlosquet, for whom he later painted the famous *Still Life with Lobsters*, now in the Louvre.[31] On numerous occasions he profited from the generosity of the wealthy, widely traveled dilettante Jules-Robert Auguste, who had brought back an assortment of costumes and artifacts from his travels in Egypt, Greece, and Asia Minor. "Monsieur Auguste," as he was respectfully called even by acquaintances of long standing, won the Prix de Rome for sculpture in 1810. Some say at Géricault's suggestion, he turned to painting upon his return to Paris in 1815.[32] His apartment on the Rue des Martyrs, next door to Géricault, became a haunt of the younger artists, including Delacroix. They were attracted, it seems, not only by his collection of curios and his copies of the masters, but also by some magnetism of his own. When he began *Scio* Delacroix had known Auguste for several years and had a high regard for his opinion.[33] The *Journal* of 1824 mentions visits to him, and on several occasions he notes having borrowed costumes or other effects for his project from Auguste.

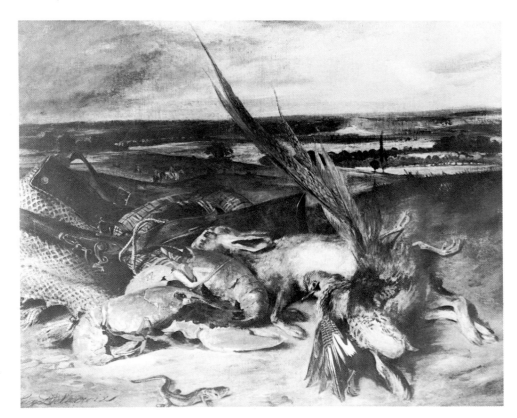

FIGURE 23. *Still Life with Lobsters*. 1827.
Oil on canvas. 0.80 × 1.06. Louvre. Photo S.D.P.

Work on the large canvas continued off and on throughout the summer, but, according to Paul Chenavard, who met Delacroix in 1825 and became one of his closest friends, it was still unfinished when it was taken to the Louvre.[34] Delacroix was apparently dissatisfied with it when he saw it in the spacious, brightly lighted gallery. Baron Gros again interceded on his behalf, and Delacroix was granted a privilege usually reserved for older and better known artists: he was permitted to revise his work in the Louvre under the lighting conditions in which it would be seen when the salon opened.

The Salon of 1824 attracted its usual flurry of excitement. Once more Delacroix's critical reception was mixed. Adolphe Thiers, writing as before in the influential *Constitutionnel*, selected for special comment "a *Massacre of the Greeks of Scio* by the young Lacroix, where he not only fulfills but surpasses all the promise of his painting of *Dante*, and where, side by side with the disorder of a powerful imagination still somewhat lacking in self-control, are to be found heartrending expressions, some admirable groups, and astonishing coloristic effects."[35] He did not, however, wholeheartedly approve Delacroix's boldness and found Léopold Robert's *Neapolitan Singer* superior in its smoother execution.

One of Delacroix's most enthusiastic supporters was the vocal Auguste Jal, who presented his opinions through the mouths of two fictitious visitors to the salon. One of these, a philosopher, found the *Massacre at Scio* "the most beautiful picture in the exhibition, for it is the most expressive."[36] Jal's further comments suggest that he was moved more by moral passion than aesthetic conviction when he wrote: "I do not know M. Delacroix, but if I should meet him, I would create the most extravagant scene. I would embrace him. I would congratulate him, and I would weep—yes, weep for joy and gratitude. Brave young man! May fortune aid him! He deserves well of friends of the arts! He deserves well of the enemies of despotism, for he has shown it in all its horror!"[37]

Unfortunately, the majority of the critics seem to have shared neither Jal's opinion nor his appreciation of the new spirit of individualism that was widely apparent at the salon. Étienne Delécluze, an unremitting opponent of the new art, stubbornly returned to the attack on Delacroix's reputation that he began in 1822, this time curtly dismissing the young painter as a "fool hawking his wares from the housetops."[38] Another unidentified defender of the *status quo* praised only as a means of disparagement. "His bad picture is superb in color," he wrote, "and it is not without certain very fine facial expressions, *but everything ought to aim at common sense.*"[39] The similarly minded Auguste Chauvin called down the judgment of a history not yet written: "The delirious author meaninglessly gathers together scenes of atrocity, spills blood, tears out entrails, paints agony and despair. *Posterity will never accept such works*, and contemporaries of good faith will tire of them. They are tired of them already."[40]

It is strange that Baron Gros was conspicuous among those who led the attack upon Delacroix. In a sudden shift of attitude that has never been satisfactorily explained, he disdainfully quipped that Delacroix's *Scio* was "the massacre of painting." When Delacroix respectfully greeted him at the salon, Gros reprimanded him sharply: "It's not a matter of bows. You have to draw well and not confuse good painting with bad."[41] Yet Dumas, who reports the scene, also insists—in this case credibly enough—that Delacroix later admitted to him that

FIGURE 24. Léopold Robert. Detail of *Neapolitan Singer*. 1824. Oil on canvas. Musée des Beaux-Arts, Neufchatel. Photo Bulloz.

34. See Michel Florisoone, "Constable and the 'Massacres de Scio' by Delacroix," *Journal of the Warburg and Courtauld Institutes*, 20 (January, 1957):183, n. 15. Florisoone cites a rarely mentioned source of information on the subject, Boyer d'Agen, *Ingres d'après une correspondance inédite* (Paris: Daragon, 1909), p. 168. For Chenavard, see Joseph C. Sloane, *Paul Marc Joseph Chenavard: Artist of 1848* (Chapel Hill: University of North Carolina Press, 1962).

35. Quoted in Escholier, *Delacroix*, 1:132. Thiers' position as a spokesman was very powerful. Of the 55,000 subscribers to Parisian political journals in 1824, more than 16,000 read the *Constitutionnel*, as compared with 13,000 subscribers to its leading competitor, the *Journal des débats* (see P. Grate, *Deux critiques d'art de l'époque romantique: Gustave Planche et Théophile Thoré* [Stockholm: Almquist and Wiksell, 1959], p. 32, n. 4). Grate summarizes the critical attitudes of the period and discusses the critics considered radical, conservative, and middle-of-the-road (see pp. 15–47). The "middle" view eventually prevailed during the July monarchy and continued to dominate

public taste even after the Revolution of 1848. See also Grate, "The Art Critic and the Romantic Battle," *Gazette des Beaux-Arts*, 6th ser., 104 (1959):129–48.

36. Quoted in Grate, *Deux critiques d'art*, p. 33. Delacroix eventually came to know Jal well enough to correspond with him during his trip to Morocco. He wrote a long and friendly letter to Jal from Tangier on June 4, 1832 (see C, 1:329–31).

37. Jal, *L'Artiste et le philosophe, entretiens critiques sur le Salon de 1824*, quoted in C. Blanc, *Les artistes de mon temps* (Paris: Firmin-Didot, 1876), pp. 35–36. The disclaimer of personal acquaintance can only be taken as a literary device, since Delacroix noted in his *Journal* that on April 15, 1823, he had gone to Jal's to borrow a Turkish costume to use in *Scio* (J, 1:78).

38. His views are summarized in R. Baschet, *É.-J. Delécluze, témoin de son temps* (Paris: Boivin, 1942), pp. 269–81.

39. *Aristarque français*, October 28, 1824, quoted in Grate, *Deux critiques d'art*, p. 21.

40. Quoted in Escholier, *Delacroix*, 1:133. See also A. Chauvin, *Salon de mil huit cent vingt-quatre* (Paris: Pillet, 1825).

41. Quoted in Escholier, *Delacroix*, 1:126.

42. J, 1:118 (Aug. 19, 1824).

43. The story was first told by Delacroix's friend Baron Rivet (see Piron, *Delacroix*, pp. 65–66, and cf. Delacroix, *Oeuvres littéraires* [Paris: Crès, 1923], 2:233, hereafter referred to as O). Silvestre (*Les artistes français*, 1:28) reports a more tactful response: "I certainly do see the inaccuracy, but since you tell me the face is expressive, I'd better not retouch it; there isn't enough time."

44. See his *Mélanges d'art et de littérature* (Paris: Michel Lévy Frères, 1867), pp. 179–81. His comments on Delacroix appeared in the seventh of a series of seventeen articles for the *Revue de Paris et des départments*. This particular piece appeared on October 9.

45. C, 1:152.

the first idea for his *Massacre at Scio* came to him as he stood admiring *Pesthouse of Jaffa*. Was Gros blind to the young man's visible debt to his own art, or did he interpret that resemblance not as a compliment but as a threat, a rival claim to what he considered his own genre?

Not all of Delacroix's older colleagues were so hostile. The *Journal* indicates that during a visit to the salon Delacroix met Baron Gérard, who was "very fulsome in his praise."[42] The good wishes of Girodet-Trioson, who was a member of the jury of selection, were less gratifying. After congratulating Delacroix and praising the expression on the face of the dead mother, he admitted his disappointment on finding on close inspection that the mother's eye was not "finished" and urged that the pupils be made more distinct. Delacroix is reported to have said that if M. Girodet had to approach the painting so closely to discern its faults, he should have kept his distance.[43]

Girodet's modest technical suggestion sounds harmless enough in comparison with the reservations voiced by Henri Beyle. In a review whose harsher passages are usually overlooked, Stendhal admitted his inability to admire either *Scio* or its author. He claimed that the work was a plague scene converted into a massacre "on the basis of newspaper accounts": "I can only see in that large, animated cadaver which occupies the middle of the composition an unhappy victim of the pestilence, who has tested on himself the eradication of the bubonic plague. That is the meaning of the blood that appears on the left side of the figure," he added slyly. He then observed that "another incident that young students never fail to include in their pictures of the plague is that of the infant who seeks milk at the breast of its dead mother; it is to be found in the right corner of M. Delacroix's picture. . . . A massacre urgently requires an executioner and a victim. And a fanatic Turk is needed, handsome like the Turks of M. Girodet, sacrificing Greek women angelic in their beauty and threatening an old man, their father, who will fall beneath his blows after them." Severe though he was, Stendhal was not wholly negative: "M. Delacroix, as well as M. Schnetz, has a feeling for color; and that is a great deal in this age of *draftsmanship*," he wrote. "It seems to me that I see in him a pupil of Tintoretto. His figures have movement."[44]

Stendhal's review betrays some ambivalence. Rejecting the claim of the *Journal des débats* that *Scio* was a piece of "Shakespearean poetry," he pronounced it "mediocre" for "its lack of reason," not for the "vacuousness" which he felt in many classical pictures. However, he added: "M. Delacroix always has this immense superiority over those authors of the huge pieces that tapestry the great halls—at least the public takes an interest in his work. That," he concluded, "is worth more than to be extolled in three or four newspapers committed to stale ideas and, lacking the ability to refute the new, misrepresenting it." Perhaps it was this tempering of Stendhal's criticism that prompted Delacroix to write him a note of thanks for his review, but perhaps there is a touch of coolness in the brief note: "I have read the article in the *Revue*. I find it extremely well done and fair, *independent of the good* that you say about me, for which I thank you."[45]

On the other hand, Delacroix was not the only one singled out for praise or blame at the salon. Much of the critics' discussion of the show was general and comparative, and much of it was pejorative. The words "romantic" and "Shakespearean" had come into common use in response to a visibly increasing sense of individualism among participating artists. It was, for example, at this time that Charles Nodier, who had published *Trilby* in 1822, began his famous soirees in his

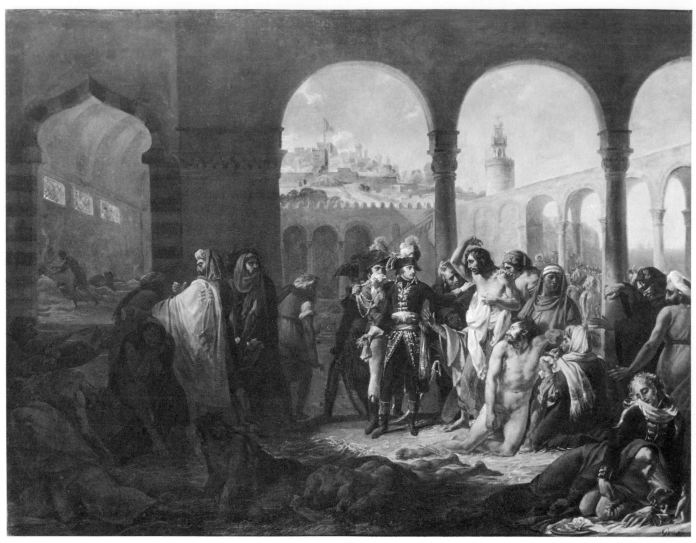

FIGURE 25. Antoine Jean Gros. Study for *Pesthouse of Jaffa*. Ca. 1802?
Oil on canvas. 0.91 × 1.16. Musée Condé, Chantilly. Photo Giraudon.

rooms at the Arsenal library, of which he was curator, as Victor Hugo's famous *cénacle*, or literary society, soon came to be a similar hothouse of romantic feeling.

Fortunately, the public slights Delacroix suffered were not greatly damaging. Perhaps through the intervention of such influential men as Baron Gérard, Georges Rouget, François-Marius Granet, and the Count de Forbin, he was awarded at least some recognition in the form of a medal of the second class. Moreover, not long after, *Scio* was purchased by the government for the Luxembourg at the very substantial price of six thousand francs. Under the circumstances, it is possible to understand subsequent speculations as to a special favor that Delacroix may have enjoyed.

Seen today magisterially installed in the Louvre as one of Delacroix's major masterpieces, it is hard to recognize *Massacre at Scio* as the work that caused such scandal. It is now difficult to understand how its color could have been thought "crude," even though it is no longer the same painting it once was. Aside from

the muting of its once "too glaring" hues, one must consider the fact that the surface was reworked at least twice within Delacroix's lifetime. Commercial standards of craft and materials had sunk to unprecedented levels by the time that it was painted, and the fading and crackling characteristic of most nineteenth-century canvases may be observed here. In 1847 Delacroix himself complained that it was yellowing and obtained official permission to restore the picture. In 1854, in preparation for his showing at the Universal Exposition of 1855, the painting was once more cleaned. Unfortunately, some of the glazes had been mixed with varnish, so that they were "stripped off" in that process along with the dirty coating of protective varnish. Delacroix saw to it that suitable adjustments were made.[46] The painting, therefore, has been considerably "restored" and, accordingly, altered in appearance. It seems safe to assume, however, that the over-all effect of *Scio* is probably not dramatically different from that of 1824. To modern viewers, conditioned by over a century of aesthetic redefinitions, its forms as well as its colors seem relatively traditional, despite the baroque abundance and the freedom of movement so alien to neoclassicism. It is no longer easy to comprehend the excitement it aroused among those who resented any sign of a return to what they considered to be the outmoded art of Boucher and Van Loo. In a sense, Delacroix's painting is at once old-fashioned and revolutionary, a contradiction that dogged his entire career.

As in *Dante and Virgil* there is evidence of the artist's youth in *Scio*. The *Journal* records Delacroix's awareness of his difficulties in obtaining an over-all unity of effect.[47] He decided in the end not to seek a "vain perfection" at the expense of vigor and conviction. Reassuring himself that "it is often what the vulgar consider faults that lend life,"[48] he chose to risk possible inconsistencies by leaving alone what was well done. As a result, by abstract, formal standards, there are certain inconsistencies of style and technique in his picture. The handling of the sky (which is perhaps distractingly expansive) differs from that of other areas. Here, as elsewhere, there is a reminder of the artist's struggle to describe most effectively the great variety of material he has crowded within the borders of his huge composition. The shifts of technique in the handling of the foreground detail similarly betray his inexperience in working on a grand scale. These practical problems of execution were, of course, the result of the changes of mind and shifts of focus natural to a young artist reflecting the work of others as he develops his own approach.

The most celebrated of Delacroix's discoveries of this period was that of the painting of John Constable. Romantic legend has it that at the *vernissage* he suddenly spied Constable's *Hay Wain*, which was to be shown in the exhibition. Struck by the brilliance of the Englishman's colors, he was inspired to repaint most of his background in the brief time remaining before the opening of the salon. This assertion is suspect. Delacroix was already very much aware of England and its culture. He had studied English, affected English dress and manners, and had even shared a flat with the landscapist Thalès Fielding. What is more, he was familiar with Constable's art and had doubtless seen the pastel copy of his *View of the Stour Near Dedham* made in 1822 by his friend Auguste. As early as November 9, 1823, the *Journal* records his admiration for a sketch by Constable that he had seen at Regnier's. On June 19, 1824, while his canvas was under way, he noted having seen other Constable paintings recently acquired by the dealer Arrowsmith[49] including *Hay Wain*, which he must have already known by reputation.

46. See Florisoone, "Constable and the 'Massacres de Scio,'" p. 183, for further details on some of these "restorations."

47. *J*, 1:96 (May 8, 1824).

48. *J*, 1:73 (Apr. 11, 1824).

49. See, *J*, 1:35, 115, and Florisoone, "Constable and the 'Massacres de Scio,'" for a more detailed account of the sources of this confusion and the author's own analysis of the specific artistic results. *Cf.* A. Shirley, "Paintings by John Constable in Paris, 1824–1826," *Gazette des Beaux-Arts*, 6th ser., 23 (March, 1943): 173–80, and Grate, *Deux critiques d'art*, p. 36ff. Grate discusses some of the French critical reactions to Constable's canvases. See also Graham Reynolds, *Constable, the Natural Painter* (New York: McGraw-Hill, 1965), pp. 96–98.

Géricault had seen the picture in 1821 at Somerset House and was probably the first to urge the showing of Constable in Paris. By the summer of 1824 enough French artists had, in fact, seen Constable's work to make it the topic of lively debate in Parisian circles, as a letter written by Delacroix on May 8 makes clear.[50] What remains uncertain is at just what point and to what extent Delacroix decided to affect features of Constable's technique in his *Scio*. His assistant of later years, Pierre Andrieu, claimed that he began his retouchings a fortnight before the opening of the salon.[51]

Comparisons between the *Hay Wain* and *Scio* do not reveal much direct evidence of Constable's influence. In neither technique nor over-all character does Delacroix's arid plain with its spaceless, banded sky resemble Constable's cloud-laden, almost tangible atmosphere. While certain local areas, such as the broadly handled earth of the foreground, may hint of some relationship, even here the resemblance is hardly striking. The "hatchings of pink, orange-yellow and pale blue" which Johnson has observed on the arm of the old woman[52] and

50. This is confirmed by the artist's biographer, (see C. R. Leslie, R.A., *Memoirs of the Life of John Constable*, ed. Jonathan Mayne [London: Phaidon, 1951], pp. 133–34).

51. See Johnson, *Delacroix*, pp. 24–25. Although he may exaggerate the visual result of Constable's influence upon Delacroix in *Scio*, there is evidence that the sequence of events did permit repainting. The canvas was accepted by the jury on August 6, nineteen days before the opening and hence within the period mentioned by Andrieu (see Lee Johnson, "Eugène Delacroix et les salons: Documents inédits au Louvre," *La revue du Louvre et des musées de France*, 16, nos. 4–5 [1966]:217, 227, n. 2).

52. *Delacroix*, p. 25.

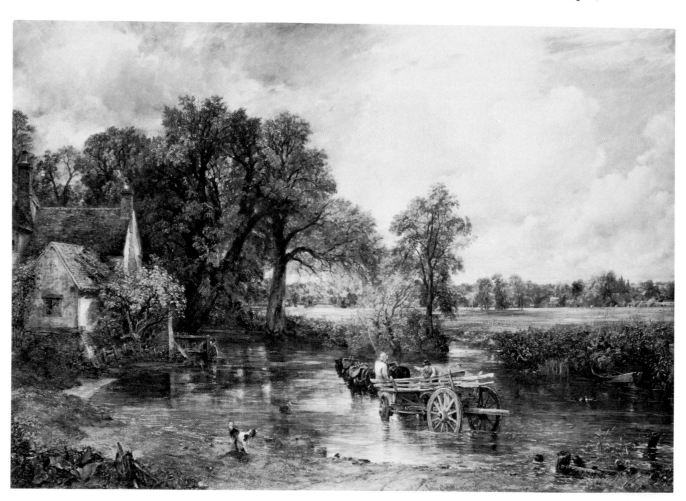

FIGURE 26. John Constable. *Hay Wain*. 1821.
Oil on canvas. 1.30 × 1.85. Reproduced by courtesy of the Trustees, The National Gallery, London. Photo National Gallery.

53. *J*, 1:65.

54. Some connection with Girodet may also be seen here. Delacroix refers favorably to the *Revolt at Cairo* in his *Journal* for April 11, 1824, at which time he was working on the *Massacre at Scio* (see *J*, 1:72). As late as 1857 he wrote of the "grandeur, fire, and pathos" of Girodet's art (*J*, 3:53 [Jan. 25, 1857]).

55. *J*, 1:97 (May 7, 1824).

56. *J*, 1:69 (Apr. 7, 1824).

57. See Florisoone, "La genèse espagnole," p. 196, n. 4, and *cf. J*, 1:75 (Apr. 11, 1824), where Delacroix mentions his desire to own this particular copy.

58. *J*, 1:63–64 (Mar. 25, 1824); *cf.* 1:72, n. 5.

59. *J*, 1:72 (Apr. 11, 1824); 1:94 (May 7, 1824).

60. *J*, 1:72 (Apr. 11, 1824).

61. *J*, 1:74 (Apr. 11, 1824).

62. He points out the physical resemblance of this figure to one of the writhing shades in the waters of *Dante and Virgil* and suggests that the same model, Mme Clément, may have been employed for both figures (see "La genèse espagnole," p. 198, plates 2 and 3).

63. See Florisoone, "Comment Delacroix a-t-il connu les 'Caprices' de Goya," p. 133, n. 1.

the other touches (or retouches?) of lively color may, after all, be seen in baroque and rococo painting as well—in Lebrun, for instance.

Delacroix was at this time subject to a whole nexus of influences. The *Journal* indicates, for example, that on March 30, 1824, he admired Poussin and Veronese at the Louvre, "standing on a stool."[53] In the same entry he states that he tried that day to repaint the head of the dying figure in *Scio*. Elsewhere he speaks of other masters who especially attracted him at this time, not least of all Velásquez, and it will be recalled that his initial inspiration for his picture came from the works of Baron Gros. These associations must therefore be explored.

At least in the most general sense, the precedence of Gros must be admitted. It was he, after all, who in *Pesthouse of Jaffa* had given a certain sanction to the theme of suffering and pathos set within an exotic environment.[54] Surely this was the basis of Stendhal's insistence that Delacroix's painting had begun as a plague scene. There is no less preoccupation with grim details and violent emotion in Gros's *Battle of Eylau* than in *Scio*, and *Battle of Aboukir* betrays a no less strained attempt to reconcile an innate preference for bold color and turbulent forms with prevailing standards of academic propriety. Gros's introduction of sharp contrasts of scale and tone to create dramatic spatial effects finds an echo in Delacroix's own practice, with its comparable suppression of the middle distance.

The possible influence of Spanish art must also be considered. During the spring of 1824 Delacroix wrote of his preoccupation with a small painting of Don Quixote, a subject he only later abandoned as "unworthy,"[55] and of his desire to do a series of "caricatures in Goya's manner" employing the new lithographic techniques he was then trying out with Leblond.[56] What may be technically more important for *Scio*, however, is his acquaintance with the art of Velásquez, which he knew largely from copies, including one by Géricault of a "family group," perhaps *Maids of Honor*.[57] This was one of eighteen items, mostly copies, which Delacroix bought at the posthumous sale of Géricault's work for Fr. 957—a considerable portion of the proceeds from the sale of *Scio*. Other copies and originals by Spanish masters were to be seen at the Louvre and in the private galleries of the Duke of Orléans and Marshal Soult. In March, 1824, on a visit with Leblond to the Orléans Gallery at the Palais Royal, what most caught his eye was "an admirable Velásquez," a portrait of Charles II of Spain now attributed to Carreño de Miranda.[58] On April 11 he got permission to copy it. He began work the following day but eventually lost interest in the project,[59] yet he found even in this school piece strong suggestions for his own art. "This is what I have been searching for so long," he wrote, "this impasto, at once firm and melting. . . . It seems to me that by uniting this style of painting with strong, bold contours one could easily make some small pictures."[60] Then, recalling some Drolling copies after Michelangelo that he had seen that day, he speculated as to what strangely beautiful effects might be obtained by combining Michelangelo's sense of outline with that special softness of interior form which the impasto of a Velásquez could produce.[61] As Florisoone suggests, the figure of the dead mother in *Scio* shows this very combination of attributes.[62] He also points to notable parallels between Delacroix's landscape setting and that of the *Surrender of Breda*, as well as to a more than passing resemblance of the Turkish rider to Velásquez' equestrian portrait of the *Count-Duke of Olivares*, which Delacroix knew from Goya's etching.[63]

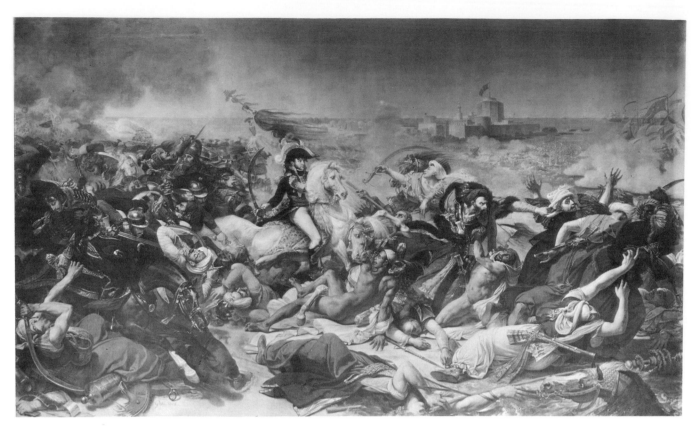

FIGURE 27. Antoine Jean Gros. *Battle of Aboukir.* 1806.
Oil on canvas. 5.78 × 9.68. Musée de Versailles. Photo S.D.P.

Still other influences, of course, suggest themselves. Florisoone's hypothesis of affinities with Murillo, as in the figure of the old woman, who is plausibly "Spanish" in type, is not to be lightly dismissed, nor are the overtones of Rubens' *Rape of the Daughters of Leucippus* easy to ignore. Yet what is in the end more important than any specific derivation is the protean wealth of Delacroix's associations and the success—if one just barely achieved— of their coordination within a single frame. The picture's difficult and straining parts have by sheer force of will been brought together to produce a powerful artistic statement. As in *Dante and Virgil,* Delacroix is attempting to reconcile his urge toward novelty with his respect for tradition, his desire to create stirring visions with his abiding sense of formal control.

For many a twentieth-century viewer this very quality may constitute an obstacle to spontaneous response. The scenes of greatest violence have been discreetly placed in the distance, where their details are softened. A few foreground figures wait in simple resignation. Except for the struggling female nude —a figure perhaps too voluptuously presented to be dramatically convincing— the prevailing tone is one of understatement. It is as though time has been stopped and these hapless creatures have been frozen in perpetual allegory. Their mute and static response to their plight lacks the force of Goya's *Street Fighting of May 2* and *Executions of May 3, 1808.* Delacroix's meanings must, on the contrary, be patiently unlocked.

64. Quoted in Edmund Wilson, *Axel's Castle* (New York: Scribner's, 1935), p. 284.

One might here find an analogue for Valéry's characterization of modern literature as "an art based on the *abuse of language*, that is, based on language as the creator of illusions, and not on language as a means of transmitting realities."[64] In this respect Delacroix was at once curiously modern and respectful of the rationalist traditions of French culture. He presented not an image of reality but a purified and heroic illusion, which in its air of abstract detachment links the art of Poussin and the antique past with that of Manet and Cézanne.

This is not to deny the expressive power of *Massacre at Scio*, but its meaning depends on mind, not emotion. Such drama as Delacroix projects is interior, a matter of awareness, not of action. No direct response from the viewer is called for—perhaps it is not even possible. This is not Goya's scene of bestialization, of the reduction of human existence to the simplicity and anonymity of terror. This is that final, suspended, paralyzing moment when death has ceased to be the future's final and most forbidding menace.

Of England and the English

With the government's purchase of *Massacre at Scio*, Delacroix was established as a public figure at the age of twenty-six. These last years of the Restoration were marked by a relatively permissive atmosphere—in taste, if not in politics—and the orthodoxy and stuffiness that Louis Philippe represented had not yet cast its pall over social behavior and aesthetic choice. Signs of change in the traditional notions of class structure were apparent. The old aristocracy now had to face the fact of the presence not only of a *parvenu* Bonapartist nobility but of a no longer insignificant bourgeoisie.

More than a few members of the middle class, to which Delacroix belonged, possessed not only the wealth but the wit and enterprise to assert an independent authority in matters of taste and fashion, much as their English counterparts had recently done. This process was given impetus by the rush of cosmopolitan feeling which replaced the patriotic appeals of militaristic nationalism. The French male, now out of uniform for the first time in a generation but still imbued with notions of manly glory, was disinclined to return to the effeminate modes of the *ancien régime*. More appealing was the refined but masculine figure of the Prince Regent of England and his still more elegant Falstaff, Mr. Beau Brummell, who epitomized, before his exile to Dunkirk in 1816, the picturesque figure of the dandy.[1]

Although the dress of the Regency dandy was not rigidly specified, it derived generally more from the country than the court: its cut suggested the gentilities of the drawing room less than more virile pursuits. But even though the London dandy's clothes reflected their ancestry in hunting garb, he was no stranger to the ballroom or the parlor, where his practiced, often insolent wit could be displayed to fullest advantage. To Frenchmen, devoted as they were to the art of conversation, the dandy's role was thus doubly attractive, once translated into the vernacular.

The English *haut monde* preferred that wit be purified of matter. At White's or Almack's, superciliousness might be tolerated, but never a seriousness of tone that might subvert diversion. The party in a Parisian salon, however, tended to respect one another and had a set of social patterns derived from deep-rooted rationalist traditions. Affected more by pictures of their English counterparts than by personal contact with them (although many well-born Frenchmen—including the Duke of Orléans himself—had benefited from a stay in England), the Restoration dandy assumed a distinctly French appearance that soon found its fullest expression in the glittering figure of the Count d'Orsay. Before the "lion" of later days or Baudelaire's elegant aesthete had appeared, the Restoration dandies —Carle Vernet's "*Incroyables,*" "*Fashionables,*" or "*Merveilleux*"—had impressed their style upon the nation.

For all its many national guises, the cult of dandyism had certain common

1. See E. Moers, *The Dandy, Brummell to Beerbohm* (New York: Viking, 1960). For general discussions of dandyism in France, see J. C. Prevost, *Le dandysme en France (1817–1839)* (Geneva and Paris: Droz and Minard, 1957); J. Boulenger, *Sous Louis-Philippe, les dandys*, new ed. (Paris: Ollendorf, n.d.); Huyghe, *Delacroix*, pp. 233–54.

characteristics. It represented an effort to establish a recognizable caste outside the traditional social order. Conformity to capricious conventions of dress, speech, and behavior was invited. An aggressive sense of ego motivated that collective withdrawal from everyday society and at the same time justified the cultivation of refined and often costly whimsy as the badge of individuality. Nineteenth-century dandyism was, in other words, a kind of genteel adult equivalent of the adolescent fads in our own period of social flux.

The high value placed upon style in the salon was soon extended to arts and letters, which had become, in Paris, at least, a proper concern of fashionable company. Many now sought glory not in Revolutionary political affairs or in the army of Napoleon but in the arts. The role of the dandy provided both a means of reaching hitherto inaccessible levels of society and a handy guide to comportment once those heights were reached. Accordingly, there was widespread imitation of the pure and costlier modes of "High Dandyism" among aspiring young artists, writers, and intellectuals of Delacroix's day. While dandyism had little impact upon society at large, it had real meaning for those who believed that an "aristocracy" might as properly be the product of wit and determination as of wealth and inherited station.

Delacroix had early been introduced into the *ambiance* of Parisian dandyism through his regular attendance at the brilliant *soirées à l'italienne* held every Wednesday by Baron Gérard. At those late evening gatherings he met an assortment of personalities and nationalities, from explorers and men of affairs to actresses and divas. At the Baron's apartment one evening in 1823 Delacroix's friend Prosper Mérimée introduced him to a M. Beyle, to whose reminiscences of Byron and Napoleon his listeners paid rapt attention. Although Delacroix disliked Stendhal's dandyish insolence, he himself eventually adopted more than a few of his attitudes, including a formality which kept others at a convenient and unencumbering distance. More than once in his *Journal* he later recalled Stendhal's rule, one of uncompromising self-interest: "Neglect nothing that can make you great."

His pose perfected, Delacroix was able to move in many circles—to visit the zoo with Stendhal; to meet the charming Miss Clarke's visiting friend, the author of the recently published *Frankenstein*, Mary Wollstonecraft Shelley; to dine with the famous dandy Eugène Sue and his American guest, James Fenimore Cooper; or to talk with the popular hypnotist and ladies' man Dr. Koreff, who often appeared at Gérard's salon.

This social mobility was attractive to Delacroix, Auguste, and Géricault. They all came from middle-class families of some affluence and pretensions but without high social station. As the son of a wealthy family of goldsmiths, Auguste, for example, could not pretend to the aristocracy of birth, but he could and did insist upon such chilly elegance of conduct that he fashioned a personal aristocracy according to his own specifications. He was, by all accounts, a minor masterpiece of dandyism, a worthy product of generations of fine jewelers and craftsmen. As one descended of cabinet-makers, not kings (putting aside all question of his father's identity), Delacroix's position was not unlike that of his slightly older and more prosperous acquaintance.

A letter writen by Delacroix to Auguste in the spring of 1827 refers to the latter's "regular soirees," held on Saturdays.[2] A note from Prosper Mérimée to Delacroix conveys a like sense of their friendly but rigidly formal relationship with the strange but kindly "Monsieur,"[3] who has been described thus:

2. *C,* 1:191–92.

3. See Mérimée, *Correspondance générale* (Toulouse: Privat, 1961), 1:6–7. Auguste's guests included other literary figures, such as Balzac and Stendhal.

4. Saunier, "Monsieur Auguste,"
p. 56.

5. Most of these had been bequeathed
to Delacroix by Auguste upon his
death in 1850, at the age of sixty-one.
He left as part of his estate a group
of about 210 paintings, pastels, and
gouaches, to be divided among
Pierret, Delacroix, Carrier, Schwiter,
and De Triqueti. In his own will,
Delacroix later stipulated: "I
bequeath to MM. Carrier, Huet,
Schwiter, and Chenavard all my
sketches by Poterlet and the drawings
by M. Auguste" (see Saunier,
"Monsieur Auguste," pp. 67–68).
Delacroix mentions a visit to Auguste
in which he was distressed to find the
elderly man "sitting in his dusty
armchair, alone in the middle of that
great dark glory-hole" (quoted in
Huyghe, *Delacroix*, p. 248). Huyghe
points to a possible association of this
scene with Delacroix's portrayal of
Michelangelo in His Studio, painted
only two years later. See also *J*,
1:291 (May 16, 1849).

6. See R. Boutet de Monvel, *Les
Anglais à Paris, 1800–1850* (Paris:
Plon, 1911).

7. See E. Jones, *Les voyageurs français
en Angleterre de 1815 à 1830* (Paris:
Boccard, 1930).

8. Chasles was a schoolmate at the
lycée with whom Delacroix was very
friendly for a time. By 1824 the two
had drifted apart (see *J*, 1:55–56
[Mar. 1, 1824]).

9. See *C*, 1:112 (to Soulier, Jan. 26,
1821). He referred to his friend
Carrier as "Ravenswood." See
George Heard Hamilton "Hamlet or
Childe Harold? Delacroix and Byron:
II," *Gazette des Beaux-Arts*, 6th ser.,
26 (July-December, 1944): 368.

10. *L*, pp. 83–85 (Sept. 23, 1819).

11. *J*, 1:61. Interest in spoken English
was great among intellectuals. An
English-speaking circle that gathered
regularly *chez* Delécluze included
Mérimée and Albert Stapfer, whose
translation of *Faust* Delacroix later
illustrated (see Jones, *Voyageurs
français*, p. 97). In 1826 Mérimée,
Delécluze, and Baron Gérard all
visited London.

In spite of a genuine affability and a manifest desire to surround himself with an elite whose tastes and ideas corresponded with his own feelings, there was never any intimacy between Monsieur Auguste and his friends. The cause is not to be looked for in differences of age, almost non-existent with Géricault and slight enough with Delacroix, but in his faintly chilly look, which by its very correctness forbade all familiarity, not only at the beginning of a relationship but later as well.[4]

Auguste in this account strongly resembles Delacroix himself. In his aloof, forbidding, but impeccably "correct" manner, in his deft but often cutting wit, even in his entrenched bachelorhood, the mature Delacroix continued in the tradition of Restoration dandyism. Fortunately, he affected neither Auguste's dilettantism nor his disinclination to fulfill himself in his art as well as in his person, yet the resemblance was so pronounced as to suggest some degree of conscious emulation. Delacroix never forgot his mentor, and in his will he was careful to specify the close friends who were to receive the works by Auguste which he himself had owned with so much pleasure.[5]

Another fashionable attitude of the day, one closely related to Restoration dandyism, was the Anglomania that manifested itself just after Waterloo. Communications between the two nations were quickly re-established after the long lapse, and the British tourist was readmitted to an accommodating Paris.[6] French fascination with England soon exceeded that of the days of Louis XVI. By 1829 Lady Morgan, the author of *France in 1816*, could hardly recognize the picturesque country she had described in her travel book, so enthusiastically, if inaccurately, had the natives adopted English words and English ways. During the 1820's at least some Frenchmen also managed to simulate English prosperity to the extent that they too could play the tourist by travelling to England.[7] The list of those who sought to escape the provincialism of Paris in England includes many famous writers and artists. In 1817 both Stendhal and Philarète Chasles[8] made the journey. In 1820 Géricault began his protracted stay in the land of Epsom, where he could pursue the haunting image of the horse. Auguste, newly returned from travel in the East, went to England in 1822, and Delacroix followed his countrymen across the Channel somewhat belatedly.

When he left France, Delacroix had some vicarious knowledge of the English and their culture, partly from his schoolmate Soulier, who had been raised in England. While Delacroix was still at the lycée, he studied English with his friend Pierret, and, for a time at least, his correspondence bore the marks of that enthusiasm, as seen in his awkward attentions to Elizabeth Salter and his affectation of English nicknames for himself and some of his friends—Soulier was a "cruel Lovelace," and Delacroix, it will be recalled, signed himself "Yorick."[9] In 1819, as a young student, he read *Richard III* in English and translated certain passages into French. That effort was conducted partly for the instruction of his friend Félix Guillemardet, to whom he was trying to teach English.[10] The early *Journal* contains other evidence of the young man's already entrenched Anglophilia. For example, his brief entry for March 16, 1824, reads: "Dined with Soulier and Fielding at Tautin's. *And after*," he added in English, "*to english Brewery and drunk Gin and Water*."[11] It will also be remembered that some of his earliest artistic efforts were drawings after caricatures by Rowlandson and Gillray.

By 1825 Delacroix had a good number of acquaintances among the "Islanders," as he and, later, Whistler, called the British who were then living in Paris. It was probably through Soulier, who had studied water color in England with Copley

Fielding, that Delacroix became acquainted with Thalès and Newton Fielding, both of whom were also competent artists.[12] Under their tutelage he continued to practice the novel English water-color techniques he had first learned from Soulier. His relationship with Thalès became particularly close. In the fall of 1823 Delacroix left his own atelier for a time to share his friend's "digs." In such company dandyish manners and Anglomania would naturally be encouraged. It is likely that the brothers Fielding helped him plan his trip to England, for their family was prominent among those who extended hospitality to Delacroix during his four-month stay abroad.

Of more importance to his artistic development, however, was Delacroix's friendship with the charming and talented Richard Parkes Bonington, whose work strongly attracted him. In 1861 Delacroix still remembered his first sight of Bonington in the Louvre "about 1816 or 1817," "a tall adolescent clad in a short jacket," who, like himself, was silently at work making water-color copies, mostly after Flemish landscapes.[13] In view of this quickening of his English associations during an impressionable phase of his life, it was natural for him to decide to use some of the proceeds from the sale of *Massacre at Scio* to make a trip across the Channel.

It is regrettable that there is no *Journal* to give us the details of Delacroix's stay in England, but the surviving letters provide a sampling of his impressions.[14] Although he was pleased that he survived the Channel crossing without getting sick, he was generally disenchanted by his experiences upon arrival. He traveled from Dover to London in the company of an elderly French countryman who shared his hostile first impression. In their coach was a "*gros goddam d'Anglais* who, to tell the truth, did not understand a word of what we were saying, at first because of not knowing French, and later because of two bottles of port wine that he had obtained in Dover to assuage the boredom of the trip."[15]

Delacroix, who liked Paris little enough, found London inconceivably immense and shocking in its lack of "all that we call architecture." Even the behavior of the sun seemed most "singular." "It's continually a day of eclipse," he wrote. "The sunshine is not the most brilliant part of England," he complained in a later letter. "I still haven't been able to cure a cold that I brought from France because of the cold spells that continually return."[16] Perhaps to compensate for the cold, "I break lances for France against all possible Englishmen," he reported to Pierret. "There is something savage and ferocious in the blood of these people that shows through horribly in the ill bred—it is hideous. But then it is a famous government. Liberty is not an empty word here. The pride of their nobles and their distinctions of rank are pushed to a point that shocks me immeasurably, but it results in some good things. . . . If I perish in the storms on my rounds, I will die not English but very French."[17] Yet the picture was not all black. He was impressed by the fine shops, with their abundant displays of luxuries. He admired the countryside, especially the Thames embankments, the parks filled with horses and carriages, and the towns of Greenwich and Richmond, which he visited by boat. He was delighted by the six-oared boat that carried them along the Thames and compared it with an Amati violin. That excursion with the Fieldings to Richmond, he later said, was worth the entire trip to England.

12. For a summary of the activities of the Fieldings in Paris, see A. Dubuisson, *Richard Parkes Bonington: His Life and Work*, trans. C. E. Hughes (London: John Lane, 1924), pp. 28–31. According to Dubuisson, Thalès (and presumably Newton as well) came to Paris about 1820. Copley Fielding, the best known of the brothers, did not settle in Paris but did exhibit some water colors in the Salon of 1824. Theodore was the fourth brother. The Fieldings were also friendly with the Mérimée family, so that Delacroix might easily have met them there (see Jones, *Voyageurs français*, p. 54).

13. *C*, 4:285–89 (to M. Th. Thoré, Nov. 30, 1861). Since the Bonington family did not arrive in Calais until 1817, Delacroix's earlier date is obviously wrong. Bonington studied there for a time with F. L. T. Francia, a French artist who had studied water color in England with Girtin. Following a quarrel with his father, who opposed his becoming an artist, Richard left Calais for Paris, apparently at the urging of M. Morel, a wealthy shipowner and mayor of the town. He is said to have carried a letter of introduction from Morel to Delacroix (see Dubuisson, *Bonington*, p. 25, and A. Shirley, *Bonington* [London: Kegan Paul, Trench Trubner, 1941], pp. 12–13). The letter has not come to light. Although the evidence is not conclusive, it suggests that the two met during 1818, when Delacroix was also copying the masters in the Louvre. The real friendship between the two dates from the summer of 1825 (see M. L. Spencer, *Bonington* [Nottingham: Castle Museum and Art Gallery, n.d.], p. 5).

14. See *C*, 1:153–71.

15. *C*, 1:154–55 (May 27, 1825).

16. *C*, 1:158 (to Soulier, June 6, 1825).

17. *C*, 1:166 (Aug. 1, 1825).

18. See Escholier, *Delacroix*, 1:157–58, and *cf. C*, 1:160 (June 18, 1825, not June 1, as Escholier states). Pierret has suggested subjects from *Goetz von Berlichingen* (*cf. J*, 1:54 [Feb. 28, 1824]). Delacroix later did illustrate episodes from *Goetz*.

19. *C*, 1:155–56 (to Pierret, May 27, 1825).

20. *C*, 1:168–69 (Aug. 1, 1825).

21. *C*, 1:161 (June 18, 1825). If only by coincidence, the next year he received a commission from the Council of State for a large painting, *Emperor Justinian Drafting His Laws*.

22. See Huyghe, *Delacroix*, pp. 31, 184, 517, n. 15; Philippe Jullian, *Delacroix* (Paris: Albin Michel, 1963), pp. 60–61; and *cf. C*, 1:168. Delacroix here refers to "the nymph" of "Princess Street," for whom he had a ring ("*anneau*"). Joubin (*C*, 1:168, n. 4) proposes that the nymph was Mrs. Dalton, who did in time become his mistress, a liaison that lasted for many years. *Cf.* Dubuisson, *Bonington*, pp. 61–66, and Huyghe, *Delacroix*, pp. 15, nn. 15–16, 184, 517.

23. Meyrick's *Critical Inquiry into Antient Armour* appeared in 1824.

24. *The Gothic Revival: An Essay in the History of Taste* (New York: Scribners, 1950), p. 150. Though it lacked the force of the English Gothic Revival, the French showed a new interest in the medieval past. Signs of the times included the appearance of the Duchesse de Berry (later a patroness of Delacroix and Bonington) at the Greffuhle Ball dressed as a medieval queen and—even more significant—the publication, in 1820, of the first volume of Baron Taylor's *Voyages en France* (see J. Robiquet, *L'Art et le goût sous la restauration, 1814 à 1830* [Paris: Payot, 1928], pp. 198ff., and E. Maingot, *Le Baron Taylor* [Paris: Boccard, 1963]). In 1821 the School of Chartres was founded. In 1822 Defaut-Conprêt's translations of Scott began to appear. By then the French interest in the Middle Ages was well established. As in England, there were many more premonitions of this taste in eighteenth-century France than customarily realized (see R. Lanson, *Le goût du Moyen Age en France, au XVIIIe siècle* [Paris and Brussels: G. Van Oest, 1926]).

In late June he wrote of "lovely weather rare for London" and of the plays he had been attending, He was enchanted by some of the theatrical productions he saw, which were to have a marked effect on his art, especially the Shakespeare. He was particularly enthusiastic about Edmund Kean's Othello and his equally famous interpretation of Shylock. Drawings of Iago and other Shakespearean characters are souvenirs of those theatrical evenings. (One wonders whether Kean's performance in *Merchant of Venice* had some influence on *Marino Faliero*, which Delacroix painted the following year.) He saw other Shakespeare plays— *Richard III*, *The Tempest*, and *Henry VI*—and was particularly struck by a performance of *Faust*. He wrote of it to Pierret, who had been the first to call his attention to Goethe's works.[18] In the same letter he mentions attending two different productions of Weber's *Freischütz*, presented with the music that had been omitted in the Paris versions, and praises the superior sensitivity of the English sets, which, being less elaborate, "make the performers stand out better." As for the actresses, their beauty was "divine" and was often itself more than half the show. Their voices were "charming," and they had a shapeliness only found among Englishwomen.

After a time, however, Delacroix came to regard much of the English theater— apart from Shakespeare—as an inferior imitation of the French. He found a popular spectacle, *Napoleon's Retreat from Russia*, laughable.[19] English music was "atrocious": "Even their blind people have still less feeling than ours for an instrumental part—whether it be for violin or clarinet and flageolet. There is no theatrical air so sentimental that they will not set it to the trumpet. When John Bull in the top balcony cannot hear the musicians, he believes that they are asleep and that there is no music."[20] Those who have traveled abroad are familiar with such alternating moods of approval and annoyance, and a political motive might well be suspected in his letter to Pierret containing a message to M. Rivière, Master of Petitions for the Council of State: "Tell him a thousand things for me and that his judgments on this country have been right for me, that I am altogether convinced that we are the equals of these islanders and even better in many respects."[21]

No small part of Delacroix's visit was spent with a number of French painters who were then in London. He made a trip to Cornwall with Eugène Isabey and spent time with Alexandre Colin, who made a vigorous pencil portrait of him in profile at about this period. His acquaintances also included Eugène Lami and Hippolyte Poterlet, whose exceptional gifts much impressed Delacroix. Perhaps most welcome of all was the chance to renew his acquaintance with Bonington. It was probably through Bonington himself that Delacroix met Bonington's mistress of the time—his mistress, that is, until she transferred her allegiance to his French friend.[22] If so, Bonington seems to have been unaffected by the lady's defection. He and Delacroix remained friends and sketched the armor collection of the antiquarian Dr. Samuel (later Sir Samuel) Rush Meyrick together.[23]

There was, of course, more than the Meyrick Collection to remind Delacroix of England's continuity with the medieval past. The full force of the Gothic Revival had not yet expressed itself, but the indications were clear. As Kenneth Clark has pointed out, by 1825 the popularity of Gothic forms had reached such a height that "almost all Gothic mouldings or ornament could be bought wholesale,"[24] and, of course, Westminster Abbey and other national monuments had

never been deprived of their medieval character by the kind of "renovations" that had disfigured the interior of Notre Dame in Paris.[25]

Delacroix was hospitably received in England, thanks to letters of introduction from Auguste and other friends who had visited there.[26] Prominent among his hosts was an acquaintance of Auguste, Mr. Elmore, a well-to-do dealer in horses. He gave riding lessons to his young visitor and allowed him to make sketches in his stables. "I am involved in riding horseback," Delacroix wrote Pierret: "I am in great good spirits. I have just barely missed breaking my neck three or four times—but all that builds character."[27] In addition to these activities, Delacroix made an effort to meet some of the famous British artists, especially two whose works had made a deep impression on him, John Constable and Sir Thomas Lawrence. A letter of introduction to Constable from Schroth is preserved among the Constable family papers,[28] and there is some evidence that Delacroix met Constable. One of his sketchbooks contains a number of drawings made at Brighton which have recently been identified as by Constable, not Delacroix. Although the evidence is circumstantial, it would appear that Graham Reynolds is right in suggesting that the sketchbook was a gift from Constable to his young admirer.[29] With the exception of Constable, Delacroix appears not to have been attracted to the English landscapists. Turner was away, and the two did not meet until

25. See Michèle Toupet, "L'assassinat de l'Évêque de Liège par Delacroix," *La revue du Louvre et des musées de France*, 12, no. 2 (1963):88, in which she points out the remarkable similarity of the vaults at Westminster Abbey to those in Delacroix's painting. For information concerning the remodeling of Notre Dame, see P.-M. Auzas, "La décoration intérieure de Notre-Dame de Paris au dix-septième siècle," *Arts de France*, 3 (1963):124–34.

26. See Étienne Moreau-Nélaton, *Eugène Delacroix raconté par lui-même*, 2 vols. (Paris: Henri Laurens, 1916), 1:71.

27. C, 1:166–67 (Aug. 1, 1825). In this letter he reports that he plans to leave the next day on a yachting trip with one of Elmore's friends (see p. 164).

28. See Shirley, "Constable in Paris," p. 180.

29. See "Newly Discovered Drawings by Constable in a Louvre Sketch-Book," *Burlington Magazine*, 108 (March, 1966):141, n. 5. Reynolds cites the letter of introduction from Schroth as transcribed in R. B. Beckett, "Correspondence and Other Memorials of John Constable, R.A.," manuscript, 12:137–40.

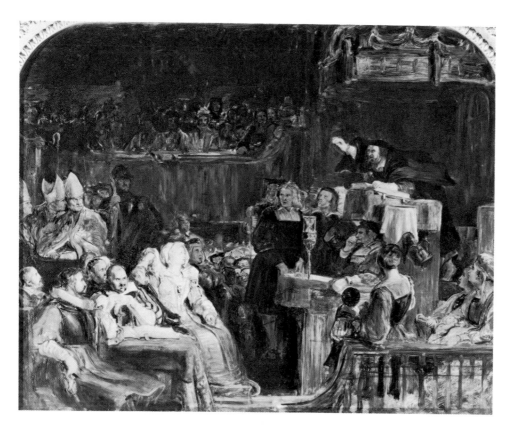

FIGURE 28. Sir David Wilkie. Study for *Knox the Puritan Preaching before Mary Stuart*. 1822. Oil on panel. 0.50 × 0.62. From the Petworth Collection, Petworth, Sussex. Photo Royal Academy of Arts.

30. *J*, 2:321 (Mar. 23, 1855). Delacroix lived at 15 Quai Voltaire from January, 1829, to October, 1835. Turner made several trips to the Continent during this period. In fairness to Delacroix's judgment of the art, not the man, it should be noted that he called him and Constable the "true reformers" of landscape painting in their time (*C*, 4:60 [to Théophile Silvestre, Dec. 31, 1858]).

31. See *C*, 1:156 (May 27, 1825).

32. See E. Wind, "The Revolution of History Painting," *Journal of the Warburg Institute*, 2 (1938–39):116–27, and R. Hirsch, *The World of Benjamin West* (Allentown, Pa.: Allentown Art Museum, 1962), p. 42.

33. Quoted in Jullian, *Delacroix*, p. 59.

34. Delacroix had learned about Fuseli at an early point from Soulier (see *C*, 1:38, n. 2, and F. Antal, *Fuseli Studies* [London: Routledge and Kegan Paul, 1956], pp. 132–36 *et passim*).

35. *C*, 1:160; 4:60. Delacroix states that the final version was reported to be inferior to the study he had admired. He says that he had told Sir David, with an "altogether French impetuosity," that "Apollo himself taking the brush could only spoil it with finishing." It will be recalled that Delacroix's own work had been criticized for its lack of "finish."

36. White, "Delacroix's Painted Copies after Rubens," p. 43.

37. D. Farr, *William Etty* (London: Routledge and Kegan Paul, 1958), pp. 43–44.

38. See Jullian, *Delacroix*, p. 59, and Lee Johnson, "*William Etty* by Dennis Farr," *Burlington Magazine*, 101 (July–August, 1959):298.

39. See Farr, *Etty*, pp. 125–26. The letter does not appear in the *Correspondance générale*.

40. *C*, 4:57–58 (Dec. 31, 1858).

1835, at which time Turner made a "mediocre" impression on Delacroix (he recalled in his *Journal* that Turner "looked like an English farmer, with his coarse, black dress, heavy shoes, and cold, hard mien" [30]).

Delacroix took more interest in the history painters and seems to have been particularly impressed by the works of Benjamin West, then being shown in a retrospective exhibition.[31] It is logical that he should have been attracted to the man who, more than any other, might be said to have popularized historical (as opposed to history) painting in the late eighteenth century,[32] and a marginal note on one of the studies for *Death of Sardanapalus* (Louvre R.F. 5 278) reads "Study the sketches of West."[33] The aged Fuseli died on April 16, a month before Delacroix arrived in England,[34] and of Blake there is no mention.

In view of the length of Delacroix's stay in England, the list of practicing artists he is known to have visited is not long. He did go to see both William Etty and the Scottish painter Sir David Wilkie. Wilkie's ably executed, if sentimental, paintings were widely praised by his contemporaries. Delacroix himself was impressed by his skill and took a particular interest in his sketch *Knox the Puritan Preaching before Mary Stuart*.[35] Although his fear that "finishing" would spoil the quality of spontaneity he admired in the sketch was justified, the more nearly completed variants of the John Knox subject bear a distinct resemblance to some of Delacroix's own efforts a few years later. Both the technique and the organization of *Murder of the Bishop of Liège*, *Boissy d'Anglas*, or *Mirabeau and Dreux-Brézé*, for example, may well show traces of what Delacroix's retentive eye took in at Sir David's studio. It is known that he was there long enough to paint a copy of Rubens' *Apotheosis of the Duke of Buckingham*, which was then a part of Wilkie's collection.[36]

In most respects Delacroix had more in common with William Etty, whose artistic development was similar to his own. A former pupil of Lawrence and Fuseli, Etty's range of taste was broad. He too had come to admire Rubens and the Italians and had respectfully climbed onto a stool in the Louvre to study the work of Veronese. In 1822 Etty, like Delacroix, had copied the sirens from Rubens' *Debarkation of Marie de Medici at Marseille*; he also copied Giorgione's *Fête Champêtre*, although the date of the latter copy is uncertain.[37] Both artists were passionate admirers of the Venetians; both were dedicated to an art of bold subjects, striking visual appeal, and technical opulence. Philippe Jullian's observation of an affinity between Etty's nudes and those in *Death of Sardanapalus*, a painting begun while Delacroix's memories of England were still fresh, is highly suggestive.[38] But any rapport the two men may have had appears to have been short-lived. That Delacroix was favorably impressed by Etty is clear from his letter of August 24, 1825, written just after his return to Paris, in which he expresses his regret that he could not see Etty again before leaving and invites him to visit his studio in Paris.[39] Apparently Etty did not do so, and Delacroix lost interest in his subsequent career. In a summary of his English experiences written in 1858 for Théophile Silvestre, he refers to Etty as recently dead, although Etty died in 1849.[40]

A high point of Delacroix's visit was his interview with Sir Thomas Lawrence, "the flower of politeness and truly the painter of great men." Lawrence received his caller with great courtesy and showed him "very beautiful drawings by the masters and paintings by himself, sketches, drawings as well—admirable. Nobody has ever made eyes, especially women's eyes, as Lawrence does, and those mouths

partly open and perfect in their charm. He is inimitable."[41] In his letters to Silvestre his impressions were, as he himself noted, "modified a bit" as he recalled his relationship with Lawrence: "He was a man gracious in the highest sense—except, that is, when his pictures were criticized."[42] Delacroix's portraits of the period following his return from England, particularly *Baron Schwiter*, show his attempt to capture something of Lawrence's mode of composition and brilliance of touch, as is evident in the isolation of the Baron on a terrace against a sweeping, rather somber sky and a lush distant landscape.[43]

In the summer of 1825 Delacroix found that the delights of London suddenly disappeared with the end of the "season." In a letter to Félix Guillemardet he complained that the theaters were almost all closed and that not a carriage was to be seen in the streets. "Those who remain in London (I mean the fashionable people) keep out of sight or live in the rear of the house. It would be the ultimate impropriety to be in town at this time of year."[44] No admirer of English musical taste, he took small comfort in the fact that the opera played on, for "music is one of those things to which neither energy nor stage effects can give feeling." The company of other French artists, who were working together at the time, consoled him, but his enthusiasm for the English had exhausted itself. Months

41. *C*, 1:165–66.

42. *C*, 4:59. In 1829 he paid tribute to Lawrence's *Portrait of Pope Pius VII* in a brief essay written for the *Revue de Paris* (see *O*, 2:157–62). In 1855 he still maintained his admiration for Lawrence and the English school (see *J*, 2:338–42). In later years, however, he did qualify that praise (see *J*, 3:263 [Feb. 8, 1860]).

43. *Cf.* K. Garlick, *Sir Thomas Lawrence* (London: Routledge and Kegan Paul, 1954), p. 15. The landscape background has been attributed by some to Huet. There is, however, no objective reason to accept that attribution. Despite the similarity of style, the resemblance could easily derive from the close personal and artistic relationship of the two painters. The lush and fluent handling characteristic of Delacroix at this period is consistent throughout the picture.

44. *C*, 1:171 (Aug. 12, 1825).

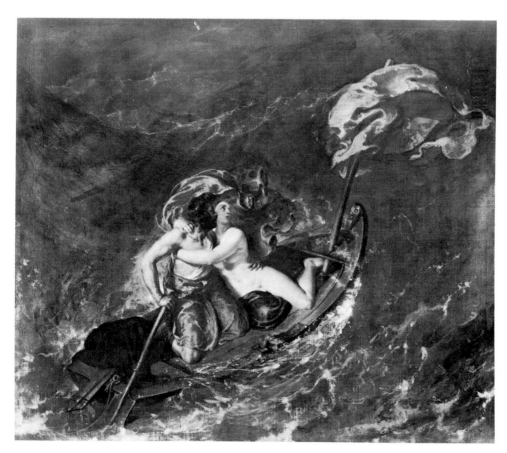

FIGURE 29. William Etty. *The Storm*. 1829–30. Oil on canvas. 0.91 × 1.06. City Art Gallery, Manchester. Photo City Art Gallery.

FIGURE 30. ▷
Baron Schwiter. 1826?–30.
Oil on canvas. 2.18 × 1.43.
Reproduced by
courtesy of the Trustees.
The National Gallery, London.
Photo National Gallery.

FIGURE 31. Detail of *Baron Schwiter*. Photo National Gallery.

later he insisted in a letter to Soulier, "I am not an enemy of the English, however you may think," [45] but by this time he was once again in Paris.[46]

Delacroix's voyage to England held a variety of meanings for him. He was exposed for the first time to a foreign environment and gained that special clarity of definition which only contrast often can provide. He thus returned to France in certain ways more "French" than he had left it. At the same time his intellectual boundaries were extended and his responses refined. His already strong predisposition toward English literature was reinforced—his "discovery" of Shakespeare as a living theatrical experience was especially important. Byron and Scott took on a meaning for him that they could not have had before his visit. These impressions were lasting, and Delacroix repeatedly returned to his favorite subjects from English literature throughout his career.

45. *C*, 1:174 (Jan. 31, 1826).

46. The exact circumstances of the return voyage are not certain. There is a story that Delacroix was in the company of Bonington, Isabey, and Colin and that the four remained for a time at St. Omer, where they went sketching together (see Dubuisson, *Bonington*, pp. 63–64, citing the accounts of Jules Jouets in *L'École des Beaux-Arts de St. Omer*).

47. By tradition, Géricault made the large copy, now in the Louvre, of Stubbs's *Horse Attacked by a Tiger*, a version of which subject is in the collection of Mr. and Mrs. Paul Mellon.

48. It has recently been proposed that some of these portraits, traditionally assigned to Delacroix, are actually by Bonington. They are so close to Bonington's style that the attribution seems reasonable (see Spencer, *Bonington*, p. 38, No. 290, and *cf.* Lee Johnson, "Bonington at Nottingham," *Burlington Magazine*, 107 [June, 1965]:319). However, Delacroix did exhibit a portrait of the Count at the Salon of 1827–1828.

49. *C*, 1:173 (Jan. 31, 1826). Delacroix never forgot how attractive Bonington's gifts had been. Late in life he wrote Thoré: "I sometimes said to him, 'You are king in your own domain, and Raphael himself could not have done what you do. Don't trouble yourself about the qualities of others, nor about the size of their pictures, for yours are masterpieces'" (*C*, 4:288 [Nov. 30, 1861]).

50. While there is reason to suppose that Bonington may have gone briefly to Rome, his stay in Venice was of central importance. Rivet, whose diary and letters furnish the account of the trip, makes a comment that suggests having visited Rome: "I hardly like to admit that Raphael looks to me all brick colour. I have been spoiled by the Venetian school" (quoted in Dubuisson, *Bonington*, p. 74).

The stay in England also was significant in confronting Delacroix for the first time with an aesthetic tradition entirely different from his own. Even as medieval elements had survived in English architecture and institutions, baroque techniques and attitudes had persisted in English painting far more than in French. Next to Lawrence's brilliant, painterly virtuosity, Baron Gros's color could only seem timid and his execution flat. And where could the viewer of 1825 find the match for Constable's and Turner's magical translation into color of the effects of light and atmosphere? The baroque tendencies in composition and handling that Delacroix had already exhibited were therefore encouraged by his expanded contact with English painting.

The paintings of this period bear witness to that inspiration. The small water colors of a horse frightened by a storm, which Delacroix gave to Louis Schwiter, and a wild horse attacked by a tiger both suggest an interest in the art of George Stubbs, whose imaginative animal subjects had earlier attracted Géricault.[47] The portrait of Baron Schwiter and the smaller portraits of Count Palatiano in Souliote costume (about which some problems of attribution persist[48]) reflect the influence of Lawrence's gracious, fluent portraits of aristocracy. The portrait study *Woman in a Large Hat*, sometimes said to represent Mrs. Dalton, recalls the offhand bravura of Hogarth's *Shrimp Girl* and the dashing ease of Lawrence's portrayals of his more elegant models, and the noble *Still Life with Lobsters* succeeds in capturing something of Gainsborough's rare freshness of touch. Its heap of game, dominated by a golden pheasant and complemented by the two red lobsters and a flash of Scottish plaid, presents a momumental image of plenty against a background of English countryside and an overcast but glowing English sky.

Of a different order is *Marino Faliero*, a work which Lawrence himself once considered purchasing and which is now, appropriately enough, a part of the Wallace Collection in London. It has been said—and not without reason—that here Delacroix painted Bonington's masterpiece. At the same time, a Byronic subject has been given form, recalling the poet's own Italian pilgrimage. In this sense the picture epitomizes what his contemporaries sometimes called the Anglo-Venetian manner. It both sums up the lessons he learned from his English interlude and leads directly to the high points of his romantic extravagance, *Justinian Drafting His Laws* and *Death of Sardanapalus*, which he showed in the Salon of 1827–1828.

The personal and artistic relationship between Delacroix and Bonington is a difficult and complicated subject. The available documentation is skimpy, and one must depend heavily on conjecture. The two became close friends during the months following their return to France, when Bonington lived with Delacroix for a time. In a letter to Soulier Delacroix described that association: "For some time I have had Bonnington [*sic*] in my studio. I have greatly regretted that you haven't been around. There's an awful lot to be gained from the company of that rascal, and I assure you I've got a great deal from it."[49]

During the spring of 1826 Bonington went to Italy with Baron Charles Rivet, another painter and a close friend of both men. It was an almost deserted Venice, not Rome or Naples, that drew them there.[50] Like Delacroix, Bonington was a confirmed admirer of Venetian painting, particularly that of Veronese, whose colorful flair and sensuous abundance appealed to his own tastes, and on their return Delacroix must have studied and discussed their portfolios of sketches made along the way. In spite of bad weather and failing health, Bonington was

able to study the works of Titian, Giorgione, Tintoretto, Veronese, Guardi, Tiepolo, and Canaletto in the galleries of the Accademia. Their influence is visible in the pictures he painted in the remainder of his brief career, those brilliant little "fancy pictures," which rival his landscapes glowing with Venetian atmosphere as the fullest expression of his art. These and the documentary studies he and Rivet brought back with them must have been useful to Delacroix in creating a Venetian scene that was, as Gautier later pointed out, "free from anachronism."[51]

Execution of Marino Faliero is one of the most important pictures of Delacroix's early career, and, according to Lassalle-Bordes, it remained one of his favorite pieces. The canvas demonstrates his narrative insight and his ability to portray an intricate psychological situation. Given the complexities of Byron's plot, the economy of Delacroix's depiction is all the more impressive. The Doge, a man of ability and courage, has come to an ignominious end for conspiring against the state of which he was the leader. Beheaded for betraying his class, he lies, alone, at the foot of a ceremonial staircase. The mark of his shame is covered, but the heavy cloth serves not to disguise but to emphasize his defeat.[52] Over the body the Chief of the Venetian Council of Ten raises his sword to indicate that "justice hath dealt upon the mighty Traitor!"

The pageantry of the ranks of aloof aristocratic witnesses and the stately setting intensify, rather than relieve, the grim mood of the occasion,[53] as does the stark expanse of empty staircase at the exact center of the composition. The presence of the people is indicated by a few figures at the lower right. Their response to the execution is excited, in contrast to that of the nobles, and in this discrimination of social class, as in the surprising device of emptying the focal center of the picture, Delacroix has exploited all the dramatic possibilities of the incident. In effect, he has established a kind of dialogue that is more theatrical than traditionally pictorial. (We may recall that Degas studied the art of Delacroix assiduously.) In *Marino Faliero* that mode was far from inappropriate,[54] for Byron's poem itself is written in the form of a play and was, in fact, put on the stage, first in England and shortly thereafter in France. In October of 1821 it was presented in a verse translation at the Comédie Française, and on November 7 it opened at the Théâtre Porte Saint-Martin, this time in a prose translation.[55] In view of Delacroix's fondness for the theater, he may well have seen one or both of those productions.

Even if Delacroix did not see *Marino*, however, he could have found a similar stimulus in other plays telling of violent events set in exotic Venice. In 1819 he wrote that Thomas Otway's *Venice Preserved* was "one of the most admirable plays in the English theater,"[56] and since that piece remained in the standard repertory of the Paris stage, it is likely that he saw it performed. In 1816 he apparently saw Lafosse's *Manlius Capitolinus*, a play inspired by Otway's. His interest in Venetian subjects was, in any event, persistent. In 1824 he gave what may be the first hint of his interest in the story of Marino: "Not knowing what to do, I worked at composing the *Condemned at Venice*."[57]

In 1826 these interests finally found concrete expression. The particular circumstances that led Delacroix to choose the subject at this time are unknown. It may be that he merely wished to explore new technical ideas and to employ Venetian motifs; on the other hand, the picture may have political connotations. It could have been intended as a cryptic reference to the unpopularity of Bourbon rule.

51. Théophile Gautier, *Les beaux-arts en Europe* (Paris: Michel Lévy Frères, 1855), p. 176. A sketch attributed to Bonington, now in the National Gallery of Canada, has been credited as a source for Delacroix's *Marino* because of its depiction of the Staircase of the Giants, where his scene is set. While the subject is admittedly similar, the attribution itself (and hence its date) is so highly suspect that its relevance remains uncertain. Huyghe proposes Schwiter or some other French painter as the possible artist, but with little proof (see *Delacroix*, p. 522, n. 8 *et passim*).

52. Byron's Preface includes the following comment: "The black veil which is painted over the place of Marino Faliero amongst the doges, and the Giants' Staircase where he was crowned and discrowned, and decapitated, struck forcibly upon my imagination, as did his fiery character and strange story."

53. The inclusion of stately patrician groups is, of course, common in Renaissance painting. Comparisons with Veronese or Mantegna are therefore warranted (see Escholier, *Delacroix*, 1:176).

54. Walter Friedlaender here glanced off the point when he wrote that "the effect of the picture is too illustrative. . . . perhaps it is still too much under the influence of the stage setting of a Byronic drama" (*David to Delacroix*, trans. Robert Goldwater [Cambridge, Mass.: Harvard University Press, 1952], p. 116).

55. Edmond Estève, *Byron et le romantisme français* (Paris: Boivin, n.d.), pp. 82–83.

56. *L*, p. 82 (to F. Guillemardet, Sept. 23, 1819). He was reading the play in a French adaptation. As the letter indicates, he was at the same time reading a book entitled *The Conspiracy of the Spaniards against Venice*.

57. *J*, 1:57 (Mar. 3, 1824). Three days later he mentioned an interest in doing scenes from *Jane Shore* and Otway's plays (*J*, 1:59 [Mar. 6, 1824]).

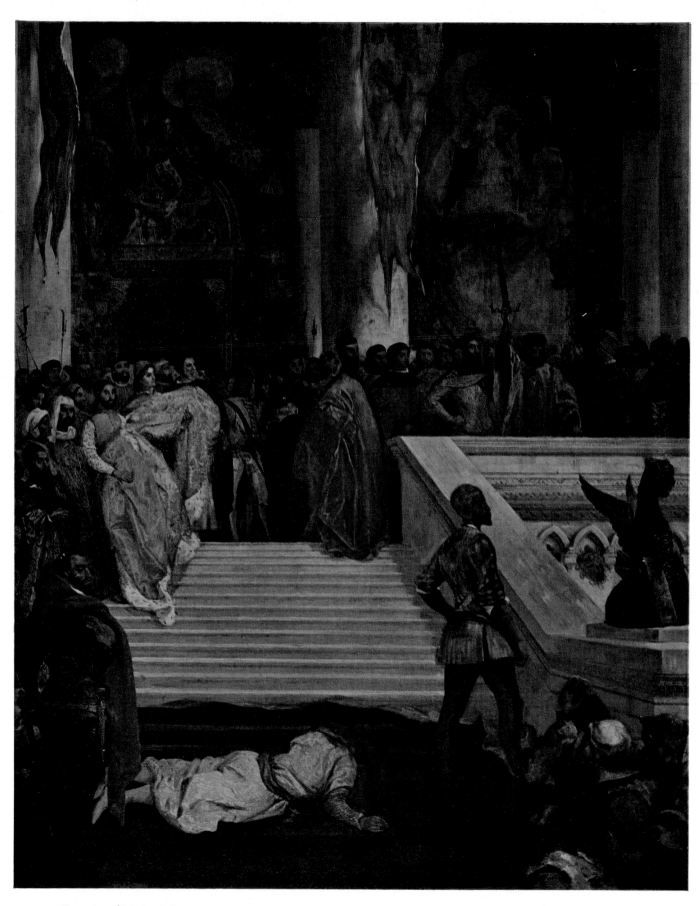

PLATE V. *Execution of Marino Faliero.*
1826. Oil on canvas. 1.47 × 1.14. Wallace Collection, London.

58. C, 1:161 (June 27, 1825).

59. Lucie Horner, *Baudelaire: Critique de Delacroix* (Geneva: Droz, 1956), p. 18, discusses the wide variety of critical evaluations of the subject.

60. J, 1:57 (Mar. 3, 1824).

61. See George Heard Hamilton, "Eugène Delacroix and Lord Byron," *Gazette des Beaux-Arts*, 6th ser., 22 (February, 1943): 99–110, and "Delacroix and Byron: II," pp. 365–86.

62. J, 1:105 (May 16, 1824).

63. J, 1:99–100 (May 11, 1824).

Once reinstated, that house had infringed upon civil liberties and defaulted on its responsibilities to the people. Delacroix's sympathies seem to have been fervently aristocratic but only moderately royalist, and the story of Marino Faliero may well have been symbolic of the triumph of state and class over individual ambition. Delacroix's absence from the ceremonies marking the coronation of Charles X may thus be explained. "Many people have complained," he wrote Pierret, "that I am not attending any of the coronation ceremonies, but I believe that my presence would not have added any charm."[58] Was it an unintended irony that when the picture was exhibited at the Salon of 1827 it was hung next to Gérard's *Coronation of Charles X*? If so, it went unnoticed by the critics. Delécluze dismissed the canvas as a picturesque genre piece, Vitet saw it as a re-enactment of a page from history, and Auguste Jal called it "a police report in oils."[59]

Apart from political considerations, it was natural that Delacroix should be drawn to Byron, who presented an image to the world that was bound to attract the admiration of the young. At once a hero and a rogue, a vain, self-indulgent, dandyish noble who was nonetheless actively engaged in the struggle for freedom, his life itself came to be regarded as a kind of romantic fulfillment. At Baron Gérard's soirees Stendhal fascinated his listeners, Delacroix among them, with descriptions of his encounters with Byron in Italy. For one who, like Delacroix, sometimes wished he were a poet and who repeatedly turned to poetry for inspiration, Byron's poems provided themes of violence, death, and sentiment, richly embellished with picturesque detail. What is more, the narrative and descriptive impact of Byron's verse survived translation and was magnified by its historical relevance and its associations with the poet's own biography.

Delacroix was somewhat familiar with Byron's poetry by 1821, when he did a small oil painting on panel, *Castaways* (Robaut 1473). Three years later he noted in his *Journal* that he wanted to return to the subject, this time to paint the castaways in safety "on the seashore."[60] Apparently in the intervening years he had become better acquainted with Bryon's works, most likely in the translations by Amédée Pichot, which were then popular,[61] although he seems to have made some effort to read the poems in English (on at least one occasion he "construed" passages from *Childe Harold* with his Aunt Riesener).[62] On the other hand, his repertory of Byronic subjects is actually rather limited and is largely derived from earlier illustrations. His interest in Byron's poetry was, it appears, less in understanding the other's art than in using it to stimulate his own creative powers. "Keep in mind forever certain passages of Byron to excite your imagination," he wrote; "they suit you well." He then lists subjects: "the end of the *Bride of Abydos*, the *Death of Selim*, his body tossed about by the waves . . . the *Death of Hassan* in the *Giaour* . . . the *Curses of Mazeppa* against those who have bound him to his steed."[63] As if to fulfill this pledge to himself, on the very afternoon of this *Journal* entry he began to paint a combat between Hassan and the Giaour. He later returned twice to the scene for lithographs. By then he had used Tasso and the shipwreck of Don Juan as subjects, and eventually the Prisoner of Chillon, Marino Faliero, the Two Foscari, and the death of Sardanapalus also attracted him. However, such a list gives a misleading impression of Delacroix's range. Except for the poems of captivity—*The Lament of Tasso*, *Mazeppa*, and *The Prisoner of Chillon*—and to some extent even there, the Byronic works Delacroix selected are all concerned with death, whether recent or impending. As he

indicated in his note, only "certain passages" were in fact suitable to "excite" his imagination—those of death, madness, anguish, and frustration.

Along with the leitmotif of violence in Delacroix's gleanings from Byron there is another common quality, exoticism. Whether medieval, Venetian, or Oriental, colorful costumes and unusual settings reinforced the shock and emotion of the narrative. Far from being "literary," as is often supposed, Delacroix was motivated at least as much by purely pictorial concerns as by those of subject matter. When compromise was indicated, fidelity to the text or accuracy of literary interpretation were sacrificed in the interest of pictorial advantage.

In view of what proves to be a limited and sometimes superficial reference to Byron's poetry, one is led to imagine that some intermediate source may often have determined Delacroix's selection and his emphasis. To a certain extent, Géricault was that source. In 1820 he made a lithograph of the Giaour, showing him, to be sure, not fighting but shaking his fist at a distant Mohammedan city; however, both he and his horse resemble the Giaour and horse of Delacroix's painting of 1827.[64] In 1823 Géricault returned to the subject with *Giaour and the Pasha* (Delteil 95). In this case too similarities are too striking to be accidental.

Much as Delacroix resented his dependence upon external stimulation, whether verbal or visual, he was well aware of it.[65] In 1828 he did an oil after Géricault's lithograph of Mazeppa (Delteil 94).[66] While Géricault illustrated an episode from

64. It may not be an accident that Delacroix's first mention of the Giaour in the *Journal* of May 11, 1824, directly follows a soliloquy on Géricault's recent death (*J*, 1:99–100). Such associations in the *Journal* are often the result of some specific visual stimulus such as (in this case) the lithograph. Delacroix owned many of Géricault's prints, as well as other works.

65. See, for example, *J*, 1:104 (May 14, 1824).

66. Géricault's print was made in collaboration with Eugène Lami. Delacroix had done some sketches of the Mazeppa subject as early as 1824 (*J*, 1:73 [Apr. 11, 1824]). Horace Vernet and Louis Boulanger had both exhibited paintings of Mazeppa in the Salon of 1827, which may account for Delacroix's return to the theme in 1828. Here one of his comments about himself would seem to apply: "I now observe that my mind is never more stimulated to create than when I see a mediocre treatment of a subject suitable to me" (*J*, 1:87–88 [Apr. 27, 1824]).

FIGURE 32. Théodore Géricault, in collaboration with Eugène Lami and Villain. *Giaour and the Pasha.* 1823. Lithograph. 0.15 × 0.21. Cabinet des Estampes, Bibliothèque Nationale, Paris. Photo Bibliothèque Nationale.

FIGURE 33. *Giaour and the Pasha.* 1827.
Lithograph. 0.36 × 0.25. National Gallery of Art, Rosenwald Collection. Photo National Gallery of Art.

Chapter 10 of *The Bride of Abydos* (Delteil 96), his print is formally unlike Delacroix's later oils showing scenes from the poem, although he also locates his action in a dark grotto. Another Géricault lithograph of 1823, *Death of Lara* (Delteil 97), is too close to Delacroix's painting of the same subject, done in 1847, for coincidence. The same formal attributes are present in Delacroix's earlier lithograph, *Young Clifford Finding the Corpse of His Father*, and while the subject is not Byronic, it should be noted that his *Goetz Wounded* also suggests Géricault's *Lara Wounded* (Delteil 45). Given the visual evidence, it would be hard to deny the importance of Géricault's essays in Byronic subject matter from 1820 to 1823.[67]

There are indications, however, that Delacroix may also have been indebted to other sources, such as the Cruikshank and Stothard illustrations of Byron. As George Heard Hamilton has pointed out, nine of Delacroix's Byronic subjects —three-fourths of the total—also occur in the illustrations Cruikshank made for George Clinton's *Memoirs of the Life and Writings of Lord Byron*, one of a number of editions that appeared just after the poet's death in 1824.[68] Clinton's memoirs were published in parts, from June 30 to July 16, 1825, while Delacroix was in London. In view of the young painter's admiration of Byron, it is likely that he soon saw the book.[69] When the two artists' versions of the death of Hassan, the confession of the Giaour, the shipwreck of Don Juan, the Prisoner of Chillon, or the death of Lara are compared, the correspondence of theme and treatment can hardly be ignored. On the other hand, it must be remembered that Géricault did illustrate some of these subjects even earlier, and that Delacroix's *Death of Lara*, for example, may be indebted to a print by Stothard, or to some common antecedent of them all.

The large canvas *Greece on the Ruins of Missolonghi* was at once a kind of monument to Delacroix's Byronism and a synthesis of what he had learned abroad. The painting has traditionally been dated 1827, but it now appears that it was begun in 1826, during the months when the Hellenic struggle took a discouraging turn.[70] The Turks once more laid siege to the stronghold of Missolonghi, and its garrison of 4,000 finally succumbed to an overwhelming force of 35,000 attackers, reinforced by the Ottoman fleet. On the night of April 22, 1826, recognizing the certainty of defeat, the Greek defenders blew up the crumbling walls of the city and destroyed it and themselves. The tragic fate of Missolonghi was soon as well known in Europe as that of Scio. Benefits were organized to raise funds for the victims, and among them was an exhibition at the Galerie Lebrun, in which artists of all schools participated. When it opened, on May 17, 1826, works by David, Gros, Girodet, and Guérin faced those by Delacroix, Géricault, Eugène Devéria, and Ary Scheffer.[71] Delacroix contributed a scene of a Turkish officer killed in the mountains, along with *Marino Faliero*.[72]

Greece on the Ruins of Missolonghi shows a handsome young woman standing in mute despair among broken ruins. She is dramatically outlined against a brooding, gray-green sky, which intensifies the mood of desolation. In contrast with the warm tonalities of *Scio*, the effect is dark and slaty except for a few touches of brilliant color. The dominant mood here, more marked than in *Scio*, is one of a constraint that removes the scene from the world of literal reality. The figure is a kind of *tyche*, or personification, of Greece in the tradition of classical allegory (perhaps for that reason her cap resembles the architectural crowns often worn

67. See K. Berger, *Géricault and His Work*, trans. W. Ames (Lawrence: University of Kansas Press, 1955), p. 32. Berger makes a general observation to this effect but does not support it in detail.

68. See Hamilton, "Delacroix, Byron, and the English Illustrators," *Gazette des Beaux-Arts*, ser. 6, 36 (October, 1949): 261–78, for a lengthy discussion of some of these relationships.

69. It is also probable that Delacroix had come to know Thomas Medwin's *Conversations with Lord Byron*, which was first published in London in 1824 and in a French translation by Amedée Pichot later that year. Delacroix's *Journal* for 1850–1857 contains quotations and paraphrases from the book, which indicate his continuing interest in Byron (see Hamilton, "Delacroix and Byron," pp. 104–5).

70. See Lee Johnson, "The Delacroix Centenary in France—II," *Burlington Magazine*, 106 (June, 1964): 261, and *Eugène Delacroix: 1798–1863* (Toronto: Art Gallery of Toronto, 1962), p. 71, n. 1.

71. Maximilien Gauthier, *Achille et Eugène Devéria* (Paris: Floury, 1925), pp. 25–26.

72. Johnson, "Delacroix Centenary— II," pp. 260–61. Although it is not listed in either edition of the catalogue, another picture by Delacroix, referred to as "Greece Still Standing on the Ruins of Missolonghi," is mentioned in the September 2 issue of the *Journal des débats* by the critic Boutard, in a discussion of revisions of the benefit exhibition.

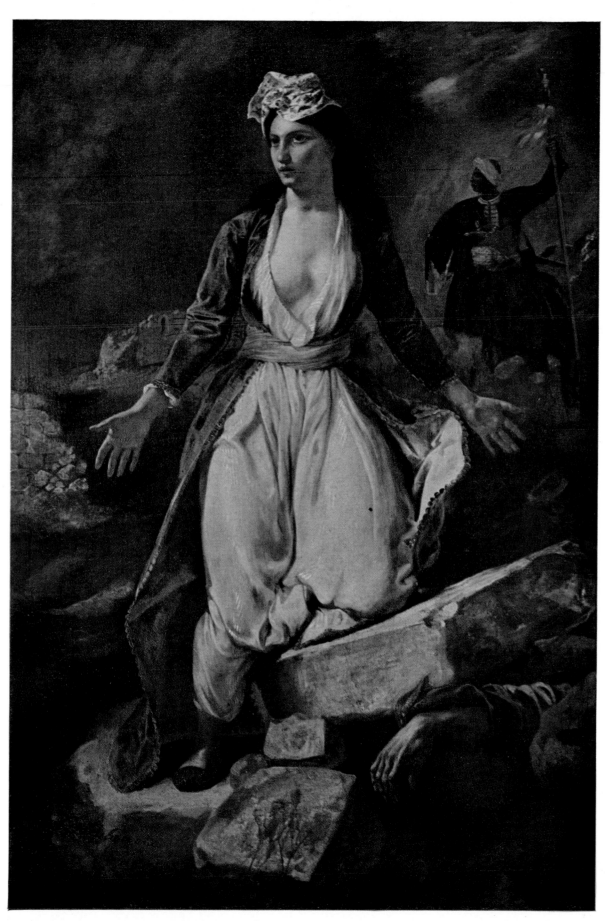

PLATE VI. *Greece on the Ruins of Missolonghi.*
1827. Oil on canvas. 2.09 × 1.47. Musée des Beaux-Arts, Bordeaux.

73. The pose of this figure, but not the costume, is identical with that of a drawing of a Greek warrior (Louvre R.F. 9 217) signed and dated 1826, and hence associable with this and the other Greek subjects of 1826 and 1827, not least of all the various versions of Count Palatiano dressed in souliote costume. Because of the nature of the costume, Sérullaz does not accept the assumption that this is a study for the Turkish figure (*M*, p. 76). It is, however, impossible to deny the similarity of pose. In spite of its size and importance, there is relatively little known about the genesis and early history of this painting. A sketchbook containing sixteen pages of sketches for *Greece on the Ruins*, some of them annotated in Delacroix's hand, indicates the variety of treatments he considered before settling on the final pictorial solution. There is no other record of the progress of the canvas. There is, however, later correspondence concerning the exhibition of the painting in 1851 at the Société des Amis des Arts in Bordeaux and the sale of the work to that city in February, 1852, for the sum of Fr. 2,500 (*C*, 3:84 [Oct., 1851], 107, n. 2 [Feb., 1852], 112 [Mar. 31, 1852]). For a summary of this history, see *M*, pp. 74–76.

74. "Delacroix's Memorial to Byron," *Burlington Magazine*, 94 (September, 1952):257–61.

75. Étienne J. Delécluze, *Journal, 1824–1828* (Paris: Grasset, 1948), p. 482.

by such figures). The dark warrior in the middle distance is a token of the Turkish tyranny at Missolonghi.[73]

Delacroix has produced here not so much an image of catastrophe as a memorial to a city, a people, and a cause. (He himself called the painting an allegory.) At the same time, it may also be true, as Hamilton has proposed,[74] that the painter wished to commemorate the heroic part played by Lord Byron in the Greek wars of independence before his death and burial at Missolonghi, for the very mention of the place invokes his image. In considering such associations, Hamilton points to correspondences between the painting and Byron's poetry, in particular *The Bride of Abydos*. Delacroix's landscape is desolate, as is Byron's, and the hand of a fallen combatant does protrude from a mass of debris, but whether the hand is to be identified as Selim's or the rubble as the toppled "shrine of the mighty," as Hamilton suggests, remains a matter of opinion. Aside from these suggestive resemblances, there is no consistent parallel between the two versions. Byron's image of Greece is a lifeless woman on her deathbed, not the brave, beautiful creature of Delacroix. Yet the Byronic overtones of the painting cannot be lightly dismissed. Delacroix seems to have freely appropriated the poet's verbal images, as he did visual motifs, to build his own monuments.

At a purely stylistic level, there is much in *Greece on the Ruins* reminiscent of Delacroix's recent exposure to English painting. In style, if not in subject, it also recalls his portrait of Baron Schwiter of about the same time. Both compositions are based on a single dominant figure strongly illuminated against a dark, atmospheric background. These traits were observed, if not appreciated, by Delécluze. He complained of the pernicious influence of English painting on what he saw at the Salon of 1827, with its "compositions in which the modern Greeks, with their ugly garments and their scratchy look, appear in the midst of horses, strange weapons, and a sky as dark as though Greece were on the latitude of Edinburgh."[75]

As Delécluze's comment indicates, by 1827 the artistic influence of England was considerable among young artists, and nowhere was it more evident than in Delacroix's work. Not only was his technical debt obvious, but the image of Byron loomed large at the next and last exhibition of the Restoration, the Salon of 1827–1828. In his *Giaour and the Pasha*, *Death of Sardanapalus*, and *Marino Faliero*, Delacroix's taste for the role of "Anglo-Venetian" radical remains apparent.

The Salon of 1827–1828

The year 1827 was at once typical and exceptional in the annals of romanticism. Victor Hugo published his *Cromwell*, the Introduction to which is mentioned in almost every commentary on the arts of the period. Delacroix undertook the project of designing costumes for Hugo's play *Amy Robsart*, an adaptation of scenes from Scott's *Kenilworth*, which was presented at the Odéon theater the following year, and spent long evenings walking in the suburbs with Hugo, Sainte-Beuve, and others of their circle. Berlioz was composing his *Death of Orpheus*, a score now lost, sometimes considered as important a landmark in his career as *Cromwell* was in Hugo's.[1] Paris audiences—long impervious to the charms of alien languages and theatrical traditions—finally succumbed to the art of the Shakespearean actor Sir Charles Kemble and his troupe of English players. The company's leading lady, Harriet Smithson, was particularly popular. (Berlioz's response was the most extravagant: he married the lady, with very unhappy results.) A further indication of changing taste was the auction of Talma's costumes in March. His Hamlet costume, complete with dagger, brought the highest price (Fr. 236). Closely related to the interest in Shakespeare was the new popularity of Goethe, whose *Faust I* had just been translated with success by Gérard de Nerval. Delacroix had completed a set of lithographs to illustrate another edition of Goethe's play, as well as the first of his scenes from *Hamlet*.

In the world of the visual arts, the main event of the year was the simultaneous opening, on November 4, of the Salon of 1827 and, in another section of the Louvre, the newly redecorated rooms comprising the Museum of Charles X. Other works had been recently commissioned for the Council of State chambers in the Palais Royal. Charles X and his ministers were seeking to attract whatever prestige and good will a munificent cultural program might afford an unpopular administration. The works of art resulting from these two programs constituted a kind of anthology of contemporary taste. The decorations were, as Delécluze put it, the product of

all the painters of reputation today: Gros, H. Vernet, Abel de Pujol, Picot, Fragonard (the "Lesser"), Meynier, Heim, Ingres, Bouillon, Guillemot, Hesse, Dubufe, Gassies, Blondel, Delaroche, Lethière, Rouget, Schnetz, Thomas, Drolling, Mauzaisse, Alaux, Franque, Coutan, Colson, Dejuinne, Lancrenon, Steuben, Delacroix, etc. The persons named here comprise the elite of the present school, so that it follows that when one sees the works that they finished for the Museum of Charles X and the Council of State one can get a good notion of what our school accomplished in the year 1827.[2]

It is amusing to observe how grudgingly Delécluze included Delacroix at the end of his exhaustive list. He was forced to acknowledge him because he had been entrusted with a major role in the government's program: he was one of four artists commissioned to paint large canvases for the chambers of the Council of

1. See Jacques Barzun, *Berlioz and His Century* (New York: Meridian, 1956), p. 63.

2. *Journal*, pp. 477–78.

State. Delacroix's contribution, *Emperor Justinian Drafting His Laws,* was exhibited at the Salon of 1827 before its installation in the Palais Royal. Although the painting was destroyed in 1871 when the Communards set fire to the council rooms, preparatory sketches and an old photograph of the completed work permit some estimate of its character, and the still extant murals for the Museum of Charles X provide an index of the efforts of his competitors.

Delacroix's *Justinian* seems to have been a distinguished exception to the generally lackluster response to the government's venture into large-scale patronage. Gros's and Devéria's contributions to the royal museum, if not embarrassingly bad, certainly do not represent their finest work. Ingres' imposing *Apotheosis of Homer* is more successful as now exhibited—as an easel painting—than in its

FIGURE 34. Jean-Auguste-Dominique Ingres. *Apotheosis of Homer.* 1827. Oil on canvas. 3.86 × 5.15. Louvre. Photo Agraci.

FIGURE 35. François Picot. *Study and Genius Unveiling Ancient Egypt to Greece*. 1827. Oil on canvas *marouflé*. Dimensions unknown.
Ceiling, Hall of Egyptian Antiquities. Louvre. Photo Agraci.

3. The Duke of Blacas, whose coin collection Delacroix studied, was a patron of Ingres and had purchased his *Henry IV and the Spanish Ambassador* from the Salon of 1824. As Master of the King's Household and a supporter of Champollion, the Duke was instrumental in creating the Museum of Charles X. He went into exile when Charles X was deposed in 1830.

4. *Salon de 1827, esquisses, croquis, pochades ou tout ce qu'on voudra* (Paris: Dupont, 1828), p. 1.

former placement (now filled by a replica) as a ceiling decoration.[3] As for the rest—Pujol, Picot, Schnetz, and their "elite" company—for the most part, it is difficult even to reconstruct an *oeuvre* aside from the pallid, derivative murals in the Museum, almost universally ignored by those who pass below, and a few works apologetically scattered among the provinces. Picot's *Study and Genius Unveiling Egypt*, a tribute to the Egyptian Museum and its new director, Champollion, is a notable case in point.

The Salon of 1827 was the last of five such exhibitions held during the Restoration. The public reaction was one of dissatisfaction. "The first day of the Salon is always bad," Jal wrote in *Le miroir*. "Later it is different. The chaos has been cleared away and opinions modified a bit. Only the fastidious persist, those La Fontaine complained of, who don't know how to be satisfied—they have the glory of finding everything pitiful. You have to seem to be a connoisseur," he concluded philosophically, "so severity is in good taste."[4] Delacroix himself was little impressed by what he saw on the walls of the Louvre. "The Salon is

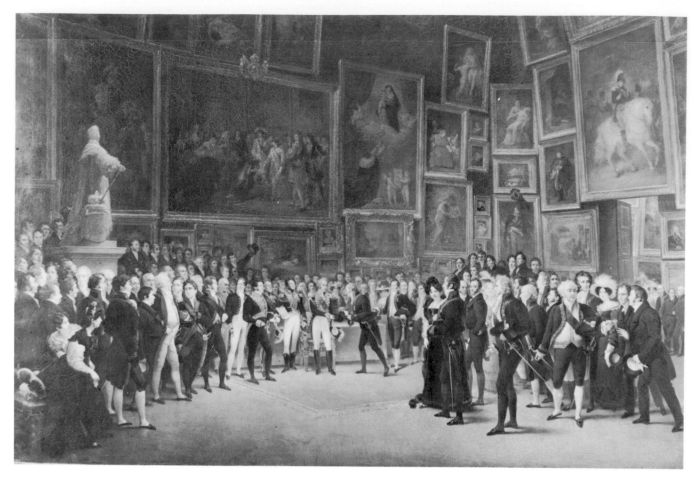

FIGURE 36. François-Joseph Heim. *The King Awarding Prizes at the End of the Salon of 1824.*
Commissioned 1825; Salon of 1827. Oil on canvas. 1.73 × 2.56. Louvre. Photo S.D.P.

like every other year—a potpourri of detestable paintings, among which some have a certain merit," he wrote Schwiter soon after the opening. "You will be quickly disgusted with it."[5]

This disavowal of any novelty in the Salon of 1827 was, by and large, warranted. Most entries were predictable. Baron Gros exhibited an equestrian portrait of the King, and Baron Gérard showed a large canvas of the recent coronation. Heim celebrated the generosity of the Bourbon monarchy in his enormous *The King Awarding Prizes at the End of the Salon of 1824.* Although Delacroix won a "prize of encouragement" for his *Massacre at Scio*, he is not recognizable in Heim's version of the ceremony. As was the case with many other participants, Delacroix included, Ingres was unable to complete his major painting, *Apotheosis of Homer,* in time for the opening, but he did exhibit it before it was installed in the Salle Clarac of the Museum of Charles X.[6] The lesser academicians showed a variety of subjects, ranging from Picot's *Annunciation* and Guérin's *Expulsion of Adam and Eve* to Pujol's *Baptism of Clovis* and Court's *Scene of Deluge.*

5. *C*, 1:205 (Nov. 21, 1827).

6. Such delays and revisions were the cause of confusion and annoyance. One contributor wrote, for example, that he had never known an exhibition so plagued with "changes, disruptions, and breaking up." He is referring to the fact that many artists—including Ingres, Heim, Horace Vernet, and Delacroix—had made it difficult for the critics to discuss their works adequately or to reproduce them in reviews because of their late arrival at the Louvre (see Anthony Béraud, *Annales de l'École Française des Beaux-Arts, recueil de gravures au trait, d'après les principales productions exposées au Salon du Louvre par les artistes vivants . . .* [Paris: Pillet Aîné, (1828)]).

The catalogue thus tends to confirm Delacroix's sour assessment of the exhibition. At the same time, it includes such works as Sir Thomas Lawrence's *Master Lambton* and the landscapes of Constable and of Newton Fielding. Bonington was well represented, as was Isabey, and Camille Corot, a newcomer to the salon, showed his now famous *View of Narni* and another Italian landscape that was subsequently destroyed.

The young artists were also distinguished by their choice of subject matter. Eugène Devéria's *Birth of Henry IV* elicited enthusiastic comparisons with Veronese. His *Marco Bozzaris*, Ary Scheffer's *Souliote Women*, and other "modern Greek" subjects by Vernet and Dupré were obviously intended to capitalize on popular interest in the plight of Greece. Another of Delacroix's friends, Henri Champmartin, who had recently returned from the Levant, showed drawings he had made there and an enormous massacre of a company of Janissaries by the Turks, entitled *Barracks Conflict*. The new interest in English history (the first volume of Guizot's *History of the English Revolution* appeared in 1826) found expression in Delaroche's *Death of Queen Elizabeth* and Devéria's *Mary Stuart*. The former canvas was purchased from the exhibition for the collection of Charles X. Lord Byron's poetry was represented by Boulanger and Horace Vernet, who both showed scenes from his *Mazeppa*, while Robert Fleury showed *Tasso at the Monastery of St. Onuphrius*.

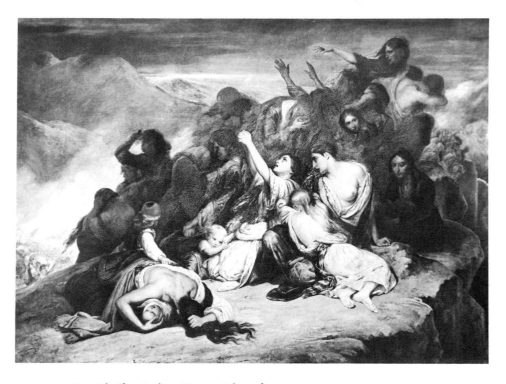

FIGURE 37. Ary Scheffer. *Souliote Women*. Salon of 1827.
Oil on canvas. 2.61 × 3.59. Louvre. Photo Archives Photographiques, Paris.

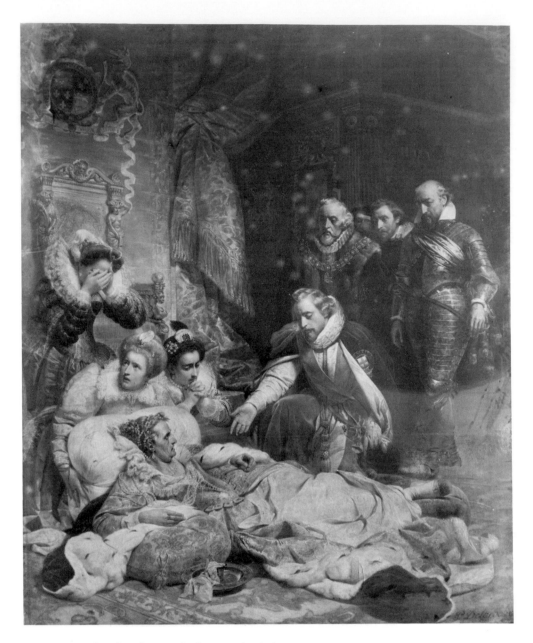

FIGURE 38. Paul Delaroche. *Death of Queen Elizabeth*. 1828.
Oil on canvas. 4.22 × 3.43. Louvre. Photo S.D.P.

Delacroix's own subjects generally reflected the taste of his contemporaries. For sheer quantity alone his contribution must have been conspicuous. The exhibition catalogue and the two supplements to it list twelve pictures by the artist.[7] The largest and most controversial of his entries, *Death of Sardanapalus*, was not finished in time for the opening but made its appearance in February, when the salon was refurbished. *Scene of the Present War between the Turks and*

7. Sixteen entries appear in the salon register of works received for exhibition, but it seems that not all were hung.

8. See Johnson, *Delacroix: 1798–1863*, pp. 9–10.

9. That harsh judgment was not supported by its subsequent history. The portrait was later purchased by Degas, who owned 13 paintings and 191 water colors and drawings by Delacroix. According to Gerhard Fries (verbal communication to the author, July 7, 1963), these were not acquired until the late 1880's and after. By that time, however, Degas had long admired Delacroix. See also T. Reff, "New Light on Degas' Copies," *Burlington Magazine*, 106 (June, 1964):250–59; "Addenda on Degas' Copies," *ibid.* (June, 1965):320–23; "The Chronology of Degas' Notebooks," *ibid.* (December, 1965):606–16; "Copyists in the Louvre," *The Art Bulletin*, 46 (December, 1964):552–59.

Greeks, once called *Giaour and the Pasha*, also made its appearance at that time, along with a small canvas, *Milton Dictating "Paradise Lost" to His Daughters*.[8] Other works deriving from literary sources were *Marino Faliero* and *Mephistopheles Appearing to Faust*. Two large compositions, *Agony in the Garden* and *Justinian*, represented official commitments recently fulfilled, while *Still Life with Lobsters* and *Count Palatiano in Souliote Costume* represented other aspects of his activity. The full-length portrait of Louis Schwiter was rejected by the jury.[9]

Delacroix's selection of Milton as a subject is of decided interest. Like his water color of 1831, *Cromwell before the Coffin of Charles I*, it reflects the prevailing interest in English history (Boulanger also did an oil of the subject). Milton had taken on new stature in French literary circles as the result of the publication of Chateaubriand's *Le génie du christianisme*. *Milton* was not only a subject without precedent for Delacroix but was also unusual for its genre-like character. Reminiscent of English "conversation pieces" or seventeenth-century Dutch interiors —even to the presence of a Turkey carpet—the over-all manner is appropriate both to the narrative and to the physical size of the picture. The almost sentimentalized attentiveness of the blonde daughter dressed in pale blue may well be the result of the collaboration of Ary Scheffer, whom Robaut has suggested as

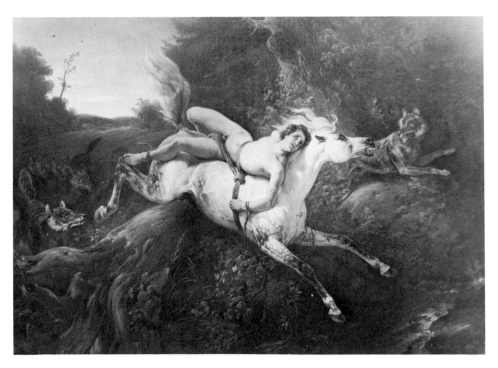

FIGURE 39. Horace Vernet. *Mazeppa.* 1826.
Oil on canvas. 1.00 × 1.38. Musée Calvet, Avignon. Photo Musée Calvet.

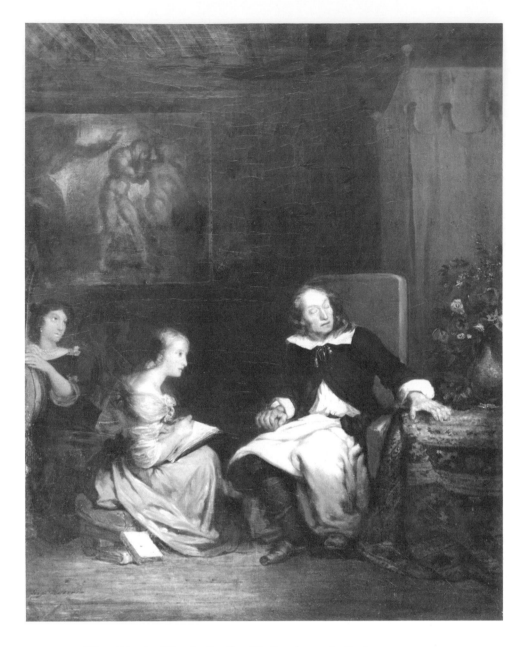

FIGURE 40. *Milton Dictating "Paradise Lost" to His Daughters.* 1824?–28.
Oil on canvas. 0.80 × 0.64. Collection Mr. and Mrs. George Heard Hamilton, Williamstown,
Mass. Photo Cliff Vallieres.

the author of this passage.[10] Stronger in handling is the figure of Milton himself
and the *Expulsion from the Garden of Eden* (similar to that of Raphael's *Stanze*)
hanging on the back wall of the dark, beamed room. For all its interest as an
early document, however, the canvas does not have the boldness or the *brio* of
certain other works of his in the same salon.[11]

Related in many ways to the conservatism of style in the *Milton*—the sharpness
of edge and the relative lack of coloristic or textural animation—is *Agony in the
Garden.* This work was commissioned in 1824 by the Prefect of the Seine, Count

10. See Robaut's annotations to No.
87 of his catalogue of Delacroix's
work.

11. Robaut and others have concluded
that the painting was done in 1824 and
reworked at a later date. Johnson
observes that *Milton* was turned down
by the jury on January 14, 1828, but
accepted for exhibition when it was
resubmitted on January 28. He
suggests that the Expulsion scene may
well have been added during that
interval ("Delacroix et les salons,"
pp. 218–19).

12. *J*, 1:44–45 (Jan. 11, 1824), 91 (May 3, 1824).

de Chabrol.[12] There is little here to recall the virtuosity of technique in *Marino Faliero*, *Faust*, or the other works of his Anglo-Venetian manner. This may, of course, reflect the nature of the commission as much as its relatively early date. Its drier, more "official" cast may represent an effort to cater to official preferences in the hope of further commissions. If so, Delacroix's expectations were frustrated. Many failed to see how little, if at all, traditional canons had been violated. While Louis Vitet, writing for the *Globe*, found an "ineffable poetry" derived of "genuine inspiration" in the three angels "who have come to announce to their divine master His unhappy destiny,"[13] in the *Journal des débats* Delécluze

13. Quoted in *M*, p. 58.

dismissed Delacroix as the sole remaining representative of the "Shakespearean school," disparaged his persistent devotion to "those bizarre ideas," and concluded: "He has made a Christ in the Garden of Olives in which one again finds for the composition a Jesus in the manner of Rubens thrown in with some angels

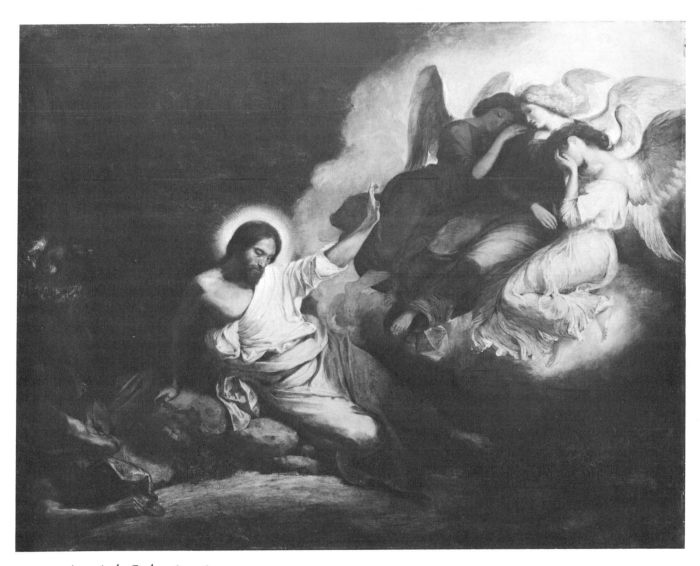

FIGURE 41. *Agony in the Garden.* 1824–26.
Oil on canvas. 2.94 × 3.62. Church of St. Paul-St. Louis, Paris. Photo Giraudon.

as gracious as little English schoolgirls, the whole thing colored with the technique of the school of Rembrandt."[14]

14. Delécluze, *Journal*, p. 482.

Such comments are not altogether unjustified. The influence of Rubens is confirmed by comparison with an etching after a Rubens *Agony in the Garden*, a reproduction of the kind Delacroix frequently studied. Certain relationships are reversed, and there is only a single angelic messenger in the Rubens, but the comparison is nonetheless striking. The two figures of Christ are similar, despite modifications of the head and right arm. The character of the angel, the sleeping apostles, and the distant torchbearers, as well as the massing of the foliage behind Jesus, are too similar to be accidental. Even if we allow for its present darkened state, moreover, the deep shadows and sharply contrasting lights do recall Rembrandt. While the angels may suggest the dancer's pose of an Aimée Dalton rather

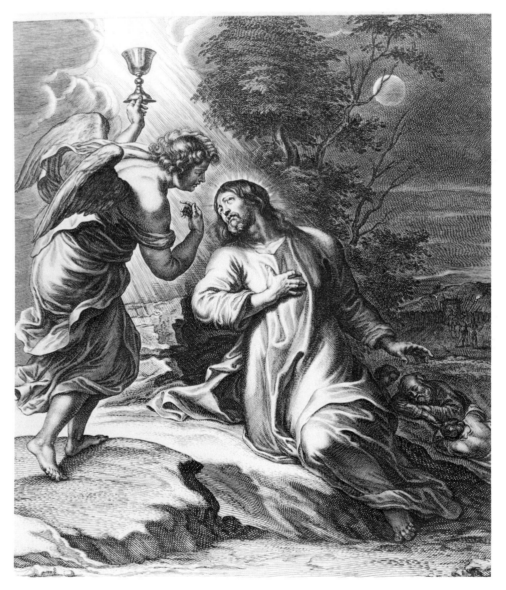

FIGURE 42. Petrus de Bajlliu after Peter Paul Rubens. *Agony in the Garden*. N.d. Engraving and etching. 0.31 × 0.26. Collection of the author. Photo James Gerhard.

than "English schoolgirls," the picture is otherwise clearly in the baroque tradition. To be sure, Delécluze's resentment of those baroque elements is no longer fashionable, and the names of Rembrandt and Rubens have lost their alarming connotations. For many of Delacroix's contemporaries, however, even a modest deviation from neoclassical orthodoxy was unacceptable, as the adverse reactions to *Dante and Virgil* and *Massacre at Scio* had demonstrated.

Not only the largest but in many respects the most interesting of Delacroix's entries was *Justinian*. The official correspondence, now in the archives of the Louvre,[15] shows that the stretcher for the canvas was provided late, in August, 1826; hence the shape of the picture and its size (3.70 × 2.75 m.) were predeter-

15. See Moreau-Nélaton, *Delacroix*, 1:78–79.

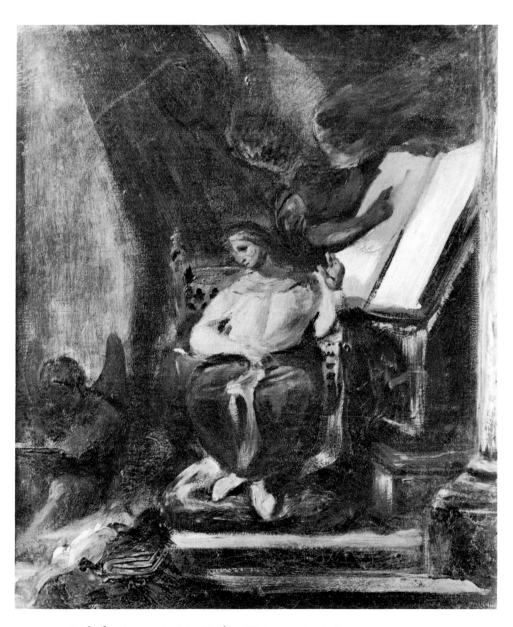

FIGURE 43. Study for *Emperor Justinian Drafting His Laws*. Ca. 1826. Oil on canvas. 0.55 × 0.47. Musée des Arts Décoratifs, Paris. Photo Archives Photographiques, Paris.

mined. The choice of subject, on the other hand, seems to have been more flexible. It was agreed that by November 1 of the following year Delacroix would deliver his work, for which he would receive a substantial fee, four thousand francs.[16] A letter of September 18, 1827, records that the artist had met these terms and had been paid.

Except for the duration of Delacroix's retrospective show at the Universal Exposition of 1855, the canvas remained in the Palais Royal. Delacroix was a double victim of the Commune's violence when the contents of the council rooms were destroyed, for the murals he had painted for the Hall of Peace at the Hôtel de Ville were also lost at that time. Subsequent discussion of *Justinian* has, therefore, been based on slender visual evidence. Although the studies have been accepted as indicative of the over-all character of the composition, a photograph taken while it was on display at the Universal Exposition suggests that, as with the *Agony in the Garden*, the completed version showed some sacrifice of spontaneity and freedom of drawing in the interest of finish and representational credibility.[17] Even so, there were complaints that in the years since his promising debut with *Dante and Virgil*, he had produced no more than sketches—*Justinian* included—to substantiate the high claims of his admirers.

Both the photograph and the studies show the same basic pictorial elements. The Emperor is shown enthroned, dictating his codification of the Roman law to a scribe.[18] He is accompanied by a winged genius. Even the friendly Auguste Jal was dissatisfied with this conception. "The figure of Justinian has provided good sport for the painter's enemies," he wrote. "There is no sort of gibe that they haven't thought up to characterize that personage—who is in fact quite bizarre. One has compared him with a bird and another with a monkey, while yet a third has made the Emperor an Asiatic playing the first scene of the *Malade Imaginaire*."[19] The writer then, in a more serious vein, compares the head of Justinian with those of Sardanapalus and the officer of his palace guard, but this praise is restrained: "The Genius, cast into a field of shadow which conceals a bit the poverty of its forms, is beautiful in tone. What is most praiseworthy in the work is the vivid color of the velvets, the golden ornaments and precious stones that adorn the volumes with which the foreground of the picture is furnished. Time could only add to the merit of these accessories," he concludes glumly, "but this merit is quite secondary in a piece in which the main point is missing."[20]

Adverse criticism notwithstanding, that Delacroix himself thought well of *Justinian* is evident in his decision to include it in his retrospective showing at the Exposition. There, at last, words of praise were uttered by Théophile Gautier: "All the late Roman Empire is summarized in the figure of *Justinian Drafting His Laws*, as the ample draperies of antiquity begin to give way to gem-studded brocades, to the Asiatic luxury of Constantinople. Something subtle and feminine insinuates itself into that imperial majesty."[21]

Curiously, this perceptive comment constitutes the whole of Gautier's discussion of the painting, and Baudelaire no more than mentions *Justinian* in his essay on Delacroix's show. One wonders whether the picture was truly inferior or whether there was some peculiar quality in the work that discouraged contemporary enthusiasm. Both friends and foes agreed that its characterization was highly arbitrary, but it is Gautier who articulates its distinguishing trait: Delacroix had turned to Byzantium for more than his subject.

16. *Dante and Virgil* had been sold for twelve hundred francs. Two years later, in 1824, *Massacre at Scio* brought six thousand francs. Because the latter canvas is larger and more complex than *Justinian*, the difference in price is understandable.

FIGURE 44. Detail of *Emperor Justinian Drafting His Laws* (from Plate XIII of the album of the Universal Exposition of 1855). George Eastman House, Rochester, N.Y. Photo George Eastman House.

17. The photograph is one of a series of plates showing the fine arts section of the Exposition. The view of Delacroix's gallery shows *Justinian* hanging next to *Justice of Trajan*, along with other famous works (see Frank Trapp, "An Early Photograph of a Lost Delacroix," *Burlington Magazine*, 106 [June, 1964]:266–69).

18. The reference is to the compilation of the *Corpus juris civilis*, accomplished in 529–35 under Justinian I. The importance of the *Corpus* for all subsequent legal codes made this an appropriate subject for a hall dedicated to the use of the Council of State.

19. *Salon de 1827*, p. 444.

20. *Ibid.*, p. 445.

21. *Les beaux-arts en Europe*, p. 191. Antony Deschamps was also moved to praise (see *M*, p. 51).

22. *Delacroix*, Fig. 50, facing p. 77.

23. C. Chauvin, *Moniteur universal*, January 29, 1828, quoted in *M*, p. 50.

24. Yvonne Deslandres, *Delacroix: A Pictorial Biography* (New York: Viking, 1963), p. 42.

25. *J. W*, p. 49 (Oct. 4, 1824).

26. He wrote Soulier that he had "actually completed" his "massacre number two." See *C*, 1:211 (begun Feb. 6 and completed Feb. 8, 1828). Lee Johnson points out that the transcript of the jury proceedings ("*proces-verbaux du jury*") indicates that the canvas must have been completed about a month earlier than has been supposed on the basis of this letter ("Delacroix et les salons," p. 217).

27. Many additions and substitutions were made at this time. It was then that Delacroix withdrew *Marino Faliero* to place it on exhibit at the "British Gallery" in London (see *C*, 1:213–14 [Mar. 11, 1828]). The letter notes that the picture was enthusiastically received by the English press. It was not purchased for the Wallace Collection, however, until later. *Greece on the Ruins of Missolonghi* was shown with it at the gallery.

With his usual care when preparing a major work, Delacroix made numerous studies of appropriate physical types, poses, and costumes. Moreau-Nélaton reproduces an album page of such preliminary sketches whose accompanying notations indicate that he was working from an illustrated Italian book.[22] In view of Delacroix's antiquarian interests, however, it is likely that he also sought out actual examples of Byzantine art. He owned a small collection of antique coins that Louis Schwiter had given him, and in 1825 he issued a series of lithographs illustrating coins in the collection of the Duke of Blacas (Delteil 42–47). One critic wrote that he had been assured that the Emperor's head had been "faithfully reproduced from a medal of the period."[23] The pose of the Emperor is curiously familiar, not just in its vague suggestion of Michelangelo's Isaiah in the Sistine Chapel, but in its marked resemblance to late antique and Byzantine images of the Evangelists and of officials of the court. Justinian might almost be taken for St. John with his inspiring angel. His figure looms above the scribe in a recollection of Byzantine conventions, even to the weightlessness of the body and the downward turn of the feet resting against their cushion. Although no specific model has yet suggested itself, it seems apparent that Delacroix was here willing to forego acceptable classical amplitude of forms to attain an effect of "the Asiatic luxury of Constantinople." And while the photograph of the completed painting shows some modification of the bold simplifications of the studies, enough flavor of the Roman East survives to suggest the need for a more illuminating interpretation of a painting dismissed even recently as a "somewhat theatrical composition."[24]

The inference that Delacroix may have wished not only to document his work but also to suggest a style appropriate for the period is lent credence by a comment in his *Journal*, written two years before his receipt of this commission. He tells of speaking with Auguste about "the new character one could give religious subjects by drawing inspiration from mosaics of the time of Constantine."[25] The *Journal* stops just after this note was entered, and his further speculations on this matter, if any, are unavailable. It must be admitted that *Justinian* stands alone in its apparently deliberate archaism. While *Marino Faliero* also indicates an interest in Byzantine art, its references are local and are presented as straightforward description. The lost painting indicates the individualistic vision that assumed even more daring form in his next project, the controversial *Death of Sardanapalus*.

The largest and most important of Delacroix's paintings in the salon, *Death of Sardanapalus* was ready for exhibition by February 6.[26] Two days later (the morning on which the refurbished gallery was reopened[27]) he complained that, despite the fact that his "daub," as he put it, had been given the best possible place, he was pained—as he admitted he had often been before—by the first sight of his latest work in the gallery. It had, he said, the effect on him "of a *première* performance at which everyone may hiss." His apprehension that it would have a similar impact on others was fully justified.

Delacroix's letter makes it clear that work on *Sardanapalus* must have begun as soon as *Justinian* was completed in September of 1827. The full-scale execution was again preceded by an extensive exploratory process. Delacroix made studies in pastel, as well as in the more usual media of pencil, pen and ink, wash, water color, and oil. These pastels indicate the degree to which Delacroix had by this point abandoned traditional notions of modeling form as light and shadow in

favor of freer, more coloristic art. As Johnson has observed, these works, which came to light only a few years ago, lend substance to the insistence of Andrieu, Delacroix's loyal assistant of his later years, that he had sought to obtain in his canvas the brilliance and variety of tone afforded by the pastel medium,[28] and that Delacroix regretted that he had been unable to attain that pastel or tempera quality in his final painting.[29] It is also noteworthy that he turned to theatrical scene painting—especially to the work of the well-known designer, Ciceri—for information about obtaining such effects. His interest in stage settings had shown itself earlier, in his letters from London.[30]

However ingenious, Delacroix's borrowing from the stage was in this instance misdirected. His decision to use underpainting in distemper with overpainting in oil for the final canvas ultimately frustrated the preservation of the freshness of tone he had so fervently desired. Yet in spite of that deterioration and the later restorations it made necessary, *Sardanapalus* remains extraordinary for its brilliance of hue. Apart from technical considerations, Delacroix's study of stage *décor* may be indicative of those broader affinities with the theater and opera which are frequently observed in his treatment of the Sardanapalus subject. There is more than a little theatrical hyperbole in this profligate confusion of straining figures scattered over a heap of precious objects. To understand its meaning, one must consider first the subject itself, then its formal and thematic origins, and finally its place in Delacroix's artistic development.

The scene is related, at least broadly, to Byron's poetic drama *Sardanapalus*, which was pubished in 1821 and was dedicated to Goethe. Delacroix certainly knew the poem, at least in Pichot's popular translation. The canvas shows the final moments of Semiramis' last descendant, Sardanapalus, King of Assyria.[31] He is faced with defeat at the hands of Arbaces, Governor of Media, and his ally, the Governor of Babylon. As the insurgent armies approach the royal palace at Nineveh, the King, whose dissolute life has been an invitation to rebellion, orders the destruction of his wives and all else he treasures. Delacroix shows the frenzied execution of that command as the funeral pyre is made ready.

The Second Supplement to the Catalogue of the Salon of 1827–1828 includes the artist's own scenario for his picture, which is listed there as no. 1630:

> The rebels besiege him in his palace. Reclining on a superb bed at the summit of an immense pyre, Sardanapalus gives the order to his eunuchs and the palace officers to slaughter his women, his pages—even his horses and his favorite dogs, so that nothing that had served his pleasure might survive him. . . . Aischeh, a Bactrian woman, not wishing to be put to death by a slave, hanged herself from one of the columns supporting the vaulted ceiling. . . . Sardanapalus' cupbearer, Baleah [Byron's Balea], finally committed the pyre to flame and threw himself upon it.[32]

In her extended discussion of Delacroix's interpretation of the subject, Beatrice Farwell proposes that there are differences in Byron's interpretation of the scene. She therefore infers some other literary source, not just the "artistic license" sometimes assumed to explain such variants.[33] Deriving their information from the lost *Persica* of Ctesias, the ancient writers Diodorus Siculus and Athenaeus both portray King Sardanapalus as a corrupt and licentious man whose reign finally led to popular revolt. Learning of the rebel's decision to divert the Tigris (Diodorus called it the Euphrates), the King recognized the fulfillment of an old prophecy that Nineveh could only be taken when the river itself became the city's enemy.

28. See Johnson, *Delacroix*, pp. 37–38.

29. Quoted in Bruyas, *La galerie Bruyas*, pp. 366–67.

30. See C, 1:160–61 (June 18, 1825).

31. The catastrophe took place in 612 B.C. The Medes and Scythians (before whose alliance Nineveh finally fell) had been attacking the Assyrian Empire for some time. Sardanapalus and Arbaces are the Greek names used by Byron.

32. Quoted in *M*, p. 64.

33. For a detailed discussion of possible origins of Delacroix's adaptation of the text and some of the visual sources that he may have used, see her "Sources for Delacroix's *Death of Sardanapalus*," *The Art Bulletin*, 40 (March, 1958):66–71, especially pp. 68–69. Farwell notes that Delacroix's description of the scene in the catalogue is in quotation marks, which suggests that he may have been giving an extant text rather than his own commentary. The programmatic character of Delacroix's plot summary and its inclusion of Aischeh, who appears in none of the known accounts of the legend, has suggested that some now forgotten stage production—perhaps one seen by Delacroix in London— may have served as the immediate source for this version of the story, but Johnson points out that there is no evidence of a London production of *Sardanapalus* at the time of Delacroix's visit (see "The Etruscan Sources of Delacroix's *Death of Sardanapalus*," *The Art Bulletin*, 42 [December, 1960]:297–98, n. 15), and no record of a Paris production has come to light. It is evident, however, that the theme was well known, for in 1830 Berlioz used it as the basis for a cantata with which he won the Prix de Rome for that year. While the score has been lost, Berlioz's description of his text suggests Delacroix's treatment of the subject rather than Byron's (see Berlioz, *Memoirs* [New York: Knopf, 1935], p. 112).

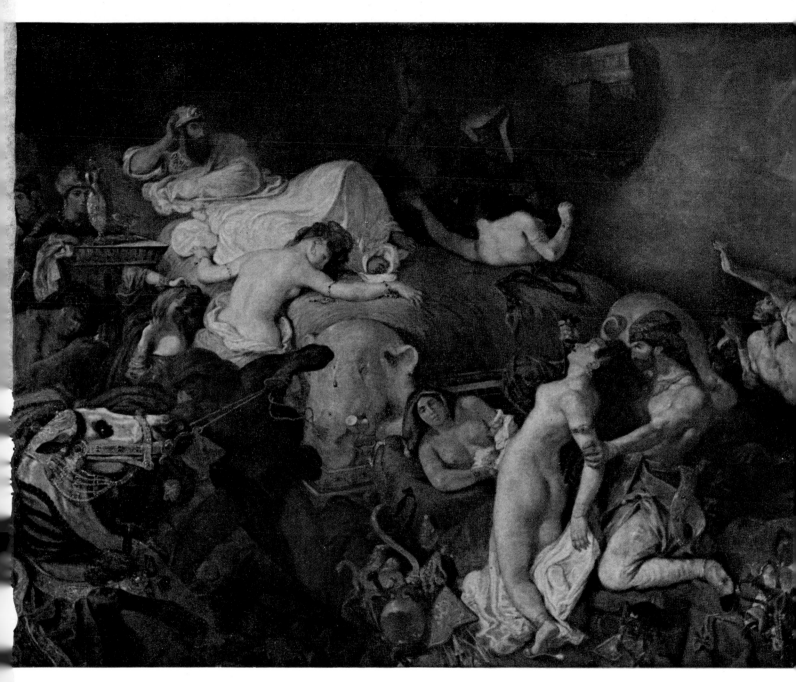

PLATE VII. *Death of Sardanapalus*. 1827. Oil on canvas. 3.95 × 4.95. Louvre.

PLATE VIII. Study for *Death of Sardanapalus*. 1827. Pastel. 0.40 × 0.27. Louvre.

Faced with certain defeat, he ordered his palace put to the torch. According to Athenaeus' account, the fire burned for fifteen days.

Byron's monarch is a far nobler figure than legend would have him. More an elegant epicurean than a libidinous monster, he emerges in the poem almost as a replica, as Farwell suggests, of Byron's image of himself. He dies alone except for his favorite concubine, who, having fought by his side, chooses to remain with him to the end. The Queen and the rest of the court, all almost as devoted to him, have been sent out of the palace to safety. Byron's tragedy, therefore, could not have provided the literal basis for Delacroix's scene of wholesale destruction. Except for the King's attitude of resignation, there is little to recall Byron's restrained interpretation of the ancient narrative.

There are further difficulties in establishing exact sources for Delacroix's interpretation. The notations he jotted on one of the pages of small pencil sketches for the painting (Louvre R.F. 5 278) indicate that he consulted archeological material as well as literary and historical documents:

Etruscans of all sorts—exaggerated sketches after the Negro—colossal crocodile—remember the character of the Jew who posed for the scribe—look at the primitive figures of vases from Sicily—make them very Oriental—look at types of Indians and their monuments, their divinities—try to have drawings after Michelangelo—study the sketches of West—ferocious Ethiopians—heads of priests [*marabouts*], Africans, Nubians —do a head of a man along with a head of a camel—Leblond's licentious paintings from Delhi for the heads of the men—Persepolitan paintings.[34]

Following these clues, Farwell assumes that, lacking visual knowledge of ancient Assyria (the first excavations at Nineveh did not occur until the 1840's), Delacroix must have depended on representations of Persepolis as an acceptable approximation of Sardanapalus' surroundings. She points to similarities between the painting and illustrations in Cornelis de Bruyn's *Voyages . . . par la Moscovie, la Perse, et les Indes Orientales*, which was published in 1817, and suggests the book as a possible source.[35] She further notes that much of the painter's detail derives from other sources, perhaps artifacts borrowed from Auguste, some of which were of more recent Islamic origin. Philippe Jullian's inference that Delacroix may have been thinking of the practice of suttee[36] is lent credence by the fact that not long before Delacroix had copied details from a Persian manuscript illumination of a woman burning herself alive with the body of her betrothed.[37] Yet other elements hint of Greece and Egypt, as would be natural at a time when Champollion was a protégé of the Duke of Blacas and Egyptian objects were being installed in the Museum of Charles X next to those from the classical world.[38]

Eclectic though his sources may have been, Delacroix's version is in some details unexpectedly accurate. The King, for example, is heavily bearded, not clean-shaven, as the ancient chroniclers describe him. This detail would seem to derive from acquaintance with Persepolitan remains as well as from established conventions for representing "Orientals," or perhaps, as Farwell proposes, from recollections of the antique coins he had studied, some of which were Greco-Persian.[39]

Pursuing another line of inquiry, Johnson has examined Delacroix's interest in Etruscan art. He makes an illuminating comparison between the King's pose and those of the reclining effigies on the lids of Etruscan sarcophagi and funerary urns. His central argument, however, relating Delacroix's picture to an engraving after an Etruscan slaughter scene once in the Pitti Palace collection,[40] is uncon-

34. Both Farwell and Johnson refer to these notations, but neither gives a complete transcription. Because they appear at random on the original page, I have put them in the order in which they are listed in *M*, p. 70.

35. See Farwell, "Sources for *Sardanapalus*," pp. 70–71 (she adds that he may have heard of the elephant caryatids at Elura or the great reliefs at Elephanta). Of course, he may have come upon some representation of Ganesha which suggested the motif.

36. *Delacroix*, p. 72.

37. See Johnson, "Two Sources of Oriental Motifs," p. 164.

38. This combination of interests is evident in some of the decorations in the museum, especially those by Picot for Room D, *Study and Genius Unveiling Egypt*. Egypt, symbolized by a dusky queen, is enthroned in the lower left corner, surrounded by a pyramidal assortment of artifacts and accompanied by a river god, with his symbolic crocodile (*cf.* Delacroix's "colossal crocodile").

39. See "Sources for *Sardanapalus*," pp. 70–71. It will be recalled that Auguste Jal remarked upon the resemblance between the figures of Sardanapalus and Justinian.

40. See "Etruscan Sources," pp. 296–300. The slaughter scene appears as plate 2 (from Mongez, *Palazzo Pitti* [Paris: n.p., 1789–1814], vol. 4, last plate).

vincing. The resemblances he sees between the pose of the slave tugging at the frightened horse's reins and that of a male figure almost cut off by the right margin of the Pitti scene are not at all striking to my eyes. The slave, for example, is at least equally like an illustration published in 1817 of a classical Ganymede, which, quite by chance, is reproduced in the issue of the journal in which Johnson's article on these Etruscan sources appeared.[41] I mention the Ganymede not to introduce yet another "source" but to indicate that there are long-standing artistic conventions of pose and that the repertory of gestures that artists have traditionally utilized is surprisingly limited.[42] Johnson's further proposals that the iconography and the nature of the pictorial space may also have been derived from Etruscan sources seems strained beyond the evidence.

In the course of his discussion, Johnson refers in passing to Delacroix's apparent borrowings from Rubens in the development of his composition. This relationship may be seen in the attitude, if not the type, of a study for the struggling concubine at the right center (Louvre R.F. 5 277) and even more so in the nude in the *Rape of the Daughters of Leucippus*. Although Rubens' painting was in the Alte Pinakothek in Munich, Delacroix might have known it from a print.[43] The final version of the figure is, however, closer to the middle nereid in the *Debarkation of Marie de Medici at Marseille*. As Johnson points out, however, the final pose seems to derive from a pastel done from a model. There is, of course, no contradiction in this. Since Delacroix had made an oil copy of that section of *Marie de Medici*, he may have worked both from the model and from recollection to create a paraphrase of the motif.

In much the same spirit, the rearing horse in *Sardanapalus* recalls a counterpart in the Rubens, but the type is different, and Rubens himself was dependent upon an established tradition for the depiction of such action. It is, moreover, true, as Johnson observes, that Gros used a similar device in his *Battle of Aboukir*. The deeper stylistic affinities between the work of the two men are often overlooked, however. Delacroix has set his tangle of sensuous bodies against a mannered and uncertain space in much the same way that Gros sometimes conceived his compositions. Such a compounding of influences was characteristic of Delacroix. A third possible influence is Benjamin West, not mentioned by Farwell and Johnson. Delacroix may have had in mind, in referring to "the sketches of West,"[44] *Death on a Pale Horse*, which he saw in the West exhibition in London.

Related in some more complicated—and thus far unexplored—way to the genesis of *Sardanapalus* is the aloof, mysterious figure of Auguste. The little drawings and pastels he produced, with their deft touch and brilliant color, remind the viewer that long before the Goncourts Auguste had perceived the charm of the Rococo, a taste Delacroix himself came to share.[45] It is noteworthy that Delacroix elected to employ the pastels favored by Auguste in carrying out his studies for *Sardanapalus*. The intensity of hue he strove to attain in the final composition may equally well have derived from the example of Auguste's pastels, dominated by bright blues, greens, reds, and yellows.

In style and expression and in treatment of form and space, as well as in color and technique, the older man's influence can be seen in Delacroix's work of this period—so much so that even Raymond Escholier mistook Auguste's *Negress Mounting a Horse* for a Delacroix,[46] and others have been similarly misled. As Johnson points out, even in Delacroix's own day the spatial anomalies in the picture were rather critically observed,[47] and although it is impossible to accept Johnson's

41. See K. M. Phillips, Jr., "Subject and Technique in Hellenistic-Roman Mosaics: A Ganymede Mosaic from Sicily," *The Art Bulletin*, 42 (December, 1960): 259 and plate 20.

42. See E. Gombrich, *Art and Illusion* (London: Phaidon, 1960), pp. 86–87.

43. See *J*, 1:243 (Oct. 5, 1847), in which he mentions a sketch he made in 1837 from a print of the Rubens. It therefore seems likely that he may have known the picture still earlier. Similar echoes of this composition are observable in *Massacre at Scio*.

44. It is uncertain whether Delacroix's reference here is to sketches by West's own hand or to copies after West by someone else—perhaps himself.

45. See Huyghe, *Delacroix*, p. 122, where he points out that Auguste was "one of the first, perhaps the first, to rehabilitate Watteau" and other eighteenth-century masters. He owned works by a number of them, including half of the famous sign Watteau painted for Gersaint's shop and Chardin's *House of Cards*, both now in the Louvre. See also S. O. Simches, *Le romantisme et le goût esthétique du XVIIIᵉ siècle* (Paris: Presses Universitaires de France, 1964), pp. 10–11. It is of interest that in the spring of 1827, when Henri Champmartin returned from the Near East with "a huge store of information," which may itself have been influential in forming *Sardanapalus*, Delacroix promptly asked Auguste's permission to bring Champmartin to one of his soirees (*C*, 1:191 [Spring, 1827]).

46. See Huyghe, *Delacroix*, p. 521, n. 17.

47. See Johnson, "Etruscan Sources," p. 298.

FIGURE 45. Jules-Robert Auguste. *Two Female Nudes.* N.d.
Pastel. 0.30 × 0.36. Cabinet des Dessins, Louvre. Photo S.D.P.

48. See *Delacroix*, p. 174.

characterization of it as frieze-like, it is equally difficult to see how Huyghe
could see the picture as "closer than ever" to Rubens and the Baroque.[48] It is,
if anything, Mannerist in its arbitrary and inconsistent space. There is more of
Tintoretto than of Rubens in the great diagonal that leads upward to the brooding
Sardanapalus.

The articulation of the individual figures shows much the same ambiguity
and contradiction. The strong linear emphasis of the contours, particularly those
of the struggling woman in the lower left, compromises the illusion of foreshort-
ening and three-dimensional relief. The figures tend to be rubbery and insub-
stantial, and the quality of anatomical exaggeration that often occurs in works by
Auguste is present here.

In part, these Mannerist traits may relate to the anticlassicism which is also
apparent in the troubadour manner of 1810–1820. For a time even the work of
Ingres was not exempt from such affectations. There is a distinctly erotic element
in Delacroix's painting that again suggests certain works of Ingres, and it is cer-
tainly far grander in scale and conception than Auguste's distinctly minor art.
Yet if *Sardanapalus* does not lapse into the overt suggestiveness of Auguste's
intimate juxtapositions of female nudes, sometimes linking dark-skinned and
white, it does show the taste for the peculiar beauty of struggling flesh which had
been conspicuous in *Scio*. Here, however, that theme has been expanded, and the

mingling of female loveliness and male brutality, dark skin and light, intensifies by contrast. Could it be that here one finds a clue to the meaning of his note to consult "Leblond's licentious paintings from Delhi for the heads of the men"?

Related to Sardanapalus and closer in size to Auguste's works are a number of other paintings and drawings of the immediately preceding period, which are more openly erotic. Most notable among these subjects is his small painting, *The Duke of Burgundy Showing His Mistress to the Duke of Orléans*. One might also mention the odalisques, particularly the handsome *Young Woman with a Parakeet* and the no longer innocent *Woman with White Stockings*.[49] Compared with Bonington's chaste odalisques, such as his *Woman with a Parakeet* in the Wallace Collection, those of Delacroix—although they lack Auguste's persistent innuendo—reveal an undisguised and unapologetic carnality.[50] The early *Journal* abounds in references to the writer's sexual preoccupations, his recurrent distrust of himself, his fleeting liaisons, and his frequent sense of insecurity and loneliness. His self-consciousness about his frail build and neurotic concern for his health were compounded by growing fears of impotence that had led him, as early as 1824, to seek medical advice.[51] While we can only speculate as to the psychic cause or the consequence of these anxieties, it may be that his decision to convert the final actions of Byron's heroic king into a massive burning of the "vanities" was motivated by more than purely pictorial considerations.

A *Journal* entry many years later, at a very different stage of Delacroix's life, expresses feelings that may also relate to *Sardanapalus*. "*The world was not made for man*," he wrote. "Man is the master of nature and is mastered by it. He is the only living creature who not only resists, but overcomes the laws of nature and extends his authority by energy and force of will. But," he continues, "to say that the universe is made for man is a very different matter. All man's constructions are as transitory as man himself; time overthrows his buildings and blocks his canals, it reduces his knowledge to nothing and obliterates the very names of his nations. Where is Carthage now? Where is Nineveh?"[52]

The critics were, as usual, divided in their opinions of the Salon of 1827–1828, but they were agreed almost to a man in their contempt for *Death of Sardanapalus*. In the *Gazette de France* the picture was singled out as the worst in the salon. A commentator in the *Observateur* sarcastically claimed that Delacroix would have had to hire "two vans to move the furniture of Sardanapalus, three hearses for the dead, and two buses for the living."[53] Delécluze declared that the painting was liked neither by artists nor by the public. It was an impenetrable collection of isolated details, he said, "in which the eye cannot disentangle the confusion of lines and colors, in which the first rules of art have been violated from the very beginning. The *Sardanapalus* is an error of painting."[54] The critic of the *Moniteur universel* admitted that a misguided few had found the picture "sublime" but insisted that opinion was almost unanimous in condemning it as "ridiculous." As a "true" friend of the painter, he advised that he "curb his pictorial and poetic imagination, force himself to acquire style, consent to draw, and raise his language to the level of his thoughts."[55] Victor Hugo was almost alone in his defense of the picture, even though he regretted Delacroix's one note of restraint: the funeral pyre was not yet in flames.

Delacroix himself seems to have had mixed feelings about his painting. The "abominable effect" he confessed it had on him when he first saw it hanging at

49. *Woman with White Stockings* bears a close resemblance to Rubens' *Sleeping Angelica* in the Kunsthistorisches Museum in Vienna.

50. One might in this context also point out a drawing (Louvre R.F. 5 276) that Escholier considers preparatory to *Sardanapalus*. It has, for example, notations along the top margin that read, "Europa playing with the Bull—Diana with a Stag." One of the female nudes is identified as Leda, a subject Delacroix later adopted for his first experiment in fresco. Technically, the drawings resemble some of Géricault's, with a heavy pen-and-ink hatch stroke. Géricault himself, of course, had done some erotic drawings, including a Leda. Riesener and Etty also did versions of the Leda subject.

51. See, for example, *J*, 1:106–7 (June 1, 1824).

52. *J*, W, p. 256 (Sept. 21, 1854).

53. Editorial, *L'Observateur des Beaux-Arts*, May 8, 1828, quoted in Escholier, *Delacroix*, 1:219.

54. Quoted in *ibid.*, pp. 217ff.

55. *Ibid.*, p. 192.

FIGURE 46.▷
Eugène Devéria. *Birth of Henry IV.* 1827. Oil on canvas. 4.84 × 3.92. Louvre. Photo Bulloz.

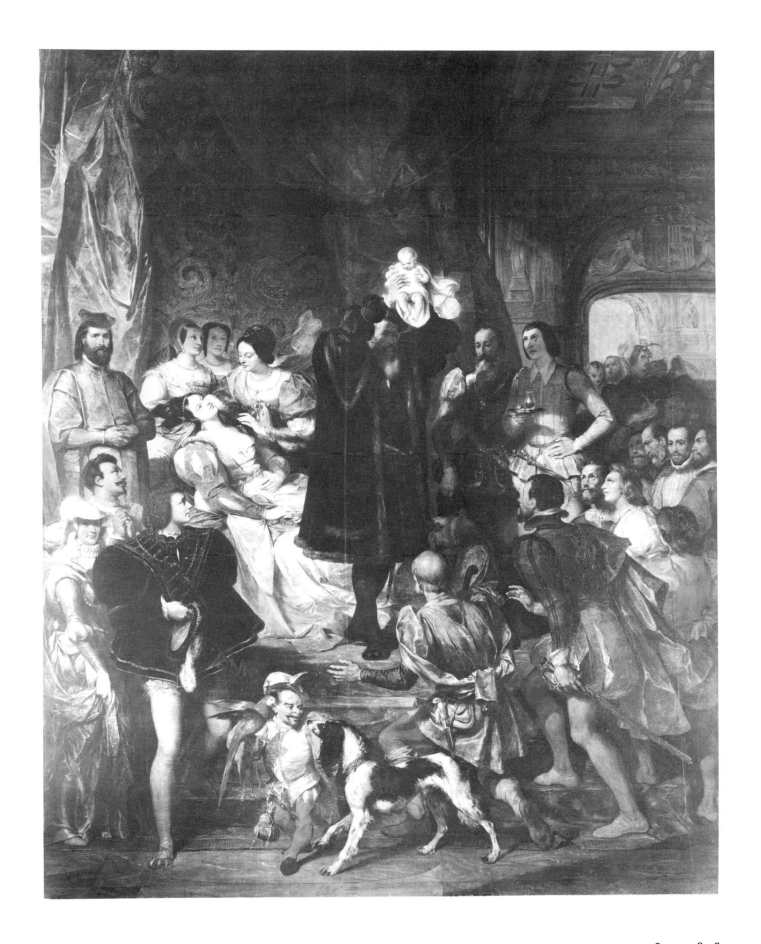

the Louvre[56] was modified a month later, as he explained to Soulier. He did not concede that *Sardanapalus* was a painting "of the romantics, since romantics there are." His critics were imbeciles, he insisted, and the picture had its merits as well as its faults. Vitet had published an article in the *Globe*, urging that Delacroix be denounced by the new school, and Delacroix quoted him: "When a foolhardy soldier fires at his friends as he does at his enemies, he must be dismissed from the ranks." Contemptuous though he was of such charges, Delacroix was well aware of their threat to his "material interests—that is to say," he added in English, "the *cash*."[57]

This lesson was rudely brought home when the Minister of Fine Arts, Sosthène de la Rochefoucauld, called Delacroix to his office. According to the painter's later account, he at first naïvely supposed that the invitation promised some forthcoming honor—at the very least, a new commission. He soon realized his mistake. The Minister, who was, he admitted, "a pleasant man," told him politely but firmly that if he "wished to share in the favors of the Government, he would have to mend his ways." To underline the message, he withheld his recommendation for the purchase of *Sardanapalus*.[58] Delacroix retired his rejected work to the obscurity of his studio, where it remained for the rest of his life. He painted a small replica of the composition in 1844, indicating his continued affection for it, but it was excluded—deliberately, it would seem—both from his retrospective at the Universal Exposition of 1855 and from the posthumous exhibition of 1864. Not until 1921, when it passed into the collection of the Louvre as part of the bequest of a distant relative and ardent admirer of Delacroix, Baron Vitta, was it publicly displayed.

According to Delacroix, from the moment of his conversation with M. de la Rochefoucauld, the painting seemed suddenly "very much superior to what I had believed."[59] Such defensiveness does not disguise the fact, however, that the whole venture was most disheartening. If Delacroix was ever a "romantic," this picture is the evidence. For all their sometimes daring individualism, his later pictures show a degree of respect for convention which suggests that the Minister's words had made a deep—and in some ways an unfortunate—impression. He watched the honors passed on to others, even to other members of Vitet's new school. Eugène Devéria's *Birth of Henry IV*, for example, brought him immediate, if ephemeral, wealth and reputation. Whether or not Delacroix actually attended the elaborate "Veronese Ball" given by his friend in celebration of the state purchase of his work and the other benefits it had brought him, he surely knew of it.[60] For the moment, at least, Devéria did seem to be the new leader of the Anglo-Venetian school. He lived to regret the brevity of that success and wrote, forty years after that great day: "If I had died, I should have been for France one of those noble names radiating hope, whose talent each age completes according to its pleasure. . . . If I had died! . . . my life would have been short, but my glory of a day would not have been followed by sorrowful disenchantments; I would not have come to lament my faded spirit."[61]

Delacroix's setback, like Devéria's fame, proved to be only temporary. While it was not until after the July Revolution of 1830 that he again enjoyed state patronage, he was not abandoned during the intervening years. Along with many smaller undertakings he received major commissions of a quasi-official character, some of which, and their place in Delacroix's artistic development, are discussed in the following chapter.

56. *C*, 1:211 (Feb. 6–8, 1828).

57. *C*, 1:213 (Mar. 11, 1828).

58. Quoted in Piron, *Delacroix*, p. 72. See also *C*, 1:217 (to Soulier, Apr. 27, 1828).

59. See Piron, *Delacroix*, p. 72.

60. In addition to the purchase price of Fr. 6,000, the sum that *Birth of Henry IV* had brought, Devéria made an additional Fr. 6,500 on the sale of reproduction rights to a publisher. The subject would naturally have been popular: Henry IV was the first of the Bourbon kings and had led a gallant life, distinguished by religious tolerance and a concern for the common people. He offered his less attractive descendants, including Charles X, a desirable public image to draw upon. Hence the song "Vive Henri IV" was played as an anthem before theatrical performances. His statue is prominent in Heim's *The King Awarding Prizes at the End of the Salon of 1824*.

61. Quoted in Gauthier, *Achille et Eugène Devéria*, p. 46. Devéria's melancholic reminiscence alludes to a celebration of his success on the opening day of the salon, when he and his brother had joined some soldiers in a cafe. Toward midnight, a quarrel arose, which almost ended in a duel.

For King and Country

Delacroix's disappointment with the results of his participation in the Salon of 1827–1828 increased his already deep resentment of officialdom, with its unhappy mixture of power and inertia. Never a robust person, that winter his health had been seriously weakened, largely, it would seem, by the heavy strain of his social activities. In February, 1828, he confided to Soulier that he had been "close to death," although he added reassuringly that he was "no longer quite so thin."[1] He found the parties he attended—"from habit," as he insisted—altogether boring and exhausting:[2] he wrote to Pierret that he no longer found "the same charm in things."[3]

Four years earlier he had announced that "glory is not an empty word." Now he had come, for a time at least, to regard "the love of glory" as no more than a "lying passion, a ridiculous will-o'-the-wisp that always leads straight to the abyss of sadness and vanity."[4] "As I expected," he wrote Soulier, "the picture [*Sardanapalus*] has not been purchased, nor have there been any commissions for the future."[5] Equally alarming and mysterious to him was the absence of any reference to *Justinian* or his own name in recent articles on the decorations painted for the Council of State. This obvious slight, he concluded—as if accepting Rochefoucauld's well-meaning admonition about non-conformity—"demonstrates that I must return to other ways."[6]

Here, as elsewhere, the biographer must exercise some caution as he consults the surviving documents. For Delacroix, reverie seems often to have meant a lapse into melancholy and self-dramatization. He did have, after all, both personal and professional satisfactions. His liaison with Aimée Dalton continued and provided moments of release from his states of depression.[7] After his creative inactivity in the spring of 1828, just following his "retreat from Moscow," he returned dutifully to his work. New projects continued to suggest themselves, eventually new commissions came in, and the favorable reception the London public accorded his *Marino Faliero* and *Greece on the Ruins of Missolonghi* advanced his career abroad.[8]

In 1828 he completed his large canvas *Cardinal Richelieu Celebrating Mass in the Chapel of the Palais Royal*.[9] A second commission from the Duke of Orléans, which resulted in his *Murder of the Bishop of Liège*, was awarded in 1829. Early the same year the Duchess of Berry negotiated for a picture of the Battle of Poitiers, but she fled France in the summer of 1830, upon the overthrow of Charles X, and never saw the completed canvas. However, she eventually granted Delacroix's request to be paid for it even though it was not delivered. (Ironically, he invested the money thus obtained in materials to complete *Liberty Leading the People*, in which Delacroix commemorated the very events that had led to her exile.)

During the early months of 1830 the French political situation steadily grew worse. In March repressive measures were taken against the press, and the manag-

1. C, 1:212 (Feb. 6, 1828), 217 (Apr. 27, 1828).

2. C, 1:216 (to Soulier, Apr. 26, 1828). In later years he attributed his decline in health to his earlier habit of staying up very late at night after working at his studio all day (see Piron, *Delacroix*, p. 78).

3. C, 1:229 (Oct. 27, 1828).

4. J, 1:88 (Apr. 29, 1824).

5. C, 1:216 (Apr. 26, 1828).

6. *Ibid.*

7. Mme Dalton remained his mistress until at least 1839, when he helped her to obtain a teaching position in Algiers (see Huyghe, *Delacroix*, p. 517, n. 15).

8. See C, 4:59 (to Silvestre, Dec. 31, 1858). Sir Thomas Lawrence himself had considered buying *Marino*, a fact which must have been reassuring, if also disappointing (it was not sold).

9. The copy, made by Jourdy on the occasion of the appearance of the picture in the Salon of 1831, is reproduced in Moreau-Nélaton, *Delacroix*, vol. 1, Fig. 70, facing p. 96.

ing editors of the *National* and the *Globe* were imprisoned and fined for publishing open attacks on the King. Three days later an intransigent Chamber of Deputies was dismissed by Charles X. New elections were held in June, and the opposition gained a two-thirds majority, in spite of limitations on the franchise. Governmental efforts to regain popularity by capitalizing on France's recent acquisition of Algeria failed. The King therefore took counter-measures. On July 25 he ordered the new Assembly dissolved, changed the electoral laws, and removed what vestiges of freedom of the press remained.

The hostility of the people grew into overt violence two days later. Sporadic fighting began, heaviest in the working-class districts of Paris. The arms shops in the Palais Royal area were looted, and the aroused citizens prepared for combat. What began as a sporadic display of resistance became the first of the "Three Glorious Days." July 28 marked the turning point in what had suddenly developed into a full-scale revolution. Fighting spread, students joined in the street combats, and barricades were erected, restricting all communication in the older, central sections of the city. The Hôtel de Ville was taken by the insurgents, was lost to the military forces, and was taken once more by nightfall. The capture of this symbolic structure was a turning point in the struggle. On the following day the Essonne Armory, the barracks at Babylone, the Louvre, and the Tuileries were taken by the revolutionaries. In many confrontations the government troops refused to fire on their countrymen and joined their ranks instead. In the meantime, a provisional government, formed by liberal leaders who hoped to take advantage of the prevailing disorders, refused the offer of Charles X to negotiate or to step down in favor of his younger son. After many complications, among them overtures to Lafayette for leadership, the Duke of Orléans conveniently arrived on the scene. On July 31 he accepted the lieutenant generalship the new government offered him. On Monday, August 9, he was installed as King of France in front of the Assembly, which had hastily reconvened a few days before, and began a rule of eighteen years, the "July Monarchy."

The artists who had remained in town during the summer responded to these events in different ways. Some, such as Paul Huet and the sculptor David d'Angers, helped man the barricades, and Daumier's participation in the fighting earned him a saber cut on the forehead.[10] Some, like Balzac, Hugo, Musset, and Gavarni, apparently took no interest in the revolution. Ingres, on the other hand, stood guard in the galleries of the Louvre throughout the violent nights of July 29 and 30 with his friends, sabers in hand, to protect his beloved Italian paintings.[11] Delacroix's own reactions were neither so extreme nor so partisan. Like Eugène Lami and Louis Boulanger, he ventured into the streets to see what was happening. Alexandre Dumas tells of meeting him on July 27 near the Pont de la Grève, later renamed the Pont d'Arcole in honor of a young patriot of that name who was killed during the fighting around the Hôtel de Ville. According to Dumas, Delacroix was alarmed at the sight of the angry mobs and was especially frightened at the sight of men whetting the edges of their weapons on the paving stones of the quays. But, said Dumas, Delacroix's fears turned to enthusiasm "when he saw the tricolor flying over Notre Dame."[12]

Almost before civil order was restored, the makers of myths and legends went to work, and artists were soon busily engaged in their versions of the events. A flood of popular images appeared, of which a number show young Arcole's bold action at the bridge. In one he is shown as he charges ahead, flag in hand, shouting

10. Daumier's cartoon, published in the last issue of *La caricature* (suppressed in 1835), shows three of the "dead for liberty" of July 27–29, 1830, who come back to life: "It really was worth the trouble of killing us!"

11. *Cf.* Hélène Adhémar, "La Liberté sur les Barricades de Delacroix, étudiée d'après des documents inédits," *Gazette des Beaux-Arts*, 6th ser., 11 (1954): 83–92. This article summarizes the documents relating to the origins of the painting and its later history.

12. *Ibid.*, p. 87. This account may include some of the romantic embellishments typical of Dumas, but it does sound credible in view of other known facts. See also Agnes Mongan, *One Hundred Master Drawings* (Cambridge, Mass.: Harvard University Press, 1949), pp. 148–49. An eyewitness account of the fighting near the Pont de la Grève has been given by a Dr. Poumiès de la Siboutie: "The heat was overpowering, the sun hung like brass in the heavens. . . . The insurgents occupied the left bank. . . . The Royal troops were on the right. . . . Youths in shirtsleeves occupied every possible point of vantage. . . . The number of armed men increased hourly. Weapons belonging to dead or wounded soldiers were instantly annexed. . . . The firing slackened towards evening, and the Garde Royale took the occasion to withdraw" (*Recollections of a Parisian*, ed. A. Branche and L. Dagoury, trans. T. Davidson [London: John Murray, 1911], pp. 199–200). The large pen-and-ink drawing discussed by Mongan, which is known as *Skirmish at the Pont d'Arcole*, has long been considered evidence that Delacroix actually witnessed the street fighting. Miss Mongan has called my attention to the fact that both the attribution and the date are put in serious question by Michael Wentworth in an article he is preparing on the subject.

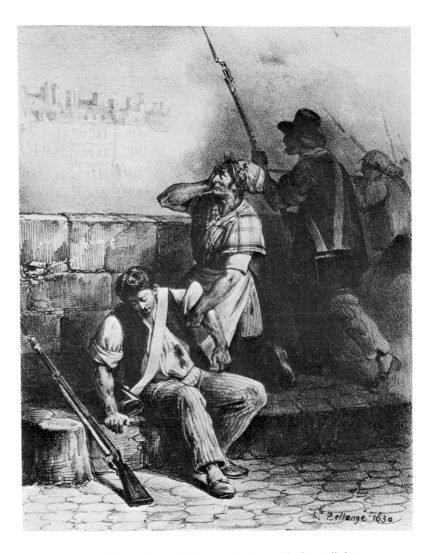

FIGURE 47. Hippolyte Bellangé. *The Scoundrels! . . . They've Killed Him!*
(*July 28, 1830*). 1830. Lithograph. 0.19 × 0.15. Collection of the author.
Photo James Gerhard.

to an admiring citizenry, "If I die, remember that I am called Arcole." The image
of youth is prominent in virtually all these accounts of the July Revolution, and
justly so, for many of the combatants were boys like Arcole, armed with whatever
weapons came to hand. The distinction of Delacroix's image is made all the more
evident when it is compared with his contemporaries' efforts to record the same
events. Hippolyte Lecomte's *Barricade of the Rue Rohan, July 29* is stiff, lifeless,
unfocused, and devoid of larger meaning, as is *An Episode of the Days of July,
1830*, once attributed to Jean-Victor Schnetz. Delacroix's superiority lies in the
fact that he has transformed a moment of history into an emblem of militant
patriotism.

Early in the new administration, a board headed by the Minister of Commerce
and Public Works was appointed to distribute some thirty thousand francs in

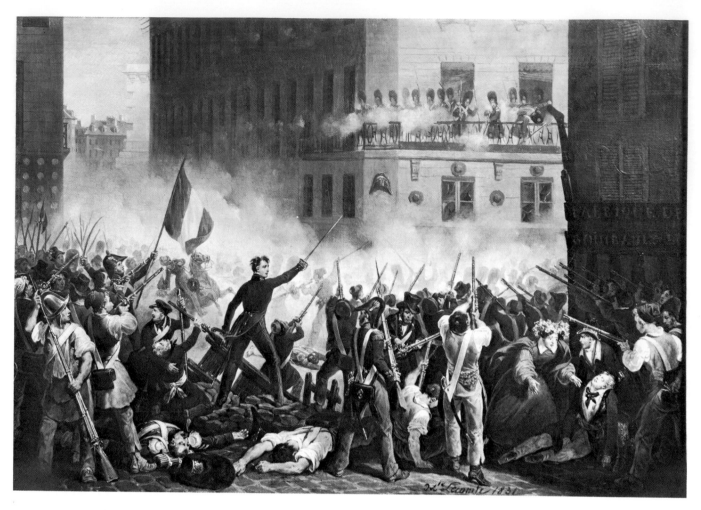

FIGURE 48. Hippolyte Lecomte. *Barricade of the Rue Rohan, July 29, 1830.* 1831. Oil on canvas. 0.43 × 0.60. Musée Carnavalet, Paris. Photo Bulloz.

commissions for works of art, both to display the King's generosity and to reaffirm the royal family's established reputation as patrons of the arts. Delacroix's work was admired by Louis Philippe's son, the new Duke of Orléans, and he was in a good position to share in the government's largess. His cause was enhanced by the fact that his close friend Prosper Mérimée was the chief assistant to the Minister, the Count d'Argout, and served on his board of artistic advisers.

Contrary to the usual practice, the Minister decided to assign the subjects of the commissioned paintings himself, rather than leaving that choice to the artist. Each picture was to represent some significant event in the life of the King, whose biography was, alas, ill furnished with suitable heroic moments. In 1793, at the age of twenty, Louis Philippe deserted from the army and took refuge in England and the United States until the end of the Restoration. Before that precocious retirement, he participated in two victorious military engagements in 1792, the defeat of the Austrians at Jemmapes and of the Prussians at Valmy, but it was nevertheless hard to establish a martial identity for him. Nor were the alternative

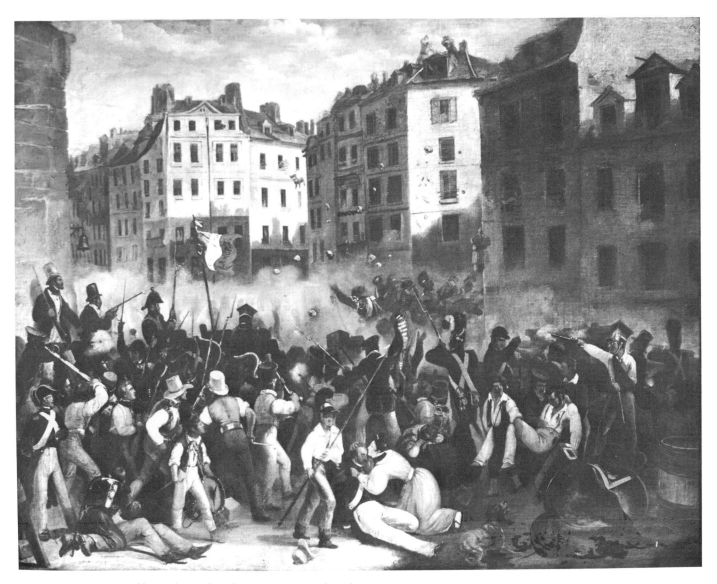

FIGURE 49. Anonymous [formerly attributed to Jean-Victor Schnetz]. *An Episode of the Days of July, 1830* (*The Charter or Death!*). N.d. Oil on canvas. Musée Carnavalet, Paris. Photo Bulloz.

13. *Correspondance générale*, ed. Maurice Parturier, vol. 1, *1822–1835*, (Paris: Le Divan, 1941), pp. 120–21.

14. See Escholier, *Delacroix*, 1:268. Whether one battle scene was ordered or two, as Escholier states, is not entirely clear.

possibilities any more attractive. Writing to Stendhal, who had recently been appointed French counsul at Cività Vecchia, Mérimée reported with exasperation that D'Argout had proposed "such eminently picturesque subjects as the following: The King Recognizing the Cottage Where He Spent the Night of Vigil before the Battle of Valmy; His Royal Majesty the Duke of Orléans Receiving a Prize for a Theme at the College of Henry IV; The King Drawing Blood from an Elderly Savage in America, etc. You can imagine the catcalls and execrations he got from the artists he treated in this impossible way. Delacroix, who had I don't know what subject of that kind, intends to do another; he says, in a year, the King, that jackass, or I will be dead."[13]

Delacroix decided to ignore the Minister's stipulation that he paint a Battle of Jemmapes or Valmy[14] in favor of a reference to the July Revolution (he may

have had in mind Goya's success with such scenes). Aside from its greater pictorial possibilities, such a subject promised to be politically "safe" in its assertion of popular support for the current regime and the artist's own satisfaction with the outcome of the Three Glorious Days. He could not have realized that any allusion to insurrection, however well intentioned, might eventually cause discomfort in official circles and undercut the very approval he sought to gain in painting *Liberty Leading the People*.

The importance Delacroix attached to this painting is indicated by the number of surviving preparatory drawings for it,[15] as well as by his references to it in his letters. The sketches include a revolutionary in the act of destroying a coat of arms, and a street fight, with a wounded combatant lying on a stretcher prominent in the foreground. Another extensive set of sketches, mostly in pencil, documents details of costume, pose, or architecture. Some of these, such as several representing Liberty, are among the artist's most spirited efforts as a draftsman. By December 6, 1830, Delacroix wrote Guillemardet that his picture was finished —or almost finished.[16] Early in 1831 he let it be known that he was at work on a sensational painting celebrating the advent of the new regime. In March of that year he was awarded the Legion of Honor, although for unspecified reasons. His fellow artists, who knew that official honors were unknown to him, were astonished. (Some, like Jean Gigoux, naïvely supposed that the decoration was a recognition of his service in the National Guard, which Delacroix and Villot joined December, 1830.[17])

On April 14, 1831, the first salon of the July Monarchy was opened to an eager public. Delacroix's major entry was listed in the exhibition catalogue as No. 511, *The 28th of July*, *Liberty Leading the People*. In spite of his admirers' and his own hopes for it, it too was badly received. Delécluze did grant it a "verve" of execution and admitted that its artist had a talent as a colorist in the manner of Jouvenet—a comment that was not without insight in its observation of Delacroix's affinities with the French Baroque[18]—but Auguste Jal and Gustave Planche were almost the only critics to defend it with any enthusiasm. The rest of the comments ranged from neutrality to hostility. The figure of Liberty was condemned as clumsy and ignoble. The dead man at the left was dismissed as "killed eight days before the conflict." And then there were those, such as the reviewer of the *Journal des artistes*, who found the very subject somehow subversive in its "proletarian" emphasis.[19]

It is ironic that Delacroix should have been accused of proletarian sympathies because *Liberty* failed to emphasize the engagement of the upper classes in the Revolt. It is hard to believe that he, with his highly developed sense of personal superiority, could have felt any but the most transient egalitarian sentiments, despite the fact that Charles Delacroix had won distinction in the first revolutionary government. To some extent he may have retained Bonapartist loyalties, as certain writers have inferred, but the sight of the tricolor would naturally stimulate his memories of other days whose "glories" were a prominent part of his youth. Both his older brothers had served under Napoleon: Charles Delacroix retired as a general, and Henri was killed in the Battle of Friedland. It seems reasonable to suppose that Eugène shared the patriotic traditions of his family and that in his *Liberty Leading the People* he wished to declare his faith in the destiny of France.

15. See Adhémar, "La Liberté sur les Barricades," p. 87. Robaut mentions a hundred or so ("*une centaine*") preparatory drawings for the painting, many of which are now in the Cabinet des Dessins at the Louvre.

16. *C*, 1:262. A note of September 20, 1830, ordering supplies from Haro, the color merchant (*C*, 1:258), implies that work on the canvas was either then in progress or about to start. Joubin assumes that the note refers to *Liberty*, and Adhémar agrees with him (see *C*, 1:258, n. 1, and "La Liberté sur les Barricades," p. 87). Sérullaz, however, is justifiably cautious as to the meaning of the note, which need not have any direct connection with this particular painting (*M*, p. 85). In any case, it is clear that a start was made during the following weeks, for on October 18 Delacroix wrote his brother that he had begun "a modern subject, a barricade," and that if he could not fight for his country, he could at least paint for her (unpublished letter, Bibliothèque Nationale, quoted in *M*, p. 85). He was still trying to collect money from the Duchess of Berry to purchase the necessary supplies (see *C*, 1:258–61 [Nov. 1, 1830]).

17. See Gigoux, *Causeries sur les artistes de mon temps* (Paris: Lévy, 1855), pp. 80–81. These reminiscences contain some fragments of biographical interest, although the account is clearly biased. Gigoux loyally points out the seriousness with which Delacroix regarded his duties in the Guard and the good grace with which he accepted the inconveniences his military commitments sometimes imposed upon him. His acquiescence may reflect his family tradition of respect for military authority, but Huyghe points out that his interest was also dandyish and sartorial. He also emphasizes Delacroix's apparent interest in politics at this time; he joined the Société Libre de Peinture et de Sculpture and drafted its petition to the Minister requesting reforms in the function of art juries (*Delacroix*, p. 199).

18. Quoted in *M*, p. 86, from *Journal des débats*, 1831.

19. Summarized in Adhémar, "La Liberté sur les Barricades," pp. 88–89. See also *M*, pp. 85–86.

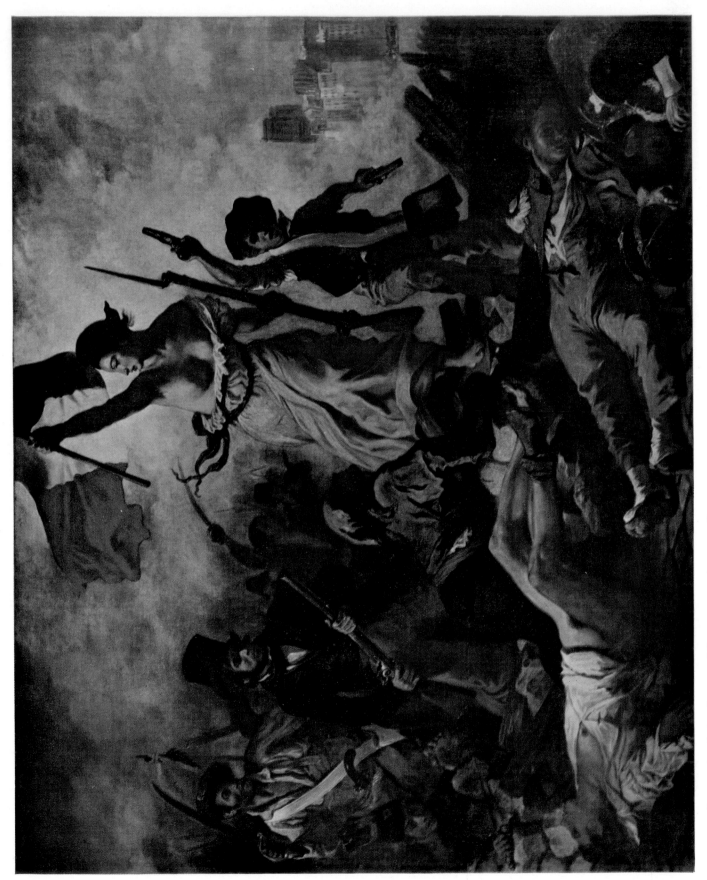

PLATE IX. *Liberty Leading the People.* 1830. Oil on canvas. 2.60 × 3.25. Louvre.

FIGURE 50. Studies of military dress for *Liberty Leading the People.* 1830. Pencil. 0.20 × 0.13. Cabinet des Dessins, Louvre. Photo S.D.P.

All critical reservations notwithstanding, the government duly paid the artist three thousand francs for his painting—perhaps, as Adhémar suggests, to avoid offense to Republican sentiment. The picture was assigned to the Royal Museum, later the Luxembourg, where it remained for a few months, but it was soon judged by the Director of Fine Arts to be dangerous and was accordingly removed from the public eye. The work remained in obscurity until 1855, when Napoleon III permitted Delacroix to show it at the Universal Exposition. The canvas was subsequently kept on display at the Luxembourg until it was transferred to the Louvre in November, 1874.

In view of the continuing political uncertainties during the reign of Louis Philippe, it is understandable that Delacroix's *Liberty* might seem inflammatory. The concept is in many ways an outgrowth of *Greece on the Ruins of Missolonghi*, particularly obvious in the dominant role of the female allegorical figure. Compared with the earlier picture, however, *Liberty* is more elaborate and less abstract. In the place of the introspective melancholy of *Greece*, there is a sense of urgent, animated engagement, a quality that may, in part, reflect the fact that it originated in direct experience. The introduction of the figure of Liberty serves to add appropriate symbolic significance to the scene and to enhance the drama of the action in which she is a spirited participant.

The single most striking figure is, of course, Liberty herself, a powerful young woman, very similar facially to one of Michelangelo's *ignudi* near the first scene of Genesis on the Sistine ceiling. A kind of Wingless Victory, she boldly strides forward, with musket, fixed bayonet, and fluttering flag. She may have been included in deference to tradition, but her pictorial character has little in common

FIGURE 51. Studies for the figure of Liberty. 1830. Pencil with touches of chalk. *Left*, 0.28 × 0.21; *right*, 0.29 × 0.20. Cabinet des Dessins, Louvre. Photo S.D.P.

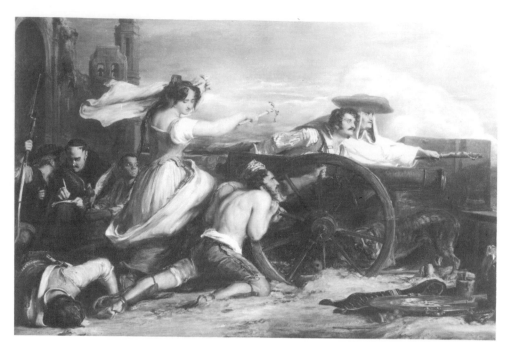

FIGURE 52. Sir David Wilkie. *Maid of Saragossa*. 1828.
Oil on canvas. 0.94 × 1.41. Collection H.M. the Queen, St. James's Palace, London.
Copyright reserved. Photo A. C. Cooper, Ltd.

with the pallid academic allegories or awkward popular illustrations which may have suggested the basic motif.[20] The figure is dominant not only for its placement at the apex of the complicated tumble of bodies above which she looms, framed by the patriotic emblem of the tricolor, but for the vigor and credibility of her presence in the midst of the combat. It is an impelling image, one that is all the more remarkable for its simultaneous projection of the real and the ideal connotations of the struggle.

The plausibility of the figure of Liberty is partly dependent on the prominence that women had assumed in revolutionary legend. In many of the local engagements, especially in the proletarian quarters of Paris, women took an active part, like Molly Pitcher in the American Revolution or Maria Augustin, the "Maid of Saragossa," during the Peninsular Wars in Spain.[21] (There may well be some significance in the fact that in 1828 Delacroix went to see a two-act "military play," *The Siege of Saragossa*, at Franconi's Circus.[22]) There were many stories— both true and apocryphal—about women's role in the Three Glorious Days. One of these, untrue, it now appears, was used to support the contention that Delacroix actually witnessed the scene he painted in his *Liberty*: a young working girl, seeing the nude corpse of her brother, who had been shot by the Swiss Guards, took arms and killed nine Royalist troops before she herself was felled by a captain of the Lancers.[23] Such anecdotes soon became a part of an enlarged "reality," the after image of the July Revolution, and took graphic form in

20. For a stimulating discussion of possible thematic associations, see George Heard Hamilton, "Iconographical Origins of Delacroix's 'Liberty Leading the People,'" in *Studies in Art and Literature for Belle da Costa Greene*, ed. D. Miner (Princeton, N.J.: Princeton University Press, 1954), pp. 55–66.

21. The "Maid of Saragossa" was celebrated by Lord Byron in *Childe Harold's Pilgrimage*, Canto I, stanzas 54–59. See Arts Council of Great Britain, *The Romantic Movement* (London: Tate Gallery and Arts Council Gallery, 1959), p. 235. Sir David Wilkie painted the subject in 1828, but it is unlikely that Delacroix knew the canvas. Hamilton illustrates an engraving after Richard Westall's water color of the Maid of Saragossa, which appeared in the first edition of Pichot's *Oeuvres de Lord Byron*, published in Paris, in 1822–1824 ("Origins of 'Liberty Leading the People,'" p. 62 and fig. 28, facing p. 63). As is usual with comparisons of this sort, the resemblance is a very general one.

22. See C, 1:232. The play was written by Ant. Béraud. Delacroix mentions having seen the performance in a letter of November, 1828, to Mme Pierret.

23. See Adhémar, "La Liberté sur les Barricades," p. 89.

24. Joubin suggests, not unpersuasively, that Delacroix's friend Frederick Villot, who taught him etching and who later, in 1848, became director of the Louvre, posed for this figure (see "Les modèles de Delacroix," pp. 352–54). Joubin further suggests that Villot, a man of strong republican and revolutionary sentiments, may even have been the one who originally proposed the subject to Delacroix. Sérullaz is cautious about such associations (*M*, p. 86). Others, Huyghe among them, prefer to see the face as resembling Delacroix himself (see *Delacroix*, p. 198). Johnson argues that the figure may have been Étienne Arago (*Delacroix*, p. 39). None of these proposals is conclusive.

popular prints. The actual events had been so brief, so dramatic, so decisive, and so classical in their sequence that history took on the guise of art.

There can be no doubt that Delacroix wished to give his picture verisimilitude. The members of the triumphant citizen army clustered about the allegorical figure wear the top hat, beret, or cap that symbolized the insurrectionist cause, which joined patriots of all classes—workers, shopkeepers, businessmen, professional men, and even some members of the nobility. The seriousness of their purpose is epitomized by the grim-faced man on the left holding a musket.[24] However, some of the revolutionaries will not celebrate the victory. A fallen lad in tattered clothing is catching a last glimpse of Liberty, to whose presence only he responds. Through a small break in the cloud of gunsmoke the west towers of Notre Dame appear, the tricolor fluttering on one of them, as Dumas described it. The architectural setting, however, does not conform to the reality of the Île de la Cité, and the exact location of the scene is unspecified. Many small touches—missing shoes, torn and patched clothing, and bits of military bric-a-brac—further indicate an attempt at accuracy. Yet they are judiciously placed, and Delacroix has avoided that clutter of detail which dissipates the effect of many nineteenth-century historical paintings. A balance has been struck between the general and the particular, and it is this balance which prevents what is clearly a studio painting and the product of synthesis from seeming a *tableau vivant*.

For all its vividness, *Liberty* seems to represent some degree of artistic retrenchment. The choice of a subject that was both contemporary and patriotic was a marked shift from the extravagant exoticism of *Sardanapalus* and, it would seem, implies some attempt to avoid criticism. In other respects as well, there are changes in techniques and attitudes. Compared with *Sardanapalus*, or even with *Scio*, *Liberty* is more orthodox in its return to the time-honored expedient of using a broadly based pyramid of figures as the structural core of the picture. The frieze-like grouping of the more distant figures further recalls classical devices. The formal order is, on the other hand, unobtrusive and appropriate to the situation. The viewer observes the scene from a close vantage point and must experience the dominance of the figure of Liberty. The combatants—especially those in the immediate foreground—take on an almost Davidian plasticity, compared with the rubbery forms of their counterparts in *Sardanapalus*. That pejorative analogies with Géricault's art were made by some disgruntled critics is not altogether strange, in view of Delacroix's return to a concept of form that invites such a comparison.

There are adjustments of color and technique here as well. The prevailing tonality is cooler than that of *Sardanapalus* and less rich than that of *Scio*. Much of the surface area is given over to rather neutral tones. The tricolor states a contrasting color theme, with its reds and blues the most positive notes of color in the picture. This more subdued tonality is, of course, also appropriate to the subject. The paint surfaces are less heavily reworked than those of *Scio* and less agitated than those of *Sardanapalus*. Delacroix uses a method of execution that he later employs more and more, particularly in his murals: broad areas of local color are first laid in and then are developed to indicate interior detail and secondary tonal modulations. Largely because of this initial simplification, the component parts remain relatively self-contained. As in Poussin, the pictorial unity has been produced by combining, not, as in Rubens, by fusing the parts into a complex whole. In this respect, Delécluze's comparison of Delacroix with Jouvenet is apt.

Delacroix had well learned the studio practices of Guérin, himself an inheritor of the "classic baroque" traditions of France, which were closer to Raphael and the Bolognese than to the great Venetians and Rubens. This tendency may also be observed in the abrupt, slightly awkward spatial shifts from the foreground to the more distant elements. As in *Scio*, the softening effect of the smoky atmosphere dictated by the subject helps to conceal structural strains, but one becomes aware of the artificiality of the device and suspects in it a symptom of the artist's continuing struggle to command the full resources of baroque illusionism.

The ultimately synthetic nature of the painting, however, its very element of abstractness and convention, serves the useful purpose of moderating the effect of an inherently unpleasant scene. That Delacroix himself appreciated this kind of balance is evident from his comment in the *Journal* for 1849. The reign of Louis Philippe had been violently terminated by another revolution, that of 1848. "I went with Meissonier to his studio to see his drawing of the 'Barricade,'" he wrote. "It is horribly realistic, but, although you cannot deny its accuracy, it does perhaps lack that indefinable quality which *makes a work of art out of an odious subject*."[25] We can agree that Meissonier in his picture does attain a certain grimly convincing reportage, but his mute, inglorious scattering of corpses over a nameless, deserted Paris street conveys only futility. There is no indictment of the oppressor, no encouragement for the oppressed, no recognition of the fallen, while Delacroix's struggle recalls with equal force the resentments of the past, the commitment of the moment, and the brave promise of the future. Perhaps his recognition of Louis Philippe's default on that promise prevented him from painting the companion piece some people had expected after the Revolution of 1848—so, at least, one might suppose from his letter to Soulier during that troubled spring: "I have laid to rest the man of other days along with his hopes and his dreams of the future," he announced sadly. "And now I calmly pass the tomb where I have buried all that, just as though it belonged to someone else."[26]

In addition to commissions like this one, a number of open competitions for other assignments were held during the early days of the Orléans regime. One of these projects was a painting of King Louis Philippe taking the oath of office before the Chamber of Deputies. Delacroix himself did not participate in the contest, but his friend Eugène Devéria managed to render this unpromising subject with surprising grace. Early in 1831 another *concours* was announced, this time for three paintings to decorate the wall opposite the hemicycle of the Chamber of Deputies. Three subjects were designated: *Mirabeau protesting to the Marquis de Dreux-Brézé upon his announcement of the discharge of the Estates-General by Louis XVI*; *Boissy d'Anglas at the Convention*; and *The National Convention after its vote for the execution of Louis XVI*. Delacroix participated in the competition for the first two subjects but was unsuccessful. Soon afterwards, in 1833, he did receive the commission to provide the murals for the Salon du Roi at the Palais Bourbon. In 1838 he began a second and even more extensive decorative project, a cycle of murals for the ceiling of the library of the Chamber of Deputies. These monumental works will be discussed at length in another context.

Of the two competition subjects, *Boissy d'Anglas* was the more interesting. It posed a real challenge to Delacroix's ability to depict an ugly situation with neither excess nor loss of pictorial interest.[27] On May 20, 1795, an unruly mob of Jacobin sympathizers stormed into the National Convention, then in session at

25. *J*, W, p. 90 (Mar. 5, 1849).

26. *C*, 2:347 (May 8, 1848).

27. The competition entry is now in the museum at Bordeaux. A smaller version of the subject was once supposed to have been a preliminary sketch, but both Sérullaz and Johnson now suppose it to be a later replica, perhaps by Andrieu. The quality of the canvas is, however, superior to what one would expect of Andrieu, and the rejection of the work as a copy seems unduly severe (see Johnson, "The Delacroix Centenary in France," *Burlington Magazine*, 105 [July, 1963]: 301, 302; *M*, p. 103). Of some fifty versions of this subject, the jury preferred that of an artist named Vinchon. The decision did not go unchallenged, however, for Delacroix's partisans were quick to spring to his support. Even before the final decision was announced, Louis Boulanger had written a laudatory article on the piece in *L'Artiste*. Achille Ricourt, the editor of that journal, later condemned the jury's judgment (see *M*, p. 101).

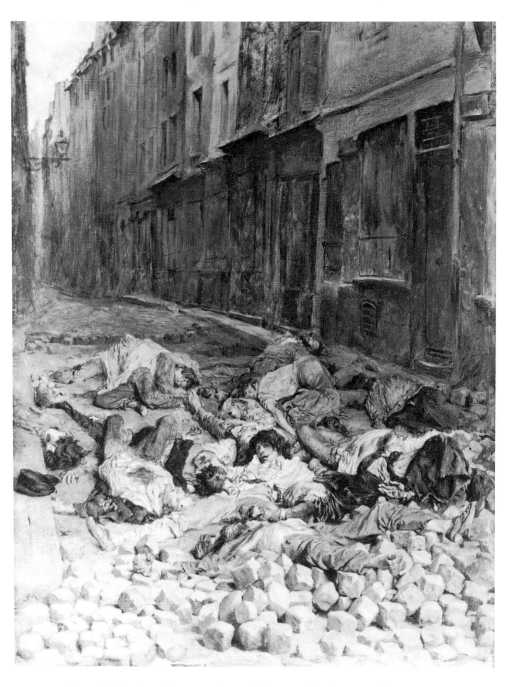

FIGURE 53. Ernest Meissonier. *The Barricade, Rue de la Mortellerie (June, 1848)*. 1848. Oil on canvas. 0.29 × 0.22. Louvre. Photo Giraudon.

28. This famous incident may well also have held personal associations for Delacroix, since one of his schoolmates at the Lycée Louis-le-Grand was the son of J. B. Louvet de Couvrai, who, as president of the Convention, delivered the funeral oration in honor of poor Féraud (see *C*, 1:7). Delacroix's letter of January 10, 1814, to Louvet's son, Félix, makes clear his admiration for his friend's father.

the Tuileries, murdered a young deputy named Jean Féraud, severed his head, and struck it on the end of a pike, which they then waved threateningly before the presiding officer of the Assembly, François-Antoine Boissy d'Anglas. Boissy composedly doffed his hat in a formal gesture of respect for his colleague, and the effect on the rabble of his presence of mind and dignity was powerful enough to restore order. His bravery provided a model for those after him who had dealings with the people.28

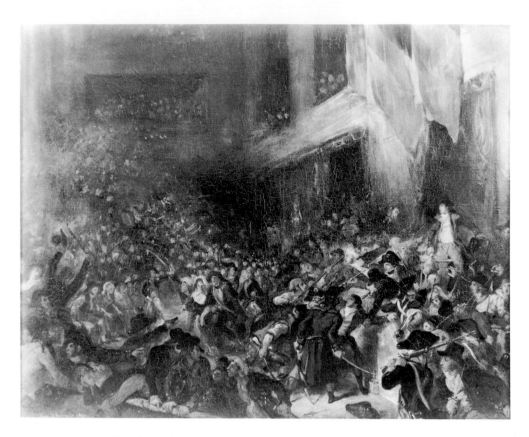

FIGURE 54. *Boissy d'Anglas at the Convention.* 1831.
Oil on canvas. 0.79 × 1.04. Musée des Beaux-Arts, Bordeaux. Photo S.D.P.

Delacroix chose to show not Boissy's heroic gesture but the scene of confusion just before his decisive response to the challenge of the mob. Some of the artist's contemporaries were, in fact, upset by what they considered his inaccuracies in representing Boissy as standing and wearing his hat, rather than seated and hatless.[29] It must be supposed that Delacroix's interpretation resulted neither from ignorance nor neglect of the facts but from a desire to use the moment of action that was richest in dramatic incident and most promising in pictorial effects. The climax of the narrative itself would have been, as Lee Johnson has pointed out, visually static. Delacroix expanded a grisly anecdote into an ominous pictorial drama. By contrast, the more literal interpretation of the scene in a canvas by Tellier, now at Versailles, reduces it to the status of a genre painting, in which the narrative has been dutifully but dispassionately summarized in all its bloody detail. Tellier has been faithful only to the facts of the story.

Delacroix has managed to capture the threatening presence of the noisy crowd, with its surging physical energy and jangling, nervous excitement. There is animation not only in the gestures but in the technique itself and the very composition of the picture—the flashing, broken accents of light, in the bold, deep, mysterious reach of the architectural setting, and the swarm of forms that fill it. Dark, freely handled surfaces, predominantly deep brown in tone, provide the illusion of an almost pulsing atmosphere. Small glints of reflected light contrast

29. See "Boissy d'Anglas, Concours," *L'Artiste*, 1 (1831):122, quoted in Johnson, *Delacroix: 1798–1863*, p. 15.

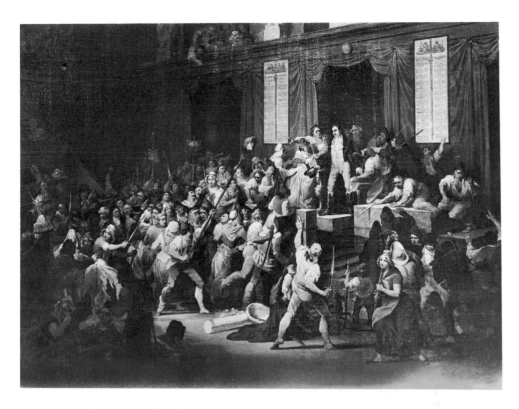

FIGURE 55. Tellier. *Boissy d'Anglas at the Convention*. Concours of 1830.
Oil on canvas. 0.84 × 1.08. Musée de Versailles. Photo Giraudon.

30. See *Delacroix*, pp. 187ff.

31. As early as 1827 Delacroix had expressed his interest in Rembrandt (see *C*, 1:193–94 [to Poterlet, Aug. 9, 1827]).

32. See *C*, 1:270, n. 1. Paul Chenavard met Delacroix in 1825 and became one of his favorite acquaintances. He had submitted his *Mirabeau and Dreux-Brézé* along with a companion piece representing the vote of the National Assembly and also failed to win a commission (see Sloane, *Chenavard*, pp. 17, 165, 183–85). Sloane refers to the competition as taking place in 1832, but other sources give the date as 1831. The Delacroix paintings are dated 1831. Delacroix later summarized a discussion with Chenavard on the subject of their respective treatments of the theme. The passage is important in showing Delacroix's approach to subject matter (*J*, 2:283–85 [Oct. 4, 1854]).

with the areas of shadow. Overhead the blue and red slashes of the flags—almost the only touches of brilliant color—are reminders of the state, whose principles and process are sustained by Boissy's conduct.

René Huyghe has suggested that the influence of Rembrandt's *chiaroscuro* manner may be inferred in this and certain other pictures of the period, especially *Murder of the Bishop of Liège*, which Delacroix exhibited along with *Boissy d'Anglas*, *Liberty Leading the People*, and other works at the Salon of 1831.[30] However, although Delacroix greatly admired Rembrandt and copied a number of his works,[31] one should recognize that there are other affinities. Guardi and later masters, Constable included, freely used small accents of light to animate their surfaces. At the same time, there is more than a little in *Boissy d'Anglas*, perhaps because of its modest scale and the fact that it is a preliminary sketch, that recalls the fluid touch of Delacroix's earlier Anglo-Venetian manner. One cannot know what transformations the painting would have undergone if Delacroix had received the commission. It can be supposed, however, that not even he could have retained the freshness that made this sketch a worthy contribution to the Salon of 1831.

Delacroix's second competition piece represented *Mirabeau Protesting to the Marquis de Dreux-Brézé*. Thirty-two sketches of the subject were placed on display at the École des Beaux-Arts on February 3, 1831. Among these was one by Chenavard which won praise from both Delacroix and Baron Gros.[32] Delacroix's

FIGURE 56. *Mirabeau Protesting to the Marquis de Dreux-Brézé*. 1831.
Oil on canvas. 0.78 × 0.92. Ny Carlsberg Glyptotek, Copenhagen. Photo Ny Carlsberg
Glyptotek.

canvas (once owned by Degas) is now in the Ny Carlsberg Glyptotek in Copenhagen. A smaller preliminary version of the composition, differing in some minor details, is in the Louvre. The episode represented took place on June 23, 1789, when Dreux-Brézé appeared before the Third Estate to announce the King's decision to dismiss the Estates-General, and Octave Mirabeau responded: "Go tell your master that we are here by the will of the people and will not leave except by the force of bayonets." Delacroix has illustrated the scene in a more or less orthodox manner, with Dreux-Brézé, to the right, listening to Mirabeau, who stands towards the middle of the hall at the head of the recalcitrant parliamentary group. Dreux-Brézé stands hat in hand before a canopied throne, symbol of the King's disputed authority. In the Louvre sketch, but not in the later version, some soldiers are seen in the distant corner of the room.

33. See *M*, p. 105.

The various surviving drawings made in preparation for the trial canvas include vigorous studies for the massive head of Mirabeau and other details of face and costume. One sheet of pencil sketches bears a reminder to "borrow engravings of Trumbull and West."[33] Delacroix was therefore aware of English and American history painting, which had anticipated the concern for "accuracy" in the later works of David and his followers. Copley's *Death of Major Pierson* is a characteristic example and is of interest for its relationship to *Liberty Leading the People*. Other notes refer to his intention to study Reynolds and English caricatures (the latter had been an interest of his since youth). In this respect, *Mirabeau and Dreux-Brézé* may be regarded as typical of Delacroix's interests and work habits. The final result, however, is neither altogether typical nor a fair sample of his talents.

34. See *Delacroix*, p. 202.

Some critics—most recently and notably René Huyghe—have chosen to see in the *Mirabeau and Dreux-Brézé* a kind of "classical" companion piece to the "romantic" *Boissy d'Anglas*, an indication of "the conflicting inclinations of his temperament and of his education."[34] Although this time-honored dichotomy provides an attractively simple characterization of the two works, it has only limited utility as a critical tool. The assertion of so patent a contrast between two compositions otherwise closely linked in time and circumstance is puzzling. Elsewhere in his book Huyghe suggests an explanation for that apparent contradiction: at this juncture Delacroix had reached what threatened to be an impasse between his need for imaginative, passionate expression and his determination

FIGURE 57. J. F. E. Prud'homme after John Trumbull.
Declaration of Independence, 4 July 1776, at Philadelphia. 1820; published 1823.
Engraving. 0.22 × 0.32. Yale University Art Gallery, Mabel Brady Garvan Collection.
Photo Yale University Art Gallery.

FIGURE 58. John Singleton Copley. *Death of Major Pierson*. 1782–84.
Oil on canvas. 2.40 × 3.66. The Tate Gallery, London. Photo Tate Gallery.

to endow his visions with form and structure. His journey to Morocco provided him with the catalytic experience he required. In the years following this trip he arrived, by this interpretation, at the synthesis which marked his fulfillment as an artist.

Such schematic explanations ignore questions of personal motivation. While it is impossible to know Delacroix's intentions, it is possible to evaluate the progress of his career at this time. We know, for example, that he needed commissions and wanted public recognition and that he had been made to regret the extremism of his earlier efforts. Under the circumstances, it seems probable that *Mirabeau and Dreux-Brézé* represented, after all, a deliberate attempt to gain official favor and that its "classical" cast is as much a concession to prevailing taste as it is an indication of his preferences and habits. Whatever historical, formal, or motivational interpretation may be placed upon his approach to the Mirabeau project, the fact remains that the jury awarded the commission to Joseph Court, whose huge painting of the subject is now in Rouen.

"Pastils of Seralio"

1. For a summary of Delacroix's travels, see Raymond Escholier, "Delacroix Voyageur," *La revue de l'art*, 57 (January, 1930): 13–48; Annie Conan, "Delacroix à l'Abbaye de Valmont," *Arts de France*, 3 (1963): 271–76; Jonathan Mayne, "Delacroix's Orient," *Apollo*, 78, no. 19 (September, 1963): 203–7; G. Diehl, ed., *Delacroix au Maroc* (Rabat: Mission Universitaire et Culturelle, 1963).

2. See *J*, 1:80–81 (Apr. 20, 1824).

3. His brother Charles and his brother-in-law had both visited Turkey. Auguste, Decamps, Isabey, and Champmartin had traveled in various parts of the Islamic East (see Léon Rosenthal, *Du romantisme au réalisme* [Paris: Renouard, 1914], p. 92).

Throughout his life Delacroix traveled a good deal, especially in the provinces of France.[1] Having passed most of his childhood outside Paris, he never lost his taste for the special charms of rural life. The provinces also provided new visual experiences. At Valmont he studied the ruins of the local abbey, which adjoined his relatives' estate, and made excursions to the famous cliffs at nearby Étretat and the harbor at Dieppe. Not far away, Rouen still had a distinctly medieval character, and on occasion its architectural motifs were incorporated in his work. At Strasbourg there were the Gothic sculptures of the cathedral, the imposing art collection in the Château Rohans, and the visual appeal of the town itself, whose quaint but tidy streets are affectionately described in the *Journal*. Visiting the Pyrenees, he found a wild and imposing natural grandeur that excited him, but with the passing years he became ever more content just to be in the country which he loved for itself—the smell of vegetable gardens, the brilliance of flowers, and the seclusion of forest, stream, and field. In the summers of 1842 and 1843 he enjoyed visits to George Sand's villa at Nohant, where, according to her, he began to paint flower subjects, those luminous practice pieces of the sort he continued to paint after he bought his own country retreat at Champrosay, in 1844, in which his mature colorism is delightfully revealed.

On four occasions Delacroix did travel abroad. He made two brief visits to the Low Countries: in September, 1839, he went for the first time to Antwerp, The Hague, and Amsterdam. In 1850 he returned to Belgium to take the waters at Ems and saw the Rubens paintings at Antwerp, Brussels, Malines and Cologne. Although for some reason he never visited Italy, he did make a longer and more arduous journey: in 1832 he spent several months in North Africa and a fortnight in Spain. This was his first and only experience of an exotic environment, and it was a crucial one.

By 1824 he had become fascinated with the Moslem world. He dreamed of going to Turkey and possibly Greece and Egypt as well, and even thought of studying Arabic to prepare for the venture.[2] His curiosity had been aroused by reports brought back by visitors to those places, among them members of his own family.[3] Yet at first he was hampered by a lack of money and then, it seems, by insufficient determination. New preoccupations distracted him from his earlier enthusiasms.

Delacroix's artistic expression of his interest in an Orient he had never seen was based on books, pictures, travelers' tales, and borrowed artifacts and costumes. With the exception of one vision of the ancient East, represented in *Death of Sardanapalus*, his attention largely centered on Turkey, which for him epitomized the world of Islam. His Turkish subjects range from the Greek wars or episodes from Byron to the purely picturesque, such as *Young Turk Stroking His Horse* or *Turk Smoking on a Divan*. Delacroix, like his contemporaries, became familiar

with Egypt and Asia Minor through Napoleon's Near Eastern campaigns. The Moslem lands of North Africa, on the other hand, remained hostile to European intrusion and unknown to artists and travelers.

European curiosity about the Orient suddenly revived, with a different focus, when, on August 30, 1827, during an acrimonious exchange between the Dey of Algiers and the French consul, M. Deval, the Dey struck Deval. That insult precipitated a series of incidents, complete with well-publicized atrocities, which finally led to the forcible establishment of French rule over Algeria in 1830.[4] The entire affair at the same time served to dramatize the weakness of King Charles X and the incompetence of his government, and public dissatisfaction with the conduct of the Algerian crisis ultimately contributed to the downfall of the Bourbon regime.

On his accession to power in 1830 Louis Philippe was faced with a legacy of problems deriving from French involvement in North African affairs. Among them was the necessity of establishing friendly relations with the Sultan of Morocco, now a reluctant neighbor of France. Accordingly, in 1831 the elegant Count de Mornay, a former gentleman-in-waiting to Charles X, was chosen to head a special mission instructed to conclude a treaty with Sultan Muley Abd-Er-Rahman.

4. For a summary of these events, see R. Hardy, "La double révélation du voyage en Afrique," in Huyghe et al., Delacroix, pp. 138–39.

FIGURE 59. *Still Life with Flowers.* Ca. 1842.
Oil on canvas. 0.74 × 0.93. Kunsthistorisches Museum, Vienna.
Photo Kunsthistorisches Museum.

5. *L*, pp. 193–94, n. 1. The information in this note derives from a series of unpublished letters written by the famous actress to M. Randouin the sub-prefect of Dunkirk, from February 3 to March 31, 1832. See also Huyghe *et al.*, *Delacroix*, pp. 265–66.

6. *C*, 1:302 (Dec. 8, 1831).

7. *C*, 1:303–4 (Jan. 8, 1832).

8. At the time of Delacroix's visit a painter named Alaux, "the Roman," was at work "restoring" the damaged murals by Niccolò dell' Abbate. Unfortunately, this protégé of the King succeeded only in ruining them. The visit to Fontainebleau was of some importance, for Delacroix's decorations in the Salon du Roi of the Palais Bourbon show traces of that experience (*cf.* *C*, 1:304, n. 1).

9. *C*, 1:305 (Jan. 24, 1832).

10. *C*, 1:307 (Jan. 25, 1832).

11. *J*, 1:124 (Jan. 29, 1832).

12. *J*, 1:125 (Feb. 2, 1832).

13. *J*, 1:149 (Apr. 11, 1832).

14. *J*, 1:144 (Mar. 24, 1832).

Surviving correspondence makes it clear that the Count de Mornay's mistress, Mlle Mars, was instrumental in arranging for Delacroix to join the party.[5] Unwilling to make so long and arduous a trip without suitable companionship, Charles de Mornay invited Eugène Isabey to accompany him, but Isabey declined. Mlle Mars then asked the director of the opera, M. Duponchel, to recommend an alternative candidate. On the advice of Armand Bertin, of the *Journal des débats*, Duponchel proposed Delacroix, who gladly accepted the offer.[6] Arrangements for the departure were quickly made, and after a farewell visit with Mlle Mars on New Year's Eve, Count Mornay and his companion began an uncomfortable trip to Toulon,[7] from which they would sail. Along the way they stopped at Fontainebleau. Although Delacroix was dismayed at the vandalism the chateau had suffered—he was convinced that he would encounter "nothing so barbarous in Barbary"[8]—the ultimate effects of that visit are appreciable in the example provided him by the mural decorations there in his own first attempts at murals.

On January 11 the party sailed abroad the "Pearl," a fast corvette armed with eighteen cannon. It anchored off Tangier on January 24, after bad weather necessitated a stop at Algeciras to obtain fresh provisions. Quarantines because of a cholera epidemic in France prohibited the travelers from visiting the city or from putting into port at nearby Gibraltar, but for Delacroix even a brief glimpse of Algeciras was rewarding:

Still, I touched Andalusian soil when I went ashore with the members of the crew sent to take on supplies. I saw the solemn Spaniards in costume *à la Figaro* surrounding us at pistol range for fear of contagion, throwing us turnips, salad greens, chickens, etc., and nevertheless taking the money we deposited on the sands of the shore without disinfecting it with vinegar. That was one of the liveliest sensations of pleasure, to find myself outside of France, transported, without having touched other soil, to this picturesque land; to see their houses, their cloaks, worn by the very poorest of them, even by the children and beggars, etc. All of Goya pulsed around me.[9]

The day after the "Pearl" anchored at Tangier, Count de Mornay's mission went ashore and was met by the Pasha and other local dignitaries. After his first day exploring the city, Delacroix wrote excitedly to Pierret:

We have landed among the strangest people. The Pasha of the city has received us, surrounded by his soldiers. I would need twenty arms and forty-eight hours in the day to do a passable job of it and give some idea of it all. The Jewish women are admirable. I fear it would be difficult to do other than to paint them: they are the pearls of Eden. Our reception has been the most brilliant the place affords. We have been regaled with the most bizarre kind of military music. I am at this moment a man who is dreaming and who sees things that he fears will escape him.[10]

Delacroix's notes and letters of the period trace his tourist's rounds. At every turn he encountered something novel or something already half familiar. The names of his favorite artists are often invoked in his descriptions. Fighting horses remind him of Gros and Rubens.[11] An old Jew in a shop resembles a painting by Gérard Dou, while a Moor with a white turban recalls Rubens.[12] A native has the head of a Michelangelo.[13] A clouded, azure sky provokes a comparison with Veronese.[14] But the most powerful and recurrent image is that of the classical past. Benjamin West had found the Apollo Belvedere to be a Mohawk warrior, and by some related process Delacroix discovered, in this still half-barbarous culture, a reincarnation of the antique. "The heroes of David and company, with their pink

limbs, would cut a sorry figure next to these children of the sun," he wrote Villot.[15] Elsewhere he explained his feelings to Pierret:

15. C, 1:317 (Feb. 29, 1832).

Imagine, my friend, what it is to see lying in the sun, strolling in the street, or repairing old shoes, men of the consular type, Catos, Brutuses—even possessed of the disdainful air that the masters of the world ought to have; these people own only a single garment, in which they walk, sleep, and are buried, and yet they appear as satisfied as Cicero would be in his curule chair. I tell you that you will never believe what I shall bring back because it will be so far from the truth and the nobility of these natures. The antique has nothing more beautiful.[16]

16. C, 1:319 (Feb. 29, 1832).

As Delacroix later reiterated to Bertin in a letter from Meknes, "The picturesque abounds here. At every step there are pictures ready-made that would assure the fortune and the glory of twenty generations of painters. You would suppose you were in Rome or in Athens without the Atticism, but with the mantles, the togas, and a thousand antique traits. A villain who cobbles a shoe for a few sous has the dress and the bearing of Brutus or Cato of Utica."[17]

17. C, 1:327–28 (Apr. 2, 1832).

The Count and his companions remained in Tangier for several weeks while preparations were made for the final stages of their journey to meet with the Sultan. Although that potentate seems to have been less than eager for the meeting, he finally granted permission for them to proceed to Meknes. After enervating delays and mysterious complications, on March 5 the French party finally left Tangier.[18] In one of her letters Mlle Mars relayed Mornay's report of the cortege which had been provided him. The force, under the command of Mohammed Ben Abou, was "composed of a hundred men the Emperor sent for his safe conduct and that of his interpreter, Eugène Lacroix, his valet, and his courier. The caravan is armed to the teeth," she continued (with a certain relish), "and their long and punishing route will be made by horse, mule, and possibly by camel."[19] The formidable bodyguard proved necessary on several occasions to protect the party from a people hostile to infidels. From the first day the expedition had excited the curiosity of the tribes through whose lands they had to pass. Sometimes they witnessed military "powder play," in which charging cavalrymen shot off their muskets to create a frightening din (Delacroix recalled that scene in his paintings), and there were other, even more startling episodes. At Alcassar-el-Kebir a man shot at the visitors and was seized and dragged off by his turban, presumably for execution—Delacroix reports only that "the saber was already drawn."[20] Another day, after fording a river under sporadic fire, the party passed through a long defile of menacing-looking tribesmen. There were more rifle shots at their horses. In one village some children threw stones at them, and the entire population was arrested for the offense.

18. See L, p. 194n. In a letter of February 29 to Pierret, Delacroix spoke of leaving "Monday, the day after tomorrow" (C, 1:320; J, 1:130 [Mar. 5, 1832]).

19. L, 1:193–94, n. 1.

20. J, P, p. 111 (Mar. 8, 1832).

21. J, 1:133–34 (Mar. 9, 1832).

Delacroix's verbal picture of Alcassar-el-Kebir is typical of his comments on the villages and towns he passed through: "Rain. Entered Alcassar to cross through it. A crowd, soldiers striking heavy blows with straps; horrible streets; pointed roofs. Storks on all the houses, on top of the mosques; they seem very large for the buildings. Everything made of brick. Jewish women at the attic windows." The procession then continued "through a big passage-way lined with hideous shops, roofed with badly joined bamboo," then on to a nearby river lined with olive trees.[21] On the other hand, the beauty of the countryside through which he passed had its compensations, as his notes on the terrain and its color make clear.

22. *J*, 1:139 (Mar. 15, 1832).

23. *C*, 1:327 (to Bertin, Apr. 2, 1832).

24. *C*, 1:326 (to Pierret, Apr. 2, 1832).

25. *J*, 1:148 (Apr. 10, 1832).

26. See André Joubin, "Quinze jours en Espagne avec Delacroix, 16–30 Mai 1832," *Revue de l'art ancien et moderne*, 57 (1930):49–56; Élie Lambert, "Delacroix et l'Espagne," *La revue des arts*, 3 (September, 1951): 159–71. Other more detailed discussions by these and other authors will be cited where appropriate.

27. As with his early "Oriental" works, however, Delacroix here showed no great concern for historical accuracy. He freely adapted his motifs from available sources, basing his architecture on that of the Great Hall of the Palace of Justice at Rouen, not on a more plausibly Spanish prototype. For further discussion of this work, now in the Krannert Art Museum at the University of Illinois, see below. See also Lee Johnson, *Delacroix: 1798–1863*, pp. 18–20; *Delacroix: An Exhibition of Paintings, Drawings, and Lithographs Arranged by the Arts Council of Great Britain in Association with the Edinburgh Festival Society*, intro. Lorenz Eitner (Edinburgh: Arts Council of Great Britain, 1964), p. 24, No. 23; *M*, pp. 145–46.

28. See *J, P*, p. 124 (May 23, 1832).

29. *J*, 1:152 (Apr. 28, 1832). The overtones of Rousseau's doctrines to be sensed here had manifested themselves in Delacroix's early novel, *Les dangers de la cour*. In later years his retreats to Champrosay provided him a necessary antidote to the pressures of a "modern" society which he consistently resented. The notion of escape—whatever form it assumed—was, of course, an underlying trait of romanticism.

Finally, on March 15, after ten days of hard travel, they arrived in the broad valley in which Meknes is situated. The company was met by emissaries from the Sultan, headed by "a horrid mulatto with mean features: very fine white burnous, pointed cap without turban, yellow slippers and gilt spurs; violet belt embroidered in gold, heavily embroidered cartridge belt, the bridle of his horse violet and gold."[22] Accompanied by these officials, a banner guard, and a marching band, the French party filed past curious crowds through the gate to the city.

Much to their disappointment, the visitors were not granted an imperial audience until March 22. In the meantime, their movements were rigidly restricted. After their official reception they were permitted in the city, but it was impossible to go into the streets without armed guards. The crowds openly resented the presence of Christians in their midst,[23] and the atmosphere was so hostile that Delacroix was the only one of the party to tour Meknes. Under the circumstances he was unable to sketch from life—not even the most ordinary subject. In fact, it was unsafe for members of his party even to go onto the terraces of their quarters for fear of being stoned or shot at by the Moors, who were jealous of the privacy of their women, who gathered there.[24] At the same time, Delacroix qualified his complaints. He found an abundance of "ready-made pictures" and was impressed by the Emperor's reception (he even gave his guests a tour through his private apartments).

On April 5 the emissaries left Meknes for Tangier. "Beautiful country," Delacroix observed: "the mountains are violet in the morning and evening, blue during the day. Carpet of yellow flowers, violet before reaching the river of Wad-el-Maghzen."[25] On April 12 the party reached Tangier, where it remained until June 10. In the less constrained atmosphere of the port city Delacroix was free to explore, and he visited Cadiz and Seville.[26] He had already painted Spanish subjects—in 1831 he did *Interior of a Dominican Convent in Madrid*, inspired by Charles Robert Maturin's Gothic novel, *Melmoth the Wanderer*.[27] Cadiz, with its houses shining white and gold against the blue sky, delighted him. He explored the great cathedral of Seville and particularly admired the elaborate grillwork and carvings of its vast, shadowy interior.[28] He climbed the Giralda and discovered other vestiges of Moorish culture, saw Murillos, Zurbaráns, and Goyas in their own environment, and sketched the churches and monasteries. (He later used his drawings of the Carthusian church of Seville in *Columbus at la Rábida*.)

Back in Morocco Delacroix continued to sketch and collect bits of local lore. He was impressed by the dignity, humanity, and beauty of the lives of the natives:

It must be difficult for them to understand the unmethodical minds of the Christians and that restlessness which urges them on to novelties. We notice a thousand things which these people lack. Their ignorance is the source of their equanimity and their happiness; are we ourselves at the limit of what a more advanced civilization can produce?

They are closer to nature in a thousand ways: their dress, the cut of their shoes. Consequently, beauty has a share in everything that they make. As for us, in our corsets, our tight shoes, our ridiculous coverings, we are pitiful. Gracefulness is avenged for our knowledge.[29]

For Delacroix, the greatest virtue of the Moroccan adventure was that it provided an escape from the drabness of contemporary life in France. In North Africa he found aesthetic satisfaction, not only in the appearance of the country

but in the way its rituals gave visible form to the underlying cultural values. Like others later in the century—Gauguin, for example—he found a partial embodiment of his own idealistic yearnings in some exotic actuality. He was not blind to the brutality, cruelty, and injustice that he saw in the daily life of Morocco, under what he called the "scimitar of tyrants." But his delight in the picturesque, his fascination with the dramatic, even the drama of pain and suffering, and his abiding respect for form subverted any negative moral judgment of that corner of Islam.

Mornay's stay in Tangier was prolonged, probably in the hope of avoiding the cholera epidemic at home, but the mission finally left Tangier on June 10. There was a brief stop at Oran on June 18 and a two-day stay at Algiers. By July 5, after six months' absence, the travelers were once more in France. Delacroix returned with seven albums of notes and sketches. Although they were all intact when the contents of his studio were sold after his death, four albums have since been broken up and sold piecemeal. Two complete albums are now in the Louvre, and a third is in the Musée Condé at Chantilly. The notes in the Joubin edition of the *Journal* were transcribed from these three notebooks. Another product of the trip was a folio of eighteen larger, more elaborate water colors done as a gift for Mornay.[30] These latter works were dispersed by public sale in 1877.

The drawings and water colors made on the trip were mostly intended as *aide-mémoires* to serve in developing future works. Many are little thumbnail sketches, or *croquis*, stating the facts with simplicity and verve. In more leisurely circumstances, when Delacroix worked from a posed figure, an interior, or a landscape, the studies were more detailed, and color was added in a light wash in the English manner. Delacroix soon began to use his new material, chiefly on a small scale. He made some etchings of Oriental subjects and did five prints in a lithographic process known as "autography," by which the character of a pen-and-ink drawing is approximated. In contrast with the freshness of the drawings he did on the spot, most of these prints have a lack of conviction which gives even the best of them, like the etching *Collision of Moorish Horsemen*, something of the look of a reproduction. They do, however, indicate the subjects that would be developed in Delacroix's subsequent Oriental paintings.

Broadly speaking, these canvases may be divided into two categories, subjects deriving directly from Delacroix's experiences abroad, such as *Women of Algiers in Their Harem*, *Jewish Wedding in Morocco*, or *Sultan of Morocco Surrounded by His Court*, and a number of pictures which show less the adoption of new themes than the revision of older ones. Such a distinction is, of course, quite arbitrary. *Women of Algiers*, for example, is not without precedent. Even Ingres had done odalisques and harem interiors, as had others before him. But, unlike Delacroix, he did not actually visit such a room and draw its occupants. Similarly, *Jewish Wedding* or *Fanatics of Tangier*, both of which lie outside previous thematic traditions, reflect the artist's direct experience. By contrast, the hunting scenes with Arab riders derive from a long-standing tradition, modified to allow appropriate costumes and types. There is no evidence that Delacroix ever saw a wild animal hunt, but he did study comparable compositions by Rubens. Certain other subjects, such as the combat of the Giaour and the Pasha, have a literary source that is of interest in itself, although Delacroix introduced references to his travels. These works may therefore be considered in the second category.

30. There is some confusion about the date of these water colors. Joubin (*C*, 1:334, n. 2) believes that they were done during his brief quarantine at Toulon, which seems unlikely in view of their general level of finish and elaborate composition. Robaut (*R*, pp. 132ff.) gives the date as 1833, which seems more credible. They were in any case done when the trip was over.

PLATE X. *Outside Tangier*, from the Moroccan Notebooks.
1832. Water color. 0.12 × 0.19. Louvre.

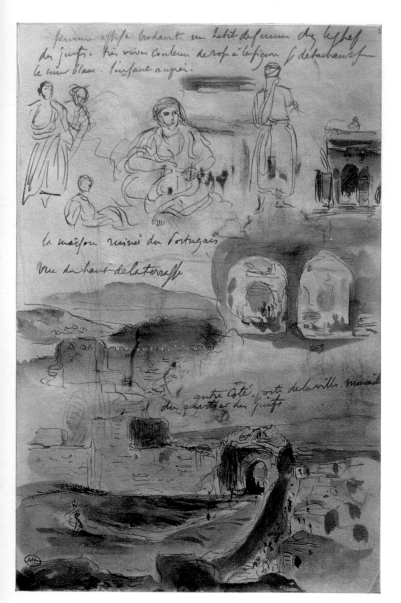

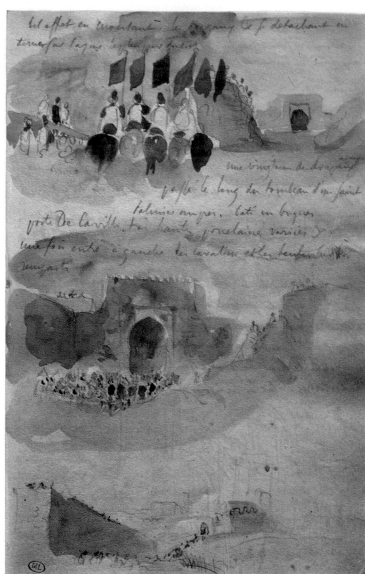

PLATE XI. Two pages from the Moroccan Notebooks. 1832. Water color. 0.19 × 0.12. Louvre.

31. There are other comparable Byronic references, most notable of which are the three small canvases illustrating Cantos II and XXIII of *The Bride of Abydos*, in which Selim and Zuleika are being pursued in the cave.

Two versions of the combat of the Giaour and the Pasha, one painted before and the other after Delacroix's trip to North Africa, with a few other associated works, will indicate his refurbishing of older themes.[31] The first of these Giaour subjects was painted around 1826. The second version was not done until 1835, by which time the interpretation of the theme had undergone a marked transformation in both style and expression. The *Journal* indicates that Delacroix had been attracted to Byron's poem since the spring of 1824. At some point during that summer he painted what was probably his first scene from *The Giaour*,

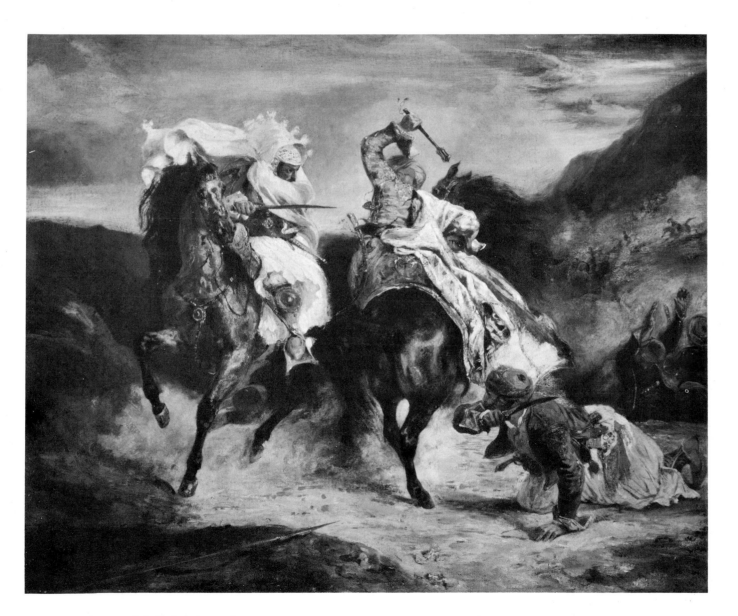

FIGURE 60. *Giaour and the Pasha.* 1824–27?
Oil on canvas. 0.58 × 0.72. The Art Institute of Chicago. Photo courtesy of The Art Institute of Chicago.

Death of Hassan, for which various dates and identities have been proposed.[32] He went on to do other versions of the subject, including a lithograph issued in 1827,[33] which is clearly indebted to Géricault's earlier treatments of the story.

While Delacroix's composition closely reflects its prototype, even the most superficial comparison of the two prints reveals equally significant differences of style and expression. The motif of the Giaour's triumph has been so transformed by Delacroix that it has been made completely personal. Still astride his dark charger, the Giaour pauses to gloat over his fallen adversary, whose riderless horse is bolting away into the distance. Since the outcome of the contest has already been decided, the provocative power of this agitated vision derives more from the character of the forms themselves than from the narrative. There is the same mannered style and nervous intensity of expression that mark *Death of Sardanapalus,* the tantalizing spatial elisions and weightless form, and once more the artist has symbolized the cruel disillusionments of mortal vanity.

By 1827 Delacroix had executed other versions of the story, including a small oil and a water color, both of which show the victor standing over the dead Hassan.[34] It is apparent that a third version of the theme was shown at the Greek Benefit Exhibition in 1826. In a letter to Pierret, Delacroix refers to his entry as a *"Combat of the Giaour and the Pasha.—Taken from Lord Byron. 'I recognize by that sallow front him who robbed me of Lelia's love: it is the accursed Giaour.'"*[35] In view of the nature of the subject, it would seem that the painting described is the one now in the Art Institute of Chicago. It is, however, unlikely that this was the canvas shown at the Salon of 1827 under the title *Scene of the Present War between the Turks and the Greeks,* a work with which it has sometimes been confused.[36]

An association of the two paintings is natural enough, since one warrior's dress is like that of *Count Palatiano in Souliote Costume.* He is thus identified as the Christian Giaour, while Hassan appears as a turbaned Moslem. To that extent, there may be some interweaving of the Byronic episode with the Greek wars. The subject is, moreover, rather freely treated. The poem describes the Giaour's mount as "jet-black," while it is his opponent's steed here that is dark. Puzzling too is the inclusion of a third figure, presumably one of Hassan's men, who crouches as though about to hamstring not the Giaour's but his master's horse. The main action has a similar suspenseful character: the two riders are poised in the moment of attack, with the decision of their contest still in doubt, unlike the lithograph, where the Giaour's long, remorseful future has been irretrievably determined by the Pasha's fall.

While the beauty of the surfaces of the earlier picture is not to be denied, it lacks the concentrated force of the second canvas. In the 1835 version there is no question as to the outcome of the fight. The Giaour, clad again in Greek costume but now appropriately mounted on a black horse, prepares to drive his sword into the body of his adversary. The Turk's dagger is raised above his head, thus exposing himself to the Giaour's fatal blow. The horses share their masters' fury and bite and kick at each other.[37] The third combatant has fallen beneath their hoofs.

The extent to which both representations remain within the context of the early works is evident from a comparison of either with a similar subject, *Two Arabs in Combat,* which Delacroix painted in 1856. This scene, whose relationship to Byron's story is, at most, attenuated, depicts a very different kind of engage-

32. Johnson suggests a date of 1824 on the basis of his own stylistic interpretation (see "Delacroix at the Biennale," *Burlington Magazine,* 98 [September, 1956]:327–28). See also his *Delacroix: An Exhibition,* pp. 44–45, Nos. 87 and 88, and "Delacroix Centenary II," pp. 260–61. Sérullaz is inclined to place the work slightly later. He cites its close resemblance to the *Mortally Wounded Shepherd of the Roman Campagna,* which was exhibited at the Salon of 1827 (see *M,* p. 49). Hamilton considers the work to have been done in the years just after his trip to England, that is to say, from 1826 to 1829. His hypothesis is based in part on his assumption that the composition may have derived from a Cruikshank illustration of the poem, which was published in the summer of 1825 while Delacroix was in England (see "Delacroix, Byron, and the English Illustrators," pp. 261–78). Another more likely source is a print by Géricault.

33. Delteil gives a date of 1827 for this print. It should, however, be observed that the drawings in the lower margin of the first state proofs (illustrated by Delteil) include a head of a Turk which closely resembles some of the pencil studies for the horseman in *Massacre at Scio.* This suggests an earlier date, but it may simply indicate that the same drawings served the artist once again as he considered what use he might make of the Giaour's visage. The marginal sketch bears a distinct resemblance to the final version.

34. One of these, probably the water color, may be the picture he began the day after he first mentioned Byron's poem in his *Journal* (see *J,* 1:100 [May 11, 1824]). He does not specify whether this was an oil or a water color, such as that illustrated in color in Escholier, *Delacroix,* vol. 1, facing p. 182. Except for the fact that it is reversed, the pose of the fallen figure is close to that in the oil of Hassan. In style, however, the water color is very similar to the detailed water-color study, now in the Louvre, for *Massacre at Scio* and hence is perhaps slightly earlier than the oil.

35. *C,* 1:185 (June 14, 1826).

36. Robaut (R, p. 60, No. 202) calls *Scene of the Present War* the "true" title of this work. See Farwell, "Sources for *Sardanapalus*," pp. 66–67, n. 3, in which she summarizes the history of the confusion of the two paintings. Both were submitted to the Salon of 1827, but apparently only one (*Scene of the Present War*) was exhibited. The usual dating of the Chicago painting as 1827 would therefore be too late. Sérullaz (*M*, p. 167) assumes that there were two versions of the subject, since Delacroix included a "Combat of the Giaour and the Pasha, from Lord Byron" in a list of works he had exhibited which he drew up for Thoré (see *C*, 1:407 [Jan. 18, 1836]). There is no mention of his having shown the Chicago *Giaour* (as he apparently did) in 1826.

37. Here, as in his *Arab Horses Fighting in a Stable*, painted in 1856, Delacroix may have freely incorporated recollections of a fight between two horses that he saw during his stay in Morocco (see *J*, 1:124 [Jan. 29, 1832]). Géricault had done a print of a comparable subject.

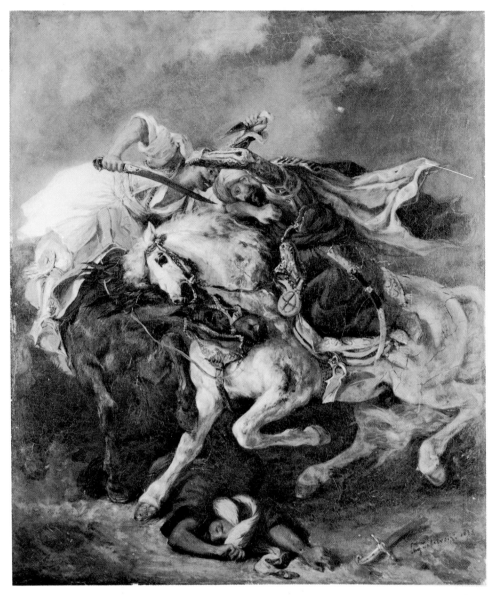

FIGURE 61. *Giaour and the Pasha.* 1835.
Oil on canvas. 0.74 × 0.60. Petit Palais, Paris. Photo S.D.P.

ment. One warrior, astride a rearing horse, trains his pistol at a kneeling enemy, who holds his rifle as though in surrender or a futile gesture of defense. The whole sense of the action has been transformed. Where the Chicago picture stressed the glittering elegance of the sparring horsemen and the second version showed the pair at the climax of their engagement, the latest picture presents the last moment of hesitation before the deed. The shift from steel to firearms separates the adversaries physically in a further alteration of their pictorial relationship.

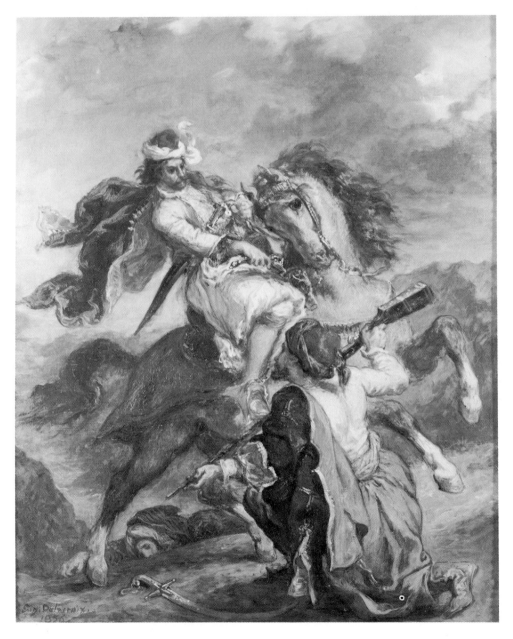

FIGURE 62. *Two Arabs in Combat*. 1856.
Oil on canvas. 0.82 × 0.65. Fogg Art Museum, Harvard University,
Grenville L. Winthrop Bequest. Photo courtesy of the Fogg Art Museum.

FIGURE 63. *Street in Meknes.* 1832.
Oil on canvas. 0.46 × 0.64. Albright-Knox Art Gallery, Buffalo, N.Y.
Photo Albright-Knox Art Gallery.

Delacroix has abandoned bold physical contrast in favor of subtler psychic tensions.

That new emphasis is equally appreciable in the technique. The poses and expressions of the warriors are generalized, so that the meaning of the action cannot be grasped precisely. Similarly, the paint surfaces have been developed more with an eye to formal unity and coloristic richness than to sensuous textural variety. By this time Delacroix's visual intentions were in firm control of his subject matter.

Constituting a separate category are those Oriental subjects which are purely picturesque genre scenes with no specific literary, historical, or traditional associations. In his catalogue descriptions of works of this kind Delacroix often alludes to their "accuracy." This deference to factualism may well represent another effort to compensate for the unpopularity of *Sardanapalus,* for in Oriental scenes Delacroix could satisfy the public demand for fidelity to nature without compromising his own fondness for the exotic.

His first direct pictorial reference to his experiences in Africa was a small oil, *Street in Meknes,* done shortly after his return. The picture was shown at the Salon of 1834, the first salon to include works from his trip. When it was noticed at all, *Street in Meknes* received little praise. Even Gustave Planche wrote in the *Revue des Deux-Mondes* that it was no more than a study which might be developed into a good picture (this was not the first time, of course, that Delacroix had

failed to satisfy the contemporary taste for "finish"). The relative self-contain-
ment and frontality of the figures, shown against a flat wall, is more than a classical
device. In limiting the illusion of depth, Delacroix has suggested lateral movement,
an impression which is emphasized by the central placement (presumably opposite
the observer) of the shadow of a doorway that masks the disparity between the
two sides of the composition. The pictorial space is thus synthetic in nature, as
though it is presented more as a sequence of impressions received in a passing
glance than as a homogeneous perspective view in the Renaissance tradition.

For a man fond of feminine company, Delacroix's stay in North Africa had its
frustrations. The strict segregation of the women of Islam firmly excluded him
from the seraglios he longed to visit. Although he was accepted by the Jewish
population at Tangier, as *Jewish Wedding* indicates, he felt he could understand
Moorish life only by visiting a Moslem household. He was only able to satisfy
that ambition in Algiers, where the port engineer arranged with one of his native
employees to let Delacroix make a secret visit to the women's quarters of his
home. There he made the water-color studies which he eventually developed
into *Women of Algiers*.[38]

According to Mornay, who accompanied Delacroix, he was so excited by
the sight of what Mornay called those "beautiful human gazelles" that he was
seized by "a fever that could barely be held in check by sherbets and fruit."[39]
The engineer himself, a M. Poirel, is reported to have said that Delacroix exclaimed
that it was like a visit to the times of Homer and that this was the kind of women
he could understand, withdrawn from the outer world but dwelling at its secret
heart.[40] Delacroix spent two days there making sketches and took away with him
an assortment of "arms, costumes, cushions, scarves, etc."[41]

The names that Delacroix noted on his drawings and the distinctions he made
among the faces indicate that at least six ladies served as models. The studies, in
pencil touched with water color, show these figures posed singly and in pairs.
Two sketches are particularly important for their relationship to the final com-
position. In one, Moûnî Bensoltane is seen reclining in a pose recalled in the
extreme left figure of *Women of Algiers*. Even closer to the final work is another
study representing Moûnî and Zohra Bensoltane sitting on the floor, much like
the two women in the completed canvas.[42] Similar fidelity to the documentary
studies may be observed in a water color representing the interior of a tiled room,
which served as a model for the setting of *Women of Algiers*. A fourth drawing of
a Moslem woman seen from behind and slightly turning may have inspired the
figure of the Negress in the final composition, although here the similarities are
less pronounced.[43] It is, in any case, evident that Delacroix depended heavily
upon these studies for a sense of authenticity in the finished piece.

Delacroix's first attempt at such a view of a harem interior is an "autograph"
of 1833, showing two Algerian women reclining in a Moorish setting. While
the print lacks both the complexity and the refinement of the later painting, it
indicates the artist's early notion of the theme. Surviving drawings show that
for the painting he made additional figure studies from studio models. The
reclining figure to the left and the Negress to the right are products of that inter-
mediate process of elaboration.

The transformation of the servant into a Negress is one of the most obvious
changes in the final composition. The pose of the figure has also been altered.
Although it is somewhat awkward in movement and crowded with relation to

38. See Élie Lambert, *Delacroix et les femmes d'Alger* (Paris: Laurens, 1937), pp. 9ff., which discusses in detail the documents relating to the origins and execution of this painting and qualifies previous notions deriving from Burty's traditionally accepted commentary. See also Huyghe, *Delacroix*, pp. 279–81.

39. Quoted in Lambert, *Les femmes d'Alger*, p. 9.

40. *Ibid.*, pp. 10–11.

41. Many of these objects are still well preserved and were shown at the commemorative exhibition held at the artist's studio, 6 Rue Furstenberg, from March to September, 1963 (see *Exposition Delacroix citoyen de Paris* [Paris: Direction Générale des Musées de France, 1963], pp. 17–18, Nos. 162–66).

42. The names are Moslem and so, one assumes, was the household Delacroix visited. Zohra Touboudji is identified as one of the models for another drawing. According to Georges Marçais, "Touboudji" is actually Turkish in origin. It is an occupational name meaning "cannoneer," which would probably make Zohra the descendant of some pirate artilleryman or cannoneer. See Lambert, *Les femmes d'Alger*, p. 13, and Johnson, *Delacroix: 1798–1863*, pp. 76–77, in which he reproduces two rather advanced studies not mentioned by Lambert. See also *M*, pp. 148–55.

43. See Lambert, *Les femmes d'Alger*, p. 24.

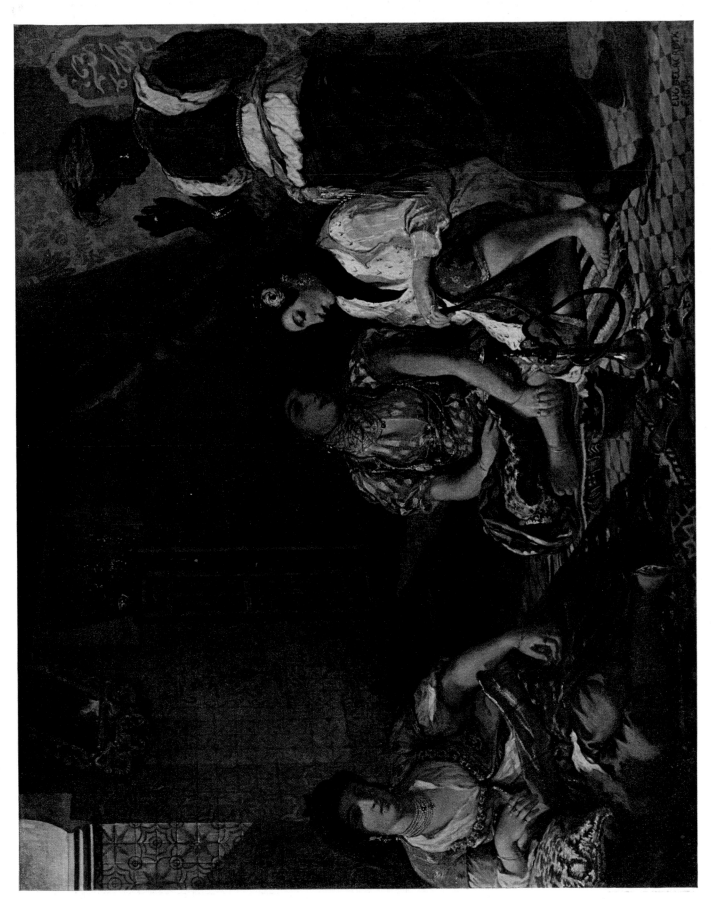

PLATE XII. *Women of Algiers in Their Harem.* 1834. Oil on canvas. 1.80 × 2.29. Louvre.

PLATE XIII. *Women of Algiers in Their Harem.* 1849. Oil on canvas. 0.84 × 1.11. Musée Fabre, Montpellier.

44. See Joubin, "Les modèles de Delacroix," pp. 356–59.

the frame, it does serve to balance the visual weight of the reclining Algerienne opposite her. The latter figure, changed from the initial studies, may also seem a trifle cramped in its placement. It represents a contrasting ethnic type and seems too European for the role, probably because the model for this houri was Élise Boulanger (later Mme Cavé), who became Delacroix's mistress upon his return from Africa.[44]

In its finished form the picture has formal characteristics observable in Delacroix's earlier works. The space is more synthetic than illusionistic, and the articulation of the figures is abstract. There is a distinct change in expressive tone, a note of quiet, reflective repose. *Women of Algiers* continues the colorism of the earlier works, but now with a subtlety that is surely the result, at least in part, of his recollections of the effects of Moroccan interior lighting. The color, while rich, is restrained in comparison with the bold excesses of *Sardanapalus*. The forms are firm and close in technique to those in *Liberty Leading the People*, yet the modeling is more gentle, the tone more subtle, and the light and dark contrasts less extreme. The picture space is limited in depth, and its further reaches are at once mysterious and subordinate because of their veil of atmospheric shadow.

In its mood of composure and balanced, formal clarity, *Women of Algiers* is a fundamentally classical work, but to refer to Delacroix's "classicism" here is not to ignore the ways in which the painting is unorthodox. A comparison of,

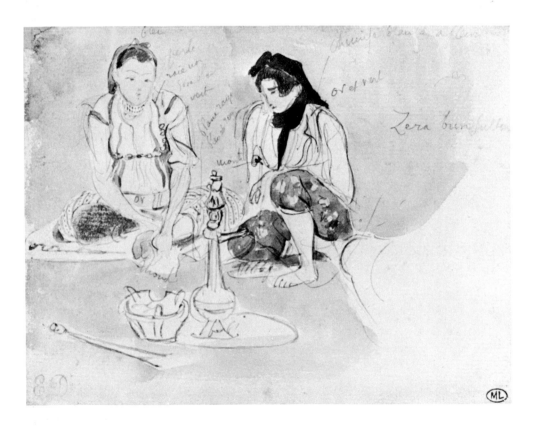

FIGURE 64. Study for *Women of Algiers*. 1832. Water color and pencil. Cabinet des Dessins, Louvre. Photo S.D.P.

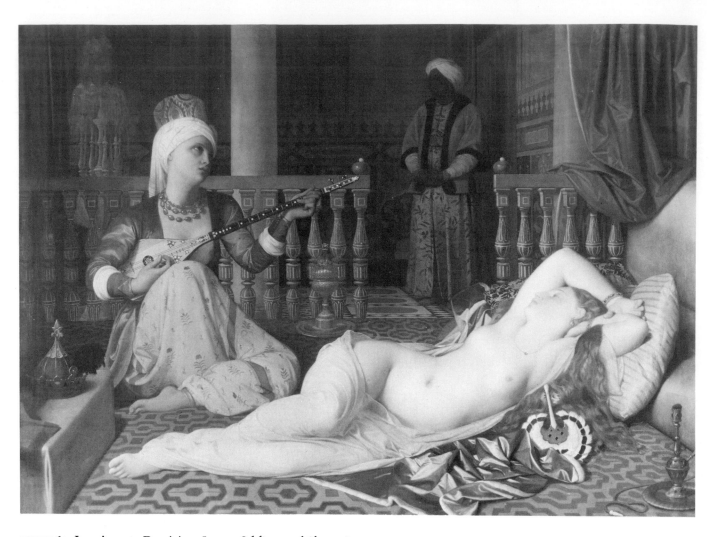

FIGURE 65. Jean-Auguste-Dominique Ingres. *Odalisque and Slave.* 1839–40.
Oil on panel. 0.72 × 1.00. Fogg Art Museum, Harvard University, Grenville L. Winthrop
Bequest. Photo courtesy of the Fogg Art Museum.

for example, Ingres' *Odalisque and Slave* indicates how little he was attracted by neoclassical linearity or traditional notions of perspective construction. The figures of the women are seen against rather than in their environment. Although the architecture indicates a vantage point well above the heads of the seated figures, the spectator sees them from close by and at his own eye level. As a result, their proximity is emphasized, while the room beyond is diminished in substance. At the same time, the insistence on their silhouettes and those of the still-life elements shows more than a trace of their origins as separate studies. In its stress on pattern, and consequent flattening of the picture surfaces, as in its arbitrary spatial relationships, *Women of Algiers* is a notable departure from the contemporary insistence on faithful representation of nature. Following this example, Manet and other artists of his generation were more overt, but hardly more daring, in their formal and expressive manipulations. In this respect, at least, *Women of Algiers* is far closer to *Déjeuner sur l'herbe* than one might at first suppose.

As he sometimes did with favorite subjects, Delacroix returned to this theme and made a second version, now in the Musée Fabre at Montpellier. It is smaller but still imposing and represents a very different phase of Delacroix's development. Begun in 1846 and not completed until 1849, it is far from a duplication of the earlier version. The scene has greater simplicity and atmospheric unity; the figures are smaller in proportion to the whole and fit more easily within their pictorial environment; the vantage point implied by the perspective is coordinated with that implied by the figures. Such gains in spatial consistency have been accomplished, however, only at some sacrifice of the intimacy of the original version.

The more unified construction is reinforced by the bolder contrasts of light and shadow produced by a single light source. Here as elsewhere there is evidence of Delacroix's admiration for Rembrandt's subordination of detail to over-all unity. The blue and white faience wall and the patterned tile floor of the 1834 painting do not recur, and the architecture no longer has any particular identity. The figures have been transformed in a similar way. They are more generalized types, with a common resemblance. While it is true, as Lambert suggests, that they recall the studies from which they derive, these later Algerian ladies have the quality of images from memory, Delacroix's mellow recollections of the seraglio.

The second *Women of Algiers* has undergone a marked coloristic transformation as well. The tonal contrasts are more extreme, not only in the bold *chiaroscuro* throughout but also in the local accents. As in other works of this period, Delacroix's developing interest in vivid contrasts may be observed, particularly in the pronounced opposition of greens and reddish tones in the costumes. Also of interest is the fact that given areas of local color may contain a variety of related hues, combined to produce complex harmonies. This treatment is apparent in such passages as the trousers of the woman at the center, where the interplay between red-violet and red-orange attains a peculiar intensity, especially in contrast with the greenish blouse. Although Delacroix's search for these unaccustomed effects is not to be confused with those of the Impressionists later, it is not difficult to appreciate their admiration for Delacroix's coloristic intensities and his freedom of touch. One need only imagine a sudden flash of sunlight cast into Moûnî's shadowed retreat to see in her Renoir's *Seated Algerian Girl*. Mention of Renoir in the context of *Women of Algiers* is not simply capricious. His devotion to the art of Delacroix was a significant influence on his development, as attested by the fact that late in 1875 or early in 1876 he made a large and faithful copy of a closely related subject, *Jewish Wedding in Morocco*.[45] The qualities of brushwork and color that so impressed Renoir's generation are evident in this product of Delacroix's brief taste of North African sun.

Jewish Wedding was originally commissioned by Count Maison. When it was completed he was dissatisfied, and thought the two thousand francs Delacroix asked too high. In 1841 it was shown at the salon and was purchased for fifteen hundred francs by the artist's long-time patron, the Duke of Orléans.[46] Despite the Count's doubts, the painting was reasonably well received by the critics. Even Delécluze wrote favorably of its "simple verity" of composition, although he did object that "seen closely, everything becomes confused and vague, and the eye suddenly is preoccupied by the little brushmarks of reds, yellows, and blues

45. See C. Brahm, "Two Copies of Delacroix's Noce Juive dans le Maroc," *Gazette des Beaux-Arts*, 6th ser., 40 (1952):269–86. Brahm discusses the circumstances of copies of the picture by Renoir and Louis de Planet, who was for a time an assistant of Delacroix, and gives many details about Delacroix's own picture, its early history, and the artist's technique.

46. The picture was subsequently given to the Luxembourg Gallery, where it remained until 1874, when it was transferred to the Louvre.

presented as if by chance, and in a thousand different directions."[47] The salon catalogue contains the artist's own description: "The Moors and the Jews are mixed together. The bride is closed up in one of the interior apartments, while others rejoice throughout the rest of the house. Some Moors of distinction give money for the musicians, who play their instruments and sing continuously, day and night. The women are the only ones who take part in the dance, which they perform in turns to the applause of the assembled company."[48]

Delacroix was a guest at a Jewish wedding through the good offices of Abraham Ben Chimol, the dragoman attached to the French vice-consul at Tangier, who accompanied Mornay's party to Meknes. On numerous occasions Abraham helped gain Delacroix entrance to certain Jewish homes, which were less firmly barred to Europeans than those of the Moslems. After the wedding celebration, Delacroix entered a detailed description of what he had seen in one of his sketchbooks:

The Jewish wedding. The Moors and the Jews at the entrance. The two musicians. The violinist, his thumb in the air, the under side of the other hand very much in the shadow, light behind, the haik on his head transparent in places; white sleeves, shadowy background. The violinist; seated on his heels and on his gelabia. Blackness between the two musicians below. The body of the guitar on the knee of the player; very dark toward the belt, red vest, brown ornaments, blue behind his neck. Shadow from his left arm (which is directly in front of one) cast on the haik over his knee. Shirtsleeves rolled up showing his arms up to the biceps; green woodwork at his side; a wart on his neck, short nose.

At the side of the violinist, pretty Jewish woman; vest, sleeves, gold and amaranth. She is silhouetted halfway against the door, halfway against the wall; nearer the foreground, an older woman with a great deal of white, which conceals her almost entirely. The shadows full of reflections; white in the shadows.

A pillar cutting out, dark in the foreground. The women to the left in lines one above the other like flower pots. White and gold dominate, their handkerchiefs are yellow. Children on the ground in front.

At the side of the guitarist, the Jew who plays the tambourine. His face is a dark silhouette, concealing part of the hand of the guitarist. The lower part of his head cuts out against the wall. The tip of a gelabia under the guitarist. In front of him, with legs crossed, the young Jew who holds the plate. Gray garment. Leaning against his shoulder, a young Jewish child about ten years old.

Against the door of the stairway, Prisciada; purplish handkerchief on her head and under her throat. Jews seated on the steps; half seen against the door, strong light on their noses, one of them standing straight up on the staircase; a cast shadow with reflections clearly marked on the wall, the reflection a light yellow.

Above, Jewesses leaning over the balcony rail. One at the left, bareheaded, very dark, clear-cut against the wall, lit by the sun. In the corner, the old Moor with his beard on one side; shaggy haik, his turban placed low on the forehead, gray beard against the white haik. The other Moor, with a shorter nose, very masculine, turban sticking out. One foot out of the slipper, sailor's vest and sleeves the same.

On the ground, in the foreground, the old Jew playing the tambourine; an old handerchief on his head, his black skullcap visible. Torn gelabia; his black coat visible near the neck.

The women in the shadow near the door, with many reflections on them.[49]

With a few minor exceptions, the picture is faithful to this verbal account. More than thirty figures are shown gathered in an interior court, partly shaded by an overhanging balcony and a stretch of awning. The architectural setting

47. Quoted in *M*, p. 231, from the *Journal des débats*, March 21, 1841. Generally speaking, Delacroix's Oriental subjects were fairly well accepted by his contemporaries.

48. *R*, p. 184.

49. *J*, P, pp. 106–8 (Feb. 21, 1832). The sketchbook containing the original description has been lost (see *M*, p. 230). Delacroix expanded it into an article for the January, 1842, issue of *Magasin pittoresque*. That version is reprinted in his *Oeuvres littéraires*, 1:103–7. See also Élie Lambert, "Un document sur le séjour de Delacroix à Tanger tiré de l'album de voyage du Musée Condé," *Gazette des Beaux-Arts*, 6th ser., 11 (1934):185–86.

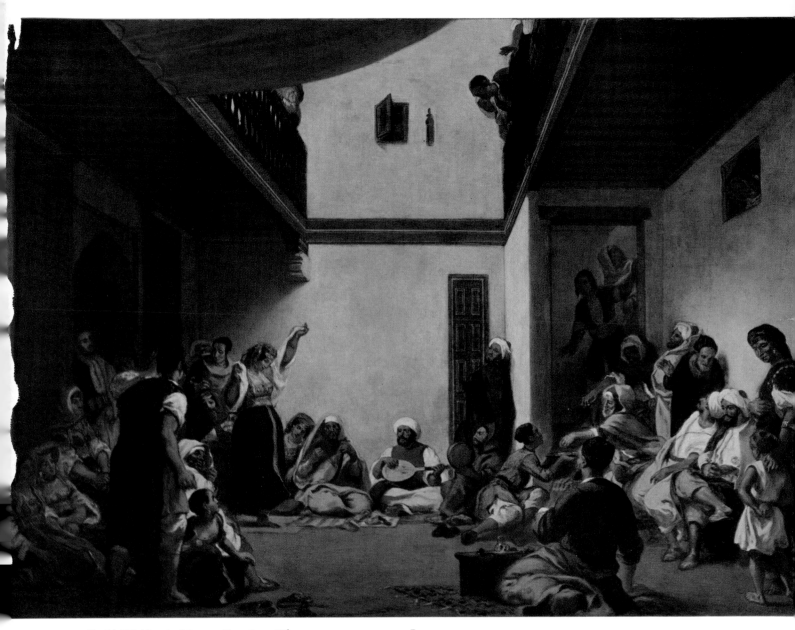

PLATE XIV. *Jewish Wedding in Morocco.* Ca. 1839. Oil on canvas. 1.05 × 1.40. Louvre.

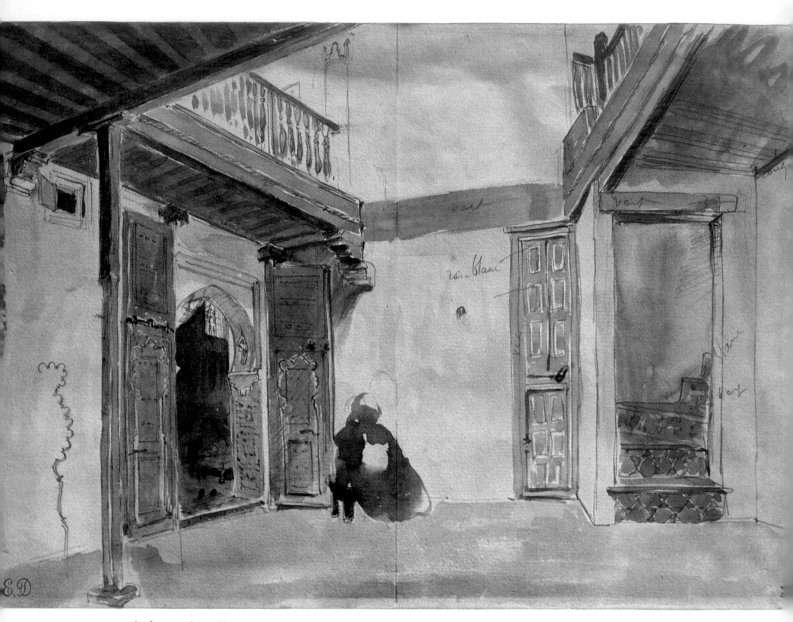

PLATE XV. Study for *Jewish Wedding in Morocco*. 1832. Water color. 0.21 × 0.29. Louvre.

closely follows a water-color study of the same courtyard made when it was empty except for a figure seated against the center wall, suggesting that Delacroix was already considering the pictorial possibilities of the scene and returned at some time after the wedding to record these details. In the final version the space has been made more formal: the angle of an overhanging balcony shown in the foreground of the sketch has been retained in the form of an awning, which introduces another note of color. The Moorish men, who wear light-colored garments, yellow slippers, and turbans, are seated to the right. Ancient Moroccan law restricted the dress of Jewish men, and they are seen here in their prescribed costume of dark blue or black overgarments with red-brown belts and black skull caps and slippers. Jewish women were not thus restricted in their costumes and they are ranged in tiers to the left, like pots of flowers, as Delacroix said.

Although *Jewish Wedding* is somewhat smaller than *Women of Algiers*, it is much more complex. In its mediation between the focal character of the setting and the varied movement and color of the figures, the composition is at once orderly and spontaneous. It also shows the changes in Delacroix's use of color in the intervening years. Although the surface has seriously deteriorated, particularly in the darker passages, it is nevertheless easy to see what attracted Renoir. The over-all tonality is rather pale and slightly warm, with sharp accents of bright green in some of the architectural details, such as the railing of the balcony. The purplish tint of the floor is repeated elsewhere, most strikingly in the shaded underside of the balconies. Here is an instance of "induced contrast": the close association of the purple with the green makes it seem far more intense than it is.[50] The yellow ocher tones of the canvas also recur somewhat more intensely in the half lights behind the figures in the open door at the right. Still brighter color notes, such as the vermilion of the guitarist's jacket and the bright blue-green touches in the costumes of the men putting money into the collection plate, all contribute to the brilliance of the sunlight, the friendliness of the shade, and the mood of festivity.

The palette Delacroix employed for *Jewish Wedding* included the usual range of earth colors—burnt sienna, raw umber, Venetian red and yellow ocher—along with lead white and black. Some of the additional colors used—cobalt blue, Naples yellow, and vermilion—were also reasonably stable. Unfortunately, certain others were less reliable. The lead yellow, Prussian blue, yellow lake, and Vandyke brown that he and other nineteenth-century painters used were not permanent pigments.[51] Because of this, and perhaps also because of an inexpert use of varnishes and driers, the dark passages have suffered badly. However, modern conservation methods have made it possible to recapture much, at least, of the original coloristic appeal.

All technical considerations aside, however, the journey to North Africa did have a very direct impact upon Delacroix's color. Morocco, Spain, and Algiers reinforced his already pronounced coloristic preferences, and he came to see in his subject an opportunity for creating an autonomous world of beautiful forms and colors. A small Arab boy being taught to ride a horse, a troupe of Arab musicians gathered in the countryside or a pair of Jewish musicians performing in the streets of Mogador, a band of riders fording a stream or watering their mounts at a well—such scenes retain an artistic meaning for a generation with little interest in the picturesque for its own sake. By contrast, *Arab Chiefs in Council*

50. This use of "simultaneous contrast" may have been deliberate: it is possible that by this time Chevreul's theories were known to Delacroix, although he does not mention them specifically. Some of the discussion of color in the *Journal* makes it clear that he was aware of effects of "simultaneous contrast" and "induced color sensation" (see, for example, 1:419–20 [Nov. 3, 13, 1850]; 2:175–77 [Apr. 29, 1854]). He mentions reflections, which are also prominent in the description of *Jewish Wedding*. Huyghe points out that "a notebook written by someone who had attended Chevreul's lectures" was included in Moreau-Nélaton's files on Delacroix. His inference that this transcript was consulted by Delacroix (*Delacroix*, p. 343) must, however, remain highly speculative.

51. Brahm lists a "Van Dyke red" ("Delacroix's Noce Juive," p. 278). This color may actually have existed, though it seems probable that the reference is to Vandyke brown, a pigment popular in the nineteenth century because of its rich, deep coloration in mixtures. Unfortunately, it crackles badly. The ruinous crackle of *Jewish Wedding* could therefore indicate the use of such a pigment in that picture. See R. Mayer, *The Painter's Craft* (Princeton, N.J.: Van Nostrand, 1948), pp. 27–57, for a convenient summary of the characteristics of various pigments, with Vandyke brown discussed on p. 53.

or the closely related *Arab Story Teller* (1829) by Delacroix's popular contemporary Horace Vernet now seem dated and lifeless, for all their technical skill and expertly contrived composition. Vernet's ability as an illustrator no longer claims our admiration, deprived of its former narrative and picturesque appeal. As Delacroix himself often said in later years, "To compose is to associate—to bring things together with eloquence."⁵² The measure of his success in fulfilling that aim is the fact that his art has survived the changes in taste that dated the efforts of so many others.

52. Quoted in Piot, *Les palettes de Delacroix*, p. 23.

Aside from *Jewish Wedding* and *Women of Algiers*, the most imposing picture to derive from the visit to North Africa was *Sultan of Morocco Surrounded by His Court*, which was painted in 1845. In a monograph devoted to this and a group of closely associated works, Élie Lambert proposes a plausible explanation for Delacroix's long delay in rendering this scene: the Sultan never ratified the

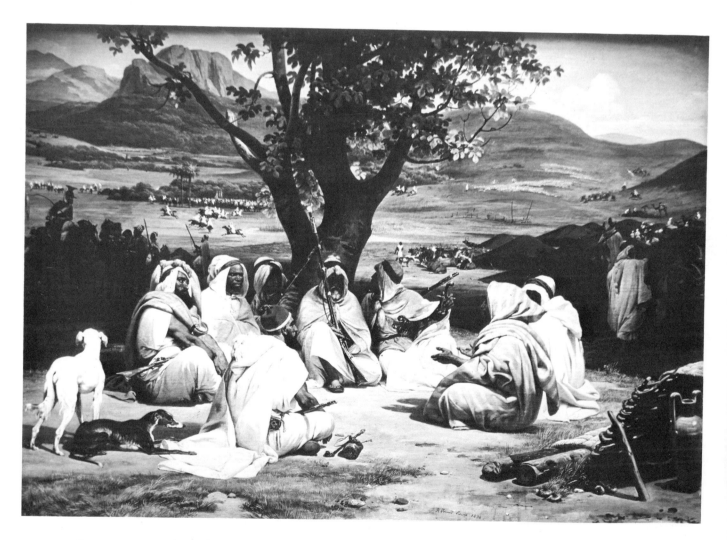

FIGURE 66. Horace Vernet. *Arab Chiefs in Council*. 1834.
Oil on canvas. 0.98 × 1.37. Musée Condé, Chantilly. Photo Giraudon.

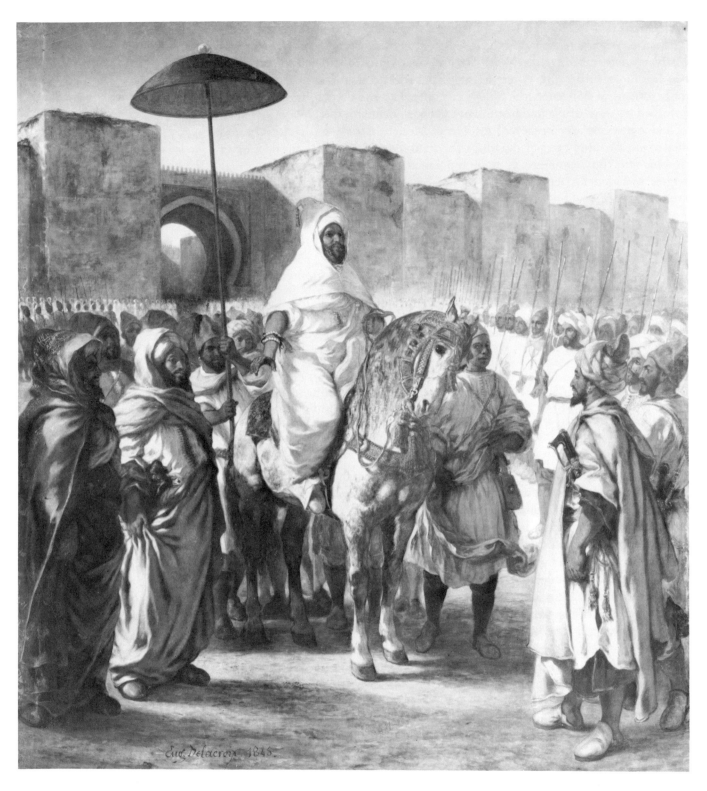

FIGURE 67. *Sultan of Morocco Surrounded by His Court.* 1845.
Oil on canvas. 3.77 × 3.40. Musée des Augustins, Toulouse. Photo Bulloz.

treaty Count de Mornay had worked so hard to obtain,[53] and in 1835 new complications in Algeria necessitated the dispatch of another French envoy, who was equally unsuccessful. In 1844 North African affairs took a still worse turn, and open hostilities broke out. After defeat of the Moroccan forces at Isly and the bombardment of Mogador, the Sultan capitulated to the French, who had been reinforced by ships of the line from many nations, including the United States.

These events excited a renewed interest in Moslem Africa, and Delacroix was called upon to supply pencil drawings for reproduction as wood engravings in *L'Illustration*. The September 21 issue announcing the signature of the treaty at Tangier included his representation of the Emperor and two attendants. This motif later recurs as the central group in the large painting, which Delacroix completed for the salon of the following year. His catalogue description again asserts its "authenticity":

The picture reproduces exactly the ceremony of an audience which the author witnessed in March, 1832, when he accompanied the King's special mission to Morocco. To the right of the Emperor are two of his ministers, the closer of whom is Muchtar, who was then his favorite: the other is Amyn Bias, the Customs Administrator. The closest figure, with his back turned to the viewer, is Caïd Mohammed-Ben-Abou, one of the most respected military chiefs, whose name figured in the last war and the negotiations. The Emperor, distinctly mulatto, wears a bracelet of mother-of-pearl beads wrapped around his arm. He is mounted upon a Barbary horse of great size, as horses of that breed generally are. To his left is a page whose duty is to chase away the insects by waving a bit of cloth from time to time. Only the Sultan is on horseback. The soldiers to be seen bearing arms in the distance are dismounted. They are lined up close to each other, but never two men deep, and when they are mounted they have no other way of marching, while to fight means to form a battle line or a semicircle with standards ahead of them.[54]

In his notes made on the day of the actual reception, March 22, 1832, Delacroix gives fresh details of the Sultan's appearance. The French party was led through great gates, past a crowd, which was whisked out of the way, to a large esplanade, where the reception was to take place at about nine or ten o'clock. Finally the Emperor appeared, preceded by small groups of black soldiers in peaked caps, who fell into lines to the right and left. Delacroix describes the Sultan as resembling Louis Philippe but younger, dark complexioned, and wearing a thick beard. He was dressed in a "burnous of fine dark cloth closed in front. A haik underneath on the upper part of his chest and almost completely covering his thighs and legs. White chaplet with blue silk around his right arm, of which one saw little. Silver stirrups. Yellow slippers which hung loose in back. Harness and saddle of pinkish color and gold. Gray horse, with cropped mane. Parasol with unpainted wooden handle; a small golden ball at the tip; red on top and in the folds, red and green underneath."[55]

It is clear from the number of these details which found their way into the picture that Delacroix wished to produce a convincing translation of what he had witnessed at Meknes. The resemblance Lambert observes between his representation of the Sultan and his much earlier wash drawing *Du Guesclin at the Château de Pontorson* (Robaut 1564)[56] would be puzzling except for the frequency of such correspondences in his work. Its possible relationship to an engraving made in 1819 by Henry Fielding after a drawing by Richard Westall of the entry of Wellington into Toulouse may be explained in the same way.[57] Delacroix tended to accommodate his perception of events to his sense of artistic conven-

53. See Élie Lambert, *Histoire d'un tableau: L'Abd er Rahman, Sultan du Maroc de Delacroix*, Institut des Hautes Études Marocaines, no. 14 (Paris: Larose, 1953); M, pp. 249–58. I disagree with some of Lambert's conclusions concerning the various studies for the work, in which distinctions between those done from life and those from memory are difficult to make. In addition to the studies, there are three copies in oil. One of these (Robaut 1743) Sérullaz places toward 1856, rather than in 1845, as Robaut proposes. A second version (Robaut 1295) dates from 1856. The third variant (Robaut 1441) was not painted until 1862.

54. Quoted in Lambert, *Histoire d'un tableau*, p. 26.

55. J, P, p. 115 (Mar. 22, 1832).

56. Although Robaut gives a date of 1831 for this work, later writers have pointed out its association with the lithograph of the same subject (Robaut 302), which was done in 1829 for inclusion in a publication entitled *Les chroniques de France*.

57. See Lambert, *Histoire d'un tableau*, pp. 28–32, p. 46, figs. 29 and 30.

tion. By the time that he undertook *Sultan of Morocco* he had already utilized much the same formula in two smaller oils, *Interior of a Moroccan Court* and *Moroccan Caïd Visiting a Tribe*, both of which were exhibited at the Salon of 1838. In the latter—a work notable in its own right—the mounted chieftain bears a particularly strong resemblance to the portrayal of the Sultan.

Delacroix's *Sultan of Morocco* and the phalanx of his retainers present the very image of the implacable hostility of an entire culture. Delacroix has, it seems, given us a ceremony in which the whole structure of the state is embodied in the person of a sovereign who is as aloof and uninviting as the bleak walls of his capital that loom behind him.

Once again, the degree to which the full meaning of Delacroix's subject is integrated with his visual forms may be illustrated by comparing his *Sultan of Morocco* with a similar subject of about the same time by another artist. *Punishment of the Hooks*, by Decamps, is typical of his accomplishment an an Orientalist. Criminals are shown being cast from the battlements of a city onto great hooks projecting from the walls below. In the foreground a horseman whips a thief or beggar, and two dogs crouch near a scatter of bones. The dramatic impact of the subject is, however, dissipated by Decamps' discursive exotic detail.

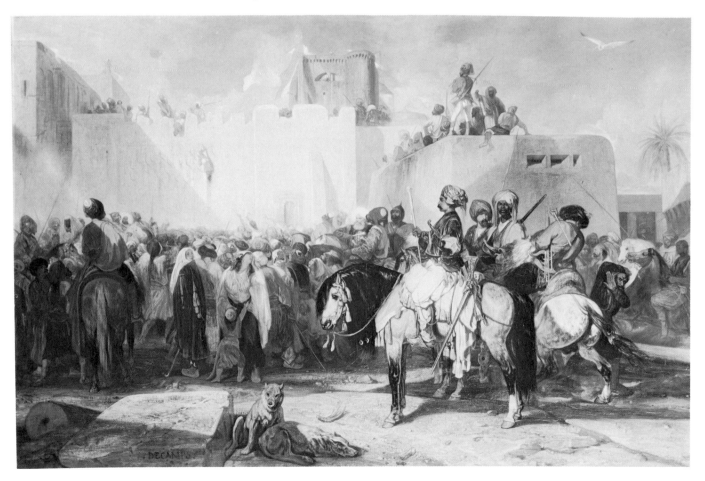

FIGURE 68. Alexandre Decamps. *Punishment of the Hooks*. 1833.
Oil on canvas. 0.91 × 1.37. The Wallace Collection, London.
Photo The Wallace Collection.

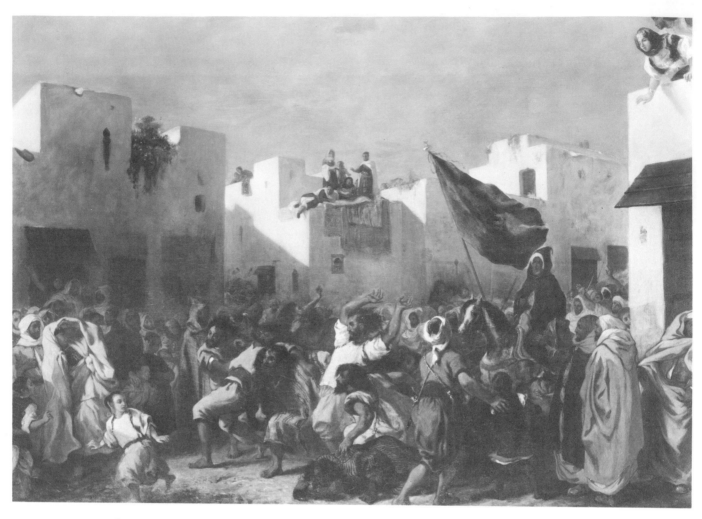

FIGURE 69. *Fanatics of Tangier.* 1836–38.
Oil on canvas. 0.98 × 1.31. Private collection. Photo National Gallery of Art.

From time to time Delacroix also represented the darker, more violent side of life in the Orient, but with more forceful results. He had seen how grace and natural elegance, classical in its composure, was found side by side with brutality and force. Aside from such fictitious subjects as the Giaour or the wild animal hunts, examples include his *Fanatics of Tangier.* The earlier, larger, and more important version of this frightening demonstration of devotional excess was begun some time in 1836 or 1837 and completed by 1838, when it was exhibited in the salon along with other North African subjects.[58] The catalogue describes these followers of a leader Delacroix identified as "Ben Yssa" (hence known to him as "*Yssaouis*"), excited into frenzy by prayers and cries, proceeding from their gatherings outside the town into the streets and giving themselves over to wild and sometimes dangerous behavior, usually involving paroxysmic contortions.[59] Although the letters and the notes made on the journey contain no mention of this startling procession, there is a much abbreviated water-color sketch of some of the *convulsionnaires*, probably done either at the time of the encounter or soon

58. See *M*, pp. 190–93. Sérullaz points out that the response of such critics as Planche and Gautier was highly favorable.

59. Delacroix's transcription is not altogether accurate. As Sérullaz indicates, the *convulsionnaires* were known as "*Aissaouas*." They were members of a secret sect founded some two centuries earlier by Sidi-Mohammed-Ibn-Aïssa. It has been suggested that Delacroix observed this scene at Meknes, where the priest's tomb is to be found, not after his return to Tangier, as has been assumed (see Johnson, *Delacroix: 1798–1863*, pp. 22–23; *M*, p. 190). For a discussion of the later version, see Johnson, *Delacroix: An Exhibition*, pp. 38, 57, Nos. 65, 139.

afterwards. A more elaborate water color very similar in composition was included in the album which he gave Mornay. In *Fanatics of Tangier* Delacroix has captured a sense of the curiosity of a cultivated European suddenly confronted with a culture whose behavior and values he can never fully understand. The massing of the architecture lends formal stability to the dramatic characterizations of the figures. Casting the entire scene into immediate and agitated relief is a sky of almost oppressively brilliant blue. Even more than *Sultan of Morocco*, that unbroken stretch of "purest azure" burns itself into the viewer's consciousness.

Delacroix was also much attracted by the variety of equestrian and military subjects he could observe at almost every turn in Morocco. The Arab steed had long since become a part of romantic iconography. Free, spirited, and strong, it was a kind of animal embodiment of passion and grace. His first canvas to show these handsome, often half-tamed creatures was *Arab Fantasy*, which he painted in 1832, soon after his return from Morocco. The following year he did another *Arab Fantasy*, now in Frankfurt, which is quite dissimilar in composition, and *Collision of Arab Horsemen*, now in the Walters Gallery in Baltimore.[60] The special appeal of the latter motif is evident in the fact that he submitted a second, closely related *Collision* to the Salon of 1834, along with *Women of Algiers*, *Street in Meknes*, and *Battle of Nancy*, but it was rejected by the jury. A water color in the Mornay album and an etching (Delteil 23) also show the scene.[61] In 1847 Delacroix returned once more to the theme in a canvas at present in the Oscar Reinhart Collection, Winterthur, Switzerland, entitled *Moroccan Military Exercises*.

60. Although the attribution of the canvas in the Walters Gallery has been questioned, most recent opinion is to accept it. For a discussion of this and other issues surrounding Delacroix's treatments of Arab military subjects, see Lee Johnson, "Delacroix's Rencontre de Cavaliers Maures," *Burlington Magazine*, 103 (October, 1961):417–23; *Delacroix: An Exhibition*, p. 27; M, pp. 133–36.

61. The etching, signed and dated 1834 and probably deriving from the same preliminary study, shows the main group in reverse. The rest of the composition has been greatly simplified in the print.

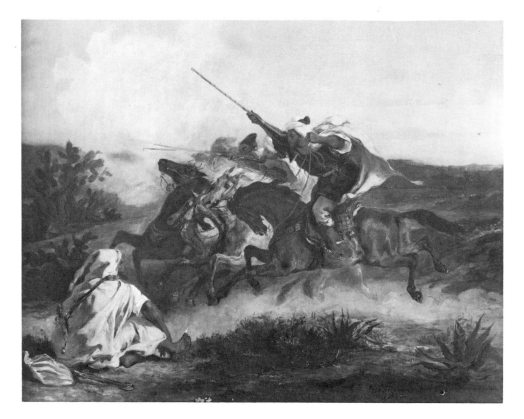

FIGURE 70. *Arab Fantasy.* 1833.
Oil on canvas. 0.60 × 0.74. Städelsches Kunstinstitut, Frankfort. Photo Bulloz.

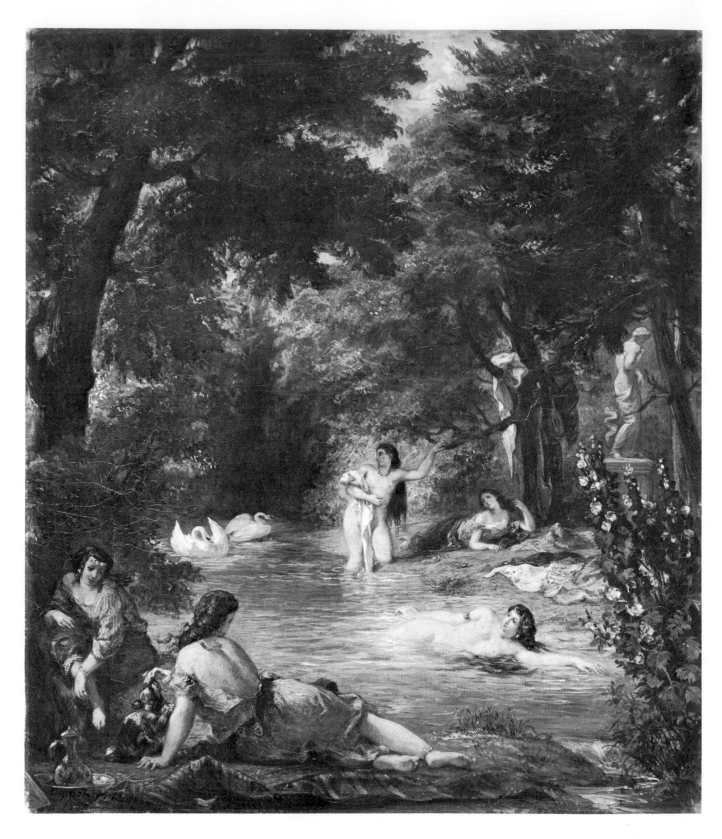

FIGURE 71. *Turkish Women Bathing.* 1854.
Oil on canvas. 0.92 × 0.78. Wadsworth Atheneum, Hartford, Conn.
Photo Irving Blomstrann, courtesy of the Wadsworth Atheneum, Hartford.

62. *J*, 1:131 (Mar. 6, 1832). It was reported that the Sultan himself sometimes joined in these exercises.

63. See Johnson, *Delacroix: 1798–1863*, p. 31, and *cf. C*, 2:38 (May 26, 1839).

64. See Johnson, *Delacroix: 1798–1863*, figure facing p. 60. He suggests that in the absence of any mention of having seen such a scene, it might be based on an unrecorded conversation with Amyn Bias, the Sultan's Customs Administrator, who spoke of facilitating "the imposition of taxes and the arrest of the seditious" (*J*, 1:137). This is a credible suggestion in view of Delacroix's frequent mention of his curiosity about local customs and his intention to ask for explanations of them.

65. *J*, 2:232 (Aug. 12, 1854). Excerpts from these documents are conveniently available in *M*, pp. 346–48. A note of April 13, 1854, indicates that the work was begun by that date (*J*, 2:163). It appears to have been completed by June 22, 1854 (*J*, 2:204). Delacroix's allusion to distasteful circumstances doubtless refers to the following incident. After the French mission returned to Tangier from Meknes, Delacroix, Mornay, and their guide, Abraham Ben Chimol, left the city one day to explore the surrounding countryside. They paused along the banks of a *wadi* so that Delacroix could sketch some women laundering. One of the women decided to undress, and at that point some Moorish men approached. The bather cried out, as though she had been surprised by the strangers, not deliberately enticing them. Delacroix and his companions fled back to Tangier, narrowly escaping the bullets of the Moors (see Escholier, *Delacroix et les femmes*, p. 80).

66. See *J*, 2:92 (Oct. 17, 1853); *cf.* Johnson, *Delacroix: An Exhibition*, p. 38, No. 65.

67. See *J*, 2:175–76 (Apr. 29, 1854).

All these pictures describe an Arab custom known as *courses de poudre*, or "powder play," which Delacroix first saw on the second day of the trip to Meknes. He describes how on that occasion two of the horsemen crashed into each other with such a jolt that the haunches of one horse touched the ground.[62] This characteristic Arab sport consisted of racing at top speed until a gun was fired, at which instant each rider would rein in his horse to a sudden stop. Delacroix tells in one of his letters that the horses sometimes "carry away their riders and fight with each other when they collide."[63] In one of his very last paintings, the glowing *Arabs Skirmishing in the Mountains*, he is still recording the things he had seen, or at least heard about, in North Africa.[64]

As late as 1857 he returned to the subject of the fanatics of Tangier and painted the smaller version now in the Toronto Art Gallery. The surfaces are, if anything, more agitated than in the earlier work and the general tone is not only darker in color but more unsettling in its effect. Yet, by contrast, he painted during that same decade, in 1854, the lovely *Turkish Women Bathing* and other reflections of the more idyllic aspects of life that he had glimpsed during his stay among the Arabs. Although it was done under conditions that, as Delacroix himself admitted, did not altogether please him, his canvas nonetheless struck him as "a masterpiece."[65]

By 1854, however, his concern for descriptive "accuracy" had long since been absorbed into the larger framework of his expressive preoccupations. *Turkish Women* testifies to the artist's own conviction, as stated in the *Journal* of the previous year, that his finest works deriving from his North African experiences were done only after he had "so far forgotten the small details as to recall . . . only the striking and poetic aspects."[66] And one can observe here the delight in color, to which he also referred in the *Journal* in a passage devoted to discussion of this composition.[67] But the transparencies and vibrant reflections he sought belong as much to the springtime freshness of Champrosay, where the picture was painted, or to his enjoyment of Rococo painting, as to his nostalgia for his youthful adventures.

Dark Prince and Troubled Scholar

Two series of lithographs, one illustrating *Faust*, the other *Hamlet*, provide added insight into the contrasts between Delacroix's art of the period following his trip to Morocco and that of the late 1820's. The *Faust* subjects, all of which were executed over a relatively short space of time, epitomize his earlier, highly individualistic manner. The *Hamlet* illustrations were not begun until 1834 and hence represent another distinctive phase of his development. Even though Delacroix's graphic works are uneven and seldom show him at his best, these illustrations demand close attention. Along with a number of closely related works in other media, they indicate his approach to subject matter deriving directly from theatrical literature and reveal with unusual clarity his process of pictorial transformation.

His early efforts as a print-maker are, on the whole, of more documentary than artistic interest. While his first lithographs, two copies after Persian miniatures, probably done in 1819,[1] are more refined that his other early prints, their primary claim to attention is as evidence of an awakening orientalism. It was not until the years 1825 through 1827 that the drawings after antique medals owned by the Duke of Blacas[2] and a few other scattered works formally announce their maker's development as a print-maker. Another project of those years was illustrating seventeen scenes from *Faust*.[3] After some delays this suite of lithographs was published in 1828 along with a portrait of Goethe and a frontispiece by Achille Devéria and the text of the play as adapted and translated into French by Albert Stapfer.[4]

The *Journal* indicates that as early as February 20, 1824, Delacroix had come to share Pierret's enthusiasm for Goethe's *Faust*, a theme that later had equal appeal for Berlioz, Liszt, and Wagner. Apparently he did not pursue the idea until 1826, after his return from London. As has been mentioned, he had been struck by a London performance of *Faust*: "I have seen here a play of *Faust* which is the most diabolical one could imagine. The Mephistopheles is a masterpiece of character and intelligence. It is Goethe's *Faust*, but adapted. The principle has been preserved. They have made it into an opera, mixing together the comic with all the blackness it contains. One sees the scene of the church with the chant of the priest and the organ in the distance. The effect could not be carried further in the theater."[5]

Over thirty years later, replying to Burty's inquiries concerning the *Faust* illustrations, Delacroix recollected that the English actor Terry was "an accomplished Mephistopheles, although he was stout; but that took nothing away from his satanic character."[6] As the part of Faust was played by James-William Wallack,[7] another member of the company at the Drury Lane Theatre Company at that time, the performance Delacroix saw must have been given there.[8] Further evidence of Delacroix's enthusiasm is a spirited pencil drawing, *Faust in Doctor's Robes* (Louvre R.F. 9 214), done a few days later, on July 2, which vividly reflects his experience that evening at the Drury Lane.

1. See Laran, "Péchés de jeunesse d'Eugène Delacroix," in which he questions the dating of some of these early efforts, including the *Ambassador*, which Delteil dates 1817 (see *Le peintre-graveur illustré*, Nos. 26 and 27).

2. One of these is now known by a tracing made after it by Robaut (Delteil 42).

3. See P. Hofer, *Delacroix's Faust* (Cambridge, Mass.: Harvard University Press, 1964); Georges Vicaire, *Manuel de l'amateur de livre du XIXᵉ siècle: 1801– 1893*, 8 vols. (Paris: Rouquette, 1894–1920), vol. 3, cols. 1013–14; Léopold Carteret, *Le trésor du bibliophile romantique, livres illustrés du XIXᵉ siècle: 1801–1875*, 4 vols. (Paris: By the author, 1927), 3:270–72; *Delacroix et la gravure romantique*, pref. Julien Cain, intro. Jean Adhémar (Paris: Bibliothèque Nationale, 1963). An annotated copy of Delteil in the Print Room of the British Museum refers to states that are not numbered and described by Delteil (see Johnson, *Delacroix: An Exhibition*, pp. 67–70). See also P. Jamot, "Goethe et Delacroix," *Gazette des Beaux-Arts*, 6th ser., 8 (July–December, 1932):279–98, in which he explores the relationship of the two great artists in a general sense, rhetorically rather than philosophically.

4. Stapfer (1802–1892) was a man of some distinction. A student of Guizot's, at the age of twenty he translated three works by Goethe: *Goetz*, *Egmont*, and *Faust* (*C*, 1:207–8, n. 3).

5. *C*, 1:160 (to Pierret, June 18, 1825).

6. *C*, 4:303–4 (Mar. 1, 1862); see also *J*, 2:349 (June 29, 1855). "Terry was perfect as the Devil," he adds here.

7. *J*, 2:349.

8. See J.-L. Borgerhoff, *Le théâtre anglais à Paris sous la Restauration* (Paris: Hachette, 1913), p. 46.

As the letter and other evidence indicate, Delacroix knew the story of Faust both from Stapfer's adaptation and from the 1827 translation by Gerard de Nerval.[9] It appears that he did not read German, so that his introduction to Goethe's play must have been indirect. The *Journal* entry for February 20, 1825, mentions the set of twelve engravings that the German artist Peter von Cornelius published in 1816, which alerted him to the possibilities of "an altogether new kind of painting."[10] His letter to Burty refers to another larger set of twenty-six small line engravings by a commercial illustrator named Moritz von Retzsch. Delacroix recalled first chancing upon them "around 1821,"[11] and he was thus aware of precedents for his own edition.

He was dissatisfied with the series of *Faust* lithographs and complained at length about it to Burty. "You recall that Motte was the publisher," he wrote.

He had the unhappy idea of issuing those lithographs with a text that greatly hurt sales, not to mention the strangeness of the plates themselves, which were the object of caricature and which set me up more and more as one of the heads of the *school of the ugly*. . . . I don't recall what I got out of it: something like a hundred francs or so and an engraving after Lawrence—the portrait of Pius VII. All my speculations have been like that, the Hamlet even more so. I had it printed at my own expense and published it myself. The entire business cost me five or six hundred francs, of which I recovered something like half. The *Medals* (the proofs of which I have found for you) were shown at the dealers, but nobody wanted them.[12]

In fairness to Delacroix's collaborators, it should be pointed out that his memory served them badly. Letters written to Motte indicate that Delacroix received more money than he later was willing to admit. They also show that despite the fact that Motte was the father-in-law of Delacroix's friend Achille Devéria, who contributed the frontispiece and an advertising poster, Delacroix drove a hard bargain.[13] He was quite capable of being unfair to others when his interests were involved. His demands for money were harsh, and he made no secret of his need for it: "I am very sorry to dwell so persistently upon the subject of my last letter [requesting money]. Not having received a reply, I have had to count on it all the more, and I will be in great difficulties if you cannot do me this service in this emergency."[14] Although Motte's reply to this abrupt demand has not been preserved, something of his reaction to business dealings with Delacroix may be inferred from the fact that he never acted upon Delacroix's offer, made the preceding year,[15] to execute a series of *The Giaour* at two hundred francs a plate. The one completed scene gives a hint of what might have been another informative series.

Delacroix must have been encouraged by reports of Goethe's favorable reaction to the first samples of his work, which M. Courdray brought him from Paris late in 1826. Eckermann mentions that on November 29 of that year Goethe showed him two of the prints, *Faust and Mephistopheles on Walpurgisnacht* and *Faust and Mephistopheles in Auerbach's Wine Cellar*, both of which they admired: "'M. Delacroix,' said Goethe, 'is a man of great talent, who found in *Faust* his proper aliment. The French censure his wildness, but it suits him well here. He will, I hope, go through all *Faust*, and I anticipate a special pleasure from the witches' kitchen and the scene on the Brocken. We can see he has a good knowledge of life, for which a city like Paris has given him the best opportunity. . . . I must confess that M. Delacroix has in some scenes surpassed my own notions.'"[16]

9. Nerval's prose translation led directly to Berlioz's composition of his *Eight Scenes from Faust*, which was completed in the fall of 1828. *The Damnation of Faust* is a later reworking of this early inspiration (see Berlioz, *Memoirs*, [New York: Knopf, 1935], p. 97).

10. *J*, 1:52. Joubin's publication date of 1810 for the series would appear erroneous (see K. Andrews, *The Nazarenes* [Oxford: Clarendon Press, 1964], pp. 31–32).

11. Retzsch's illustrations were first published in Leipzig in 1816 and appeared in a London edition in 1821.

12. *C*, 4:304 (Mar. 1, 1862). It is clear that one of his motives in undertaking the series was the profit they promised: "There is a fortune to be made with aquatints [*aquatinta*]," he wrote to Soulier (*C*, 1:179 [Apr. 21, 1826]).

13. See *C*, 1:201–3, 208–9, 219–20; Gauthier, *Achille et Eugène Devéria*, pp. 55–62.

14. *C*, 1:219–20 (July 2, 1828); originally published in Gauthier, *Achille et Eugène Devéria*, pp. 61–62.

15. See *C*, 1:203 (Nov. 13, 1827).

16. Johann Peter Eckermann, *Conversations with Goethe*, ed. J. K. Moorhead, trans. John Oxenford, Everyman ed. (New York: Dutton, [1930]), pp. 135–36.

17. See R. Benz, *Goethe und die romantische Kunst* (Munich: Piper, 1940), pp. 182–84. The text included is an excerpt from *Über Kunst und Altertum*, vol. 6, pt. 2, pp. 387ff. (1827): "*Faust, Tragédie de Mr. De Goethe*, traduite par Mr. Stapfer, ornée de XVII [*sic*] dessins par Mr. De Lacroix." That Delacroix was aware of Goethe's esteem is further indicated in his reference to this notice in a letter to Thoré (*C*, 1:407–8 [Jan. 18, 1836]).

18. *C*, 4:303 (to Burty, Mar. 1, 1862).

19. See Maingot, *Le Baron Taylor*.

20. *C*, 1:200–1, and Gauthier, *Achille et Eugène Devéria*, p. 59.

21. "Et je me garde bien de lui rompre en visière" (Goethe).

It seems that some time in 1827 Goethe acquired an almost complete set of plates. In a review of the new French edition, he discussed them and was again generous in his praise: "Delacroix seems to have felt at home here," he wrote, "as though on familiar ground, in a strange fusion of heaven and earth, the possible and the impossible, between the coarsest and the most delicate."[17] Less generous is a comment made later by Delacroix about the second part of *Faust*: "I was not acquainted with the *Second Faust*, and still knew it only superficially long after my plates were made. It seemed to me badly digested and not very interesting from the literary point of view, yet one of those works that are most appropriate to inspire painters by the mixture of characters and styles they permit."[18]

There is a strong possibility that Delacroix recognized in the story an opportunity for exploring the kind of fantasy he admired in Goya's art, along with medieval costumes and settings. The new interest in the Middle Ages was reflected in a flood of illustrated travel books, most important of which were the large volumes issued under the direction of Baron Taylor, *Voyages pittoresques et romantiques dans l'ancienne France*.[19] The series, which came to fill twenty-four volumes, contained more than 2,700 illustrations, including works by the finest landscape artists of the time, Bonington and Isabey among them. The volume on Normandy, containing many views by Bonington, appeared in 1825, and Delacroix may have found Taylor useful for some of his own "picturesque" settings. Their further implications for Delacroix's ventures into history painting will be examined in other contexts.

Although there are discernible differences among the individual plates of the *Faust* series, it seems most profitable here to consider them in the order of the narrative rather than in some presumed order of execution. The frontispiece portrait of Goethe is not an intimate part of the suite. There had been considerable dissatisfaction with it, and Delacroix's sour memory of the project may, in fact, largely reflect the misunderstandings that arose over its completion. A letter of October, 1827, written to Charles Motte, indicates the unpleasantness of the situation:

I am distressed at the delay of the portrait [of Goethe]. But it inconveniences me terribly to do it. I by no means have the necessary time. I have to complete my picture [*Sardanapalus*], make two moves [of his lodgings and of his studio], and for some time to come will be very busy. It seems to me that if absolutely necessary the medal could count for a portrait. If you wish to wait I will be at your disposal, but it pains me greatly to see the publication of a work that has already dragged on for the past two years further delayed. It is not impossible to say in a note that we are satisfied with including the medal and an extra plate. Take my word, the subscribers will gain by it, for I am obliged to recognize my own inability to make lithographic portraits, which always demand a certain degree of finish.[20]

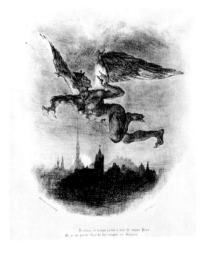

FIGURE 72. *Mephistopheles Flying over a City*. 1826–27. Lithograph. 0.27 × 0.23. Collection of the author. Photo Donald Witkoski.

The first illustrative plate is a vignette, *Mephistopheles Flying over a City*, which bears the inscription, "I like to see the Old Father from time to time, / And I take good care not to cross swords with him."[21] Although the technique, with its predominance of rich darks, suggests a relationship to his 1825 lithograph *Macbeth and the Witches*, the drawing of the demon is surer and the form more plastic here. His powerful figure successfully conveys a sense of movement, as though he is swimming in the air. The figure type and the pose—particularly the compression of the left leg—recall the spirits in *Dante and Virgil*, with their

FIGURE 73. *Faust in His Study.* 1826–27.
Oil on canvas. 0.46 × 0.38. The Wallace Collection, London.
Photo the Wallace Collection.

heavy musculature and uncomfortable torsion. Yet there is a fresh note in the predatory expression of Mephisto as he hovers over a sleeping medieval city, its sharp spires and jagged rooftops silhouetted against a large moon on the horizon.[22]

Different structurally, and to some degree technically as well, are the second and fifth plates of the series, *Faust in His Study* and *Mephistopheles Appearing to Faust*. Similarities to Bonington are observable both here and in a comparable painting of the latter subject, now in the Wallace Collection. These compositions

22. A spirited pen-and-ink sketch of this subject showing the figure in reverse, now on anonymous loan to Harvard University, is not this elaborate but does show clear affinities of style with some of the studies for *Sardanapalus*. Many other studies for the *Faust* series that are known to have existed have disappeared (see Hofer, *Delacroix's Faust*, Introduction). It is of interest to note the anticipation of this motif of the flying Mephistopheles in the winged demons of Delacroix's early cartoon, *Moving House*.

FIGURE 74. Richard Parkes Bonington. *Henry III and the English Ambassador.*
Royal Academy exhibition, 1828. Oil on canvas. 0.55 × 0.66.
The Wallace Collection, London. Photo The Wallace Collection.

closely recall a lithograph Delacroix made as a kind of practice piece in 1826
after a Bonington water color, *The Message.* The arrangement of the room as a
dark, shallow stage, with the action of the figures boldly set in the foreground,
is typical of Bonington's "fancy pictures." The high shelf of books and other
oddments strewn about and the heavy furniture and draped tables recur in other
interiors, as in the seventh plate, *Mephistopheles Receiving the Student,* and the
later episodes, *Mephistopheles Introducing Himself to Martha* and *Marguerite at the
Spinning Wheel.* What is different here is the underlying character of Delacroix's
expression. There is an uneasy quality to these scenes, unlike the innocuous,
casual little moments of Bonington. Where Bonington stresses easy and natural
pose and fluid movement, Delacroix's figures tend to assume awkward, almost

FIGURE 75. *Mephistopheles Introducing Himself to Martha.*
1826–27. Lithograph. 0.24 × 0.20. Amherst College. Photo Donald Witkoski.

FIGURE 76. *Marguerite at Church*. 1826–27.
Lithograph. 0.26 × 0.22. Collection Lessing J. Rosenwald,
Jenkintown, Pa. Photo National Gallery of Art.

FIGURE 77. *Auerbach's Wine Cellar*. 1826–27.
Lithograph. 0.27 × 0.22. Collection Lessing J. Rosenwald,
Jenkintown, Pa. Photo National Gallery of Art.

23. *C*, 1:202 (to Motte, Nov. 1, 1827).

24. As early as 1824 Delacroix was interested in such subjects: "I have taken a fancy to do some lithographs of animals—tigers, for example, on the carcass of a dead beast, vultures, and so on" (*J*, 1:76 [Apr. 12, 1824]).

25. Delacroix copied some of Goya's subjects early in his career. At the time of his first serious interest in lithography he again referred to Goya: "In the evening, Leblond. Tried some lithography. Superb projects along that line. Caricatures [*charges*] like Goya's" (*J*, 1:69 [Apr. 7, 1824]). An unfinished aquatint of 1819, *Interior Scene* (Delteil 7), already shows his debt to Goya.

puppet-like postures, which sometimes make their actions and, by implication, their attitudes, ambiguous.

The extent to which these plates were regarded as experimental may be seen in the marginalia of some of the stones, much like the annotations on Delacroix's copy of Bonington's *Message*. The little drawings around the edges of *Duel between Faust and Valentine* relate more or less directly to the episode at hand, but the drawings of wild beasts and combatants in the margins of *Mephistopheles Introducing Himself to Martha* have surprisingly little relation to the print in style, technique, and subject matter. To judge by Delacroix's reference to "small pen drawings made along the margins" of one of his plates,[23] one may safely assume that they were made in late 1827. If so, they represent the first signs of Delacroix's fascination with wild animals.[24] Although these small "Goyesques"[25] were not for inclusion in the published lithograph, Delacroix's concern that they be preserved in the last proofs may indicate his wish to simulate spontaneity.

One of the accomplishments of the *Faust* series is that it captures some of the variety, the shifts of pace, and the contradictions of the play itself. *Marguerite at Church* or *Mephistopheles Appearing to Faust* convey a fine sense of the powerful presence of Mephisto. *Faust and Wagner*, on the other hand, is more reserved, in keeping with its less violent subject. A drawing in wash, now in the Louvre (R.F. 9 234), gives, if anything, a livelier picture, particularly in its strong contrast between the animated, eager Wagner and the sly, cynical withdrawal suggested in the face of Faust. Other plates, like *Faust Accosting Marguerite in the Street* or *Auerbach's Wine Cellar*, exhibit animation, if not strict consistency in controlling

the figures. Yet in the adventure at Auerbach's the statuesque withdrawal of Faust (bearing here a curious resemblance to the Ghost in the future *Hamlet* series) and Mephisto's jaunty, dandyish air neatly contrast with the confusion and alarm of the four students over Mephisto's trick of turning spilt wine into hell fire. For Faust this episode was not only a symbol of fleeting youth but a vision of man reduced to bestiality.[26]

The seduction scene has somewhat the same feeling of moral revulsion. The sinister implications of the action are belied, superficially, by the courtly elegance of the figures, which recalls both the mannerism of the troubadour style and the Gothic sway of Delacroix's later drawings of the sculptures of Strasbourg Cathedral. But in the lurking family resemblance of the profiles the artist indicates that all share a common evil. An entry in the *Journal* may be illuminating here: "I saw myself in the mirror, and I was almost frightened by the wickedness of my features. Yet this is the man who must carry in my soul a deadly torch, which, like the candles for the dead, shines only upon the funeral of the remains of the sublime."[27]

It must be admitted that these plates are of uneven quality. When Faust, fleeing from the scene of Valentine's murder, realizes that Mephisto has completely ensnarled him in his schemes, we can see that his discovery has dazed him and made him older. In *Marguerite at Church* Mephisto has paralyzed her will and movement. Limp and pallid, she retreats from him, while the rest of the congregation, who can still turn to a consoling priest, are unaware of his presence. Here Delacroix has caught the "blackness" of the stage version. However, others are not so successful. *Mephistopheles Receiving the Student* is stiff and perfunctory when compared with the wash drawing of the same subject.[28] So too is *Faust, Wagner, and the Black Poodle*, where Mephisto, disguised as a dog, makes his first visit to Faust. There is also a strange discontinuity between this scene and the next: moments after his first appearance, Wagner reappears as an altogether new type, beardless and in different clothes. Plate fifteen, the scene in the Harz Mountains with Faust and Mephisto on their way to the Witches' Sabbath, may have its advocates, but it seems technically sloppy and superficial in characterization when compared with some of the other illustrations in the series. *Faust Seeing an Apparition of Marguerite* is similarly uninspired, as though, as with the portrait of Goethe, Delacroix approached the task perfunctorily, without interest or conviction.

Delacroix was never fully at home in a world of grotesques and phantasms, as he himself admitted. In later years he referred to the "sense of the mysterious" with which he used to be concerned and which he "threw off by working *in situ*, allegorical subjects, etc."[29] It may be for this reason that he avoided the subject of the Witches' Kitchen, in which Faust drinks the elixir that gives him youth, even though the episode is peculiar to Goethe's adaptation of the old legend, important to the plot, and one which the poet expressed a wish to see done. Delacroix's closest approach to the subject, *Macbeth and the Witches*, is not an outstanding success. *Faust Seeing an Apparition of Marguerite* is not altogether convincing as an illustration of the narrative, nor is it technically unified, but it does manage to capture something of Faust's magnification of one woman into the image of all women, the "distant beloved" more real as a symbol or a vision than as a living person.

26. The present commentary makes no pretense at literary interpretation beyond the immediate context of the illustrations. Some of the comments on the symbolic meanings of Goethe's play are indebted to Stuart Atkins, *Goethe's Faust. A Literary Analysis* (Cambridge, Mass.: Harvard University Press, 1958).

27. *J*, 1:107 (June 1, 1824).

28. This plate seems to have been lost or broken, since the later editions contain a copy. The copy is drier and very much inferior, but even the original plate is not of especially high quality (see Delteil 63 and 63B). The preparatory drawing is reproduced in Hofer, *Delacroix's Faust*, plate 3.

29. *J*, 2:450 (May 30, 1856).

FIGURE 78. *Faust Seeing an Apparition of Marguerite*. 1826–27.
Lithograph. 0.35 × 0.26. Collection Lessing J. Rosenwald, Jenkintown, Pa.
Photo National Gallery of Art.

30. *J*, 1:56 (Mar. 1, 1824).

31. A vigorous study for this composition, now in the Boymans van Beuningen Museum at Rotterdam, shows a notably different characterization of the event. As the riders approach the grim scene, Faust and his horse both shy back in alarm, while Mephisto and his black horse press on without noticing their surroundings. In the lithograph the relationship of the riders has been reversed, and they have left the gallows behind.

That this aspect of the play may have had particular meaning for Delacroix is suggested in a melancholy section of the early *Journal*—by no means the only such passage—in which he tells of rereading old letters one lonely evening. He quotes from a letter he wrote to a schoolboy friend whom he had not seen for a long time, fragments of which may here apply: "The human heart is a wretched pigsty: I am not to blame. But who dares answer for himself? Write to me, make my heart recapture certain emotions of youth [Delacroix was then twenty-five years old] which come no more. Even if it would only be an illusion, it would still be a pleasure. Farewell, etc." He then adds that he had, that evening, also reread letters from Elizabeth Salter: "A strange impression, after so long a time."[30]

It is curious that Delacroix, a romantic watcher of the night, did not have more feeling for the visionary, the free play of nocturnal fantasy required by Goethe's ghostly apparitions. With his affinity for the human and the physical, he was most successful in such plates as *Faust and Mephistopheles on Walpurgisnacht*, in which the two are astride great galloping steeds speeding past a shadowy gallows on the way to Marguerite's cell. The mortal Faust clings desperately to his mount, his hat and hair caught by the wind; his escort sits bolt upright, chatting effortlessly, as they ride through the night.[31] A sardonic demon watches at the lower left. The last plate, *Faust with Marguerite in Prison*, represents the denouement of *Faust*,

FIGURE 79. *Faust and Mephistopheles on Walpurgisnacht.* 1826–27.
Lithograph. 0.28 × 0.21. Collection Lessing J. Rosenwald, Jenkintown, Pa.
Photo National Gallery of Art.

FIGURE 80. Sketch for *Faust and Mephistopheles on Walpurgisnacht.* 1826–27.
Pencil. 0.23 × 0.29. Cabinet des Dessins, Louvre. Photo S.D.P.

Part I. The maddened girl, looking like one of Goya's court puppets, refuses first to recognize, then to accompany, her lover. As Mephisto urges him away frantically, Faust stands baffled, a symbol of the human condition, caught between a regretted past and an uncertain future.

Of the two other sets of *Faust* illustrations mentioned, that of Moritz von Retzsch, which, curiously enough, Goethe himself preferred, seems to have been the first that Delacroix encountered. However, it was not the source of his enthusiasm for *Faust*. Although there are some corresponding elements—a vague similarity between the relative positions of Faust and Mephisto in Delacroix's scene of the arrival of Mephisto and Retzsch's plate of Faust signing the contract—the resemblance is general enough to be accidental. Other similarities, such as the still-life elements included in the interior scenes, could well have been invented independently or derived elsewhere. Only the scene of the Brocken in the Harz Mountains, the *Walpurgisnacht*, shows more than a passing resemblance in pose and composition. While Delacroix may have consulted Retzsch's engravings, it is remarkable that, given his penchant for borrowing compositions and motifs, there is so little in common between the two series, and in technique and artistic merit they are worlds apart.

FIGURE 81. Moritz von Retzsch. *Walpurgisnacht*. Published 1816. Engraving. 0.11 × 0.18. Department of Printing and Graphic Arts, The Houghton Library, Harvard University. Photo The Houghton Library.

As for the other possible direct graphic sources, the smaller set of illustrations issued by Cornelius, then a member of the Nazarene group, there is no stylistic link between the harsh and archaic elaboration of Cornelius' pale engravings and the more extended, "coloristic" tonalities of Delacroix. Yet there are sufficient similar details in at least three of Delacroix's prints to suggest that he did study Cornelius' work with some attention. In Cornelius' sixth plate the figures of Mephistopheles and Martha in the garden bear some resemblance in attitudes and costumes to Faust and Marguerite in *Faust Accosting Marguerite in the Street*. In *Marguerite at Church* the similarity is too great to be accidental, and there appears to be a similarity between the two Mephistos and perhaps between the two priests as well. The differences are more striking, however. Delacroix has avoided such distractions as Cornelius' happy, pious young mother and her children, concentrating the spectator's attention directly on the drama of Mephisto, gesturing toward heaven and menacing the shrinking Marguerite. Cornelius' reference to Mephisto's cloven hoof and other literal touches fail to equal the effect of Delacroix's spare and gloomy church interior.

The next to last plates in both series show the two riders on their way from the *Walpurgisnacht* to Marguerite's prison cell, where the final scene takes place. Nowhere is there a clearer demonstration of the technical and artistic distinctions between Cornelius' neoclassical avoidance of color and intricate surface modeling and the more summary, atmospheric handling Delacroix preferred. There is no denying a certain power in the massive spring of Cornelius' heavy animals and their sharply differentiated riders, and there are strong similarities in the general arrangement of the composition and in the pose and horse of the two Mephistos, but the result is strikingly different. What is, in the end, remarkable is the degree to which Delacroix's lithographs stand apart from their probable antecedents, except for these limited correspondences.

Two further questions must be entertained, if only briefly: first, what is the development of the compositions *as a series*, and second, what special personal significance, if any, do they seem to imply? The narrative emphasis is indicated by the scenes omitted. The early part of the series stresses Faust's isolation, in his study or with his friend Wagner, and Delacroix repeatedly expresses this preoccupation in his *Journal*: "I must go back to being alone. Moreover I must try to live austerely as Plato did. . . . However pleasant it may be to communicate one's emotion to a friend, there are too many fine shades of feeling to be explained." "Loneliness is the torment of my soul," he wrote a few months later. Another entry reads: "I wish I could identify my soul with that of another person. . . . Nature has put a barrier between the soul of my greatest friend and myself."[32]

In the opening plates, *Mephistopheles Flying over a City* and *Mephistopheles Appearing to Faust*, Delacroix introduces another important element, that of temptation. Mephisto questions the truth of Faust's beliefs and the satisfactions of his accomplishments, for which he had paid the price of isolation. Delacroix's own desire to possess, to create, to excel, is relevant here: "All my days lead to the same conclusion; an infinite longing for something which I can never have, a void which I cannot fill, an intense desire to create by every means and to struggle as far as possible against the flight of time and the distractions that deaden my soul." Life's preoccupations are fleeting and immaterial, however beguiling for the moment: "Everything tells me that I need to live a more solitary life. The

32. J, W, pp. 27 (Mar. 31, 1824), 40 (May 14, 1824, written May 15), 34 (Apr. 26, 1824).

FIGURE 82. F. Ruschewey after Peter von Cornelius. *Marguerite at Church.* Ca. 1816. Engraving. 0.46 × 0.57. Yale University. Photo Yale University.

FIGURE 83. F. Ruschewey after Peter von Cornelius. *Faust and Mephistopheles on Walpurgisnacht.* Ca. 1816. Engraving. 0.40 × 0.52. Yale University. Photo Yale University.

loveliest and most precious moments of my life are slipping away in amusements which, in truth, bring me nothing but boredom." "What are most real to me," he wrote, "are the illusions I create with my painting. The rest is shifting sand."[33] Yet it is clear that Delacroix did have a real need for society and was an active participant in the pleasures of table and bed. Prosper Mérimée's account of Delacroix's performance with the girls at Leriche's[34] makes the scene at Auerbach's tavern seem like a church supper by comparison, and there are many references in the letters and the *Journal* to seductions.[35]

Some of the remaining subjects, which concern sin, repentance, or mystical vision, are more difficult to associate directly with Delacroix's life and attitudes. It should be noted that, in contrast with Retzsch, Delacroix excludes the more idyllic aspects of Goethe's plot. His emphasis on contrition, not pleasure, is almost Puritan. It is also clear that Mephisto, not Faust, was in some ways the sustaining force in Delacroix's version of the narrative. He personifies the motive power that Delacroix had come to regard as a fundamental attribute of genius, in this case, of evil genius.

As Goethe wryly observed, Delacroix learned something of life in Paris, and despite the technical and formal shortcomings of individual plates, the series as a whole has unity and power. He somehow manages to suggest those brilliant enigmas, those startling and dramatic contradictions, that make Goethe's play an appealing but elusive masterpiece.

Goethe's writings continued to provide subjects for Delacroix. He painted Marguerite at church and the death of Valentine, and, although he did not undertake another complete set of illustrations of a work by Goethe, in 1843 he issued a series of seven lithographs based on *Goetz von Berlichingen*, which he began in 1836. In 1850 he did two canvases of episodes from the story of Goetz. While in many ways more sophisticated technically than some of the *Faust* illustrations, the basic manner and motifs of the *Goetz* series are sufficiently similar to make extended discussion here unnecessary.[36] One of the most successful, *Goetz Writing His Memoirs* (Act IV, scene v), again uses the shallow stage of *Faust in His Study* and includes hanging armor that is no doubt the product of his earlier sketches of Meyrick's collection. Here and in *Weislingen Captured by Goetz's Men* (Act I, scene iii), to choose a different subject, the range of contrast between strong whites and rich blacks and the rather sharp detail and careful execution indicate an earlier date. (In 1853 Delacroix returned to the scene of Weislingen's capture in a painting now in the City Art Museum in St. Louis.) In the later plates, such as *Weislingen Dying* (Act V, scene x), the prevailing tone is grayer and the scale of execution broader, and there is a more obvious retention of the mark of the crayon. This shift in style and technique is characteristic of Delacroix's other graphic works, but it may perhaps be more profitably surveyed in a larger group of works, the series illustrating *Hamlet*, begun in 1834 and completed in 1843, the year in which the *Goetz* suite was published.

Delécluze was not altogether wrong to call Delacroix's generation "the Shakespeareans."[37] Perhaps no other author had so profound an impact upon them during the latter days of the Restoration. In 1821 Guizot published his new translations of Shakespeare and boldly stated in his Preface that the old systems of tragedy were insufficient for a generation that had gone through the torment of revolution. The Shakespearean drama alone "could furnish the plans after which

33. *J*, W, pp. 34 (Apr. 26, 1824), 27 (Apr. 4, 1824); *J*, P, p. 64 (Feb. 27, 1824).

34. See *Correspondance générale*, ed. Parturier, 1:122 (to Stendhal, Sept. 14, 1831).

35. See, for example, *J*, 1:1–5 (Sept. 3 and 5, 1822).

36. For a more extensive discussion of this series, see G. Rouches, "La suite lithographique de Eugène Delacroix pour 'Goetz de Berlichingen,'" *L'Amateur des estampes*, 6 (1927):33–42.

37. See his *Journal*, p. 482 (Nov. 6, 1827).

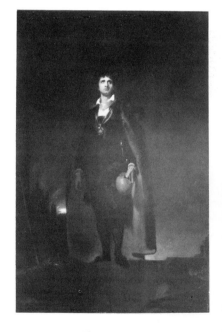

FIGURE 84. Sir Thomas Lawrence. *Sir Philip Kemble as Hamlet*. Ca. 1801. Oil on canvas. 2.38 × 1.98. The Tate Gallery, London. Photo The Tate Gallery.

38. Quoted in Borgerhoff, *Le théâtre anglais*, p. 29.

39. The play also inspired an oil, *Lady Macbeth Sleep-Walking*, painted in 1850.

40. Hamilton ("Delacroix and Byron: II," pp. 365–86) discusses at length some of these problems of dating and identification See also Huyghe, *Delacroix*, p. 520, n. 16.

41. The French attitude is brilliantly summarized in F. P. G. Guizot's Preface to *Shakespeare and His Times* (New York: Harpers, 1855) (this work was written in 1852, more than thirty years after Guizot presented his original translations of Shakespeare).

42. "Delacroix and Byron: II," p. 378. *Hamlet* had been presented since 1803, but only about three times a year. It was played fifteen times at the Comédie Française and once at the Odéon in 1822–1824 (*ibid.*, pp. 377–78). Talma himself, however, knew English and, according to Stendhal, had often read *Hamlet* in English even before his performance of the Ducis text (see G. Strickland, ed., *Selected Journalism from the English Reviews by Stendhal with Translations of Other Critical Writings* [London: Calder, 1959], pp. 134–45).

43. Borgerhoff, *Le théâtre anglais*, p. 1. This and other information on these early Restoration productions of "translated and adapted" Shakespeare derives from Borgerhoff.

genius could work."[38] In January of the following year Stendhal published the first two chapters of *Racine et Shakespeare*. To a certain extent, Stendhal's artistic preferences were generationally as well as culturally conditioned. Delacroix, for example, never found the power in Racine that he did in Shakespeare, who maintained a hold on his imagination throughout his life. In 1859 he painted a somber death of Ophelia, did a version of Hamlet and the body of Polonius, and completed the last of his several renditions of Hamlet and Horatio in the graveyard. By that time his first scenes from *Hamlet* were more than thirty years old.

It is somewhat strange that Shakespeare's influence did not fully assert itself in Delacroix's work until the 1830's, when he undertook his *Hamlet* series. Isolated early works, such as the lithographs *Macbeth and the Witches* (1825)[39] and *Hamlet and Horatio in the Graveyard* (1828) may unquestionably be associated with Shakespeare. His small self-portrait, painted about 1821, which is sometimes taken to represent him as Hamlet, is uncertain both as to date and costume, and even if it be considered somehow "Shakespearean," it would be another minor exception.[40] Delécluze's pointed identification of Delacroix with Shakespeare was a bit premature and may be regarded as a disparaging generalization intended to link the two names with the new "school of the ugly."

For those of an earlier generation dedicated, as Delécluze was, to a rationalist and skeptical tradition, to the classical virtues and staunch artistic nationalism, the appearance of Shakespeare's plays represented the decay of older and better ways. His works were not unknown in Paris before 1827, but until the reopening of France's cultural frontiers during the Restoration, there had been no opportunity to see his plays performed. Some Frenchmen knew the original texts (Delécluze himself read English fluently), but the plays lacked the traditional unities of the French classical stage and were generally regarded as coarse and barbarous. Such adaptations as were made were not faithful to the originals; in fact, no other playwright suffered as much at French hands.[41] The development of a popular appreciation of Shakespeare was slow. In the early years of the century French actors, Talma among them, occasionally performed the plays from texts whose inadequacies their audiences could not have realized. The plot of *Hamlet*, for example, barely survived in the standard adaptation, by Ducis, which was used until 1847, when it was replaced by that of Dumas and Meurice. Hamilton summarizes the changes:

As for the character of the play itself, this is *Hamlet* quite literally without the Ghost. He, poor soul, had to be banished from the stage when Shakespeare's drama was cut to fit the standards of French tragedy. Hamlet is king, not prince, of Denmark. Claudius is not the elder Hamlet's brother, but an ambitious relative and the father of Ophelia[,] who does not run mad. Laertes is omitted and Horatio is rechristened Norceste, while Hamlet survives the deaths of Claudius and Gertrude with the sage remark: "*Je fais plus que mourir.*"[42]

In view of Delacroix's early admiration for Talma and the actor's fame as Hamlet, it is likely that, if he had not read it until then, he would have come to know the Ducis version through his contact with Talma, which began in 1821, when he was commissioned to paint decorations for the actor's dining room. It may also be that he encountered Hamlet and other Shakespearean characters in some other form. In 1816 Hamlet was presented as a "tragic pantomime in three acts, combined with dances by Louis Henry and music by the Count of Gallenburg."[43] Other variations were similarly "free." In 1817 *The Visions of*

Macbeth, or the Scottish Sorceresses was given as a "spectacular melodrama." The following year saw *Othello* reduced to "pantomime interspersed with dialogue and dance."

The first, ill-fated company of English Shakespearean players arrived in Paris in July, 1822. Their efforts aroused latent Bonapartist sentiments and provoked hostility toward England, Shakespeare, and themselves. The opening performance of *Othello* was greeted by showers of debris, hissing, and shouts of "Down with Shakespeare! He's Wellington's lieutenant!" The players accordingly retreated from the Porte Saint-Martin theater to a smaller hall on Rue Chantereine, where they continued giving performances to subscribers only.[44] Delacroix was in Paris during part of their stay, but he does not mention the company in the *Journal*, which he began at Louroux on September 3 and continued after his return to Paris on September 22.

Interestingly enough, the company presented almost all the plays Delacroix later illustrated: *Hamlet, Macbeth, Othello, Romeo and Juliet, The Taming of the Shrew*, and *Richard III*, as well as *The School for Scandal* and Nicholas Rowe's *Jane Shore*, one scene of which Delacroix illustrated in a lithograph of 1828.[45] Only *Anthony and Cleopatra* was missing from the repertory.[46] Perhaps Delacroix later heard Stendhal, or perhaps Talma himself, talk of the performances. Both Talma and Mlle Mars applauded Miss Rosina Penley's Juliet;[47] Stendhal was less favorably impressed.[48]

Delacroix is known to have seen *Richard III*, which he was reading six years earlier, in London. He noted that in the London production the death of Henry VI had been substituted for that of "Gloster" at the opening of the play, an anomaly that may have inspired his later lithograph, *Young Clifford Finding the Corpse of His Father on the Battlefield*.[49] He also attended *The Tempest, The Merchant of Venice*, and *Othello*.[50] For all his admiration for Shakespeare's creations Iago and Othello and for Edmund Kean's performance of Othello, his knowledge of the plot seems to have been much colored by Rossini's opera, which he probably saw at the Théâtre des Italiens when it opened on June 5, 1821.[51] Although he continued to use Shakespeare's spelling of Gloucester's name, his scenes contain elements derived from the opera by Rossini's collaborator, Berio.[52] In much the same way, although he did not see *Romeo and Juliet* in play form until Kemble's troupe came to Paris in 1827, he was generally familiar with the characters and plot through Zingarelli's opera *Romeo e Giulietta*.[53]

There can be no doubt that he welcomed the arrival of Kemble's company and faithfully attended their performances. The fare presented was much the same as what he had encountered in London. Because of difficulties in getting organized and mustering a full cast, the season opened with *The Rivals* and *Fortune's Frolics* as substitutes for the Shakespearean pieces that were to be the staple of the season. By September 11 the full cast was finally assembled, and the main season began with *Hamlet*. In the following months *Romeo and Juliet, Othello, Macbeth, King Lear, Richard III*, and *The Merchant of Venice* were presented, along with other offerings such as *Jane Shore, She Stoops To Conquer*, and Otway's *Venice Preserved* (*Anthony and Cleopatra* was again omitted). This was also the first time that Delacroix is known to have seen *Hamlet*.[54] He described the arrival of the players at the Odéon in a letter to Soulier:

The English have opened their theater. They are working wonders that so fill the auditorium of the Odéon that the very pavingstones of the quarter shake under the

44. These events are recounted in more detail in *ibid.*, pp. 12ff., and by Stendhal in a letter to A. M. Stritch dated September 1, 1822 (see Marie Henri Beyle, *Correspondance* [1800–1842], ed. A. Paupe and P.-A. Cheramy, 3 vols. [Paris: Bosse, 1908], 2:255–60). A letter of September 7, 1822, adds some details (*ibid.*, pp. 261–63).

45. In 1824 Delacroix did a small oil on panel of an earlier scene in the play, *The Penance of Jane Shore*, perhaps based on a performance of Liadières' or Lemercier's versions of the plot, both of which were done in Paris that year (see Johnson, *Delacroix: An Exhibition*, pp. 19–20, 66, Nos. 12, 188).

46. The handsome canvas *Cleopatra*, painted in 1838, derives from Act V, scene ii, of Shakespeare's play. The painting, now in the William Hayes Ackland Memorial Art Center, Chapel Hill, N.C., is discussed by Joseph C. Sloane, "Delacroix's 'Cleopatra,'" *Art Quarterly*, 24, no. 2 (Summer, 1961):124–28. See also Johnson, *Delacroix: 1798–1863*, pp. 24–25.

47. Reported by Stendhal in a letter to A. M. Stritch, Sept. 1, 1822, quoted in Borgerhoff, *Le théâtre anglais*, p. 26. It should, however, be pointed out in this context that Delacroix appears to have been aware of *Romeo and Juliet* as a theme at this time: a pencil drawing of Romeo's farewell to Juliet is included in one of his sketchbooks, the contents of which are usually dated 1820–23 (Johnson, *Delacroix: An Exhibition*, p. 42, No. 77; see also *J*, 3:342).

48. See "Macready and Kean on the Parisian Stage," in Strickland, ed., *Selected Journalism*, pp. 146–47.

49. *C*, 1:162 (to Pierret, June 27, 1825).

50. See *C*, 1:166 (to Pierret, Aug. 1, 1825), 162–63 (June 27, 1825).

51. *L*, p. 133 (to Piron, June 4, 1821).

52. He attended a performance of Acts II and III, which contain all the four scenes he subsequently represented (*J*, 1:211 [Mar. 30, 1847]). See also Jean Cassou, *Delacroix* (Paris: Éditions du Dimanche, 1947), legend to Fig. 28; Johnson, *Delacroix: 1798–1863*, pp. 37–38.

53. See J, 1:22.

54. It is generally assumed that Delacroix did not see *Hamlet* in London, since one of his letters states that he had not managed to see the Young performance. However, he may have seen either that performance or one by a rival London troupe later that season (see C, 1:162 [June 27, 1825]).

55. C, 1:197 (Sept. 28, 1827). As might be expected, Delécluze's praise was qualified, and in many ways it may show greater insight, for he had read Shakespeare in English and had seen some of the plays in London. His criticisms are therefore those of a highly informed and fair, if conservative, contemporary observer. His *Journal* entry for September 16, 1827, contains a long and highly intelligent critique of the productions of *Hamlet* and *Romeo and Juliet* (*Journal*, pp. 452–66 *et passim*). Delécluze also contributed criticism to the *Journal des débats* and other publications.

56. Talma's costumes for Hamlet are discussed in Hamilton, "Delacroix and Byron: II," pp. 379–81.

57. Both Devéria and Louis Boulanger were habitués of Charles Nodier's *cénacle* at the Arsenal. The entire group was naturally drawn to the Kemble company's performances (Borgerhoff, *Le théâtre anglais*, pp. 178–80). For a convenient summary of the artists in Nodier's circle, see A. Marie, *Alfred et Tony Johannot* (Paris: Floury, 1925), pp. 21–28. The general type of costume and setting appearing in Delacroix's illustrations also appear in those of these other lesser figures of the time (see A. Marie, *Le peintre poète Louis Boulanger* [Paris: Floury, 1925]).

58. The phrase occurs in a letter to Guillemardet of October 4, 1828 (L, p. 151).

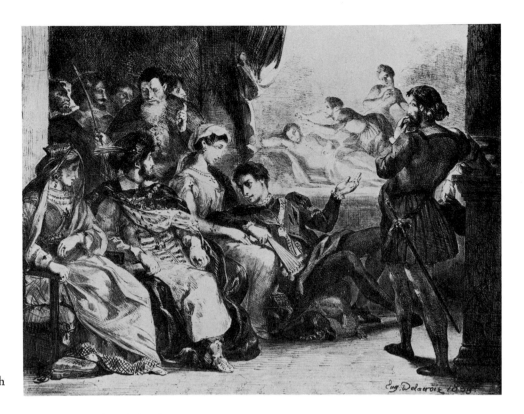

FIGURE 85. *Hamlet and the Players*. 1835.
Lithograph. 0.25 × 0.32. Collection Lessing J. Rosenwald, Jenkintown, Pa.
Photo National Gallery of Art.

carriage wheels. At last they are in style. The most obstinate classicists have struck their colors. Our actors are going to school and are opening their eyes wide. The consequences of this innovation are incalculable. There is a Mlle Smithson who has caused a furor in the part of Miss O'Neill. Charles Kemble has simplified his ways and has done more than one would have believed possible.[55]

Any influence of the stage on Delacroix's visualizations of Shakespeare was thus English and to some degree Italian, not French. From all that is known of Talma's style and performances, it is unlikely that he could have been directly influential. His Hamlet costume consisted of a long-sleeved tunic trimmed in mourning black, over which he usually wore a black mantle edged with fur,[56] in sharp contrast to the short black jacket of Delacroix's prince. Comparisons with the album of lithographs by Devéria and Boulanger representing the English theater in Paris[57] show that the costumes worn by Kemble's company were in the tradition initiated years before by David Garrick. The backgrounds in the album also closely resemble those employed by Delacroix. It therefore seems reasonably certain that in general appearance and "staging" Delacroix's treatments reflect what he saw of the English theatrical companies, whether in London or in Paris, and at the opera. Similarly, his plots derive from English, not French, dramatic notions, and his interpretative insights were those of "Shakespeare, the savage,"[58] not Racine.

Unlike the *Faust* illustrations, those for *Hamlet* were not all completed in a short time. Some of the plates were done as early as 1834; others are dated 1835; a final group bears the date 1843, the year in which thirteen of the sixteen plates in the series were finally published as a set. It was not until 1864, however, when Paul Meurice purchased the stones in the sale of Delacroix's studio effects, that a complete posthumous edition was issued, with *Hamlet and Ophelia*, *Ophelia's Song*, and *Hamlet and Laertes Struggling in Ophelia's Grave* included. It is not known why Delacroix chose to delete these three plates in the original edition, which he published at his own expense. He may have been dissatisfied with them, although they compare favorably with the rest, or he may have done so out of deference to French taste (Ducis had tactfully omitted Ophelia's suicide from his abridgement of the plot).

Delacroix is more faithful to the play in this series than he had been in the *Faust* illustrations. The first scene, *The Queen Consoling Hamlet*, and the next two, showing the attempt to restrain Hamlet from following the Ghost and his encounter with that specter on the terrace, have no counterpart in Ducis. There Hamlet, not Claudius, was king, and the Ghost was not permitted to appear. The fourth scene, where Hamlet feigns madness for the benefit of Polonius, is not in Ducis, where Polonius is omitted and Claudius is made Ophelia's father. The fifth plate, *Hamlet and Ophelia*, and the sixth, *Hamlet with Rosencrantz and Guildenstern*, might have reflected a French production, but not the seventh, *Hamlet and the Players* (the players were omitted in Ducis). In the French version Hamlet was not tempted to kill Claudius, as in Delacroix's eighth plate, and, of course, he did not kill and then expose Polonius, as in plates nine and eleven. The encounter between the Queen and her son would not have taken the form that it does in plate ten, nor would plates twelve and thirteen, *Ophelia's Song* and *Ophelia's Death*, have been included. The French adaptation eliminated the scene of Hamlet and Horatio in the graveyard, Delacroix's fourteenth illustration.[59] Laertes did not appear at all, and Hamlet survived the deaths of Gertrude and Claudius in the Ducis corruption of the plot; thus the last two plates, *Hamlet and Laertes Struggling in Ophelia's Grave* and *Hamlet's Death*, are also unrelated to Ducis.

It also seems clear that the badly cut Kemble version was not the only source for Delacroix's sequence. In the version used by the English players, the King and Queen were demoted to Duke and Duchess, perhaps to avoid offense to royalty in a country where royal heads lay uneasy. Perhaps there was as well some desire to eliminate the vulgar amusement that, according to Stendhal, some of the audiences of 1822 expressed at the pronunciation of the English word "queen."[60] The graveyard scene had only one gravedigger. The censor had proscribed talk of burying a suicide in hallowed ground, and the scene of Hamlet's death was therefore irrelevant. In Kemble's production the curtain fell at the words, "The rest is silence."[61]

There is, however, evidence that in some scenes Delacroix followed Kemble's production quite literally. Delécluze's description of the depiction of the Gonzagas' story could apply equally well to Delacroix's lithograph:

Reclining[62] . . . he holds Ophelia's fan, with which he contrives to conceal his observation of the effects produced by the actors' words upon the expressions of the King and Queen.[63] He turns alternately toward the players, to urge them on, toward the King, to penetrate his secret by surprise, and toward Ophelia, to make her attentive to everything that is going to happen. . . . Interest mounts. At the moment when on the little stage the poison is poured into the ear of the sleeping king, and King Claudius and his

59. What was substituted as a more classical device for demonstrating Gertrude's guilt was her inability to swear her innocence on the urn containing her father's ashes. This, Talma's most famous scene, was not included in Delacroix's series of lithographs.

60. See Beyle, *Correspondance*, 2:255–60 (to Stritch, Sept. 1, 1822). The French "*couenne*," literally "thick skin" or "rind," in popular usage meant "fathead."

61. Borgerhoff, *Le théâtre anglais*, pp. 56–71. All the plays were heavily cut to satisfy what were presumed to be French preferences and what was sometimes French law, and the results were usually disastrous to the dramatic meaning. Bad—and extensive—as they were, the *Hamlet* cuts were not the most damaging. Borgerhoff's summaries are based on texts of the plays published in Paris in 1827 and 1828 under the title *The British Theatre or a Collection of Plays Which Are Acted in Paris, Printed under Authority of the Managers from the Acting Copy*. An anonymous French translation appeared at the same time, "printed for Mme Vergne, Publisher, 1, Place de l'Odéon" (Borgerhoff, *Le théâtre anglais*, p. 59, n. 1). Borgerhoff assumes that the plays were performed as printed. The commentary in the *Journal* of Delécluze, which Borgerhoff does not cite, leaves a little room for doubt.

62. The original manuscript here includes a sketch of Hamlet's pose.

63. It may be noted that here Delécluze refers to the King and Queen, although the acting texts supposedly designated them as Duke and Duchess, which may reflect his knowledge of the original text.

wife are struck by the similarity between the crime and what they have themselves committed, Hamlet (Kemble) leans eagerly toward them; fixing them somehow in their seats, he cries with a fluent outburst of words that only the English tongue could produce: "He is poisoning him to gain his kingdom! His name is Gonzaga! The story is true; it is to be found in an Italian anthology. You are going to see next how the murderer gets the love of Gonzaga's wife! Ah! Ah! Bring on the music."[64]

64. Delécluze, *Journal*, pp. 455–56.

Delécluze's account of the impact of the scene on the audience, which included Charles Nodier, Hugo, Berlioz, and De Vigny, as well as Delacroix, is evidence that it was regarded as a high point in the play (Eugène Devéria's *Hamlet and the Players* is one of the finest plates in his own series on the English company). Delécluze describes the fourth scene of Act III, on which Delacroix based three of his plates, all of which were included in the original edition:

The fourth scene of the third act . . . where Hamlet has just found the Queen, his mother, in her closet, also appeared quite fine. The entire role of old Polonius seems ridiculous to the French. His death and Hamlet's exclamation in killing him: "A rat? Dead for a ducat, dead!" [given in English] which opens that great and beautiful scene are both entirely contrary to French taste. But when Hamlet forces his mother to look at the portraits of her first and second husbands, stressing the differences between them as he speaks with such power of the victim and the murderer, the applause resumed with renewed vigour.[65]

65. *Ibid.*, p. 457.

A final correspondence is the following scene:

Ophelia goes mad upon learning of the death of her father, killed by Hamlet. Miss Smithson, who was entrusted with this role, played the scene in which, deprived of

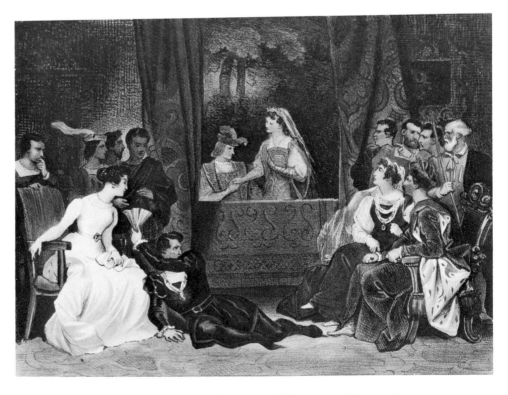

FIGURE 86. Eugène Devéria and Louis Boulanger in collaboration with Gaugain. *Hamlet and the Players.* 1827. Lithograph. 0.15 × 0.20. The Folger Shakespeare Library, Washington. Photo The Folger Shakespeare Library.

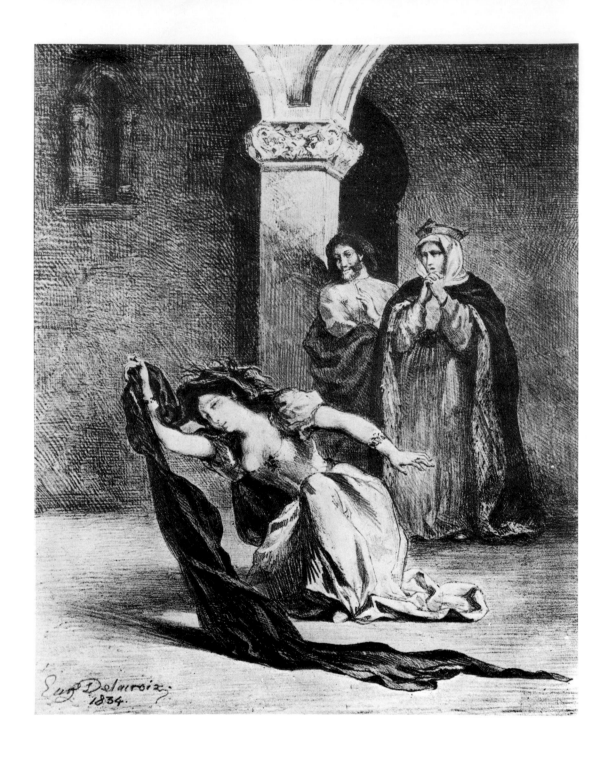

FIGURE 87. *Ophelia's Song.* 1834. Lithograph. 0.26 × 0.21.
Collection Lessing J. Rosenwald, Jenkintown, Pa. Photo National Gallery of Art.

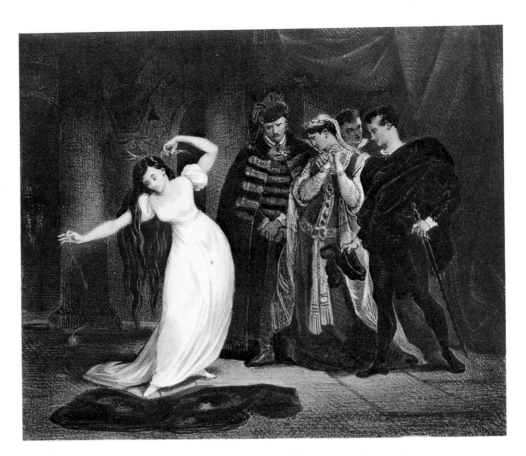

FIGURE 88. Eugène Devéria and Louis Boulanger in collaboration with Gaugain.
Ophelia's Song. 1827. Lithograph. 0.18 × 0.21.
The Folger Shakespeare Library, Washington. Photo The Folger Shakespeare Library.

reason, she mistook her veil for the body of her father with a grace matching her sense of truth. That whole passage, which seemed protracted, rather insignificant, and even exaggerated in the reading, made a considerable impact upon the stage, at least as we saw it played by Miss Smithson. The actress was showered with applause. What is most remarkable about her performance is the pantomime: she assumes fantastic postures; without ceasing to be natural, she captures the inflections of a dying voice to produce a tremendous effect.[66]

66. *Ibid.*, pp. 457–58.

While *Ophelia's Song* is skillfully handled, it is Ophelia who gives life to the interpretation. As in *Faust with Marguerite in Prison*, she has a strange resemblance to Goya's distraught women, particularly in the curiously spastic character of her movement.

Delacroix never returned to the subject of Ophelia's song, but he did rework his *Polonius Behind the Arras* and *Hamlet and the Corpse of Polonius* in oil paintings. In each instance the scene is handled broadly. It may be that Delacroix's arbitrary and unconvincing drawing of the Hamlet figure also led him to exaggerate the size of the victim in the latter scene. Since the contrast in scale is even more startling in the subsequent painting, here illustrated, it must be supposed that this was deliberate. Delacroix's lack of concern for consistency is also evident in the contradictions in Hamlet's costume and features in sequential moments within

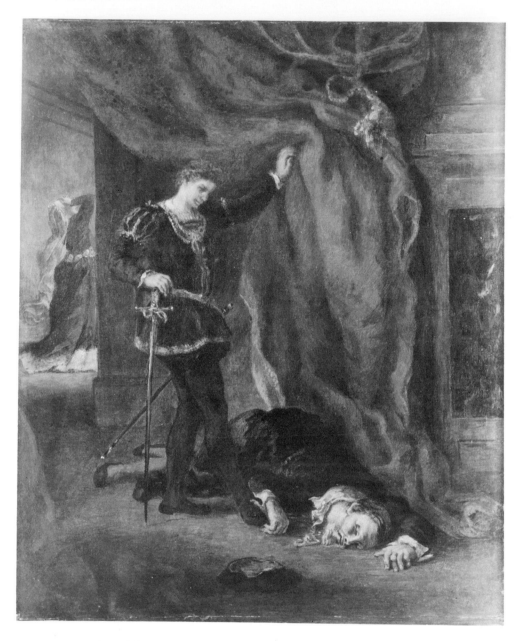

FIGURE 89. *Hamlet and the Corpse of Polonius.* 1854–55.
Oil on canvas. 0.58 × 0.48. Musée des Beaux-Arts, Rheims. Photo S.D.P.

one scene. That arbitrariness, which had asserted itself even less apologetically in the *Faust* series, remains typical of the artist's work. At times, as in the murder scene, the effect is awkward. The figure of Gertrude is more successful.

A number of plates in the series, such as the confrontation of Hamlet and Gertrude, betray a dryness of composition and a too obvious geometrical simplification of the figures, which probably represents a desire to make them dominate their environment, in emulation of the English productions. (One is reminded of Delécluze's observation that "the English actors are more isolated on the stage . . . so with less talent they can obtain a greater effect."[67] If this precept

67. *Ibid.*, pp. 467–68 (Sept. 18, 1827).

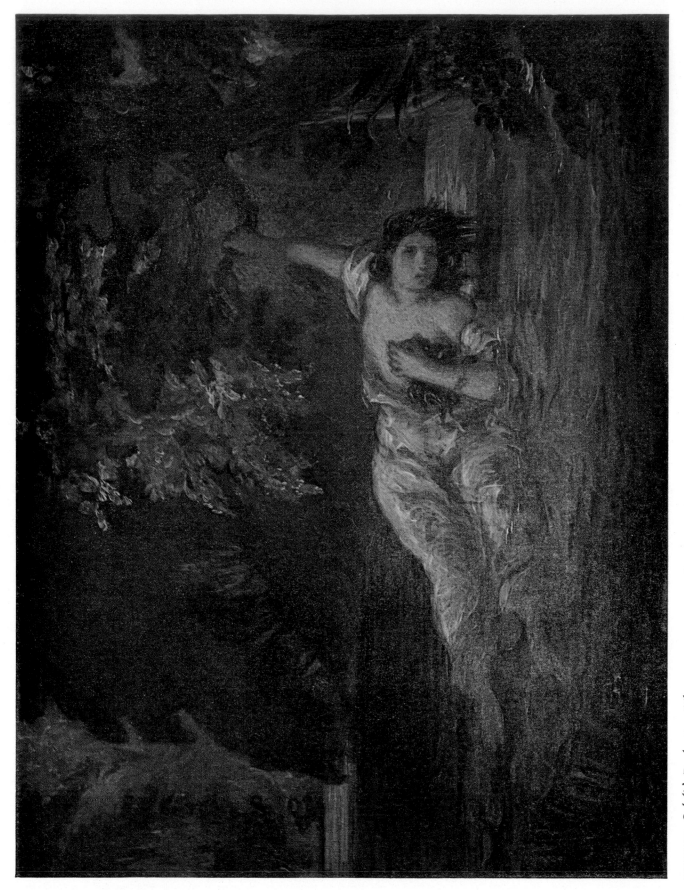

PLATE XVI. *Ophelia's Death*. 1853. Oil on canvas. 0.22 × 0.30. Louvre.

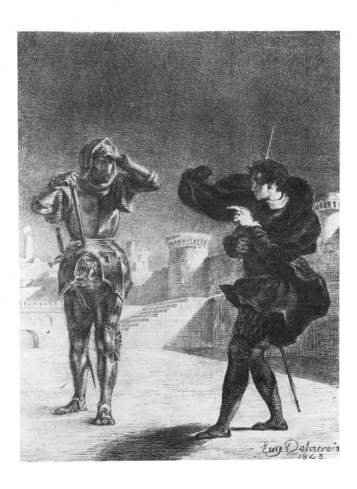

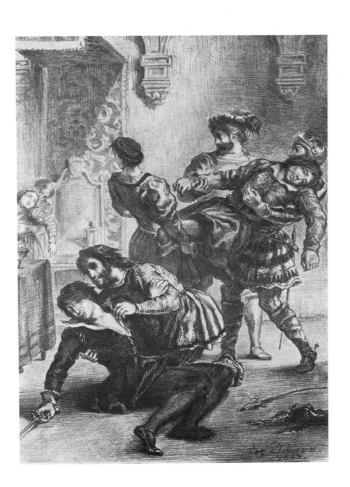

FIGURE 90. *Hamlet Confronting the Ghost.* 1843. Lithograph.
0.26 × 0.19. Collection Lessing J. Rosenwald, Jenkintown, Pa.
Photo National Gallery of Art.

FIGURE 91. *Hamlet's Death.* 1843. Lithograph. 0.29 × 0.20.
Collection Lessing J. Rosenwald, Jenkintown, Pa.
Photo National Gallery of Art.

applies, *Hamlet Confronting the Ghost* shows its successful application.) Although it is rich in descriptive interest, *Hamlet and the Players* is somewhat confusing in its insistently pedimental arrangement of the principals. In this respect, the last scene, *Hamlet's Death*, is more satisfying, despite a sometimes faltering grasp of structure in individual figures, especially Hamlet and Horatio. The general blocking of the composition is, however, consistent and readily understandable. The group bearing the dead Laertes may indicate another of Delacroix's borrowings: it is a reversal of the main figures in Raphael's *Deposition*, which suggests that Delacroix knew the painting through a print.

Considered in their order of execution, these plates reveal the general direction of Delacroix's development as a draftsman. They become broader and freer in execution and sketchier and grayer in tone as the series progresses. *Hamlet and the Players* (1835) or *The Queen Consoling Hamlet* are typical of the earlier manner, in which a wider, more carefully graded tonal range is evident. The later, more spontaneous mode of execution is typified by *Hamlet Tempted To Kill the King*, *Hamlet and Horatio in the Graveyard*, and *Ophelia's Death*.

These last two plates deserve particular attention for other reasons as well. Delacroix later did three canvases of Ophelia's death—in 1838, 1844, and 1853.

They are all very similar, although in the more detailed canvas of 1844, now in the Reinhart Collection, Winterthur, Switzerland, the landscape is more extensive than in the other versions.[68] The scene is, of course, derived from Shakespeare's description of an offstage action, which permits the artist to introduce a contrasting natural setting. The plate is distinguished by the economy with which an airy landscape suffused with light has been captured. The oils, especially the last version, now in the Louvre, retain something of that same quality, which helps to make visually credible one of the play's less convincing incidents.

It is instructive to compare Delacroix's broad and luminous interpretation of the theme, first, with the preciously wrought Ophelia exhibited by Millais in 1852, and then with a closely related composition by Delaroche, *Young Martyr*, of about 1853, which exemplifies the unabashed sentimentality cultivated by many of Delacroix's and Millais' popular contemporaries.

Delacroix's favorite Shakespearean scene is *Hamlet and Horatio in the Graveyard*. His several versions indicate the changes in his approach over a span of thirty-one years. In the earliest representation, the lithograph of 1828 (Delteil 75), the two companions contemplate the skull Hamlet holds in his hand, while a workman perched on the edge of the grave watches them. The figure of Hamlet, with his large head, long neck, small chin, and deep, wide-set eyes, is particularly strange. In the middle distance appears the funeral procession and, beyond it, a medieval chapel. The style is very similar to that of the *Faust* series. The figures in the front plane are arbitrarily separated from the rest of the picture space, which is itself somewhat unclear and contradictory, particularly at the lower left.

68. There is often a confusion in the chronological relationship among these three versions of the theme (see Johnson, *Delacroix: 1798–1863*, p. 30, No. 39). Stylistically, Johnson's proposed dating is convincing.

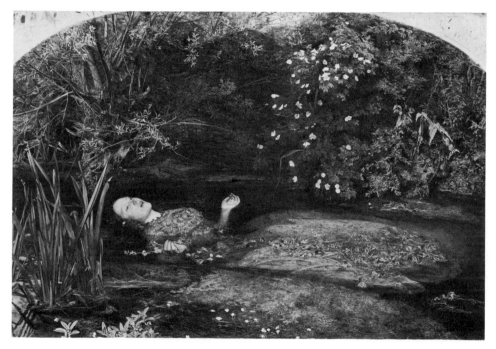

FIGURE 92. Sir John Everett Millais. *Ophelia*. 1851–52. Oil on canvas. 0.75 × 1.12. The Tate Gallery, London. Photo The Tate Gallery.

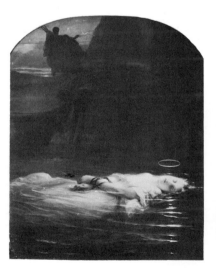

FIGURE 93. Paul Delaroche. *The Young Martyr*. Ca. 1853. Oil on canvas. 1.71 × 1.48. Louvre. Photo Bulloz.

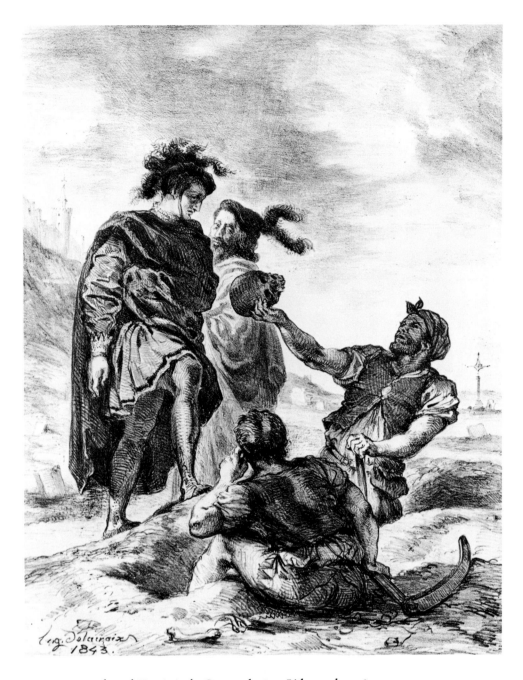

FIGURE 94. *Hamlet and Horatio in the Graveyard.* 1843. Lithograph. 0.28 × 0.21.
Collection Lessing J. Rosenwald, Jenkintown, Pa. Photo National Gallery of Art.

The last version of the subject is almost identical in composition, but reversed. The execution is, however, altogether different. The touch is broader; the forms are loose but convincing; the surfaces are generally more lively and more unified, especially in the handling of the procession, which now includes flaming torches as added coloristic and atmospheric notes. Among other changes a second workman has been introduced, and the action of the two main figures is reversed. Horatio holds Yorick's skull as Hamlet shies back in mixed repulsion and fascination. The stocky workman, now bearded, takes a casual interest in the scene.

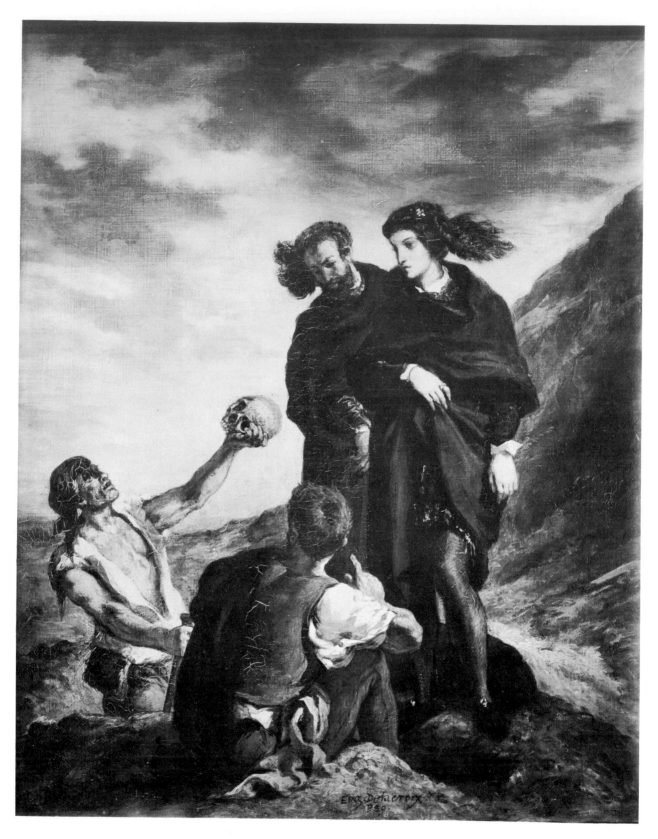

FIGURE 95. *Hamlet and Horatio in the Graveyard.* 1839.
Oil on canvas. 0.82 × 0.65. Louvre. Photo Giraudon.

Although the procession is somewhat confusing spatially and the architecture is slightly simplified, the scene is generally more animated than in the early lithograph. It is a kind of critique of the earlier work.

In the later lithograph of the 1840's there is a similar shift to larger forms, more freely and boldly executed. Delacroix's handling of the medium becomes more direct and personal, and he has moved, like Daumier in a similar phase of his development, from relative constraint toward expressive freedom. Perhaps the finest interpretation of all, however, is his canvas of 1839, which captures the gathering gloom of Shakespeare's narrative. The dominant figures of the close-knit group, now enlarged to monumental proportions reflective of his new mural enterprises of the period, are carefully discriminated psychologically. At the same time, Delacroix's popular identification with the "Shakespearean school" is justified here in his portrayal of enveloping darkness and a mood of tragedy. An entry in the *Journal* many years earlier could almost serve as an epigraph to these portrayals of the graveyard scene:

Ignorant middle-class people are very lucky. Everything in nature seems simple to them; things are as they are, and that is explanation enough. And really, are not they more reasonable than the dreamers who go so far that they begin to mistrust their own minds? A friend dies. Because they believe that they understand the meaning of death, they do not add to the sorrow of mourning him the cruel anxiety of being unable to explain so natural an event. He was alive, he is alive no longer; he talked with me, we understood each other; nothing of all this remains, except this tomb. Is he lying in this cold grave, as cold as death itself? . . . Familiarity with an idea reduces us all to the level of the common herd. After the first shock we realize "he is dead" and the idea no longer disturbs us. Wise men and philosophers seem to be far less advanced in this than the ignorant, since the very thing that should serve them as proof is not even proved for them. I am a man. What is this *I*? What is this thing *a man*? They spend half a lifetime in verifying, and pulling to pieces bit by bit, something that has already been discovered. During the other half, they lay the foundations of an edifice that never rises above the level of the ground.[69]

69. *J, W, p. 24 (Feb. 27, 1824).*

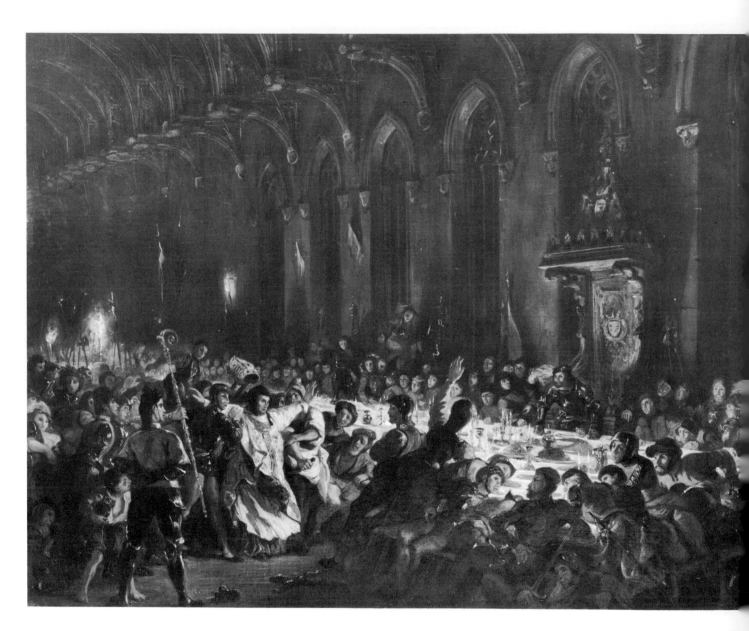

FIGURE 96. *Murder of the Bishop of Liège.* 1829.
Oil on canvas. 0.90 × 1.18. Louvre. Photo S.D.P.

Visions of the Past

1. Around 1825, when Delacroix was sharing his studio with Bonington, the latter did a painting of Quentin Durward at Liège (see D. Cooper, "Bonington and *Quentin Durward*," *Burlington Magazine*, 88 [May, 1946]:112ff.).

2. Quoted in R, p. 81. In this instance, as in others, it is likely that Delacroix's acquaintance with the characters, settings, and plots derived from stage productions. Casimir Delavigne based his *Louis XI* (1832) on the Scott novel, which by that date had already served another, lesser playwright, Jean-Marie Mély-Janin, for his *Louis XI à Péronne*. Although criticized in *Le Figaro* as a "slavish imitation," it had over fifty performances at the Théâtre Française, from February 27, 1827, until Mély-Janin's death that December. Delacroix probably saw one of the performances. For Scott themes on the stage, including French productions, see H. A. White, *Sir Walter Scott's Novels on the Stage* (New Haven, Conn.: Yale University Press, 1927); for the *Quentin Durward* references, see pp. 178–79, 243.

3. See Escholier, *Delacroix*, 1:263. The setting of *Melmoth*, which in many ways resembles both *Boissy d'Anglas* and the *Bishop of Liège* and which was painted at about the same time, also recalls the Palais de Justice in Rouen. For a discussion of this work, see Johnson, *Delacroix: 1798–1863*, pp. 18–20.

4. See Toupet, "L'Assassinat de l'Évêque de Liège," p. 85. A detailed discussion of the final version and the preliminary sketches is found on pp. 83–94.

5. Quite apart from the reverence for Rembrandt he expresses in the *Journal*, the copies he made of *Tobias and the Angel* and the *Slaughtered Ox*, both in the Louvre, give evidence of his understanding of Rembrandt's art.

Delacroix repeatedly used subjects from literary evocations of the past, whether classical, medieval, or Renaissance. His "dictionary" was not only nature but the works of man—his monuments and records. The *Murder of the Bishop of Liège*, for example, was based on an episode from *Quentin Durward*. (Scott's romance was also used as a source by Bonington.[1]) That it was the romantic and picturesque possibilities of the scene which attracted Delacroix's attention is evident in his description in the catalogue of the Salon of 1831, when it was first shown: "William de la Marck, nicknamed the 'Wild Boar of the Ardennes,' with the help of the rebellious townsmen seized the episcopal palace. Installed on the Bishop's throne during an orgy in the Great Hall, he ordered the Bishop to be led in, mockingly invested in his pontifical regalia, and had his throat cut while he watched."[2]

As in the slightly later *Boissy d'Anglas*, the fierce tension between the two principals is set off by the insensibility—or even inattention—of many of the other participants. In a formal sense *Murder of the Bishop of Liège* also resembles *Boissy d'Anglas*. The recession of the room along a strong diagonal is similarly achieved in both works. The technique is much the same, with the fluidity of the paint handling showing the influence of the English school. While the architecture itself is usually supposed to derive from an actual interior in Rouen,[3] it has recently been pointed out that the structure bears an even stronger resemblance to the Westminster Abbey ceiling, another reminder of the artist's recent visit to England.[4] On the other hand, the over-all character of the painting forcefully recalls Rembrandt, particularly the earlier works. The relatively small figures are dwarfed by a monumental architectural setting. The lighted areas are small, dramatic focuses within a generally obscure and mysterious environment.[5] Although Delacroix's technique is altogether personal and the expressive tone of his picture is quite unlike anything in Rembrandt, the achievement of his great predecessor is more profoundly expressed here than in any of the other works of this period in which his influence is clear.

During the years between Delacroix's return from England and his departure for Morocco in 1832, his work shows numerous other borrowings from Scott's historical romances. Among these are lithographs representing a scene from *The Bride of Lammermoor* and three illustrations of episodes from *Ivanhoe*, two of them showing Front-de-Boeuf with the sorceress and with Isaac, the Jew of York, and a third showing Richard and Wamba. Also from Scott is *Redgauntlet Pursued by a Goblin*, which, like the other prints, was done in 1829. Horace Vernet's *Ballad of Lenore*, painted the following year, and Ary Scheffer's *The Dead Move Fast* are other specimens of the taste for the macabre and medieval subjects of Scott and other contemporary writers.

By this time Scott's works were readily available in French translations, as well as in their various adaptations for the stage. It is uncertain whether Delacroix

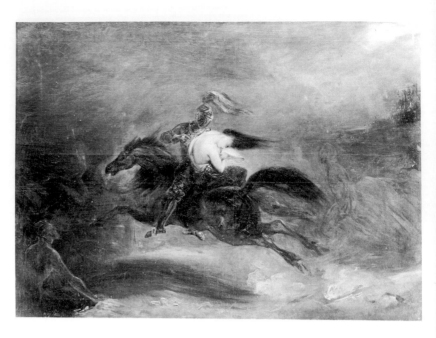

FIGURE 97. Horace Vernet. *Ballad of Lenore*. 1839. Oil on canvas. 0.61 × 0.55. Musée des Beaux-Arts, Nantes. Photo Archives Photographiques, Paris.

FIGURE 98. Ary Scheffer. *The Dead Move Fast*. 1830. 0.59 × 0.76. Oil on Canvas. Musée des Beaux-Arts, Lille. Photo Giraudon.

ever saw a stage version of *Redgauntlet*, although two productions of it did appear briefly in Paris. Around 1830 Alfred de Musset wrote a three-act "tableau drama," *Quittance du Diable*, or *The Devil's Receipt*.[6] *Ivanhoé*, by Émile Deschamps and Gabriele Gustave de Wailly, was presented at the Odéon in 1826.[7] The play was published in 1829. Delacroix did the costume designs for Victor Hugo's *Amy Robsart*, presented at the Odéon in 1828, a story derived from *Kenilworth*, which was popular in France as early as 1822. As for *The Bride of Lammermoor*, there was a musical adaptation by Adam in 1827, another in 1828, and two more the following year.[8] Whether Delacroix derived specific details of composition, situation, or setting from these adaptations is difficult, if not impossible, to determine.

Two versions of the *Rape of Rebecca by the Templar Bois-Guilbert* illustrate Delacroix's return to Scott's novels in later life. While the two versions of this scene from *Ivanhoe* differ considerably, both the canvas of 1846, now in the Metropolitan Museum, and that of 1859, in the Louvre, have much the same tumultuous expression. In a broad sense they relate to numerous other canvases, such as those of knights in combat—*Weislingen Captured by Goetz's Men*, in St. Louis, for example, and other scenes involving violent action. The second *Rape of Rebecca*, bitterly criticized when it was shown at the Salon of 1859, is uneven. Although in certain passages it rivals the 1846 painting, it must be admitted that the coherence and unity of the earlier example are lacking. While it is not formally related to Rubens' *Rape of the Daughters of Leucippus*, the first *Rebecca* does approach the Flemish master's power and intensity of form.

The character of the picture space, the arbitrary articulation of the figures, the abstraction of the movement, and the handling of paint surfaces are all typical

6. See White, *Scott's Novels on the Stage*, pp. 181–82.

7. *Ibid.*, pp. 112–14, 237–38.

8. For details of these performances, see *ibid.*, pp. 80–81, 234.

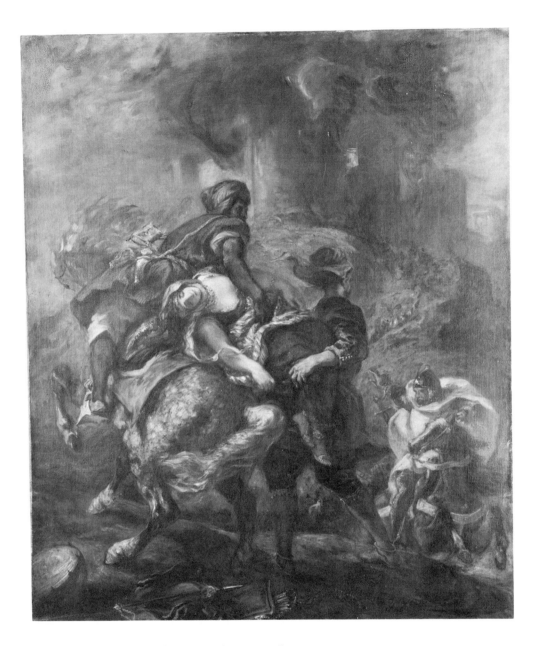

FIGURE 99. *Rape of Rebecca by the Templar Bois-Guilbert.* 1846.
Oil on canvas. 1.00 × 0.82. The Metropolitan Museum of Art, Wolfe Fund, 1903.
Photo The Metropolitan Museum of Art.

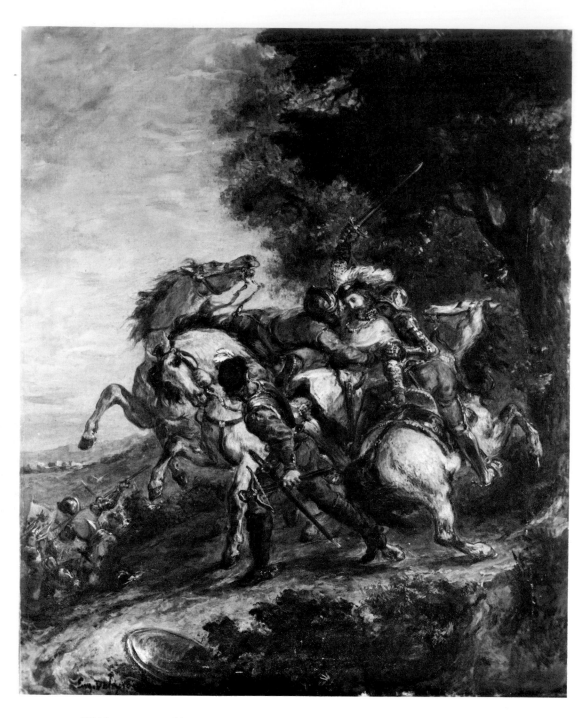

FIGURE 100. *Weislingen Captured by Goetz's Men.* 1853.
Oil on canvas. 0.73 × 0.59. City Art Museum of St. Louis, Emelie Weindal Bequest Fund.
Photo City Art Museum of St. Louis.

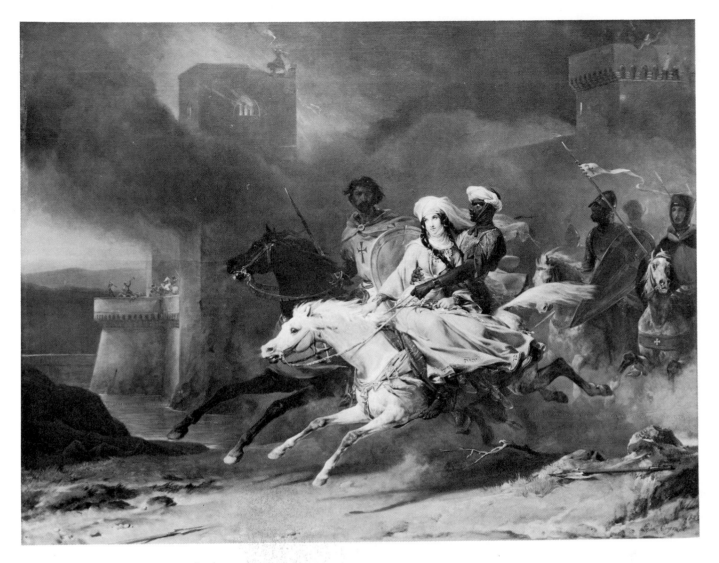

FIGURE 101. Léon Cogniet. *Rape of Rebecca*. 1828.
Oil on canvas. 0.90 × 1.17. The Wallace Collection, London.
Photo The Wallace Collection.

of Delacroix's mature style. An interpretation of the same subject painted in 1828 by Léon Cogniet, now in the Wallace collection, serves as an index of Delacroix's accomplishment. In both versions Front-de-Boeuf's castle, Torquilstone, is shown burning in the distance, while in the foreground the lovely Rebecca is being carried away by the dark knight and his men. Here the resemblances cease. Delacroix's Rebecca struggles against her captors, while Cogniet shows her placidly resigned to her uncertain journey. Sir Brian's Saracen slave, who holds her during the flight, becomes in Cogniet another ethnic type of the paintings of the period, and the Templar himself bears little resemblance to Scott's violent, threatening figure.

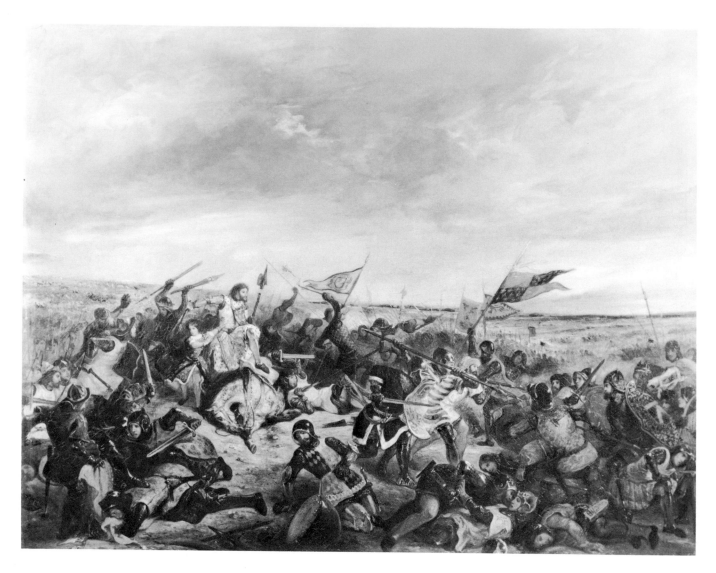

FIGURE 102. *Battle of Poitiers (September 19, 1356)*. 1829–30.
Oil on canvas. 1.14 × 1.46. Louvre. Photo S.D.P.

Delacroix's medievalism, expressed in the *Faust* illustrations, the scenes from *Goetz von Berlichingen*, and his *Louis XI*, made in 1829 as an illustration for Béranger's *Chansons*, is equally apparent in the lithographs of Vercingetorix, Du Guesclin, and Shakespearean subjects. His commission in 1829 to illustrate Mme Amable Tastu's *Chroniques de France* was therefore in line with his developing taste. These historical interests found monumental expression in the three large battle pieces that he worked on for about ten years, beginning in 1828. They show famous military engagements at Poitiers, Nancy, and Taillebourg. In their sequence and associations they form a unit worthy of extended attention.

The *Battle of Poitiers (September 19, 1356)* was the second of these pieces to be commissioned but was the first completed. Work on the painting was begun in 1829 in response to a request by the Duchess of Berry. The painting must have

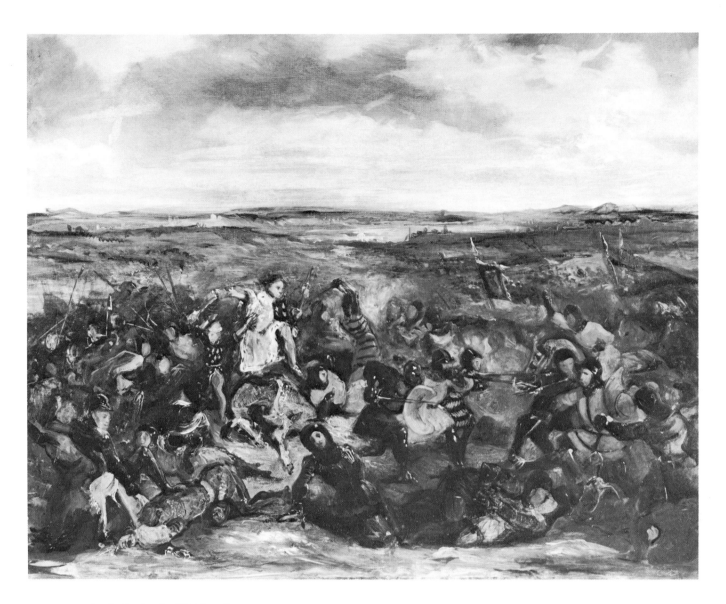

FIGURE 103. Study for *Battle of Poitiers*. Ca. 1829.
Oil on canvas. 0.54 × 0.66. The Walters Art Gallery, Baltimore.
Photo courtesy of The Walters Art Gallery.

9. C, 1:259 (Nov. 1, 1830). The documentation is summarized in M, pp. 83–84.

been virtually finished in May of 1830, for Delacroix mentions that the visit of the Duchess's father, the King of Naples, interfered with her intention of giving final approval of the work.[9] The canvas is therefore the major product of the months immediately preceding *Liberty Leading the People*. It depicts the last moments of the contest between John the Good of France and Edward, the Black Prince. The combat is here shown at the point at which King John is faced with certain defeat and capture. His fourteen-year-old son, the future Philip the Bold, bravely defends himself and his father.

Apart from the scale of execution, the only major difference observable between the elaborate oil sketch, now in the Walters Gallery in Baltimore, and the finished canvas is the lowering of the horizon in the final composition. That single change, however, is important. It basically alters the relationships of the figures and the

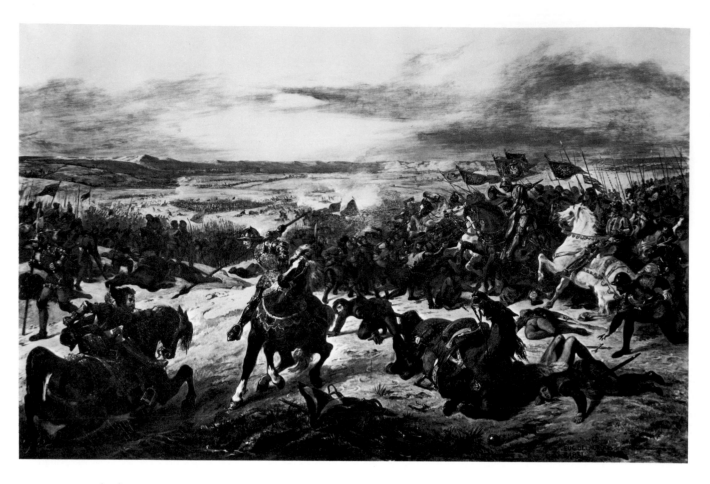

FIGURE 104. *Battle of Nancy.* 1831.
Oil on canvas. 2.39 × 3.59. Musée des Beaux-Arts, Nancy. Photo Bulloz.

landscape, with a gain in formal variety and narrative clarity. The combatants' weapons and their pennants are made to break into the gloomy sky. The only head rising above the horizon is that of the French King, standing to the left, elegant in ermine, with his flagging soldiers, fallen horses, and loyal son. The composition functions in large measure as a series of localized oppositions within three main zones of conflict. The focus of the action is, of course, the group comprised by the King and his son, not only because of its high placement but because of the isolable shape of the group. That configuration is emphasized by the crisscrossed accents of red in the royal costumes and the harness of the horse. Other touches of blue and gold in this, the most brightly lighted section of the picture, lend it special emphasis within the complicated action.

The *Battle of Nancy* is a major variation within the same genre. A letter to Soulier mentions the commission by M. de Martignac, the Minister of the Interior, in October, 1828,[10] before Delacroix began *Battle of Poitiers*. The following February[11] Delacroix wrote to the Superintendent of Fine Arts, Count

10. *C*, 1:223.

11. *C*, 1:237–38 (Feb. 25, 1829). For a more complete account of these events and a detailed analysis of the evolution of the theme, see Thérèse Charpentier, "A propos de la Bataille de Nancy par Eugène Delacroix," *La revue du Louvre et des musées de France*, 12, No. 2 (1963):95–104. Toupet points out that the local press at Nancy regarded the commission as initiated by Charles X himself (p. 95, n. 3). She further observes that despite the prevailing notion that Delacroix was neglected by the Restoration government the artist was, in fact, well treated in the years 1824–1830 and that Thiers' intervention on his behalf would only

be "directly effective after 1830," and even then with reference to commissions received before 1830 (p. 96, n. 8). See also M, pp. 141–45; Johnson, "Delacroix Centenary II," pp. 261–62, and Delacroix: An Exhibition, p. 25. Johnson points out that the painting may have been completed earlier than has been supposed. He also suggests that the subject may have appealed to the government of Charles X, in whose name it was donated to Nancy, because it represents the triumph of legitimacy over adventurism and hence is a possible allusion to the restoration of Bourbon rule after the defeat of Napoleon.

12. Charpentier, "La Bataille de Nancy," p. 95, n. 1.

13. Quoted in R, p. 98; M, p. 141. The guide to the Salon of 1834, where the picture was first exhibited, gave a slightly different description: "Embittered by his previous reverses, the Duke rashly gave battle (contrary to all prudence) facing into the snow with his cavalry hampered by the icy weather. He himself became mired in a pond and was killed by a knight of Lorrain just as he was struggling to extricate himself."

14. See Charpentier, "La Bataille de Nancy," p. 100, n. 22.

15. Ibid., pp. 95–104. Following his commission Delacroix was told of an anonymous contemporary account quoted by Dom Calmet in his Histoire de Lorrain (Nancy [1757]). Among his other sources is Philippe de Comine's Mémoires, whose description tallies with Delacroix's pictorial rendition. It may be, as Charpentier proposes, that Scott's Charles the Bold, which appeared in a French translation in 1829, suggested certain details. She further notes that there was a production in Paris in 1814 of a "pre-Romantic" drama by Guilbert de Pixérécourt, based on the Battle of Nancy. The graphic sources are less convincingly handled than her other documentation.

16. For a review of this genre in French art before and during the nineteenth century, see Arsène Alexandre, Histoire de la peinture militaire en France (Paris: Laurens, n.d.).

Sosthène de la Rochefoucauld, who seems to have recovered from his annoyance over *Sardanapalus*, to make an appointment to discuss his completed sketch for the picture. Inasmuch as the changes between the preliminary and the final versions of the painting are relatively minor, one may assume that there was no serious disagreement over the commission. A church, seen to the left in the sketch, was eliminated from the larger canvas to give it a greater focus. The immediate foreground has also been simplified and the color tonality modified. The action of the figures remains very much the same except for the greater clarity and refinement of the completed work.

Although the precise date of completion of *Battle of Nancy* is uncertain, it may have been all but finished before Delacroix's departure for Morocco. It was delivered to the municipality of Nancy in 1833[12] and was exhibited there prior to its appearance at the Salon of 1834. The catalogue for the 1855 Exposition, where it was later shown, reads: "On January 5, 1477, the Duke of Burgundy, Charles the Bold, gave battle in icy weather, which cost him his cavalry. He himself became mired in a pond and was killed by a knight of Lorrain just as he was struggling to extricate himself."[13] Delacroix has chosen the moment just before the death of Charles, here seen in shadow in the lower left corner. His opponent has just reined in his horse, which is caught at a moment of transition from one pace to another, and thus serves as a foil to the forward thrust of its rider. In the foreground each man seeks his own survival, sometimes without apparent awareness of the rest: one bearded man, fallen to his knees in the trampled snow, watches the last moments of Charles, but another soldier to the far left walks away from the death struggle so close at hand. For the youth to the lower right, who looks so much like David's figure of Barra, the battle is already over. The inclusion of a single cannon ball is perhaps intended to suggest the failure of the Duke's artillery to function in the snow—a tactical disadvantage that contributed to his defeat.[14]

As this last touch suggests, Delacroix was faithful to the historical facts as they were known to him. In her article on this subject, Thérèse Charpentier has pointed out that he used a great variety of sources in preparing the picture.[15] Far from being "inaccurate," as some earlier critics have claimed, it is remarkably faithful to the accounts of the battle. Of particular interest is the device for introducing variety of pose without loss of basic unity by establishing sequential movements in the actions of closely related figures, such as the pikemen facing the cavalry at the center of the composition. They suggest an almost continuous sequence of movement of the sort Degas later captured in his ballet pictures. Perhaps Degas' use of the single model shown in multiple stages of a total action is another evidence of his acknowledged debt to Delacroix (he once owned the oil sketch for this picture).

The traditions of battle painting, out of which Delacroix's compositions evolved, were well established. The genre was particularly popular in the seventeenth century, was revived under Napoleon, and persisted throughout much of the eighteenth century.[16] One of the most popular painters of battles was Baron Gros, and both Delacroix and Géricault learned much from him. Gros's *Battle of Nazareth* and *Battle of Aboukir* are fine examples of his accomplishment. The latter is an enormous canvas, now in the museum at Versailles. Its figures, heroic in scale, make a dense, shallow relief within which there is a wealth of

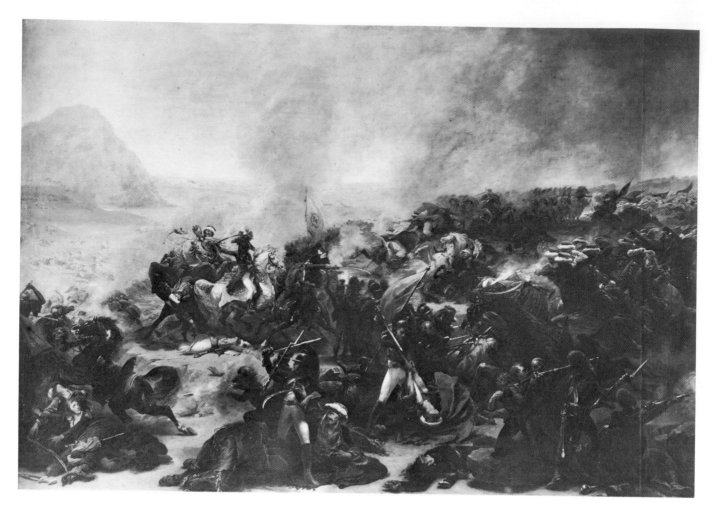

FIGURE 105. Antoine Jean Gros. Study for *Battle of Nazareth*. 1801.
Oil on canvas. 1.35 × 1.95. Musée des Beaux-Arts, Nantes.
Photo Archives Photographiques, Paris.

individual action. The picture is so boldly conceived and powerfully executed
that one is led to overlook such neoclassical contrivances as the presence of the
male nudes—here Negroes, and hence exotic elements. With Aboukir in the
distance, General Murat receives the scimitar of the wounded Pasha from his
son.[17] But while Gros develops the action admirably, he virtually eliminates the
landscape, while Delacroix uses the setting as a means of intensifying the human
situation.

From this point of view, Gros's *Battle of Nazareth* is closer to Delacroix's
battle pieces. This subject is now known from his entry in the competition,
held in 1801, for the commission to paint the scene. Gros was diverted from this
project before he could complete it. The unfinished picture was later cut in half
to provide the canvases on which *Battle of Aboukir* and *Pesthouse of Jaffa*, both
huge, were painted, but the subject became well known on the basis of the pre-

17. Further documentation relating
to the painting is presented by J.-B.
Delestre, *Gros, sa vie et ses ouvrages*
(Paris: Renouard, 1867), pp. 103ff.
In later years Delacroix came to be
disappointed with the picture for
its "rawness of tones" and "tangling
up of men and horses" (*J*, P, p. 482
[Aug. 25, 1855]).

18. See J. Tripier le Franc, *Histoire de la vie et de la mort du Baron Gros* (Paris: Jules Martin and J. Bauer, 1880), pp. 192ff.; see also Arts Council of Great Britain, *The Romantic Movement*, p. 155.

19. See *C*, 5:147 (receipt, Dec. 7, 1828). Vernet later gave the painting to the Musée Calvet, in Avignon, the city from which his family came.

20. Cf. *O*, 2:173–74 (from the article on Gros, in the *Revue des Deux-Mondes* for September 1, 1848).

liminary version. Géricault paid a thousand francs to obtain permission to copy it.[18] Horace Vernet, who obtained the copy from Géricault in 1828, left it with Delacroix when he went to Rome to become Director of the French Academy there.[19]

Delacroix described the picture many years later in an article for the *Revue des Deux-Mondes*, as of rare quality, extraordinary in its fusion of elegance with strength.[20] His enthusiasm is understandable. Less "finished" in its handling, partly because of its smaller size and relatively broader scale of execution, the technique resembles Delacroix's own more than do most other works by Gros, particularly in its suggestion of atmosphere, its lively, painterly surfaces, and its somewhat suppressed detail. Compositionally, it differs from *Battle of Aboukir* in that the French leader, General Junot, astride his white steed, appears to one side, not in the more formal central position of Murat in *Aboukir*. In its intricate play of oblique movements and asymmetrical pictorial tensions, *Nazareth* directly anticipates the compositional devices that both Delacroix and Géricault came to prefer.

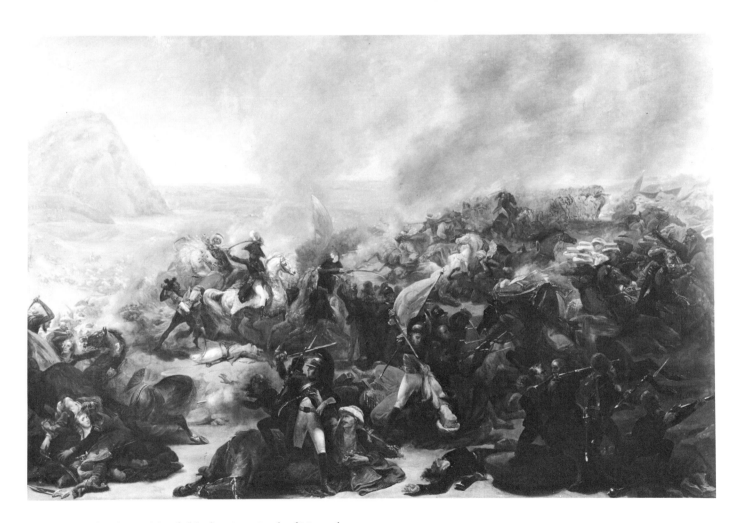

FIGURE 106. Théodore Géricault [?] after Gros. *Battle of Nazareth.*
Oil on canvas. 1.33 × 1.93. Musée Calvet, Avignon. Photo Giraudon.

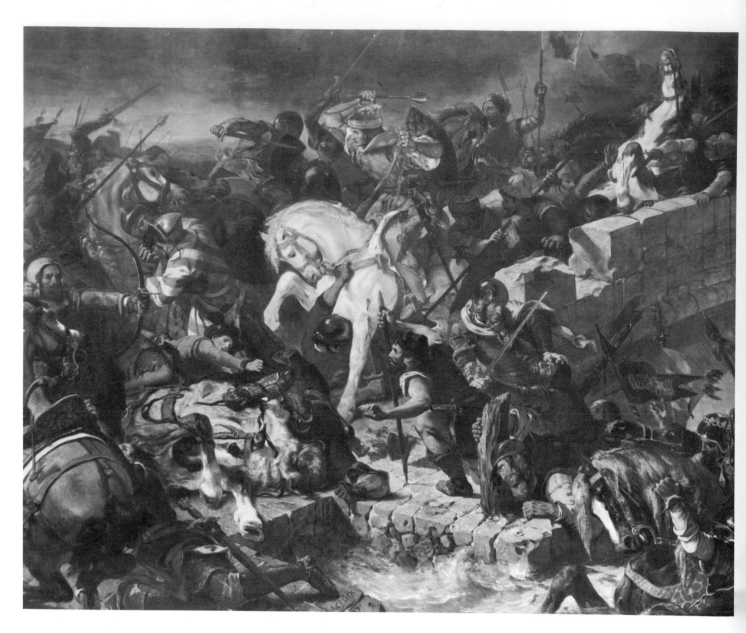

FIGURE 107. *Battle of Taillebourg*. 1837.
Oil on canvas. 4.85 × 5.55. Hall of Battles, Musée de Versailles. Photo Archives
Photographiques.

For Delacroix the culmination of this military tradition was *Battle of Taillebourg*, which he painted in 1837 for Louis Philippe's Hall of Battles at Versailles. The subject is Saint Louis' victory in 1242 over the English guarding the bridge over the Charente at Taillebourg. Perhaps the fiercest and most complex of Delacroix's large battle subjects, this composition is handled rather differently from the others. The field of vision is reduced, and the figures are enlarged in scale accordingly, giving greater immediacy to their action. There is a kind of wave-like shock as the attackers rush across the bridge and surge up from the dark, churning waters of the river. If anything, the setting is even more intimately involved here as a major factor within the battle, for it dictates much of the movement of the figures.

A comparison of the final version of *Taillebourg* with the oil sketch shows that the composition was extensively revised to satisfy the conditions of the commission. It was to be part of a series, each uniform in height and roughly comparable in width. Out of consideration for over-all coherence of effect, the size of the figures had to be kept relatively consistent with those of the neighboring canvases in the hall. The field of vision, therefore, had to be reduced and the figures enlarged. The completed picture thus represents some compromise of the original plan—not without a certain loss of sweep. At the same time, its simplifications give the final version a bolder, more decisive character. The dominance of the King more than compensates for any loss of variety of action on the periphery.

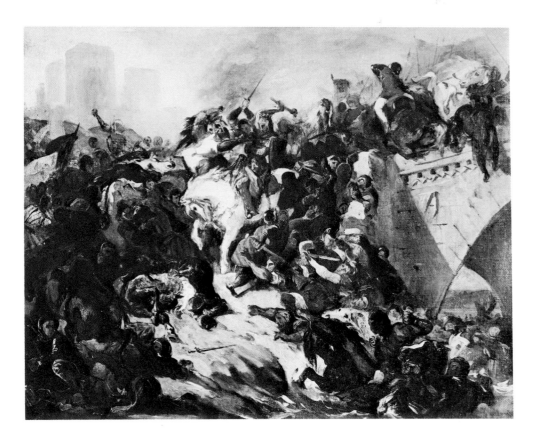

FIGURE 108. Study for *Battle of Taillebourg*. 1834–37.
Oil on canvas. 0.53 × 0.66. Louvre. Photo Giraudon.

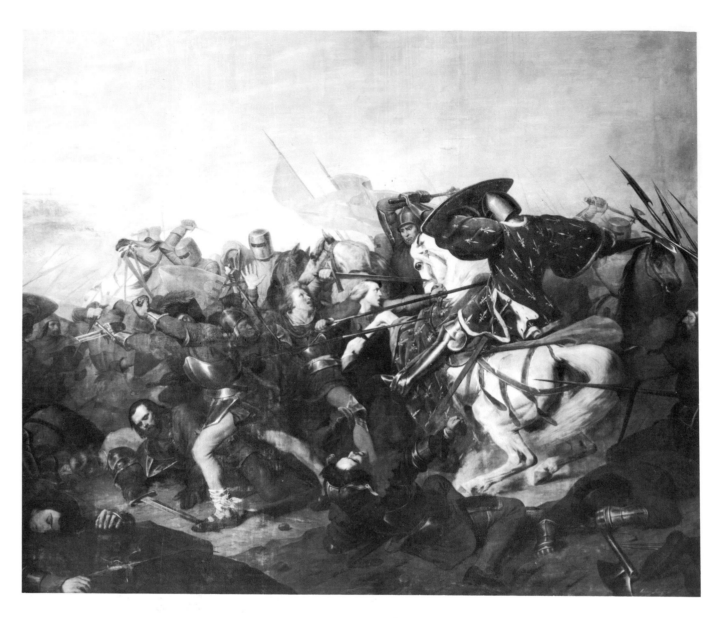

FIGURE 109. Henry Schaeffer. *Battle of Cassel, 1328.* 1837.
Oil on canvas. 4.65 × 5.43. Hall of Battles, Musée de Versailles. Photo S.D.P.

Delacroix's success in balancing narrative interest and monumental decorative form may be gauged from a glance at the companion pieces to *Taillebourg* in the Hall of Battles. *Battle of Cassel*, by Henry Schaeffer, for example, is technically admirable. The scene is skillfully composed and the figures are convincingly rendered. Their arms and costumes have obviously been studied thoroughly, and their gestures and facial expressions are appropriate. But for all this, the work remains pedestrian, with too many traces of the studio—the model, the properties, the costumes. More ambitious in its way is Charles Steuben's depiction

of the earlier Battle of Poitiers, won in 732 by Charles Martel. Steuben's desire to infuse the scene with emotion has been carried to an extreme typical of the nineteenth century. The slippery, sliding movements of the participants are too gracefully practiced, and the combat takes on the character of a scarf dance. The engagement between the old Saracen at the right center and his three opponents to the lower left is cleverly drawn, but once again too pat.

The Hall of Battles is nevertheless of uncommon interest as a symbol of nineteenth-century historicism, a typical expression of which was Louis Philippe's fascination with the glories of the French past. It will be recalled that even before Chateaubriand, an interest in the early history of France was awakening and that the foundation of the Musée des Monuments Français was an early announcement of that new turn of mind. The establishment of the Gaelic Academy in 1805, soon followed by the publication of Saint-Michel's *Charles-Martel*, was a forecast of the wide favor "epic" treatments of Merovingian and Carolingian themes came to enjoy. By 1830 the Middle Ages was firmly established as part of the continuity of French history to which the ensemble in the Hall of Battles alludes.

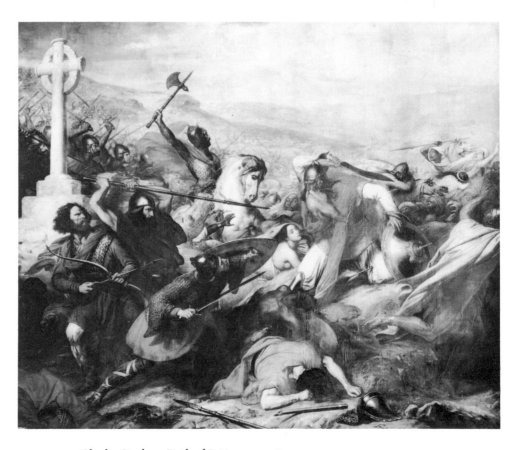

FIGURE 110. Charles Steuben. *Battle of Poitiers, 732.* 1837.
Oil on canvas. 4.65 × 5.42. Hall of Battles, Musée de Versailles. Photo S.D.P.

The last of Delacroix's monumental depictions of medieval subjects was his famous *Entry of the Crusaders into Constantinople*. It was commissioned by Louis Philippe in 1838 for the Hall of the Crusades at Versailles, another of his ventures into historical *décor*, and was exhibited in the Salon of 1841. The painting shows the arrival in Constantinople of the leaders of the infamous Fourth Crusade, which greed had diverted from any pretext of religious purpose. The city was sacked in 1204, much to the benefit of the Venetians and their leader, Enrico Dandolo, and the French under the Count of Flanders, who was made Emperor of Byzantium.[21]

Various sources for the work have been proposed. There is a lithograph by Federico de Madrazo, a Spanish artist, done as a frontispiece for the 1831 edition of a poem by the Spanish liberal Fernandez de Moratin, *The Taking of Granada by the Catholic Monarchs Don Fernando and Doña Isabel*. Moratin was in Paris in 1838 and knew some of Delacroix's friends.[22] Another plausible but equally hypothetical proposal is that a print dating from 1573 by Jean Stradan may have provided the initial motif.[23] On the other hand, the interpretation may have been indebted to some now forgotten stage production or public spectacle. For example, in 1825 a "Panorama of Constantinople" was opened at 17 Boulevard des Capucines, one of several such popular attractions that were surely known to Delacroix.[24] In view of his excellent visual memory, it may well be that his "panoramic" view of Constantinople had its origins in some such humble and unexpected form of popular art.

The situation in *Entry of the Crusaders* in some respects resembles that in *Massacre at Scio*,[25] but where *Scio* lacked visual unity, *Entry of the Crusaders* shows a notable gain in compositional clarity. The kneeling and prostrate women are almost child-like in comparison with the towering horsemen. The appeal to the viewer's sympathy is reinforced by the fact that the lower figures are seen from a closer viewpoint than the rest. The high horizon and the elevated position of the spectator implied in the perspective of the buildings is in marked contrast to these figures. It may be, of course, that these inconsistencies are evidence of the artist's attempt to fuse images derived from different areas of his experience. The spatial ambiguities of the painting nevertheless introduce an element of contradiction that qualifies the initial effect of pictorial unity, a tendency observable in *Massacre at Scio*, *Women of Algiers*, and other earlier works.

Perhaps in recognition of this problem, in 1852, Delacroix painted another, smaller version of the theme in which, as in the second *Women of Algiers*, the picture space has been made homogeneous by the enlargement of the foreground and by a radical transformation of the relationships of the figures within it.[26] Unfortunately, the gain in spatial unity is accomplished very much at the expense of dramatic impact. The mounted crusaders and their pleading victims are less dominating and forceful than they are in the original composition.

The technique and the color of the 1840 version, on the other hand, are fully unified. The color, which may be more accurately judged in the copy now at Versailles than in the Louvre original, which apparently is less well preserved, is rich and predominantly cool. The over-all effect has often been called "Venetian" or, to be more precise, "Veronese" in quality. There are, however, many evidences of Delacroix's growing taste for harmonies based on strong contrasts of hue. The juxtaposition of yellow and violet in the garments of the protesting old man at the left and the polar opposition of greens and red-oranges in the trampled banner in the immediate foreground are repeated elsewhere. Delacroix's

21. In the catalogue of the Salon of 1841 Delacroix described his subject thus: "Baudoin, Count of Flanders, commanded the French, who had assaulted the city on the land side, and old Doge Dandolo at the head of the Venetians had attacked the port by ship. The principal leaders took over various quarters of the city, as families appeared weeping along their way to call for mercy" (quoted in *M*, p. 221).

22. See Michel Florisoone, "Moratin, inspireur de Géricault et Delacroix," *Burlington Magazine*, 99 (September, 1957):303–11.

23. See A. Linzeler, "Une source d'inspiration inconnue d'Eugène Delacroix," *Gazette des Beaux-Arts*, 6th ser., 19 (May, 1933):309–12.

24. In 1826 a Panorama of Rome and a "Cosmorama" showing principal views of Greece were opened. In 1827 a "Neorama" appeared, complete with a view of St. Peter's in Rome. Also popular was the "Georama," a hollow globe of the earth measuring 40 feet in diameter. Also of interest in this context is the fact that in 1826 a play opened by the well-known Népomucène Lemercier, a tragedy in three acts entitled *Baudoin, Empereur*. Although it seems to have been little more than a *succès d'estime*, it ran for almost three weeks. An avid theatergoer, Delacroix is likely to have seen a performance (it was given at the Odéon, his favorite theater, only a few blocks from his apartment). The plot does not contain the action Delacroix has shown, and many years separate this production from the commission for the painting, yet remembrances of that spectacle may also have contributed in some way to its genesis.

25. The association of the two paintings is far from arbitrary. Delacroix himself referred to his "three Massacres," *Scio*, *Sardanapalus*, and *Entry of the Crusaders*.

26. For details, see *M*, pp. 328–29.

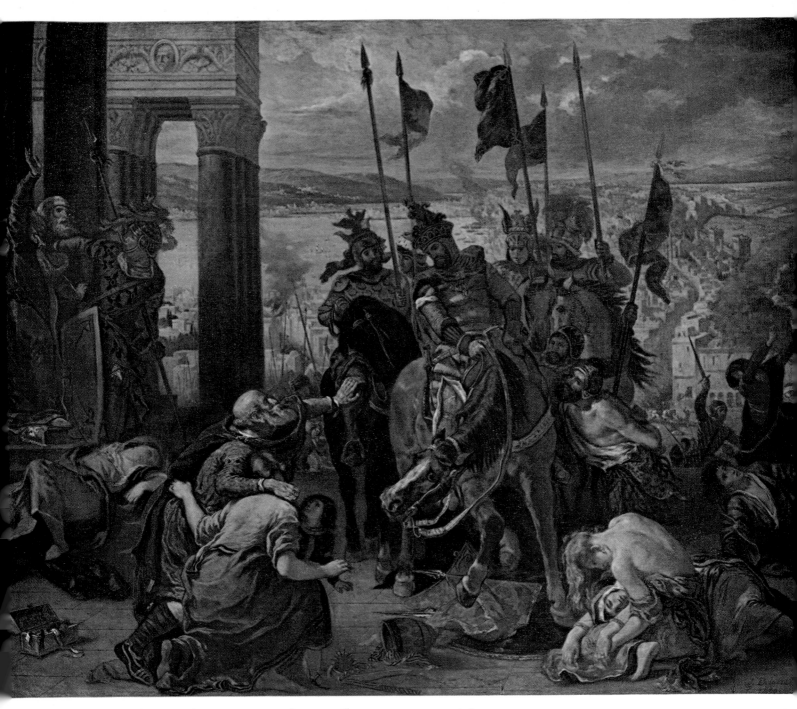

PLATE XVII. *Entry of the Crusaders into Constantinople.* 1840. Oil on canvas. 4.10 × 4.98. Louvre.

handling serves at once to enhance the richness of the basic color selection and to maintain unity of surface. The pronounced, interpenetrating strokes he has employed here form a cohesive fabric, and this technique permits elaboration of tonal nuances within individual passages.

This more structurally conceived technique is apparent in *Battle of Taillebourg*, where there is little emphasis on individual textures. Consistent with that bolder, more "mural" handling is Delacroix's increased dependence upon broad gesture rather than facial expression as his major narrative device. In expressive character as well as technique, *Entry of the Crusaders* reflects the artist's accommodations to the problems posed by murals. In the process he abandoned his former concern for highly individuated characterization, as in *Scio*, in favor of grander action, a public dignity echoed in the scale of the architecture and its panoramic backdrop.

Although none of Delacroix's major commissions of later years gave him the opportunity to undertake further monumental statements of medieval themes, he did return to such subjects from time to time on a small scale. His two versions of *The Rape of Rebecca* have been mentioned as examples of his later, more personal manner, in which his compromise with the demand for "finish" in large official compositions did not overcome his free, suggestive technique. He extended his thematic repertory to include Ariosto's *Orlando Furioso*, *Amadis de Gaule*,[27] and the writings of Tasso, where his earlier interest had been only in the Byronic life of the Italian poet.

27. See Johnson, *Delacroix: 1798–1863*, pp. 58–60.

FIGURE 111. *Entry of the Crusaders into Constantinople.* 1852. Oil on canvas. 0.81 × 1.05. Louvre. Photo S.D.P.

FIGURE 112. *Marfisa and Pinabello's Lady*. 1852.
Oil on canvas. 0.82 × 1.01. The Walters Art Gallery, Baltimore.
Photo courtesy of The Walters Art Gallery.

Among these canvases, *Marfisa and Pinabello's Lady*, now in the Walters Gallery, is typical in conception and exceptional in quality.[28] The subject derives from Canto XX of Ariosto's *Orlando Furioso*. The female warrior Marfisa, having challenged and defeated Pinabello, forces his companion to strip off her clothes and give them to an old woman whom she has mocked. In spite of the violence of the scene, the painting is more lyric than dramatic in effect. Painted in 1852, it represents Delacroix's mature style. The luxuriant color, the tremulous surfaces, the melting, fluid forms remove *Marfisa* from the category of a picturesque moral

28. See E. King, "Delacroix's Paintings in the Walters Art Gallery," *Journal of the Walters Art Gallery*, I (1938):92; Johnson, *Delacroix: 1798–1863*, p. 41.

episode and rival the rich, sensuous beauty of *Turkish Women Bathing*, painted two years later.

Although themes of chivalry recur among Delacroix's historical paintings, on occasion he found inspiration in other period subjects. His *Cardinal Richelieu Celebrating Mass* has been mentioned; in his canvas of 1855, *The Two Foscari*, he returned to the theme of Venetian justice, which he had previously treated in *Marino Faliero*. Other notable examples of his interest in the Renaissance are his two compositions based on the life of Christopher Columbus. The earlier, painted in 1838, shows Columbus and his young son Diego at the Franciscan friary of La Rábida. Old accounts tell of his chance meeting with Fray Juan Pérez, who understood and furthered his cause at the Spanish court, where he had great influence with Queen Isabella.[29] Although subsequent scholarship has cast doubt on this old tale of "chance encounter and timely charity," which "set the wheels rolling that led to the great discovery,"[30] it is this concept of the event which Delacroix portrays.

With greater than usual concern for accuracy of setting, Delacroix shows architecture that resembles the Capuchin monastery at Seville. (This is one of the few specific visual references to his brief visit to Spain.[31]) Columbus examines a map, his weary son slumped into a chair by his side, as they both await the monk, who is approaching them.[32] While it is not insisted upon, there is an air of quiet

FIGURE 113. *Columbus and His Son at La Rábida*. 1838.
Oil on canvas. 0.91 × 1.19. National Gallery of Art, Washington, D.C.,
Chester Dale Collection. Photo National Gallery of Art.

29. See, for example, A. Lamartine, *Christopher Columbus* (New York: Delisser and Procter, 1859), pp. 26ff., and various French editions. Here again a theatrical source may in some way have served to stimulate Delacroix's interest in the subject. An essay by De Broglie, included in Guizot's *Shakespeare and His Times*, refers to Lemercier's play, *Columbus*. It will be recalled that Guizot considered Lemercier a "pre-romantic." There is a theatrical quality to both of Delacroix's Columbus pictures, particularly the *Reception*.

30. See Samuel Eliot Morison, *Admiral of the Ocean Sea, a Life of Columbus* (Boston: Little, Brown, 1942), pp. 108ff.

31. See Joubin, "En Espagne avec Delacroix," p. 56. See also Lambert, "Delacroix et l'Espagne," pp. 159–71, and the drawing in pencil with touches of wash dated May 20 (Louvre, Cabinet des Dessins, R.F. 9 255). Delacroix was ordinarily concerned only with general credibility of setting, as may be seen in his interior of a Dominican convent in Madrid, painted in 1831, where the architecture is based on the Great Hall in the Palais de Justice at Rouen.

32. Robaut (R, p. 178), following nineteenth-century accounts, combines the names of two monks who on separate occasions helped Columbus and his son. He refers to "Don Jan Pérès de Marchena," which appears to be a combination of Fray Juan Pérez, Guardian of La Rábida in 1491, and Fray Antonio de Marchena, Custodian of the Franciscan sub-province of Seville (see Morison, *Admiral*, pp. 108–9).

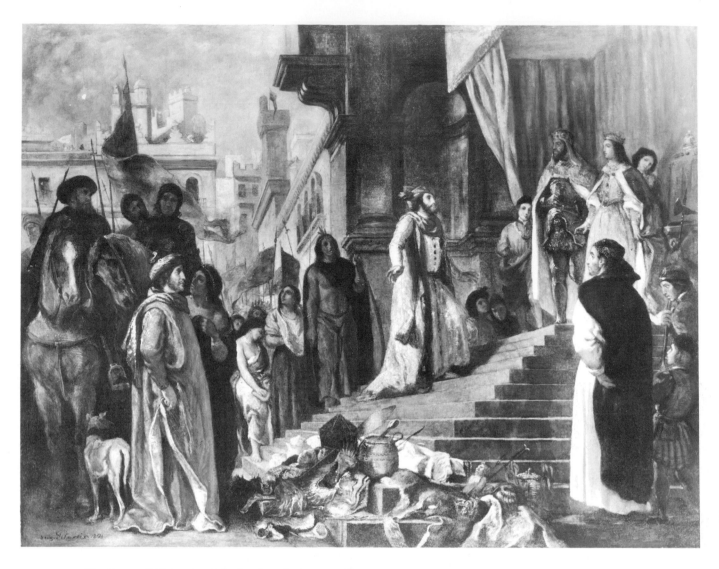

FIGURE 114. *The Return of Christopher Columbus from the New World.* 1839.
Oil on canvas. 0.85 × 1.16. The Toledo Museum of Art, Toledo, Ohio,
Thomas A. DeVilbiss Bequest, 1938. Photo The Toledo Museum of Art.

anticipation of the meeting, not shared by the monks who are absorbed in conversation. The narrative is thus implied for the knowledgeable spectator.

In 1839 Delacroix painted *Return of Columbus from the New World.* The event was also painted by his friend Devéria; his *Reception of Christopher Columbus* shows the explorer, who looks a bit like Shakespeare, kneeling to kiss Isabella's hand. Aside from the *dramatis personae,* the two interpretations are very different. Devéria's ceremony takes place indoors, with attention lavished on a Moorish *décor,* in strong contrast with Delacroix's Italianate city. The scene is packed with elaborately dressed figures, trophies, and what appear to be Indian impersonators from the Opéra Comique. (In Delacroix's version a party of Indians also awaits the royal attention.[33])

If Devéria's academic vulgarization of baroque abundance has overwhelmed any meaning his canvas might have had, Delacroix better understood the need

33. As in the earlier painting of the Natchez, a subject from Chateaubriand's *Atala,* Delacroix here pictures American Indians as he imagined they might look. Apparently he did not see an Indian until 1845, when George Catlin brought a troupe of Iowa Indians to Paris. They made a vivid impression on Delacroix, and he made a number of sketches of them (see Robert Beetem, "George Catlin in France," *Art Quarterly,* 24, No. 2 [Summer, 1961]:129–45).

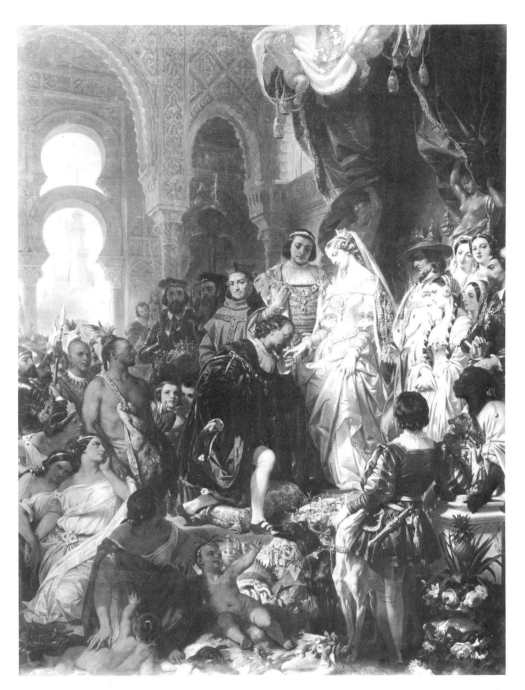

FIGURE 115. Eugène Devéria. *Reception of Christopher Columbus by Ferdinand and Isabella.* 1860. Musée Clermont-Ferrand. Photo Bulloz.

for pictorial form. In *Return of Columbus* he used elements from paintings by Titian. The right half of the composition, for example, is undeniably related to Titian's *Presentation of the Virgin*, in the Accademia in Venice, which he knew from reproductions. The scale of Delacroix's scene is somewhat diminished and some of the detail has been eliminated, but the essentials are retained, even to the inclusion of a balcony like Titian's in the upper center of the picture. Columbus occupies the place of Mary, and Ferdinand and Isabella replace Titian's priests. Although the left half of the scene has little to do with the *Presentation*, it does echo Titian's *Mocking of Christ* in the Kunsthistorisches Museum in Vienna. Although Delacroix's physical types differ from Titian's, they assume similar poses. In the most amusing transformation, the pale woman seen near the center holding the hand of her son has been metamorphosed into a dusky West Indian lady and her child. These figures appear in reverse, perhaps as they looked in the print that Delacroix used. He has also introduced architectural elements from yet another source without incongruity: the Palazzo Vecchio in Florence is strongly suggested in the building with a tower to the left of the balcony. What is most impressive, however, is that for all his debt to Titian the *Return of Columbus* is no less recognizable as a painting by Delacroix than any of his other works.

We have seen that, in spite of the popular view of Delacroix as "Shakespearean," he was often drawn to the classical past, not only in his murals, where antique references abound, but in other works as well. Such early efforts as *Roman Matrons Giving Up Their Jewels for Their Country* of 1818 and the allegories painted for Talma's dining room reflect the neoclassical atmosphere of Guérin's atelier. When he later attempted murals, his sense of classical authority revived, and he found in allegory the dignity he felt to be appropriate to monumental decoration.[34] It would seem that his inclusion of classical motifs in his other work, conspicuous by their absence in his painting of the immediately preceding period, is a related development.

The first major example of a classical reaffirmation is his *Medea*. The theme attracted him as early as 1824,[35] but he did not undertake a painting of it until 1836,[36] while he was finishing the murals for the Salon du Roi.[37] The style of the murals can be seen in his several versions of the Medea subject, in every one of which there is the same basic composition: the furious queen and her two struggling children, whom she is about to stab, form a compact, brightly lit vertical mass in a dark setting. The most successful rendition of the theme is now at Lille, along with studies for it which include an oil sketch that is different in color, handling, and compositional detail. A later version, similar to the one at Lille, is now in the Louvre.[38]

Delacroix's literary source was not the Greek myth. In that account Medea's children, seven sons and seven daughters, are stoned by the angry people of Corinth as punishment for her treacherous murder of King Creon and his daughter Creusa, whom Jason, tiring of Medea, his wife, planned to marry. In Euripides' play, perhaps because of Corinthian influence, the Queen is made to murder her two sons, the only children of her marriage. It appears that Delacroix's concept of the action is closer to the classical play than to the myth. In Euripides' drama, however, the murder is done offstage, behind the barred doors of the palace, and Medea tells Jason of her deed only after it is done. In Seneca's version, if not in Corneille's adaptation of it, on the other hand, Medea is seen to murder

34. It is noteworthy that his trial frescoes at Valmont, done prior to the Palais Bourbon project, utilize classical subjects. For further discussion of these panels, see Chapter Ten below.

35. See *J*, 1:58 (Mar. 4, 1824).

36. See *M*, pp. 184–90.

37. For further discussion of these decorations, see Chapter Ten below.

38. See *M*, pp. 404–5.

FIGURE 116. *Medea*. 1838.
Oil on canvas. 2.60 × 1.65. Musée des Beaux-Arts, Lille. Photo S.D.P.

the children, in defiance of Horace's dictum: "Let not Medea kill her children before the audience." In Seneca the murderess appears on the battlements; in Corneille, on a balcony. There is, therefore, no precise literary precedent for Delacroix's removal of Medea to a forbidding, rocky landscape. Once again, as, for example, in his *Bride of Abydos*, he provided a setting that he considered suitable to the action, without concern for fidelity to literary sources.

Delacroix's Medea is unremitting in her malevolent fury. It is understandable that the painter should have turned for inspiration to Seneca in particular, as he reflects the more violent spirit of Roman art, that melodramatic and personalized tragedy which he admired in Shakespeare. It is likely that he was attracted to this subject by Medea's unnatural willingness to make the most terrible of sacrifices in the name of honor.

Medea has other relationships with past pictorial art. Of interest here are its strong affinities with the paintings of Leonardo, in particular his great compositions in the Louvre, *Madonna of the Rocks* and *Virgin and Child with St. Anne*. Leonardo's popularity was great at this time, not only as a revered Italian master but as an attractive historical figure. He died in France, and it was supposed at the time that Francois I was in attendance—Ingres himself portrayed that apocryphal scene in one of his entries in the Salon of 1824. Delacroix's adoption of a mysterious grotto as his setting suggests a pictorial rather than a poetic deference to Leonardo, however. The shadowed rocky landscape suggests Leonardo's settings, even to the inclusion of carefully differentiated plants and flowers in the foreground, and there are general resemblances of technique and structure as well. There is in *Medea* something of that *sfumato*, or "smokiness," of Leonardo's paintings, with their softened edges and simplified interior modeling, to which Delacroix refers in his *Journal*.[39] The spiraling torsion of the figures also recalls that magician who "discovered everything," as Delacroix once put it.[40] At the same time, this configuration even more strongly recalls Michelangelo's *Medici Madonna*, as though Delacroix intended to play upon qualities of "half-concealment" to point up the horror of his scene. Thus considered, *Medea* becomes a kind of troubling paraphrase of the theme of the Madonna and Child and St. John, the protectress turned assailant.

Vastly different from *Medea* in expression, scale, and traditional associations is another classical subject Delacroix completed two years later, his monumental *Justice of Trajan*. Even in its present bad repair and awkward placement in the library at Rouen, it is one of the most imposing and thoroughly resolved of the artist's large official works. When he went to Rouen to see it in 1849, Delacroix wrote with satifaction in his *Journal*: "I cannot ever remember being so much pleased with one of my pictures when I have come across it in a gallery long after I have forgotten it. Unfortunately, one of the most interesting parts, probably the most interesting of all, was hidden [by a temporary scaffolding]; the woman who is kneeling at the feet of the Emperor. But what I did manage to see of the picture struck me as having so much depth and vigour that everything else, without exception, was put in the shade. Curiously enough, the picture seemed brilliant, although it is mostly dark in tone."[41]

The subject is an episode from Dante's *Purgatorio*, which Delacroix probably read in a French translation by Antony Deschamps.[42] In Canto X the Emperor meets a grief-stricken widow, who stops him on his way to war at the head of his legions. The woman demands justice for the killing of her son. Preoccupied

39. *J*, 1:75 (Apr. 11, 1824).

40. *J*, 1:274 (Mar. 10, 1849).

41. *J*, W, p. 101 (Oct. 3, 1849).

42. See Escholier, *Delacroix*, 2:259.

FIGURE 117. *Justice of Trajan.* 1840.
Oil on canvas. 4.90 × 3.90. Musée des Beaux-Arts, Rouen. Photo S.D.P.

43. This story and some of its appearances in art and literature are conveniently summarized in Jean Seznec, "Diderot and 'The Justice of Trajan,'" *Journal of the Warburg and Courtauld Institutes*, 20 (January, 1957): 106–11. The iconography here suggested follows that proposed by Seznec. For a further discussion of the work, see Maurice Allinne, *La genèse d'un chef d'oeuvre: La Justice de Trajan* (Rouen, 1930).

with his military mission, Trajan tries to disregard her pleas, but she persuades him of her right under ancient law to demand his attention, and he grants her suit. This legend was preserved throughout the Middle Ages and led finally to the Emperor's incorporation into Christian legend as an example of the purification of the proud.[43] It is said that in the seventh century Pope Gregory the Great was so moved by the story that he interceded with God on behalf of Trajan, who therefore found his way into Paradise despite the fact that he was a pagan. Thus in Canto XX of *Il Paradiso* Trajan's soul is among those comprising the eye of the eagle, a part of the symbol for universal empire. Delacroix's subject is therefore at once both Christian and classical.

FIGURE 118. Studies for *Justice of Trajan*. Ca. 1839.
Pencil. 0.21 × 0.34. Musée des Beaux-Arts, Rouen. Photo Ellebé.

The stories of Trajan and of other emperors such as Augustus, Titus, and Marcus Aurelius, who were also men of good will, served as themes for French artists of the eighteenth century. In his essay on Diderot and Trajan Jean Seznec reports the critic's contemptuous response to a picture by a painter named Hallé, in which he felt the meaning of the scene had been lost:

I will tell you how another artist might have tackled it. He would have halted Trajan in the center of his canvas; the chief officers of his army would have been standing around him, and the face of each one of them would have revealed the impression made on them by the suppliant's words. . . . And why shouldn't your woman, overcome with sorrow, be surrounded and supported by companions in the same way? You want her alone, and kneeling? Very well, then—but in heaven's name, don't show her to me from the back. Her face should express her grief; she should be beautiful, and have the dignity suited to her condition, her gestures should be strong and pathetic. . . . go and study the "Family of Darius," and you will find out how to make the subordinate characters contribute to the interest of the main personages.[44]

An arresting detail in Diderot's commentary is, of course, the mention of the theme of the family of Darius, which appears prominently in Delacroix's decoration of the hemicycle in the library of the Luxembourg Palace. Diderot's conjunction of the two subjects may well explain their occurrence in these two works. One long passage in the *Journal*, for example, summarizes Diderot's views on actors, along with his own ideas about the theater and dramatic literature.[45] Delacroix's effort to reconcile passion and artistic control are of profound biographical interest. At the same time, their common acceptance of the classical unities and the interdependence of form and structure indicates that both men spring from the same cultural roots. It is therefore not surprising to find a striking correlation between Diderot's exhortations and Delacroix's practice in *Justice of Trajan*: "Why could not the presence of an army be indicated by a crowd of faces grouped round the Emperor? A few of these figures cut by the edge of the

44. Seznec, "The Justice of Trajan," p. 110. Diderot's text is given in English in this essay.

45. 1:170–74 (Jan. 27, 1847).

46. Diderot, quoted in Seznec, "The Justice of Trajan," p. 111.

47. "Delacroix et Rubens, La Justice de Trajan et L'Élévation de la Croix d'Anvers," *Gazette des Beaux-Arts*, 6th ser., 18 (July–December, 1932): 245–48.

canvas would have been enough to suggest to my imagination an infinite number beyond the limits of the picture. And why are there no witnesses, no spectators on the woman's side of the scene? ... In this way, it seems to me, the composition could have been greatly enriched." [46]

One could detail the sources for *Trajan* in traditional art, but let it suffice to say that there are recollections of Poussin (*Victory of Gideon over the Amelak*, in the Vatican), of the equestrian bronze of Marcus Aurelius in Rome, especially obvious in one of Delacroix's preparatory drawings (Louvre R.F. 9 363), and a general debt to the Venetians, particularly to Veronese, in the character of the architectural setting. Élie Lambert has pointed out further similarities to the wings of Rubens' *Elevation of the Cross*, which Delacroix saw in Antwerp in 1838, not long before he finished *Trajan*. [47] In some details, however, he has, in effect, quoted from his own works, as in the figure of the mother, whose pose he employed with minor variations for the Prisoner of Chillon, the Giaour, Arab huntsmen, and others. More important is the fusion of decoration, narrative, and expression. The touch is broader and surer, the spatial organization is clearer, and the pictorial structure is more controlled. No longer "the pupil of Tintoretto," he is now the rival of the whole Venetian school. Where *Massacre at Scio* was remarkable for its promise, *Justice of Trajan* has fulfilled that promise.

A further indication of Delacroix's interest in classical themes is his *Last Words of Marcus Aurelius*. It appears that he had originally considered it for inclusion

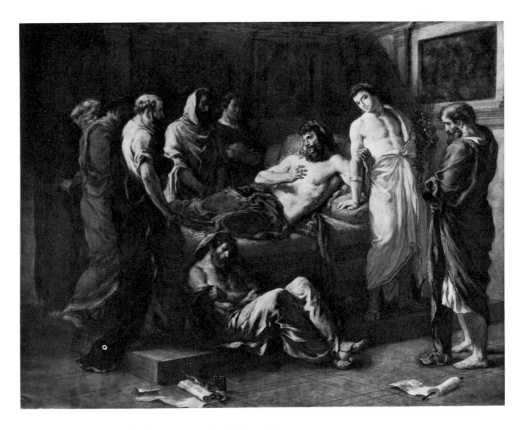

FIGURE 119. *Last Words of Marcus Aurelius*. Salon of 1845.
Oil on canvas. 2.56 × 3.30. Musée des Beaux-Arts, Lyon. Photo Archives Photographiques, Paris.

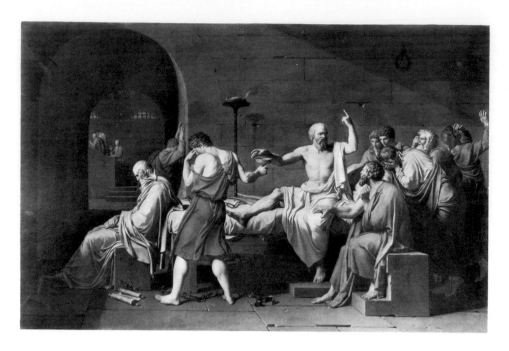

FIGURE 120. Jacques-Louis David. *Death of Socrates.* 1787.
Oil on canvas. 1.30 × 1.96. The Metropolitan Museum of Art, Wolfe Fund, 1931.
Photo The Metropolitan Museum of Art.

in his program for the library of the Palais Bourbon.[48] For some reason, however, he chose not to do so, perhaps because of the difficulty of accommodating the scene to the format of the pendentives there. As with his other major projects of the period, he entrusted much of the initial work on the canvas to an assistant. In this case it was Louis de Planet who laid in the *ébauche* and the basic glazes in accordance with Delacroix's preparatory oil sketch and under his supervision. Most of the present knowledge of the execution of the picture derives, in fact, from De Planet's *Souvenirs*, in which he mentions his own part in carrying out the enlarged version.[49] It is clear from his notes that this phase of the undertaking was begun in the summer of 1843 and was completed within a few weeks. The length of time required for Delacroix's refinement of the prepared canvas is uncertain, although it would seem that the composition was finished well before it was exhibited at the Salon of 1845.[50]

Although Baudelaire praised *Marcus Aurelius* without qualification, other reviewers were annoyed by Delacroix's historical inaccuracy. Some saw his interpretation as "trivial" and "debased," perhaps referring to the fawning, effeminate Commodus. There can be little doubt, however, that the portrayal of this profligate is effective as a contrast to the other figures around the deathbed. Consistency of tone is violated in deference to dramatic values, values quite different from those inherent in, for example, David's *Death of Socrates*, with which this composition may be fruitfully compared in other ways. Delacroix was something of a philosopher and a stoic and was committed to the ideals symbolized by the dying Emperor.[51] His withdrawn and pessimistic intellectual outlook gives ultimate coherence to what often seems a miscellany of subject matter. In the following chapter I shall offer further evidence for this suggestion.

48. See *PM*, pp. 51–52; *M*, pp. 245–49.

49. *Souvenirs de travaux de peinture avec M. Eugène Delacroix* (Paris: Colin, 1929), pp. 17, 69, 74, 76–77. De Planet states that he received the oil sketch and two additional pencil drawings on June 7, 1843 (pp. 76–77).

50. *Ibid.*, p. 97. De Planet implies that it had been completed by January 18, 1844. The salon catalogue contains the artist's customary statement about the subject matter of the entry: "The perverse tendencies of Commodus were already apparent. As a dying act the Emperor pointed out the youth of his son to some of his friends, philosophers and stoics like himself; but their doleful mien makes all too clear the vanity of his charges to them and their own deadly forebodings as to the future of the Roman Empire."

51. The tradition of death as a moral exemplum has recently been explored in detail by Robert Rosenblum (*Transformations in Late Eighteenth-Century Art* [Princeton, N.J.: Princeton University Press, 1967], chap. 2, "The *Exemplum Virtutis*").

Two Sides of the Moral Universe

1. Charles Baudelaire, *The Painter of Modern Life and Other Essays*, trans. and ed. Jonathan Mayne (London: Phaidon, 1964), p. 45.

FIGURE 121. Drawings of dissected animals. N.d. Pencil. 0.25 × 0.19. Cabinet des Dessins, Louvre. Photo S.D.P.

2. *Cf. C*, 1:152–53. A letter to Stendhal, written in October, 1824, invites him to go to the Jardin des Plantes. Another letter of the same period, written to Mme Cuvier, the wife of the director of the Jardin, seems to indicate Delacroix's desire for authorization to sketch there.

3. See C. O. Zeiseniss, *Les aquarelles de Barye: Étude critique et catalogue raisonné* (Paris: Massin, n.d.), pp. 11, 35ff.

4. Robaut's date of 1854 seems rather too late for these.

5. *C*, 1:225.

6. See *M*, p. 46, No. 70.

Two recurrent and contrasting themes in Delacroix's art were wild animals and religious subjects. Each in its way satisfied certain needs he felt for external stimulation. Baudelaire put it brilliantly: "Delacroix was passionately in love with passion and coldly determined to seek the means of expressing it."[1] Within this apparently incongruous range of subjects that quality of passion was persistent whether at the level of animal behavior or at the heights of spiritual and moral revelation. In Delacroix's world bestial, amoral force coexisted with love and sacrifice. The moral spectrum ran from animal to human, and whatever the spiritual level of the life depicted, its inevitable end was death.

The Robaut catalogue contains almost two hundred wild animal subjects, ranging from small studies in pencil or pen and ink to large paintings in oil, such as *Young Tiger Playing with His Mother*. They vary in complexity as well as size. Some, including several large scenes of the hunt, are quite ambitious. Others are modest in both scale and composition and were done, it would seem, solely for the private satisfaction of their maker. The *Correspondance* implies that as early as 1824 Delacroix had followed Géricault's example and had sketched from time to time in the Jardin des Plantes.[2] In 1828 he was visiting the menageries at Saint-Cloud in the company of Barye, who had been studying animal anatomy and zoology since 1825.[3] It would appear that it was Barye who introduced Delacroix to drawing cadavers of the "great cats," many of which *écorchés* are now in the Cabinet des Dessins at the Louvre.[4] His interest in dissections of such rare and valuable specimens may explain a curious note written to Barye on Saturday, October 16, 1828: "The lion is dead.—Full speed ahead [*au galop*]. The weather should enliven us. I wait for you."[5]

In the period 1825–1828 these studies began to appear as artistic motifs. Sometimes the reference is only indirect, as in the small autograph sketches in the margins of his lithograph of Bonington's *Visit* and in some of the *Faust* illustrations. Perhaps related is a marginal drawing of a bull attacked by a lion on the sheet showing six antique medals owned by the Duke of Blacas. At about the same time he did the small water colors *Tiger Attacking a Wild Horse* (Louvre R.F. 4 048) and *Horse Frightened by a Storm*, now in the Museum of Fine Arts, Budapest, which he traded to Schwiter for some prints after antique medals.[6] In 1828 he did a lithograph of the former subject. In the following year two of his finest lithographs were issued, *Atlas Lion* and *Royal Tiger*. After that, for every year except three (1831, 1836, and 1860) Robaut's catalogue lists some surviving representation of the lion. Of course, it is not always certain that Robaut's dates are accurate. Some twenty representations of the *grands fauves* are listed without date in the supplement to the catalogue, and others not listed there at all have subsequently come to light. It may be, therefore, that after 1824 there was no year at all when Delacroix did not use animal subjects in some fashion. Like Géricault, Delacroix undertook sculptures of animals as well, if only in a small

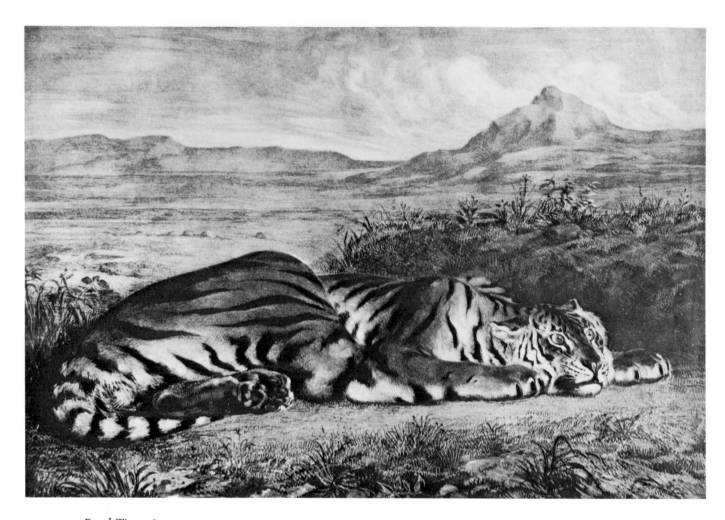

FIGURE 122. *Royal Tiger.* 1829.
Lithograph. 0.33 × 0.47. Amherst College. Photo Donald Witkoski.

way.[7] Unfortunately, none of those efforts has survived. Many of the animal pieces, particularly those dating from the artist's later years, seem to have been done during periods of recovery from illness or of respite from work on major projects, almost as though Delacroix sought to revive his own strength through the vigor of these beasts. Both the number and the spacing of his animal subjects may be explained in this way.

Tiger Attacking a Wild Horse is one of the earliest surviving examples of the genre and is important because it suggests Géricault's prints *Horse Attacked by a Lion* (Delteil 42), which was probably made in 1821, and his two versions of *Horse Devoured by a Lion* (Delteil 26 and 27), which are dated 1821 and 1823, respectively. Géricault's oil *Lion Attacking a White Horse*, done around 1820–1822 from a composition by George Stubbs,[8] may have been known to Delacroix. He may also have seen such splendid drawings by Géricault as his Louvre *Horse Attacked by a Lion* (Inv. 26–739), which is close in composition to Delacroix's lithograph of the subject. In any case, Géricault, who was himself working out of older traditions derived through Stubbs and his own teacher, Carle Vernet,

7. See *C*, 1:226–27, n. 1 (to Barye).

8. Géricault's copy, now in the Louvre, was apparently made from the print published by Stubbs in 1788, based on one of his several painted versions of the subject. See *Painting in England 1700–1850: Collection of Mr. and Mrs. Paul Mellon*, intro. Basil Taylor, 2 vols. (Richmond: Virginia Museum of Fine Arts, 1963), 1:174–75. The attribution of this canvas is not unquestioned (see, for example, Charles Sterling and Hélène Adhémar, *Musée National du Louvre, peintures école française XIXᵉ siècle*, 4 vols. [Paris: Éditions des Musées Nationaux, 1959], 2:37, plate 345).

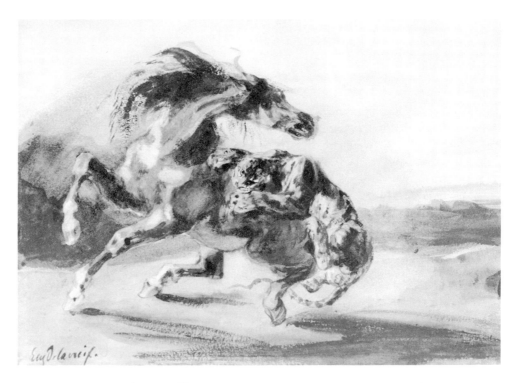

FIGURE 123. *Tiger Attacking a Wild Horse.* 1825–28.
Water color. 0.18 × 0.25. Cabinet des Dessins, Louvre. Photo S.D.P.

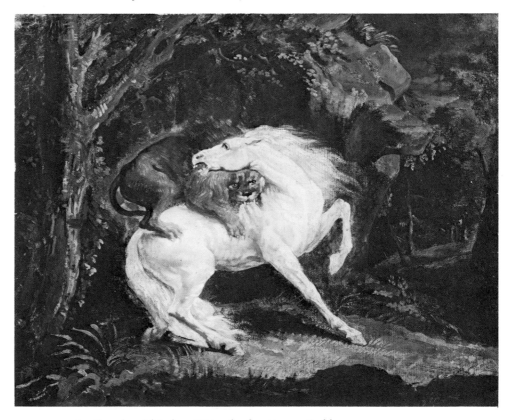

FIGURE 124. Attributed to Théodore Géricault after George Stubbs.
Lion Attacking a White Horse. 1820–22?
Oil on canvas. 0.54 × 0.65. Louvre. Photo Giraudon.

appears to have been the one who passed on to Delacroix the motif of the horse as prey to the *grands fauves*.

The new note of realism in Delacroix's animal studies may represent a further debt to Géricault. Where the animals of Stubbs, Boucher, and Vernet were stylized and decorative, Géricault's creatures are convincingly rendered from study of actual specimens. He had returned to a more vigorous, baroque realism. His beasts are neither pets nor stuffed effigies, as are those of his rococo predecessors. But Géricault's growing fidelity to nature, so suggestive of Courbet, was ultimately at variance with Delacroix's taste for artful fantasy in his animal subjects.

For the romantic generation the big cats, at once dangerous and beautiful, were superb symbols of grace, power, and adventure. Long before art was made into Matisse's "armchair," it served as a magic carpet, and nineteenth-century Europeans bored by the routine of their lives but unwilling to suffer the risks and discomfort of a real safari to the Moslem lands or to newly British India could satisfy their curiosity in a vicarious world of images. The new and often drab realities of the nineteenth century could be forgotten in the fierce amorality of nature, and Delacroix clearly shared this taste.

There can be no doubt that his two earliest animal subjects, the lithographs *Atlas Lion* and *Royal Tiger*, are outstanding. They are vivid in characterization, powerful in form, and rich in tone. As with his other lithographs of the time, the contours are clearly defined and the interior modeling and surface textures convincingly differentiated. He is in technical command of the medium, and the tonal range is at once subtle in gradation and bold in over-all effect. While the execution is actually freer than it may at first seem, there is more attention to detail than is characteristic of his later work. These two prints, done as pendants, mark the beginning of a series of compositions in which a single animal is shown, as here, against a landscape setting. Although the landscape is more detailed here than it will be later, the dominant figure engaged in a typical action remains a frequent device. Many of Delacroix's animal compositions are more complex than these prints. His *Tiger Attacking a Wild Horse* is typical of his more elaborate subjects. Another early work, the large oil *Young Tiger Playing with His Mother*, demonstrates on a more ambitious scale the painter's keen observation, his compositional ingenuity, and his wide range of mood.

Where some of his depictions stress the ferocious and predatory instincts, the harsh beauty of the kill, observed with curious—almost ceremonial—objectivity, others, such as *Young Tiger*, present what is, in effect, a portrait of the beast done with sympathy or even amusement. The guile of the royal tiger, the poise of the Atlas lion, the awkward affection of the young tiger, give each a charm that is not ordinarily found in works of the genre, not even those by Delacroix's talented friend Barye. There is often a human quality in the behavior of many of Delacroix's beasts that recalls his drawings of house cats and his interest in trained animal acts, those *animaux savants* that had been popular since the eighteenth century. A loyal patron of the Franconi Cirque Olympique, Delacroix must have seen the famous menagerie of Henri Martin, whose "Lions of Mysore" were much admired by Gautier, among others.[9] Subjects like *Lion Watching a Turtle* strongly suggest such tame, not wild, beasts.

As the years went on Delacroix undertook larger and more complex compositions employing the vocabulary of feline forms and movements he had observed. His fantasies representing scenes of the chase witness his devotion to the fierce and

9. For a discussion of these acts and illustrations of some of the more famous ones, see Marian Hannah Winter, *Le théâtre du merveilleux* (Paris: Olivier Perrin, 1962), chap. 9, pp. 158–75. My conversations with Miss Winter were also illuminating.

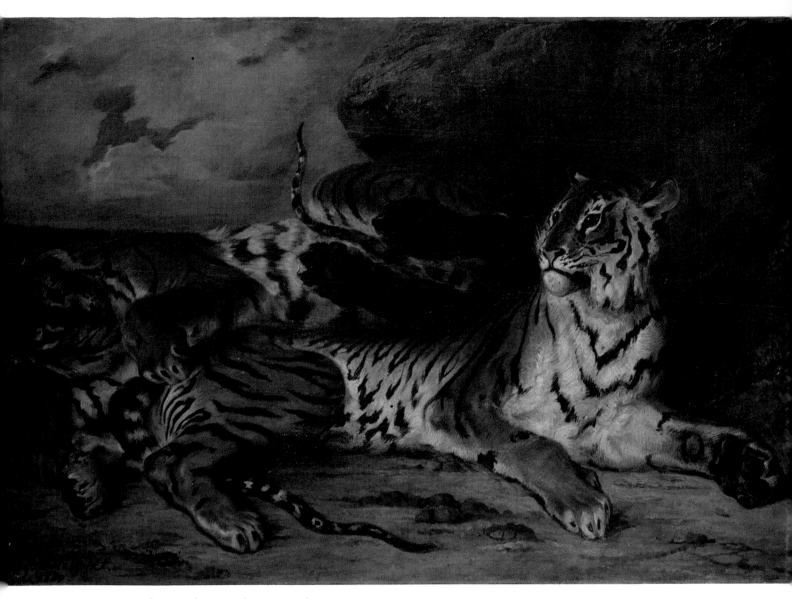

PLATE XVIII. *Young Tiger Playing with His Mother*. 1830. Oil on canvas. 1.30 × 1.95. Louvre.

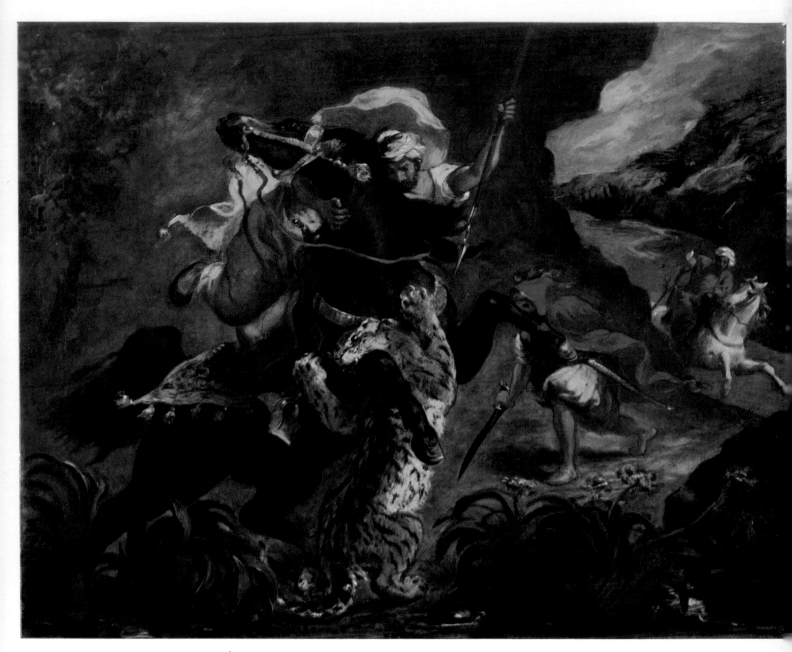

PLATE XIX. *Tiger Hunt.* 1854. Oil on canvas. 0.74 × 0.93. Louvre.

10. See, for example, Art Institute of Chicago, *Paintings in the Art Institute of Chicago, a Catalogue of the Picture Collection* (Chicago, Ill.: By the Art Institute, 1961), p. 123: "When Delacroix went to Africa in 1832 he had the opportunity of seeing actual combats between Arabs and wild beasts." No source for this information is given. The letters and the notes of the trip included in the *Journal* make no reference to such incidents.

11. These subjects were originally designed for the heir-apparent as the main features of a lavish *surtout de table*, but when that costly project was abandoned, the models were cast in base metal rather than silver, as originally intended. The entire set was sold at auction by the Duke's widow in 1863. Three of the groups (*Tiger Hunt, Elk Hunt,* and *Bear Hunt*) were then purchased by Prince Demidoff, whose portrait Delacroix painted. Along with two other pieces from the set (*Ox Hunt* and *Lion Hunt*), they are now in the Walters Art Gallery in Baltimore. The fate of the remaining groups has not come to light. See George Heard Hamilton, "The Origin of Barye's *Tiger Hunt*," *The Art Bulletin*, 18 (June, 1936): 248–57, in which he points out (p. 250, n. 4) that the five Walters pieces were not all finished and cast in 1834, as had once been supposed. *Tiger Hunt* is dated 1836, *Lion Hunt* 1837, and the other three compositions 1838. See also Roger Ballu, *L'Oeuvre de Barye* (Paris: Quantin, 1890), pp. 56–58, 72–78; P. Verdier, "Delacroix's 'Grandes Machines': 2," *Connoisseur*, 157 (September, 1964): 9 and n. 65.

12. *J*, 3:15 (Jan. 13, 1857).

13. See *J*, 2:171, n. 1.

deadly beauty of wild creatures. *Tiger Hunt* of 1854, now in the Louvre, is a particularly fine example. Here the exotic East converges with the life of wild animals. A mounted Arab horseman is about to spear a tiger who is attacking his rearing, agonized horse, a motif which first appeared in 1849 in the canvas *Arab on Horseback Attacked by a Lion*. In the manner of the late paintings, the handling of the paint is itself emotion-laden. Its complex surface ranges from lustrous accumulations of glaze to rough scrapings of the palette knife, as in the pink saddlecloth of the nearest rider. Although the general tonality is olive, there are touches of white, vermilion, and emerald green, in addition to the yellows of the tiger and the blue-greens of the sky. Lively yet unified, the color is both appropriate to the subject and an independent source of sensuous delight.

The tiger is a masterpiece of ferocious energy, as is the main equestrian group, yet only the most uncritical admirer could fail to perceive the uneven quality of the painting. The landscape is perfunctory: the dominant rock formation is stagy, as is the row of nursery plants lined up along the lower edge of the composition. In the stance and structure of the horse there are spatial elisions that do not add to the power of the image, nor does the crouching figure share in the vigor of the central action. Somewhat mechanical in pose and lacking in spirit, he would seem to be included more for the sake of compositional or spatial balance than for his inherent dramatic interest. The same uneven quality can be observed in the execution. Some sections, including the billowing white cape of the main horseman and the upper section of his pink tunic, appear unfinished or crudely reworked despite the fact that the detail has been painted over this surface, which suggests that these passages were considered "finished."

Although it has been suggested that the sight of such combats between man and beast inspired these hunting scenes, we have no evidence that any such experience took place.[10] Ample models for their general character, however, are found in the art of Rubens and other traditional sources. De Troy's *Lion Hunt*, in the Louvre, shows the genre in the playful manner of a rococo artifice, a taste for which survived even into the days of David (for example, Carle Vernet's *Combat between a Mounted Greek Warrior and a Lion*, now in the Museum of Picardy at Amiens). Géricault's water color *Lion Hunt*, in the Fogg Museum at Harvard University, and Horace Vernet's oil of 1836, now in the Wallace Collection, continue the thematic tradition transmitted by the older Vernet. Perhaps an even more direct model may be found in the sculpture and painting of Barye, who cast nine bronze hunting scenes (one a lion hunt) for the Duke of Orléans in the years 1836–1838.[11] Delacroix doubtless knew these works done for a patron who had furthered his own artistic career, although his admiration could not have been unqualified (he later called Barye's wild beasts "mean"[12]).

Younger artists could also find visual inspiration for their animal pieces in contemporary albums of prints and books about life in Africa and India. One such album, which Delacroix might easily have seen, was *Foreign Field Sports*, issued by Samuel Howett after drawings and descriptions by Captain Thomas Williamson. Originally published in England in the first decade of the nineteenth century, it was soon issued in France, the prints accompanied by a parallel French text. If a further stimulus were needed, a book entitled *La chasse aux lions* was published in 1854 by Jules Gérard, "the Lion-Killer," which immediately became popular.[13]

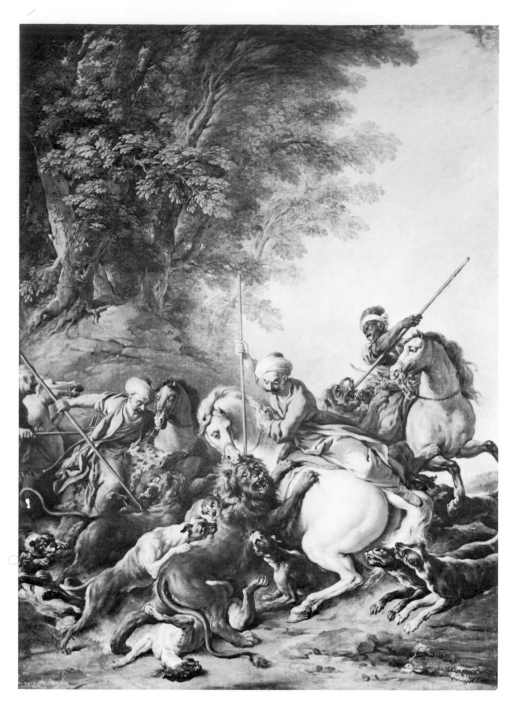

FIGURE 125. Jean-François de Troy. *Lion Hunt*. 1736.
Oil on canvas. 1.70 × 1.30. Musée d'Amiens. Photo Giraudon.

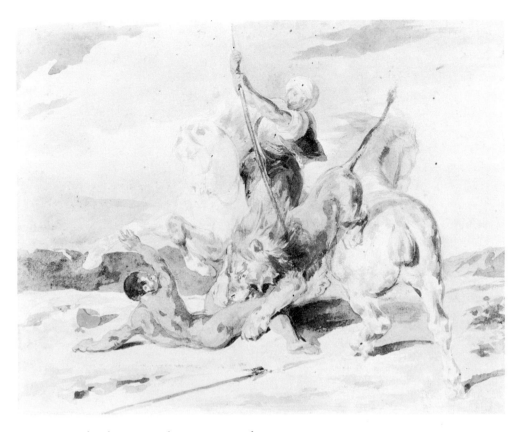

FIGURE 126. Théodore Géricault. *Lion Hunt*. N.d.
Pencil and water color. 0.33 × 0.41. Fogg Art Museum, Harvard University,
Grenville L. Winthrop Bequest. Photo courtesy of the Fogg Art Museum.

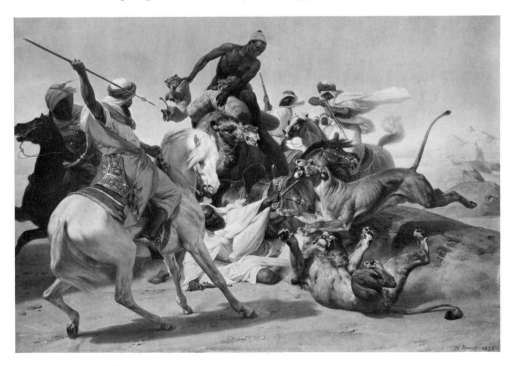

FIGURE 127. Horace Vernet. *Lion Hunt*. 1836.
Oil on canvas. 0.57 × 0.82. The Wallace Collection, London. Photo The Wallace Collection.

Whatever the significance of these sources, Delacroix's debt to Rubens must be considered central. He knew Rubens' hunts largely through prints, especially those by Rubens' pupil, Pieter Claesz Soutman, done from the paintings themselves.[14] Delacroix's *Journal* for January 25, 1847, gives an extensive description of these prints and provides a framework for discussion of his own hunts. This commentary is at once astute in its observations about Rubens and informative in its indication of the attraction such subjects had for the writer:

The influence that the principal lines have upon a composition is immense. At the moment I am looking at the *Hunts* of Rubens, and particularly at the lion hunt, etched by Soutman, in which a lioness springing out of the background of the picture is brought to a standstill by the spear of a horseman who is turning around in his saddle: you can see the spear bending as it pierces the breast of the furious beast. In the foreground, a Moorish horseman has been thrown; his horse, also down, has already been seized by an enormous lion, but the beast is looking back, with a hideous grimace, toward another hunter who is stretched out flat upon the ground and, in a last effort, is plunging a tremendous dagger into the body of the monster. He is pinned to the ground by one of the hind paws of the brute, which is clawing his face in a frightful manner as it feels itself stabbed. The rearing horses, the shaggy manes and tails, a thousand props, unbuckled shields, tangled bridles, all this is calculated to strike the imagination, and the execution is admirable. But the point of view is confused; the eye does not know where to rest; one has the impression of fearful conflict, but it appears that art is not sufficiently in control to enhance through careful arrangement or selectivity the effect of so many brilliant inventions.[15]

14. Delacroix made a copy of part of the Rubens *Wolf Hunt*, which is now in the Metropolitan Museum in New York. It has been suggested that he may have seen the Rubens painting when it was exhibited at the Louvre in 1815 because, as Michael Jaffe has observed, he represents the animals as they appear in the original and not in reverse as they are shown in Soutman's print (see Jean Claparède, *Dessins de la collection Alfred Bruyas et autres dessins des XIXᵉ et XXᵉ siècles*, Montpellier, *Musée Fabre* [Paris: Musées Nationaux, 1962], No. 60, quoting Jaffe).

15. J, 1:168.

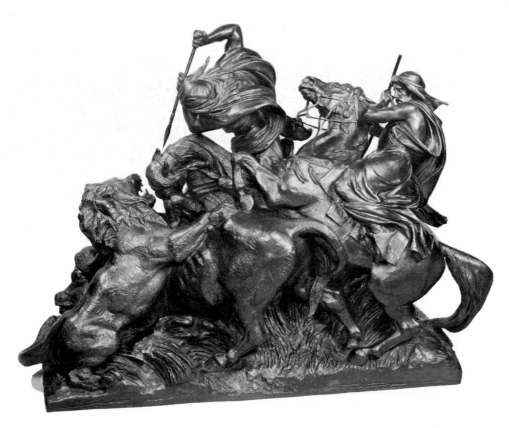

FIGURE 128. Antoine-Louis Barye. *Arab Horsemen Killing a Lion.* 1837. Bronze? Height 0.48. The Walters Art Gallery, Baltimore. Photo courtesy of The Walters Art Gallery.

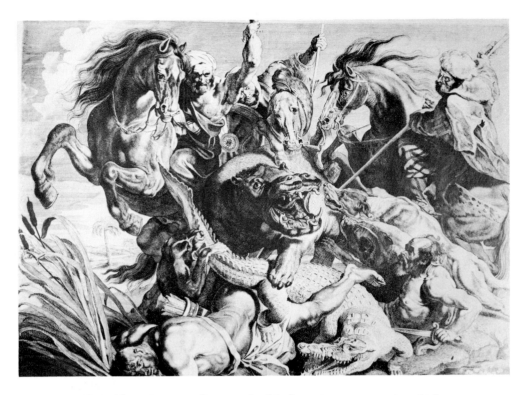

FIGURE 129. Pieter Claesz Soutman after Peter Paul Rubens. *Hippopotamus Hunt*. N.d. Engraving and etching. Dimensions and location unknown. Photo Archives Photographiques, Paris.

Delacroix then proceeds to discuss another etching, *Hippopotamus Hunt*, which he finds inferior in detail and in some of its action but superior in its general organization. His argument for the superiority of *Hippopotamus Hunt* suggests what he may have been striving for in his own hunting scenes: "On the basis of the description, this picture would appear inferior to the preceding one [*Lion Hunt*] in every way: however, because of the manner in which the groups are arranged, or rather because of the single and unique group that forms the entire picture, our imagination receives a shock that is repeated every time we look at it."[16]

Delacroix's praise underlines his precise attention to formal factors. In his analysis of the work, he notes, for example, that the composition assumes the basic shape of a St. Andrew's cross, with the hippopotamus appearing toward the center of the configuration. He also observes the importance of the line of light indicated by the fallen man along the lower margin of the picture, which balances what might have otherwise seemed a top-heavy design. Delacroix's commentary concludes in the same vein: "One incomparable effect is that great sheet of sky which frames both sides of the picture, especially the left side, which is entirely empty, and gives the whole scene, by the very simplicity of the contrast, an incomparable movement, variety, and at the same time unity."[17]

Here we have not only a demonstration of Delacroix's analytical powers but a clear statement of his intentions in the three lion hunts he painted between

16. J, 1:168–69.

17. J, 1:169.

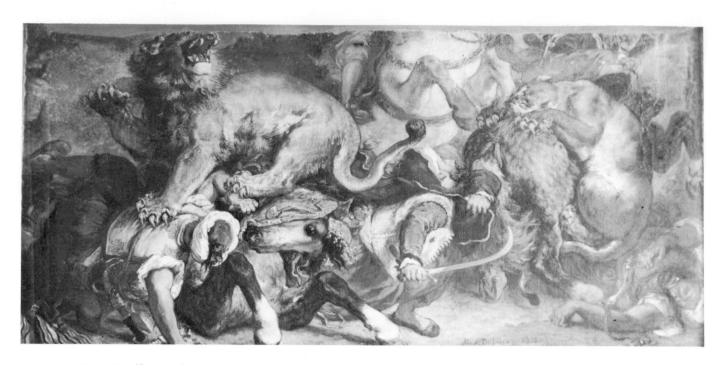

FIGURE 130. *Lion Hunt* (fragment). 1855.
Oil on canvas. 1.77 × 3.60. Musée des Beaux-Arts, Bordeaux. Photo Musée des Beaux-Arts.

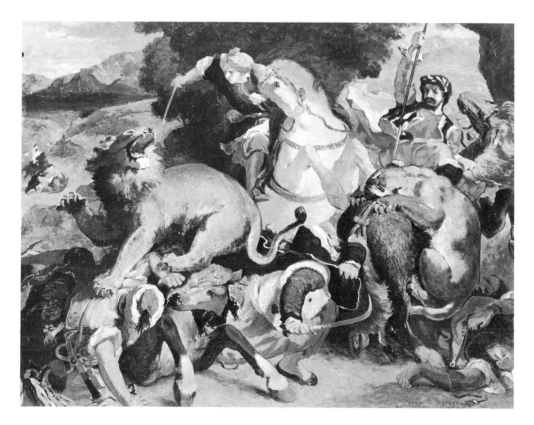

FIGURE 131. Odilon Redon after Delacroix. *Lion Hunt*. Before 1870.
Oil on canvas. 0.50 × 0.40. Musée des Beaux-Arts, Bordeaux. Photo Bulloz.

1854 and 1858. The earliest and largest of these was shown at the Universal Exposition of 1855. The upper section of the painting was destroyed by fire in 1870, so that what remains of the canvas, now in the museum at Bordeaux, is no more than a mighty fragment. The remaining portion is imposing in itself, particularly for its splendid color, and one can derive some sense of the original with the aid of a handsome study and old copies, one by Redon, but it seems more profitable here to consider the two slightly later variants on the theme. The first of these, completed in April 1858, is now in the Museum of Fine Arts in Boston. Another slightly smaller lion hunt, painted three years later, is now in the collection of the Art Institute of Chicago.

The basic themes and even certain pictorial devices are similar in all three versions of the subject. Each contains, for example, the motif of the male lion

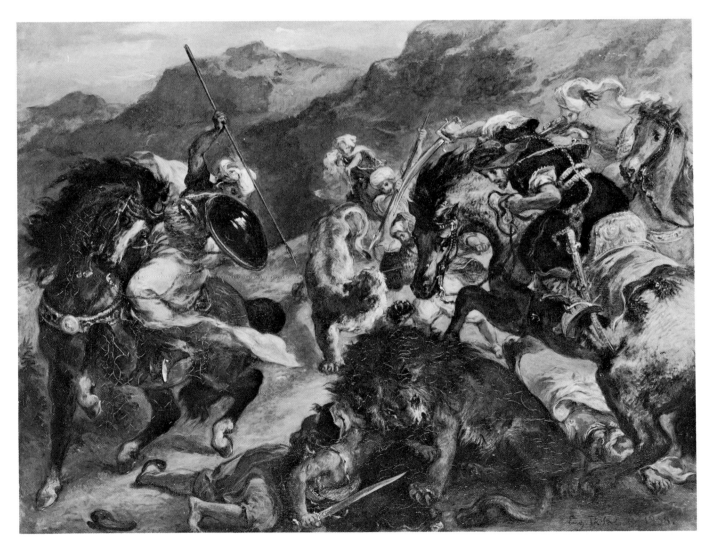

FIGURE 132. *Lion Hunt.* 1858.
Oil on canvas. 0.90 × 1.16. Museum of Fine Arts, Boston, S. A. Denio Collection.
Photo Museum of Fine Arts.

directly attacking a fallen swordsman. The poses of the lions in the Bordeaux and Chicago canvases are, in fact, very similar. As a whole, however, each composition constitutes a distinct formal variation. The Bordeaux picture follows Rubens' hunts more closely, with the figures in a dense foreground cluster. The tangle of fallen and struggling men and beasts of Delacroix's Bordeaux canvas is (or was) dominated by a horseman on a pale steed rearing above them. The later variants utilize a deeper picture space, within which the figures are relatively small and more dispersed. This is particularly marked in the Chicago canvas, in which the participants form a kind of elliptical center of furious activity.

Delacroix's third lion hunt, in many ways the most fully resolved of these compositions, has greater urgency of action and unity of effect. The effort at

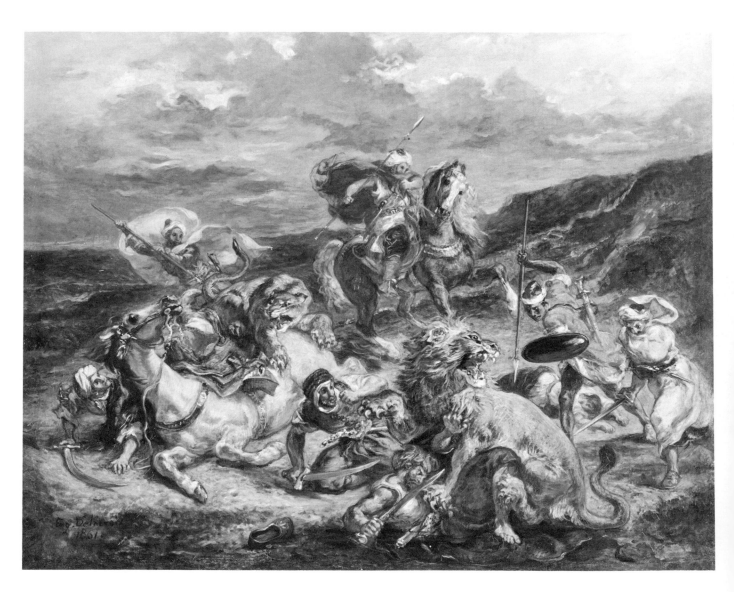

FIGURE 133. *Lion Hunt.* 1861.
Oil on canvas. 0.72 × 0.98. The Art Institute of Chicago, Potter Palmer Collection.
Photo courtesy of The Art Institute of Chicago.

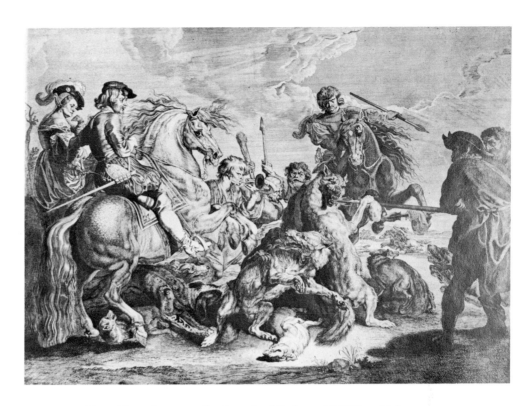

FIGURE 134. Pieter Claesz Soutman after Peter Paul Rubens. *Wolf Hunt*. N.d.
Engraving and etching. Dimensions and location unknown.
Photo Archives Photographiques, Paris.

clarity in the Boston *Lion Hunt* is, in the end, a trifle awkward and obvious.
Although the horse and rider in the right foreground are energetic and the massive,
pyramidal lion is the epitome of crushing power, the painting as a whole is not
as successful as the later one. In the center of the Boston picture the space is ingeni-
ously screened, except for an opening into the middle ground, where a lioness is
under attack. This progression into the picture space is awkward. In an apparent
effort to gain the clarity he felt was wanting in the Rubens hunts, Delacroix has
arranged his figures in compartmental units with too much precision. Their
relationship to each other is neither smooth nor convincing.

Both of the later lion hunts and the closely related *Tiger Hunt* also show certain
qualities of figural articulation that had come to be characteristic of Delacroix.
Although the pose of the tiger resembles that of a wolf in the Rubens *Wolf Hunt*
and a tiger in his *Tiger and Lion Hunt*, now in the museum at Rennes, it could
never be confused with an animal painted by the Flemish master or one of his
assistants.[18] Issue must be taken with those critics who see evidence of "a more
profound knowledge of feline anatomy" in these works; it is simply not there.[19]
They must be admired for other reasons. What is physically and anatomically
convincing movement in the Rubens becomes nervous and arbitrary in the
Delacroix.

As he developed as an artist Delacroix paid less and less attention to accuracy of
anatomical structure and convincing physical movement. His figures, and his

18. The Rennes picture is thought
to include a great deal of work by
Franz Snyders (see Claparède,
Dessins de la collection Alfred Bruyas;
see also H. Gerson and E. H. Ter
Kuile, *Art and Architecture in Belgium
1600–1800*, trans. Olive Renier
[Baltimore: Penguin Books, 1960],
p. 159, plate 146a).

19. *Cf.* Johnson, *Delacroix: 1798–1863*,
p. 55.

space as well, were compounded of associations that depended little upon verisimilitude. Where one senses the ripple of muscle and bone in Rubens' snarling wolf, Delacroix's tiger is a bundle of almost disembodied energy. His picture demonstrates the "sacrifices" he asked of Rubens and his heavy reliance upon the imagination of the spectator. Detail is minimal, as in the tiger's tooth and claw and glistening eye. Even in the more elaborate Bordeaux *Lion Hunt*, the lioness at the right, clearly derived from the tiger clawing the rider in the center of Rubens' composition, is comparatively simple. This concentration on crucial passages at the expense of elaboration doubtless represents an attempt to resolve what Delacroix sometimes regarded as a qualification of Rubens' success. At the same time, his profound admiration for—even dependence upon—Rubens is evident.

Hunting subjects had a further attraction because they provided an opportunity to exploit the pictorial possibilities of the horse. In the hunts the horse traditionally appears both as man's ally and as the hapless victim of the attack of carnivores. Often, however, Delacroix pictured the horse as itself a wild creature, possessed of those same qualities of fleetness, ferocity, and strength that made the *grands fauves* fascinating. He therefore preferred the nervous, quick-tempered Arabian horses, to which his favorite agitated, arching movements and flying tails and manes were especially suited, and, unlike Géricault, was disinclined to explore the range of domestic breeds.[20] The early *Horse Frightened by a Storm* or the late *Arab Horses Fighting in a Stable* are therefore more indicative of the meaning of the horse image in his art than are his numerous more literal equine studies, handsome though many of them are.[21]

One of the earliest surviving notes from his stay in Morocco mentions "the scene of the fighting horses," which is usually taken to relate to *Collision of Arab Horsemen* and perhaps, in some general way, to the later *Arab Horses Fighting*:

From the start, they reared and fought with a ferocity which made me tremble for those gentlemen [their riders], but which was really admirable for painting. I saw there, I am sure, the most fantastic and graceful movements that Gros and Rubens could have imagined. Then the gray got his head over the neck of the other one. For what seemed like an eternity it was impossible to make him let go. . . . the black reared furiously. The other one continued to bite him fiercely from behind. . . . they kept on fighting with each other as they got to the river bank, both falling down there, continuing to fight and at the same time trying to get out of the water; their feet slipping in the mud on the bank, all dirty and shiny, their manes and tails soaking.[22]

While the horses' "ferocity" made Delacroix "tremble," he was attracted by their "fantastic and graceful movements," which he inevitably associated with art—especially that of Rubens and Gros. Proceeding from these initial impressions, in a typical fusion of imagination and reality, he then made the detailed observations which would serve to reawaken the image later. In 1860, when he began *Arab Horse Fighting*, his recollection of the scene of thirty years earlier must have coalesced with his memory of Géricault's lithograph of the subject. On March 8, 1852, he wrote: "Looked again at the lithograph by Géricault of the horses fighting. Great rapport with Michelangelo. The same power, the same precision, and, despite the impression of power and of motion, a slight immobility, probably because of the excessive attention to details."[23]

The *Journal* helps to explain some of the feelings which lie behind these works. It is clear that the painter was inclined to reject ideas of "progress" and the

20. He admired Auguste's representations of the Arabian horse, as well as those of Baron Gros, but was sometimes critical of Géricault's horses and once asserted that Auguste's drawings of horses were superior to Géricault's (*J*, 1:116 [June 30, 1824]).

21. It should, however, be noted that Delacroix continued to make such studies for a long time, until as late as 1855.

22. *J*, 1:124 (Jan. 29, 1832).

23. *J*, 1:462.

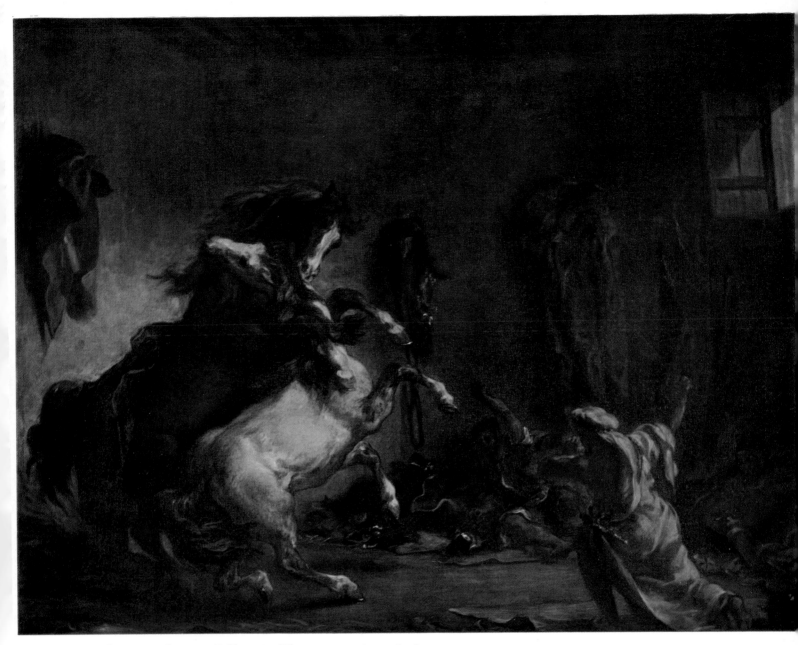

PLATE XX. *Arab Horses Fighting in a Stable*. 1860. Oil on canvas. 0.64 × 0.81. Louvre.

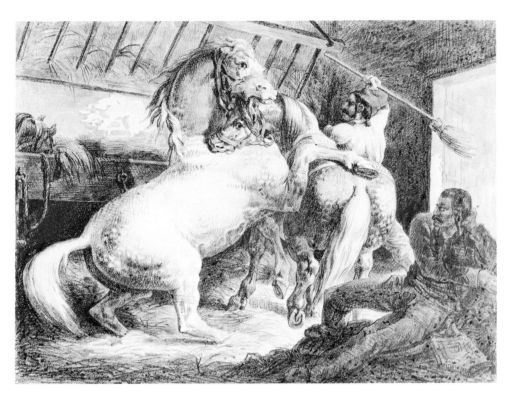

FIGURE 135. Théodore Géricault. *Two Horses Fighting in a Stable*. 1818.
Lithograph. 0.27 × 0.35. Bibliothèque Nationale, Paris. Photo Giraudon.

24. His vehement rejection of the notion of progress is explained at length in an entry made after a visit to "the famous agricultural exposition" on June 6, 1856 (2:451–55).

25. *J*, 2:355 (July 15, 1855).

26. *J*, 2:472 (Oct. 13, 1856); quoted in Rudrauf, *Delacroix*, p. 176.

essential goodness of nature, preferring to regard the cosmos as the pitiless operation of irresistible forces.[24] This attitude is summarized in his reaction to a battle between a group of ants and a beetle, which he saw on a visit to Augerville (where he was also struck by the way in which the shapes of the local rocks suggested figures of men and animals). The ants finally overcame their victim in the little "tragedy," and "death finally came in the end."[25] Again at Augerville the next year he saw the same struggle for survival and impending death as a part of natural order: "I admire this multitude of little cobwebs which the morning mist, as it loads them with moisture, makes visible to the eye," he wrote. "What a quantity of flies or other insects will have to be caught in these nets to feed the spinners, and what a multitude of the latter offered up to the appetite of the birds, etc."[26]

Delacroix's pessimism involves acceptance of nature as a powerful but amoral force in the life of man. The struggle between the weak and the strong—or between the strong and the stronger—is an inevitable aspect of nature's imperialism, in which man's sentiments and values play no part. While they were not painted as parables, his animals reflect these underlying attitudes in some sense. In the mindless and undirected ferocity of the beast a vital, if cruel, part of nature's meaning is revealed. Rejecting notions of material or political progress, Delacroix counseled resignation. "The moralists and the philosophers," he once wrote, in an apparent reaction to a political discussion with his friends, "I mean the real ones, like Marcus Aurelius and Jesus, never talked politics, since they did not consider it save from the standpoint of humanity. . . . all they recommended to

men was resignation to fate, not to that obscure *fatum* of the ancients, but to that eternal necessity which no one can deny, and against which the philanthropists will not prevail when they try to escape from the severe laws of nature. To follow those laws, and to play his part in the place assigned him amidst a general harmony, is all that the philosophers have demanded of the wise man. Sickness, death, poverty, the torments of the soul, all are eternal," he concluded, "and will torture humanity under every kind of government; the form, democratic or monarchial, has nothing to do with the case." [27]

The path of reason was to accept the ways of nature. Rejecting the doctrine of Rousseau and others that "man is born free," Delacroix insisted that he is creation's greatest slave, not only in his dependence on the elements and his fellows but in the passions that he must fight within himself. But in the end it is "submission to the law of nature, resignation to the sorrows of humanity," that is "the very last word of reason." [28] Although he considered man to be a "wretched and frightened beast," [29] the salvation of reason and moral order was possible—especially for the genius, who is "simply a being of a more highly reasonable order." [30] In the broadest sense, Delacroix was a stoic: he accepted the power of nature as a condition to which man must adjust, finding whatever meanings he can through the use of his reason.

Man's role is not, on the other hand, regarded as utterly ignoble. Even wild beasts occasionally assume a less violent guise in Delacroix's more pastoral views of nature, where animal life appears as a state earlier than that of man and behaviorally related to lower forms of human development. "Animals do not feel the weight of time," he once wrote. "The hunt for food, for brief moments of animal passion, the nursing of the young, the building of nests or lairs are the only labors that nature has imposed on the animals. Instinct urges them to it; no calculation directs them in it. Man bears the weight of his thoughts as well as that of the natural miseries that make him an animal. In proportion as he gets away from the state most like the animal, that is to say the savage state in its varying stages, he perfects the means of nourishing that ideal faculty denied to the beasts." [31]

It may be that Delacroix had some such meaning in mind when he undertook a subject that in a curious way brings together all these relationships, *Daniel in the Lions' Den*. It is his most overt confrontation of two of his favorite themes. He has chosen a dramatic, rather than a purely devotional, religious subject. The juxtaposition of man and beast represents the contrast of enlightenment and unreasoning but miraculously tamed brute force. The artist's faith in the ultimate power of mind is implied in this illustration of its triumph.

Delacroix painted two versions of *Daniel in the Lions' Den*. The earlier, now in Montpellier, done in 1849, shows the prophet seated in the brownish, murky depths of a grotto surrounded by tawny lions. One of them has been aroused by the presence of two persons peering over the edge of a high ledge. A small patch of blue-green sky shows beyond them. In the later version, which was painted in 1853, these observers have been eliminated. Instead, the hole in the roof of the cavern is filled with a misty, "supernatural" glow which dramatizes the angel hovering benevolently above the head of the prophet. The lions are similar to those in the earlier canvas, although they are differently disposed within the imprisoning rocks.

In spite of their differences of emphasis, the two canvases are closely related in style and composition. Although the handling generally suggests Rembrandt,

27. J, P, p. 147 (Feb. 20, 1847); see also Rudrauf, *Delacroix*, pp. 44, 168.

28. J, 1:239.

29. C, 2:202 (to George Sand, Nov. 22, 1844).

30. J, P, p. 483 (Aug. 31, 1855). Although the immediate context of the statement is a condemnation of eccentric and mannered behavior and pretentious performance, it seems to be applicable to the larger context of the present discussion as well.

31. J, 1:464–65 (Apr. 7, 1852).

FIGURE 136. *Daniel in the Lions' Den.* 1853.
Oil on canvas. 0.74 × 0.60. Private collection. Photo Archives Photographiques, Paris.

the direct source of Delacroix's inspiration seems to have been a print after Rubens' *Daniel in the Lions' Den*. While Delacroix's adaptation is free, the relationship is unquestionable. He has shifted the locale to a natural cavern or ravine but has retained in his rocks the arch-like character of Rubens' ruined masonry.

It may, of course, have been coincidental that in 1849 he also painted *Ugolino and His Children,* a story of starvation and degradation. Even more than in *Tasso,* painted some years earlier, one sees the horror of isolation, the cracking of the will, and bestiality. The Pisan traitor Ugolino was condemned to die of starvation, along with his two sons and two grandsons. Dante's account of their story is sometimes interpreted to mean that Ugolino was driven by hunger to eat the flesh of his own children. While it is impossible to interpret this episode from the

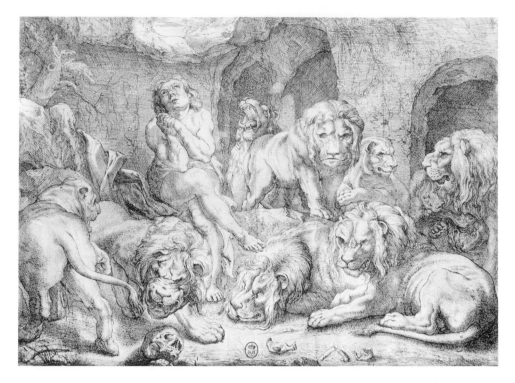

FIGURE 137. Jan Weenix after Peter Paul Rubens. *Daniel in the Lions' Den*. N.d.
Engraving. Bibliothèque Nationale, Paris. Photo Giraudon.

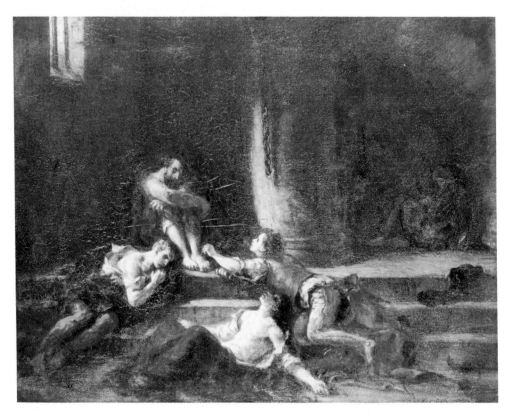

FIGURE 138. *Ugolino and His Children*. Begun 1849; dated 1860.
Oil on canvas. 0.50 × 0.61. Ordrupgaard Museum, Copenhagen.
Photo John R. Freeman & Co.

Inferno precisely, it is at least certain that it presents—intentionally or not—a contrast to *Daniel*. Where Ugolino's survival is brief and dearly bought, Daniel's is nobly won and lasting. In Daniel's presence the very beasts are calm, while Ugolino and the dead and dying humans around him are reduced to the lowest level of their humanity.

In 1853, the year in which he painted the second *Daniel*, Delacroix undertook a number of other religious subjects. Of particular importance was a large canvas, *Disciples and Holy Women Rescuing the Body of St. Stephen*, which was shown

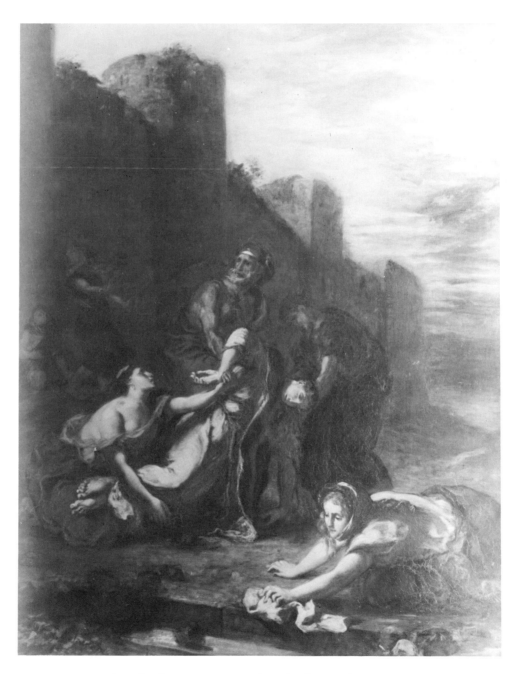

FIGURE 139. *Disciples and Holy Women Rescuing the Body of St. Stephen.* 1853. Oil on canvas. 1.48 × 1.15. Musée Municipal, Arras. Photo S.D.P.

in the salon of that year and was purchased in 1859 for the museum at Arras. In 1853 he also painted several versions of Christ on the Sea of Galilee. As animal themes recur, so biblical episodes provide an element of thematic continuity throughout Delacroix's career. Many, such as *Daniel*, represent Old Testament stories, but he also used the Good Samaritan and the education of the Virgin as subjects. Most often, however, it was the life of Christ that attracted him.

Numerically considered, religious themes comprise only about one-tenth of Delacroix's total output. However, they include some of his most important works. Beyond doubt the most significant of all are the murals in the church of St. Sulpice, which will be discussed elsewhere. It will be recalled that Delacroix's first commissioned painting was *Virgin of the Harvest*, and in the years that followed he received other such contracts. The early *Sacred Heart* and *Agony in the Garden* for St. Paul-St. Denis date from the Restoration, when there was a reaction against the anticlericalism of the Revolutionary and Napoleonic regimes. A "painter of history," as he later called himself, Delacroix naturally accepted all such commissions. For the most part, however, the subject to be represented was not specified in the contract, and we may assume that his choices reflect his personal preference, as in his secular works. His versions of Christ on the Sea of Galilee strongly invite comparison with *Shipwreck of Don Juan*, and in *The Two Foscari* the young Venetian's piteous expression also recalls traditional images of Christ.

What saved these paintings from the banality of other church art of the period was his evocation of the intellectual and emotional meaning of the incidents shown. Christ appears not as an abstraction but as a moral hero. The supreme but tragic genius, he epitomized certain of Delacroix's notions of human destiny and natural order. Suppositions about the nature of Delacroix's religious beliefs must remain just that. He seems to have had no formal religious ties (as the son of a high Revolutionary official, he was never baptized), did not practice any form of religious observance, and was not attended by a priest at his death. He detested Protestantism as "an absurdity"[32] and blamed it for contributing to the growth of a materialism he despised.[33] The latter accusation is surprisingly like later sociologists' interpretations of the impact of Protestantism, especially that of Max Weber:

> In the morning, sitting in the forest, I was thinking of those charming allegories of the Middle Ages and the Renaissance, those cities of God, those luminous Elysian fields, peopled with gracious forms, etc.... Isn't that the tendency in periods when belief in higher powers has preserved its full strength? The soul is ceaselessly rising above the trivialities or miseries of real life into imaginary dwellings which are supplied with everything that is lacking around you.
>
> It is also the tendency of unhappy periods when formidable powers weigh upon men and cripple the flights of imagination. Nature, which has not been conquered by the genius of man in these periods, increases our material needs, makes us find life harsher, and makes us dream with greater enthusiasm of an unknown well-being.... Then, as always, desire poetizes the existence of unhappy mortals, condemned as they are to disdain what they possess.
>
> Action is directed solely toward elevating the soul above matter. In our day, just the reverse is the case.... It was Protestantism which first disposed us toward this change. It depopulated heaven and the churches. Nations with a genius for the positive embraced it with ardor. Material happiness is, then, the only happiness for the moderns.[34]

Delacroix's nostalgia for a simplicity of belief he considered no longer possible

32. *J*, 2:295 (Oct. 27, 1854); see also Rudrauf, *Delacroix*, p. 168.

33. *J*, 1:227–28 (May 22, 1847).

34. *J*, 1:226–27 (May 22, 1847).

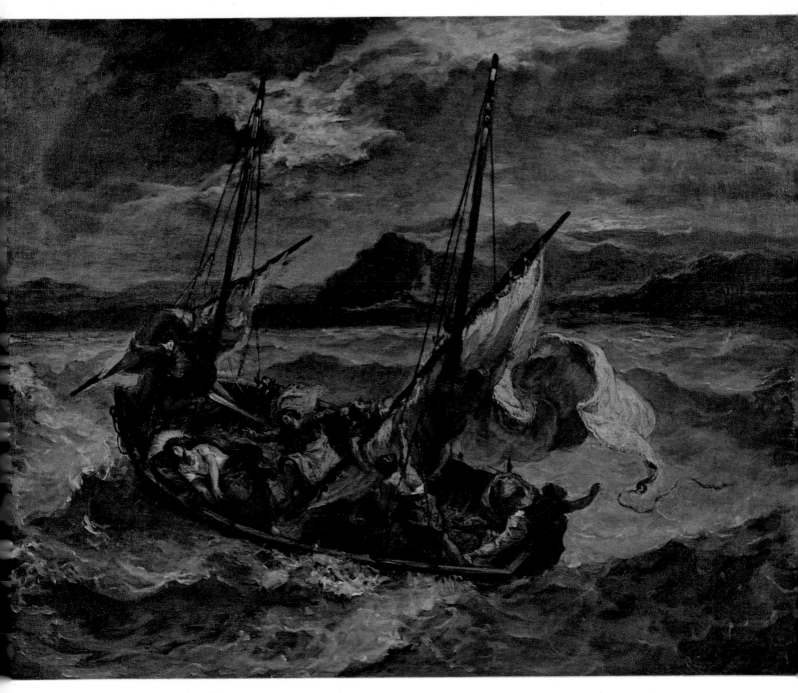

PLATE XXI. *Christ on the Sea of Galilee.*
1854. Oil on canvas. 0.59 × 0.72. Walters Art Gallery, Baltimore.

from detestable materialism. "I cannot and must not live in any other way than through the mind," he once wrote. "To live in a material fashion is not to live.... Most men live only that life; but as they do not know the life of the mind, they do not feel themselves deprived of anything in the various kinds of limbo where they vegetate, nearer to the animals than to man."[42]

Delacroix believed that death was final and that the end of man was oblivion, not eternal life. He rejected Christ's divinity and the eschatological meaning of his mission. It was mentioned earlier that in 1824 he saw "poor Géricault ... go down into the narrow house where there are no longer even dreams."[43] Much later, in 1860, he wrote a long soliloquy on the soul in which an interlocutor named Jacques articulated his own anxieties:

> *As to the soul.* Jacques had difficulty in persuading himself that what is called *the soul,* that impalpable *being*—if one can call *being* that which has no body, which cannot be perceived by the senses, not even like the wind, which, invisible as it is ... [Delacroix's ellipses]—can continue to be that thing which he feels, which he cannot doubt, when the habitation formed of bone, of flesh, in which the blood circulates, in which the nerves function, has ceased to be that moving factory, that laboratory of life, which stands firm amid adversity, through so many accidents and vicissitudes.
>
> When the eye has ceased to see, what becomes of the sensations that reach that poor thing the soul, a refugee I know not where, through that window, as we call it, opened upon visible creation? ... What becomes of it when, brought to bay in its last refuge through paralysis or imbecility, it is finally forced, by the definite cessation of life and by perpetual exile, to separate itself from those organs which are then no more than inert clay? Exiled from that body which some call its prison, is it present at the spectacle of mortal decomposition, when the priests ceremoniously murmur paternosters over that unfeeling clay, or when by chance a voice is raised to say a last farewell? At the brink of the tomb about to close, does it gather up its share of those funeral mummeries? What does it become at that supreme moment when, forced to banish itself completely from that body to which it gave or from which it received life; what condition does it assume in that widowhood of all the senses and at that moment when the blood ebbs and freezes, ceases to give impetus to this bizarre composite of matter and spirit, somewhat like the balance wheel of a clock which, when it stops, stops the works and the movement?[44]

"Once the great man disappears," Delacroix once said, "all is ended with him,"[45] but he sought in his art to stave off ultimate personal oblivion: "Jacques grieved over his mortal doubt ... —and yet he sacrificed to glory. He spent days or nights in perfecting a work or works destined, he hoped, to perpetuate his name. This singular contradiction, a search for an empty fame to which his ashes would be indifferent, could neither break him of his pursuit, on the one hand, nor, on the other, give him the hope of outliving his time and of being conscious of admiration when he would no longer be conscious of life."[46]

Glory had "never been an empty word" for Delacroix, and he often quoted Stendhal's advice to "neglect nothing *that can make you great.*"[47] But at the same time he realized that this "fatal gift," as he once called it, imposed unwelcome burdens. Considering the "real man" to be the "savage" who is "in tune with nature as she is," he saw the role of the creative artist as that of a warrior fighting an endless and losing battle with a jealous nature that would destroy his accomplishments, "impatient at the masterpieces of the imagination and of the hands of man."[48] "Not only is the man who is greatest through talent, through audacity, through perseverance, usually the most harassed, but he is himself wearied by this burden of talent and imagination. He is as ingenious in tormenting himself

42. *J,* 1:385–86 (July 14, 1850).

43. *J, P,* p. 87 (May 11, 1824).

44. *J,* 3:257–58 (Jan. 31, 1860). Delacroix must have known Diderot's *Jacques, le fataliste.*

45. *J, P,* p. 179 (n.d., 1847).

46. *J,* 3:258 (Jan. 31, 1860).

47. Over the years Delacroix repeatedly referred to this advice. The concept made a deep impression on him (see *J,* 1:334 [Jan. 31, 1850]; 2:194 [May 27, 1854], 398 [Oct. 4, 1855]).

48. *J,* 1:360 (May 1, 1850).

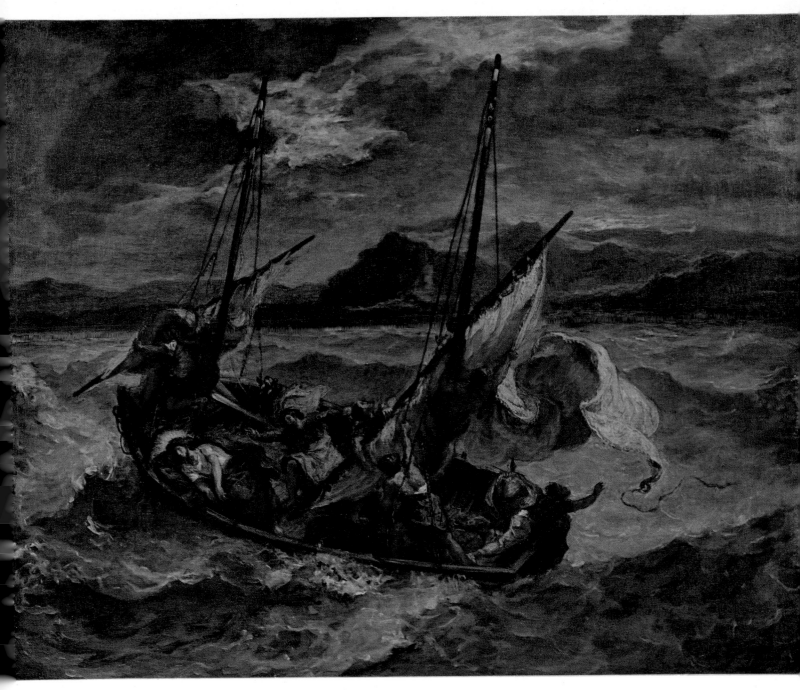

PLATE XXI. *Christ on the Sea of Galilee.*
1854. Oil on canvas. 0.59 × 0.72. Walters Art Gallery, Baltimore.

is clear. In the rest of the passage there are hints of regret that "the Revolution completed the process of pinning us down to earth." His objections, however, are basically aesthetic ones. He felt that the world had suffered a loss of beauty, whether of social order or of a commonly shared imaginative life. It would be superfluous to point out the Rousseauist doctrines inherent in such romantic notions.

When Delacroix was painting his murals at St. Sulpice, he liked to work at Plombières on Sundays, despite some objection by the local clergy, so that he could enjoy the experience of hearing the Mass: "I have profited well from the time I spend at my church, not to mention the music they make there, beside which everything else sounds thin," he wrote his cousin. "I work twice as hard on the days the masses are sung."[35]

Delacroix's religious attitudes were thus an amalgam of aesthetic, moral, and metaphysical concerns. Truth, beauty, genius, and God are brought together in a typically romantic association, summarized in this comment: "I was greatly struck by the Mass on the Day of the Dead, by all that religion offers to the imagination, and at the same time how much it addresses itself to man's deepest consciousness. *Beati mites, beati pacifici*: when was there ever a doctrine which made gentleness, resignation, and simple virtue man's one goal on earth in this way. *Beati pauperes spiritu*: Christ promises heaven to the poor in spirit, that is, to the simple people: this saying is designed less to abase the pride in which the human mind delights when contemplating itself," he added, a bit self-consciously, "than to show that simplicity of heart takes precedence over understanding."[36]

On another occasion Delacroix heard the *Te Deum* presented after a formal luncheon at the Hôtel de Ville and delighted in the "rather grand impression of that crowd in dresses of all colors and in embroidered habits: the music, the bishop, everything is done to move one; the church seemed to me, as always, one of the least suited to elevate and impress."[37] The ultimate expression of this attitude is to be found in his comment while at Plombières: "I like churches: I like to be there almost alone, to sit down on a bench and stay there in a good reverie."[38]

While it is clear that Delacroix was far from a devoted churchgoer, it does not necessarily follow that he was, as Joubin has suggested, "the spiritual son of Voltaire and of the Encyclopedia, unbelieving and probably atheist."[39] On the contrary, there is reason to suppose that, if only by habit, he believed in some kind of deity as a source of moral order in the universe. His God was therefore personal and transcendental. As he wrote in 1862, "God is within us: it is that inner presence which makes us admire the beautiful, which delights us when we have done right and consoles us for not sharing in the success of the wicked. It is he who, beyond a doubt, creates the inspiration of men of genius and who warms them at the spectacle of their own productions. There are men of virtue as there are men of genius; both are inspired and favored by God."[40]

The statement makes it fully apparent that Delacroix regarded creation as a form of good and its powers as divinely ordained. In contrast, insensitivity and wickedness are also associated in this dualistic world, in which human destiny is an endless struggle between misery and grandeur, in which man's weakness is no less prominent than the singular power of his creative genius.[41] There can be no doubt, however, that Delacroix was convinced of his own genius and proud of that superiority which he discovered in the life of the mind and its emancipation

35. *C*, 4:52 (to Antoine Berryer, Nov. 2, 1858); quoted in Escholier, *Delacroix*, 3:88.

36. *J*, 2:300 (Nov. 2, 1854).

37. *J*, 2:365–66 (Aug. 5, 1855); quoted in Rudrauf, *Delacroix*, p. 166. In a letter to Mme de Forget he makes an ironic reference to the event, saying that when one is mingled with the crowd one can share the spirit of the occasion, even with fools. He adds, "It is a spectacle full of interest for a philosopher who has not yet abandoned all the vanities" (*C*, 3:283 [Aug. 16, 1855], copied into the *Journal*). It is quite possible that his attendance was related to the fact that he was prominently represented at the Universal Exposition, which was then current. He was a member of the Imperial Commission that organized the art exhibition there and was one of four exhibitors honored with one-man shows.

38. *J*, 2:122 (Aug. 29, 1857).

39. *C*, 3:133 (introductory note for the year 1853).

40. *J*, 3:329 (Oct. 12, 1862); quoted in Rudrauf, *Delacroix*, p. 163.

41. See Rudrauf, *Delacroix*, p. 139.

from detestable materialism. "I cannot and must not live in any other way than through the mind," he once wrote. "To live in a material fashion is not to live.... Most men live only that life; but as they do not know the life of the mind, they do not feel themselves deprived of anything in the various kinds of limbo where they vegetate, nearer to the animals than to man."[42]

Delacroix believed that death was final and that the end of man was oblivion, not eternal life. He rejected Christ's divinity and the eschatological meaning of his mission. It was mentioned earlier that in 1824 he saw "poor Géricault . . . go down into the narrow house where there are no longer even dreams."[43] Much later, in 1860, he wrote a long soliloquy on the soul in which an interlocutor named Jacques articulated his own anxieties:

> *As to the soul.* Jacques had difficulty in persuading himself that what is called *the soul,* that impalpable *being*—if one can call *being* that which has no body, which cannot be perceived by the senses, not even like the wind, which, invisible as it is . . . [Delacroix's ellipses]—can continue to be that thing which he feels, which he cannot doubt, when the habitation formed of bone, of flesh, in which the blood circulates, in which the nerves function, has ceased to be that moving factory, that laboratory of life, which stands firm amid adversity, through so many accidents and vicissitudes.
>
> When the eye has ceased to see, what becomes of the sensations that reach that poor thing the soul, a refugee I know not where, through that window, as we call it, opened upon visible creation? . . . What becomes of it when, brought to bay in its last refuge through paralysis or imbecility, it is finally forced, by the definite cessation of life and by perpetual exile, to separate itself from those organs which are then no more than inert clay? Exiled from that body which some call its prison, is it present at the spectacle of mortal decomposition, when the priests ceremoniously murmur paternosters over that unfeeling clay, or when by chance a voice is raised to say a last farewell? At the brink of the tomb about to close, does it gather up its share of those funeral mummeries? What does it become at that supreme moment when, forced to banish itself completely from that body to which it gave or from which it received life; what condition does it assume in that widowhood of all the senses and at that moment when the blood ebbs and freezes, ceases to give impetus to this bizarre composite of matter and spirit, somewhat like the balance wheel of a clock which, when it stops, stops the works and the movement?[44]

"Once the great man disappears," Delacroix once said, "all is ended with him,"[45] but he sought in his art to stave off ultimate personal oblivion: "Jacques grieved over his mortal doubt . . . —and yet he sacrificed to glory. He spent days or nights in perfecting a work or works destined, he hoped, to perpetuate his name. This singular contradiction, a search for an empty fame to which his ashes would be indifferent, could neither break him of his pursuit, on the one hand, nor, on the other, give him the hope of outliving his time and of being conscious of admiration when he would no longer be conscious of life."[46]

Glory had "never been an empty word" for Delacroix, and he often quoted Stendhal's advice to "neglect nothing *that can make you great.*"[47] But at the same time he realized that this "fatal gift," as he once called it, imposed unwelcome burdens. Considering the "real man" to be the "savage" who is "in tune with nature as she is," he saw the role of the creative artist as that of a warrior fighting an endless and losing battle with a jealous nature that would destroy his accomplishments, "impatient at the masterpieces of the imagination and of the hands of man."[48] "Not only is the man who is greatest through talent, through audacity, through perseverance, usually the most harassed, but he is himself wearied by this burden of talent and imagination. He is as ingenious in tormenting himself

42. *J,* 1:385–86 (July 14, 1850).

43. *J, P,* p. 87 (May 11, 1824).

44. *J,* 3:257–58 (Jan. 31, 1860). Delacroix must have known Diderot's *Jacques, le fataliste.*

45. *J, P,* p. 179 (n.d., 1847).

46. *J,* 3:258 (Jan. 31, 1860).

47. Over the years Delacroix repeatedly referred to this advice. The concept made a deep impression on him (see *J,* 1:334 [Jan. 31, 1850]; 2:194 [May 27, 1854], 398 [Oct. 4, 1855]).

48. *J,* 1:360 (May 1, 1850).

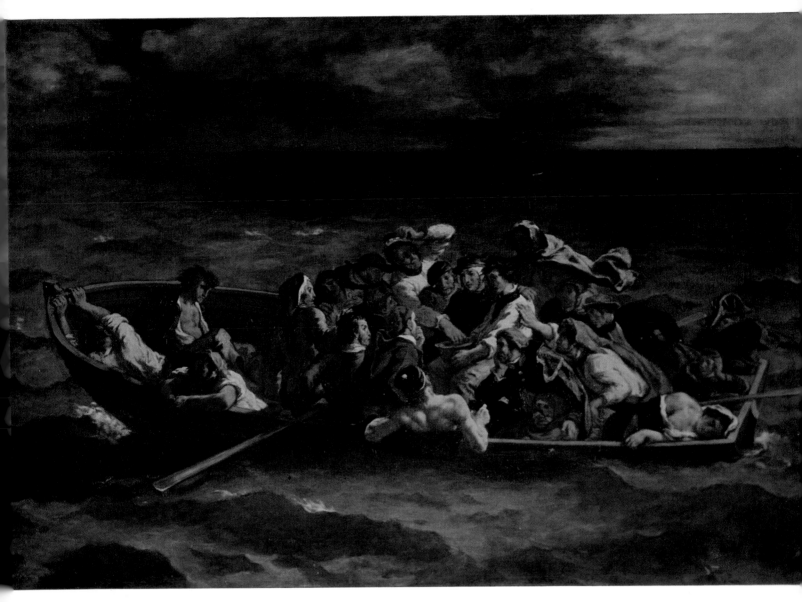

PLATE XXII. *Shipwreck of Don Juan.* 1840. Oil on canvas. 1.35 × 1.96. Louvre.

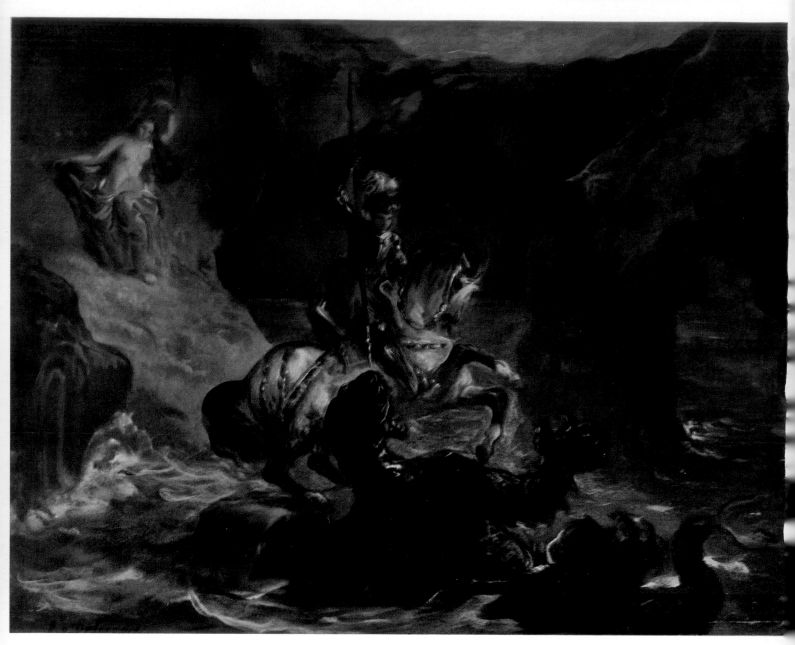

PLATE **XXIII**. *St. George and the Dragon*. 1847. Oil on canvas. 0.28 × 0.36. Louvre.

49. *J*, 1:361 (May 1, 1850).

50. *J*, 2:34 (May 2, 1853).

51. *J*, *P*, p. 64 (Feb. 27, 1824).

52. *J*, 3:166 (Dec. 20, 1857).

53. *J*, *P*, p. 141 (Feb. 3, 1847).

54. *C*, 4:49–50 (Oct. 18, 1858).

as in enlightening others. Almost all great men have had a life more thwarted, more miserable, than that of other men."[49]

There is, of course, a strong element here of self-dramatization, but the suffering was no less real. And if it was not without a certain bittersweet satisfaction that he alluded to his increasing sense of isolation from his former friends and associates, whom he felt to be resentful of the advantages "chance" had given him,[50] he was certainly lonely. More and more, his satisfactions were provided by his work alone. "What are most real to me are the illusions I create with my painting," he said as a young man; "the rest is shifting sand."[51] Thirty-three years later he wrote: "The studio is quite empty. . . . My ambition is bounded by these walls."[52] His picture *Michelangelo in His Studio* and his melancholy description of his visit with the aged Auguste come to mind here. It may be that many times more in his old age he experienced the "bitter reflections on the profession of the artist; this isolation, this sacrifice of almost all the feelings which animate most of mankind."[53] Yet five years before his death, while he was engaged in his exhausting project at St. Sulpice, he could write: "I always applaud myself for having worked at my chapel, that such fatiguing labor has—extraordinary thing—given me strength. It makes me leave home at all sorts of hours. Only I cannot in the evening be a man of the salon. I dine on leaving there, that is at four o'clock. Afterwards I do a total of two or three hours [work], and toward ten o'clock in the evening I go out for a stroll of a league or two in the streets of Paris. What do you think of this pretty routine on which I thrive?"[54]

These quotations can do no more than suggest the main lines of speculation expressed at length in Delacroix's writings. We may reasonably expect such preoccupations to be reflected in his paintings. It is of interest to observe, for example, that the biblical episodes which attracted him were those which most fitted his image of the struggle of heroic genius against a hostile and unenlightened society. What one sees of the life of Christ in Delacroix's portrayals is the trials, sorrow, and sacrifice. Except for the early *Virgin of the Harvest*, two small Annunciations, and two minor versions of the Baptism, he showed little interest in representing the triumphs of Christ or his times of tranquillity. He elected as his subjects not the Nativity or the Adoration of the Virgin but the Agony in the Garden, the Way to Calvary, the Crucifixion, and *Pietà*. When he received the commission for a mural in St. Denis-du-Saint-Sacrement, his original proposal of an Annunciation was never carried beyond the sketch. He abandoned the idea in favor of a *Pietà*, the Virgin in her role of compassion and sorrow. Christ's heroism was sometimes referred to, as in the storms of Galilee. To be sure, some minor works do refer to Christ's miracles or to his lustrous presence—*Doubting Thomas* and the two versions of the *Supper at Emmaus*, both from 1852, are representative examples—but Christ's divinity is generally played down in favor of the dramatic and pathetic aspects of his story. So far as one can tell, Jesus was for Delacroix the supreme hero, great among men, but nevertheless mortal. Curiously enough, his ministry is not directly represented in the four pendentives representing religion in the Chamber of Deputies library.

The mood of suffering that interested Delacroix was also emphasized by Baudelaire. He resolutely imposed upon Catholicism a truly romantic subjectivism, referring to it as "profoundly sad—a religion of universal anguish, and one which because of its very catholicity, grants full liberty to the individual and asks no better than to be celebrated in each man's own language—so long as he knows

grief and is a painter."[55] Whether or not Baudelaire's analysis is accurate, we may accept it as a romantic statement of religious experience, which lent itself to artistic expression. The comment also corroborates Delacroix's belief that religious themes allowed the artist an unusually free range of personal expression. In a letter to Dutilleux concerning the murals for St. Sulpice he wrote, not without candor, "You see me in these different subjects treading in the footsteps of the great and imposing masters. But among all the attractions they present, religious subjects have that of allowing full play to the imagination, so that each person finds there his own particular feelings to express."[56]

Except for a copy after Raphael and a few very minor trial pieces, Delacroix's early religious paintings are directly related to his first three commissions: *Virgin of the Harvest, Sacred Heart,* and *Agony in the Garden.* From 1829 on, independent religious motifs begin to occur with some regularity, if not frequently. This emphasis may reflect his move toward a more conservative approach after his reverses at the Salon of 1827. Of these early works *Christ on the Cross between Two Thieves,* painted in 1835 and now in the museum at Vannes, is probably the most important. In later years religious themes increase, but it was not until St. Sulpice that he had the opportunity to do a major religious project. There he created what is perhaps the one nineteenth-century devotional mural whose appeal did not diminish for succeeding generations.

Aside from their drama, biblical subjects had affinities with certain moods or pictorial effects in Delacroix's own experience of art and nature. He has provided an unambiguous statement of this relationship:

In the evening, took a walk with Jenny. The sight of the stars shining through the trees gave me the idea of doing a picture in which I might use that effect, so poetic but difficult in painting because of the darkness of the whole scene: *Flight into Egypt.* Saint Joseph leading the ass and throwing the light of a lantern on a little ford in a stream; that faint illumination would be enough for contrast; or indeed the *Shepherds Going To Worship Christ in the Stable,* which would be seen in the distance, wide open; or the *Caravan of the Magi.*[57]

Delacroix's occasional insistence on effect at the expense of narrative is indicated by the fact that the subjects of two pictures, both done in 1847, are unknown. A small canvas in the Louvre and another larger version at Grenoble are now believed to represent St. George and the dragon, yet Adolphe Moreau called them Perseus and Andromeda, while Robaut listed them as Roger and Angelica. Delacroix's often casual and primarily pictorial attitude toward his subjects has been nicely summarized by Raymond Régamey in his book on the late works. He points out Delacroix's list of "*beaux sujets*" in his *Journal,* at the end of which appears an untitled work, "the hero on a winged horse who is fighting the monster in order to save the nude woman. (See in the catalogue the subject of the picture by Jollivet.)."[58] In his edition Joubin adds that the Jollivet painting represents Perseus and Andromeda. Régamey omits both Delacroix's parenthetical comment and Joubin's identification. However, he does include a relevant, if perhaps apocryphal, anecdote: Delacroix was told once that if he had not missed a recent soiree he could have seen Wellington chatting with Talleyrand, to which Delacroix is supposed to have replied, "For a painter, it is simply that a man in red was chatting with a man in blue."[59]

Despite his inclusion among the "rebels" of his era, even as a young man Delacroix rejected the notion that he was their leader. He had a lively respect for

55. See Charles Baudelaire, *Art in Paris 1845–1862,* trans. and ed. Jonathan Mayne (London: Phaidon, 1965), p. 61.

56. *C,* 3:37 (Oct. 5, 1850).

57. *J,* 2:287–88 (Oct. 12, 1854). In this instance the starry night was never used by Delacroix: it remained for Van Gogh to explore its promise.

58. *J,* 1:293; quoted in Régamey, *Eugène Delacroix: L'Époque de la Chapelle des Saints-Anges (1847–1863)* (Paris: La Renaissance du Livre, 1931), p. 129.

59. Régamey, *Delacroix,* p. 129.

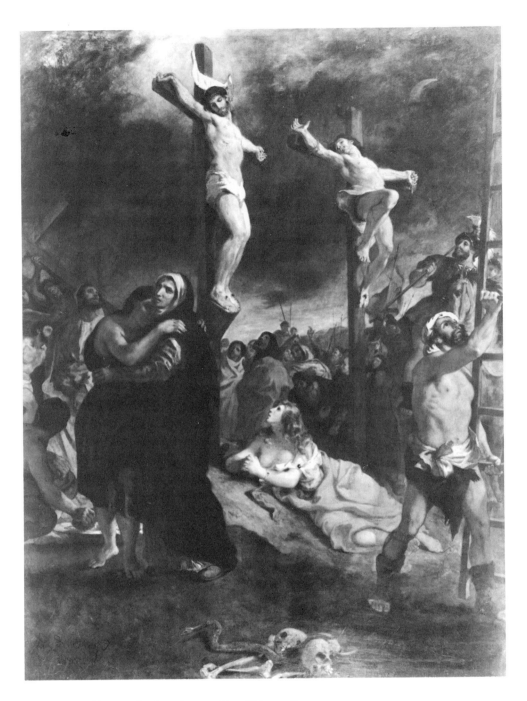

FIGURE 140. *Christ on the Cross between Two Thieves.* 1835.
Oil on canvas. 1.82 × 1.35. Musée Municipal des Beaux-Arts, Vannes. Photo S.D.P.

tradition and authority, and yet he had been denied not only commissions but the academic status to which he never ceased to aspire. He seems to have identified that rejection by the bureaucrats and the philistines (critics), and the suffering it caused him, with the trials of Christ himself. At the same time, his trust in tradition provided him with standards more appropriate to his artistic goals than those afforded by the Academy, and since much of the greatest art of the West had been religious, it was natural for him to use such themes as a kind of test of his prowess.

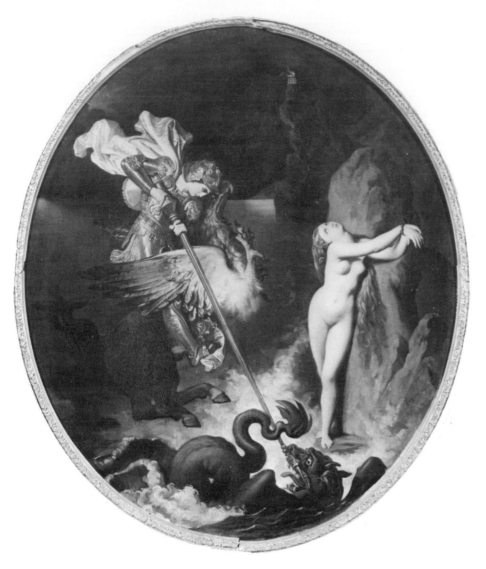

FIGURE 141. Jean-Auguste-Dominique Ingres. *Roger and Angelica*. 1841.
Oil on canvas. 0.54 × 0.46. Musée Ingres, Montauban. Photo Giraudon.

60. A letter of April 19, 1835, from the Minister of Fine Arts refers to its delivery to the local church. According to old records, it was relegated to the church tower because of the Magdalene's too carnal appearance, in spite of the fact that more drapery had been added over her breast. Around 1864 it was retrieved from the tower and relined by Haro, the expert at the Louvre, and was further "restored" by Andrieu in 1868. The original appearance of the painting is thus uncertain. This information is summarized from the records of M. Henri de Parcevealt, Director of the Museum at Vannes, and is confirmed by a letter of 1860 from Delacroix to the Minister of State complaining of the bad treatment of his picture. He was aware of some objection to the Magdalene's *décolleté*, which he saw as a possible motive for its relegation to a damp, ill-lit corner of the church and its general neglect (*C*, 4:222–23; *M*, pp. 158–60).

At the same time an effort to renew traditions which have lost their vitality is clearly anachronistic, and in this Delacroix was—as he well realized—at odds with both his own time and the future.

The events that took place on Calvary are prominent subjects in Delacroix's easel paintings. The most complex and imposing of these representations is the large canvas at Vannes, in which Christ is shown crucified between the two thieves. Although the painting suffered a quarter century of neglect after its original installation in the church of St. Paturn at Vannes, it remains one of Delacroix's most important religious works.[60] It is, moreover, typical in many ways of the prevailing tone of the later canvases, in which the action is usually set in a stormy landscape, an extension of the troubled mood of the participants. Unlike the later works, however, the figures are substantial, in keeping with Delacroix's realistic tendencies at the time. That substantiality is especially striking

in the bold movement of the crucified thief to the right. In color, as in pose, he contrasts with the pale but solid image of Christ. There is also an unusually large range of specific characterization of the participants. The stoical Virgin, clasped in the arms of St. John, dominates the scene even in the face of the Magdalene's extravagant grief. The businesslike stride of the workman with the ladder introduces a realistic touch. Affinities between this canvas and Rubens' crucifixions are observable (Delacroix later painted a "souvenir" of the Flemish master's *Coup de lance*).

In this, as in his other versions of the Crucifixion, such as the one now in the Walters Gallery in Baltimore, the emphasis is dramatic in the Venetian and

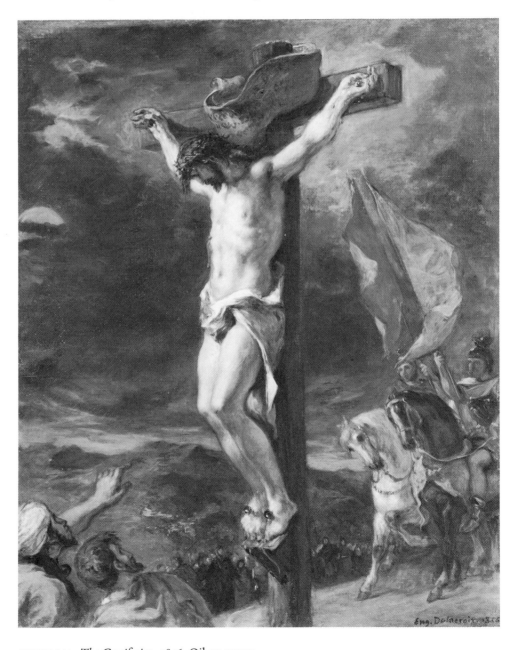

FIGURE 142. *The Crucifixion.* 1846. Oil on canvas.
0.81 × 0.65. The Walters Art Gallery, Baltimore. Photo courtesy of The Walters Art Gallery.

baroque traditions he admired. The two horsemen in the middle distance, with their pawing steeds and fluttering banners, form a diagonal opposition to the figures in the immediate foreground. The landscape once more serves to intensify the drama. The bloody, overcast sky opens to cooler tones only in a diamond-shaped mandorla behind the crucified Christ. While in pose and simplification of modeling the figure of Christ strongly recalls the art of Prud'hon, whom Delacroix greatly admired,[61] the handling is his own.

In view of the size, complexity, and finish of the earlier Crucifixion at Vannes, it may seem improper to compare it with the Walters Gallery sketch, which is only 9.8 × 6.8 in. It is easy to exaggerate the degree of technical change in this and other late works of Delacroix because of differences in scale, especially when the works are seen only in reproduction. It is also true, however, that even in such a small study a tendency to simplify the pictorial structure and to emphasize fluid, loosely handled forms can be seen. The distinctions between the sketches and "finished" paintings, ever tenuous in Delacroix's art, were breaking down even further as time went on. The conservative Charles Blanc had therefore been accurate, if unduly disturbed, in noting these tendencies in the much earlier *Street in Meknes*, and ever since the first showing of *Dante and Virgil* Delacroix had faced similar criticism.

These qualities are equally conspicuous in the small but powerful *Way to Calvary*, now in Metz, one of several versions of the subject Delacroix painted during his late years. The basic concept of the scene is orthodox, a spiraling procession within which Christ struggles up the hill beneath his burden.[62] The details, however, are handled in a highly personal way. Particularly convincing are Christ and St. Veronica, who approaches to mop his brow. Yet, as in late Tintoretto, what is ultimately the dominant expressive note in the picture is less individual narrative detail than the generalized agitation that permeates the unfocused, pressing crowd.

As is usually the case, these freer tendencies were most pronounced in Delacroix's sketches. But he differs from most other artists in that he transferred these sketch-like qualities to "finished" compositions. The notion of fluidity of surface or spontaneity of effect on a large—even monumental—scale was unusual, if not altogether unprecedented.[63] However, what is most individual in Delacroix's evolution out of that broad tendency, already evident in baroque art, is his awareness of discriminations to be made between "form" and "content." The *Journal* provides an abundant record of his concern for these matters. "In what art does execution so intimately follow invention?" he wrote, in a note for his projected dictionary of the fine arts. "In painting, in poetry, *form and concept are inseparable*."[64] The very notion of compiling a dictionary was both a sign of change and a link with academic traditions. He wished to provide a theoretical base for what had been habitual eclectic practices. In his trust in analysis, theory, and intellect, even at times at the expense of intuition, Delacroix resembled Reynolds. At the same time, there is something "modern" in his preoccupation with theory.

Delacroix's curious ambivalence toward tradition and innovation may be clearly observed in two other subjects from the life of Christ: the *Entombment*, of 1848, now in Boston, and the *Pietà* he did five years earlier for St. Denis-du-Saint-Sacrement. The *Journal* indicates that he began work on the oil sketch for

61. See, for example, *J*, 2:136 (Dec. 24, 1853). He speaks of a copy of the Prud'hon Christ at St. Philippe du Roule. Delacroix wrote an appreciative article on Prud'hon for the *Revue des Deux-Mondes* for November 1, 1846, about the time this painting was done (*O*, 2:125–55).

62. See Régamey, *Delacroix*, p. 176, n. 1. He considers this canvas to have been "visibly inspired" by the Tiepolo *Way to Calvary* in San Alvise, Venice. Delacroix had originally contemplated including it in a projected set of murals, never undertaken, for the baptismal chapel of St. Sulpice (see *M*, pp. 379–81).

63. Further implications of this aspect of Delacroix's theory and technique will be discussed in a later chapter. A discussion of this quality of execution, which becomes increasingly important in the later works, is given by George P. Mras *Eugène Delacroix's Theory of Art*, Princeton Monograph in Art and Archaeology no. 37 (Princeton, N.J.: Princeton University Press, 1966), pp. 79ff.; "A Game Piece by Eugène Delacroix," *Princeton University*: *Record of the Art Museum*, 18, no. 2 (1959):65–76.

64. *J*, 3:28 (Jan. 13, 1857).

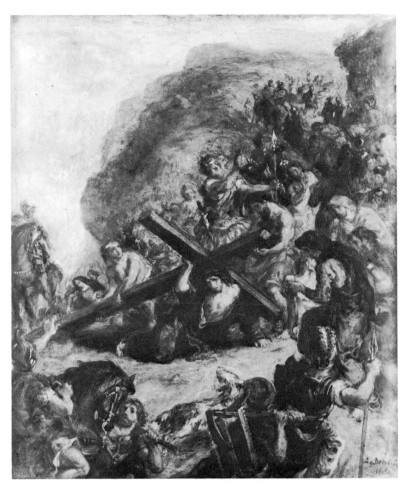

FIGURE 143. *The Way to Calvary*. 1859.
Oil on panel. 0.57 × 0.48. Musée des Beaux-Arts, Metz. Photo S.D.P.

65. J, 1:187 (Feb. 15, 1847), 195–96
(Mar. 1, 1847).

The Entombment some time before February 15, 1847.[65] The final version expresses
his notions of stoical resignation: the stunned mourners who have gathered are
mute with grief. St. John, who appears in the immediate foreground, lends an
original note of tragic irony as he contemplates the crown of thorns, the tribute
of the multitude to the superior man.

One can find prototypes for many of the individual elements in the painting,
particularly in the art of Titian and Poussin, but the powerful and resonant color
is original. The intense hues of the draperies, the warm flesh tints, and the greenish
pallor of the Christ figure glow against the dark, absorbent tones of the landscape.
Yet these contrasts, stressed almost to the point of dissonance, attain dramatic
unity. Startling though they are, the bold reds of St. John's garment and the stark
white of the shroud serve not to disrupt but to lend force and focus to the scene
as a whole. It was that very unity of total effect that Delacroix admired on seeing
the painting some years later: "The details are, generally speaking, mediocre

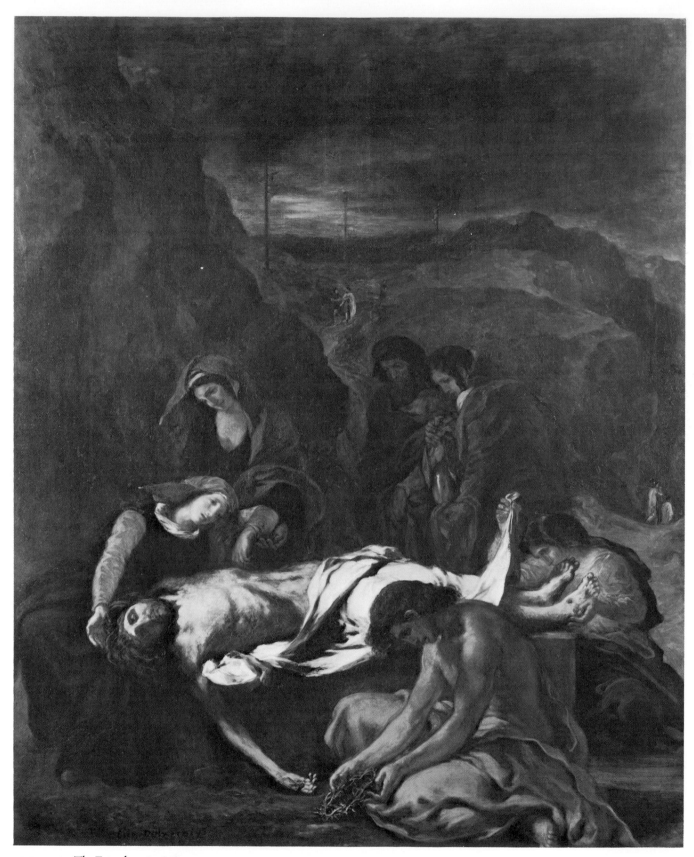

FIGURE 144. *The Entombment.* 1848.
Oil on canvas. 1.60 × 1.30. Museum of Fine Arts, Boston. Photo Museum of Fine Arts.

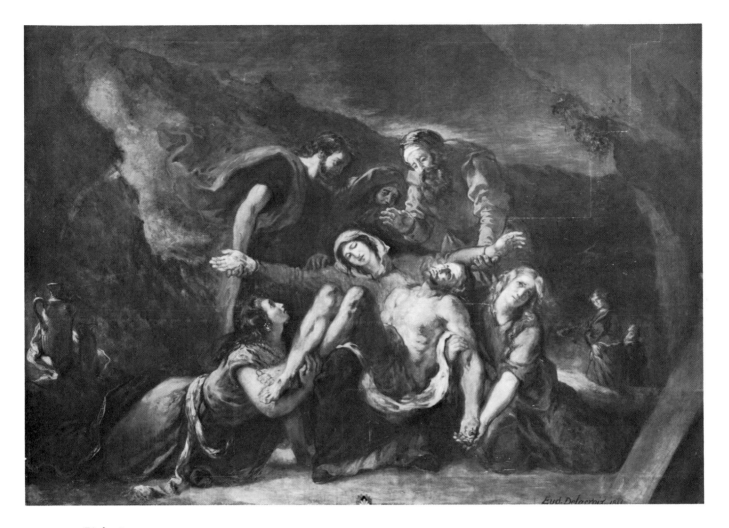

FIGURE 145. *Pietà.* 1844.
Oil and wax. 3.56 × 4.75. Church of St. Denis-du-Saint-Sacrement, Paris. Photo Agraci.

66. *J*, 2:415–16 (Dec. 11, 1855).

67. *J*, 3:452 (Supplement, written
September 23 on his return from
Champrosay, about 1846). Roché, a
Bordeaux architect, designed the
tomb of Delacroix's brother at
Bordeaux. An oil of a lion Delacroix
sent him in gratitude (Robaut 1019)
was exhibited in the Salon of 1846
(*J*, 3:452, last entry of Supplement
and note). See also *C*, 2:304–5 (Mar.
6, 1847).

and scarcely bear close inspection. On the other hand, the whole arouses an
emotion that astonishes even me. You cannot tear yourself away from it, and
no single detail seems to call for special admiration or distracts your attention.
It is the perfection of this kind of art, the object of which is to create a simulta-
neous effect."[66]

Over-all unity of expression is perhaps the most notable quality of this and
Delacroix's other mature works, both in consistent handling and judicious em-
phasis. He kept in mind his own observation that "a very minor accessory will
sometimes destroy the effect of a picture: the brambles that I wanted to place behind
M. Roché's tiger took away the effect of simplicity and the expansiveness of the
plains in the background."[67] *The Entombment* is a masterful example of that
pictorial economy.

Unity of effect dependent upon execution is nowhere more apparent than in
the *Pietà* at St. Denis-du-Saint-Sacrement. In both the final mural and the splendid
preparatory drawings for it there is a quality of powerful physical and emotional
engagement among the large human forms clustered in an elliptical mass at the
center of a shimmering space. In accordance with his own warning about distract-

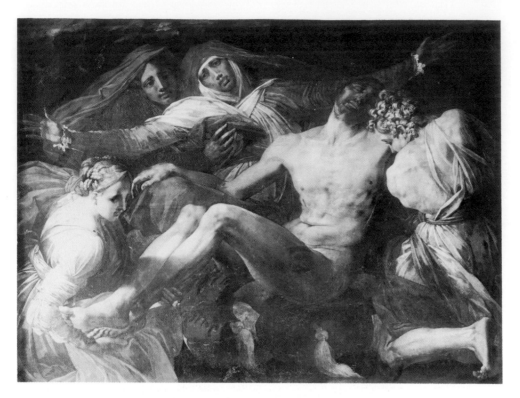

FIGURE 146. Il Rosso Fiorentino. *Pietà*. Ca. 1540.
Oil on panel, transferred to canvas. 1.25 × 1.62. Louvre. Photo Giraudon.

ing details, Delacroix simplified his final version by omitting the floating angels he had originally intended to show parting curtains to reveal the scene. That his deletion was wise is indicated in the more somber, concentrated impact of the finished mural.

The *Pietà* is more distraught than *The Entombment* and is in some ways less original. It is based on a specific historical model, a painting by Il Rosso Fiorentino, in the Louvre.[68] However, its richness of color and surface has far more affinities with the late works of Titian than with Rosso. Even the drawing suggests Christ's pose in Titian's *Crowning with Thorns*, which Delacroix must have known. There are further resemblances in the soft and elusive handling of edges. Yet, as with *The Entombment*, these possible derivations define neither the real meaning nor the originality of the work. In the years since he painted *Agony in the Garden*, Delacroix had evolved his own approach to the problems of form and expression he encountered in baroque art. At this point his work conformed to his own dictum that pictorial form and concept should be as one.

Works such as these, however successful artistically, are not without certain persistent shortcomings, for Delacroix's will to understand and his hunger to possess did not always enable him to penetrate the deepest meanings of religious events. His discussions of the masterpieces he constantly studied reveal the strain that the demands of faith imposed upon his powers of analysis. For example, after comparing Raphael's and Rubens' *Feast in the House of Simon*, he announced

68. This relationship has been demonstrated by Lucien Rudrauf, *Imitation et invention dans l'art d'Eugène Delacroix: Delacroix et le Rosso*, Acta et Commentationes Universitatis Tartuensis (Dorpatensis) no. 43 (Tartu, Lithuania: Mahiesen, 1938), pp. 1–10.

his preference for the Rubens. "Compare this foolish representation of the most touching subject in the Gospel," he wrote of what was most probably a bad copy of Marcantonio's engraving after Raphael, "the one richest in tender and elevated sentiments, in picturesque contrasts arising from the different natures that are brought into contact—that beautiful creature in the flower of her youth and her health, those old men and those mature men, in whose presence she does not fear to humiliate her beauty and to confess her errors—compare, I say, what the divine Raphael has made of all that with what Rubens has made of it." (He is again speaking of a print, as the original was in the Hermitage.) In effect, he is describing his concept of the subject:

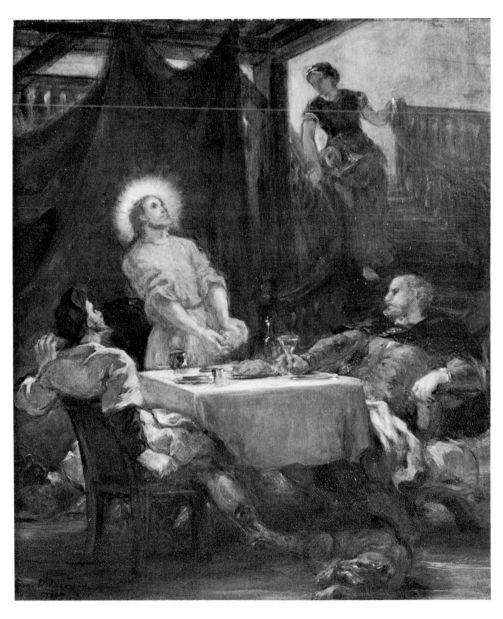

FIGURE 147. *Supper at Emmaus.* 1853.
Oil and canvas. 0.56 × 0.46. The Brooklyn Museum, gift of Mrs. Watson B. Dickerman.
Photo courtesy of The Brooklyn Museum.

He did not fail in any element of the characterization. The scene takes place in the house of a rich man: numerous servants surround the table; the Christ, in the most prominent place, has an appropriate serenity. The Magdalene, in the outpouring of her feeling, drags in the dust her brocaded robes, her veils, and her jewels; her golden hair, streaming over her shoulders and spread in confusion over the feet of Christ, is not an accessory, empty and without interest. The vase of perfumes is the richest he could imagine; nothing is too beautiful or too rich to be laid at the feet of this master of nature, who has become an indulgent master toward our errors and our weaknesses. And can the spectators look on with indifference at the sight of such beauty, prostrate and in tears, at such shoulders, at such a bosom, at such eyes, glistening and gently raised? The people speak to each other, they point to each other, they look upon the whole scene with animated gestures, some with an air of astonishment or of respect, others with a surprise mixed with malice. There is nature, and there is the painter![69]

Cogent though they are, these observations remain superficial. Christ has "an appropriate serenity." The Magdalene's appearance is described in effusive detail. Fine distinctions are attempted, but for the most part they are those of form, not feeling. There is a certain hollowness of characterization that sometimes mars Delacroix's religious paintings. His *Supper at Emmaus*, of 1853, for example, is a fine and serious specimen of his work. It need hardly be said that it owes a debt to Rembrandt, whose painting of the subject was in the Louvre. Although Rembrandt's canvas is not mentioned in the *Journal*, his etching of the scene is described: "In Rembrandt, [see] the sketch for this subject, which he has handled several times and with fondness: he flashes before your eyes that light which dazzles the disciples at the moment when the Divine Master is transformed as he breaks the bread. The spot is lonely: no obtrusive witnesses to this miraculous apparition. Deep astonishment, respect, terror are displayed in those lines etched by feeling upon the copper plate, which, to stir you, has no need of the glamor of color."[70] The painter's eye is true, his description brilliant, but it is external. It is not that it is "inaccurate": it is simply incomplete. In some ways it gives his own sense of the event more than it does Rembrandt's.

It is in his religious works that Delacroix most suffers from the comparison with other great artists. There his own convictions were shallow, his originality counted least, and his subjective limitations were greatest. Humility, patience, and altruism were not in his vocabulary of feeling. At best, his religious expression was dramatic, exciting, fine or imposing, but his faith in the probing mind was not coupled with an appreciation of the Christian ideal of *agape*.

69. *J*, 2:115–16 (Nov. 19, 1853). The high quality of the prints after Rubens' paintings was not accidental: Rubens carefully supervised the making of such reproductions and even touched up the plates, when necessary. Over seven hundred plates of this sort, made by various artists, were issued during his lifetime.

70. *J*, 3:35 (Jan. 25, 1857).

CHAPTER TEN

Murals for the State

1. A letter to Thoré, written on January 18, 1836, refers to the works as "nearly finished. Only some grisailles in the lower section remain to be done. The rest has progressed so far that it was possible to receive the King in the hall on the opening day of the Chamber" (*C*, 1:409). The work was not completed, however, until late in 1836 or early in 1837. For a more detailed account of the project and contemporary critical response to it, see *PM*, pp. 27–46.

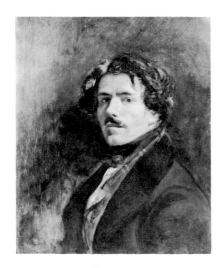

FIGURE 148. *Self-Portrait*. 1835–37. Oil on canvas. 0.65 × 0.54. Louvre. Photo S.D.P.

2. *C*, 1:358. Cavé later became the husband of Élise Boulanger, whom Delacroix had recently met and who became his mistress.

3. *C*, 1:381–82 (Sept. 23, 1834). For a convenient and authoritative discussion of the various applications of the fresco process, see *The Great Age of Fresco, Giotto to Pontormo, an Exhibition of Mural Paintings and Monumental Drawings* (New York: Metropolitan Museum of Art, 1968), pp. 18–31.

When Delacroix returned from Morocco, Thiers, the new Minister of the Interior, engaged him to decorate the Salon du Roi, a large room near the Assembly Hall of the Chamber of Deputies in which the king received dignitaries when he came to open legislative sessions. Delacroix received the commission in 1833 and worked there until 1837.[1] His commitment to this and the decorative projects that followed decisively influenced his development as an artist. State patronage was of particular importance in providing occasions for him to demonstrate his faith in the tradition of monumental painting.

By 1833 Delacroix bore little resemblance to the unknown student Talma had engaged to decorate his dining room. He was a man of thirty-five, sure of his powers, ambitious, and eager to put them to use. Although the architecture of the Salon du Roi was far from ideal, it did offer the opportunity to work out a complex program on a large scale. The result, which has its shortcomings, is nevertheless more successful than most critics have been willing to admit, and it deserves our attention.

Delacroix approached his major assignment as a muralist with understandable caution. On May 30, 1833, he wrote the Director of Fine Arts, M. Cavé, requesting that measures be taken to control the dampness of the walls, which had shown itself through several preparatory layers of paint on the ceiling. He recommended a process to curb such damaging effects and an architect who could provide the necessary details and estimates of costs.[2] For a time he contemplated using fresco, favored by so many of the great Renaissance decorators. The novelty and limitations of that quick-drying and recalcitrant medium appealed to him strongly, if temporarily, as a challenge. Accordingly, while on a visit to his cousins the Batailles at Valmont in the early fall of 1834, he painted three small trial panels representing classical subjects in the upper hall of their manor house. The panels remain there, in an excellent state of preservation. That September he discussed the project at some length in a letter to his friend Villot:

I said, by the way, that I have done nothing; I am wrong. It may be that I have done more than I think, since I have tried fresco. My cousin had a small section of wall prepared for me with suitable colors, and in a few hours I did a little subject in this, for me, rather novel medium, but which I believe I could make some use of should the occasion arise. It is easier than distemper: the difficulty lies mainly in completing and rounding out the forms properly, but I believe that the change which takes place in the colors is not as great as in distemper. Nevertheless, it is very slow to dry, and four or five days after it was done, I am still not sure that the colors will recover their brilliance. I confess that I would be remarkably stimulated by an experiment in this medium if I could make it seriously and on a large scale. I believe the process is much simpler than it is made out to be. Besides, I would be free to make a trip to Italy to watch some old plaster-dauber in order to complete my education.[3]

The following month Delacroix made a second experiment with the fresco

technique, and more patience led to what he felt were superior results. Whether the first efforts were destroyed or remain among the three extant compositions is uncertain from the surviving correspondence. He defended the use of the medium by one so little inclined as himself to "colored drawing," observing that its technical limitations excited in him a spirit very different from that induced by "lazy oil painting," which encouraged his habit of retouching. "You know that effort always grows in accordance with difficulty," he continued. "All intractable media invite mastery: as easy conquest arouses less enthusiasm." [4] He admitted that, unlike the Venetian oil technique, the fresco method presupposed certain internal contradictions and lapses in unity. On the other hand, it alone permitted the development of "the *ideal* of which great painting is capable." Granting that both oil and fresco are beautiful, he told Villot that he had "with regret" realized that oil painting required frequent recourse to nature, while fresco, because of the character of its conventions, obviated that dependence.

The small Valmont frescoes are of interest in subject as well as technique. They reaffirm Delacroix's tendency toward allegory as appropriate to decorative works, evident earlier in the Talma decorations. The right panel represents a seated Bacchus, holding out a bowl from which a docile tiger drinks. The two figures easily dominate their setting. They fill much of the picture space and are placed close to the picture plane. Treated almost in relief, with a resultant emphasis on the surface, they show the limitations of neoclassical planarity. In this respect, as well as in the subject itself, Bacchus and the other "first thoughts" at Valmont defer more than a little to classical canons. Sérullaz finds here clear parallels with two versions of Silenus from the Villa of Mysteries at Pompeii,[5] which Delacroix may have known from prints.

The central panel, showing Leda, continues the use of classical motifs and the general disposition of figural elements found in the Bacchus. Leda and her avian suitor form a mirror image of the relationships in the group containing Bacchus. For all its lightness of touch and air of playful improvisation, this piece effectively demonstrates the technical characteristics of the medium. The back of the Leda figure, for example, is rather elaborately modeled, in an apparent attempt to give roundness to the forms. Such other details as the hints of reflected light in the water and the pearls entwined in Leda's brown hair further suggest the painter's exploration of the medium. This is not to say, however, that Delacroix was not interested in the subject itself: a note written sometime between 1820 and 1826,[6] now included in the Supplement to the *Journal*, makes the conception of this little Valmont image seem chaste by comparison:

Leda. Her naïve astonishment on seeing the swan at play in her bosom, surrounding her beautiful bare shoulders and the shining whiteness of her thighs. A new feeling awakens in her troubled spirit; she hides from her companions her mysterious love. Something divine that escapes definition shines in the whiteness of the bird whose neck passes softly over her delicate limbs and whose bold and amorous bill ventures to touch her most secret charms. The young beauty is at first troubled and seeks to reassure herself with the thought that it is only a bird. No witness beholds her transports. Lying in cool shadow beside the brooks [sic] which reflect her beautiful bare limbs while their crystalline waters gently touch the tips of her feet, she asks of the winds the object of her ardor, which she dares not remember.[7]

A third panel shows, appropriately enough, the Greek poet Anacreon, whose lyrics dealt mainly with love and wine. Celebrated in legend for a life of ease and

4. *C*, 1:387 (to Villot from Valmont, October, 1834). Delacroix's reference to oil painting as "lazy" may have derived from Michelangelo, who insisted on painting the Sistine Chapel ceiling in the time-honored technique of "true fresco" rather than in the new mixed technique for which the ceiling had been prepared, declaring that "oil painting is for women and for rich and lazy people" (*ibid.*, p. 23).

5. See *PM*, p. 23.

6. *PM*, p. 23. Because of the style and subjects of the drawings in the notebook containing the description, Sérullaz rejects Joubin's date of 1834 for the passage given in *J*, 3:425, n. 1.

7. *J*, P, p. 712 (Supplement).

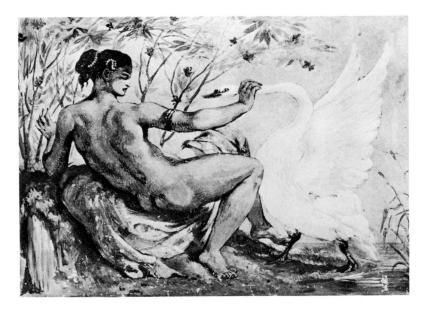

FIGURE 149. *Leda and the Swan*. 1834.
Fresco. 0.67 × 0.88. Valmont Abbey, near Fécamp. Photo Hermann, Éditeurs.

8. See Escholier, *Eugène Delacroix et sa "consolatrice."* Delacroix's closest approach to a sustained romance was with his distant cousin, Baroness Joséphine de Forget, who had close ties with the House of Bonaparte. Her father, Count de la Valette, known as "the Mameluke," had risked supporting Napoleon during the Hundred Days. A god-daughter of the Empress Josephine, who was also her mother's aunt, she regularly visited her cousin, Prince Louis Napoleon, during his exile in Ham, and after his ascension to power used her influence in ruling circles to further Delacroix's cause. In retrospect, it is fortunate that some of those efforts failed, such as her attempt in 1850 to get him the directorship of the Gobelins after he failed to be nominated as Director of Museums. Gaps in the documentary evidence render this love affair somewhat mysterious, despite the evidence assembled by Escholier (see *ibid.* and *Delacroix et les femmes*) and some additional papers recently published by Huyghe (*Delacroix*, pp. 528–32). Fond as he was of his "Consuelo," or his "Consolatrice," as he sometimes called her—at other times his letters are addressed simply to "J"— Delacroix remained incapable of monogamous commitment. His long-standing affair with "J" had begun well before the death of her husband, Baron de Forget, in 1836, and one may suspect that the lady may have preferred to maintain her own independence. It is also clear that she was familiar with her cousin's moods. On one occasion, for example, she reminded him a bit sternly: "As for all your little afflictions, they are not sent by heaven but are of your own making and you must have strength to bear them" (quoted in *ibid.*, p. 531).

pleasure, he is shown here with a white beard, sitting on a white sarcophagus, holding a gold lyre, facing a younger woman. As in the other panels, the color harmony here is delicately pale.

Intimate in size and essentially exploratory in character, these works take on something of the biographical interest of letters; in their gaiety they hint of the other, secret part of Delacroix's life. At about this time he formed his liaison with Mme de Forget, his *"consolatrice,"*[8] so that the references to love and wine seem particularly appropriate. The iconography of the small cycle, in any case, indicates his still lively hedonism, that healthy sense of the corporeal which asserted itself on a grander scale in the murals in the Salon du Roi.

The technique of these small paintings is also of interest. Unlike that usually employed by the masters of the Italian Renaissance, whose murals in "true fresco" Delacroix could not, of course, have seen, apart from a few fragments removed from their original sites to museums, his surfaces are relatively opaque, freely brushed, with touches of rather heavy but fluid impasto in some of the highlights. They resemble those of later fresco painters, who abandoned true fresco in favor of less complex techniques. Delacroix's use of the medium to achieve painterly effects, rather than the sparseness and precision observable in early Italian frescoes, was consistent with his personal style. He may have been encouraged to deviate from true fresco by the study of the small fragments of wall paintings from Herculaneum at the Louvre, which are generally classified as Greco-Roman "fresco" decorations, although they are actually done in encaustic.

In spite of Delacroix's initial enthusiasm for his "new" technique, he decided to paint his Salon decorations directly on the wall surface, in a kind of encaustic. Apparently he was following a formula prescribed by Reynolds as a means of

obtaining mat effects that somewhat resembled distemper.[9] In the poorly lit ceiling panels, where greater brilliance was required to make the subjects stand out, he chose the commoner medium of oil on canvas, which was later glued into place. This procedure also had a practical advantage over painting directly on the ceiling, which would have been awkward at best. Another technical consideration was the damp climate of Paris, which was ill suited to fresco, as Delacroix himself observed.[10] Beyond that, a man so dedicated to rich coloristic effects could hardly have remained satisfied by the relatively pale tones natural to fresco.

The Salon du Roi is a large square room with a skylight dominating the center of the ceiling, which serves more to obscure than to illuminate the neighboring decorations. On one side of the room are three large windows opening onto the court of honor. These other sources of natural light have been hung with heavy draperies. (Delacroix requested, without success, that they be hung with muslin.) The elevation of each wall is similarly composed of three arched openings, with the three doors to the room and a niche for the throne marking the main axes. The windows that occupy the one flanking wall are balanced by mirrors on the others. The two piers separating the arches on each wall have been decorated with figures in grisaille representing the rivers of France and the bordering seas. In the rather meager area formed between the arches and the ceiling cornice, Delacroix elected to place compositions symbolizing the power of the state, as represented by the figures of Justice (above the throne), Agriculture (to the right), Industry (to the left),[11] and War (directly opposite). The coffered ceiling is divided into nine panels of varied sizes and shapes, some square, some oblong. The skylight almost fills the large, square center panel. Masks, ribbons, and other "fillers" decorate the corners and border. On each side of the central coffer, four elongated panels contain reclining figures whose allegorical significance corresponds with that of the adjoining section of the frieze. The four corners are filled with square panels containing small *putti*, each bearing an emblem appropriate to the neighboring allegories: Minerva's owl; a basket of flowers and a shepherd's crook; scissors, a compass, and a hammer; and Heracles' club. As each assumes a strong diagonal relationship both to its immediate frame and to the whole composition, these small figures act as transitional and formal elements, as well as symbols.

Although the initial impact of the Salon du Roi decorations is disappointing, this impression is not altogether the artist's fault. The colors are badly dulled by accumulated dirt and varnish, the illumination is insufficient, and, as Delacroix later complained, the architecture ill served a decorator's purpose.[12] The shapes left to him were cramped and awkward. However, in some respects he lacked a full sense of "measure." With a first novelist's delight in excess, he has crowded too much into the niggardly space afforded by the frieze, nor is the heroic scale of the figures decorating the pilasters altogether harmonious with that of the smaller, though still imposing, scale of the others. There are, in short, many standpoints from which the decorations of the Salon du Roi may seem unresolved, marred by their maker's lack of experience in architectural decoration. Although such "shortcomings" as these have led to the neglect of these works in favor of the other mural commissions, they are nonetheless impressive—indeed, their execution is superior to much of the work in his later decorations for the libraries of the Palais Bourbon and the Luxembourg.

Delacroix's paintings for the Salon du Roi differ from the efforts of his con-

9. See *PM*, p. 29. According to Lassalle-Bordes, Delacroix's formula was a mixture in which wax had been dissolved, producing a jelly-like substance that could be handled in much the same way as real encaustic. This would appear to be the process that Eastlake described as recently revived in France and Germany on the basis of the recommendations of Montabert in his *Traité complet de la peinture* (1829) (see Sir C. L. Eastlake, *Methods and Materials of Painting of the Great Schools and Masters*, 2 vols. [New York: Dover, 1960], 1:163–64ff.); originally published as *Materials for a History of Oil Painting* [London: Brown, Green, and Longmans, 1847]). Eastlake's treatise includes "Extracts from Notes by Sir Joshua Reynolds," which comment on the use of wax additives (1:538–46). In the strictest sense the technique used by Delacroix seems not to have been "encaustic," in which the pigment is mixed with wax and melted to produce a manageable working consistency, hence its name, which means "burning in" (see Mayer, *The Painter's Craft*, pp. 186–89; Max Doerner, *The Materials of the Artist and Their Use in Painting* [New York: Harcourt, Brace, 1938], pp. 300–3). Delacroix kept his "encaustic" medium in a pot and mixed it as it was needed because the paint hardened quickly and could not be reused. This characteristic was particularly bothersome in cold weather, and therefore he used the wax medium in his work at St. Sulpice (see Chapter Eleven, n. 12, below).

10. *J*, 3:31–33.

11. The original intention was to include Commerce here (see *PM*, p. 37).

12. See *L'Art*, 13 (June, 1878): 257–58, a long account written by Delacroix in 1848, along with an article by J. Guiffrey. The frieze section was slightly enlarged, but that adjustment was at best an unhappy compromise.

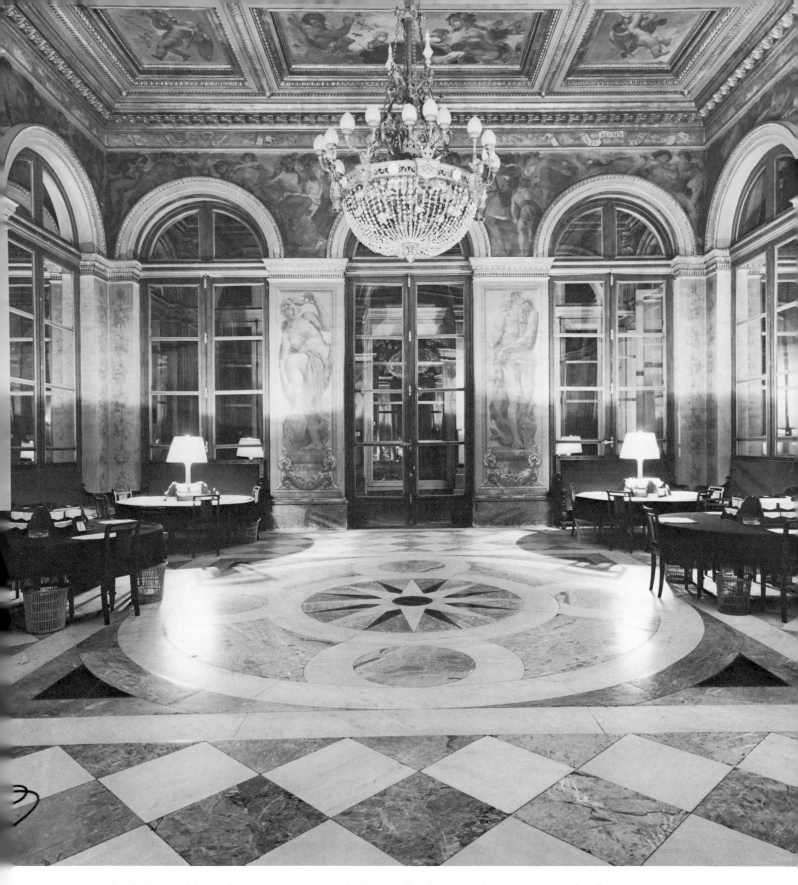

FIGURE 150. Salon du Roi, Palais Bourbon. 1833–38. Frieze and pilasters, oil and wax on plaster; ceiling panels, oil on canvas *marouflé*. Frieze sections, 2.60 × 11; pilaster sections, 3 × 1; large ceiling panels, 1.40 × 3.80; small ceiling panels, 1.40 × 1.40. All photos Marc Lavrillier unless otherwise noted.

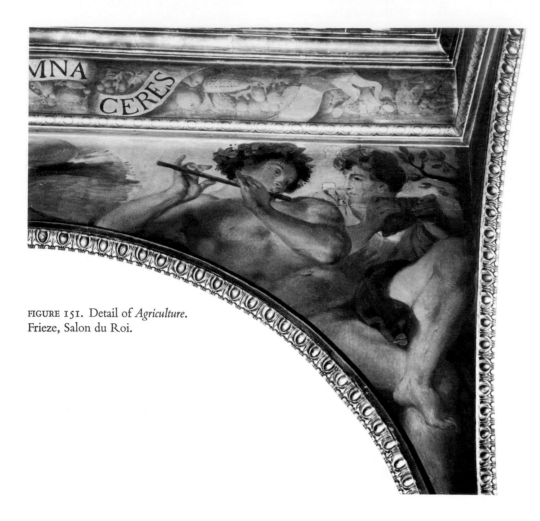

FIGURE 151. Detail of *Agriculture*. Frieze, Salon du Roi.

temporaries, such as the decorations that had recently been completed for the Museum of Charles X, in several ways. First, they are the product of a single designer, while the Louvre murals are in most instances collaborative efforts. The room is further distinguished in that it was done—aside from some ornamental borders—without the aid of the usual assistants or "*rapins*" employed by muralists. In later years Delacroix assigned much of the preparatory and auxiliary work to his *rapins*, sometimes to the detriment of the end product. What is, however, most striking is his recognition of the need to establish a relationship between the painting and the architecture. In contrast to the Museum of Charles X program, Delacroix's Salon du Roi shows a respect for architectural function. The design and handling of his paintings varies in accordance with their location on the piers, frieze, or ceiling. Delacroix has also realized, as Pujol, Schnetz, and Heim did not, that the virtues of a pictorialism suitable to easel painting are likely to be vices in monumental decoration. He therefore did not emphasize spatial illusionism but contrived the poses and placement of his figures with an eye to the physical character of their frame. Delacroix's concern for his compositions as architectural adornment reveals his understanding of Michelangelo, Raphael, and the great Venetian and baroque decorators and anticipates the notions of Puvis and others concerning the "integrity" of the wall.

Of the three distinct decorative areas, the frieze is the most important. Typical in its symbolism and especially fine in style and concept is *Agriculture*, the last

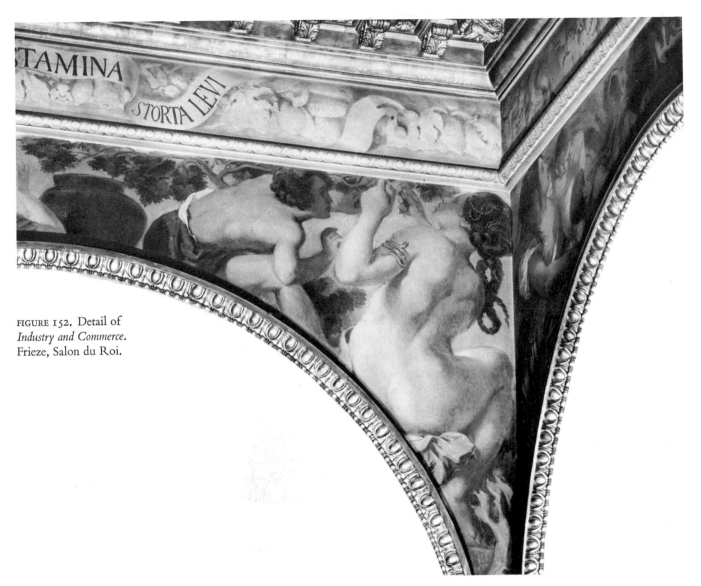

FIGURE 152. Detail of
Industry and Commerce.
Frieze, Salon du Roi.

13. See *PM*, p. 34, where Sérullaz
cites an article in *L'Artiste* which
appeared in the winter of 1836–1837,
indicating that the frieze subjects
were executed in the following
sequence: War, Justice, Industry,
Agriculture.

14. Quoted in R, p. 137. See also
Johnson, "Talma's Dining-Room,"
p. 89, where he points out that this
figure is a repetition of the motif of
Autumn in Delacroix's earliest
decorative series.

15. Quoted in R, p. 140.

part of the frieze to be completed, which appears on the courtyard wall and on
the corresponding ceiling panel.[13] Delacroix himself summarized his decorative
scheme in a comment published many years later:

> Agriculture occupies the large coffer on the court side. She nourishes the infants who
> press to her burnished breast. Close by, a workman fertilizes the earth and commits to
> it the next season's seed.[14]

In the frieze corresponding to Agriculture, on one side the vintage is represented by
fauns and followers of Bacchus, who celebrate the festivities of autumn; on the other
side, the harvest, in the form of a robust peasant who quenches his thirst from a foaming
cup of wine presented to him by some women and children. A weary female harvester
has fallen asleep under the sheaves. Beyond, in the shadow, one forest creature crowned
with ivy plays upon a woodland flute, another on the reed pipe. Elsewhere a youth
pets a goat held by a child. On the border [appears] the inscription: in the middle,
"*Agricultura*"; at the left, "*Plenis Spumat Vindemia Labris*" ["The Vintage Foams in
Full Vats"]; at the right, "*Pacis Alumna Ceres*" ["Ceres the Child of Peace"].[15]

Clearly, Delacroix intended to epitomize a spirit of festive abundance. There
is, of course, a long tradition of celebrating the happy accord between man and

a smiling, productive nature. The Bacchic group is particularly suggestive of the antique. Bacchus himself, represented as a tipsy oldster supported by a gay crowd of younger companions, may reflect a specific classical source, such as the Louvre relief showing the visit of Dionysus to the home of the poet Icarios. The stout deity is also a familiar figure in the art of Rubens and other baroque masters.[16] There are clear overtones of baroque amplitude and of the splendid variety of the Venetians in these decorations.

The opposite wall, to the left of the throne, is devoted to industry and commerce. The corresponding ceiling figure, Commerce, is surrounded by tokens of marine travel and accompanied by two geniuses, one bearing a trident to indicate the importance of the merchant fleet, the other, who is winged, holding a caduceus to symbolize the mercurial speed and security of business transactions. To the left of the frieze below, under the rubric "*Indi Dona Maris*" ("Gifts of the Indian Ocean"), "Negroes," brightly clad, "trade dates, ivory, and gold dust for European wares. Ocean nymphs and marine gods bearing coral and pearls preside over the embarkation of sailors, symbolized by children, who decorate the prow of a ship with flowers."[17] A sense of richness prevails throughout, as in the effulgent tangle of jewels and fruit heaped over the central arch that joins *Industry*, to the right. In the latter section activities related to the fabrication of silk are shown. Women spin, while children gather cocoons into baskets. As in *Agriculture*, the tone throughout this section is one of peace and abundance.

The forces of right and law that sustain man's material well-being are appropriately symbolized on the throne side of the room. Justice, an allegorical figure, adorns the ceiling panel above the niche in which the king's throne was placed. She holds out a scepter to a group of women, children, and the aged, who seek her protection. The frieze below continues this exposition of the primary function of the state. As Delacroix described it, "On one side, Truth and Prudence attend an old man busy writing the laws. Meditation applies herself to the interpretation of the texts. The people rest under the shield of their principal protection. On the other side, three old men are seated on a judicial bench. Nearby, and with the air of readiness to make their decisions respected, stands Authority (Force), depicted as a young woman, almost nude and leaning on a club, with a snarling lion at her feet. Further on, an avenging genius carries out their [the judges'] commands and discovers in their lairs the thieves and sacreligious ones who steal treasures and then try to conceal the fruits of their crime."[18]

Perhaps even more ingeniously than in the other sections of the decoration, Delacroix has here succeeded in animating an intrinsically unpromising subject. As elsewhere, he seems to have made a deliberate attempt to suggest the art of the past: the decorative contortions of the figures and the prophetic cast of the judges strongly recall the Sistine ceiling. At the same time, his personal interests are reflected in many ways, for example, in such details as the lion, which is by no means the only reminder of his exoticism and his recent trip to North Africa.

The generally optimistic tone of the symbolism is qualified by the section representing war, which stands here for protection of the state from outside attack. Part of the frieze represents the preparations for battle—the gathering of arms and the all-pervasive spirit of activity, similar in tone to *Industry*. The left section, however, bears the device "*Invisa Matribus Arma*" ("Arms Are Hateful to Mothers"). Here the victims of war are shown, "women taken into slavery, casting desperate looks toward heaven, their arms made powerless by their

16. See *PM*, p. 45. Sérullaz suggests that Delacroix may have seen a similar example in the British Museum during his London visit. The fact that the figure is reversed, however, may indicate the use of a reproduction.

17. Quoted in R, p. 141.

18. Quoted in R, p. 139.

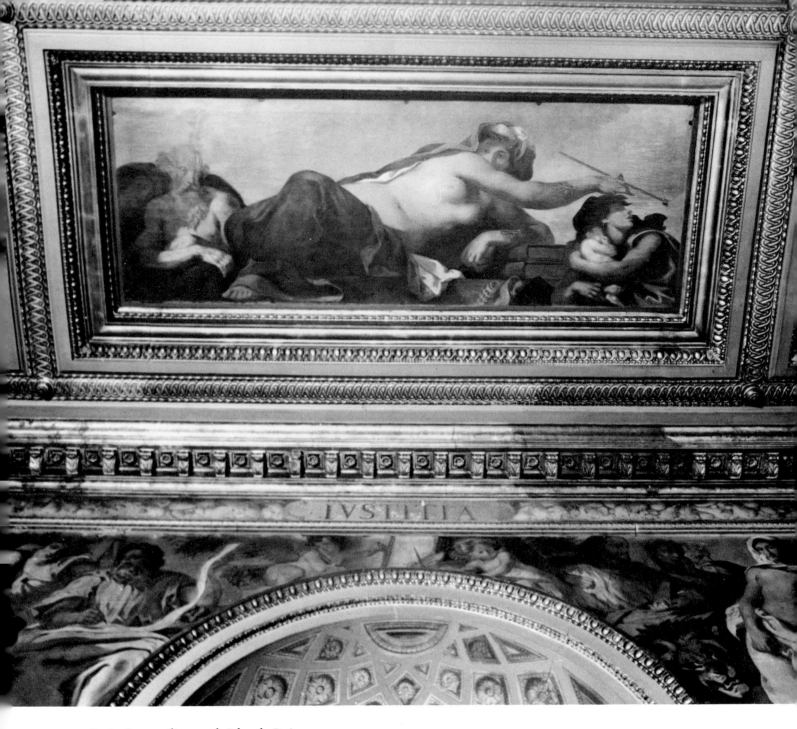

FIGURE 153. *Justice*. Large ceiling panel, Salon du Roi.

19. Quoted in R, p. 142.

bonds." [19] This fiery and dramatic display recalls *Death of Sardanapalus*. Delacroix continued to use scenes of violence and conflict in his murals and was criticized for so doing. These references, however, do not violate the formal unity of the works of which they are a part. In *War*, the shift of symbolic tone punctuates but does not disrupt the continuity of the frieze.

The four themes of the frieze are echoed in the four coffers of the ceiling, where the artist faced a different problem. Because of the dazzling contrast created by the skylight at the center—a hazard compounded by the poor illumination of the rest of the hall—Delacroix utilized more intense color here than in the spandrels.

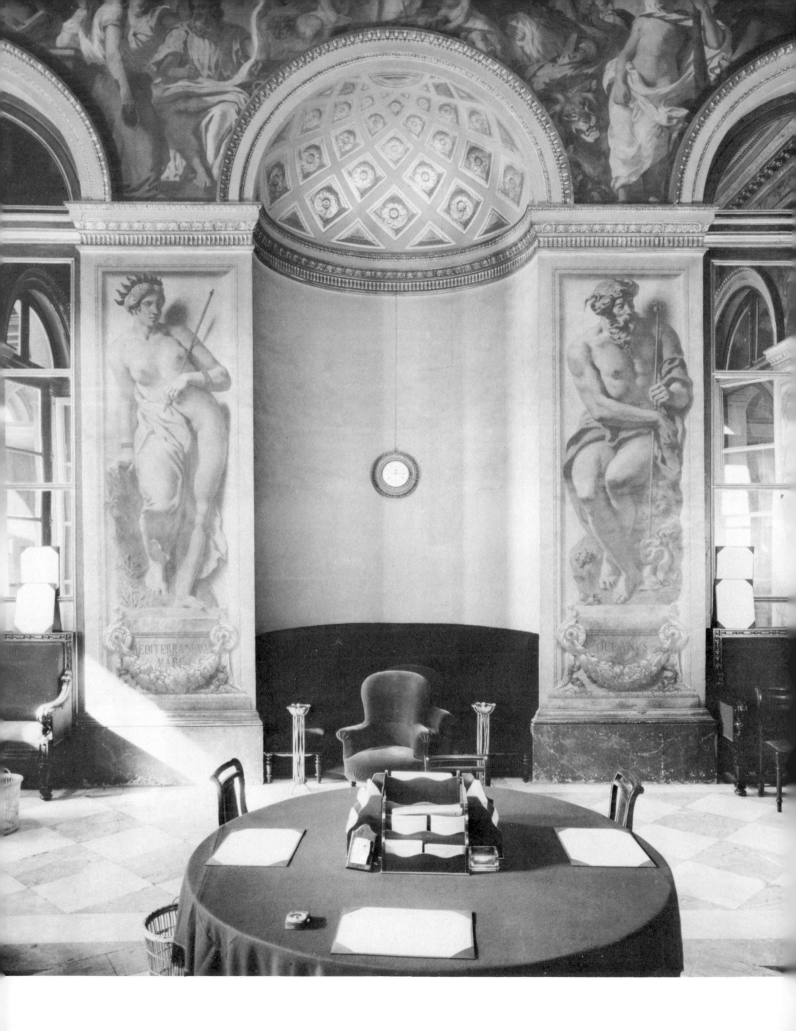

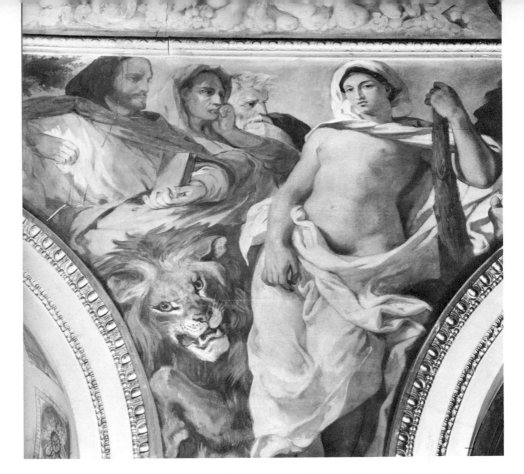

FIGURE 155. Detail of *Justice* showing Authority, Lion, and Judges. Frieze, Salon du Roi.

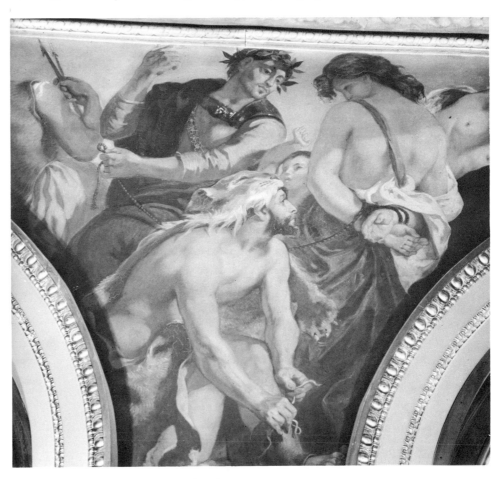

FIGURE 156. Detail of *War*. Frieze, Salon du Roi.

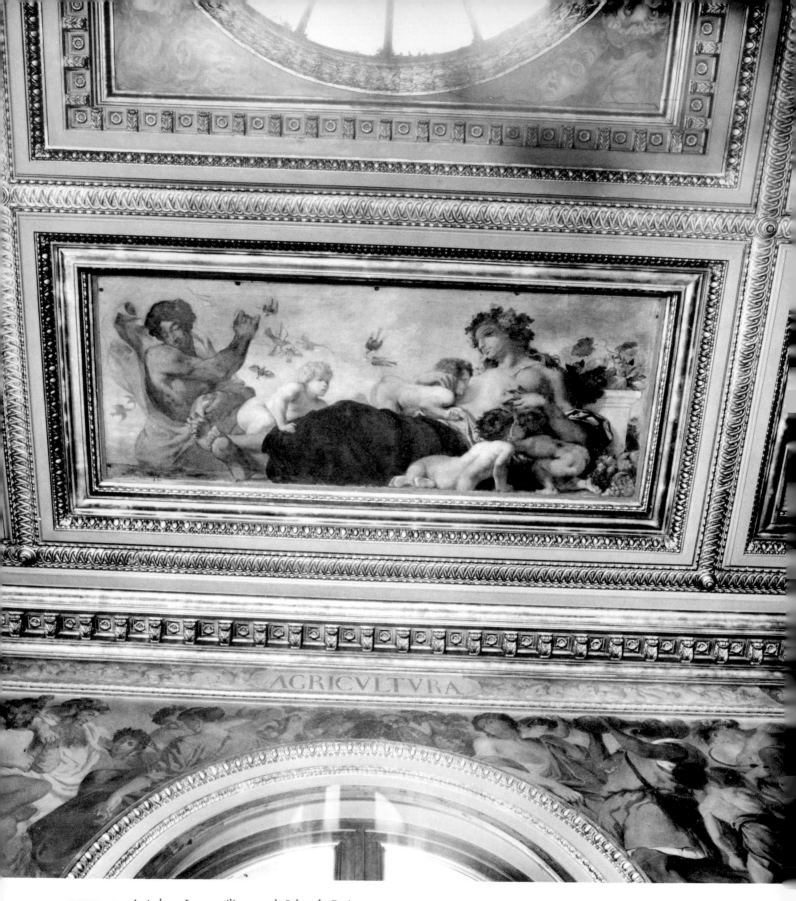

FIGURE 157. *Agriculture*. Large ceiling panel, Salon du Roi.

20. The upper sections were completed by December. The hall was provisionally opened on December 29, 1835, when they were seen by the King (see *PM*, p. 31).

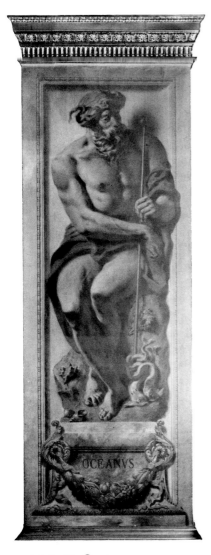

FIGURE 158. *Ocean.*
Pilaster, throne niche wall,
Salon du Roi.
Photo Archives Photographiques.

The ceiling panels have also been more simply treated. In each, a single reclining figure dominates a simple composition involving other subordinate figures. Agriculture is represented by Fecundity, shown as a mature female nursing a swarm of infants whose presence is at once innocent and serious. Beyond the womanly figure is a sower, forceful in his upward-swinging gesture and the wind-blown forms of his red-orange garment. A scatter of birds seen against a lightly clouded sky and the fruits of the earth gathered around Fecundity provide both a color accent and a symbolic referent. In this, as in the other panels, including those with the small *putti* with their attributes (one next to *Agriculture* is scattering flowers), there is an authority of conception and execution that bears comparison with the artist's models in the art of the past. The Venetian splendor of the ceiling happily complements the baroque energy of the frieze.

The decorations of the eight oblong piers that articulate the arcade above and mark the wall apertures were the last murals to be completed.[20] They contain figures of heroic size representing the principal rivers of France, the Atlantic Ocean, and the Mediterranean Sea. It has been proposed that this device was suggested by Jean Goujon's *Fountain of the Innocents,* but the use of such figures in an architectural setting—whether in grisaille, as here, or in true relief—had long been a commonplace of architectural decoration. Their appearance in the Salon du Roi may simply indicate Delacroix's general debt to tradition. The figures are striking not only as a group within the hall but as a link with the outside courtyard. Newly cleaned and once more yellowish in tone, like the murals, it is visible through the windows to the left of the *Justice* wall as the viewer faces it. Delacroix's choice of ocher rather than the neutral tones more often employed for such *trompe l'oeil* "reliefs" would seem to indicate his desire to relate the murals to the larger architectural situation. This intent is also implicit in the use here, as in the spandrels above, of his encaustic-like medium, which was applied directly to the wall surface. This contrasts with the free-standing effect of the oil-on-canvas panels attached to the coffers of the ceiling.

The grisailles are not wholly successful. As mentioned earlier, the heroic figures on the piers are not only too large for their frames but out of scale in relation to the figures in the frieze above them. Although there is a similar shift of relative size between the frieze and the ceiling panels, those elements are on different planes, so that their disparities are more readily accepted. The larger and simpler design of these sculptural figures calls undue attention to the actual paucity of space in the upper zone, which is strained to contain its abundant, colorful forms. On the other hand, the grisailles represent some of the finest painting in the room. The relatively restricted foreshortening of the individual figures recalls the Mannerism of Primaticcio at Fontainebleau, for example, yet their robust, muscular forms suggest, doubtless intentionally, Michelangelo, Bernini, and Puget. As in the figures in *Justice* above, the *Atlantic Ocean* and *Mediterranean Sea* display that heightened sense of physical energy which is characteristic of Delacroix's art immediately after he completed *Liberty Leading the People.* As for the river figures, even though some seem rather awkward and cramped in their settings, the impact of the group as a whole is considerable.

An attempt to appraise Delacroix's full artistic accomplishment in the Salon du Roi must take the subjects into account. The allegorical nature of these murals is a major determinant of their effect, but it arouses mixed feelings in the modern viewer, with his disaffection for "literary" painting. Even in Delacroix's own

day there was what Gautier called, in his long commentary on the murals published in *La presse* while the work was in its later stages, a "modern aversion for allegory." It is ironic that in an age that required some sort of subject matter allegory should fulfill formal and decorative requirements almost better than didactic purposes, in that it tended to minimize the subject. Delacroix's academic contemporaries were nevertheless inclined to judge such conventions on the irrelevant basis of their literal credibility. Gautier therefore attempted to explain the distinctive artistic advantages of allegory:

One very simple fact that people seem to want not to understand is that above all a painter needs arms, shoulders, torsos with beautiful movement, grand airs of the head, the fall and flutter of draperies, a free and simple costume that permits him to make visible what he knows and what he can do; and allegory responds perfectly to all those conditions. It permits the nudity without which, to be truthful, drawing does not exist. It allows great freedom of arrangement. It offers frequent opportunities to create types and to search at leisure for ideal beauty. Nothing is better suited to a painter who wishes to reveal himself fully than an allegorical subject.[21]

He goes on to call the decorations in the Salon du Roi "veritable masterpieces . . . of ingenious arrangement and felicitous symmetry," and his article provides not simply an affirmation of Delacroix's achievement but a more general insight into some of the problems of subject matter. His emphasis upon abstract and painterly options is in agreement with Delacroix's own attitudes, but beyond that, Gautier has pointed to what was to become a contradiction inherent in much realist and naturalist painting. Delacroix, after all, realized in his *Massacre at Scio* and *Liberty Leading the People* the possibility of "real allegory"—and its limitations—long before the phrase and the aesthetic conundrum it proposes occurred to Gustave Courbet.

In 1837, as in our own day, it was very difficult for the public to gain access to the murals in the Palais Bourbon. Delacroix, fearing that they might remain unknown (a fear which was perfectly realistic) and, in spite of his objections to the furnishing of the room and its obvious architectural shortcomings, confident that they would greatly enhance his reputation, managed to obtain authorization to open them temporarily to the public.

The financial outcome of the project proved disappointing, but the disagreements and misunderstandings resulting from the delays in the completion of the Salon du Roi decorations[22] did not prevent Delacroix from receiving other state commissions. In September of 1838, while he was visiting his relatives at Valmont, he learned from a newspaper account that he would be commissioned to decorate the library of the Chamber of Deputies. His undisguised pleasure in hearing of this assignment, one for which he had been scheming, is evident in his letters.[23] When he returned to Paris from his first trip to the Low Countries, he received official word of this opportunity to earn both glory and the sum of sixty thousand francs, and wrote the new Minister of the Interior an enthusiastic acceptance.[24] With the tact of which he was capable, he also wrote a long letter of appreciation to Thiers, whose influence had undoubtedly been crucial, even though he relinquished his ministerial post in April, 1837.[25] Thus, at the age of forty, a mature artist with a considerable public reputation, Delacroix embarked upon a project that absorbed much of his time and energy for almost a decade.

Delacroix summarized some of his initial ideas about possible subjects in a

21. Quoted in Escholier, *Delacroix*, 3:11–12. The original article appeared in *La presse*, August 26, 1837.

22. Even before the murals were completed, Delacroix wrote to Thiers outlining the successive revisions of the program and the resultant growth of his own task far beyond stipulations of the contract (*C*, 1:419–21 [Dec. 27, 1836]; other letters concerning problems of payment are cited by Sérullaz in *PM*, pp. 29ff.; this letter, with some correction of Joubin's transcription of it, appears there on pp. 35–36). The original plan was to decorate only the ceiling panels and the piers separating the windows. The frieze was added later when that area was enlarged in order to improve the general proportions of the room and to relieve its excessively heavy effect. The idea of replacing the whole ceiling had been considered, and Delacroix had persuaded the architect, M. de Joly, and Thiers to change the construction of the frieze instead. This was done, but with the understanding that Delacroix would paint an additional "sixty or seventy figures more or less developed." The government saved a good deal of money by retaining the original ceiling and the alternative revisions occasioned him much added work and expense, not to mention the cost of the ornamental painting, which he had done by "professional decorators" (*C*, 2:41 [to Villot, Nov. 4, 1839]; Pierre-Luc Ciceri was hired as decorator). He was therefore dissatisfied with the sum of Fr. 35,000 originally agreed upon and pointed out that lesser projects by others at the École des Beaux-Arts and the Madeleine were relatively better paid. There is, however, no record of his ever having received an additional fee (on January 10, 1837, he received an authorization for payment of Fr. 13,078.81, which completed payment of the Fr. 35,000 due him [*PM*, pp. 35–37 *et passim*]).

23. *C*, 2:19 (to Pierret, Sept. 5, 1838), 24 (to Villot, Sept. 13, 1838), 26 (to Lassalle-Bordes, Oct. 16, 1838), 27 and n. 1 (to Thiers, Oct. 27, 1838).

24. *C*, 2:26 (Oct. 18, 1838). This sum was later augmented by Fr. 2,029.37 to cover extra work and expenses (*PM*, p. 65).

25. *C*, 2:27–28 (Oct. 27, 1838).

26. Arch. Nat., fol. 21, 752. See *PM*, pp. 49–51.

long memorandum preserved in the Archives Nationales.[26] Although few of these suggestions were adopted, they are nevertheless of interest. For the grand entrance hall he proposed a set of murals illustrating the power of France as protector and bearer of civilization. The large ceiling had as its principal subject Charles Martel's defeat of the Moors and the preservation of Europe as a center of Christian culture. On the supporting cove six panels, suitably related to the architecture, would show "actions that have extended the moral influence of France," as well as its military glories.

The resemblances between this program and that of the Hall of Battles at Versailles can hardly be accidental. The Hall, which was opened to the public in June, 1837, was much talked of, and Delacroix's general sympathy with the historicist point of view represented there had been demonstrated in his *Battle of Taillebourg*, painted as part of the ensemble. After the fall of Napoleon, French intellectuals were much drawn to idealism in their search for an epic national identity. The themes suggested for the entrance hall were therefore well calculated to appeal to contemporary taste.

Only a nineteenth-century Frenchman, however, could fully appreciate *la gloire* of some of the scenes planned for the cove, with the exception of the first subject, the empire of Charlemagne. Clovis' defeat of the Romans at Tolbaic may represent, as Delacroix said, a presentiment of French unity, but it is hard to see it as a great leap forward in the history of European culture. The French adventures in Italy under Charles VII and Louis XIV, also proposed, can scarcely be represented as moral triumphs, nor would we agree that the French entrance into Egypt, the fifth scene, was the "emancipation" that it appeared to Delacroix and his contemporaries. The same chauvinistic tone is clear in the sixth and final subject, the conquest of Algeria: "The revenge for an affront to our national dignity changed the face of North Africa and established the empire of our laws in the place of brutal despotism."[27] Despite the jingoistic tone, however, the program was not acted upon, for what reason is not known.

27. Quoted in Escholier, *Delacroix*, 3:27; *PM*, p. 50.

A set of four panels epitomizing patriotic devotion was suggested for the conference hall. Here Delacroix proposed Cincinnatus, Lycurgus, Phocian, and the senators of Rome, "motionless in their ivory seats,"[28] fearlessly facing the invading Gauls. They were to be flanked by appropriate allegorical figures in grisaille in imitation of sculpture. This appeal to orthodoxy in the selection of subjects was equally unsuccessful, and the commission was eventually given to another artist.

28. Quoted in *PM*, p. 50.

Delacroix drew up a third set of proposals for the library, which were accepted. The room was long, narrow, and high, with a ceiling made up of five small cupolas. Two half domes or hemicycles terminated at either end of the north-south axis of the room. These architectural elements were the largest and most prominent spaces to be decorated. Delacroix proposed to represent the branches of human knowledge in each of the cupolas. One of the hemicycles was to be dedicated to poetry. Here he suggested the crowning of Petrarch by the Senate and the Roman people. The hemicycle opposite would honor philosophy. It was to show the *Phaedo*, with Socrates at a banquet giving his last discourse on immortality, surrounded by Plato and others.[29] As the scheme was eventually revised, however, the two hemicycles were devoted to pendants of peace and war: *Orpheus Civilizing the Greeks* and *Attila and His Barbarians Trampling Italy and the Arts*. The cupola decorations were also greatly altered, although the general

29. Sérullaz gives the texts of a similar proposal, from a facsimile now in the Palais Bourbon library, and of further notes, made by Delacroix and also preserved there, which outline a variant proposal (*PM*, pp. 51–52).

notion of dedicating each set of pendentives to a branch of human knowledge was retained. The two programs are summarized below.

PROPOSED	FINAL

SOUTH HEMICYCLE

| Petrarch Crowned (Triumph of Poetry) | Orpheus Civilizing the Greeks (Peace) |

NORTH HEMICYCLE

| The Phaedon (Triumph of Philosophy) | Attila and his Barbarians Trampling Italy and the Arts (War) |

CUPOLA PENDENTIVES (south to north)

POETRY	SCIENCE
Homer	Death of Pliny the Elder
Virgil	Aristotle Describing the Animals Sent to Him by Alexander
Dante	
Ariosto	Hippocrates Refusing the Presents of the King of Persia
	Archimedes Killed by the Soldier

ART	PHILOSOPHY
Raphael	Herodotus Consulting the Traditions of the Magi
Michelangelo	
Rubens	The Chaldean Shepherds, Inventors of Astronomy
Poussin	Death of the Younger Seneca
	Socrates and His Demons

SCIENCE	LEGISLATION
Galileo	Numa and Egeria
Aristotle	Lycurgus Consulting the Pythia
Archimedes	Demosthenes Addressing the Waves of the Sea
Newton	Cicero Accusing Verres

HISTORY AND PHILOSOPHY	THEOLOGY
Pythagoras	Adam and Eve
Descartes	The Babylonian Captivity
Tacitus	The Death of St. John the Baptist
Thucydides	St. Peter Finding the Drachma of Tribute

THEOLOGY: Fathers of the Church and Doctors of Christian Law	POETRY
St. John Chrysostom	Alexander and the Poems of Homer
St. Jerome	The Education of Achilles
St. Basil	Ovid among the Barbarians
St. Augustine	Hesiod and the Muse

FIGURE 159. Library, Palais Bourbon. 1838–47.
Hemicycles, oil and wax on plaster; cupolas, oil on canvas *maroufléé*. Hemicycles, 7.35 × 10.98;
cupolas, 2.21 × 2.91. All photos Marc Lavrillier unless otherwise noted.

One can see that there were drastic revisions in the final scheme. Further documents[30] and drawings noting yet other possible thematic variants indicate that the eventual selection of subjects was neither quickly nor easily determined. Of particular interest for their association as well as for their quality are two pages with drawings of Spartan girls exercising for battle, which prefigure the canvas of a similar subject, now in the National Gallery in London, by Delacroix's fervent admirer, Degas. The ultimate changes in the hemicycles may have been made in deference to the association of the library with a legislative body responsible for peace and war, and Legislation may have been substituted for Art and moved to the cupola for the same reason. Similar considerations may have inspired the turn to an essentially classical frame of reference in all but the bay devoted to religion. In the original scheme classical figures were mingled with representatives of later periods. Perhaps some objection was made to the fact that only two of Delacroix's great "movers" of Western culture were French. Perhaps it simply seemed prudent to avoid a possible offense to national pride in granting so prominent a role to the Italians. However, the early program, although direct and symmetrical, is vague in its pictorial implications. The visual character of each episode and its appropriateness to the architectural shapes to be decorated were apparently important in the final selection. Even so, some omissions are difficult to explain. Why should Hesiod appear but not Virgil, even though the latter had formerly been proposed for a conspicuous place in one of the hemicycles? Herodotus and Seneca are included among the philosophers, but Plato is absent,

30. Quoted in *PM*, pp. 51–52.

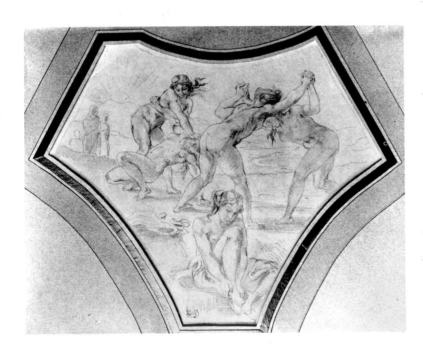

FIGURE 160. *Spartan Girls Exercising for Battle*, study for a pendentive. N.d. Pencil. 0.25 × 0.39. Cabinet des Dessins, Louvre.

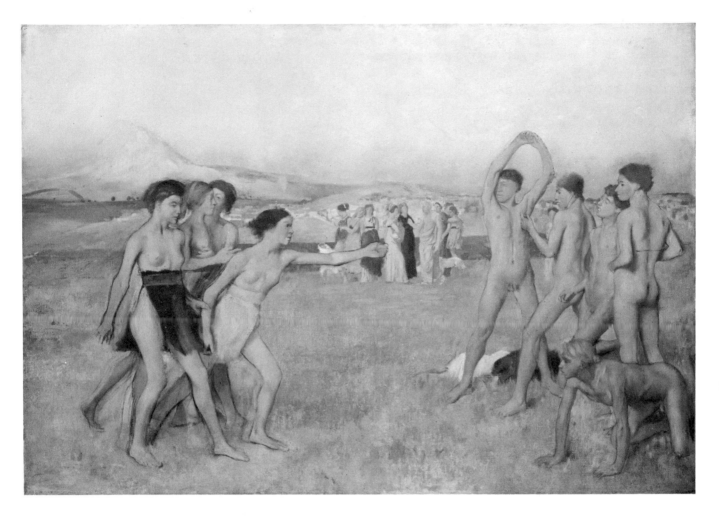

FIGURE 161. Edgar Degas. *Young Spartan Women Exhorting Spartan Youths to Combat.* 1860.
Oil on canvas. The National Gallery, London. Reproduced by courtesy of the Trustees, The
National Gallery. Photo National Gallery.

31. Sérullaz points out that Joubin
erred in stating (*C*, 2:339, n. 4) that
the article appeared on January 10
(see *PM*, pp. 66–68).

and Aristotle is exiled to the realm of science. In short, the choice of subjects, for
all their variety and pictorial interest, is far from orthodox. Christ's discrimination
between spiritual and temporal authority, rather than his mission as man's
Redeemer, is stressed.

The murals were completed in late December, 1847. On January 9 Delacroix
sent a lengthy description of the subjects to Thoré, who published the information
in the January 31 issue of the *Constitutionnel*.[31] The scenes represented on the
pendentives are listed and briefly described. The notes are restricted to the external
facts of the situations depicted, and only in the slightly more extensive accounts
of the hemicycles, with which Delacroix concludes, is there a hint of some
unifying, if unspecified, principle. His description may be summarized as follows.

The two hemidomes at the north and south ends of the room symbolize the
extremes of peace and war. To the south is *Orpheus Civilizing the Greeks*. Orpheus
appears in the center of this pastoral vision, surrounded by a small company of

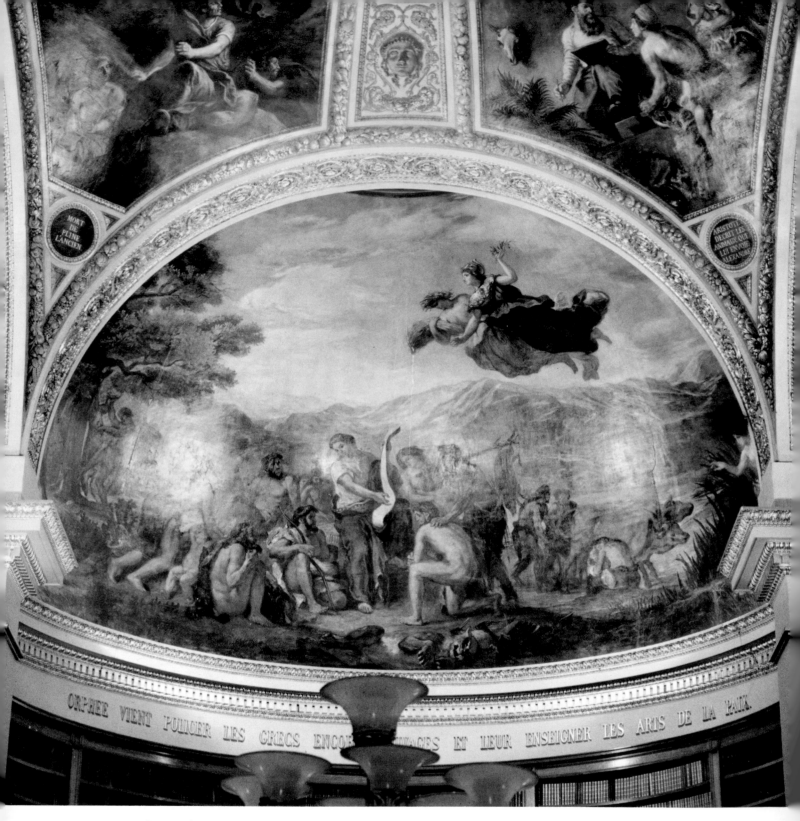

FIGURE 162. *Orpheus Civilizing the Greeks*. Hemicycle, library, Palais Bourbon.

Greeks, still barbarians clad in animal hides, who listen to his instruction in the ways of peace. Nearby, to the right, two oxen pull a plow, indicating the beginnings of agriculture. Hovering overhead are Pallas Athena and Ceres. Elsewhere are hunters, nymphs, centaurs, and other creatures of an untamed world in which antique society is about to emerge. In the opposite hemicycle, *Attila and His Barbarians Trampling Italy and the Arts*, the barbarian leader rides across a devastated land at the head of his hordes. The figure of Italy lies defenseless at the feet of his horse. Stricken in their flight by the invaders' arrows and spears, the inhabitants "bathe with their blood the land that nourished them."

Artists have frequently been indebted to the suggestions of others in devising complex iconographic programs, and it seems more than likely that Delacroix was so influenced. A letter to Villot does indicate Delacroix's dissatisfaction with his first ideas, which he found "unsuitable." He felt that his subjects should be neither too realistic nor too allegorical and should "have something for all tastes."[32]

32. C, 2:24 (Sept. 13, 1838).

However, this selection of individuals and events is so arbitrary as to hint at specific sources. His habit of entering into a private dialogue with those whose writings caught his attention is demonstrated repeatedly in the *Journal*, and such dialogues would seem to be taking place here. Although there is no *Journal* for this period, and the *Correspondance* is not especially informative in the matter, there is enough objective evidence to permit some hypotheses as to the origins of this sequence and the range of meaning that it was meant to convey. A review of some possible literary influences is highly suggestive.

In establishing the temporal limits of his symbolic structure in these depictions of the birth and death of civilization, Delacroix has invited the inference that he accepted the widely prevalent view of history as cyclical. Chateaubriand had revealed a new vision of history to a nation whose intellectuals had long been almost exclusively devoted to the classical tradition. In art and literature interest in troubadour and Christian subjects was an early manifestation of that new awareness. In the period 1820 to 1850 there was an active search for a new historical synthesis. The impact of German idealism, encouraged by Mme de Staël, was great, and the ideas of Herder had particular appeal. His *Sturm und Drang* individualism, with its insistence on the artist's duty to embody the truth of his own being in his art, had an obvious attraction to young intellectuals, as did his belief that the soul of a nation is most clearly revealed in works born of imagination and feeling. At the same time, Herder looked for cultural wholes, to be comprehended through the power and breadth of the creative imagination. Each culture was a unique entity and, like the individual, passed through the stages of growth, maturity, and death.

There are obvious correspondences here with Delacroix's own convictions. There are, of course, equally significant contrasts. Delacroix shared none of Herder's populism or his faith in progress, nor was he inclined toward mysticism or speculation about the meanings of the Vedas and other alien traditions. On the other hand, he was always eclectic in his intellectual positions and selective in his derivations. Even though Herder is not mentioned in the *Journal*, it seems reasonable to posit some influence from a German idealist tradition that had become a part of contemporary thought. Moreover, Delacroix had friends who knew the work of Herder and Hegel: the *Journal* mentions, for example, his interest in the ideas of Victor Cousin, which reflect those of the German philosophers.

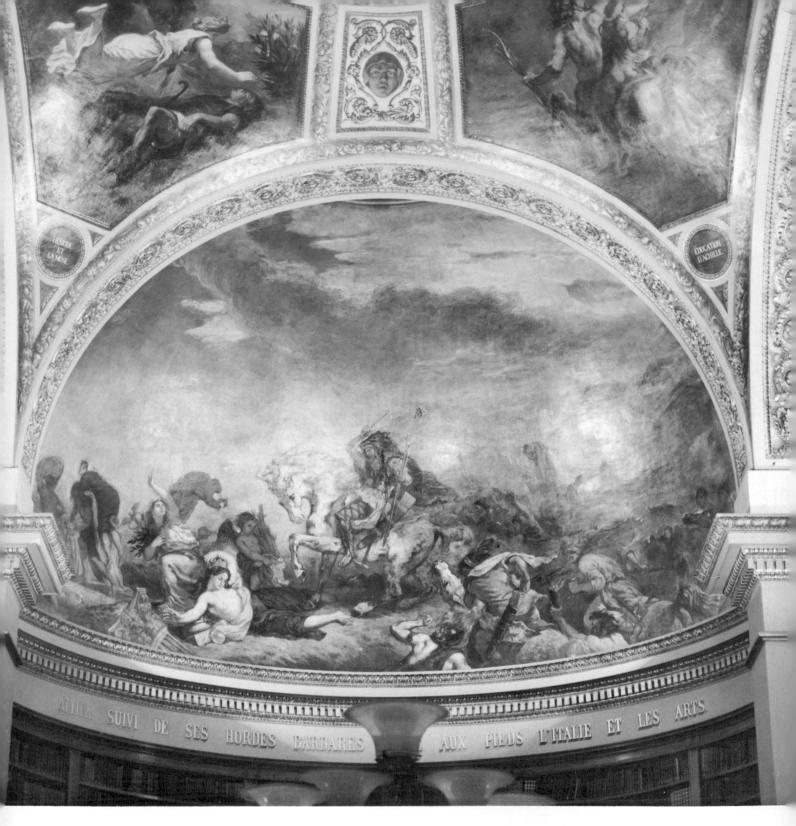

FIGURE 163. *Attila and His Barbarians Trampling Italy and the Arts*.
Hemicycle, library, Palais Bourbon.

33. See Sloane, *Chenavard*, p. 112.

34. For a more detailed discussion of these ideas and their philosophical origins, see *ibid.*, pp. 66–83 *et passim*. See also Armbruster's large folio edition of lithographs after Chenavard's work, *Paul Chenavard et son oeuvre: Première partie le Panthéon* (Lyon, 1887). See also G. L. Hersey, "Delacroix's Imagery in the Palais Bourbon Library," *Journal of the Warburg and Courtauld Institutes*, 31 (1968): 383–403. This important article, published after the present text was written, presents a learned argument for Delacroix's dependence on Vico. That possibility had first been suggested to me by an anonymous referee of this manuscript. Hersey points out that at the time of his death Delacroix's library contained Michelet's translation of the *Sciènza nuova* and suggests that Villot may have influenced Delacroix's eventual definition of his program. Chenavard's possible influence is, however, only mentioned by Hersey in passing. I am still inclined to weight his presence more heavily. Hersey's thesis is challenging and well documented, but it proceeds from an assumption that I am reluctant to accept, namely, that Delacroix was deeply committed to scholarly consistency. In matters of theme, as with visual references, he was characteristically free and more given to compounding his diverse insights than to the systematic formulations with which he has since been credited (or burdened). Alternatively, to assume that the iconography of these murals was primarily dictated by another source casts Delacroix in an unfamiliar passive role. However, there can be no doubt that Hersey's proposals illuminate the intellectual climate reflected in Delacroix's murals, whatever the extent of their pedagogical purpose may have been. His comments on the hero and the mob, on the grouping of the subjects to correspond with library classifications, and many other observations contribute much to the understanding of this complex ensemble.

The ultimate source of the cyclical view of history, of course, was Giambattista Vico. In 1827 Michelet translated his *Sciènza nuova*. Vico's ideas strongly influenced the *Introduction à l'histoire universelle* which Michelet published in 1831, and they permeate his later writing. The notion that history is both produced and revealed by its great men gained wide currency. Ballanche, Quinet, Gautier, Hugo, Lamartine, and others accepted that high estimate of human value in history. Also influential was Vico's proposal that individual freedom of action is limited by fatal forces. Delacroix does not mention Vico in his writings, but he was acquainted with Michelet's works. Furthermore, there were others in his immediate circle who were heavily indebted to the concepts expressed in the *Sciènza nuova* in their search for a global synthesis to counteract bourgeois materialism. Lamartine had adopted a palingenetic view of history, in which his own era was regarded as moribund, but the abstruse theories of Delacroix's strange friend Chenavard were perhaps more directly influential. The two men often had philosophical debates and must have discussed Chenavard's concept of history. That Chenavard often proposed subjects to his friends in this period is evident in his suggestions for an epic that the poet Laprade planned to write, made in 1839, not long after Delacroix recast his own plan for the Palais Bourbon decorations.[33]

Chenavard's palingenetic scheme of history is too complicated to be briefly summarized. Some of his basic tenets, however, may be presented as they affected a project of his own, never completed, to decorate the entire interior of the Pantheon.[34] Like Vico, Chenavard saw history as the record of man's descent

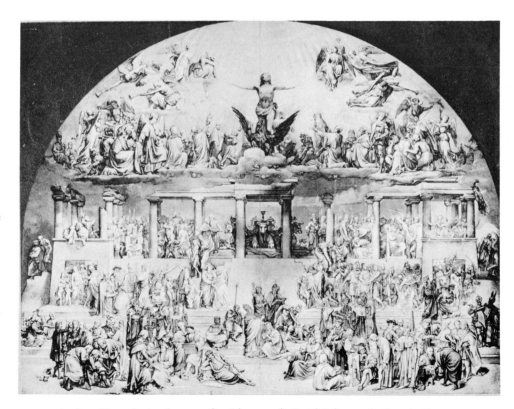

FIGURE 164. Jean-François Armbruster after Chenavard. *Social Palingenesis.* Ca. 1848? Lithograph. 0.11 × 0.34. Photo courtesy of Joseph C. Sloane.

from gods to heroes, to mortals. Unlike Vico, he divided the grand cycle of history into four, not three, epochs. Vico had posited divine, heroic, and modern ages. Chenavard conceived of a closed circle of time comprising four arcs, symbolic of the 8,400 years allotted to mankind. Adam and Eve began the first cycle in 4200 B.C. The erection of the Tower of Babel, where the tongues were multiplied, began the second cycle. The birth of Jesus marked the end of that span and the apogee of man's historical development. From then on, he saw the middle age of mankind and finally, after 2100, its decrepitude. In 2800 history would come to an end and by 3500 lingering death would begin, as man gradually returned to nothingness.

Pessimism is implicit throughout, in the progression from spiritual to materialistic values, from religion through poetry and philosophy to the iron age of science. It would be hard to imagine a more resolute denial of faith in material progress than Chenavard's dogma. At least in a general sense, Delacroix agreed with his friend's description of the present. It is unlikely, however, that he accepted his arcane timetables or all the elaborations the theory invited. For Delacroix a color wheel was apt to be more useful and inviting than a teleological diagram. Yet these explorations of French thought of the 1830's may not be altogether irrelevant to Delacroix's library decorations.

Delacroix has also envisaged an epoch of man's existence. The notion of birth and death is inherent in the hemicycles. Between them are the heroic movers of history. Although many of Delacroix's subjects are mentioned in the *Sciènza nuova*, others are either absent or are presented there in a different guise. It would therefore appear that Delacroix constructed an eclectic scheme on broadly Vichian lines, probably with the advice of his friends.

The series implies the influence of other sources as well. The emphasis on the Greeks and Romans—aside from the area of religion—is consistent with classical preferences. The pairing of illustrious Greeks and Romans recalls Plutarch, for whom Numa and Lycurgus were equally representative of politics, and Chateaubriand mentions Lycurgus as a Jacobin model of liberty and associates him with Numa. He also links Cicero and Verres. For Chateaubriand, Hesiod brought men back to nature; the Scythians enjoyed a happy, natural state, and he describes Orpheus' wanderings among them. (Delacroix copied into the *Journal* Chateaubriand's advice that one learns from the example of antiquity.[35])

One cannot insist on Chateaubriand or any other single literary source for Delacroix's themes at the Palais Bourbon, however: his wide acquaintance with literature and history makes any such speculation hazardous. But there can be no denying that the emphasis throughout is on history as finite tragedy. Although Delacroix accepted, if not the doctrine of original sin, at least the notion of man's innate weakness and corruptibility, there is a surprising emphasis on man's suffering, as he faces the cruelty and barbarism of his fellow creatures or the power of an indifferent nature. This characteristic dualism helps explain the climax of the story of antiquity: Attila's triumph over culture and the arts. It recalls the message of *Sardanapalus*, the ultimate ruin of man's accomplishment. At the same time it may symbolize the promise of the survival of humanity in the painful birth of a new historical cycle.

The technical and artistic problems posed by this ambitious program were forbidding. Delacroix therefore decided at an early point to engage assistants

35. *J*, 3:78. Chateaubriand's comment is made in his Introduction to Suard's *Vauvenargues*.

and to carry out most of the work on the twenty pendentive panels not at the Palais Bourbon but at a large new atelier he set up nearby on Rue Neuve-Guillemin, leaving only the final touches to be added in the library after each stretch of canvas was glued into place. The latter operation was supervised by the color merchant and restorer Haro, upon whom Delacroix depended heavily for this and other technical services. The great expanses of the hemicycles were less amenable to such a process and were easier than the pendentives to execute directly. As a result, they were done *in situ* upon the prepared wall surface rather than on canvas *marouflé*.[36]

Most important was Delacroix's decision to adopt the traditional practice of utilizing what he once referred to as "someone else's arms at the end of one's own." The professional assistant was a familiar figure in Paris artistic circles, where artists had long employed them for the execution of large projects. The participation of these assistants in Delacroix's later production not only affected the quality of individual works but was a factor in determining the quantity of projects he could undertake. Without the collaboration of his "shop," he could never have accepted simultaneous commissions for the libraries of the Luxembourg Palace and the Chamber of Deputies, while at the same time completing his work on the *Pietà* for St. Denis-du-Saint-Sacrement in seventeen days.[37] Such assistance required, however, that the works be developed in such a way as to permit adequate preparation. In that way the master's own task could be accomplished expeditiously. The necessary adjustments of aims and procedures had a profound influence on Delacroix's art.

The first assistant to assume any importance was Gustave Lassalle-Bordes, who acted as a kind of superintendent in the atelier and also worked by arrangement at the two libraries.[38] Delacroix's letters of instruction to him and the others

36. Unfortunately, certain structural faults in the building caused difficulties along the way (see *PM*, p. 61).

37. See *C*, 2:168, n. 2; Escholier, *Delacroix*, 3:56.

38. In a long and acrimonious note to Philippe Burty, Lassalle-Bordes later laid claim to a very large share of the work of both projects (see Burty, ed., *Lettres de Eugène Delacroix*, 2 vols. [Paris: Charpentier, 1880], 2:iii–xxvii). Burty transcribed a further note from Lassalle-Bordes continuing in the same vein but differing in certain details, which he received on September 16, 1880. It is preserved in the Cabinet des Estampes of the Bibliothèque Nationale (Yb.3–975, octavo). The professional and personal relationship between the two men is informatively discussed by Robert Beetem, "Delacroix and His Assistant Lassalle-Bordes: Problems in the Design and Execution of the Luxembourg Dome Mural," *The Art Bulletin*, 49 (December, 1967): 305–10.

FIGURE 165. *Alexander and the Poems of Homer.*
Cupola of poetry, library, Palais Bourbon.

similarly employed—Pierre Andrieu and Louis de Planet were chief among them[39]—document his procedure. These men in turn have left memoirs or other records of their employment by Delacroix which add important information about the artist and his methods.

One of the main values of having assistants was, of course, the possibility of consigning to them the demanding and often boring preparatory work: the enlargement and transfer of designs and the "laying-in" of the first coats, on which the master himself could work out the final details, in the time-honored way. The participation of these collaborators raises questions of attribution, many of which cannot be satisfactorily resolved on the basis of the existing and sometimes conflicting documentary evidence. The problem is compounded by the fact that Delacroix so thoroughly indoctrinated them in his own methods and attitudes and so carefully supervised their work that his personality dominates these collective products. All accounts agree, however, that Delacroix alone executed five of the pendentives, including *Achilles*, *Alexander*, and *Hippocrates*, while his assistants contributed to the rest. The two hemicycles and perhaps as many as ten of the other panels were probably begun by Lassalle-Bordes, who also made a not unpersuasive claim to much of the work at the Luxembourg Palace library. De Planet probably did four of the other *ébauches*, or preparatory lay-ins, in which the subject was developed in a kind of grisaille over a warm-toned ground. Other assistants[40] also contributed to this and later stages of the work and added whatever decorative details were indicated. It must be assumed throughout, on the other hand, that Delacroix himself provided not only the initial pictorial ideas and specifications but also whatever finishing touches were needed. A general study of the master's work, therefore, need not enter into such speculations, however attractive they may be as a scholarly exercise.[41]

In view of the curvature of the architectural surfaces, there were hazards in the decision to carry out most of the work in the atelier, then to glue the separate canvases into place so that only the final touches had to be rendered *in situ*. Moreover, Delacroix's recourse to this practice of *marouflage* suggests a somewhat limited understanding of the intimate relationship of mural painting to its architectural environment and to the spectator. Even with the aid of scale models and careful studies, extensive and unexpected revision was sometimes required to unify the separate pieces and to attain the desired expressive qualities. The final effect is marred by uneven surfaces, flaws that are exaggerated by the high varnish present in their restored state and by their carelessly trimmed edges. The borders of the pendentives, for example, do not bear close inspection, and some of the compositions may have been a bit unbalanced or awkwardly cut in the process of trimming and attachment.

There is always the further danger with *marouflage* that the canvas may not remain firmly attached. At the Luxembourg library, in fact, a crack developed in 1845, soon after the canvas was glued on. It was removed, the cupola was repaired, and work resumed. During the hot weather of 1846 the problem recurred, and the cupola decoration collapsed altogether in May of 1868. Pierre Andrieu supervised the restoration, a task that required fourteen months of patient effort.[42] A good deal of this difficulty was obviously the fault not of the artist but of the structural inadequacies of the buildings themselves, in which unsound combinations of wood with iron responded in various destructive ways to changes of temperature. Even the hemicycles at the Palais Bourbon library,

39. Delacroix maintained a haughty detachment with his *rapins* and treated them almost as janitors. In 1848, after several years' association with Lassalle-Bordes, he could not recall what paintings the younger man had sent to that year's salon as his independent entries (C, 2:346–47 and 347, n. 1). In a letter of sympathy written to Lassalle after he had suffered an accident, Delacroix's annoyance with the inconveniences caused by his employee's absence taints his expressions of affectionate concern (see C, 2:408–9 [Nov. 16, 1849]). Andrieu eventually assumed Lassalle's supervisory role in the studio. The most faithful and satisfactory of Delacroix's assistants and the only one to have a substantial career after leaving his atelier, he was at work on the project at St. Sulpice when Delacroix wrote him this letter (C, 5:200–1), which indicates the tenor of their relationship:

> Saturday, 23 [February, 1856]
> My dear Andrieu,
> I recall that M. Haro told me the other day that there was an unbearable odor in the chapel. I am obliged to hold you responsible for it: this could only come from the part under the planking, where there is some accumulation of refuse. You must therefore ask that M. Baltard have all that cleaned out as soon as possible. We will begin by tracing the ceiling upon the cartoon sheet which is applied above, before judging its proportions.
> With all best wishes,
> E. DELACROIX

Lassalle and the others who were accused by Delacroix of being faithless and ungrateful may have been deservedly condemned, yet it is evident that he was a severe taskmaster and, for all his elegant manners, possessed of an almost military sense of rank. On the other hand, it is likely that he tried to be friendly within the limitations imposed by his feelings of remoteness from most people and his perfectionism in all matters relating to his art. If these men had no real identity for him beyond that of workmen—or even tools—his attitude was strictly professional. The letter reflects the dispassionate precision that made possible the production of a vast body of work in the few years

remaining to him. Of all Delacroix's
assistants, Andrieu was both the
most faithful and the most successful
at imitating the master. Lee Johnson
("Pierre Andrieu, le cachet E. D. et le
Château de Guermantes," *Gazette
des Beaux-Arts*, 6th ser., 67 [February,
1966]:99–110) discusses a virtually
forgotten and most interesting series
of five mural decorations that
Andrieu painted for the Château
around 1886, well after Delacroix's
death. Andrieu's debt to Delacroix
in this "independent" decorative
project is obvious. In the course of
his illuminating discussion of them,
Johnson clarifies the origins of other
works by Andrieu formerly attributed
to Delacroix.

40. Maurice Sand, Desbordes Valmore,
and Alexandre-Martin Delestre were
also employed at one time or another.

41. In addition to the *Souvenirs* of
Louis de Planet and Andrieu's
recollections reported in Piot's *Les
palettes de Delacroix*, commentaries by
Lassalle-Bordes (including his
unpublished notes) and by Villot
provide information in these matters.
See also *PM*, p. 107. Surviving
commentaries by his major aides all
generally agree at least in their
outlines of Delacroix's process.
Their information is confirmed by
the actual appearance of the works,
which illustrate a consistency in the
artist's mature style reflective of his
adoption of a more or less standard
process of execution in works both
great and small. The following chapter
will be devoted in part to further
discussion of this process and some of
its larger implications.

42. See Johnson, "Delacroix
Centenary II," p. 263 and Appendix
IV, in which he cites two unpublished
documents, now in the Palais Bourbon
library, which mention the
restorations undertaken by Andrieu
in 1869, 1874, and 1881 and a later
restoration in 1930. See "Impressions,"
56, No. 3974: "Chambre des
Députés, Deuxième Législature,
session de 1881"; "La restauration
des peintures d'Eugène Delacroix au
'Salon du Roi' et à la bibliothèque de
la Chambre. Rapport présenté à
Messieurs les Questeurs par Arsène
Alexandre, Inspecteur Général des
Beaux-Arts, Novembre 1930,"
Archives de l'Assemblée Nationale,
Palais Bourbon, Paris.

FIGURE 166. *Hippocrates Refusing the Presents of the King of Persia.*
Cupola of science, library, Palais Bourbon.

FIGURE 167. *Death of the Younger Seneca.*
Cupola of philosophy, library, Palais Bourbon.

which are painted directly on the wall, have been damaged by the cracks that have formed as the masonry settled. In another unpredictable accident, the sky in *Attila* was damaged by a shell in 1871 and had to be extensively repaired by Andrieu. One may be surprised, as well as grateful, that these murals have survived their first hundred years as well as they have.

The documents available indicate the general progress of the decorations. Although the commission was granted in the fall of 1838, the actual execution was delayed for some time while preparations were made. It would appear that the work on the murals was not begun until 1842, by which time Delacroix, with the aid of Lassalle-Bordes, was well advanced on the commission for the Luxembourg library, which he received in 1840. The competing claims of this and other projects added to the strain of his unreliable state of health and hampered progress on the Palais Bourbon project. The architect, M. de Joly, indicates that by April 3, 1843, only two of the cupolas had been completed.[43] These were the representations of science and philosophy, which are located at the south end of the room. An anonymous critic writing for *L'Artiste* in October criticized the color as too somber and the representations as generally too heavy, complicated, and difficult to grasp at the distance at which they would be seen.[44] De Planet indicates in his *Souvenirs* that Delacroix recognized the justice of the criticism. His report of Delacroix's shift to brighter tonalities is confirmed by the appearance of the later pendentive paintings. Also noteworthy, as Johnson points out,[45] is the more successful coordination of the later panels with the *Attila* hemicycle, with which they are visually associated when viewed from the floor.

In November, 1846, the cycle remained unfinished, much to the annoyance of those who had been subjected to Delacroix's many appeals for payment during the prolonged course of the project.[46] An entry in the *Journal* for October, 1847, indicates that he was still at work on the *Attila* hemicycle.[47] In December, 1847, the task was finally finished, and Delacroix invited various artists of his acquaintance to visit the Palais Bourbon to see the results.[48] The *Constitutionnel* notice explaining the library decorations and certain critical comments that soon appeared in the Paris press have been useful in discussion of these works.

Although the murals suffer less from their architectural situation than do those in the nearby Salon du Roi, they are not enhanced by it. The natural illumination is seldom, if ever, adequate; the electric lighting that is now available is weak and unevenly distributed and badly distorts the color. After their most recent cleaning and "restoration," a too glossy varnish was applied, compounding the problem of visibility. In addition to these distractions, the ensemble suffers from its placement. The room is long, narrow, and architecturally unattractive. The cupolas themselves seem stunted in comparison with the weight of the other architectural features. Within the cupolas the figurative decoration is restricted to the pendentive surfaces; the central, domed surfaces are painted a heavy, saturated blue that—whether this was the original intention or not—clashes with the neighboring decorations.

The hemicycles have the comparative advantage of greater size and therefore seem less cramped. But here too the architecture does the decorations some disservice, for projecting elements obscure the lower portions of both compositions. Yet even these disadvantages and the uneven quality of the execution resulting from dependence upon the shop do not obscure the character of the

43. See *PM*, pp. 59–60.

44. See *PM*, p. 60.

45. "Delacroix Centenary II," p. 263.

46. See *PM*, p. 63.

47. *J*, 1:241–42 (Oct. 5, 1847).

48. *C*, 2:333–36 (Dec. 21 and 22, 1847). Of the criticisms that resulted, the most notable is the lengthy review by Clément de Ris which appeared in the January 9, 1848, number of *L'Artiste*. See *PM*, pp. 68–70.

cycle as the product of a single, coherent artistic imagination. The study of individual sections for themselves and for their role within the intellectual scheme permits a fair estimate of their particular quality.

Partly because of the demands of the subject, the *Orpheus* hemicycle lacks the drama and focus of its pendant, *Attila Trampling Italy and the Arts*.[49] Both hemicycles present difficult problems, some of which, it must be admitted, the painter has not altogether resolved. Despite his use of scale models to work out the effect he wished to achieve, the angle of vision of the spectator was not well calculated. As a result, much of the lower section of each scene is obscured by architectural projections, while the upper sections are devoted mostly to areas of sky, which are of less intrinsic and decorative interest. The sky areas, however, may represent an effort to avoid a clash of scale and orientation with the adjoining domical bays. Delacroix may have wished thereby to avoid possible distortion caused by the more obvious curvature of the upper surfaces of the half-domes. In any case, the two paintings are representative of the strengths and weaknesses of the cycle as a whole. They are intelligent in conception and at times brilliant in detail. The image of Attila is, for example, one of the high points of Delacroix's entire *oeuvre*. The ensemble, however, is somewhat disappointing as architectural decoration, to judge by the standards of the monumental painting of the past so admired by Delacroix.

The pendentive panel, *Death of the Younger Seneca*, is typical of many others in the series in tone, formal characteristics, and iconographic derivations. The Roman statesman and stoic philosopher is shown in the process of slow suicide as he obeys the command of Nero, his former pupil, that he destroy himself by opening his veins. Refused even a tablet on which to write his will, the condemned man dictates his final thoughts, leaving his sorrowing family and friends the example of his life as a legacy. Nero's ingratitude to his mentor is thus contrasted with Alexander's homage to his teacher, Aristotle, who is represented in the neighboring bay.

The choice of the *Death of Seneca* as an appropriate *exemplum* is consistent with a motif of tragedy that is prominent throughout the series: the impotence of noble resignation to triumph physically over willful and unfeeling force, but its power to assert instead a more enduring moral victory. Nearby, Archimedes is shown about to be killed by an angry Roman soldier. St. John falls victim to Salome's evil whim. Ovid is in exile among the Scythians. The Jews suffer isolation in their own sacrifice to the debt of Adam and Eve, who are also shown in a neighboring pendentive. Nature, heedless of Demosthenes' eloquence, claims Pliny as her victim, as he seeks, in a final scientific effort, to discover the secret of Vesuvius' eruption. The dark and tragic side of life reaches its apogee in Attila's invasion of Italy. Unlike Raphael, whose Vatican fresco showed the barbarian miraculously turned back by the Pope, Delacroix's Attila is triumphing over prostrate Italy and the arts. "To read memoirs and histories," he once wrote, "consoles one for the ordinary afflictions of life with the tableau of human errors and afflictions."[50] His Attila may be his terrible consolation for the daily trials of humanity.

In its formal organization *Seneca* shows the painter's skill in working out the difficult problem of accommodating his narrative elements to a highly irregular, curved, hexagonal shape. As in numerous other panels, such as *St. John*, *Archimedes*, and *Cicero*, he has included a modest indication of architectural detail for both

49. It should be noted, however, that Delacroix himself expressed great satisfaction with the former hemicycle (*J*, 1:199 [Mar. 4, 1847]), although he had some doubts about the success of Attila on horseback (*J*, 1:238 [Sept. 2, 1847]).

50. See *J*, 3:212 (Aug. 19, 1858).

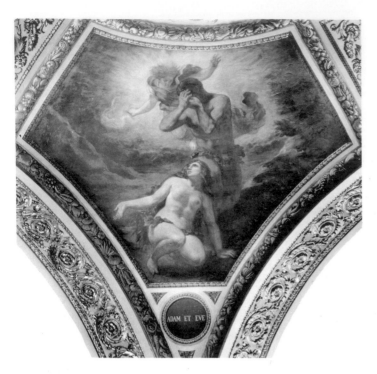

FIGURE 168. *Adam and Eve.*
Cupola of theology, library, Palais Bourbon.

narrative and structural purposes. The composition is built up with great ingenuity from the narrow base of the format, which is occupied by the bowl of blood in which Seneca stands. Delacroix's ability to convert what would appear to be a limitation into a way of attaining expressive focus and formal clarity is one of the fascinations of this and the other pendentive decorations at the Palais Bourbon.

Also characteristic is the fact that his *Seneca* incorporates a traditional motif. The figure of the dying philosopher recalls the Hellenistic type of the old fisherman, although it may well be that Rubens' adaptation of that motif in his *Death of Seneca* was a direct source for Delacroix's depiction. On the other hand, it is also possible that the striking resemblance of Delacroix's treatment to Vignon's *Seneca* in the Louvre is not accidental.

While the formal structure of the pendentive compositions varies greatly from subject to subject, certain basic devices recur. Often, as in *Seneca*, the structure is dominated by a principal figure whose pose affirms the vertical axis. Whether the company is small or great, as in *Cicero Accusing Verres*, the design is firmly oriented vertically. By contrast, many of the other scenes are built up of predominantly diagonal relationships, with an attendant emphasis on dynamic asymmetries. *Hesiod and the Muse* and *Education of Achilles* show this mode in a pronounced form. The spatial character of the settings also varies widely. In *Hesiod* and *Achilles* a simplified landscape background serves to set off the figures against a deep stretch of pictorial space, while in other subjects architectural elements have been included to suggest a more confining, tightly structured environment. In these ways the twenty pendentive panels present a richly varied sequence of formal and narrative variations accomplished within what a less inventive artist would have found to be intimidating restrictions of shape and proportions.

FIGURE 169. Claude Vignon.
Death of Seneca. N.d.
Oil on canvas. 1.46 × 1.26. Louvre.
Photo Agraci.

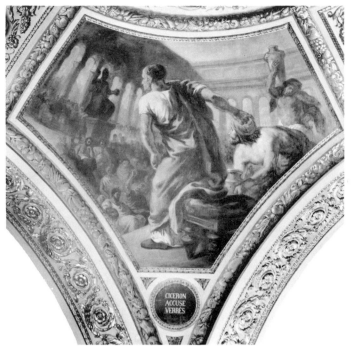

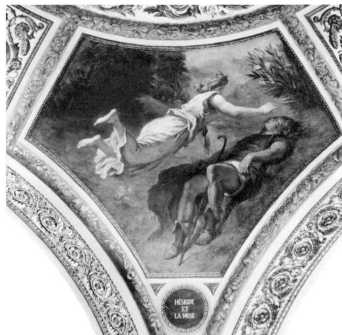

FIGURE 170. *Cicero Accusing Verres.*
Cupola of legislation, library, Palais Bourbon.

FIGURE 171. *Hesiod and the Muse.*
Cupola of poetry, library, Palais Bourbon.

Education of Achilles represents not only a notable compositional variant but an expressive one as well. It reflects the more optimistic aspect of the symbolism in the library decorations. Here man's sensitivity is not punished, nor are his heroic gestures self-defeating. Hesiod does experience divine revelation; Lycurgus and Numa find their own inspiration; the Chaldean shepherds kneel in wonder, not in fear, before the stars; Hippocrates, who pronounced that "*ars longa, vita brevis est*," was not punished for his refusal to betray his own people by aiding the Persians, and if he did not completely fulfill the highest moral claims of his art, he did at least remind his government of its responsibility for the total welfare of its people, even for their health. His appearance among Delacroix's subjects is therefore appropriate.

As a paragon of human achievement, Achilles, the handsomest and bravest of Homer's Greeks, may stand for hope. The composition, perhaps originally suggested by a tapestry designed by Rubens, shows the young hero and the satyr Chiron, who taught him the joys of the chase.[51] This, the most buoyant of all the subjects in the series, celebrates physical energy and well-being. But even Achilles could not in the end transcend mortality. His sagittarian leap is ultimately as fatal as the humble incomprehension of the Chaldean shepherds. These paintings remind us of man's hopes, his nobility, his weakness, and his faults, and the tragic message of his life is couched in a language of heroism that gives monumentality to the artist's vision of mortality.

In spite of the heavy demands placed upon Delacroix and his staff by the project at the Palais Bourbon, he undertook a number of other important works in this period. In 1840 he showed *Justice of Trajan*, a work of mural size, at the salon. The enormous *Entry of the Crusaders into Constantinople* was among the

51. See *J*, 1:443–45 (Jan. 26, 1852), where Delacroix describes a series of eight tapestries once belonging to Louis Philippe which were up for sale at the time. They were sold at a ridiculously low figure and have subsequently been lost. See also *J*, 2:212ff. (July, 1854); 3:71 (Mar. 5, 1857), 92 (Apr. 18, 1857). The subject was also treated by Puget, for example, in a handsome drawing of Achilles, now in Marseille. Better known is J.-B. Regnault's painting, *Education of Achilles* (1782), now in the Louvre, with a smaller variant (1783) now in the Musée Calvet at Avignon.

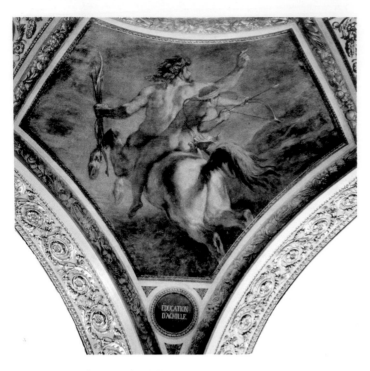

FIGURE 172. *Education of Achilles.*
Cupola of poetry, library, Palais Bourbon.

exhibits in the Salon of 1841, which also included *Jewish Wedding*. In 1843 Delacroix began working on ideas for the *Pietà* for St. Denis-du-Saint-Sacrement. That commission was finished in 1844. Other projects completed in 1843, such as the *Goetz* and *Hamlet* series of lithographs, have been discussed. At the Salon of 1845 Delacroix showed his large *Sultan of Morocco Surrounded by His Court*, along with the hardly less important *Last Words of Marcus Aurelius* and other works; in 1846 he exhibited *Rape of Rebecca* and a painting of Marguerite in church; in 1847 he exhibited *Christ on the Cross between Two Thieves* and some Moroccan subjects. Overshadowing these works in magnitude, if not necessarily in artistic importance, however, was the mural commission for the Senate library, which was done in this period.

While this endeavor was not on the scale of the Palais Bourbon sequence, it was ambitious. The ensemble comprised paintings for the cupola, pendentives, and a large hemicycle. As with his other murals of this period, the preparatory work was done on canvas in the studio and the final touches were added after the canvas had been glued in place. The cupola was saved from destruction by fire in December, 1879,[52] not without sacrifice of the quality of the work. A close examination reveals little of Delacroix's own touch. In this respect, as in others, the Senate library murals, although they were generally well received[53] and have been almost universally praised since their completion, are somewhat disappointing.

The cupola decoration represents a free interpretation of Canto IV of the *Inferno*. Great figures of antiquity symbolizing the humanistic heritage are shown in Limbo. They form four groups, oriented along the axes of the room, in an unbroken landscape under a sky of blue-green touched with warm gray and

FIGURE 173. Study for
Education of Achilles.
Pencil. 0.23 × 0.36. N.d.
Cabinet des Dessins, Louvre.
Photo S.D.P.

52. R, p. 249.

53. See *PM*, pp. 96–107.

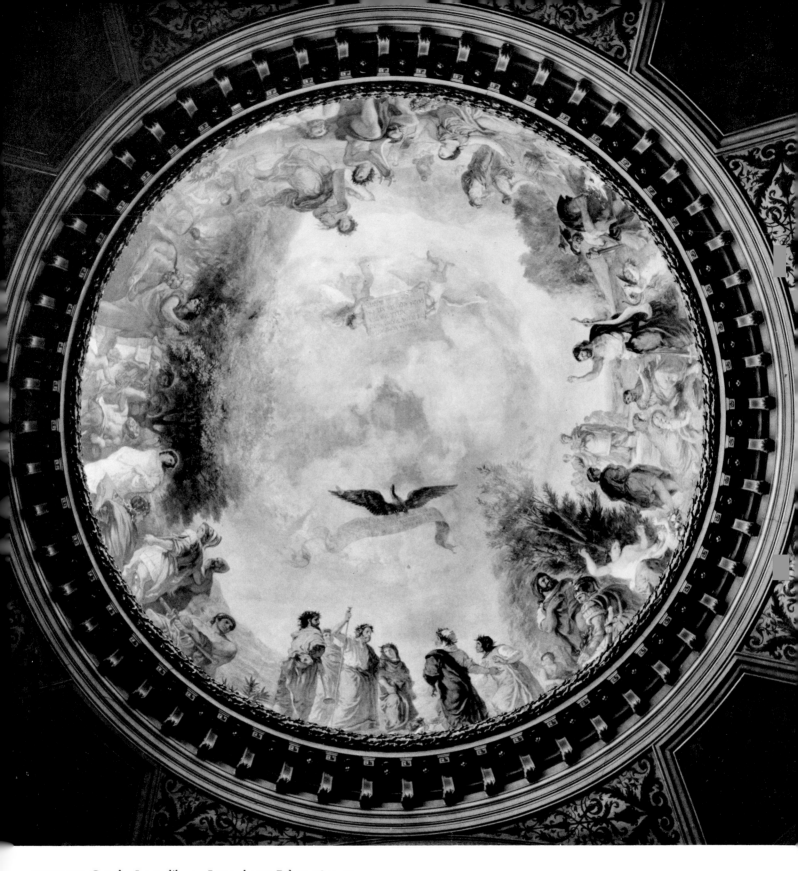

FIGURE 174. Cupola, Senate library, Luxembourg Palace. 1845–47.
Oil on canvas *marouflé*. Diameter, 6.80; circumference, 20.40. All photos Marc Lavrillier
unless otherwise noted.

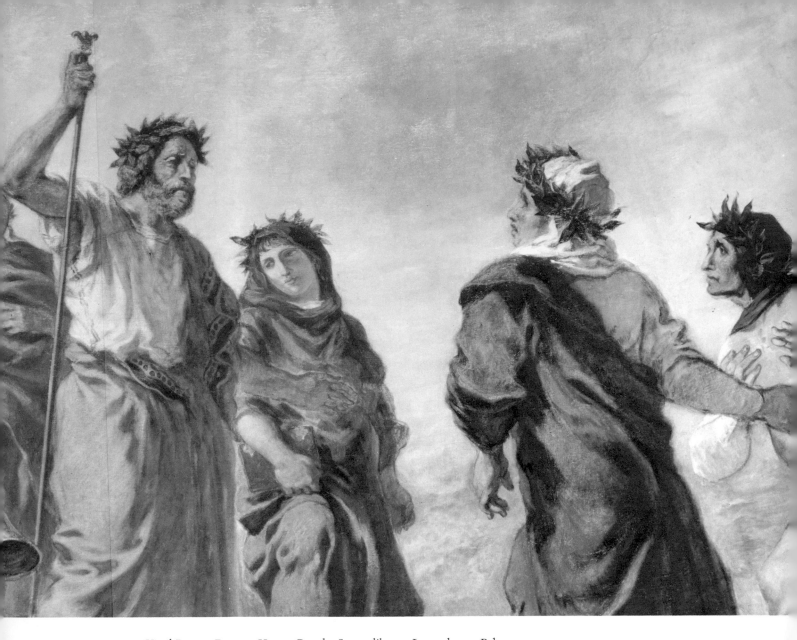

FIGURE 175. *Virgil Presents Dante to Homer*. Cupola, Senate library, Luxembourg Palace.

pink. The first group is opposite the main window and is therefore the best illuminated. In it Virgil presents Dante to Homer, while Ovid, Statius, and Horace watch. A small winged genius or *putto*, seated by a magic spring, offers the visitors a golden cup. Overhead, an eagle bears a streamer emblazoned with Dante's words: "Thus I saw assembled the goodly school of those lords of highest song, which, like an eagle, soars above the rest." [54] The clarity of this representation satisfies classical ideals without sacrificing the personality of the artist. The colors are rather harsh in some areas, perhaps from restorations, yet their simplifications, which reflect practical adjustments for convenience, also look forward to later notions of decorative pattern in mural decoration. The way to Puvis and from him to the Synthetists is indicated here.

In order to avoid awkward breaks between the main groups, Delacroix has introduced as auxiliary or transitional figures Pyrrhus and Hannibal, to the right of the central company, and Achilles to their left. They represent another aspect of

54. Carlyle-Wicksteed translation.

antique glory. Their colorful costumes and informal poses contrast with the solemn restraint of the poetic council. To the left Alexander, with his hand on Aristotle's shoulder, turns to Apelles, who is seated nearby in the foreground. Before them in a glade is Socrates, the wisest of men. He is surrounded by Aspasia, Plato, and, in the shadow, Alcibiades. A genius presents the oracular palm to Socrates. In the foreground Xenophon, crowned with flowers, converses with Demosthenes, who is seated by his side with a scroll across his knees. The tone is less formal than that of Virgil and Dante, a shift perhaps intended to indicate the grace and refinement of a later age.

The landscape of the next scene opens out to a Parnassan vista, with Orpheus, poet of a heroic age, seated in the foreground dictating the myths of Greece to Hesiod. Sappho, accompanied by a panther and two deer, who are tame and amicable because of her presence, turns to present to him her poetry. Beyond her a cousin of the Maiden of Stabiae[55] plucks flowers. Others scattered through the middle distance display a life of peaceful tranquillity.

The moist and airy landscape, generally typical of Delacroix's work from this period on, is suggestive of the allegories of the four seasons, which Delacroix began in 1861 as a set of wall panels for the dining room of a Parisian banker,

55. The relationship of this particular figure to an early study by Delacroix after the famous *Maiden Gathering Flowers* from Stabiae has been pointed out by Lee Johnson (see "Talma's Dining-Room," p. 86 and fig. 33, and the drawing in the Louvre [R.F. 09246]). There is, of course, a familiar classical ring to the murals, as may be seen at a glance in the nearby figure of Cincinnatus.

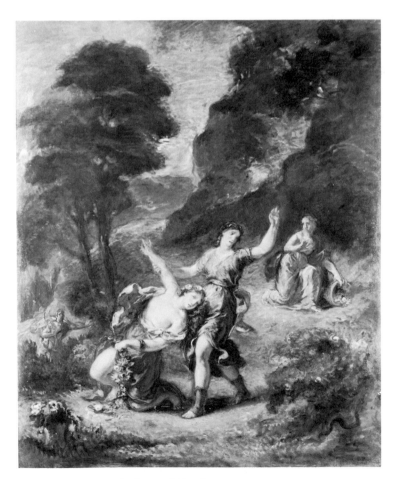

FIGURE 176. *Spring: Orpheus and Eurydice*
(one of the unfinished series *The Seasons* commissioned by Hartmann). 1861.
Oil on canvas. 1.95 × 1.67. Museu de Arte de São Paulo, Brazil. Photo Giraudon.

Fréderick Hartmann. They were never completed, perhaps because of Hartmann's death in 1862. In this late return to the theme that he had first represented in the Talma decorations, spring is shown as Euridice gathering flowers. Knowing Delacroix's penchant for assimilating impressions from the stage, one wonders whether both compositions might not relate to an opera. A sketch, *Heracles and Alcestis* (Robaut 1140), done in 1849 at the time of the work on the murals at the Hôtel de Ville, was apparently directly inspired by Mme Viardot's performances in Gluck's *Orpheus*.

There may be support here for Juliusz Starzynski's proposal that Delacroix's cupola describes a "living antiquity," both in his choice of subjects and in some of the allusions that may be inferred in his portrayals of certain participants.[56] He had articulated this preoccupation (in quite a different context from that of Starzynski) in his *Journal* and letters during his stay in Morocco. Starzynski suggests that the underlying symbolism of Delacroix's Parnassus at the Luxembourg is an amplification of the orphic meanings in the Palais Bourbon hemicycle. He sees the main group as a veiled reference to orphic rites, in which Virgil and Homer bear distinct facial resemblances to Chopin and Delacroix himself. However, the features are so generalized that this can be no more than an attractive

56. See his "La pensée orphique du plafond d'Homère de Delacroix," pp. 73–82.

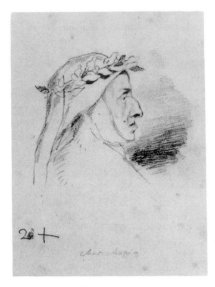

FIGURE 177. *Chopin in Costume as Dante.* Ca. 1849. Pencil. Cabinet des Dessins, Louvre. Photo S.D.P.

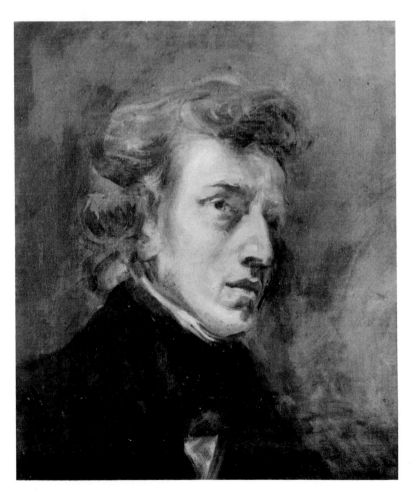

FIGURE 178. *Chopin.* Ca. 1838. Oil on canvas. 0.79 × 0.57. Louvre. Photo S.D.P.

57. The drawing, now in the Cabinet des Dessins of the Louvre, is inscribed to "*cher Chopin*" and signed with Delacroix's musical pun on his own name.

58. Delacroix's friendship with Chopin and George Sand has attracted understandable attention. In 1834, Mme Sand's publisher, Buloz, commissioned Delacroix to paint a portrait of her. She had recently returned from Venice, after her break with Alfred de Musset, and the two had met at a masked ball given the previous year by Arsène Houssaye. In 1838 she introduced Delacroix to Chopin, with whom she had formed a new attachment. The double portrait, intended to show Chopin at the piano with George Sand standing nearby, was begun the same year but for some reason was never completed. The severed images now hang separately, one in the Louvre and the other in the Ordrupgaard Museum in Copenhagen. Because of his friendship with Chopin and George Sand, Delacroix came to know a wealthy and cultivated circle of expatriates in Paris, including Princess Czartoriska, who is often mentioned in the *Journal*.

The intimacy of Delacroix's acquaintance with George Sand has often been exaggerated. It seems to have been a state of mutual confidence, in which Delacroix's main role was that of audience. Her militant, feminist eccentricity disturbed him, and it is notable that when her eventual break with Chopin came, Delacroix sided with Chopin, toward whom he expressed an admiration and fondness rare in his lexicon. That esteem was surely intensified by a deep personal identification with Chopin's strength of spirit and frailty of body. On learning of his death, in 1849, Delacroix hastily returned from Champrosay to Paris to serve as one of "poor Chip-Chop" 's pallbearers. For further biographical details, see C. Wierzynski, *The Life and Death of Chopin* (New York: Simon and Schuster, 1949); André Maurois, *Lélia, the Life of George Sand* (New York: Harper, 1953); Escholier, *Delacroix et les femmes* and *Delacroix et sa "consolatrice."*

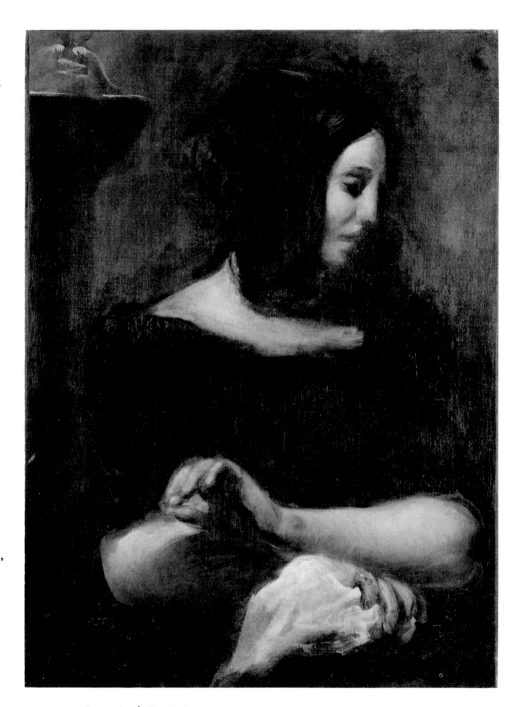

FIGURE 179. *George Sand*. Ca. 1838.
Oil on canvas. 0.45 × 0.38. Ordrupgaard Museum, Copenhagen.
Photo Ordrupgaard Museum.

hypothesis. To be sure, the fusion of the image of Dante with Chopin, whom Delacroix profoundly admired, does occur in a pencil portrait of Chopin as Dante,[57] which is supposed to have been done as a study for the Luxembourg cupola, and Delacroix had earlier begun a double portrait of Chopin and George Sand,[58] a composition now known only from preparatory studies and the two portrait fragments that were salvaged when the canvas was cut apart. Attempts

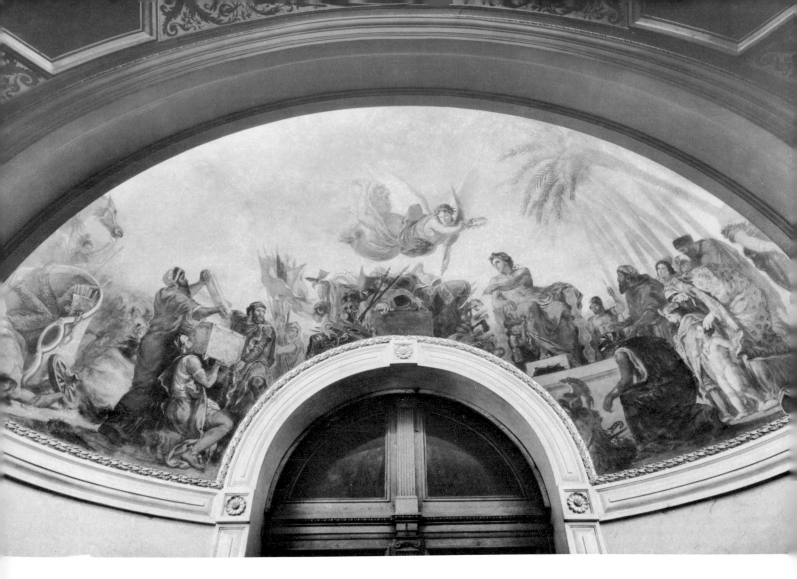

FIGURE 180. *Alexander after the Battle of Arbeles.* 1845–47.
Oil on canvas *marouflé.* 6.80 × 10.20. Hemicycle, Senate library, Luxembourg Palace.

by Starzynski, and Sandblad before him,[59] to extend the notion of the idealized portrait to include others of Delacroix's circle, with George Sand as Aspasia and Mme de Forget as Sappho, must remain tantalizing *aperçus.* It may be that Delacroix did intend some covert reference to his own participation in the revelation of a new Parnassus. Although mysticism was fashionable in certain circles, he was little given to cultism or irrationality, and such correspondences may simply be innocent private conceits of the sort that sometimes led Botticelli, Raphael, Veronese, and others to include themselves and their acquaintances, thinly disguised, in the historical and mythological events they depicted.

The fourth scene, pendant to that of the Greeks, shows the Romans. They are also symbols of moral wisdom, but wisdom in the civic mode of Rome. Portia points out the burning coals of her suicide to Marcus Aurelius. Her father, Cato of Utica, holds out a scroll containing Plotinus' tract. Further on in the landscape Trajan may be seen, shaded by a laurel, with Caesar and Cicero just beyond. At the right, Cincinnatus, shovel in hand, sits contemplating the message of the infant, representing Rome, who invites him to take up arms. Two nymphs, one with a cornucopia, and one of the Roman geese look on. The theme of the

59. N. G. Sandblad, "Le Caton d'Utique de la Bibliothèque du Sénat," *Idea and Form, Studies in the History of Art,* n.s., 1 (1959):202. Sandblad proposes an identification of Delacroix himself not with Virgil but with Cato of Utica, who appears among the illustrious Romans. The resemblance (if there is one) is hardly striking.

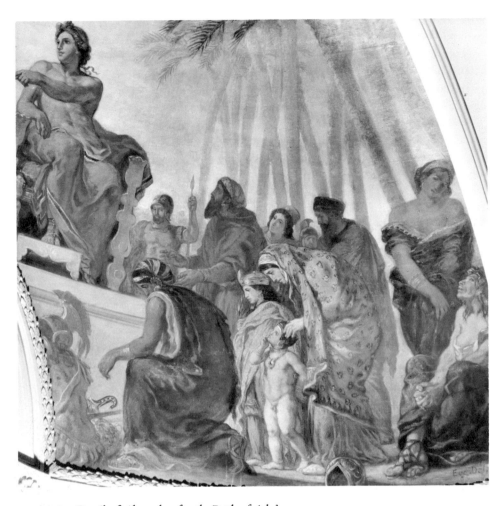

FIGURE 181. Detail of *Alexander after the Battle of Arbeles*.

60. As a youth, Delacroix considered a career in philosophy. He was fascinated by the idea of attempting an explication of Marcus Aurelius in Greek (see *J*, 2:398 [Oct. 4, 1855]).

demands of civic duty is one that occurs elsewhere in Delacroix's works of this period: one recalls *Last Words of Marcus Aurelius*[60] and *Justice of Trajan*.

Four hexagons on the pendentives represent related figures in a kind of grisaille composed of blue-green figures set against a gold-brown background. Various aspects of the human spirit are symbolized by the figures of St. Jerome (philosophy), Cicero (eloquence), Orpheus (poetry), and the muse of Aristotle (science and history seen as one). While these panels are not without iconographic interest, they are of minor significance otherwise in comparison with the hemicycle, which completes the decoration. This scene shows Alexander after the Battle of Arbeles, in which the Persian army was destroyed. He surveys the spoils while a winged Nike holds aloft the victor's crown. To the right, two young sons of Darius appear before Alexander. To the left, attendants place the writings of Homer in a gold chest. (The same episode appears in one of the pendentives at the Palais Bourbon.) Alexander, the enlightened conqueror, had long been a familiar figure in art. Delacroix knew, for example, but disliked Lebrun's series, *Battles of Alexander*.[61] Veronese, among others, had also treated his story. A passage in Delacroix's notes, written around 1840, may suggest the nature of his interest in the subject: "Alexander proceeded . . . by grand and impetuous bounds. He cherished the poets and only esteemed the philosophers.

61. See *J*, 2:151 (Mar. 22, 1854). The life of Heracles, which later appeared in Delacroix's mural cycle at the Hôtel de Ville, also occurred among Lebrun's subjects.

Caesar cherished the philosophers," he explained, "and only esteemed the poets. Both attained the pinnacle of glory. . . . Alexander was great principally because of his soul, Caesar because of his mind."[62] The inclusion of Alexander in the Luxembourg hemicycle thus complements the emphasis upon poetry in the cupola. For the men who bear the responsibilities of power, he serves as a moral example appropriate to places of learning reserved for their use.

The execution of the Luxembourg murals, however, is disappointing in many respects. Considered simply as paintings they do not equal the quality of the best work at the Palais Bourbon. The cycle in the Salon du Roi in particular displays a more sustained technical quality. Furthermore, the drawing in the Luxembourg cycle is sometimes stiff and eccentric, perhaps in part because of the participation of assistants, especially Lassalle-Bordes, who later claimed so great a share of the work.[63] The repairs necessitated by the damage to the cupola may explain the somewhat garish effect of much of the color.

On one occasion at least Delacroix himself expressed similar reservations about the murals that he had recently completed for the Salon de la Paix at the Hôtel de Ville. On May 10, 1854, he confessed in his *Journal*: "I went to look at my salon: I did not discover there a single one of my impressions; the whole thing seemed pallid to me."[64] It is no longer possible to assess the accuracy of Delacroix's self-criticism because the Hôtel de Ville murals no longer exist. One can only guess at their quality on the basis of surviving studies, some of them by Andrieu, who did much of the work on the final panels. Here again coloristic difficulties may well have been the result of reliance on assistants and simplification of tonal effects for their benefit. It also seems probable that the color may have been exaggerated in order to counteract the bad lighting of the room, in which, as Delacroix described it, "the daylight disappears before two o'clock."[65]

Théophile Gautier gave a detailed account of these murals in the *Moniteur universelle* for March 25, 1854, after the newly completed room was opened to selected visitors.[66] Although the work was almost finished by August 28, 1853, the final touches were added in the next few months. The decorations included a large circular ceiling surrounded by eight coffers and a frieze of eleven subjects. At the center Earth, personified by Cybele, begged the heavenly powers for an end to her misery. Among a host of other symbolic figures, Jupiter threatened to strike down the malevolent gods even as he had destroyed the Titans. Other ceiling panels represented the divine friends of peace, Ceres, Clio, the muse of history and daughter of leisure, and Bacchus, the father of joy. Venus was also included, along with Minerva and Mercury, sponsor of commerce. Benign Neptune was shown calming the waves. The figure of Mars, shown struggling against his chains, completed the set of coffer panels. Alternating with the window bays, a series of eleven tympanum-shaped panels of episodes from the life of Heracles formed the frieze (a monumental chimney interrupted one wall and caused the uneven number). The episodes of Heracles' life were in chronological sequence, with the final scene showing him seated at the foot of one of the two columns he erected to mark the limits of the world.

A work painted by Delacroix in 1850–1851 and therefore completed just before the murals at the Hôtel de Ville, a large cartouche representing the victory of Apollo over Python, was done for the ceiling of the Galerie d'Apollon at the

62. *J*, 3:429 (Supplement).

63. See Burty, *Lettres* 2:xii: "The immense task of the two libraries, with which I was engaged for seven years and to which I sacrificed all my personal work, was retouched by the master in less than two months."

64. *J*, 2:182 (May 10, 1854).

65. *C*, 3:189–90 (to Alexandre Arsène Houssaye, Jan. 17, 1854).

66. For Gautier's more elaborate description, see *PM*, pp. 140–41.

FIGURE 182.▷
Victory of Apollo over Python.
1850–51. Oil on canvas *marouflé*.
8.0 × 7.50. Central panel, ceiling,
Galerie d'Apollon, Louvre.
Photo Agraci.

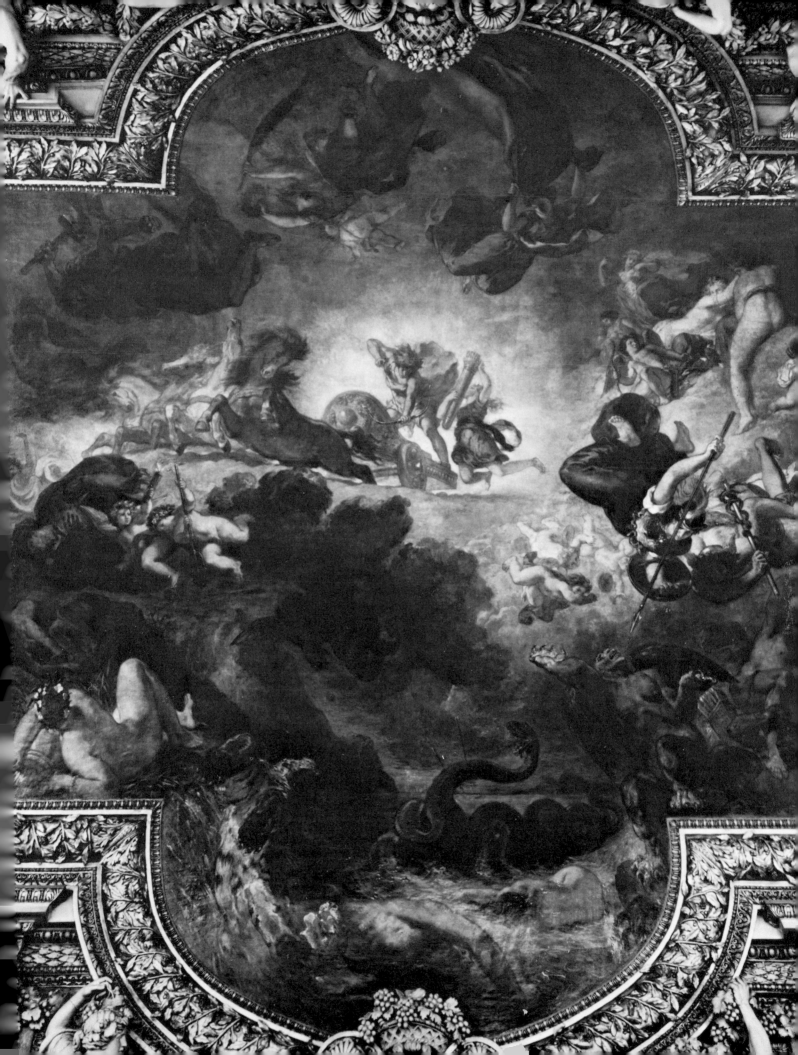

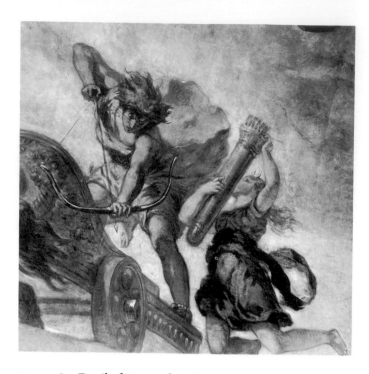

FIGURE 183. Detail of *Victory of Apollo over Python*. Photo Marc Lavrillier.

Louvre. Burned in 1661, this gallery was lavishly redecorated, under the supervision of Lebrun, at the command of Louis XIV, whose vanity was to be satisfied by the sun symbolism planned for the decorations. The King abandoned the Louvre in favor of Versailles, and Lebrun withdrew from his task before it was completed. Thus the central panel, from which the room was to take its name, remained devoid of decoration. After more than a century of neglect and deterioration under a succession of administrations, the restoration of the gallery was undertaken just after the Revolution of 1848. The architect, M. Duban, was attracted to Lebrun's original scheme, and the new Director of Fine Arts, Charles Blanc, was well disposed toward Delacroix. When the new mural was revealed to the public on October 16, 1851, it was accorded a better critical response than Delacroix usually received. Duban himself is said to have arranged an increase in payment for the commission to Fr. 24,000 in recognition of the success of Delacroix's performance.[67]

After briefly considering another subject, nymphs unharnessing the horses of the sun, Delacroix adopted the one originally proposed by Lebrun, the victory of Apollo, which he described as follows:

67. See R, p. 296. For a summary of the related documents, see *PM*, pp. 111–20.

The god, mounted on his chariot, has already loosed some of his bolts. Flying behind him, his sister, Diana, hands him his quiver. Pierced by the arrows of the god of heat and life, the bleeding monster writhes, gasping out the last of its life and its impotent rage in a cloud of flaming vapor. The waters of the flood begin to dry up, depositing the bodies of men and beasts on the mountain tops or washing them away. Indignant at seeing the earth abandoned to deformed monsters, the progeny of slime, the gods, like Apollo, arm themselves. Minerva and Mercury rush in to annihilate them so that the eternal wisdom may repopulate the universal silence. Heracles crushes them with his club. Vulcan, god of fire, chases before him the Night and its unclean vapors, while Boreas and Zephyr dry up the waters and dispel the clouds with their breath. The nymphs of the streams and rivers find their bed of reeds and their urn still polluted by mire and debris. From afar the more timid deities survey this combat between the gods and the elements. From the heights beyond them, however, Victory descends to crown

68. Quoted in R, p. 297.

Apollo victor, and Iris, messenger of the gods, unfurls her scarf as a symbol of the triumph of light over darkness and the revolt of the waters.[68]

As usual in these descriptions, one is struck by Delacroix's conviction of the importance of his poetic inventions. The details are often vivid and elaborate, but some of them, such as the pollution of the nymphs' urns, are impossible to understand without his program notes. Fortunately, such literary associations do not distract from the central allegorical and visual meaning of the composition. Neither are the familiar formal derivations an encumbrance—the Heracles descended from Rubens, the Juno from Correggio's Io, or her companion, whom it seems plausible to relate to Raphael's Galatea or a figure from Poussin's *Triumph of Neptune and Amphitrite*. The innate power of the design draws the viewer's attention beyond the peripheral elements—for all their intense activity—to the bright center of Apollo's dominion. Throughout, the flickering brilliance of the painter's touch lends nervous excitement to his monumental vision, an energy that also permeates the related *St. George and the Dragon* and other paintings of Delacroix's later years.

69. J, 1:440 (June 14, 1851).

In considering *Victory of Apollo*, the *Journal* of the period is again illuminating. It contains abundant notations on color mixtures and other technical details about the work in progress. At one point Delacroix observed with apparent satisfaction that "the execution of the dead bodies in the picture of *Python*, that is my real achievement, the one most suited to my temperament. I would not paint that way from nature, and the freedom that I display in that way compensates for the absence of the model. I must remember this distinctive difference between this part of my picture and the others." This comment is immediately followed by what seems a revealing thematic association: "*Allegory of Glory*. Freed from terrestrial bonds and upheld by *Virtue*, *Genius* arrives at the abode of *Glory*, its supreme goal: it abandons its mortal remains to livid monsters, personifying envy, unjust persecution, etc."[69] While the discrepancies between the two subjects are obvious, they were somehow fused in Delacroix's consciousness. It therefore seems warranted to see in the god's conflict something of the artist's view of his own struggle, enlarged to cosmic proportions. Working at the Louvre during the frustrating time when he was again turned down in his candidacy for the Academy, Andrieu reports Delacroix as crying, doubtless with deep feeling, "*Allons! Courage!* The serpents must be stamped out."[70]

70. Piot, *Les palettes de Delacroix*, p. 89.

The allegorical burden of *Victory of Apollo* has been abundantly served by Delacroix's attention to pictorial structure. Perhaps most instructive from this point of view are some of the observations he made about Ingres' *Apotheosis of Napoleon* in the Hôtel de Ville, a rather similar subject.[71] Here too a mighty warrior drives a celestial quadriga, accompanied by a cortege of allegorical figures. Delacroix's comment on the painting indicates what must have been his intentions for his own mural in the Louvre: "The proportions of his ceiling are altogether shocking: he did not calculate the loss that the perspective of the ceiling brings about in the figures. The emptiness of the whole lower part of the picture is unbearable, and that great even blue in which the horses—quite nude also—swim, with that nude emperor and that chariot in the air, produce an effect as discordant to the mind as to the eye."[72]

71. Some notion of the original appearance of the Ingres panel may be had from surviving studies and a photograph of the work taken while it was temporarily on display at the Universal Exposition of 1855 (see my "The Universal Exhibition of 1855," *Burlington Magazine*, 107 [June, 1965]:301).

72. J, 2:182 (May 10, 1854).

While Delacroix might well be accused of harshness in this dismissal of Ingres, the *Apotheosis* does seem somehow inappropriate as a mural decoration. Its origins in an antique cameo are all too apparent, with all the miscalculations of

FIGURE 184. Ingres retrospective (Plate XI of the album of the Universal Exposition of 1855).
Photograph shows his *Apotheosis of Napoleon*, destroyed in 1870.
George Eastman House, Rochester, N.Y. Photo George Eastman House.

scale and perspective implied in that statement. Delacroix's painting is singularly successful in these respects, for he has exploited the placement of the panel high above the spectator's head by emphasizing the upward sweep of the action.

As usual, Delacroix made careful technical preparations for *Victory of Apollo*. According to Andrieu, he vastly enlarged his palette, extending his modest range of ten basic colors to twenty-eight component hues in an attempt at a richness suitable to the elaborate baroque gallery. "For M. Delacroix," Andrieu said, "nothing was brilliant or intense enough." Yet, as he went on to insist, "his harmony is the marvelous mixture of all the tones, kept at their greatest brightness of hue, corresponding to the rainbow. It is the color of nature allied with poetic magic."[73] Before the large panel was begun, Delacroix worked for six months to evolve his final sketch. When the enlarged drawings were corrected and transferred, he let Andrieu lay on the first tones, "what Titian called making the painting's bed."[74] Then followed the complex and demanding process of building up the color, glazed and opaque, to its final luster.

In depicting the triumph of art and light, Delacroix provided a contrast to the tragic burden of the Palais Bourbon paintings. With a command of atmosphere and light rivaling, but not imitating, the great Venetians he so admired, the decoration fits effortlessly into its baroque setting. Yet there is no taint of archaism. No work by his hand is more fully Delacroix's own, and few others maintain so successful a balance between form and spontaneity of expression. If literary analogy is ever profitable, one might recall Shakespeare's late festive comedies. Aware of the world's shortcomings but rising above them in spirit, Apollo celebrates the rewards of perpetual struggle born of divine discontent.

73. See Piot, *Les palettes de Delacroix*, pp. 86–89, for a summary of Andrieu's account.

74. *Ibid.*, p. 88; see also *J*, 3:33 (Jan. 25, 1857).

The Contest with the Angels

Delacroix's murals at St. Sulpice not only recapitulate much of what had gone before but demonstrate the artist's eagerness, even late in life, to venture further along paths he himself had laid out. In their technique and color, which were truly daring for their time, they represent a continuing search for a bold personal statement, while their undisguised references to earlier art indicate an equally vigorous attempt to wed the present with the past.

As early as January 23, 1847, Delacroix had the notion of decorating the transepts of St. Sulpice. The *Journal* entry for that day gives a list of subjects he was considering, including the Assumption, the Ascension, Moses receiving the tablets of the Law, Moses on the mountain, the Deluge, the Tower of Babel, the Apocalypse, the Crucifixion, Christ carrying the Cross, and the angel routing the Assyrian Army. It is typical of Delacroix that his thoughts should move mercurially from subject matter to speculations about "effect." "For these pictures," he wrote, "think of the beautiful exaggeration of Rubens' horses and men, especially in the *Hunt* [engraved] by Soutman."[1] He then returned to reflections on possible subjects for murals in the transepts. It will be recalled that he actually executed a small version of Christ carrying the Cross. A pendant scene of the Entombment took actual, if simplified, shape in a canvas exhibited at the Salon of 1848. The subject of the third painting was to have been the Apocalypse, and its pendant was to show an angel routing the Assyrian Army, with "the army clambering up rocks; horses and chariots overturned."[2] So far as is known, neither of the latter compositions was ever painted.

Even though Delacroix's splendid plan for decorating the transepts of St. Sulpice and his still grander sequence for the nave were never realized, an opportunity to work in the church did present itself when Charles Blanc became Director of Fine Arts for the Second Republic. In 1845 Blanc had written an article in *La réforme* praising Delacroix's *Pietà* at St. Denis-du-Saint-Sacrement[3] and was well aware of his capacities as a religious painter. The assignment Delacroix actually received, however, was to decorate a single chapel.[4] Accordingly, he listed prospective subjects in his *Journal* for April 10. Of these, only Michael the Archangel and the devil remained in the final scheme. He considered other possibilities, such as Christ in Limbo and original sin, under what proved to be the false assumption that the official commission, which did not arrive until May 20,[5] would specify a baptismal chapel.[6] As it turned out, the chapel assigned him was dedicated to the souls in Purgatory, so that the subject matter had to be reworked. A letter written to Lassalle-Bordes in the following year describes this misunderstanding:

I have been putting off from day to day a reply to your good letter, for which I thank you, because at this very moment I am in the process of deciding on the subjects for my paintings at St. Sulpice. Yes, my good friend, I am still at that; however, I am just about settled, as you will see.

1. *J*, 1:165. This and other documents relating to the St. Sulpice decorations are found in *PM*, pp. 149–82.

2. *J*, 1:166.

3. See *C*, 2:212, n. 1 (to Chopin, March, 1845).

4. Régamey, *Delacroix*, pp. 178ff. In his account of the chapel Régamey has assembled the major documents pertaining to the chronology of its execution. The chapel was one of three for which the Ministry of the Interior paid one-half of the commission and the city the rest. The total paid was Fr. 26,826.27 (see *PM*, p. 150).

5. See *PM*, p. 151. Sérullaz proposes that the date of May 20 in the published *Journal* is in error (see *J*, 1:292 [May 20, 1849]).

6. The chapel may have been so designated since 1844, as is claimed by M. Malbois, *Bulletin paroissial de Saint-Sulpice*, p. 117, quoted in Régamey, *Delacroix*, p. 179.

First, here is what happened. The chapel was that of the baptismal fonts. The subjects follow of themselves: baptism, original sin, atonement, etc. I have my subjects approved by the rector and plan my pictures. After three months I receive a letter in the country informing me that the chapel of the fonts is located under the porch of the church instead of being in the place I am supposed to paint.[7] It is this mistake, which you will find as unpardonable as I, that has kept me in suspense since September, neither more nor less. The justifiable anger that I felt has bowled me over. I have worked in vain; I can think of nothing but that. Finally, since everything must have an end, I think that we will definitely consecrate the chapel to the Holy Angels. There are some subjects which are full of possibilities. I am still undecided among several of them although I have almost all of them planned. The ceiling will be *Michael the Archangel Vanquishing the Devil.*[8]

The question of the dedication of the chapel seems to have been resolved early in October, 1849. Delacroix noted in his diary for October 2, 1849, a conference with the rector and his curate. He added that this was, in fact, the Feast of the Holy Angels. Although the existing documents indicate that he made trial sketches that winter and the following spring, it is not clear just when the specific subjects were agreed upon. It is certain, however, that they were decided by October of 1850. As Delacroix described his undertaking to Dutilleux, "There are two large subjects facing each other with a ceiling and ornaments. . . . One of the subjects is *Heliodorus Driven from the Temple,* the other *Jacob Wrestling with the Angel,* and, finally, the ceiling, *Michael the Archangel Vanquishing the Devil.*"[9] Delacroix explained that he had already been diverted from the project at St. Sulpice to work on his *Victory of Apollo* for the Louvre. The Hôtel de Ville murals, which followed that commission, also seemed more urgent for some reason, so that it was not until June 15, 1854, shortly after they were completed, that he returned to serious work on the chapel.[10]

In the interim, with the help of Lassalle-Bordes, Delacroix had sketched in the four angels that were to decorate the pendentives. When work was resumed, Andrieu had succeeded Lassalle-Bordes as chief assistant, in part, it appears, because of the latter's protracted absence from Paris to prosecute a complicated damage suit.[11] Perhaps because the experienced Lassalle was not available, other problems arose. Delacroix had decided to paint directly on the wall using his "encaustic" formula, but the first coat was too thick and was not adhering properly.[12] It therefore had to be scraped off. Andrieu finished this chore in April, 1854, and began the new preparations.

For a time Delacroix seemed satisfied with the progress of the work. On June 25 he checked the tracing Andrieu was doing. "Everything is adjusted to perfection," he wrote, "and I think the work is going to go very well; the start is excellent."[13] A few days later he confirmed his favorable impression: "Went to Saint-Sulpice, which is getting along well. My heart beats faster when I find myself in the presence of great walls to paint."[14]

His enthusiasm was short-lived, however. The work on the wall soon proved unsatisfactory and also had to be removed. After the long suspension of effort in the church during the dark, cold winter months, Delacroix himself resentfully undertook to complete this menial but indispensable chore. As he put it in a letter to Dutilleux, "I myself have been obliged to 'reprint' the walls, so to speak, doing over the roughing-in, it was so bad. This has resulted in a much better preparation than the ordinary roughing-in would have been, but I did a job unusual for a painter and more that of a mason. I used so much white in a

7. For plans of the church and a detailed discussion of its structure, history, and contents, see G. Lemesle *et al.,* *L'Église Saint-Sulpice* (Paris: Bloud et Gay, [1931]). Under the north tower there is a round chapel constructed as a baptistery and decorated in the eighteenth century with a bas-relief of the baptism of Christ. It is hard to understand how the rector and the city architect, Victor Baltard, could have overlooked its presence from May until September 1, when Delacroix was finally told about it. See Régamey, *Delacroix,* p. 180; *PM,* pp. 151–52. Sérullaz points out that the change was in the designation, not the location, as Joubin suggests (*J,* 1:285, n. 2, 306, n. 1), assigned to Delacroix.

8. *C,* 3:6 (Jan. 22, 1850). Delacroix had been in touch with Lassalle-Bordes on the subject of his work for St. Sulpice (*C,* 2:395 [Aug. 31, 1849]).

9. *C,* 3:36–37 (Oct. 5, 1850).

10. See *J,* 2:201 (June 15, 1854).

11. See, for example, *C,* 3:6–9. In January, 1850, Delacroix wrote a declaration on Lassalle's behalf, in which he remarked on the inconvenience both men had suffered because of Lassalle's inability to carry on his ordinary duties. There is evidence, however, that a breach soon developed—one which Delacroix showed no interest in repairing. By June, 1850, he was obviously no longer interested in Lassalle's assistance (*C,* 3:25). A letter to Andrieu, written on December 1, 1850 (*C,* 3:48), reveals that by that time Delacroix wished no further relationship with Lassalle. For Lassalle's account, see Burty, *Lettres,* pp. xiff. Lassalle considered the "final break" to have come in 1853 (p. xiv).

12. The natural tendency of the wax mixture to harden was particularly bothersome in cold weather. Along with failing light, this difficulty inhibited work at the chapel during the winter.

13. *J,* P, p. 391 (June 25, 1854).

14. *J,* P, p. 394 (June 30, 1854).

15. *C*, 3:288 (Sept. 8, 1855).

place where there is virtually no circulation of the air that it almost gave me lead poisoning."[15]

Compounding Delacroix's frustration were the petty annoyances he encountered. His well-known love of music, for example, had led to difficulties with the rector, who forbade work in the chapel on Sundays, even though Delacroix found the music of the offices stimulating and satisfying. Outraged by this arbitrary decision, he sought allies. On August 3, 1854, he commented in his *Journal*: "In the morning, an appointment with Abbé Coquant to ask him to let me work on Sundays. One impossibility after another! The Emperor, the Empress, Monsigneur, all conspire to keep a poor painter like me from committing the sacrilege of expressing, on Sundays as on other days, the ideas he draws from his brain to glorify the Lord. However, I used to work in churches on Sunday by preference: the music of the services greatly stimulated me. I have done a lot that way at St. Denis-du-Saint-Sacrement."[16]

16. *J*, 2:224–25.

Delacroix's protests were not all equally formal, it seems. Andrieu recollected his response to the enforcement of the rector's Blue Laws by a stolid Swiss sacristan. Delacroix would sometimes chatter to Andrieu without pause, his voice rising with excitement. "The Swiss, his enemy, scandalized, came rapping at the door of the temporary partition shutting off the chapel to try to silence him. At sixty the master responded with the jokes of an art student."[17] One Saturday night Delacroix is said to have dressed a lay figure in his clothes and set it up with face averted, brush in hand, in one of his most typical gestures of contemplation, just opposite the keyhole. On Sunday morning Delacroix and Andrieu made a conspicuous appearance at church, then hid themselves. The sacristan, who saw them enter and supposed them to be at work, rapped on the door to interrupt them. Puzzled by the lack of response, he peeked through the keyhole, saw what he took to be the artist at work, and furiously battered down the door. The pair then emerged from hiding to enjoy the joke.[18] Perhaps these counter-attacks contributed to the success of Delacroix's campaign to be allowed to work on Sundays. His *Journal* of the following year records his satisfaction with his victory: "I have worked a great deal this morning at the church, inspired by the music and the chants. There was an extraordinary service at eight o'clock. That music put me in a state of exaltation favorable to painting."[19]

17. See Piot, *Les palettes de Delacroix*, pp. 4–5.

18. *Ibid.*, p. 5n.

Nevertheless, he could not complete as much of the work as he wished during the summer and early fall months, when the light was favorable. In August he wrote again to Dutilleux: "Your good letter reached me in the middle of my rude labor at St. Sulpice, which I shall still be pursuing for the whole of next month. This job, so much delayed and constantly interrupted, could have been finished in this campaign; the uncertain lighting of the late autumn will force me to stop work again, but with the resolve to finish in the spring."[20] Work continued, with the help of Andrieu.[21]

19. *J*, 3:370 (Aug. 30, 1855), quoted in Régamey, *Delacroix*, p. 183.

20. *C*, 3:338 (Aug. 24, 1856).

21. Another assistant, Louis J.-B. Boulangé, had also been employed from time to time, but he proved undependable and was eventually dismissed (see *C*, 3:321 [Mar. 13, 1856]; *PM*, pp. 156–57, 160–61; *J*, 3:285–87 [Apr. 6, 7, 9, 1860]). Boulangé was a former pupil of the decorator Ciceri. Delacroix also consulted Ciceri on matters relating to the architectural sections of *Justice of Trajan* (see *C*, 2:41–42 [to Villot, Nov. 4, 1839]). Boulangé worked on the architectural sections of *Entry of the Crusaders* (see Piot, *Les palettes de Delacroix*, p. 80).

When the weather turned cold, the penetrating chill of the big, unheated church not only made it difficult to handle the wax medium but proved a constant threat to Delacroix's precarious health. Sickness interrupted the work in 1858. In October Delacroix wrote to reassure his cousin Antoine Berryer that his work at the chapel had given him a great sense of renewal, but it is evident that he was suffering from overexertion and knew it. "I write you later than I should have wished," he began a letter to another cousin, Auguste Lamey, "but for the past

three weeks I have been *snowed under* in my great task at St. Sulpice, and it absorbs me completely—not that it does not leave me time to do anything else, but that it incapacitates me. These are labors so fatiguing to my weak constitution that, except there [in the church], I feel the weight of that fatigue. Moreover," he continued, "I commend myself for my perseverance: I have made a strenuous effort that will, I hope, enable me to finish next year—not without still being obliged to work hard."[22]

Obviously, his optimism was unfounded. Work continued on into 1860, with further interruptions from illness and the seasons. For part of that time Delacroix commuted daily to Paris from his small villa at Champrosay, where he had decided to profit from the country air and the quiet. He referred to this commuter's regimen as a "heroic resolution"[23] and in a letter gives a detailed account of his daily schedule: "Here is the inspiration I had about three weeks ago, and so I've made a success of it. I am awakened every morning at five-thirty to take the first train; I am at work toward eight-thirty and come back during the day, trying not to stay at work too long in spite of the furious zest I have for it. I can return to Champrosay at three o'clock. I dine early and go to bed the same way. There is the strange life that perhaps makes me exercise too much, but which leaves me not a single moment of emptiness or boredom and permits me to conceive the hope of finishing my undertaking."[24] In 1860, determined to complete the paintings at all costs, he worked all winter long. That November he caught a cold and again had to interrupt the work, but only briefly. By February of 1861 the decorations were virtually completed, but the final touches were not added until the following July, shortly before the chapel was opened.

On July 29, 1861, Delacroix sent out printed invitations to private viewings of the work, along with brief descriptions of the paintings for the benefit of the visitors:

Ceiling.—Michael the Archangel vanquishing the devil.

Picture to the right.—Heliodorus driven from the temple. Having presented himself with his guards to take away the treasures, he is suddenly knocked down by a mysterious horseman. At the same time two celestial envoys throw themselves upon him and beat him furiously with rods until he is cast out of the sacred precincts.

Picture to the left.—Jacob's struggle with the angel. Jacob accompanies the flocks and other presents with which he hopes to melt the anger of his brother Esau. A stranger appears who stops him along the way and engages him in a stubborn battle, which does not end until the moment when Jacob, touched on a nerve of his thigh by his adversary, finds himself reduced to helplessness. That struggle is regarded by the holy books as a symbol of the proofs God sometimes sends to his elect.[25]

According to the account of a painter named Timbal, a good number of guests arrived, and Delacroix, pale and nervous, chatted automatically while looking about him anxiously to gauge each guest's reaction.[26] The immediate response seems to have been enthusiastic, for he had acquired a certain following. His letters of the time to artist friends like Paul Huet and Eugène Lami and to friendly critics like Gautier and Thoré express his gratitude for their support. But while the opening at St. Sulpice was hardly a disaster, it was far from the popular triumph Delacroix had hoped for.

With his habitual tact, he sent special notes of invitation to various high officials, including those who had often been helpful to him. He wrote Charles

22. *C*, 4:47 (Oct. 6, 1858).

23. *C*, 4:203 (to Antoine Berryer, Oct. 14, 1860).

FIGURE 185. *Jenny Le Guillou.* 1840. Oil on canvas. 0.46 × 0.38. Louvre. Photo S.D.P.

24. *C*, 4:200–1 (to Auguste Lamey, Oct. 2, 1860). The devoted service of Delacroix's housekeeper was indispensable to the maintenance of his "heroic resolution." A native of Brest, Jeanne-Marie Le Guillou, known as Jenny, became his house-keeper around 1835. Joubin claims that she bore him a daughter, who died very young (*C*, 1:42, n. 1), the same child whose portrait Delacroix painted in 1840 as a companion piece to his portrait of Jenny, done the same year. While it is uncertain whether this was the case of paternity in which Delacroix appears to have been involved, there is no reason to accept Lassalle-Bordes' mischievous assertion in his unpublished Notes on Delacroix that she was his mistress (see Huyghe, *Delacroix*, p. 518). She was, however, the one person whose ungrudging loyalty he came to rely upon. As the years passed she assumed a protective role, often to the annoyance of Delacroix's friends, and was even helpful to him in handling certain studio dealings with his assistants. Although she did not have the intellect, appearance, or social standing Delacroix ordinarily demanded in his companions, he

trusted her plain-spoken opinions and was frequently seen with her, whether at the Louvre or along the beach at Dieppe. She nursed him through many illnesses and was at his side when he died. Théophile Silvestre, who had become a familiar figure in Delacroix's household, describes those last hours vividly in *Les artistes français*, 1:71–75. Jenny was comfortably provided for in Delacroix's will (transcribed in Philippe Burty, ed., *Lettres de Delacroix* [Paris: A. Quantin, 1878]), and a number of his works were entrusted to her care, including *Self-Portrait in a Green Vest*, now in the Louvre.

25. *C*, 4:253. The date given above has been corrected in accordance with Sérullaz's notation of errors in their transcriptions by Burty and Joubin (*PM*, p. 164).

26. Louis-Charles Timbal, *Notes et causeries sur l'art et les artistes*, p. 233, quoted in Régamey, *Delacroix*, p. 186.

27. *C*, 4:256–57 (July 23, 1861).

28. *C*, 4:266–67 (Aug. 23, 1861).

29. See Régamey, *Delacroix*, pp. 186–87, who mentions that Blanc "permitted a malicious article by Galichon to be printed in his review." The evidence does not seem conclusive, although it is possible that Blanc may have been annoyed by the many delays in completing the work. It is nevertheless true that Delacroix remained in touch with Blanc, as the letter to him from Champrosay refers to unsuccessful attempts to photograph the murals during Delacroix's absence in the country (*C*, 4:267).

30. *C*, 4:269–70 (Sept. 1, 1861).

31. Quoted by Paul Flandrin to Mme Julie Lavergne; originally mentioned in Malbois, *Bulletin paroissial de Saint-Sulpice*, p. 119, and again in Régamey, *Delacroix*, p. 187.

32. Quoted in Escholier, *Delacroix*, 3:104–5.

33. *R*, p. 358; cf. *O*, 2:217–18. The original article appeared in the *Revue des Deux-Mondes* for August 1, 1837. Delacroix had written a long article on Michelangelo in 1830 for the *Revue de Paris* (*O*, 2:19–56; *PM*, p. 165ff.).

Blanc graciously proposing a special rendezvous at the chapel.[27] A later letter implies that for some reason Blanc did not accept.[28] There is nothing in the tone of subsequent correspondence to suggest any incipient cooling of the relationship between the two men, yet Blanc may not have been wholly enthusiastic about the murals, and the long delay in the project and clashes of personality at St. Sulpice may have caused him embarrassment as the official responsible.[29]

Charles Blanc was by no means alone in his avoidance of the opening ceremonies. Thiers was invited but did not appear, nor did Achille Fould, the Minister of State, Baron Haussmann, the Prefect, and the Secretary of Fine Arts, Count Nieuwerkerke. Delacroix complained in a letter to his cousin, Léon Riesener, that "neither the Minister, nor the Prefect, nor Nieuwerkerke, nor anyone from the court and those of rank has visited, in spite of my letters of invitation. As for the 'people of the Institute,'" of which he had at last become a member, "a small number came, but, to make up for that, many artists. Aside from that," he added, "there were few of the Paris world." He concludes, rather surprisingly in view of the rest of the letter, "On the whole, I am satisfied. I was assured on all sides that I was not yet dead."[30] He would have been doubly relieved had he heard the remark Ingres is reported to have made to the rector in response to his questions about Delacroix's chapel: "*Monsieur le curé*, be convinced. Hell *does* exist!"[31]

There were some criticisms that he could not ignore, however. One of those who must have caused him pain was Louis Vitet, the critic who published an article in the *Revue des Deux-Mondes* in which a good deal of irony was mingled with praise: "Always the same, forever the young romantic of 1828—ardent, confident, bold, colliding head on with all traditions, even dead ones, for the sheer pleasure of going against them."[32]

The commentary for the chapel in Robaut's catalogue suggests something of Delacroix's disappointment at the cool reception of his decorations. Many years earlier, Delacroix had condemned the public apathy toward Sigalon's large copy of Michelangelo's *Last Judgment*. He himself had admired the work and resented the humiliation Sigalon suffered—a conspiracy of silence even more damaging than abuse. Chesneau and others have pointed out that this passage, reprinted by Robaut in his catalogue, seems almost a presentiment of what he himself would experience nearly a quarter of a century later:

Who is to be blamed for this criminal indifference? Should one say that beautiful works are not made for the public and are not appreciated by it, and that it keeps its privileged admiration only for futile objects? Could it be that it feels for all extraordinary productions a kind of antipathy, and that its instinct takes it naturally toward whatever is vulgar and ephemeral? Will there be in every work that seems by its grandeur to escape the caprice of fashion a secret quality which displeases the public, and does it see there only a sort of reproach for the fickleness of its tastes and the vanity of its opinions? Or is it that the public is simply a lazy judge who, with indifference, sees pass before its eyes the most sublime and the most shabby creations and finds there nothing but food for a blind curiosity?[33]

Delacroix had a strong sense of personal identification with his great predecessor Michelangelo. He began his essay on Michelangelo, written in 1830, with a quotation from his poetry: "I have at least this joy in the midst of my sorrows, that no one reads upon my face either my vexations or my desires. I no longer fear the desire that I capture the praise of the ignorant crowd . . . and I walk alone

in the streets unafraid." [34] Given the date of its writing, his recent disappointments, especially with *Sardanapalus*, and his attempts at redefinition of his purpose and ambition, Delacroix's selection of this romantic passage is understandable. It would be a mistake, however, to overlook the fact that many admired his work. Prominent among them was Baudelaire, who wrote a brief but enthusiastic piece about the murals, giving detailed descriptions and the biblical sources of each subject. Not least of all he admired the color, which he believed surpassed all Delacroix's earlier work. "Never," he wrote, "not even in the *Justice of Trajan* or in the *Entry of the Crusaders*, has Delacroix displayed a palette more splendidly or more scientifically supernatural, never a draftsmanship more *deliberately* epic." [35]

Delacroix wrote Baudelaire a letter of warm appreciation, in which his attention to matters of line and color, which Baudelaire had discussed in his review, is marked: "I thank you most sincerely both for your praise and for the remarks that accompany and confirm it, about the mysterious effects of line and color, which, alas, are only perceived by a few initiates. That part which is musical and arabesque," he added, "is nothing to many people, who look at a picture as the English look at a country when they travel: that is to say, they have their noses in the *Traveler's Guide* to inform themselves conscientiously as to what the land yields in hay and other produce." [36]

The St. Sulpice murals will be considered in the order in which Delacroix listed them in his invitation. The ceiling painting, *Michael the Archangel*, is generally regarded as the least important of the series. The theme is related to other triumphs of good and light, such as the pagan *Victory of Apollo* and the Christian *Saint George and the Dragon*. The central group is a paraphrase of a painting of St. Michael in the Louvre, then believed to be by Raphael (it is now thought to have been painted almost entirely, with the possible exception of Michael's head, by Raphael's gifted assistant, Giulio Romano [37]).

Delacroix did make liberal changes. The action has been shifted from the Archangel's right side to his left and has been modified in its character and emphasis. But Delacroix has kept the broad sense of the Renaissance picture, in which Michael is about to spear a struggling but beaten enemy. Delacroix's figure is less varied in its details and less interesting in its movement than its sixteenth-century prototype. The angel's wings, for example, are flattened and the figure as a whole is made more symmetrical. This relatively static interpretation was perhaps determined by its architectural placement. It is nevertheless true, as Chesneau points out, that the main group seems a bit inadequate to the task of dominating the space around it. [38] The scale may reflect a concern that the group not be too massive for its rather confined setting in a small chapel, but the over-all result is somewhat unsatisfactory in its proportions and, some have felt, in characterization.

To determine what is personal and original in this work, one must examine the auxiliary elements. Delacroix has converted Giulio's neatly manicured Tuscan hills into a wild, atmospheric expanse of landscape. A pall of smoke fills the sky, whose dark clouds are pierced by bursts of warm, yellowish light, setting off the figure of Michael. The broken bodies scattered across the blasted countryside recall the death-strewn land of Python in *Victory of Apollo* (the symbolic analogy between the two works has been mentioned). But it is in the color that

34. O, 2:19. In the essay a fragment of the Italian poem is included, with a French prose translation below. The latter is translated here.

35. Quoted in Margaret Gilman, *Baudelaire the Critic* (New York: Columbia University Press, 1943), pp. 212–13. In most editions of *L'Art romantique*, in which Baudelaire's essay appears, it is supplemented by the long quotation which he gave from the earlier article in his last essay on Delacroix, "L'Oeuvre et la vie d'Eugène Delacroix" (see *ibid.*, p. 250, n. 24). The passages omitted appear in translation in *The Painter of Modern Life and Other Essays*, pp. 50–52. Baudelaire's article originally appeared in the *Revue fantaisiste* for September 15, 1861.

36. C, 4:276 (Oct. 8, 1861).

37. See, for example, S. J. Freedberg, *Painting of the High Renaissance in Rome and Florence* (Cambridge, Mass.: Harvard University Press, 1961), p. 351.

38. *Cf.* R, p. 362.

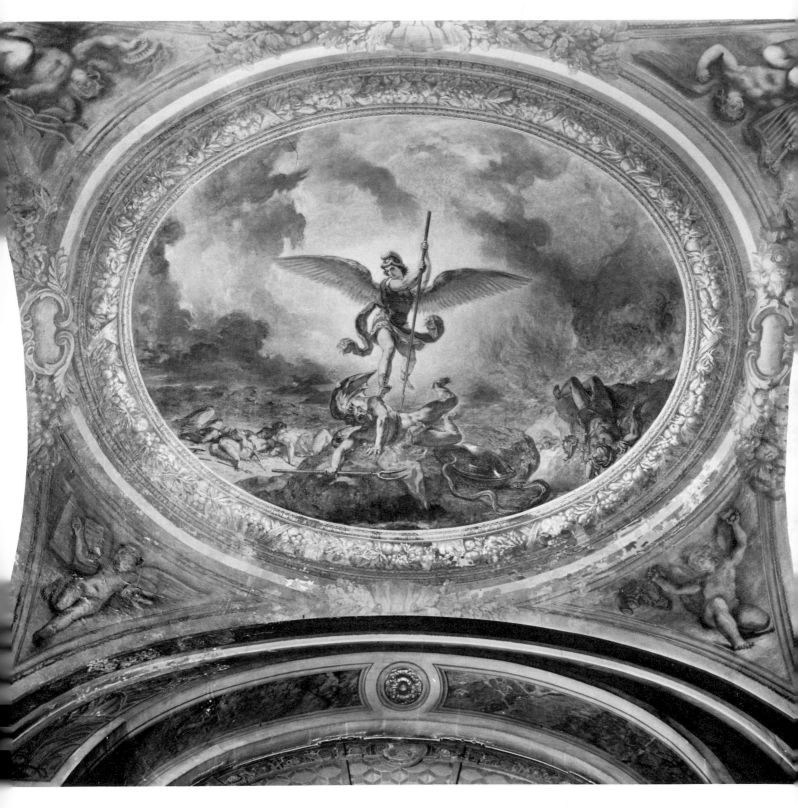

FIGURE 186. *Michael the Archangel Vanquishing the Devil.* 1856–61.
Oil and wax on plaster. 3.84 × 5.75. Ceiling, Church of St. Sulpice, Paris.
All Photos Marc Lavrillier unless otherwise noted.

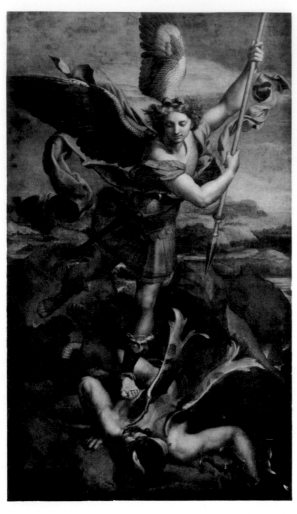

FIGURE 187. Raphael and Giulio Romano. *St. Michael*.
1518. Oil on canvas. 2.68 × 1.60. Louvre. Photo Agraci.

Delacroix's painting is free of historical precedent. As in many of his pictures, his thematic conservatism is offset by the daring of his color and technique. The Giulio *St. Michael*, with its sharp, smooth execution and its somber High Renaissance tonalities, bears little resemblance to this brilliant and intricate palette, which in some areas almost goes beyond the "purity" and "saturation" of color later adopted by the Impressionists. The lively and unorthodox touches of yellow-green that he has introduced into the half shadows of the Archangel's yellow-orange skirt and his red-violet sash echo the generally heightened tonalities of the companion walls. The freedom of execution bears equal testimony to Delacroix's awareness of the need for unity throughout the decorative ensemble.

In spite of the subsequent prestige of the St. Sulpice decorations, one is forced to admit that, of the three paintings here, *Michael the Archangel* alone seems the product of duty rather than of wholehearted enthusiasm. It is curious that this

subject was the sole survivor of the earlier thematic proposals. It may be that Delacroix was so convinced of the appropriateness of the subject and so attracted by its pictorial possibilities that he retained it. If so, it is puzzling that the result is so clearly inferior to the rest. It may simply be that failing health, the demands of painting on the ceiling, or an overdependence on assistance played a part, but the rather perfunctory character of the composition itself, which was surely not left to Andrieu, cannot be explained in this way.

While Delacroix was working at St. Sulpice, not far away the famous fountain at the Place St. Michel was under construction. Actual work began in June, 1858, and on August 15, 1860, the monument was dedicated. It was appropriate that the fountain should be a representation of St. Michael, but what is noteworthy is that the sculpture is a direct copy in bronze done on a heroic scale after the Renaissance painting that had inspired Delacroix. While there is no evidence of any specific relationship between the two, it seems plausible to suppose that some influential person had taken a special interest in the subject. Baron Haussmann is a likely candidate, or Thiers may have proposed the model. There is a further possibility that, as a member of the municipal council, Delacroix himself may have initiated the idea. In any case, the relationship seems hardly coincidental.

Also related to a Raphael composition in subject, but otherwise of quite a different order, is *Expulsion of Heliodorus from the Temple*. This rather obscure story comes from the second book of Maccabees in the Apocrypha. Its selection alerts the viewer to a probable correspondence with the Raphael fresco in the Stanza of Heliodorus at the Vatican. (Raphael's work is itself a free adaptation of an Early Christian mosaic of the Battle of Joshua in Santa Maria Maggiore in Rome.[39]) It is probable that Delacroix consulted the frescoes in this stanza when he decided upon the Attila subject for the hemicycle at the Palais Bourbon. In that case, however, the relationship is very vague. The narrative is shown at different stages of its development, and there is no formal similarity between the two treatments. In *Heliodorus* the reference to Raphael is overt. Both paintings show the same scene, and many of the pictorial elements—for example, the mysterious horseman and his two companion avengers—are directly related. *Heliodorus* suffices to show the superficiality of the resemblance, however. In each instance the painter has striven for emphatic movement and dramatic effect in the main figures. Heliodorus, an officer (and later an assassin) of the King of Syria, Seleucus Philopator, has been cast down and his men thrown into panic at the approach of the heavenly rider, a terrifying and beautiful golden figure. The other agents of God flail Heliodorus. The people watch as the great temple of Jerusalem is protected in response to the prayers of the priest Onias. The moment of the episode is therefore similar in both pictures. The method of narration, however, is profoundly different.

In his daring and original revision of classical pictorial structure, Raphael placed the principal action to the extreme right, balanced and contrasted with a large group of spectators to the far left. Between the two groups, set within a focal architectural space, is Onias, kneeling in prayer. He both joins and separates the staring witnesses and the furious participants in the expulsion. The sense of shifting and responsive action is brilliantly served by the broad, segmental arch of the composition, which provides a sense of spatial amplitude. If it were not for the static weight of the left figures and the almost gravitational pull of the archi-

39. See O. Fischel, *Raphael*, trans. B. Rackham (London: Kegan Paul, 1948), vol. 1, p. 103; vol. 2, plates 103, 221.

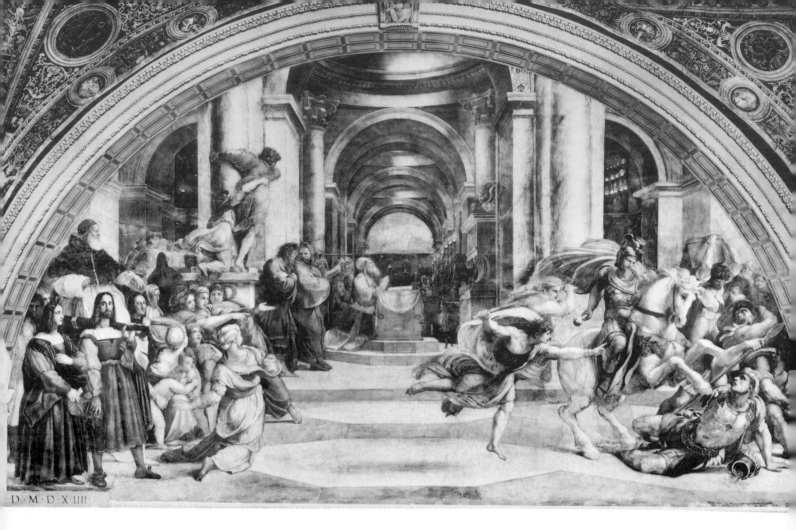

FIGURE 188. Raphael and assistants. *Expulsion of Heliodorus from the Temple*. 1511–14.
Fresco. Stanza dell'Eliodoro, Vatican. Photo Anderson-Giraudon.

tectural space, the composition would lose its precarious unity. When Louis
Vitet accused Delacroix of simply defying tradition, he could hardly have under-
stood Raphael's radicalism.

Delacroix's version is also far from orthodox, even though it is a less startling
departure from familiar formulas. Here the space extends upward. The main
action is concentrated within a cluster of foreground figures. The vertical emphasis
of the architectural space is complemented by the hovering movement of the
figures, especially the two flailing angels, who recall Tintoretto's heavenly
lieutenant in *Miracle of St. Mark*.[40] The massive architecture, seen obliquely
and from a low vantage point, also recalls Venetian art, especially that of Titian.
The whipping curtain animates what might otherwise seem a static and unwieldy
architectural section and recalls the draperies and banners of Venetian and baroque
art. The resemblances to Raphael are thus restricted to certain prominent motifs,
and the impression is not one of dependence but of purposeful analogy. At
least in the very general sense of its form and expression, Delacroix's agitated
version of the event is more suggestive of Francesco Solimena's huge panoramic
fresco of the expulsion of Heliodorus in the church of Gesù Nuovo in Naples

40. Tintoretto's *Miracle of St. Mark*
was in the Napoleonic Museum, so
that Delacroix almost certainly saw
it during his youth.

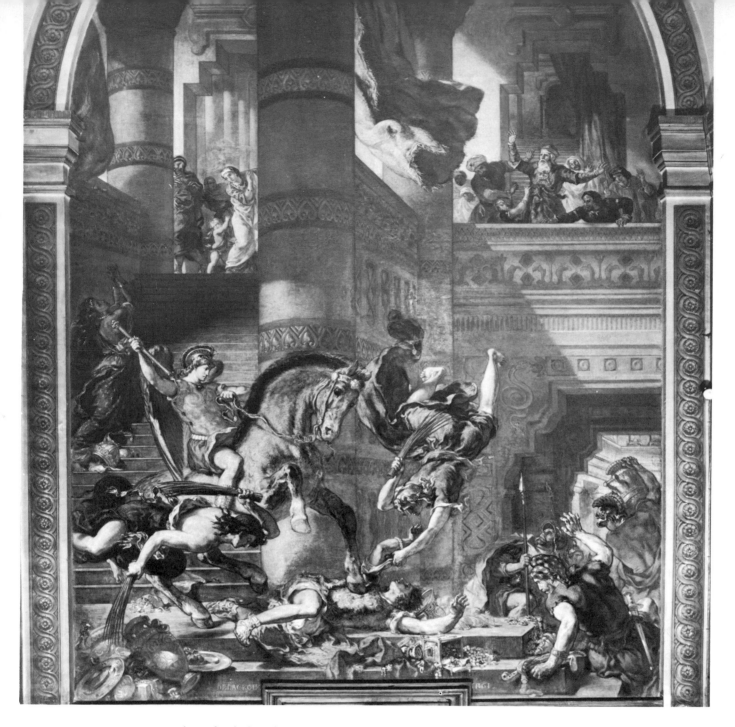

FIGURE 189. *Expulsion of Heliodorus from the Temple.* 1856–61.
Oil and wax on plaster. 7.14 × 4.88. Church of St. Sulpice, Paris.

than of any painting by Raphael. The real style and force of *Heliodorus*, however, is only to be appreciated apart from these artistic associations. This is not a baroque, a Venetian, or a Roman Renaissance painting. The types and costumes, the architecture, and even the mode of dramatic presentation are all ultimately nineteenth-century in character and, within that broad distinction, are peculiar to Delacroix—in fact, the bold color harmonies of complementary yellows and purples, reds and greens, are unprecedented even in his work.

Delacroix's attempt to suggest a specific locale and historical period, his concern for "authenticity," has resulted in great diversity of type and costume and in what he must have believed to be a plausibly Near Eastern architectural style for the great temple of Jerusalem. As in the setting and props of *Sardanapalus*, the result is more operatic than archeological, probably another reflection of his love of the theater. Heliodorus' humiliation takes on the quality of a stage spectacle suddenly grown monumental, substantial, and enduring. In terms of dramatic narrative, the closest analogies to *Heliodorus* are again to be found not in Raphael but in Delacroix's own art. The germ of the composition is evident in *Marino Faliero*, but it was not until such later paintings as *Entry of the Crusaders* and *Justice of Trajan* that he exploited the full dramatic impact of looming, active human and equine shapes suddenly arrested before an imposing architectural backdrop.

Baudelaire's characterization of those strange and iridescent color harmonies which he found in the murals at St. Sulpice as "scientifically supernatural" and of the draftsmanship as "deliberately epic" is particularly applicable to *Heliodorus*. Large areas of cold red are set against expanses of brown and gold. Curious progressions of the decorative blues, now dark, now light, are intensified by the surrounding oranges and yellows. The brilliant blue plume of the equestrian angel reiterates this color theme, and contrasts with the golden warmth of the armor and the orange tunic. Even the muted pigmental coloration of his horse is lively in the brilliant context of the surrounding hues. The violet garment of the plunging angel is set off by the yellow wall; the red and green habit of the third agent of God lends similar impact to the bold action. Throughout the composition interplays of these and other polar contrasts of yellow and violet, red and green, and their derivatives provide the peculiar vibrance of the painting.

It may in fact have been that very sharpness—one might say acidity—of tonality which accounts for the lack of enthusiasm of some contemporary critics for these murals. Compared with the rich and resonant harmonies of the somewhat more traditional and popular *Victory of Apollo*, *Heliodorus* is a bit dry. Its dissonances and harmonies are perhaps too meticulously planned to permit easy admiration. In this sense, Baudelaire's "scientifically supernatural," which so often applies to Delacroix's color structure, is particularly apt.

In technique *Heliodorus* is also somewhat difficult of access. To those accustomed to the sketchy, open handling of many of the later easel pictures, whose edges are less firm and decorative details less regular, the execution may seem dry. In part, of course, this greater precision was invited by the necessity for incorporating the architectural elements and for over-all unity of technique. Delacroix may have been particularly careful about surface refinement because the mural was to be seen at fairly close range. Other official or public works, such as *Entry of the Crusaders* and *Trajan*, also show a higher degree of "finish" than the smaller, more private canvases and studies. Delacroix himself made this distinction in an entry in the *Journal* not long before he began work at St. Sulpice:

On the way home with Grzymala, we talked of Chopin. He said that Chopin's improvisations were far more daring than his finished compositions. They probably are like the sketch for a picture compared with the finished work. No! You do not spoil a painting by finishing! Perhaps there may be less scope for imagination in a work that has been sketched out. You receive different impressions from a building under construction, whose details are not yet shown, and from the same building when it has its full complement of ornamentation and finish. It is the same with a ruin, which appears all

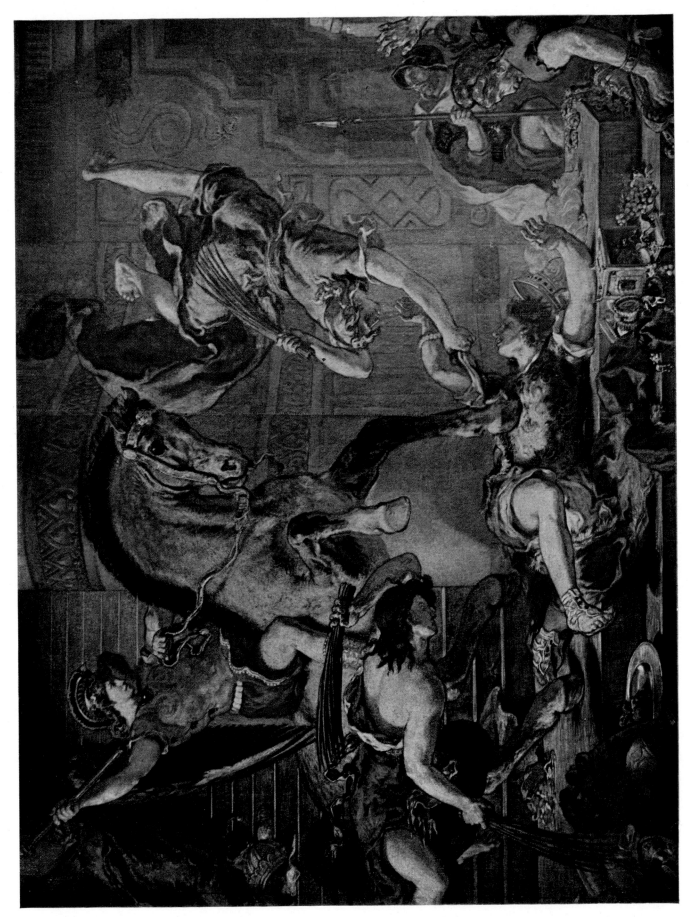

PLATE XXIV. Detail of *Expulsion of Heliodorus from the Temple*.
1856–61. Oil and wax. Church of St. Sulpice, Paris.

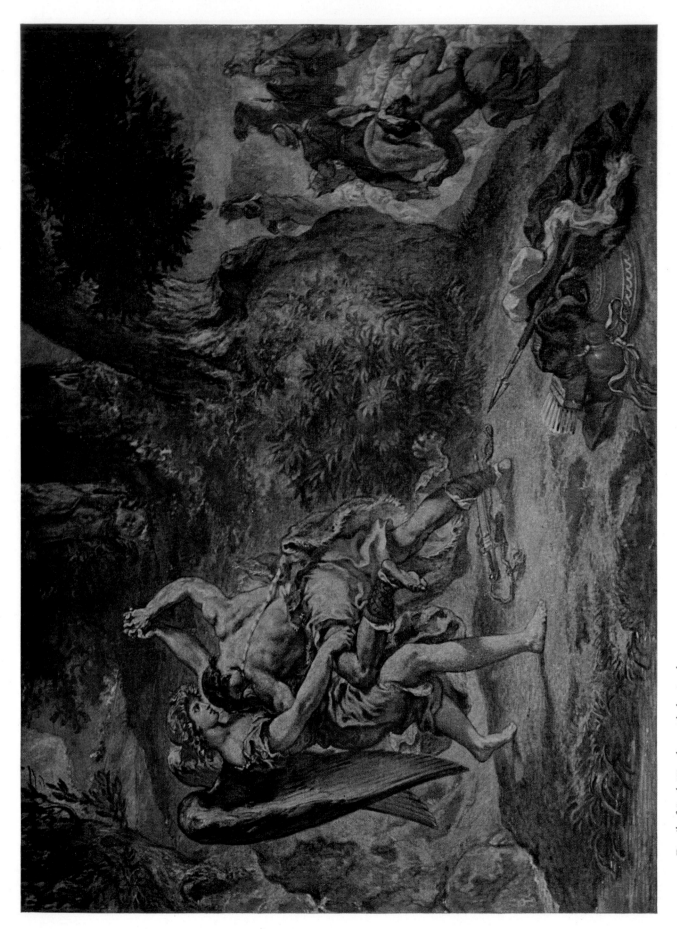

PLATE XXV. Detail of *Jacob Wrestling with the Angel.*
1856–61. Oil and wax. Church of St. Sulpice, Paris.

the more impressive because of the missing portions. The details are worn away or mutilated, in the same way that, in the building under construction, you see only the beginnings and the vague suggestion of the mouldings and the decorated parts. The finished building encloses the imagination within a circle and prevents it from straying beyond. Perhaps the only reason why the sketch for a work gives so much pleasure is that each person can finish it as he chooses. Artists gifted with very strong feeling, when they consider and admire even a great work, criticize it not only for the faults it actually possesses but also for the way in which it differs from their own feeling. When Correggio made his famous remark "*Anch'io son' pittore*," he meant, "There is a fine painting, but I would have put something into it which is not here." Thus an artist does not spoil a picture by finishing it; it is only that, when he abandons the vagueness of the sketch, he reveals his own personality more fully, thereby displaying all the scope, but also the limitations, of his talent.[41]

The reservations that may be felt about *Heliodorus* do not apply to its pendant on the opposite wall, *Jacob Wrestling with the Angel*. In this last and, it is generally agreed, greatest of the St. Sulpice murals, the world constructed by man in *Heliodorus* has been replaced by massive, irregular natural forms.

The subject, taken from Genesis, is again one seldom represented, and the formal sources of Delacroix's version, if any, are undetermined. The biblical account provides all the details necessary to explain this version, however. Delacroix has chosen the moment when the angel, seeing that not even he can best the righteous man, "touched the sinew of his thigh, and forthwith it shrank. And he said to him: Let me go, for it is break of day. He answered: I will not let thee go except thou bless me. And he said: What is thy name? He answered: Jacob. But he said: Thy name shall not be called Jacob, but Israel: for if thou hast been strong against God, how much more shalt thou prevail against men?"[42] The scene faithfully follows the text. Jacob lunges mightily at his antagonist, but that youthful and sexless figure (strongly resembling the angel who seizes Heliodorus' right arm) is ready for his attack and easily absorbs its force. He touches the sinew of Jacob's thigh, in accordance with the original narrative. The tense, muscular force of Jacob's body is contrasted with the firm but relaxed form of the angel.

The strong diagonal movement of the figures to the left is balanced by the great oak to the upper right. The other trees, more nearly vertical, recall the massive columns in *Heliodorus*. Delacroix may well have wished to suggest that "sense of the sublime"[43] he had experienced under the great oak at Antin, near Champrosay: "Perceiving only the trunk, which I am almost touching, and the base of its thick branches, which spread out over my head like the immense arms of this giant of the forest, I am astonished at the scale of its details; in a word, I find it awesome and even terrifying in its grandeur."[44] This comment may also have been influenced by the Rembrandt etching *Three Trees*, which he must have seen. In 1835 he did three small lithographic sketches of a very Dutch-looking landscape (Delteil 100), one of which is strongly suggestive of Rembrandt. The landscape in this modest study has close parallels with the stocky trees which rise from the hummock behind Jacob and the angel. (Delacroix may also have seen Rembrandt's *Tobias and the Angel* and *Jacob and the Angel*, but there is no visible parallel in the two artists' versions of the latter subject.)

The composition of *Jacob Wrestling with the Angel* is generally simpler than that of *Heliodorus*. Although Jacob's people and their flocks may be seen in the right middle distance moving away in the dusty light, the focus of the scene is on the

41. *J*, 2:22–23 (Apr. 20, 1853).

42. Gen. 32:25–28. The present quotation is taken from the Douay version.

43. Mras, *Delacroix's Theory of Art*, pp. 22–23. *Cf. J*, 2:40–42 (May 9, 1853), 3:37 (Dictionary, Jan. 27, 1857). Mras relates Delacroix's notions of the "sublime" and the "beautiful" to the ideas of Burke, with which he seems to have been familiar.

44. *J*, 2:42 (May 9, 1853).

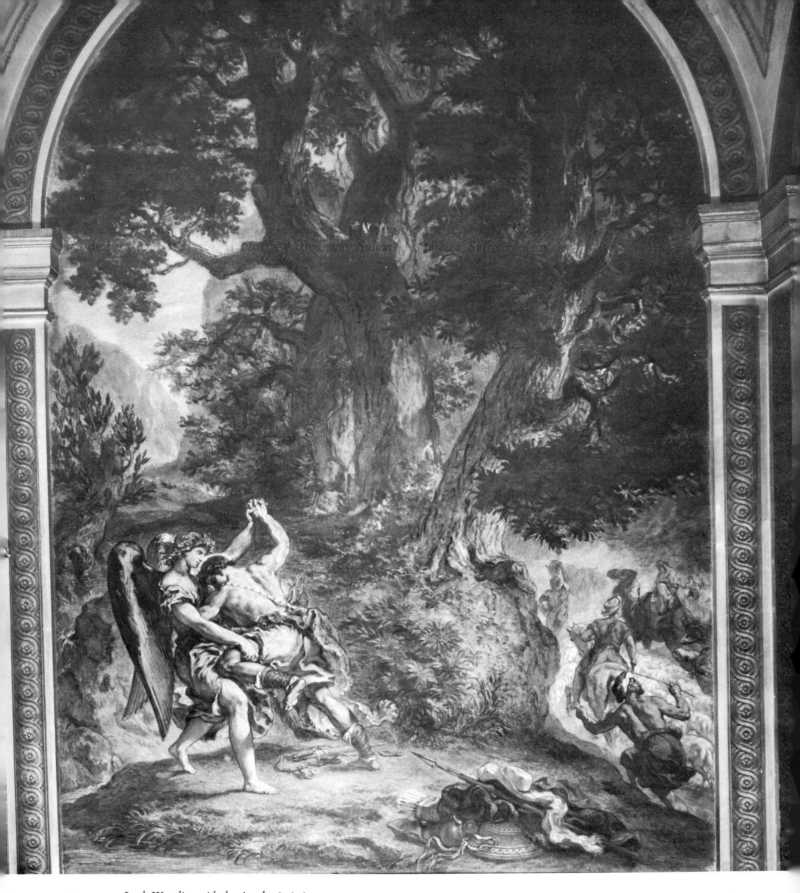

FIGURE 190. *Jacob Wrestling with the Angel.* 1856–61.
Oil and wax on plaster. 7.14 × 4.88. Church of St. Sulpice, Paris.

FIGURE 191. Study for *Jacob Wrestling with the Angel*. 1853–57.
Pencil. 0.57 × 0.38. Fogg Art Museum, Harvard University,
Gift of Philip Hofer. Photo courtesy of the Fogg Art Museum.

two main figures, locked in their mystical struggle. Confronted with divinity,
man cannot prevail, but in a stalwart contest against such odds, he may gain
rewards that no victory over a mortal opponent could provide.

As in the painting on the opposite wall, the color structure here is based on
contrasts. The richly modulated greens of the foreground landscape are set off
from the more distant areas by soft, atmospheric blues and by touches of violet,
rose, and yellow-orange in the dawning sky at the left and in the defile at the
lower right. The costumes of the figures in the defile permit the introduction of
bolder touches of blue, red, and yellow. Further positive accents appear in the
weapons and clothing in the foreground. Particularly admirable, however, is
Delacroix's understatement of the basic hues of green and rose in the garments

of Jacob and the angel. That restraint serves to unify both the figures themselves and the group within the setting. At the same time, the subtle opposition of tone animates the action. Similar refined control may be observed in the landscape. Within the prevailing greens, ruddier passages of foliage, earth, and bark, and others more golden, combine with occasional hints of violet to produce an unobtrusive but complex harmony.

The handling of the paint is intimately related to the colorism. Delacroix's manner of interweaving strokes of color, his *flochetage*,[45] affords not only a means of integrating the entire surface of the painting but also of developing complexities of tonal structure in small areas. The touch in *Jacob* is, however, unusually fresh despite its elaboration. Perhaps the irregular character of the natural forms invited a somewhat looser handling than did the pendant panel. In any case, it is *Jacob* that most strongly demonstrates the freedom of execution that younger artists, most notably the Impressionists, admired in Delacroix's art. In fact, the still-life elements in the foreground have a strong resemblance to Manet's notable still-life passage in *Déjeuner sur l'herbe*.

Andrieu says that Delacroix completed that part of the mural with remarkable speed. By his account the still life was first painted in twenty-two minutes, then left to harden for sixteen days, and completed in a quarter of an hour. Granted that Delacroix's assistant may have discounted the time spent in preparation for such a bravura performance, he has pointed to the source of the special appeal of *Jacob*: freshness. It achieves the goal that Matisse set up for himself a century later: "I have always tried to hide my own efforts and wished my works to have the lightness and joyousness of a springtime which never lets anyone suspect the labors it has cost."[46]

Although the subjects included in the chapel are unusual, Delacroix's selection is not surprising. Each represents a situation and a divine manifestation appropriate to the place. *Michael the Archangel* symbolizes in a general way the victory of good over evil. The two wall paintings bring the cosmic antagonism down to earth in their reference to specific attributes in the struggle for good. *Heliodorus* illustrates the purification of a holy place, reasserts the value of the traditions protected there, and warns of the punishment of the wicked, the blasphemous, and the unjust. *Jacob*, on the other hand, presents a more complex moral. Because Jacob was blessed by his opponent, theirs can be no battle between good and evil. The story must be taken as an illustration of the impossibility of resisting divine will. It is the fate of humanity to lose in such a battle but, in losing, to win ultimate identity.

Some writers have felt that there is a personal reference over and above these more conventional meanings. Maurice Barrès, dealing mainly with *Jacob*, has suggested that for Delacroix Jacob embodied the idea of the genius who seeks to "wrest his secret" from the angel, while the angel's mission is to "open the gate to the invisible, but he does not open it without a struggle."[47] Lucien Rudrauf prefers to see in Jacob the just man from whom the angel has required one of those "proofs" Delacroix spoke of in his invitation to the viewing. Rudrauf sees *Heliodorus* as the aesthetic corollary of the moral message of *Jacob* and the religious meaning of *Michael the Archangel*: he considers that the horseman somehow implies the man of genius who purges the temple of Philistines, doubters, and scoffers.[48]

45. This aspect of Delacroix's technique will be discussed in the following chapter.

46. "Letter," in *Henri Matisse* (Philadelphia: Philadelphia Museum of Art, 1948), p. 15.

47. Quoted in Rudrauf, *Delacroix*, pp. 178–79; *cf.* Maurice Barrès, "Le testament d'Eugène Delacroix," *Revue hebdomadaire*, 6 (June, 1921): 249–60.

48. See Rudrauf, *Delacroix*, pp. 179–82.

Rudrauf bases his argument, as he must, upon Delacroix's writings, and Delacroix did conceive of the trials of the genius and of the righteous man as ways to whatever salvation was to be had. It is questionable, however, that he ever regarded these subjects so systematically as Rudrauf suggests, or that he ever erected a structure of conscious and deliberate poetic conceits, as Barrès would have it. For him, justice, belief, genius, and effort were all part of a struggle in which the forces of "the good, the true, and the beautiful" were ranged against their opposites.

One of the last entries in the *Journal* seems particularly relevant here. Delacroix wrote it at Augerville on October 12, 1862, less than a year before he died:

> God is within us: it is this inner presence which makes us admire the beautiful, which delights us when we have done right and consoles us for not sharing the success of the wicked. It is He, beyond a doubt, who inspires men of genius and who warms them at the sight of their own creations. There are men of virtue as there are men of genius; both are inspired and encouraged by God. . . . There are, then, favorites of the Eternal Being. The misfortune which seems often, too often, to attach itself to these great hearts, does not, fortunately, make them succumb during their short passage; the sight of the wicked laden with the gifts of fortune should in no way dishearten them. What am I saying? Often they are consoled when they see the anxiety, the terror, which besets these evil creatures, making their prosperity bitter. From this life on, they often take part in the torture. The inner satisfaction of obeying divine inspiration is sufficient recompense: the despair of the wicked, struck down in their unjust enjoyments, is. . . .[49]

49. *J*, 3:329–30.

This last entry for 1862 was never completed. Delacroix wrote only a few more lines in the *Journal* before his death.

The St. Sulpice murals seem to symbolize some late, glorious dawn after the dark and eerie night of the *Pietà* at St. Denis-du-Saint-Sacrement and the pessimistic message of the Palais Bourbon library decorations. A new tone, if not specifically optimistic, at least without the earlier insistence on anguish, appears in many of the late works. This more Apollonian outlook did not assume full prominence until late in his career, but he had time to paint his allegories of the seasons, those tremulous reminders of his youthful efforts in the Talma series, most of the work in the Salon du Roi, and the scheme for the Hôtel de Ville. *Victory of Apollo* and the St. Sulpice murals are the culmination of an aspect of Delacroix's vision that is often overlooked, despite its importance.[50] Perhaps, as he suggested of Poe, his interest in allegory led him to abandon the "terrible" and "mysterious" which had so attracted him. At any rate, somehow, in his last years, Tragedy released him from her spell.

50. Since this writing, a monograph on the murals has appeared: Jack J. Spector, *The Murals of Eugene Delacroix at Saint-Sulpice* (New York: College Art Association, 1967).

Theory and Practice

Technique and artistic form have always been central to the value of a work of art. The abstract and theoretical emphasis in Delacroix's later work attracted certain artists to it, and they formed a reassuring circle of admirers at the early viewings in St. Sulpice. But the public was still attracted mainly by description and narration and therefore tended to be put off by that very formalism.

The importance of these considerations is made explicit in Baudelaire's article on the chapel murals and in Delacroix's response to that praise. As has been noted, the review stressed throughout the independence of art from nature, the role of "science," and the capacity of line and color to be appreciated for themselves. Dismissing charges that the murals were "decadent," Baudelaire declared that the artist was in fact in the vanguard of "progress" and that a retarded and ignorant public could not appreciate the refinements of his true accomplishment. He declared an independent status for art and made expertise the price of taking pleasure in it. The artist imposed his will upon a nature which Baudelaire regarded as an "incoherent heap of raw materials." Art and nature must not be confused. "Strictly speaking," he wrote, "there is neither line nor colour in nature. It is man that creates line and colour. They are twin abstractions which derive their equal status from their common origin." He then took the argument one step further: "Line and colour both of them have the power to set one thinking and dreaming; the pleasures which spring from them are of different natures, but of a perfect equality and absolutely independent of the subject of the picture."[1]

Delacroix clearly agreed with this statement of his intentions and answered Baudelaire's questions concerning the techniques employed at St. Sulpice.[2] His awareness of the formative role played by technique in the evolution of his art is a striking anticipation of "modern" attitudes. The legitimacy of the critic's attentiveness to abstract form—although he never overlooked "literary" values —can hardly be denied. On the other hand, his even more forthright rejection of "nature" and his stress on the "abstract" and "musical" characteristics of painting goes beyond Delacroix, and, if taken altogether literally, would be a distortion of his expressive message.

The fact is that, for all his talk about abstraction, Delacroix's published descriptions of his works clearly indicate his unaltered commitment to subject matter. Indeed, the verbal detail of his programs is often far more elaborate than the visual detail of the paintings themselves. Yet there is no reason to suppose that those plot summaries were provided simply as cynical concessions to the vulgar public. Rather, they would seem to indicate that the painting stimulated a chain of associations in the mind of the artist as well as the spectator (Baudelaire himself confessed that he responded to art in this associative way). Baudelaire lavishly praised Delacroix's descriptions of his paintings, particularly that of *Apollo*, which he included in his memorial essay at the time of Delacroix's death.[3] It would seem that Delacroix used his own art as he did that of others (his com-

1. Baudelaire, *The Painter of Modern Life*, p. 52.

2. *C*, 4:277 (to Baudelaire, Oct. 8, 1861): "You wrote me two months ago concerning the process I employed to paint on the wall, but I did not know where to address a reply. I am today taking the expedient of addressing my expression of gratitude to the office of the *Revue*."

3. See Baudelaire, *The Painter of Modern Life*, p. 55.

ments on Rembrandt's *Feast in the House of Simon* here come to mind), as a stimulus to his imaginative faculties.

One of the most difficult problems in discussing Delacroix's practice in his later years is that of determining the extent of his assistants' collaboration. His consignment of many duties to his shop may recall the old guild system, but any such resemblance is merely superficial. The traditional relationship between the master and his apprentices was based on the supposition that in time the young men would become independent craftsmen and perhaps eventually rival the master himself. Delacroix regarded his assistants, in contrast, merely as employees and social inferiors. They were hired as commercial workmen, and their private ambitions were never permitted to interfere with the master's interest. An even more important distinction was that they were engaged with an eye to their special usefulness at various stages of the work, not for their talent for a particular kind of representation, a notable example of the latter method being Rubens' shop. In his account of his interviews with Delacroix concerning possible employment at the Palais Bourbon, Louis de Planet documents Delacroix's astuteness on this score. Delacroix's estimates of De Planet's and Lassalle-Bordes' respective abilities were precise: "I am quite content with Lassalle-Bordes. He has qualities that you do not have, and you have also some which he lacks. However, he renders me more services because he understands better than you do the preparation of a large picture. You yourself do *bits* that *can be left*. You do better at the *parts* and he the *ensemble*."[4]

4. Quoted in De Planet, *Souvenirs*, p. 68. The organization of Rubens' shop is well summarized in Gerson and Ter Kuile, *Art and Architecture in Belgium*, pp. 85–86.

If employment in Delacroix's studio depended upon his needs, it also depended upon a willingness to accept a small salary, for he seems to have been rather miserly. He offered De Planet Fr. 150 per month for his services, along with a lame apology: "My God, I realize your talent deserves more but at this moment that's all I can offer."[5] Delacroix's attitude toward money had attracted sufficient attention for Baudelaire to feel constrained to comment upon it at some length in his necrology. He recalled the painter's long years of financial insecurity and underpayment for his work and claimed that only "economy" permitted him to be generous toward others needier than himself. He further noted the almost inevitably hostile response of society to the superior man: "His courtesy is called coldness; his irony, however much he may have softened it, is interpreted as spitefulness; and his economy as avarice."[6] Finally, calling upon Stendhal as his authority, he turned to the purely Machiavellian argument that greatness must be reconciled with prudence. The sensible man has to devote himself to acquiring an essential degree of security: Delacroix did no more than this. There is a defensive ring to these arguments that may echo the painter's own rationalizations.

5. *Ibid.*, pp. 69–70.

6. Baudelaire, *The Painter of Modern Life*, p. 67.

For young men dependent upon their earnings as casual studio helpers, Delacroix's irregularities in assignments and low pay posed real problems, as De Planet's *Souvenirs* makes evident. For Delacroix, on the other hand, such collaboration introduced its own problems. Before coordinating and supervising their efforts, he had to train them to fulfill his requirements. This aspect of Delacroix's relationship with his assistants seems to have been scrupulously fair. The surviving letters of instruction are admirably precise, and he seems to have been generous in the time he devoted to teaching. De Planet reports the care with which Delacroix conducted these critical sessions. His step-by-step account of the painting of *Aristotle* for the Palais Bourbon library is especially instructive.

FIGURE 192. *Aristotle Describing the Animals Sent to Him by Alexander.*
1838–47. Oil on canvas *marouflé*. 2.21 × 2.91.
Cupola of science, library, Palais Bourbon.

The drawing was transferred to a canvas toned with a mixture of raw umber, Venetian red, and lead white. The grisaille was painted on that ground in umber, ivory black and lead white. Then, according to De Planet, "I began with Aristotle. I used a plaster bust to make my transcription. For the robe, which is pale yellow and in the light, I changed the tones of the grisaille in one tone: lead white, Naples yellow, and [raw] umber. For the *Aristotle*, the older Cotte posed for the hand that holds the stylus. M. Delacroix made a rather black, fine drawing of it in number two lead pencil. This sketch served me for the more fixed drawing and for the grisaille of Aristotle's hand."[7]

7. *Souvenirs*, p. 32.

"After the *Aristotle*," De Planet continues,

I passed on to the *Young Man with a Goat*. Because that figure is very important and almost nude, and especially because the pose can be held, M. Delacroix used a model. It was Poche's nephew who posed for that most appropriate movement. M. Delacroix made from him a fairly elaborate sketch of the muscles, the movement, the modeling or the "effect." He made these sketches rather quickly, yet as decisively as he could. For M. Delacroix the model had to pose with the greatest possible correctness. He gave him frequent rests because the pose for these sketches had to be rendered exactly by the model, and with feeling or action.[8]

8. *Ibid.*

This passage and the description which follows agree with the visible facts of the painting and other documentary evidence about Delacroix's procedure at this time. It is, however, noteworthy that De Planet makes no mention of Delacroix's direct participation in the later stages of the work except to supervise it. Whether this omission is a slight or an oversight is uncertain. In any case, it does

appear that more of the work at the libraries was executed by assistants than has often been assumed. Even though the claims of De Planet and Lassalle-Bordes may be exaggerated, they cannot be entirely unfounded. De Planet states that from 1842 through 1844 he did three of the pendentives at Delacroix's atelier, including *Pliny*, *Aristotle*, and *Archimedes*. He claimed to have done others, including *Tribute Money, Lycurgus, Cicero Accusing Verres, Ovid among the Barbarians*, and *Numa*, at his own studio. By this account Delacroix did six subjects, which De Planet lists as *Hippocrates, Adam and Eve, Babylonian Captivity, Alexander and the Poems of Homer, Education of Achilles*, and *Demosthenes*.[9]

Lassalle-Bordes returned to his native Auch, in southern France, after his final break with Delacroix in 1850. While it is impossible to accept all of his claims to authorship of a large share of the work at both libraries, it is equally impossible to dismiss them entirely. Lassalle-Bordes credited Delacroix with having himself completed only five of the pendentives, including *Alexander*, *Achilles*, and *Hippocrates*. He also assigned to Delacroix's own hand *Archimedes* and *Cicero*, which De Planet had claimed for himself.[10] He did rather grandly grant four other panels, including *Aristotle*, to "another pupil, an amateur painter, M. Planet, from Toulouse."[11] *Socrates* remains unclaimed, but Lassalle-Bordes insisted upon his own authorship of the rest "following sketches and drawings." He also stressed his extensive work in the Senate library: "The immense labor of the two libraries (the Chamber and the Senate) which kept me busy seven years, and to which I always sacrificed my own personal works," he said bitterly, "were retouched by the master in less than two months."[12]

A comparison of Lassalle-Bordes' sweeping assertions with De Planet's more modest account shows numerous contradictions. Lassalle-Bordes may have greatly exaggerated his own role at the expense of Delacroix, not to mention poor De Planet. In some details, however, they agree. Neither mentions Delacroix's name at all in connection with the four pendentives representing philosophy, while both speak of his personal authorship of *Achilles*, *Alexander*, and *Hippocrates*. While the attribution of these murals may never be resolved beyond question, it is strange that the surviving works done independently by De Planet and Lassalle-Bordes hardly confirm their estimates of their own talents. *Vision of St. Theresa*, De Planet's most famous piece, no longer inspires such admiration as Baudelaire expressed in his review of the Salon of 1845,[13] where it was shown. The style of the early *Portrait of Mme Casimir de Planet* of 1836, curiously reminiscent of Zurburán, does support Baudelaire's observation of "an almost Spanish voluptuousness" in *St. Theresa*. However, De Planet's *Self-Portrait*, painted in 1855, is hardly exceptional for the period. It indicates that he remained a serious and workmanlike painter, but on its evidence one cannot be indignant at Delacroix's and the world's neglect of a great talent.[14]

In view of Lassalle-Bordes' extravagant claims, his independent career is still more disappointing. His major salon effort, *Death of Cleopatra*, exhibited in 1846, was given qualified approval in Baudelaire's review. The canvas, now in the museum at Autun, is not without merit in its translation of the basic elements of Delacroix's drama into a harsher, more academic vocabulary. His most ambitious efforts after his break with Delacroix were a set of murals in the apse of the church of St. Nicolas at Nérac[15] and a series of historical portraits for the museum of the Hôtel de Ville of Auch. The protracted acrimony that evolved in his dealings with the municipal authorities bears out the splenetic tone of his Notes. Most of

FIGURE 193. Louis de Planet. *Vision of St. Theresa*. Salon of 1845. Oil on canvas. Size and location unknown. From Charles Baudelaire, *Art in Paris 1845–1862*, trans. and ed. Jonathan Mayne (London: Phaidon, 1965). Photo Donald Witkoski.

9. *Ibid.*, pp. 17–18.

10. *Ibid.*, pp. 11–12.

11. See Lassalle-Bordes, Notes, in Burty, *Lettres*, 2:ix.

12. *Ibid.*, p. xii; see also De Planet, *Souvenirs*, p. 12.

13. Baudelaire, *Art in Paris*, pp. 15–16.

14. Of the thirty-odd works by De Planet that have been identified, most remain in the possession of his family or in private collections. For further information, see P. Mesplé, *A travers l'art toulousain* (Toulouse: Musée des Augustins, 1942), pp. 65–78, plates 15–18; "Louis de Planet (1814–1875)," *Art méridional*, No. 46 (June, 1939), p. 11; "Stenio II," *Art méridional*, No. 47 (July, 1939), pp. 12–13; "Stenio III," *Art méridional*, No. 48 (August, 1939), pp. 10–11. The self-portrait appears as plate 18 in *A travers l'art toulousain*.

15. The project is illustrated and discussed within the larger context of the relationship between the two men by Beetem, "Delacroix and His Assistant Lassalle-Bordes."

FIGURE 194. Gustave Lassalle-Bordes. *Death of Cleopatra*. 1845. Oil on canvas. 2.74 × 2.26. Musée Rolin, Autun. Photo Musée Rolin.

16. For a more complete account of this affair, see René Debats, "La galerie des célébrités départementales, à l'Hôtel-de-Ville d'Auch, la peinture de Lassalle-Bordes," *Société historique et archéologique du Gers* (2d trimester, 1948), pp. 100–7.

17. *Souvenirs*, pp. 57ff.

18. *Ibid.*, p. 60.

FIGURE 195. Gustave Lassalle-Bordes. *Arnaud Guilhem*. N.d. Oil on canvas. Musée de l'Hôtel de Ville, Auch. Photo Samuel.

the fifty-odd "portraits," many of them imaginary, now preserved at Auch are by Lassalle-Bordes, but only five were ordered and purchased by the town. The rest were given by Lassalle-Bordes himself or by his friends.[16]

Typical examples of the series are *Count Joseph Lagrange* and *Arnaud Guilhem*. The former is in the tradition of the full-length portrait of the Restoration period. In everything but quality, it suggests Gros. The latter canvas, a three-quarter-length portrait of a Gascon knight who served under Charles VI and Charles VII, is in the tradition of medievalism of Louis Philippe's Hall of Battles at Versailles. Here again the draftsmanship is competent and the technique expert, if mechanical. But there is nothing to suggest the handling or the artistic conceptions of Delacroix, and Lassalle-Bordes' high claims to the gratitude of posterity are not substantiated. Even viewed in the kindliest light, the murals at Nérac disclose no higher level of attainment.

The real problem Delacroix faced in relying so heavily upon his assistants was that of directing and coordinating their contribution, and while one may criticize his decorative ensembles as sometimes uneven in quality, they do have over-all unity. He not only originated, developed, supervised, and corrected whatever he did not himself complete but also saw to it that his workers were both technically informed and aware of the spirit of the larger enterprise. To attain that kind of control he had to be teacher, a role in which he seems to have excelled.

De Planet dutifully transcribed Delacroix's comments on his painting, *Babylonian Captivity*, which he exhibited in 1843 at the Galerie des Beaux-Arts.[17] The two men discussed this work on several occasions, first on December 2, 1842, when they looked over De Planet's preliminary sketches. Delacroix began by enunciating his principle that a sketch should be so clear that someone else might execute a finished painting from it. This notion of clarity runs throughout the ensuing discussion. On the second meeting the following day, Delacroix stressed another general principle, the pre-eminent demands of unity, the harmony that is achieved by the careful relationship of the parts to each other. He felt that De Planet was too attentive to detail, worked too slowly, and permitted himself to waste time in unnecessary elaboration. Homilies about rising early, eating little, and working concurrently on several projects completed the interview.

Two further talks during January were at least partly devoted to *Babylonian Captivity*. By then it had emerged as a painting of great size intended for public exhibition. Delacroix seems to have been unimpressed. He wished that he had seen the canvas earlier and warned De Planet that it would probably be poorly received, in view of the aspirant's "inexperience and the lack of finish in many of the objects."[18] There is an ironic echo here of Guérin's warning when Delacroix sought his encouragement to exhibit *Dante and Virgil*. However, it is apparent that Delacroix examined the painting carefully and gave detailed criticism, including suggestions for improving particular areas. Wherever possible, he mixed praise with his criticism. Finally, referring again to his own experience, he recommended that De Planet study the masters. Along with Rubens, he mentioned Giorgione's *Fête Champêtre*, a Salvator Rosa battle scene, and a Swanevelt landscape, all in the Louvre (De Planet later copied the landscape).

De Planet himself admits the impossibility of recalling the details or reproducing these observations exactly, yet his summary does suggest their character. Lassalle-

Bordes' Notes are also informative about some of these matters, especially in those passages where he now and then attains objectivity. It is evident that Delacroix had become more and more preoccupied with setting down his ideas about theory and his knowledge of technique. At the practical level, a chronic throat ailment, which often led to virtual loss of his voice for long periods of time, had made direct instruction too taxing. Beyond that, he seems always to have retained his determination to "neglect nothing" that could make him "great," and that ambition came to include a desire to record the insights he had gained in a lifetime of creative experience.

It is typical of an aspect of Delacroix's character that he started to keep a diary almost immediately after hearing about the success of *Dante and Virgil* and finally began work on his dictionary on January 11, 1857, the day after his long-awaited election to the Institut de France.[19] After a serious attack of laryngitis, he had a three-month convalescence, during which he was too weak to paint and passed his time browsing in his old notes and diaries. From the earliest entries the *Journal* abounds in fragmentary observations, including quotations, whose diverse sources are not always acknowledged.[20] The notes for the *Dictionnaire* are also eclectic, unsystematic, and often contradictory. Despite their miscellaneous nature, however, they do provide a basis for arriving at a reasonably clear understanding of his attitudes.

On January 5 Delacroix suggested what might be one of the motives for his project: "Most books on art are written by people who are not practicing artists, hence so many wrong ideas and judgments arrived at capriciously, or through prejudice. I firmly believe that any man who has received a liberal education is qualified to speak sensibly of a book, but by no means of a painting or a piece of sculpture."[21] This enunciation of the freedom of the artist from the judgment of society at large is an early expression of the doctrine of art for art's sake. Perhaps the clearest such statement is found in the entry for January 13, 1857:

Decadence. The arts, since the sixteenth century, the peak of their perfection, have shown a steady decline. The cause lies in the change that has occurred in thought and manners rather than in the scarcity of great artists, for the seventeenth, the eighteenth, and the nineteenth century did not lack them. The low level of popular taste, the gradual enrichment of the middle classes, the increasingly autocratic sway of a sterile criticism whose natural inclination is to discourage genius, the tendency of men with good brains to study practical science, the growth in material knowledge which frightens away works of the imagination—for a combination of all these reasons, the arts are condemned to greater and greater submission to the caprices of fashion and to loss of all grandeur.[22]

While the writer's oversimplifications and his sweeping dismissal of materialistic "modernity" are suspect, some of his views are prophetic. On August 27, 1854, he observed:

At noon a big ship called a "clipper" is going to be launched. Here is still another American invention to go faster, always faster. When travelers have been comfortably lodged in a cannon, so that it will send them along as fast as bullets in any direction that it pleases them to go, civilization will doubtless have taken a long step: we are heading for that happy era which will have done away with space but will not have abolished boredom, given the ever more pressing necessity of filling up those hours of which going and coming used to take up at least a part.[23]

Delacroix's identification of the artist as a member of an independent and

19. The notion of trying to write some kind of "memorandum" on painting had occurred to him many years before, in 1824, but nothing came of the idea in the intervening years (see *J*, 1:49 and n. 2 [Jan. 26, 1824]).

20. Some of these statements, which had passed as the artist's own, have recently been identified as quotations (some, interestingly enough, from Mme de Staël) (see Mras, *Delacroix's Theory of Art*).

21. *J*, W, p. 329 (Jan. 5, 1857).

22. *J*, 3:20–21. It is likely that in general, if not in specific details, Delacroix was affected by the lugubrious speculations of his friend Chenavard. For example, "It was today that Chenavard talked to me again of his famous idea as to decadence" (*J*, P, pp. 419–20 [Aug. 31, 1854]). Delacroix seems to have felt attacked by the theory, as his subsequent references to the conversation show. His conviction of the decadence of contemporary society was, however, recurrent. One of the notes for the Preface to his dictionary (Feb. 4, 1857) describes at length the wholesome unity of Greek and Roman society (the Luxembourg cupola here comes to mind) and the "debased" state of his own day. "Afterwards," he prophesizes gloomily, "comes the night and barbarism" (*J*, W, pp. 356–57).

23. *J*, 2:244. Delacroix strongly objected to the utopian notions of material progress espoused by Saint-Simon and other social reformers of the day.

superior social group was an assertion both of deeply felt values and of somewhat conflicting responses to the world about him. Even though he distrusted bohemianism as much as he despised the *petite bourgeoisie*, he seems to have assimilated certain romantic notions concerning the isolation and suffering of the artist and his superiority to the herd. On this basis, he felt an obligation to assume the role of educating his public. Although he had no delusion that the capacity of "imagination" could be transmitted, he retained his faith in the power of rational discourse. The topics of his notes therefore range from theoretical discussions of "boldness" ("*hardiesse*," "the hallmark of the great artist"[24]) to more technical comments about frames, mounts, foreshortenings, or the rendering of polished objects ("really mirrors"[25]). Other entries deal with historical and critical problems. Many artists are praised: many (David is usually among them) are summarily dealt with: "Rubens is a Homer ... more Homeric than Vergil," while "David's execution is cold; it would chill ideas more elevated and more animated than his own."[26]

These samplings from the *Journal* give an inkling of the range of subjects it covers. They also indicate certain underlying assumptions on the part of the writer, one of the chief of which is his artistic creed: "*form and concept are inseparable*."[27] In view of his attentiveness to questions of form, it is significant that his project should have been intended as a dictionary, which he takes pains to distinguish from a "book." The entry quoted above also includes a long summary of his ideas for a Preface. Here, as elsewhere in his *Journal*, he justifies his choice of format on the basis that it is easier to prepare and to use: "A dictionary is not a book. It is an instrument, a tool for making books or anything else."[28] Later he observes that the purpose of a didactic work is neither utility nor pleasure, and reiterates his faith in objective procedure. "Can anything be simpler or better calculated to discourage rhetoric," he asks, "than this method of dividing up the material?"[29]

Throughout, Delacroix assumes the fundamental validity of applying "scientific" procedures of analysis and exposition to artistic problems. The concrete properties and processes of painting are to be objectively examined and described, and all observations confirmed by comparison. He seems to have borrowed Leonardo's notion of the *paragone* as stated in the *Treatise on Painting*, which had come to his attention in some form.[30] He accepted the long-standing notion that because painting is in some sense an "imitation" of nature, it enjoys certain advantages over the other arts, particularly poetry and music: "You enjoy the actual representation of objects as if you were really looking at them, and at the same time the intellectual meaning which the images contain excites and enraptures you."[31] Proceeding from the familiar observation that painting is distinctive in being "simultaneous," he goes on, like Leonardo, to assert that it is therefore superior because it presents its impact immediately and does not, like the temporal arts, require the gradual release of its aesthetic "message." In its concreteness, simultaneity, and unity, as well as in its appeal to the most refined and precise of the senses, painting was the greatest of the arts and the one most naturally suited to objective analysis.

Delacroix's admiration for the simplicity and objectivity of a dictionary reflects, of course, his view of nature itself as a kind of "dictionary," to be consulted freely and selectively. Of course, this metaphor appealed to Baudelaire and strongly colored much of what he had to say. He came to regard the world

24. *J*, 3:222 (Mar. 1, 1859).

25. *J*, P, p. 560 (Jan. 25, 1857).

26. *J*, P, p. 560 (Jan. 25, 1857).

27. *J*, 3:28 (Jan. 13, 1857).

28. *J*, 3:26 (Jan. 13, 1857).

29. *J*, W, p. 340 (Jan. 13, 1857).

30. This relationship is suggested by Mras (*Delacroix's Theory of Art*, pp. 33–35, 48 and nn. 6–7); see also his *Sources of Delacroix's Art Theory* (Ann Arbor, Mich.: University Microfilms, 1960), pp. 174–75, n. 7; "*Ut Pictora Musica*: A Study of Delacroix's Paragone," *The Art Bulletin*, 45 (Spring, 1963):266–71.

31. *J*, 2:97 (Oct. 20, 1853). Here, as elsewhere in Delacroix's expression of his ideas, there is more than a little suggestion of German idealism. Huyghe has pointed out that the "real" for Delacroix went beyond the literal fact and meant that which had deep personal meaning as well. Delacroix had become aware of German philosophical notions through Mme de Staël (see Huyghe, *Delacroix*, pp. 78–79). As Huyghe notes, Delacroix was also acquainted with Kant and Leibnitz, as his conversations on those subjects with Chenavard make clear (see *J*, 2:259 [Sept. 8, 1854]).

of art as a universe apart from human events and personalities, with its own characteristic "behavior," and therefore it too was a kind of dictionary to be consulted at will. This notion of an autonomous world of artistic form and expression strikingly anticipates later critical interpretations, such as those of Focillon, Faure, and Malraux, which stress the inherent aesthetic qualities of objects, with little or no concern for the traditional interest in the historical or biographical circumstances of their creation.

Delacroix's sense of mission did not, however, carry him through his *Dictionnaire des beaux-arts*. It was not until 1893, when the first, incomplete edition of the *Journal* was published, that these notes were first made public. Nevertheless, during his lifetime he published a number of essays, more or less formal in nature, exploring various aesthetic problems. While he often deals with the art of other masters—Raphael, Michelangelo, and Poussin among them—his own attitudes dominate these discussions. These essays therefore complement the *Journal* as sources of information about his theories, while the reminiscences of his assistants tell us most about his technical procedures.

One preoccupation that runs throughout his notes and essays is that of the properties and uses of color. Even during his own lifetime distinctions had been drawn between romanticism as an art of color and neoclassicism as an art of line. While acknowledging the limitations of such artificial definitions—David and Ingres did, after all, "use" color to achieve their effects—it is possible to observe ways in which Delacroix's address to color was both individual and important for future developments.[32]

Delacroix did not believe in the "supremacy" of color, as it is usually called with misleading simplicity: he believed in it as an integral element of artistic expression. He rejected the neoclassical doctrine of the "supremacy" of drawing and line without going to the opposite extreme. Less doctrinaire than most of his opponents, he could see, for instance, that David's was not the only kind of drawing, an insight rare indeed at the time.[33] On the other hand, he did tend to disparage David as insensitive to the charms of color, as well as too rigid in his interpretation of "drawing." Although Delacroix's attitudes toward David and Ingres were not wholly ungenerous, the final impression left by his remarks is that they are to be classified as "mere talent." He could not, for example, pass up the opportunity to quip, "All you are doing are sepia drawings. David's picture is nothing else."[34] He used Ingres' *Stratonice* as an illustration of confusion between color and "coloration." He was not blind to the charms of the painting, and, according to George Sand, granted its studied effects of "coloration," its ingenuity, and its "glistening play." Yet in the end he found Ingres' use of color mannered and the canvas lacking in the more painterly unity he preferred.[35] While George Sand's account may not be perfectly accurate, the opinions she reports are in accord with the character of the picture and Delacroix's other judgments. His liberality and generosity of opinion had its limits. He disapproved of the neoclassical insistence that there is but one kind of drawing, while at the same time insisting that an approach to color other than his own was mere "coloration." On another occasion he flatly stated that "painters who are not colorists produce illumination."[36]

It is clear that Delacroix had firm convictions as to what constituted "good" drawing and color. In spite of the great range of his stylistic development, his basic attitudes toward these matters remained surprisingly consistent. While

32. For an approach to Delacroix as a colorist which differs in certain of its conclusions, see Johnson, *Delacroix*, esp. pp. 62–89.

33. See *J*, 3:49 (Jan. 25, 1857).

34. *J*, P, p. 529 (Jan. 7, 1857).

35. See Mras, *Delacroix's Theory of Art*, pp. 119–20, where he mentions this "exchange" between Delacroix and George Sand. See also George Sand, *Impressions et souvenirs*, 3d ed. (Paris: Michel Lévy, 1873), p. 77.

36. *J*, P, p. 263 (Feb. 23, 1852).

he did some drawings of a delicacy and precision that rival even the work of Ingres, he came to prefer a looser execution, particularly noticeable in his developed compositional sketches, such as the pencil studies for *Victory of Apollo* and *Rape of Rebecca*. The action of the figures in these small masterpieces is extraordinary. There is a pulsing quality of movement in the reiterative, encompassing lines that locate but do not fix the figure. The draftsmanship is exploratory. Hard edges and precise detail are avoided in the interest of emphasizing the action of the figure as a mass. "Contrary to the usual practice," he once wrote, "the contour should come last, and only a highly trained eye can get it right."[37]

37. Quoted in Piot, *Les palettes de Delacroix*, p. 50.

Delacroix's drawing was therefore aimed at first establishing "mass." Contour was defined later—and then only where precision was required. He hit upon an illuminating comparison of the ways in which the procedure of a "colorist" in drawing resembles that of a sculptor:

The sculptor does not begin his work with a contour; with his material, he builds up an appearance of the object which, rough at first, immediately presents the chief characteristic of sculpture—actual relief and solidity. The colorists, the men who unite all the phases of painting, have to establish, at once and from the beginning, everything that is proper and essential to their art. They have to mass things in with color, even as the sculptor does with clay, marble or stone; their sketch, like that of the sculptor, must also render proportion, perspective, effect and color.[38]

38. *J*, P, p. 263 (Feb. 23, 1852).

De Planet reports that Delacroix returned to this comparison on another occasion, this time to illustrate a distinction rather than an analogy between the two arts:

The public imagines that one ought to be able to follow equally well the contours of a painted figure and those of a statue. Profound error. In painting, it is not a matter of remaking any object whatsoever in an absolutely exact manner; rather, it has to do with reproducing there its effect as it appears to our eyes. Also, it is false to pretend that one should be able to retrace the contours of an object in the same manner. The contours appear and disappear according to the ground from which the object detaches itself.[39]

39. *Souvenirs*, p. 103.

FIGURE 196. Study for *Victory of Apollo over Python*. Ca. 1850.
Pencil. 0.27 × 0.44. Cabinet des Dessins, Louvre. Photo S.D.P.

FIGURE 197. Study for *Rape of Rebecca by the Templar Bois-Guilbert.* 1846.
Pencil. 0.24 × 0.21. Cabinet des Dessins, Louvre. Photo Giraudon.

The comparison recalls his early *Journal* comments on contours. On April 7, 1824, for example, he wrote: "The first and most important thing in painting is the contour. The rest could be utterly ignored since, if it is there, the painting is stable and finished. I need more than others to be on my guard in this regard: *think of it constantly and always begin there*."[40] There are other references in this period to the necessity for firm and bold contours. These statements indicate some shifts of emphasis over the years, but they do not contradict his later opinions as sharply as it may at first seem. He came to regard contour as an aspect of painting to be approached with a certain caution, one that required the utmost skill and confidence to handle successfully. His firm belief in the function of emphatic contour is seen most clearly in the murals and the other larger, more "finished" works. On the other hand, his handling of contours is unpredictable. As Johnson has pointed out, they are often discontinuous and elusive. The stress of his linear accents often varies greatly in different parts of a painting. At times,

40. *J*, 1:69 (Apr. 7, 1824).

41. See Johnson, *Delacroix*, p. 79.

42. See *J*, 1:274 (Mar. 10, 1849); Piot, *Les palettes de Delacroix*, pp. 45ff.; De Planet, *Souvenirs*, pp. 33–34.

43. See Piot, *Les palettes de Delacroix*, p. 47.

44. *Art in Paris*, p. 142.

as in the hands and arms of the women in the right foreground of *Entry of the Crusaders into Constantinople*, the underpainting has been allowed to show through in order to soften the edges of the overlapping forms and give them the desired atmospheric effect.[41]

Delacroix applied his basic method of laying out a mass and gradually developing its contours both to color and to monochromatic works. In either case, the main quality he sought was that of projection, or relief. He believed that one of the best devices to obtain it in drawings was "*boules*," as he called the oval shapes he used to build up his loosely constructed masses. He had encountered this system of drawing in Leonardo's writings and was convinced that it was derived from antiquity.[42] These complex, multiple-boundaried forms and their closely related variants were admirably suited to give the improvisatory quality Delacroix liked and apparently admired in Daumier's drawings.[43] His desire that his figures appear to be in the process of emerging from the matrix of their immediate environment was also well served by the *boules*, as the studies for *Jacob and the Angel* and *Apollo* show. The special feeling of pulsing movement that could be thus obtained was the quality which Baudelaire so admired in Delacroix that he made of it a dictum: "drawing should be like nature, alive and in motion."[44]

FIGURE 198. Figure studies. 1840.
Pencil. 0.30 × 0.26. Cabinet des Dessins, Louvre. Photo S.D.P.

Inherent in Delacroix's conviction of the essential virtues of mass and movement was his belief that time and memory helped eliminate the inconsequential. Here again a comparison with Daumier's dependence on memory is suggestive, but what for a professional illustrator was a matter of practical convenience became for Delacroix an aesthetic law.[45] In *Delacroix's Theory of Art* Mras gives an illuminating quotation from *The Spectator* for June 21, 1712, which suggests a possible source for some of Delacroix's speculations: "We cannot indeed have a single Image in the Fancy that did not make its Entrance through the Sight: but we have the power of retaining, altering and compounding those Images, which we have once received, into all the Varieties of Picture and Vision that are most agreeable to the Imagination: for by this Faculty a Man in a Dungeon is capable of entertaining himself with Scenes and Landskips more beautiful than any that can be found in the whole Compass of Nature."[46]

Although Delacroix continued to work directly from the model on occasion, in his later years such studies seem to have been made as exercises or as preliminary essays, and the final painting was several stages removed from its initial stimulus in nature. On numerous occasions in the *Journal* he criticizes David for depending too literally on the model. On January 25, 1857, he wrote: "Enslavement to the model in David. To him I oppose Géricault, who also imitates, but more freely, and brings in more of interest."[47] On March 5, after again criticizing David for coldness and enslavement to the model, he praised Géricault for passages demonstrating the intervention of "the personal ideal of the painter." He was particularly struck by a "hand in which the planes are soft and as if done without consulting the model." He here spoke also of some Rubens tapestries and determined to "do all the subjects from memory."[48] On another occasion, however, he agreed with Chenavard's criticism even of Géricault's compositions for a lack of harmony, largely because of "the way that posed figures predominate, as details also do, even though they are treated with force."[49]

Elsewhere he puts the case more generally and in his own terms: "Of the necessity of taking from the model only that which serves to explain, to corroborate, the idea. The forms of the model, be it a tree or a man, are only a dictionary to which the artist goes to give renewed force to his fugitive impressions, or rather to give them a sort of confirmation, for he must have memory. To imagine a composition," he continued, "is to combine elements of objects one knows with others which are interior, even in the soul of the artist."[50] Once more memory and imagination were brought into the intimate association which he sometimes referred to as "*liaison*."[51] As he explained in the same essay, "Realism and Idealism," "without a doubt the model is necessary and almost indispensable, but it is only a slave to the imagination. One takes from it certain characteristic details that neither the most fertile imagination nor the most faithful memory could reproduce, and which give a kind of sanction [*consecration*] to the imagined part. It goes without saying that this manner of working demands the most consummate skill [*science*], and to master it takes a lifetime."[52]

An insistence on memory as an instrument of selection with properties similar to those of imagination is common to all these precepts. Gilman gives as an example a passage from the "*Fragments métaphysiques*," which also appears in his *Oeuvres littéraires*. "Fact is as nothing," Delacroix began, "for it passes. Nothing is left of it but the idea; actually, fact does not survive in the mind because the imagination alters it, imposing its own image, colored in its own way and accord-

45. The interest in working from memory came into particular prominence a little later in the century, when such men as Horace Lecoq de Boisbaudran taught drawing from memory as a means of emancipating the individual from more and more constricting rules and regulations. Fantin-Latour, Rodin, and Dalou were among Lecoq's pupils at the École Impériale, where he taught in the 1860's and of which he was, for a time, director. Whistler, Degas, and others seem to have adopted similar ideas, perhaps under his influence. See Lecoq de Boisbaudran, *Enseignement artistique* (Paris: Morel, 1879); *L'Education de la mémoire pittoresque et la formation de l'artiste* (Paris: Laurens, n.d.).

46. See p. 55 and n. 34. The edition quoted is Joseph Addison and Richard Steele, *The Spectator*, ed. G. Gregory Smith (New York: E. P. Dutton, 1909), vol. 3, p. 56. Delacroix had read at least some of the *Spectator* papers.

47. J, P, p. 555 (Jan. 25, 1857).

48. J, 3:71 (Mar. 5, 1857).

49. J, P, p. 434 (Sept. 17, 1854).

50. O, 1:58.

51. See Johnson, *Delacroix*, pp. 26, 78–79. The concept of "*liaison*" was hardly original. Mérimée, for example, refers to it as a familiar aspect of color harmony (see J.-F.-L. Mérimée. *De la peinture à l'huile, ou des procédés matériels employés dans ce genre de peinture, depuis Hubert et Jean Van-Eyck jusqu'à nos jours* [Paris: Mme Huzard, 1830], p. 281).

52. O, 1:58. See also the long passage "On the use of the model" in J, 2:85–88 (Oct. 12, 1853), in which Delacroix discusses similar ideas with reference to other artists, especially Rubens.

53. O, 1:114–15 (Sept. 16, 1849), quoted in Gilman, *Baudelaire the Critic*, p. 153. The original French is somewhat murky, and hence a free translation is presented here. It reads, "Le fait est comme rien, puisqu'il passe. Il n'en reste que l'idée, réellement même, il n'existe pas dans l'idée, puisqu'elle lui donne une couleur, qu'elle se le représente en le teignant à sa manière et suivant les dispositions du moment. . . . C'est qu'il se passe dans la pensée, quand elle se souvient des émotions du coeur, ce qui s'y passe quand la faculté créatrice s'empare d'elle pour animer le monde réel et en tirer des tableaux d'imagination. Elle compose, c'est-à-dire qu'elle idéalise et choisit." A closely related idea appears in the *Journal* of April 28, 1854: "In reflecting upon the freshness of memories, upon the enchanted color with which they endow a distant past, I admire that involuntary work of the soul which, in the recollection of pleasant moments, wards off and suppresses whatever would diminish their charm at the very moment that they cross the mind. I compare that kind of idealization (for it is one) to the effect of beautiful works of the imagination" (2:174; quoted in Gilman, *Baudelaire the Critic*, p. 153).

54. See Frank Trapp, "The Art of Delacroix and the Camera's Eye," *Apollo*, 83, no. 50 (April, 1966): 278–88.

55. See Escholier, *Delacroix*, 3:200 and facing plate; Moreau-Nélaton, *Delacroix*. If Moreau-Nélaton's date is accurate (and it seems so), this would indicate an early interest in the process, which was disclosed to the Academy of Sciences on January 7, 1839. Photography is not mentioned in the *Journal* until the 1850's, although there is a gap in that document from the early years to 1847, when it was resumed.

ing to the moods of the moment. . . . This is what happens in the mind when tender emotions are recalled; it is what happens when the creative faculty takes over the mind to animate the real world and to derive from it works of imagination. Thought composes; that is to say, it idealizes and selects."[53]

The process of simplification and abstraction carried on by memory had an analogue in photography, in which Delacroix was keenly interested for a time.[54] That one so opposed to material progress and the usurpation of the machine should have such an interest may seem puzzling, but in the context of his theoretical speculations that apparent contradiction is resolved. At one level, the photograph had a minor and somewhat transient appeal as a useful documentary tool. What was more important, however, was the way in which it provided what Delacroix regarded as an objective demonstration of what he had come to feel were nourishing aesthetic truths.

The earliest evidence of Delacroix's recognition of photography as a promising device for artistic exploitation is a page of studies, reproduced by Escholier and dated 1842 by Moreau-Nélaton,[55] on which appear a number of heads drawn, it seems, after daguerreotype portraits of himself and perhaps his friend Mme

FIGURE 199. Jean-Auguste-Dominique Ingres. *Mme Edmond L. A. Cavé*. Ca. 1844. Oil on canvas. 0.41 × 0.33. The Metropolitan Museum of Art, Grace Rainey Rogers Bequest, 1943. Photo The Metropolitan Museum of Art.

Cavé.[56] Their apparent association in this document is of interest, for a few years later Delacroix reviewed her book, *Drawing without a Master*. The usefulness of photography is a prominent topic in his commentary. Two days after the publication of that essay, on September 17, Delacroix noted that he intended to borrow some of the daguerreotypes of nude men he had heard were being made by his friend Jules-Claude Ziégler.[57] Although there is no evidence that he did so, some time later he obtained what must have been comparable studies made by another friend, Eugène Durieu.[58] Several entries in the *Journal* refer to these photographs of nude models, a number of which were found among his studio effects at the time of his death. They are now preserved in the Bibliothèque Nationale.

The most obvious attraction of photographs was their practicality. Delacroix could easily carry them with him on trips away from Paris and consult them, freeing him from the necessity of finding live models. A number of practice studies relating to photographic prints have been identified. There could be no more eloquent demonstration of the difference between art and "nature" than Delacroix's transformation of the plain, quaint features of these images. A few other works, all similarly modest in scale, have been linked to a larger series of photographs by Durieu, now in the collection of the George Eastman House in Rochester, New York.[59]

Although these instances of direct or presumed dependence on such mechanical models are of interest, the impact of photography on Delacroix's art was both limited and transient. Not one of his major works is known to be based on a photographic source; moreover, his enthusiasm for this discovery seems to have waned rather quickly, and photography is not mentioned in the later pages of the *Journal*. The whole matter could be reduced to a footnote were it not that it has larger ramifications. It was not simply chance that in his review of *Drawing without a Master* the virtues of photography were closely coupled with those of memory.[60] Both had the peculiar property of filtering and imposing a selective order upon experience. The very artificiality of the daguerreotype, with its forced contrasts and reversed image, constituted a positive advantage. "Fact" became a challenging novelty. According to De Planet,[61] for the same reason Delacroix sometimes used mirrors to study his work. In its reduction of the original, the photograph conveniently, if artifically, isolates aspects of form or, in reproductions of works of art,[62] style.

The essential purpose of Delacroix's *boules*, his work from photographs, his belief in memory drawing, or any other procedure he adopted was to capture what he called the "tangible." His ultimate aim, however, was not to achieve literal description but to unite the two worlds that had equal claims to his loyalty, the one rational and objective, the other subjective and intuitive. That the final product was to be at once a specific object and a stimulus to the imagination is implied in his description of painting as a "hieroglyph," but one endowed with individual beauty, form, and character, as well as with compelling analogies to the world of nature.

It is clear that the chief purpose of Delacroix's theoretical speculations was that of solving his creative problems. At times, therefore, it is impossible to divorce these ideas from technical considerations. In basic matters of technique Delacroix's early habits were largely established at the Atelier Guérin, as a comparison of oil sketches by the master with those of his pupil will show.[63] Although

56. See Van Deren Coke, "Two Delacroix Drawings Made from Photographs," *The Art Journal*, 21, no. 3 (Spring, 1962):172–74. Delacroix and the future Mme Cavé first met at Arsène Houssaye's carnival ball in 1833, the same evening on which he first encountered George Sand. She was already married to a mediocre painter, Clément Boulanger, who died in 1842, leaving her a widow at the age of twenty-seven. Two years later Elizabeth Boulanger married the much older M. Cavé, who subsequently became the Director of Fine Arts in the government of Louis Philippe. It has been suggested that Ingres' portrait studies of the couple, now in the Metropolitan Museum, may have been painted as a wedding gift (see Agnes Mongan, ed., *Ingres Centennial Exhibition [1867–1967]* [Cambridge, Mass.: Harvard University Press, 1967], pp. 89–90). By that time Delacroix's liaison with Elizabeth, or "Lisa," as he often called her, was of long standing. The two visited the Low Countries together in 1839—an adventure that is now known to have been more discreetly arranged and amicably concluded than was formerly supposed (see Huyghe, *Delacroix*, pp. 517–18, nn. 15–16). At just what point their ardor was transformed into a more platonic devotion is unclear, but Delacroix did remain in touch with both Cavés. An unpublished letter of July 10, 1846 (quoted in Huyghe, p. 518), thanks them for his recent receipt of the Legion of Honor. Elizabeth Cavé's two small manuals, *Drawing without a Master* and *Watercolor without a Master*, both written after Cavé was replaced as minister by Charles Blanc and shortly before his death in 1852, reveal the wit and intelligence which Delacroix admired in her (see my "Mistress and a Master: Madame Cavé and Delacroix," *The Art Journal*, 27, no. 1 (Fall, 1967):40–47). The subject is also treated, after a fashion, in Paul Angrand, *Marie-Elizabeth Cavé, Disciple de Delacroix* (Paris: Bibliothèque des Arts, 1966).

57. See *J*, 1:416 (Sept. 17, 1850): "Laurens informs me that Ziegler [*sic*] is making a large number of daguerreotypes and, among others, some of nude men. I shall visit him and ask whether he will lend me some of them."

58. Pierret had introduced Delacroix to Durieu, a civil servant (Directeur des Cultes) and an amateur photographer, as early as 1850 (see *J*, 1:345 [Feb. 26, 1850]). For further discussion of this interest, see my "The Art of Delacroix and the Camera's Eye," cited above. Another drawing which has not, to my knowledge, been identified as made from a photograph is a handsome, quite finished, pencil study of a kneeling woman, now in the Cabinet des Dessins (R.F. 9 498). It was unquestionably modeled after photograph number seven in the Durieu album. Other drawings will doubtless be so identified in time, and it seems likely that still others were made from photographs which no longer exist.

59. See *ibid*., Figs. 11–16; Coke, "Two Delacroix Drawings from Photographs"; A. Scharf and A. Jammes, "Le réalisme de la photographie et la réaction des peintres," *L'Art de France*, 4 (1964): 182–83.

60. See Trapp, "Mistress and a Master."

61. *Souvenirs*, p. 90.

62. He wrote, for example, of his interest in a photograph of Rubens' *Elevation of the Cross* in which "the inaccuracies, no longer saved by the execution and the color, show up better" (*J*, 2:119 [Nov. 24, 1853]). Delacroix found the same isolation of particular stylistic elements in engravings after the masters, as, for example, Marcantonio's transcriptions after Raphael, which he sometimes knew only from impressions made from badly reworked plates, such as that of *Feast in the House of Simon* (Bartsch 23), which he criticized as full of "inaccuracy, mannerism, and lack of naturalism" (*J*, W, p. 188 [May 21, 1853]; see also *J*, 2:58).

63. Huyghe observes that Delacroix remained well disposed toward Guérin. He cites Maxime du Camp's mention in his *Souvenirs littéraires* of the painter's lifelong affection and respect for his former teacher (*Delacroix*, pp. 64–65).

FIGURE 200. Two male figures after Thévelin[?]. 1855.
Pencil. 0.23 × 0.27. Collection of the author. Photo Donald Witkoski.

FIGURE 201. Eugène Durieu. Photographs of models. Ca. 1854.
Cabinet des Estampes, Bibliothèque Nationale, Paris.
Photo Bibliothèque Nationale.

the break between late baroque traditions and neoclassical practice in nineteenth-century France is often stressed, certain baroque principles were, in fact, retained. They are often unnoticed in large, formal works, with their hard finish, but may be seen more clearly in smaller studies. In its most simplified form, this adaptation of traditions persisting from the late Middle Ages involved the recognition of certain tonal functions within areas of local color: the light and shade, along with the half tones and reflected lights. As René Piot observes in his somewhat haphazard but useful publication *Les palettes de Delacroix*, by Cennino Cennini's day it was an established custom for each artist to have at hand three pots. Each contained paint mixed in advance for the lights, the shadows, and the half tones for a given local color. Piot claims that the Venetians extended that fourteenth-century mode to include a fourth pot for reflected lights; in fact, this addition was probably made much earlier, but the principle remains the same. Delacroix's notion of using a form of prepared palette therefore had a humble origin in a long-standing tradition that survived among professional decorators until his day.

Needless to say, this color scale could be greatly elaborated. Initial observations of the objects to be represented determined the local tone and the range of hue. The palette was thus established, with its color scale a compromise between the variety of tones observable in the subject and the practical limitations of the pigments available. Much of Delacroix's early experiments of this sort were empirical, a matter of trial and error, of constant correction, repainting, and adjustment. In view of the uncertainties that such a procedure involved, he came to feel a need to settle on more systematic working methods to ensure success in large projects where improvisation was both time-consuming and risky. In the process of turning from a use of color as an instrument of perception and intuitive expression to more abstract notions of style and expression, his concept of color organization was similarly redefined. The direct evidence of the works themselves is corroborated by the statements of Delacroix and his assistants. De Planet's *Souvenirs* and Lassalle-Bordes' *Notes* have been mentioned, as have Andrieu's recollections, first published in *La galerie Bruyas* and later incorporated in Piot's publication.[64]

In his early works Delacroix's palette appears to have been more or less conventional. It was essentially baroque, composed mainly of the earth tones,[65] black and white, amplified with certain more brilliant hues, including blues, yellows, red, and green. He frequently added such colors as Naples yellow, vermilion, and rose madder or some other bluish red to the basic earth colors. Since Prussian blue was by then widely popular, it was also employed.[66]

Cost was also a deciding factor at times. Referring to *Death of Sardanapalus*, for example, Andrieu reports that Delacroix observed that he was "not rich" in those days and therefore had to employ colors of common quality. "Many of them," he reflected sadly, "have disappeared. The blues have turned green. Only the Mars colors and the Indian yellow have behaved well."[67] With this warning in mind, Delacroix is said to have exposed all his paints to sunlight, only to discover that all lost their original hue. He therefore concluded that it was necessary not only to buy only the finest materials but to work in such a way that, despite the alterations of tone, their relationship would remain stable.[68] Hence he decided to exclude from his palette the "immutable blues of Le Seur," as unsuited to his pictures. The striking, almost strident blues common in seven-

64. Delacroix's theories of color and his use of prepared palettes are discussed in an extremely rudimentary way in Piot, *Les palettes de Delacroix*, pp. 62ff. According to Piot, only two complete copies of *La galerie Bruyas*, which served as his source of information, are known to exist; both are in the collection of the Cabinet des Estampes at the Louvre. A more sophisticated general discussion of these theoretical matters will be found in Arthur Pope, *The Language of Drawing and Painting* (Cambridge, Mass.: Harvard University Press, 1949), pp. 115–31 *et passim*.

65. The natural earth colors (siennas, ochers, umbers, etc.) have from time immemorial provided painters with a cheap and stable range of pigments. Along with black and white of one mixture or another, they traditionally make up a basic palette. Sometimes these colors are modified by treatment with heat. The resulting colors, also stable, are known as "burnt," hence "burnt" sienna as opposed to "raw" sienna, etc.

66. "Deep greenish-blue, unlike other blues. . . . As regards absolute permanence, Prussian blue is one of the 'borderline' colors. . . . Discovered by Diesbach, Berlin, 1704; introduced as a pigment about 20 years later" (R. Mayer, *The Artist's Handbook of Materials and Techniques* [New York: Viking, 1945], p. 53). Delacroix probably did not use real ultramarine blue, however, for the synthetic pigment was unavailable before 1828 and he could hardly have afforded the lapis lazuli that provided the rich, intense blues common in seventeenth-century French painting but usually lacking in Delacroix's harmonies (see Mayer, *The Artist's Handbook*, p. 60). At times, as in *Greece on the Ruins of Missolonghi*, there is a blue unlike the more greenish tones Delacroix normally preferred, which may be cobalt blue, a pigment closer to ultramarine, which was discovered in 1802 by Thénard and was introduced for artists' use in 1820 (*ibid.*, p. 39). This color was sometimes called Thénard blue. Delacroix was much interested in color and was likely to have tried such a new product. He was known for his ready adoption of new colors—

sometimes to the detriment of the durability of his work.

67. Quoted in Piot, *Les palettes de Delacroix*, p. 74. The Mars colors are artificial oxides of iron, which are completely stable. Indian yellow was well regarded in the nineteenth century, but manufacturers often substituted cheaper but less permanent analine colors, which closely resembled it. It therefore fell into disrepute. Chemically, it was a lake of euxanthic acid, made from heating the urine of cows fed on mango leaves. It is no longer made, its manufacture having been forbidden around 1908 (see Mayer, *The Artist's Handbook*, pp. 44–45).

68. Piot, *Les palettes de Delacroix*, p. 74.

69. Delacroix frequently criticized Poussin's color for its lack of what he called "unity."

70. Piot, *Les palettes de Delacroix*, pp. 75–77. Lee Johnson has pointed out that this assertion by Andrieu is open to some question. He cites an entry in the *Journal* for July 30, 1854, in which Delacroix says that it *might* be possible to block in an oil painting with distemper (see *J*, 2:223, and Johnson, *Delacroix*, p. 52). This casts doubt on Andrieu's assertion that the technique was used as early as *Sardanapalus*. Johnson does observe that Delacroix used distemper for preliminary sketches as early as the 1840's and combined distemper with oils in the following decade, as his own writings make clear.

71. *Souvenirs*, pp. 84–85.

72. See, for example, *ibid.*, p. 59. Delacroix did not believe that oil yellowed once it was mixed with color. He used all oils indiscriminately. Before repainting an area, he first rubbed it with oil mixed with saliva "to penetrate the oil." See *J*, 2:89 (Oct. 15, 1853), where he speaks with enthusiasm of someone's absurd proposal of olive oil as a painting medium.

73. *J*, W, p. 331 (Jan. 11, 1857).

74. Piot, *Les palettes de Delacroix*, p. 80.

teenth-century French painting would in fact have been altogether alien to Delacroix's color composition, and it is easy to understand why he usually avoided them.[69] However, Andrieu's claims for Delacroix's skill in maintaining his color relationships or his scruples in technical procedures cannot be accepted literally. In an age of commercial preparation of the artist's materials, the breakdown of the old, tested methods had been accompanied by a general deterioration of professional standards. *Sardanapalus* suffered in particular, not only from the use of fugitive colors but from miscalculations of technique, particularly in the use, according to Andrieu, of a distemper underpainting. This lay-in was brittle and ill-suited to its canvas support, and its original pastel-like brilliance was completely lost once the after-layers of oil paint were applied. Andrieu was later entrusted with the restoration of the work and was an expert witness to the extent of the damage it had suffered.[70]

In view of some of Delacroix's technical "experiments," the wonder is that his paintings have survived as well as they have. Writing in 1843, at the time of the Palais Bourbon decorations, De Planet recalled one such alarming investigation: "M. Delacroix told me that he was in process of trying out a 'siccatif de Coutray,' some new drier, which he believed to be good. He wished to test it on [a layer of] bitumen which he will affix to [a ground of] bitumen spotted with thickened oil. At the end of six months he will know whether the process is better."[71] For all their good intentions, experiments like this one—and it is not an isolated example—constituted a real threat to the survival of Delacroix's work.[72]

In later years he continued the practice of beginning with a grisaille, then building up his colors. Fortunately, he did not always use distemper for the initial phase. This procedure implies an extensive use of glazes, which he understood very well as stylistic or optical phenomena but less well as elements of a durable paint structure. The often sad physical condition of his works substantiates his ignorance of the order with which "fat" and "lean" mixtures may be applied, the necessity for adequate drying time between layers, and other practical questions much better understood by the Venetian and baroque artists, from whom the mode derived. Ironically, Delacroix himself recognized this shortcoming, as indicated in one of the first entries for the *Dictionnaire*: "Technique. (To be demonstrated palette in hand.) The most perfect technique is to be found in the works of the greatest masters: Rubens, Titian, Veronese, the Dutch painters; the special care they took in grinding colours, in primings and preparations, in drying the different layers of paint. (See panels.) The tradition entirely lost in modern painting. Hence bad results, neglect of preparations, canvases, brushes, execrable oils, carelessness on the part of the artist."[73]

Delacroix's liking for mat surfaces, particularly for mural decorations, led him to use various mixtures including wax, which was fortunately sound. According to Andrieu, he mixed pure wax with his colors for the Salon du Roi, but it was not until a later period that that mixture took on visible importance. Citing *Battle of Taillebourg*, *Justice of Trajan*, and *Entry of the Crusaders* as his major examples, Andrieu pointed to the "fresher, blonder" tonalities afforded by the substitution of this mixture for those of oils, turpentine, and viscous varnishes that he had previously used.[74] Apparently, it was not yet realized that the surface gloss could be controlled by the final coating. More important, however, is the fact that the choice of medium had a pronounced stylistic effect. The special handling invited by that pastier kind of paint is apparent in some of the murals

and in parts of *Crusaders*. In the St. Sulpice murals the consistency of the paint is especially evident in the brushwork.[75] Delacroix did not, of course, invariably introduce wax into his medium. For the final execution of *Victory of Apollo*, for example, a straight oil paint was employed with neither wax nor varnish. But in the Hôtel de Ville murals a wax compound was again used.[76]

Aside from the initial selection of the medium, Delacroix was able to control his effects by adjustments of the viscosity and drying properties of his paint and by careful selection of his brushes. The matter of the brush itself introduces some important technical points that are often overlooked. Andrieu recalled Delacroix's meticulousness in the use of the kind of brush appropriate to each phase of the picture. "Short, stiff brushes for the laying-in, longer bristle brushes to finish the *ébauche*, and sables or minivers to finish and for the glazes." Softer, finer brushes were used to apply the more fluid paint, which was usually mixed with a medium composed of oil, turpentine, and water, vigorously shaken to make a kind of emulsion. Nor was Delacroix casual even as to the manner of handling the brush. According to Andrieu, "he instructed as a violinist teaches his pupil to hold the bow."[77] Delacroix himself confirmed this analogy: "The craft of the painter is the most difficult of all and it takes the longest to learn. Like composing, painting requires erudition, but it also required execution, like playing the violin."[78]

Thus, as with other aspects of his work, Delacroix was classically disposed. He believed not in a mindless virtuosity but in well-practiced method. In his later years he was even a bit distrustful of Bonington and Charlet and wrote of their work with mixed feelings: "There are talents that come into the world fully prepared and armed at every point. Since the beginning of things, there must always have existed that kind of pleasure which the most experienced men find in work, which is to say, a species of mastery, the sureness of hand keeping time with the definiteness of the conception. Bonington was that way also, but in the matter of his hand above all: that hand was so able that it ran ahead of his thought."[79]

There were times, however, when Delacroix seems to have regretted the technical competence he normally admired. In one *Journal* entry he asserts that reliance on the "model," the artistic norm, characteristic of French art was often maintained at the expense of subjective qualities or individual freedom. "The finest works of art are those that express the pure fantasy of the artist," he wrote. "Hence the inferiority of the French school in sculpture and painting, where precedence is always given to studying the model instead of expressing the feeling that dominates the artist. Frenchmen in every period have relapsed into styles or academic enthusiasms and have been satisfied with this approach, which is supposed to be the only true one, and is in reality the most false of all. Their love for reason in everything has made them...."[80] The statement was never completed, but its meaning was clear. There was in fact a conflict between freedom of individual expression and a prevalent belief in form as susceptible to precise quantification, and it is understandable that at times Delacroix may have looked back upon Bonington's wonderfully insouciant talent or on Charlet's unpremeditated gifts, which "knew no dawn," with a faint trace of envy.

Delacroix remained a believer in systems, the more so with the years. Nowhere was this predilection more apparent than in the development of his ideas about color, particularly in the adoption, beginning with the Galerie d'Apollon, of

75. See discussion below.

76. Piot, *Les palettes de Delacroix*, p. 93.

77. *Ibid.*, pp. 64, 65.

78. J, W, p. 81 (Sept. 18, 1847); see also Piot, *Les palettes de Delacroix*, pp. 66–67.

79. J, P, p. 522 (Dec. 31, 1856). An even harsher judgment is contained in an earlier entry (J, P, p. 348 [Nov. 22, 1853]). The following year, still preoccupied with Charlet (on whom he was writing an article), with Bonington, and (as ever) with himself, he wrote, as if to defend himself against an accuser, "It seems as if talents more slowly formed, or should I say more laboriously, are destined to live longer, in their strength and in their amplitude" (J, P, p. 603 [Oct. 29, 1857]; see also O, 2:201–13, esp. p. 205). He advances similar views in a discussion of the "masterpiece," in which he insists upon the evidence of sustained effort and mature works to confirm precocious signs of talent (J, P, pp. 504–5 [Jan. 21, 1856]).

80. J, W, p. 318 (Aug. 8, 1856).

81. Piot, *Les palettes de Delacroix*, p. 64.

his "synthetic palettes."[81] In the years of his maturity he became fully aware of the importance of the initial color selection in determining the total harmony of a picture. Accordingly, he experimented with various tonal combinations. He also realized that mixing colors in advance saved time in the actual execution and gave visual order to the result. This perception was bolstered by his study of the masters. The "grand manner" of Veronese had special relevance to his own decorative commissions. Veronese's massing of colors and Constable's color variations both influenced his color systems, in which the notions of unity and variety are paramount, and he sought confirmation of these qualities in the direct observation of nature.

Delacroix's admiration for Veronese was unfailing and almost unbounded. He was naturally attracted by Veronese's easy handling of large decorative ensembles and carefully studied such grand compositions as *Feast in the House of Levi* to probe his secrets. The *Journal* for 1847 suggests the meaning for him of his great predecessor's art:

Painted the Magdalen in the "Entombment."
Must remember the simple effect of the head. It was laid in with a very dull, grey tone. I could not make up my mind whether to put it more into shadow or to make the light passages more brilliant. Finally, I made them slightly more pronounced compared with the mass and it sufficed to cover the whole of the part in shadow with warm and reflected tones. Although the light and shadow were almost the same value, the cold tones of the light and the warm tones of the shadow were enough to give accent to the whole. We were saying when we were with Villot on the following day that it requires very little effort to produce an effect in this way. It occurs very frequently, especially out of doors. Paolo Veronese owes much of his admirable simplicity to it. A principle which Villot considers most useful and of very frequent occurrence is to make objects stand out as a darker note against those that lie behind; this is attained through the mass of the object and at the stage of the lay-in, when the local tone is settled at the beginning. . . . Veronese also owes much of his simplicity to the absence of details, which allows him to establish the local colour from the beginning. . . . The vigorous contour which he draws so appropriately round his figures helps to complete the effect of simplicity in his contrasts of light and shade, and finishes and sets off the whole picture. . . . His skill in refraining from *doing too much* everywhere, and his apparent carelessness about the details, which gives so much simplicity, is due to the practice of *decoration*. In this type of work the artist is compelled to make many sacrifices.[82]

82. *J*, W, pp. 79–80 (July 10, 1847). Veronese's name frequently recurs in connection with problems of color construction. At the time of the work at the Galerie d'Apollon, for example, Delacroix wrote: "In Paolo Veronese's *Susanna*, I noticed how simply he handles the light and shadow, even in the planes of the foreground. In a vast composition like the ceiling, this is far more necessary. The chest, in the figure of Susanna, seems to be of a single tone and is full of light. The contours, also, are very pronounced: another means of getting clarity at a distance" (*J*, P, p. 247 [Sept. 23, 1850]).

This passage admirably summarizes Delacroix's habit of associating his own creative intentions with those of the masters he admired. At the same time, he is alert to the ways in which observation of natural phenomena can aid him in resolving his problems. His terminology is theoretical and systematic. He has, for instance, carefully distinguished between effects of "value," or light and shade, and those of hue or color. He has further discriminated between the "warm" tones, those tending towards the orange scale, and the "cool," those on the blue side. His recognition of the possibility of distinguishing forms by hue and tonality is, in fact, tantamount to the notion of "modeling by color" rather than by light and shade. This idea builds upon the Venetian tradition and its development in the paintings of Rubens and his followers.

A statement about Constable amplifies Delacroix's observations as to how Veronese modeled his masses with variations of color: "Constable said that the superiority of the green he uses for his meadows derives from the fact that it is composed of a multitude of different greens. What causes the lack of intensity and of life in verdure as it is painted by the common run of landscapists," he

continued, "is that they ordinarily do it with a uniform tint. . . . What he said about the green of the meadows can be applied to the other tones."[83]

The two commentaries broadly indicate Delacroix's evolved approach. He massed his color boldly in local areas, with the interior modeling coloristically indicated, that is to say, less by distinctions of light and dark than by broad oppositions of "warm" and "cool" tones or secondary variations within the basic hues. In this way he could obtain richness of color without sacrifice of basic compositional clarity. The "sacrifices" he sometimes made were usually those of refinement of detail and subtlety of transition from part to part. Especially in the later works a high "saturation" of color, that is, an extreme intensity throughout any given area, whether in the lights or darks or middle tones, creates effects of unnatural brilliance, that "scientifically supernatural" palette praised by Baudelaire.

Over the years Delacroix utilized a number of different palettes. Andrieu identified the one used in the Luxembourg library as the so-called Van Dyck palette.[84] While this had a limited range of colors, generally conforming to Venetian and baroque practice—hence the name—it was enlarged by Delacroix to include ultramarine blue and viridian green. Neither had been employed by artists with any regularity, and his shift from predominantly earth colors to the purer hues dominant in his later work is forecast here. His habit of working with a "prepared" palette, on which the colors were laid out in strict order, some already mixed with white to save time, was also a striking anticipation of Seurat and the neoimpressionists.

For the Galerie d'Apollon Delacroix used twenty-eight pigments, instead of the nine of the Van Dyck palette.[85] A wide range of more "spectral" colors, such as cobalt blue and the "lakes," were added. Some of these, such as "momie" and Indian yellow, inspire little confidence as to their permanence.[86] In addition, the palette contained twenty-five secondary colors, many of them more complex. Prussian blue, for example, appears not only in pure form and mixed with white, but also combined with scarlet lake and white or in even more elaborate cross-mixtures. In so planning the entire range of tones he needed for a painting, Delacroix could both avoid the risks of improvising on a large scale and establish a simple, explicit system of reference.

While Delacroix subsequently modified his palettes for particular undertakings, he remained faithful to the principle of using a predetermined palette for the rest of his life. The purer, more vivid tones of the St. Sulpice murals are the direct result of his simplification of his mixtures to attain greater intensity or saturation of color. The less pure but more complex tonal combinations of *Victory of Apollo* more closely resemble baroque practice, in which cross-mixtures generally served to reduce the intensity of the component hues. What anticipates subsequent attitudes toward color in the murals at St. Sulpice is Delacroix's tendency to substitute brilliant, "spectral" colors for the more traditional earth tones. That is not to say that he obtained absolute purity of color, or that he even wished to do so. He did, however, anticipate many elements of later ideals of color. Cézanne, for example, did not fail to note that Delacriox had recognized the possibilities of "constructing" with color, not simply with light and shade. "We are all in Delacroix," he once said.

At the same time Delacroix believed in color as an instrument of description. As he said, "color gives the appearance of life."[87] He was also appreciative of its

83. J, P, p. 730 (Supplement, September 23). No year is given, but the comment was written "on returning from Champrosay," hence during his later years. Graham Reynolds points out that "Constable had derived this doctrine from J. T. Smith's views on the picturesque." He concludes that Delacroix could hardly have come across this notion except in conversation with Constable at the time of his visit to England (see *Constable, the Natural Painter*, p. 98).

84. Piot, *Les palettes de Delacroix*, pp. 81–84. Baroness de Meyendorf suggested that this was the palette employed by Van Dyck.

85. *Ibid.*, pp. 85–89.

86. Indian yellow has already been discussed. Of "momie" Mayer says "Mummy. Bone ash and asphaltum, obtained by grinding up Egyptian mummies. Not permanent. Its use was suddenly discontinued in the nineteenth century when its composition became generally known to artists" (*The Artist's Handbook*, p. 50).

87. J, P, p. 263 (Feb. 23, 1852); quoted in Mras, *Delacroix's Theory of Art*, pp. 120–21.

88. See Escholier, *Delacroix*, 1:123–24; 2:275.

89. Cited by Paul Signac, *D'Eugène Delacroix au Néo-Impressionisme* (Paris: Hermann, 1964), pp. 42–43.

90. See Mérimée, *De la peinture à l'huile*, pp. 272–98.

91. Silvestre, *Les artistes français*, 1:47–48.

92. *J, W,* p. 138 (Nov. 3, 1850). The dates here indicated are confusing (see *J*, 1:419–20).

93. The water scenes painted at Dieppe during the 1850's are of particular interest in this context. For example, a small oil panel done there (Robaut 1245) is a striking anticipation of the coloristic play of reflected lights, as a number of commentators have pointed out.

94. *O*, 1:71–74.

value in giving a picture unity. These two preoccupations were intimately dependent on one another. His interest in the "appearance of life" was not that of the literal imitator but of one in search of the principles that underlie visual experience. He had early learned that he could attain the more intense yellow he wished by placing next to it its "opposite" color, a purple. At this point he had begun to explore the world of color objectively.[88]

The Chantilly album from Morocco contains a most interesting note in this vein: "The three secondary colors are derived from the three primary. If you add to a secondary tone the primary that is opposite to it, you will cancel, or 'neutralize' it, that is to say, you will produce from it the necessary half-tint: it is to dirty the tone whose true half-tint is to be found in the tone we have spoken of. Hence, the green shadows in the red."[89] What Delacroix is describing here is a system of color relationships apparently based on Newtonian principles, which were well known at this time. The elder Mérimée's treatise on oil painting,[90] published two years before this entry was written, contains precisely this kind of diagram. In his discussion of color theory, Mérimée explains the system and expounds at some length on the subject of color harmony, with particular reference to the practice of the old masters. Many of his observations strikingly resemble those later expressed by Delacroix. It is reasonable to suppose that initially, at least, Delacroix's theoretical notions derived from manuals of this kind, for he clearly made an effort to apply their instruction to his own work. According to Théophile Silvestre, Delacroix referred to an "absolute system" in which, "instead of simplifying the local colors in generalizing them, he has multiplied the tones to infinity and opposed them to each other to gain a double intensity for each." He also made what Silvestre described as a kind of "chronometer" of cardboard, marked off to constitute a color wheel. With it Delacroix could easily analyze even the subtlest relationships.[91]

Among the abundant color observations preserved in the *Journal* and other writings, one of the most informative was written in November of 1850:

During this same walk [at Champrosay], Villot and I noticed some extraordinary effects. It was sunset; the *chrome* and *lake* tones were most brilliant on the side where it was light and the shadows were extraordinarily blue and cold. And in the same way, the shadows thrown by the trees, which were all yellow (*terre d'Italie*, brownish red) and directly lit by the sun's rays, stood out against part of the grey clouds which were verging on blue. It would seem that the warmer the lighter tones, the more nature exaggerates the contrasting grey, for example, the half-tints in Arabs and people with bronzed complexions. What made this effect appear so vivid in the landscape was precisely this law of contrast.

I noticed the same phenomenon at sunset, yesterday evening (13 November), it is more brilliant and striking than at midday, only because the contrasts are sharper. The grey of the clouds in the evening verges on *blue*; the clear parts of the sky are bright *yellow* or orange. The general rule is, *the greater the contrast, the more brilliant the effect.*[92]

Delacroix's desire to confirm his generalizations about visual phenomena by direct observation of nature may be seen in the passages now included in his *Oeuvres littéraires*, in which he dealt with "color, shadow, and reflections." Here he noted certain "natural" effects, such as the appearance of violet tones in shadows or in the green reflections on linen, as well as on waves. Before the impressionists, he was fascinated by reflections on water,[93] and in other situations he noted comparable modifications of the local color.[94] Here again, however, he was proceeding from strictly empirical evidence, for there is no real suggestion of

any theoretical basis for his claims, some of which are not, in fact, altogether true.[95]

Especially important in this context is Delacroix's reference to his having actually *seen* color in what had ordinarily been regarded as a "neutral" surface (white linen) on which a shadow would have been traditionally painted as "neutral" or gray unless some reflecting colored surface were shown nearby. So too is his related pronouncement of January 13, 1857: "The enemy of all painting is the gray. . . . Banish all the earth colors."[96] It was hardly surprising that some of the younger generation, especially the neoimpressionists, would seize upon these insights. Signac's book, *From Delacroix to Neo-Impressionism*, includes numerous quotations from Delacroix, including those having to do with gray, the banishment of earth colors, and the presence of violet shadows and green reflections.[97]

It was characteristic that here, as in other matters, Delacroix wished to arrive at principles that would enable him to anticipate and control his effects. Although there is, from time to time, talk of "laws," his precepts are remarkably free from cant or jargon. They consistently refer back to the painter's palette and thus to practical issues. As a result, they are of interest less as abstract speculation than as another means of access to Delacroix's paintings.

Unfortunately, Delacroix's use of such words as "law" or "contrast" has led to some confusion as to the degree to which his "systems" were truly scientific and incorporated current theories of color and optics. Baudelaire, Charles Blanc and other well-intentioned nineteenth-century writers sought to establish a kind of academic legitimacy for Delacroix's views, but while it does appear that he was to some extent aware of contemporary scientific findings, their real importance for his own endeavors is highly problematical.

On April 7, 1828, Chevreul delivered before the Institute a paper incorporating his first findings about the "simultaneous contrast" of colors. His ideas were presented in greater detail in a series of eight public lectures delivered at the Gobelins in January, 1836, again in 1838, and at two-year intervals thereafter until 1844. In the absence of a *Journal* for those years, it is not known whether Delacroix attended, although it is quite possible that he may have been attracted to such events. Rosenthal has suggested that he may have seen popular adaptations of Chevreul's theories in *L'Artiste*.[98] At any rate, without more positive evidence on the subject, it seems reasonable to suppose that whatever notions he might have derived from Chevreul's scientific explanations of color "behavior" were soon integrated into his own system based on direct empirical experience. He had, after all, shown a strong interest in color theory before Chevreul and his colleagues made public their quite differently oriented formulations.

The desire to establish a scientific basis for Delacroix's perceptions about color gained particular impetus from Baudelaire's efforts to arrive at a synthesis of their meaning in his "Salon of 1846." Baudelaire's conclusions have been eagerly accepted by those who wished either to accord the painter special qualities of "universality" or to invest his work, as Blanc and Signac wished to do, with some authority beyond its own artistry. Delacroix's own discussions of color are, nevertheless, lacking in any concern for the mathematical and theoretical fundamentals of optics or color perception. What he professed can be satisfactorily —and more simply—understood as the product of a voracious curiosity about the world of sight, fed by observation both of nature and of art. Although some

95. He did not, for example, consider the possibilities of light of another color than yellow. The violet he observed "always" in the shadow of linen would be affected by shifts in the nature of the light. So too there would be a change in the green reflections. Goethe described these phenomena more accurately in his discussion of the effects of light and shadow on the snow as he descended from a climb on Brocken peak (see *Werke*, ed. D. Schäfer, 14 vols. (Hamburg: Wegner, 1955), 13:348.

96. *J, P*, pp. 536–37 (Jan. 13, 1857). He added, "See my note on a separate sheet of paper, notebook of '52, Sept. 15." This comment has not been included in the *Journal* as it now stands.

97. See Signac, *D'Eugène Delacroix au Néo-Impressionisme*, pp. 37–77, esp. pp. 38–45. Even before Delacroix, Turner had become interested in color theory and optical effects (see L. Gowing, *Turner: Imagination and Reality* [New York: Museum of Modern Art, 1966], pp. 21–24). He was aware of Goethe's theories through the Eastlake translation (see J. W. Goethe, *Theory of Colours*, trans. and ed. C. L. Eastlake [London: John Murray, 1840]). It is conceivable that Delacroix too had read the Eastlake translation, but his apparent lapse in interest in English makes it unlikely that he would have attempted so technical a document.

98. See Rosenthal, *Du romantisme au réalisme*, pp. 132–34. Rosenthal cites Clerget, "Lettres sur la théorie des couleurs," *Bulletin de l'ami des arts*, 1843; Dr. E. V., "Cours sur le contraste des couleurs par M. Chevreul," *L'Artiste*, 3d ser., 1 (1842):148, 162.

99. The question of Delacroix's knowledge of Chevreul's theories is sensibly discussed in Johnson, *Delacroix*, pp. 63–77. His observations about Delacroix's occasional and inconsistent use of complementaries to neutralize a color (pp. 69–70) are especially interesting. As he points out, such experiments had been made by many other artists.

100. The suggestion was made in a letter to the author concerning this point and is a most illuminating observation (Philippe Jullian, in his *Delacroix*, p. 235, does mention the possibility of Delacroix's knowledge of the work but does not expand upon the point). The first question in pursuing this suggestion is, of course, whether Delacroix could have known Goethe's ideas about color and optics. He apparently did not read German, and although there were some scattered efforts to present Goethe's scientific writings in French (for example, P.-J. Turpin, *Oeuvres d'histoire naturelle par Goethe* [Paris: A. Cherbulin, 1837]; "*Traité des couleurs, par M. Goethe*," *Annales de chimie*, 79 [July, 1811]:199, described as "Exposé de la théorie et des observations de Goethe"), it is unlikely that a complete French text of *Zur Farbenlehre* was available before 1900. Nicole Villa of the Bibliothèque Nationale has kindly provided the information that the first French translation must have appeared after 1900 as part of the *Oeuvres complètes*. No nineteenth-century French edition is listed in the *Catalogue général des imprimés* or in the *Suppléments*. On the other hand, Fernand Baldensperger indicates that a project of translating the book existed; see his *Bibliographie critique de Goethe en France* (Paris: Hachette, 1907), Nos. 1269–71, "Projet de traduction du *Traité des couleurs* par Villers," where he lists a letter of June 30, 1807, from Reinhard asking Villers to take on this task. A letter of October 6, 1800, from Reinhard to Goethe makes further mention of the text: "Le *Farbenlehre* est en épreuves entre les mains de Cuvier; Delambre, avec qui Reinhard a souvent parlé de la théorie optique de Goethe, est trop mathématicien pour s'y intéresser absolument." See also Fernand Baldensperger, *Goethe en France* (Paris: Hachette, 1920), pp. 196–98.

desultory acquaintance with current theoretical beliefs may be supposed, the ultimate authority was, for Delacroix, not science, not even nature, but art. Veronese and Rubens, not Chevreul and Rood, were his inexhaustible sources of insight. The association made by artists and scholars between Delacroix's "law of contrasts" and Chevreul's "law of simultaneous contrasts" is understandable, considering their remarkable resemblances. In the absence of more evidence, however, it is prudent not to depend too heavily upon these correspondences—however suggestive they may be—as "explanations" of Delacroix's speculations about color.[99]

The difficulty of determining the theoretical sources for Delacroix's beliefs may be demonstrated by considering another quite plausible set of connections. Christopher Gray has pointed out the apparent similarity between Delacroix's attitudes toward color and ideas earlier expressed by Goethe in his *Zur Farbenlehre*.[100] Although there is no specific documentary confirmation of that association or any tradition to support it, here again there is sufficient secondary evidence to lend it some credibility. Delacroix retained an interest in Goethe even after he

FIGURE 202. Interior with fourposter bed. N.d.
Water color. 0.26 × 0.24.
Cabinet des Dessins, Louvre. Photo S.D.P.

had ceased to find pictorial inspiration in his works.[101] His scattered references to Goethe and the brief extracts he copied from his writings deal mostly with moral issues and those of ideal beauty, but on one occasion he did transcribe a passage about the comparative appreciation of nature and art.[102] Although this quotation comes not from *Zur Farbenlehre* but from a letter to the Duchess Louise, it is of interest for its coupling of the two subjects. It is, moreover, representative of a fundamental resemblance between the two men: both had originally come to their interest in natural effects through experience with the analysis of painting. Chevreul and others were inclined to be more purely scientific or practical in their bias. Goethe and Delacroix were committed to the powers of direct observation to reveal the secrets of nature and art.[103]

In spite of the uncertainty about the relationship between the ideas of the two men, a synopsis of Goethe's treatise shows many points of agreement with Delacroix's convictions. Goethe affirmed the validity of perceptual evidence and regarded the eye as a truthful instrument. Among other visual phenomena, he carefully observed the related effects of simultaneous contrast, the neutralization of complementaries, color in shadows, induced color sensation, and what is now known as "visual lag." On the basis of his experiences with the after-images produced by retinal fatigue, he constructed a color circle of opposite or "demanded" colors, those that appeared as after-images following the intensive exposure of the eye to a given hue. His circle was arranged with purple (red) at the top and green at the bottom. Violet and blue are to the right, with their "opposites," yellow and orange, to the left. He regarded these opposite or complementary relationships as fundamental and harmonious. They always involved the interaction between a primary color and a secondary or "blended" color composed of a mixture of the two primaries, much as Delacroix describes the same relationship.[104] Goethe further observed the capacity of opposite colors to neutralize each other.

Other combinations were, of course, also considered. Pairs of colors separated by one step on the circle were referred to as "characteristic combinations": blue and yellow, yellow and purple (red), purple and blue, orange and violet. Juxtaposition of tones occurring next to each other on the color wheel are termed "characterless" because of their lesser contrast. The "active" hues, yellow, orange, and purple, produce an effect of power. Combinations of blue, violet, and purple, with little green and no yellow, give an effect of "gentleness." The full range of the color scale makes for "brilliance." Monochromatic restriction is rejected as dull. No scheme is supposed to be sufficient in itself, however. The painter's power to manipulate the intensities and proportions of color combinations is recognized as critical to the attainment of satisfying harmonies.

Anyone acquainted with Delacroix's attitudes toward color will detect a familiar ring in many of these assertions. The importance placed upon contrasts, groupings of warm and cool, an interest in active and passive qualities of colors and their arrangement, and a search for particular combinations that will produce desired effects of power, brilliance, or tranquillity may be observed in statements made by both men. It is, of course, entirely possible that Delacroix came to his conclusions quite independently and with no awareness of Goethe's speculations. It is nevertheless worth reflecting briefly upon one further source of possible evidence, Delacroix's paintings themselves.

It must be kept in mind that Delacroix's references to "laws" and Baudelaire's references to "science" should be taken to mean knowing, deliberate control,

101. A *Journal* entry for February 5, 1847, reads: "Young Soulié tells me that M. Niel [one of Delacroix's assistants at the time], having read the *Neveu de Rameau* in the French translation from Goethe's rendering of it into German, preferred it to the original. Undoubtedly this derives from the effect of that vivid impression that Goethe's words produce on the mind, and that is not to be found in the original work on returning to it" (*J*, P, p. 143). It is not clear which text, Goethe's or Diderot's, is "the original," but the comment would seem to imply that it was the German rendition, not the "original" French text, that was being discussed. At any rate, he apparently joined in conversations about Goethe presumably with at least some people who were acquainted with German as well as interested in artistic matters. The available evidence is, however, purely circumstantial and very inconclusive.

102. See *J*, 3:406–7. This quotation, now included in the Supplement to the *Journal*, is not identified by Delacroix. It was part of a letter Goethe wrote on December 23, 1786. "The study and appreciation of nature comes easier than that of art. The lowliest product of nature embodies the sphere of its perfection within itself, and to discover these relationships all I need is eyes to see. I am certain that within a small sphere a wholly true existence is confined. In a work of art, on the other hand, the principle of its perfection lies outside itself. There is—most important of all—the artist's idea, rarely if ever matched by his execution. There are furthermore certain implicit laws which, though stemming from the nature of the craft, are not so easy to understand and decipher as the laws of living nature. In works of art there is always a large traditional factor, whereas the works of nature are like a word of God spoken this instant" (*Wisdom and Experience*, trans. and intro. H. J. Weigand [New York: Pantheon, 1949], p. 227).

103. It was, in fact, Goethe's very effort to found a theory upon empirical evidence and without recourse to mathematical insights that thwarted his desire to refute Newton. He was drawn into this

endeavor because he was disappointed by the results of his repetition of Newton's experiments. His first "Contribution to Optics" appeared in 1791, and other papers were published in the next few years. His definitive work on the subject, *Zur Farbenlehre*, published at Tübingen in 1810, appeared in two volumes with a companion volume of plates. Because of their distinguished origin, his ideas came to be fairly well known but were never widely accepted by scientists. On the other hand, subsequent investigators have shown many of his physiological observations to be valid. For a summary of these writings and their historical importance, see R. Magnus, *Goethe as a Scientist*, trans. H. Norden (New York: H. Schuman, 1949), pp. 125–99.

104. Goethe based his notions of primary and secondary colors largely on the behavior of pigments, rather than of light. Purple (red), blue, and yellow could not be produced by cross-mixture and were therefore considered primary. Green, violet, and orange could be produced by cross-mixture, so they were designated secondary, or "blended." Here, as elsewhere, Goethe freely combined notions that have different meanings in "additive" and in "subtractive" mixing processes, just as he fused observations relating to physiological and to psychological experience of color.

105. For a summary (and perhaps a little too excitable) explanation, see Raymond Escholier, *Eugène Delacroix* (Paris: Cercle d'Art, 1963), p. 126. Villot is the original source of the term. His comments are given in Escholier's earlier and more detailed discussion (see *Delacroix*, 2:272–76).

not dispassionate experimental exercise, the more limited connotation which those words now have. Delacroix's adaptations of his palette for major projects of his later years were clearly intended to produce given decorative and expressive effects. As has been seen, the over-all tonality of *Apollo* represents an adjustment to the character of the baroque setting for which the painting was created. At St. Sulpice, on the other hand, a "brilliance" proper to the subjects themselves was permissible within the self-contained chapel, where Delacroix could more freely elect his harmonies, and the full range of color contrast occurs, with elaborate dependence upon the juxtaposition of opposites. In certain other compositions the painter built upon a more restricted scale. *Education of Achilles*, at the Palais Bourbon, is, for example, fundamentally an elaboration of blue and orange tones. It is thus possible to observe certain similarities with Goethe's prescriptions, even though a dependence on the latter's ideas is not necessarily established by those parallels.

On the other hand, Delacroix was not an entirely free agent in his exploitation of color. To a certain extent his choices were determined by the descriptive and expressive demands of his subjects. His deviation in the tonalities of his horse in *Justice of Trajan* was, after all, severely criticized as not literally credible. Bold though his departures from "realism" or established convention may sometimes have been, his commitment to subject matter limited his options in exploring the possibilities of "scientifically" unnatural color.

Also to be considered is the degree to which his colorism was rooted in tradition. Compared with the bold contrasts of Rubens, the intense color chords sometimes employed by Poussin, or the penetrating blues of Le Seur, the total impact of Delacroix's harmonies is not startling. Where he does increasingly deviate from precedent, even the precedent of his own earlier works, is in local passages, in which the handling of color interactions assumes novel freedom and vivid complexity. With respect to basic color choices, however, it should be recalled that complementary oppositions appear very early. Dante's costume in *Dante and Virgil* gains impact in its presumably intuitive juxtaposition of green and red. The orange-brown of Virgil's cloak and the oranges of the burning city contrast effectively with the blues of Dante's sleeves and the wrap of Phlygeas. A slightly later example, *Seated Turk* of 1827, now in the Atelier Delacroix, is based almost solely on red-oranges and green. *Greece on the Ruins of Missolonghi* shows the prominent employment of blue and yellow (Goethe's "characteristic" combination?) in the woman's garment and the strong note of green and red (Goethe's "demanded" combination?) in the projecting sleeve at the lower right. One presumes that these and other anticipations of Delacroix's later modes of color structure occurred before he had evolved a sophisticated color thoery. But we are cautioned by the fact that David himself had brilliantly employed oppositions of green and red, extended by those of yellow and blue, as the positive coloristic theme of his *Oath of the Horatii*.

Aside from his "systematic" use of color, the neoimpressionists particularly admired the mode of execution Delacroix developed in his later works, which he called *flochetage*. The expression relates to a kind of coarse interweaving of brushstrokes resembling the tufted back of a tapestry ("*floché*" means "shaggy").[105] He used this technique extensively not only at St. Sulpice but also in many earlier works, including the *Pietà* at St. Denis-du-Saint-Sacrement and *Entry of the Crusaders*. In some ways it anticipated the "broken color" of the impressionists and the "divisionism" of the neoimpressionists. Of particular importance is the

way in which the strokes could differ from each other in color but blend when viewed from a distance. *Flochetage* thus suggested, if in a limited way, later theories of "optical mixture." But the importance of "distance" in seeing Delacroix's work was exaggerated by the neoimpressionists, following Baudelaire, whose ideas also made up a part of the theoretical baggage of the later groups.[106]

To make Delacroix sound like either an impressionist or a neoimpressionist would, on the other hand, be misleading. For all his acceptance of ideas of art as descriptive, he was certainly not motivated by the desire for greater realism which initially inspired impressionism. *Flochetage*, complementary color oppositions, and the purification of the palette were devices to serve an art of the imagination, not one of dedicated luministic transcription. Delacroix was too sensitive to the abstract side of color—its "harmonious," "expressive" attributes, with their appeal to the emotions as well as to the senses and to the intellect—to have been capable of full sympathy with the aims of impressionism or neoimpressionism. Signac's book might have been called *From Delacroix to Synthetism* or *From Delacroix to Expressionism*, for his use of color was also "decorative" and "expressive." And Baudelaire's analogies of color and music, his theories of *correspondances*, all owe a debt to Delacroix's prior speculations.[107] Manet, along with Monet, Renoir, Degas, Signac, and others, some of them quite different in their artistic allegiances, studied his work. Gustave Moreau found there a *"richesse nécessaire"* and recognized that Delacroix's color was sensitively "imagined," or as he would later put his ideal of color, "considered, pondered, reflective, inventive [*pensée, rêvée, réfléchie, imaginée*]," while Gauguin responded to what was "decorative" and "symbolic." Others reacted in their own ways. Something of this rapport with the unscientific side of Delacroix's art may be sensed in Redon's eloquent panegyric inspired by *Victory of Apollo*:

Here is the work he created in the fullness of his talent and his strength.

What is its dominant expression, its main idea? It is the triumph of light over darkness. It is the joyousness of broad daylight opposed to the melancholy of the night and shadows, and like the joy of relief from anguish. He paints each detail with the effect peculiar to it. Venus is surrounded by delicate blue; in a gray cloud wholly exquisite with tenderness, *amors* soar, their Oriental wings outspread. Ceres possesses all the poetry of our most beautiful landscapes; she is bathed in sunshine. Mercury in his red mantle proclaims all the ostentation of upholstered comfort and commerce. Mars is in a terrible violet, his helmet of bitter red emblematic of war. The painter conveys everything with the accessories. Mercury is somber; the entire region of the suppressed [*partie étouffée*] is represented less in the fuming monster or the so superb body of the reclining nymph—one of the most beautiful morsels to come from his hand in his last manner—than in that indefinable color scale, those grisly tones, which suggest the idea of death.

This work, so powerful, so strong because it is new, is altogether a poem, a symphony. The attribute which defines each god becomes unnecessary, so completely has the color been charged with saying all and with being just in its expression. The traces of tradition that are still retained for clarity are quite unnecessary.

. . . Let us compare now, for its thought, a picture of a school of the past, such as the *Marriage at Cana*, for example, with this essentially new chapter. Can we find there as large a place given to the idea? Not at all. Venice, Parma, Verona have viewed color only in its material aspects. Delacroix alone has reached out to moral color, to human color. There is his work and there his claim upon posterity.[108]

Redon's insight was one that others would come to share: Delacroix had made of color something it had never been before.

106. Signac, for example, makes some point of this; see *D'Eugène Delacroix au Néo-Impressionisme*, pp. 45–49.

107. It is of interest to note in this context that Mérimée too comments, if briefly, on the analogy between musical and color harmonies (see *De la peinture à l'huile*, p. 282). It seems fair to assume that this notion was not altogether original with Mérimée but was a commonly accepted comparison. See also Goethe, *Theory of Colours*, pp. 298–300.

108. *À soi-même* (Paris: José Corti, 1961), pp. 175–76.

Delacroix and His Critics

1. See *C*, 1:268–76 (Mar. 1, 1831).

2. Although Delacroix's personal associations were more Bonapartist than Orleanist, only two projects, the decorations for the Salon de la Paix and the murals at St. Sulpice, were commissioned during the succeeding administration of Louis Napoleon.

3. For example, the Duke of Orléans bought *Jewish Wedding* and gave it to the Luxembourg Gallery. *Melmoth*, *Prisoner of Chillon*, and *Murder of the Bishop of Liège* were all in the collection of his widow when it was sold in January, 1853, following her death. The interest of the youthful heir-apparent, Ferdinand Philippe, in the art of Delacroix, which continued until his early death in 1842, has been mentioned earlier.

4. *C*, 2:27–28 (Oct. 27, 1838).

When Eugène Delacroix returned from North Africa in the summer of 1832 to his familiar surroundings at Quai Voltaire, he was barely thirty-four but already had a wide reputation. His works had become a symbol of opposition to the *status quo*, and, for a time at least, he himself encouraged that public image. In the wake of the new spirit of liberal change that followed the establishment of the July monarchy he published a long letter in *L'Artiste* urging reforms in the salon jury system. He proposed that the participating artists should elect their own jurors, a change calculated to weaken the control of the Academy over aesthetic matters.[1] Almost as if to justify that expression of distrust, he was repeatedly denied admission to that august body, and when he was finally appointed to membership, it was too late for him to be anything more than relieved at recognition.

It is ironic that the July monarchy, a period generally undistinguished in aesthetic taste, should have provided the opportunity for Delacroix to fulfill himself as a painter. Yet, as we have seen, most of the monumental enterprises of the last three decades of his life were sponsored by that government. The murals for the Palais Bourbon and the Luxembourg, as well as the *Pietà* for St. Denis-du-Saint-Sacrement, all derive from this era,[2] and his large independent compositions—*Entry of the Crusaders*, *Battle of Taillebourg*, *Justice of Trajan*, *Sultan of Morocco*—were commissioned or purchased at this time. Louis Philippe himself was inclined to regard painting as little more than a by-product of history, but his costly Hall of Battles and Hall of the Crusades at Versailles did lead to Delacroix's commissions. (Other members of the royal household were more discerning in artistic matters.[3]) Most important of all to Delacroix, however, was the ascent to power of Adolphe Thiers.

Delacroix recognized his commissions as "decisive challenges,"[4] and it seems fair to assume that his artistic development would have been quite different had he lacked state patronage. It permitted him to work in the grand manner and impressed him with the desirability of devising new techniques, while encouraging him to draw upon the art of the past. Solely dependent upon easel painting as a vehicle of expression, he might well have developed differently. While he continued to exhibit at the salons until 1859, because of his monumental projects he was no longer dependent upon what remained for many other artists the primary means of presenting their work to the purchaser. Even the critical scandal surrounding the appearance of *Justice of Trajan* at the Salon of 1840 did not, therefore, have the same effect on his career as had the earlier crises. By that time he had achieved a degree of professional security, despite the critics, and, beyond that, the status of the salon itself had declined. Louis Philippe's decision in 1833 to make it an annual event deprived it of the special importance it had during the Restoration.

Nevertheless, Delacroix's submissions to the salon juries and his architectural

decorations continued to encounter the same criticism that his work as a young man had received. It is a tribute to the faith of his influential friends that his individualism did not prevent his receipt of major commissions, for his good fortune exacerbated the hostility of his rivals. Yet, like Cézanne after him, Delacroix continued to hunger for the legitimacy of official recognition, and his frustration at its absence was doubtless intensified by his background. As a member of a family of successful soldiers and civil servants, it was natural for him to want comparable distinction within the hierarchy of his own profession. It is not easy to conceive of him as a successor to Langlois, Picot, or Blondel, and it is hard to imagine that the deliberations of the Academy would have been profitable to him. Fortunately, he wasted little time in the sessions of the Institute.[5]

When Delacroix first presented himself as a candidate to the Academy in February of 1837, he was not yet forty years old (Ingres was forty-four at the time of his election in 1825[6]). The second youngest of thirteen applicants for the chair left vacant by the death of Baron Gérard (Roqueplan was younger), Delacroix need not have been offended by his failure to be elected. Yet as the years passed and his reputation grew, lesser men received the honors he wished for. His mature individualism remained as unsettling to the *juste milieu* as his youthful "excesses" had been.

Try as he might to present himself as the "classical" figure he felt himself to be, Delacroix could not escape his reputation as a romantic rebel who must remain excluded from "respectable" company. In the first two decades of his participation in the salons, he exhibited fifty-five works, many of which are today accounted masterpieces.[7] They often attracted lively attention in the press, where his "originality" was seldom denied while his competence was in one way or another continually put in question. His most consistent opponent was Delécluze, whose reviews for the *Journal des débats* typify the stance of the "right" or conservative camp.

In the course of time other voices made themselves heard, some of them outspokenly opposed to conservative opinion. Around 1828 there emerged what was for a time regarded as the "new" or "Gothic" school, whose representatives took a radical position. They were therefore favorably disposed toward Delacroix, whom they declared to be the leader of the new school. But they saw his art merely as a rejection of the Academy, not as a positive expression. The kind words from better informed sources, such as Jal or Thiers, although appreciated by Delacroix, may have been based more on political than artistic considerations, and, after the Revolution of 1830, neither man continued to write criticism, although they both remained friends of Delacroix.

For most of the less well established and more "radical" painters, the promises of greater fulfillment and freedom after the July Revolution proved deceptive. If anything, conservative taste became still more firmly entrenched, and popular preoccupation with social and economic goals prevailed. Furthermore, the notion that these younger painters formed a coherent group was illusory. As early as 1833 one critic expressed doubt that there was any meaning in the familiar "war cries of Classic and Romantic," and the following year one of his colleagues dismissed those epithets as "superannuated words, which soon will no longer make any sense."[8] Although these predictions were overstated, and trust in such mechanical distinctions has persisted, there never really was a cohesive romantic school, and Delacroix never was nor wished to be its spokesman. Thoré wrote ironically

5. For a detailed discussion of Delacroix's relations with the Academy, see L. Hautecoeur, "Delacroix et l'Académie des Beaux-Arts," *Gazette des Beaux-Arts*, 62 (December, 1963):349–64. His participation in the proceedings is summarized on pp. 360–63.

6. See Hautecoeur, "Delacroix et l'Académie," pp. 349–64.

7. This summary of the critical responses to Delacroix's work is indebted to the more detailed surveys included in Horner, *Baudelaire: Critique de Delacroix*. Also important for the understanding of these questions of contemporary criticism is the study of Planche and Thoré in Grate, *Deux critiques d'art*, especially, "L'art et la critique après 1830," pp. 48–70.

8. Quoted in Grate, *Deux critiques d'art*, p. 51.

in 1846, not wholly without justification, that he considered Ingres "the most romantic artist of the nineteenth century, if romanticism is the exclusive love of form, an absolute indifference to all the mysteries of human life, skepticism in philosophy and politics, an egotistical detachment from all common and binding sentiments."[9] Thoré's sarcasm was his response to the art for art's sake purism of Gautier and others. What is unsettling is his implication that the artist's role in the "struggle" had been reduced to that of tactician, while the grand battles were to be carried on by theorists and critics. The critic's claim to be the artist's interlocutor and collaborator, which later becomes widespread, begins to assert itself here.

A further complication was the immense proliferation of persons claiming to be professional artists and demanding attention and patronage. The salon had mushroomed: in 1837 over a thousand "artists" participated. Under the banner of the romantic shibboleths "individualism" and "liberty," a harrowing confusion of paintings was produced which, in subject, style, and quality, prompted Delécluze to complain, as early as 1827: "Thus, to make known this pictorial Tower of Babel, it is absolutely necessary that I understand all the dialects that are spoken there, that I penetrate into all the thoughts that take shape there, that I share all the tastes that are established there." He concluded, with exasperation, "Few men are endowed with such elasticity of spirit."[10]

The public was confronted with literally thousands of works and had the task of reconciling its own responses with those of the critics, while the growing partisanship of the critics deprived the uninitiated of standards to which they might refer with confidence. The growth of the power— or at least the circulation —of the press under the July monarchy was immense. There were approximately seventy thousand subscribers to journals in 1836; in 1846 there were almost two hundred thousand.[11] In addition, more specialized publications devoted especially to the fine arts, each with its particular bias, were making their first appearance. Accordingly, there were not only more artists but more critics to write about them. The layman was forced either to follow whatever critic confirmed his own prejudices or to rely on the editorial policies of a given publication, however haphazard.

In this confusion of taste and style no single orthodoxy presented itself. The trend seems to have been toward a middle-of-the-road policy, which was a natural response to the public preference for a not too demanding art, whether classical, romantic, or any other. As a result, the great artists—not only Delacroix but Ingres as well—were stranded in shallow waters, where only the small fry could move with comfort. Their genius was vaguely apprehended, but the affection of the public was reserved for others, and it was not Ingres or Delacroix but the industrious Horace Vernet who was bedecked with medals by admiring juries.[12] At the same time there was an unprecedented popular curiosity about art. In Paris, a rapidly expanding capital whose population numbered over a million by 1846, the number of visitors to the salon of that year is estimated at more than 1,200,000.[13] In addition to the salon, new commercial galleries and temporary exhibitions appeared, and unprecedented opportunities to be seen presented themselves to the artist.

Delacroix's position in this shifting scene was equivocal. As early as 1831 his reputation as an innovator had already prompted both friends and foes to evaluate his career as a whole.[14] However, some friends came to prefer the hybrid forms

9. Ibid., p. 54, n. 2.

10. Ibid., pp. 54–56.

11. Ibid., p. 57.

12. The complicated cross-currents of artistic developments from 1848 to 1870 are analyzed at length in Joseph C. Sloane, French Painting between the Past and the Present (Princeton, N.J.: Princeton University Press, 1951).

13. Rosenthal, Du romantisme au réalisme, p. 50, n. 3.

14. Horner, Baudelaire: Critique de Delacroix, p. 51.

of a declining romanticism. The influential Gustave Planche, sometimes known as "Gustave the Cruel," who had once spoken of Delacroix as one of the "beacons" of the century, in later years looked for some new synthesis between older "idealism" and the new realist tendencies.[15] For Delacroix, any such program of reconciliation would have been irrelevant.

Two of the most literate and liberal critics who took up Delacroix's cause, Théophile Gautier and Théophile Thoré, both recognized the "modern" character of his work and, in that sense, his true "originality." Although Thoré wanted a socially conscious art, he nonetheless granted Delacroix a prominent and honorable status as a poet "whose soul confides to him the secrets of life and the harmonies of the world" and as a colorist of "incomparable talent," who can "blend the richest and most diverse nuances as musicians run through the entire scale," and "the only colorist of the entire French school," not only in his paintings but in his drawings as well.[16] In 1843 he wrote of the *Hamlet* lithographs: "Like the great masters, he is as much the colorist in his drawings as in his paintings. His draperies in crayon have the splendor and brilliance of the most beautiful tones of the palette . . . so that one can say this is red or green and no longer see only black and white, as in mediocre lithographs."[17]

This latter statement suggests, however, the hyperbole of apology. In insisting upon the colorism of his drawing Thoré was perhaps trying to turn aside the familiar criticism that Delacroix was deficient as a draftsman. Other admirers had made the attempt: the painter Alexandre Decamps, who sometimes assumed the role of critic, asserted that "the shortcomings of the superior man are as inseparable from his good points as the man is inseparable from himself, for the faults are those precise qualities exaggerated; and if one were to succeed in regularizing the talent of an artist, one would be surprised to see the beautiful qualities which distinguish it lost one by one."[18]

Prosper Haussard, writing in the *National*, saw the appropriateness of his "inspirational" drawing to the portrayal of dramatic gestures, even as Decamps had praised its suggestion of movement. To explain a certain flabbiness of contour which had been criticized in Delacroix's canvas *Cleopatra*, Rosemond de Beauvallon declared that precision of line could not be expected of great colorists—that Delacroix was following the example of masters like Rubens, Rembrandt, and Murillo, whose images are distinguished from each other by light and shadow, as one sees them in nature, not by the artifice of line.[19] However, all could agree, Delacroix's antagonists included, that his drawing was different, that the difference was intimately related to his colorism, and that the colorism itself was a manifestation of deep-rooted traits which distinguished Delacroix from all other artists. As Decamps put it in a review of the Salon of 1837, "The painting of M. Delacroix is descended from that of Rubens, Veronese, Salvator, and Géricault. It is complete, energetic, and passionate—beyond the prejudices of the public, the routines of the school, and the caprices of fashion."[20]

Probably the most important critic friendly to Delacroix in these years was Gautier. "Art is more beautiful, more true, more powerful than nature," he wrote. "Nature is stupid, without awareness of itself, without thought and without passion. It is a dull, insensible thing, which to be animated needs the soul and the inspiration we lend it." Gautier conceived of beauty as subjective and placed upon the truly creative, original artist the burden of invention out of "the microcosm, the complete little world" that he bears within himself and "from

15. Grate, *Deux critiques d'art*, p. 133.

16. Quoted in *ibid.*, pp. 227, 230, from Thoré's first long essay on Delacroix, written in 1837.

17. *Ibid.*, p. 231.

18. *Ibid.*, p. 233; see also Horner, *Baudelaire: Critique de Delacroix*, pp. 51–52.

19. Quoted in Horner, *Baudelaire: Critique de Delacroix*, pp. 41–42, 218n, 119, from *Coup d'oeil général sur le Salon de 1839* (Paris: Crapelet, 1839), p. 14. See also Sloane, "Delacroix's Cleopatra."

20. Review in *Le national*, March 14, 1837, quoted in Horner, *Baudelaire: Critique de Delacroix*, p. 84. Delacroix was favorably impressed by Decamps' painting.

FIGURE 203. *Cleopatra.* 1838. Oil on canvas.
0.98 × 1.27. The William Hayes Ackland Memorial Art Center, Chapel Hill, N.C.
Photo Ackland Art Center.

21. Quoted in Grate, *Deux critiques d'art*, pp. 66–67.

22. See Horner, *Baudelaire: Critique de Delacroix*, pp. 126–27.

which he draws the thought and forms of his work."[21] It was not until 1856, after the idea had been formulated by Baudelaire, that Gautier made the direct association of "thought and forms" as one.[22]

The commentaries of these writers are often illuminating on specific issues, but their subjective responses of the occasion freely combine scraps of orthodox academicism with sometimes acute original perceptions. They lack an aesthetic to put their opinions in a coherent framework. The task of restating the fundamental premises of criticism and, in doing so, creating a new aesthetic suited to the actual state of painting in mid-nineteenth-century France, was left to Charles Baudelaire. In the process, he wrote what may well be the most brilliant criticism of the century.

In spite of the already considerable literature concerning Baudelaire's criticism, it is appropriate here to consider certain salient notions apart from their formulation in the various *salons* and other essays, for they have become so much a part of the generally accepted characterization of Delacroix as to have taken on almost

axiomatic status. There can be no question of the importance of Baudelaire's contribution as a critic. The range of his insight and the subtlety of his sensibility are truly impressive. It does seem, however, that he often interposed his own creative insights between the artist and the viewer. With a critic who was himself a supreme individualist and infinitely persuasive, the informed reader necessarily mixes caution with gratitude as he approaches his interpretations.

The earliest evidence of Baudelaire's astonishing talents as a critic of painting was a slim, seventy-two-page volume which appeared on May 24, 1845, when he was twenty-four years old. In choosing this form of presentation, he was following a tradition then nearly a century old. The first "*salon*," written by La Font de Saint-Yenne,[23] had appeared in 1747, but the most revered of former *salonistes* was Diderot. It may well be that the reprinting in 1845 of Diderot's *Salon of 1759* suggested to Baudelaire a device for presenting his own observations.[24] He had begun to acquire a taste for art early.[25] Before his death (when Baudelaire was only six years old), Baudelaire's father took young Charles for walks in the Luxembourg gardens, explaining the sculptures. He remembered vividly in later years that his father painted—very badly, he admitted. His mother also drew. Baudelaire himself was not unskilled as a draftsman, and the home was full of pictures.

The *Salon of 1845* was the first of a series of works devoted largely or entirely to discussion of Delacroix's art. In a review of the next year's salon, Baudelaire announced more clearly his principles as a critic. When he wrote his first two salon pieces, apparently he did not know Delacroix personally. It is therefore all the more remarkable to observe the degree to which his ideas reflected Delacroix's attitudes. They were no doubt gleaned in part from Delacroix's published essays. A further explanation of these resemblances is that both men shared certain common interests in earlier writers, particularly Diderot and Stendhal, and Balzac's *Chef-d'oeuvre inconnu* (1832) may have provided its own suggestions about the painter's ideas, to the extent that they are mirrored in the pronouncements of Frenhofer in that novel.[26] Mutual friends, such as Gautier and Boissard, the painter who did an early portrait of Baudelaire, must also be considered.[27] They seem to have met in 1849, probably through Boissard.[28]

The first of Baudelaire's essays is markedly poetic and subjective in character. It is couched in the traditional form of a vicarious tour through the Salon of 1845, and the discussion proceeds by genres. The emphasis shifts drastically, depending on the writer's often dogmatic response to individual works or to given details or aspects of them. Making no pretext at equal representation, he dismisses, for example, Horace Vernet's immense (60-foot-long) *Taking of Smalah* with contempt. And Vernet was not alone. "Boulanger's Holy Family is detestable." No more was said.

For Delacroix, however, Baudelaire had only praise. After a few "words of introduction" to prepare for his announcement of faith, he flatly declared Delacroix to be "positively the most original painter of the past or of modern times." He then proceeded to the four paintings by Delacroix in that year's salon. Although his principles were not yet clearly defined, certain key concepts begin to emerge in the repetition of such words as "originality" and "naïveté." His reactions to the individual pieces reveal other preoccupations that he later formulated more systematically. In discussing *Magdalene in the Desert*, he stressed the "poetic" and therefore "literary" side of the artist's work, while his remarks about *Last*

23. It will be recalled that La Font de Saint-Yenne was the first to propose to Louis XVI that part of the Louvre be transformed into a museum and opened to the public. He thus initiated the creation of that great museum.

24. This essay, Diderot's first in that genre, appeared in *L'Artiste* for March 9, 1845. The salon opened on March 15 (See Horner, *Baudelaire: Critique de Delacroix*, pp. 54–76). The ensuing discussion will in many ways reflect ideas contained in Horner's study. For the sake of simplicity, only direct quotations will be footnoted. No presentation, however summary, of Baudelaire's contribution as a critic could be undertaken without reference to the detailed and authoritative exposition of Gilman in *Baudelaire the Critic*. See also the introductory essays and annotations of Jonathan Mayne in his translations of Baudelaire's criticism, published as *Art in Paris* and *The Painter of Modern Life and Other Essays*. The debt of Baudelaire's salon pieces to those of his great predecessor have been explored by various writers; see especially Gita May, *Baudelaire et Diderot: Critiques d'art* (Geneva: Droz, 1957), which considers the relationship of Delacroix's theories to those of Diderot and Baudelaire (see pp. 27–37 *et passim*). Further insights are presented by Anita Brookner, "Art Historians and Art Critics—VII: Charles Baudelaire," *Burlington Magazine*, 106 (June, 1964): 269–79.

25. See Horner, *Baudelaire: Critique de Delacroix*, pp. 2–3.

26. Gilman, *Baudelaire the Critic*, pp. 14–15, 40–53; May, *Baudelaire et Diderot*. For the relationship between Delacroix and Balzac, Gilman cites François Fosca, "Les artistes dans les romans de Balzac," *Revue critique*, 34 (March, 1922): 133–52.

27. See Gilman, *Baudelaire the Critic*, pp. 11–14.

28. The date of the meeting is uncertain. Baudelaire later, in an article written in 1863, claimed that it was 1845. This statement is now generally doubted (see *ibid.*, pp. 10–11; *cf. J*, 1:258 [Feb. 5, 1849], where Delacroix makes the first of his few

references to the young critic). Delacroix's friendship with Boissard de Boisdenier is an example of his tendency to seek out men who were gifted and intelligent but more devoted to conversation than to professional fulfillment. Boissard's salon at the Hôtel Pimodan was a focus for the Parisian intelligentsia. Concerts were given there, and it was the meeting place of the "Hashish Club," which later attracted Baudelaire. While Delacroix was acquainted with many of the more important contemporary painters and was not necessarily hostile toward their work, his most amicable comments in the notes and correspondence of his mature years are reserved now for rather obscure artists—Chenavard, the Antwerp painter Baron Gustave de Wappers, Constant Dutilleux, and Adrien Dauzats. Late in his career, Dutilleux (1817–1865) exhibited three paintings at the Salon des Refusés. He was the father-in-law of Alfred Robaut (see Gustave Colin, *Constant Dutilleux, sa vie, ses oeuvres* [Arras: A. Brissey, 1866]). A native of Bordeaux, Dauzats (1804–1868) helped promote local interest in Delacroix's art. According to Joubin (*C*, 2:210, n. 1), the first correspondence with Dauzats occurred in 1845. Delacroix appreciated his command of perspective and called upon him to work out the architectural elements of several paintings, most notably *The Two Foscari*. It will be recalled that Thalès Fielding, Ciceri, and others had similarly aided Delacroix in the past. The fact that Dauzats had traveled extensively in Spain, had visited Egypt and Syria in 1830 and 1839, and had accompanied the Duke of Orléans to Algeria added interest to the acquaintance. Having retained a close association with the House of Orléans, Dauzats was, at least for a time, able to exert an influence at court that was favorable to Delacroix. As an artist, he is of interest today chiefly for his pictorial record of his travels in Spain and his long association with Baron Taylor. Those subjects are intensively explored in Paul Guinard, *Dauzats et Blanchard, peintres de l'Espagne romantique* (Paris: Presses Universitaires de France, 1967).

29. *Baudelaire the Critic*, p. 34.

30. *Ibid.*, pp. 152–57.

Words of Marcus Aurelius are confined to technical questions of color and drawing. He expressed his faith in the interplay of emotion and intellect in musical language, praising *Sultan of Morocco* for its "knowing" yet "spiritual" color, its "novel" and powerfully affecting harmonies. Although these notions had been expressed before, he carried them beyond any previous formulation. Clearly, an arresting critical personality had emerged.

A year later, on May 23, 1846, Baudelaire's second salon essay appeared. If less effusive than the first, it was no less explicit. Delacroix was the pre-eminent "modern." The review was not limited to the exhibits in the current salon; Baudelaire included a retrospective sketch of Delacroix's career, not without some factual errors, and an elaborate explanation of the salient qualities of his art. Discarding the word "romantic" for another term he preferred, he began by considering Delacroix as the chief figure of the "modern" school. In emphasizing the "ideal," Baudelaire sought to clarify the process which he had described in his earlier piece as the "transformation of pleasure [*volupté*] into understanding [*connaissance*]." In this essay, as Miss Gilman puts it, "the *volupté* of 1845 is transformed into the *connaissance* of 1846."[29]

One of Baudelaire's fundamental assumptions about Delacroix's creative process was that its basis was "poetic" and inspirational. The picture was a visual representation of the painter's thought; it came from a temperament little inclined to moderation and was developed with the "insolence habitual to genius." But this kind of art depended also on an "intimate" knowledge of the subject as the intellectual and analytical complement to the intuitive sources of inspiration. Where other critics had responded mainly to subject matter or descriptive effect, Baudelaire revealed a deeper feeling for painting as the material product of the artist's technique, or "science," which might give inner knowledge and subjective ideals an objective reality. He believed that the painter is inspired by memory and that paintings based on such inspiration in turn trigger the viewer's memory. However, he conceived of memory not in the Proustian sense of involuntary association but as an act of will, deliberately called into play by the maker of the work of art and by the imaginative viewer.[30]

Closely related to the idea that art has its origins in memory and is addressed to memory was Baudelaire's belief that its intensity was enhanced by distance. The spectator must complete the work of art in his own imagination. To serve this end, the painter consciously subordinates detail to boldness of touch, indefinite contour, and "free play of light" and "floating line." He provides the outlines: the spectator fills in the details. What had been considered Delacroix's weaknesses or failures of execution were thus ingeniously transformed into deliberately cultivated assets.

If Baudelaire's theories were not identical with Delacroix's, his approximation to them was at times remarkably close. His description of the effect of Delacroix's suppression of detail is accurate, but his analysis of the motivation behind it is not. Delacroix was striving for a certain unity of effect, not challenging the viewer to complete his picture according to his own preferences. He was attracted by the movement, color, and atmosphere in Delacroix's paintings. The relevance of these qualities to Baudelaire's preoccupation with "expression" and "harmony" is evident. Rather more difficult to comprehend were those characteristics, which he called "more general qualities," having to do with the artist's "originality" and "universality." By "universality" Baudelaire meant not the possession

of wide-ranging factual knowledge, which Delacroix understood by the word,[31] but the presence in the artist of certain qualities both human and aesthetic. His universality as a man implied his ability to comprehend the entire range of potential subject matter. Artless responsiveness, or naïveté, was coupled with "science," by which Baudelaire meant the practical mastery which permits "expression" in all media and at any scale, whether in a drawing, easel painting, or mural. Using the *Pietà* at St. Denis-du-Saint-Sacrement as an example, Baudelaire pointed out these double aspects of universality. In the "high and serious melancholy" of this "hymn to grief," the painter's emotional penetration or universality as a man is evident, while its brilliance as an artistic performance demonstrates the man's universality as a painter.

Apart from this synthesis of universal attributes, which permitted Delacroix his "mastery of grief, passion and gesture," Baudelaire found also that "yet more general" attribute "originality" in the *Pietà*. This notion, which emerges from his pages in a somewhat blurred fashion, meant for Baudelaire, as for Delacroix himself, not isolation from the grand traditions but emergence from them. The individual's capacity to render traditional subjects in his own way was the measure of his originality. Drawing, color, and technique were merely the evidence of the artist's will to express his own sensibility within the range of traditional forms.

Most critics of Delacroix, Miss Gilman included, apply this concept literally and without reference to the works themselves, whose innumerable ties with the past—even more eclectic than Baudelaire's own derivations—refute such claims.[32] A genius driven by an irrepressible flow of "original" ideas does not search tirelessly in the art of others, as Delacroix did, for the inspiration to begin, continue, and complete his own. This contradiction was apparent to Delacroix himself even as a young man, when imagination flows most freely. In his *Journal* for 1824 he stated the problem and indicated his life-long solution to it:

What! you say you have an original mind, and yet your flame is only kindled by reading Byron or Dante! You mistake this fever for creative power when it is really only a desire to imitate.... No indeed! The truth is that such men have not said a hundredth part of all there is to say. In a single one of the things which they touch upon so lightly there is more material for original geniuses than there is ... and nature has stored away for great minds that are yet to come more new things to say about her creations than she has created objects for their enjoyment.[33]

This mixture of bravado, self-justification, and insecurity may have been a reaction to his thoughts of the day before, when he wrote: "What creates men of genius, or rather, what they create, is not new ideas but the idea, which possesses them, that what has been said has still not been said enough."[34] He had early clarified his fundamental sense of engagement with past history and future destiny, and one must therefore reject Miss Gilman's assertion that "anything borrowed, copied, is hateful to him."[35]

In the context provided by Baudelaire, the concepts of originality and universality have great evocative value, but such comments as Henri Peyre's that "on Delacroix, no one could today write twenty lines without referring to Baudelaire's definitive formulas"[36] must be qualified. Critics have often been so struck by the brilliance and precocity of Baudelaire's observations about form and its powers of independent expression that they have neglected or ignored the rest of his argument and the other expressive concerns to be observed in Delacroix's

31. See, for example, *J*, 3:24 (Jan. 13, 1857), quoted in Horner, *Baudelaire: Critique de Delacroix*, p. 93, n. 263.

32. See, for example, Gilman, *Baudelaire the Critic*, p. 37.

33. *J*, W, pp. 41–42 (May 14, 1824). The Joubin text contains the same lacunae as the translation (*J*, 1:104).

34. *J*, 1:101 (May 15, 1824).

35. Gilman, *Baudelaire the Critic*, p. 37.

36. *Connaissance de Baudelaire* (Paris: José Corti, 1951), p. 146.

art. Discussion of the paintings has sometimes been dominated by an arid formalism that distorts their meaning. One does well to recall another of Baudelaire's statements (it has the ring of some of Van Gogh's) made in his review of the Universal Exposition:

The story is told of Balzac . . . that one day he found himself in front of a beautiful picture—a melancholy winter-scene, heavy with hoar-frost and thinly sprinkled with cottages and mean-looking peasants; and that after gazing at a little house from which a thin wisp of smoke was rising, "How beautiful it is!", he cried. "But what are they doing in that cottage? What are their thoughts? what are their sorrows? has it been a good harvest? *No doubt they have bills to pay?*"

Laugh if you will at M. de Balzac. I do not know the name of the painter whose honour it was to set the great novelist's soul a-quiver with anxiety and conjecture; but I think that in his way, with his delectable naïveté, he has given us an excellent lesson in criticism. You will often find me appraising a picture exclusively for the sum of ideas or of dreams that it suggests in my mind.[37]

37. *Art in Paris*, p. 125.

Most difficult in dealing with any criticism, and especially with Baudelaire's, is to assess fairly the extent to which the writer imposes himself upon his subject. One must, for example, question his claim for the universality of Delacroix's emotional understanding—his compassion, his breadth and flexibility of insight. The contrary might be asserted with greater accuracy. Delacroix's character was not so formed as to yield a complete or symmetrical array of human sentiments. His expressions of spontaneous and unaffected emotion were rare. With others he was chary of himself: his universe was egocentric. Assertions of his powers of imagination are also doubtful, unless one means his capacity to impose his own stamp upon what he absorbed from the art of the past. He had an innate, irrepressible sense of *style*. However, his great gifts were those of resolve and deliberation; he was not a spontaneous visionary.

The temperamental differences between Baudelaire and Delacroix were apparent at all levels, even in their contrasting attitudes toward their own relationship. While Delacroix appreciated Baudelaire's adulation, he remained aloof from him. The formality of his letters to Baudelaire indicates his wariness in the face of obvious attempts at greater intimacy. Delacroix's reserve was no doubt reinforced by the younger man's behavior and some of his beliefs. Nothing could have been farther from the stoic, almost ascetic regimen of Delacroix's mature years than Baudelaire's belief in the "insolence habitual to genius" and his exploration of the obscure corners of man's experience. His fascination with "artificial paradises," his interest in opium and hashish, his cultivation of the eccentric, his unbounded admiration for Poe, were all diametrically opposed to Delacroix's ideas about life and himself.

Delacroix distrusted Poe and his kind and felt that whatever sense of the "mysterious" their writings might once have stimulated in him was no longer possible because of his work with allegorical subjects and his study of nature. Writing in 1856 of *Ligéia*, he said: "Baudelaire, in his preface, says that I bring back to painting the feeling for that so singular ideal which delights in the terrible. He is right; but the disjointed and incomprehensible qualities which mingle with his [Poe's] conceptions do not suit my mind." The following year he said of "Descent into the Maelstrom," "nothing could be more of a bore."[38] In another disparaging reference he summed up his feelings:

For some days I have been reading with great interest Baudelaire's translation of Edgar Poe. In those conceptions, which really are *extraordinary*, which is to say *extra-human*,

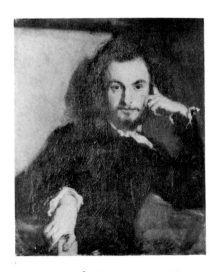

FIGURE 204. Émile Deroy. *Baudelaire.* 1844. Oil on canvas. Musée de Versailles. Photo S.D.P.

38. *J*, P, pp. 510–11 (May 30, 1856), 553 (Jan. 25, 1857).

there is the fascination of the fantastic which is attributed to certain natures of the North or of some such region, but which is denied, very certainly, to the nature of us Frenchmen. Men of that type take their sole pleasure in what is outside of nature, or extranatural: for our part, we cannot lose balance to such a degree. Reason always has to have its share in even the wildest things we do. . . . Although there is talent of the most remarkable kind in these conceptions, I believe that it is of an order inferior to the one that consists of painting things in the light of truth. . . . One must not believe that such writers possess more imagination than those who content themselves with describing things as they are, and certainly it is easier to invent striking situations by such means than by going along the beaten path that intelligent minds have followed throughout the centuries.[39]

Equally offensive to Delacroix was the notion that inspiration may be found in artificial stimulants. Writing of "boldness" in his *Journal* on another occasion, he said: "Lord Byron praises gin as his Hippocrene because of the boldness that he drew from it. And so one must almost be outside oneself, *amens*, in order to be all that one can be. A strange phenomenon which scarcely gives us a more favorable idea of our nature or of the opinion due those fine spirits who have sought in the bottle the secret of their talent." He then reminds himself: "(Add to this passage the part of the *blue book* [now lost] about the excitations of talent, about the intoxication of hashish, etc.) Happy are those who, like Voltaire and other great men, have been able to reach the state of inspiration while keeping to a simple diet, and water as a drink."[40]

This abstemiousness, along with snobbism and an almost narcissistic reluctance to lose any thought or act of one's past, however trivial, is further indicated in a short entry in the *Journal* for March 10, 1860. Although the editors of both English-language editions apparently regarded it as unimportant and omitted it from their selections, this passage is most revealing. "Try some cigarettes made of green tea," he wrote. "I read in an old memorandum book that it is fashionable to smoke them at Petersburg. At least they have not the inconvenience of being narcotic."[41] It is difficult to imagine that Baudelaire would have shared any enthusiasm for such ventures; in the same year he published his *Les paradis artificiels, opium et haschisch*. The way in which Baudelaire was able to reconcile these differences is indicated in his review of the Universal Exposition of 1855:

Edgar Poe has it somewhere that the effect of opium upon the senses is to invest the whole of nature with a supernatural intensity of interest, which gives to every object a deeper, a more willful, a more despotic meaning. Without having recourse to opium, who has not known those miraculous moments—veritable feast-days of the brain—when the senses are keener and sensations more ringing, when the firmament of a more transparent blue plunges headlong into an abyss more infinite, when sounds chime like music, when colours speak, and scents tell of whole worlds of ideas? Very well then, M. Delacroix's painting seems to me to *translate* those fine days of the soul. It is invested with intensity, and splendour is its special privilege. Like nature apprehended through extra-sensitive nerves, it reveals what lies beyond nature.[42]

After writing his first two *salons*, Baudelaire at last met Delacroix. He then wrote his shorter essays on the murals at the Palais Bourbon and the Senate library. In the 1855 Exposition Delacroix was represented by thirty-five paintings especially assembled, some of them newly restored, for the showing. (Horace Vernet and Alexandre Decamps were similarly favored with retrospective exhibitions.) Displayed conveniently nearby in the Palace of Industry, where the fine arts section was housed, was a large collection of works which Ingres had agreed

39. J, P, pp. 505–6 (Apr. 6, 1856).

40. J, P, p. 557 (Jan. 25, 1857).

41. J, 3:277 (Mar. 10, 1860).

42. *Art in Paris*, pp. 142–43.

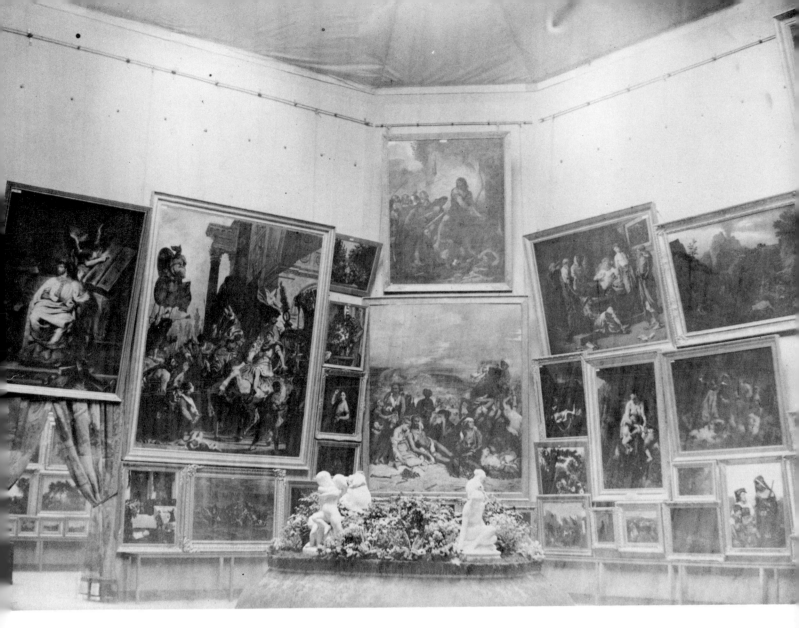

FIGURE 205. Delacroix retrospective (from Plate XIII of the album of the Universal Exposition of 1855). George Eastman House, Rochester, N.Y. Photo George Eastman House.

43. It is of interest that both artists entrusted the assembling of these works to their mutual friend Haro, whose family Delacroix had known early in his career. Both men were witnesses at Haro's wedding on April 24, 1851 (Ingres, as the elder, signed the witness book first. Having done so, he put down the pen so violently that Delacroix was unable to use it). For further details see André Joubin, "Haro entre Ingres et Delacroix," *L'Amour de l'art* (March, 1936), pp. 85–93.

44. See Trapp, "An Early Photograph of a Lost Delacroix."

to present, after twenty-three years of absence from the salon.[43] This occasion provided a unique opportunity to compare the works of the famous rivals.

The selection of Delacroix to share in this public honor indicates that his reputation was at last firmly established, and he was handsomely represented. From the Luxembourg came *Dante and Virgil*, *Massacre at Scio*, *Jewish Wedding*, and *Women of Algiers*. *Liberty Leading the People* was retrieved from storage at the Louvre. Such large paintings as *Battle of Nancy*, *Entry of the Crusaders*, and *Justice of Trajan* were returned to Paris from the provinces. *Justinian* (not yet destroyed) was brought from the State Council Chamber in the Palais Royal[44] and *Agony in the Garden* from the church of St. Paul-St. Louis. Private owners lent smaller works, including *Tasso*, *Giaour*, *Prisoner of Chillon*, *Shipwreck of Don Juan*, and many others. Delacroix submitted his newly completed *The Two Foscari* and the *Lion Hunt* (still intact) which had been commissioned for the

museum at Bordeaux. Other more recent works included *Magdalene* and *Last Words of Marcus Aurelius*, both much discussed at the Salon of 1845. Older paintings (*Marino Faliero* and *Boissy d'Anglas*) reappeared, along with smaller canvases—portrait studies, still lifes, and figure pieces. Conspicuous by its absence, which was surely no accident, was *Death of Sardanapalus* (Baudelaire observed its omission with regret).

The critical response was predictable. For the seventeenth time Delécluze attacked Delacroix's reputation (only once, in reviewing the murals in the Salon de la Paix, had he said a few approving words about his work), while his admirers were unstinting in their praise. However, it had become obvious to all that no account of the contemporary scene could neglect him. Gustave Planche's *Portraits d'artistes* (1853), Gautier's *Les beaux-arts en Europe, 1855,* and Théophile Silvestre's *Histoire des artistes vivants français et étrangers,* published in 1856—to name three contemporaneous surveys—all credit his importance. By 1857 even the Academy grudgingly conceded his claims to recognition. (A recalcitrant Ingres is reported to have cried, "Now they've let the wolf into the sheepfold!" Others, Gautier and Houssaye among them, were vociferous in their approval.)

Baudelaire's essay on the fine arts section of the Universal Exposition indicates the development both of his aesthetic theory and of his perception of Delacroix. His review contains an introduction on critical method and separate essays on Ingres and Delacroix. Other pieces which he originally intended to write were never completed, apparently because the first essays were not considered entirely satisfactory by the editors of *Le pays,* by whom they were commissioned.[45] Most of the remarks on method refer to a section, never written, on foreign painting, but they nevertheless reveal much about his approach to art. He denied, for example, that ideas of "progress" could be applied to artistic discussion, although he accepted and applied genetic metaphors to the "lives" of nations. He avoided the rigid application of a system and the use of studio jargon and pedantic technicalities. As he put it, he was "content to *feel*," taking "refuge in an impeccable naïveté."[46] But that very denial of method in fact became a principle. He insisted somewhat mystically that "painting is an evocation, a magical operation (if we could consult the hearts of children on the subject!)"[47] Closely related are the leitmotivs of beauty and a kind of aesthetic cosmopolitanism, which permits the strange to become familiar by an act of deliberate, imaginative will. Memory and *correspondances*—those elusive, Platonic analogies—were fundamental to the process. The assumption throughout (somewhat Kantian in its ring[48]) is that apart from underlying qualities of universal beauty there are more particular emanations, varying in their nature in accordance with time and place, and in some senses "always bizarre."[49]

These assertions of the supremacy of subjective feeling, the insistence on the distinction between universal and relative beauty, and the rejection of notions of progress all may be observed throughout the next two essays. In the section on Delacroix Baudelaire reiterated his claim that the artist's "effect" had the power to make its meaning felt even before the subject was recognized. Closely related is his reaffirmation of Delacroix's coloristic gifts, his "wonderful *chords* of colour [that] often give one ideas of melody and harmony."[50] He observed what he called Delacroix's "Shakespearean" insights: "For after Shakespeare, no one has excelled like Delacroix in fusing a mysterious unity of drama and reverie."[51]

45. The introduction and the article on Delacroix appeared in *Le pays* on May 26 and June 3, respectively. The piece on Ingres did not appear till August 12, when it was finally printed in *Le portefeuille.* The three essays were later reassembled as a group in slightly amplified form in *Curiosités esthétiques,* which first appeared in 1868. See Baudelaire, *The Mirror of Art,* trans. Jonathan Mayne (Garden City, N.Y.: Doubleday Anchor, 1956), pp. 192, n. 1, 210, n. 1. See also Gilman, *Baudelaire the Critic,* pp. 85–89.

46. *Art in Paris,* pp. 123–24.

47. *Ibid.,* p. 125.

48. Huyghe points out that Delacroix himself was acquainted with the Kantian aesthetic (*Delacroix,* p. 78).

49. *Cf.* Gilman, *Baudelaire the Critic,* pp. 86–87, where these ideas are associated somewhat differently. The notions of "Universal Beauty" and "Temporal Beauty" appeared in more developed form in Baudelaire's essay on Constantin Guys, "The Painter of Modern Life."

50. *Art in Paris,* p. 141.

51. *Ibid.,* p. 138.

He praised Delacroix's portrayals of women, with which others had found fault, for their "modernity," their "distinction." He defended the artist's much abused drawing as superb at best, if uneven. He once more returned to the poetic, the "essentially literary," quality of Delacroix's art.

Beyond all these passionately enunciated observations, Baudelaire introduced a new and significant concept: that of the essential interdependence of all of these factors within a single instant of time, a kind of fusion of form and function.[52] The emergence of this synthesis in itself recommends this essay as exceptional. As Baudelaire put it, having first praised the scope and probity of Delacroix's translations from literature, "rest assured that it is never done by mere feint, by a trifle or trick of the brush that M. Delacroix achieves this prodigious result; rather is it by means of the total effect, the profound and perfect harmony between his colour, his subject-matter and his drawing, and the dramatic gesticulation of his figures."[53]

In 1855 Baudelaire's was not the only voice praising Delacroix, but it was both the most complex and the most lucid. Others, the great Gautier included, joined him, and Delacroix was established as a quasi-official figure. This fact was finally acknowledged in his election to the Academy, but by that time his career was approaching its end, and he had been put into what was in some ways a "conservative" position. The ideals of the younger generation were as inimical to his own as those of the Academy had been. The most threatening of these new attitudes was, of course, realism, and the most aggressive of its spokesmen was Courbet. An obvious symptom of changing times was Delacroix's place of honor at the Universal Exposition and Courbet's meager and controversial representation there.

In addition to the large retrospective showings of the work of Delacroix and Ingres, the Exhibition included a section of French painting, selected by a special commission headed by the Emperor's cousin and including Ingres and Delacroix among its members.[54] Over seven thousand paintings were submitted, among them fourteen by the young Courbet. Lack of space may have been a factor in the jury's decision to reject three of Courbet's works. Two of them, *Burial at Ornans* and *The Studio*, were huge. Indignant at what he considered a deliberate attempt to frustrate his career, Courbet decided to set up a private showing of his works. He did not, however, withdraw the canvases that had been accepted, which remained at the Palace of Industry. A temporary pavilion constructed at his own expense was opened on June 28, 1855, and Courbet was there to greet the visitors. According to his friend, Champfleury, among the first to arrive was "the enemy," Théophile Gautier.[55] Gautier's review of the show in *Les beaux-arts en Europe, 1855*, was rather brief but surprisingly mild. Others were more severe. Delacroix's reactions were mixed, if more favorable than might have been expected in view of his previous reservations about Courbet and his general rejection of the literalism Courbet himself regarded as a cardinal virtue. Delacroix's first mention of Courbet in his *Journal*, two years earlier, had been harsh, if not wholly negative:

To the exhibition of paintings by Courbet. I was amazed at the strength and relief of his principal picture—but what a picture![56] what a subject to choose! The vulgarity

52. See Horner, *Baudelaire: Critique de Delacroix*, p. 142.

53. *Art in Paris*, p. 142.

54. For further discussion of this and other aspects of the exhibition, see Trapp, "The Universal Exhibition of 1855."

55. See G. Mack, *Gustave Courbet* (New York: Knopf, 1951), p. 137. For a useful account of the episode, see pp. 133–41.

56. He is referring to Courbet's *Bathers*, shown at the Salon of 1853, now in the Musée Fabre, Montpellier. (It was purchased by Alfred Bruyas, also a great admirer of Delacroix.)

of the forms would not signify; the vulgarity and futility of the idea is what is so abominable, and even that might pass if only the idea (such as it is) had been made clear! But what are the two figures supposed to mean? A fat woman, backview, and completely naked except for a carelessly painted rag over the lower part of the buttocks, is stepping out of a little puddle scarcely deep enough for a foot-bath. She is making some meaningless gesture, and another woman, presumably her maid, is sitting on the ground taking off her shoes and stockings. You see the stockings; one of them, I think, is only half-removed. There seems to be some exchange of thought between the two figures, but it is quite unintelligible. The landscape is extraordinarily vigorous, but Courbet has merely enlarged a study that can be seen near his picture;[57] it seems evident that the figures were put in afterwards, without any connexion with their surroundings. This links up with the question of harmony between the accessories and the principal object, a harmony lacking in the majority of great painters. It is not, however, the great weakness of Courbet. There is also a "Woman asleep at the Spinning-wheel" that shows the same qualities of vigour and imitation. The spinning-wheel and distaff—admirable; the dress and armchair—heavy and ungraceful. In the "Two Wrestlers," the action is weak, proving the artist's lack of inventive ability. The background kills the figures. A strip, at least three feet wide, needs to be cut off all round.

O Rossini! O Mozart! O inspired genius in every art, you who draw from things only so much as you need to reveal them to our minds! What would you say before such pictures? O Semiramis! O entry of the priests to crown Ninias![58]

In this little coda Delacroix's discomfort in facing this alien world is clear. He could not deny Courbet's great gifts, nor could he dismiss the necessity of analyzing his dissatisfaction with what he saw, for all its admirable attributes. It may have been this preoccupation that led him a few days later to comment in another context that "when they consider and admire even a great work, artists gifted with very strong feeling are apt to criticize it not only for the faults it actually possesses but also for the way in which it differs from their own feelings."[59]

Delacroix later modified his opinion of Courbet. After a visit to Courbet's 1855 exhibition, he entered a more benign judgment in the *Journal*:

Afterwards I went to the Courbet exhibition. He has reduced the price of admission to ten sous. I stayed there alone for nearly an hour and discovered a masterpiece in the picture which they rejected; I could scarcely bear to tear myself away. He has made enormous strides, and yet this picture has taught me to appreciate his "Enterrement." In this picture the figures are all on top of one another and the composition is not well arranged, but some of the details are superb, for instance, the priests, the choir-boys, the weeping women, the vessel for Holy Water, etc. In the later picture ("The Studio") the planes are well understood, there is atmosphere, and in some passages the execution is really remarkable, especially the thighs and hips of the nude model and the breasts—also the woman in the foreground with the shawl. The only fault is that the picture, as he has painted it, seems to contain an ambiguity. It looks as though there were a *real sky* in the middle of a painting. They[60] have rejected one of the most remarkable works of our time, but Courbet is not the man to be discouraged by a little thing like that.[61]

Delacroix's reservations were natural. No two men could have been much more unlike than he and Courbet. Their aims as artists were, if anything, even more opposed than those of the classicists and the romantics. Courbet's declaration of principles in the catalogue of his exhibition makes this contrast of personality and purpose clear:

The appellation of realist has been imposed upon me just as the appellation of romanticists was imposed upon the men of 1830. At no time have labels given a correct idea of things; if they did so, the works would be superfluous.

57. Cf. *J*, 2: 91–92 (Oct. 17, 1853), where Delacroix refers to the same relationship between the landscape sketch and the background of the figure composition but mentions having seen Courbet's study "next to his easel." He had visited Courbet's studio a month before *Bathers* was shown at the Salon, where it was bitterly attacked.

58. *J*, W, pp. 171–72 (Apr. 15, 1853).

59. *J*, W, p. 173 (Apr. 20, 1853).

60. It will be recalled that Delacroix had served on the selection committee. Apparently, his role was largely honorific, and (as the language here implies) he did not directly participate in the jury's decision to reject *The Studio* and *Burial at Ornans*.

61. *J*, W, p. 288 (Aug. 3, 1855). The exhibition did not prove the financial success Courbet had expected, hence the reduced entrance fee.

Without discussing the applicability, more or less justified, of a designation which nobody, it is to be hoped, is required to understand very well, I shall confine myself to a few words of explanation to dispel misunderstandings.

Unhampered by any systematized approach or preconceptions, I have studied the art of the ancients and the art of the moderns. I had no more desire to imitate the one than to copy the other; nor was I any more anxious to attain the empty objective of *art for art's sake*. No! I simply wanted to extract from the entire body of tradition the rational and independent concepts appropriate to my own personality.

To know in order to create, that was my idea. To be able to represent the customs, the ideas, the appearance of my own era according to my own valuation; to be not only a painter but a man as well; in short to create living art; that is my aim.[62]

In a grouchy entry in the *Journal* in 1860, Delacroix made a blunt case against the realist doctrine: " *Realism* should be defined as the antipode of art. It is perhaps more odious in painting and in sculpture than in history and the novel; I do not mention poetry: for, by reason of the mere fact that the instrument of the poet is a pure convention, a measured language, in a word, which immediately places the reader above the earthly quality of everyday life, one sees how grotesque

62. See Mack, *Courbet*, pp. 136–37, quoted from *Exhibition et vente de 40 tableaux et 4 dessins de l'oeuvre de M. Gustave Courbet, Avenue Montaigne, 7, Champs-Elysées* (Paris, 1855). Mack points out that "the ideas may have been Courbet's but the phrases were composed by Champfleury" (p. 136).

FIGURE 206. Gustave Courbet. *The Studio: A Real Allegory.* 1855. Oil on canvas. 3.61 × 5.98. Louvre. Photo Agraci.

would be the contradiction in terms if anyone spoke of realistic poetry, admitting that such a monster could be conceived."[63] He then went on to explain that in sculpture, considered from the point of view of strict realism, "mere casts from nature would always be superior to the most perfect imitation which the hand of man can produce." (Later accusations about the origins of Rodin's *Age of Bronze* are suggested here.) He reaffirmed his deep conviction of the necessity in art not only of convention but of the presence of mind and the imagination that convention presupposes. "If *realism* is not to be a word devoid of sense," he concluded, "all men would have to have the same mind, the same fashion of conceiving things."[64] His countryman Matisse made the point succinctly: "Accuracy is not truth."

Baudelaire could not have been inimical to Courbet's cause. A portrait of him was included in Courbet's exhibit, and his image also appears in the favored group to the right in the huge "real allegory," *The Studio.* However, in an ingenious effort to justify the way in which both Ingres' neoclassicism and Courbet's realism tended to denigrate the imaginative qualities he most adored in painting, particularly that of Delacroix, Baudelaire made one sweeping claim. Both Ingres and Courbet, he said, deliberately sacrificed "imagination and movement." He states his case with particular force in a paragraph on Courbet in his essay on Ingres at the time of the 1855 exhibition:

> However enormous a paradox it may seem, it is in this particular that he [Ingres] comes near to a young painter whose remarkable début took place recently with all the violence of an armed revolt. I refer of course to M. Courbet, who also is a mighty workman, a man of fierce and indomitable will; and the results that he has achieved—results that for certain minds have already more charm than those of the great master of the Raphaelesque tradition, owing doubtless to their positive solidity and their unabashed indelicacy—have just the same peculiarity, in that they also reveal a dissenting spirit, a massacrer of faculties. Politics and literature, no less, produce robust temperaments like these—protestants, anti-supernaturalists, whose sole justification is a spirit of reaction which is sometimes salutary. The providence which presides over the affairs of painting gives them as confederates all those whom the ideas of the prevailing opposition have worn down or oppressed. But the difference is that the heroic sacrifice offered by M. Ingres in honour of the idea and the tradition of Raphaelesque Beauty is performed by M. Courbet on behalf of external, positive and immediate Nature. In their war against the imagination they are obedient to different motives; but their two opposing varieties of fanaticism lead them to the same immolation.[65]

Courbet's "protesting spirit" reflected the romantic ethos of rebellion in the arts. In his dedication to "external, positive, and immediate Nature," however, he was responding to urges that lay outside the accustomed range of sentiment, whether classical or romantic. Obviously, he was in many ways formed by the environment created by his elders, but he reacted to it and to them in ways they themselves could not fully understand. For Courbet, Delacroix was already a part of history. His creative personality had been formed by 1830, a quarter century earlier. In the meantime, the "modernity" that Delacroix hated and feared had gradually come to dominate French art, and, rightly or wrongly, Courbet believed himself in touch with the new realities.

Delacroix, who still felt the sting of rejection in spite of his fame, was inclined to regard the newer reactions against the Academy as an implicit criticism of his own attempts to return art to the great tradition of the past. In his later years he

63. *J*, P, p. 665 (Feb. 22, 1860). He expresses similar ideas at length in the essay "Réalisme et idéalisme," in *O*, 2:57–68.

64. *J*, P, p. 666.

65. *Art in Paris*, pp. 131–32.

was in possibly the most difficult position of all for an artist, for without becoming generally popular, his art had lost its power to shock. Those staunch conservatives who succeeded Delécluze set their sights on other targets. The old issues were not settled, but they had become tiresome. For young warriors nothing is more dispiriting than aging veterans' talk of combat.

Delacroix continued to expect that his causes would regain their original relevance, and in the deeper sense, of course, they had never lost it. He had fought for freedom of individual expression. He had argued for freshness and probity of vision. He had by his own example demonstrated the virtues of uniting emotion, intellect, and rigorous perception, and for these qualities young artists respected him. But they could not accept even his authority, and he in turn could not accept the new aesthetic of the men of talent who had appeared. As one reads some of the later pages of the *Journal*, one realizes that a hundred years ago they would not have seemed, as they do now, exciting, illuminating, and bold, but rather a bit old-fashioned. They were fading into history but were not yet historical. Their full meaning revealed itself much later. Some such awareness is suggested in Delacroix's note of thanks to Baudelaire for his enthusiastic review of the Salon of 1859: "You treat me as one treats the *great dead*. You make me blush even as you give me great pleasure."[66]

66. *C*, 4:111 (June 27, 1859).

Baudelaire's remarks about Delacroix in 1859 were in sharp contrast with other comments on his entries of that year. In spite of the fact that Dumas, Gautier, Saint-Victor, and Zacharie Astruc had all written *salons* that were unreserved in their praise of him, other critics were unkind about the eight small canvases he exhibited.[67] Far from protecting him from attack, his recent recognition stimulated a personally abusive rhetoric in some quarters. He was offended beyond all by Maxime du Camp, who sneered, "Satisfied with the Universal Exposition and the results it had for him, M. Delacroix ought to return to the literary efforts he loves and to music—for which he was certainly born."[68] As a result, Delacroix determined never again to exhibit at the salon.

67. These included *Way to Calvary, Christ Taken to the Tomb, St. Sebastian, Hamlet, Rape of Rebecca, Herminie and the Shepherds, Ovid in Exile among the Scythians*, and a landscape, *Banks of the River Sebou*.

68. Quoted in Horner, *Baudelaire: Critique de Delacroix*, p. 145, n. 240, from Maxime du Camp, *Le Salon de 1859* (Paris: Librarie Nouvelle, 1859), p. 34.

69. See Horner, *Baudelaire: Critique de Delacroix*, p. 156.

It was perhaps recognition of Delacroix's plight that led Baudelaire to claim, in his review of the Salon of 1859, that he was not only the equal of previous geniuses but was all the more commendable for having succeeded in perfecting his art in a hostile atmosphere.[69] This time he presented his ideas in the form of four letters to Jean Morel, editor of the *Revue française*. They appeared in installments between June 10 and July 20, 1859. In the first letter, "The Modern Artist," he dismissed most contemporary artists as "spoiled children" laying claim to the intellectual respectability earned by their elders. Granting a few exceptions —Delacroix and Daumier prominent among them—he attacked the moderns as lacking wit, knowledge, and inspiration, and advanced the common confusion between the true and the beautiful as the cause of this state of intellectual decline.

The second letter, "The Modern Public and Photography," gave the camera as the symptom of this taste for the literal and lazy dependence upon machines and a material progress which could not but harm art. Unlike Delacroix, who quickly accepted the photograph as a new artistic tool, Baudelaire saw in "the photographic industry" an enemy of standards, "the refuge of every would-be painter, every painter too ill-endowed or too lazy to complete his studies."[70] But underlying these and other condemnations—including the photograph's

70. *Art in Paris*, p. 153.

potential as a source of pornography—was a more profound distrust. The re-shaping and in some ways tyrannous force of industrialism was intruding upon art and taste. Others, Delacroix among them, had made this observation. "Went to the Exhibition, where I noticed the fountain that spouts artificial flowers," Delacroix wrote in his *Journal*. "I think all these machines are very depressing. I hate these contrivances that look as though they were producing remarkable effects entirely on their own volition."[71] As Baudelaire put it: "Could you find an honest observer to declare that the invasion of photography and the great industrial madness of our time have no part at all in this deplorable result? Are we to suppose," he continued, "that a people whose eyes are growing used to considering the results of a material science as though they were the products of the beautiful, will not in the course of time have singularly diminished its faculties of judging and of feeling what are among the most ethereal and immaterial aspects of Creation?"[72]

In the next two letters, "The Queen of the Faculties" and "The Government of the Imagination," Baudelaire proposed his remedy for a materialism which had encouraged the servile copying of nature as the sole aim of the artist. "*Since Imagination created the world*," he declared, "*it is Imagination that governs it.*"[73] All other faculties were secondary to the imagination, for without it they could not function effectively. In this panegyric Baudelaire synthesized the qualities celebrated as the sources of romantic creativity. Genius and universality, the poetic and the original, naïveté and other attributes have all been incorporated into a larger whole—a whole not without its magical, mysterious elements. He insisted that imagination, which was not to be confused with mere fancy,[74] was the opposite of the disdained "imitation" in function. But he went beyond Delacroix's more limited concept of imagination as a combining power, stimulated by memory and served by the ability to select and reproduce. For Baudelaire this "Queen of the Faculties" was, as Miss Gilman points out in her summary, even more vigorous. It had the "power of crossing the bridge from the visible world to the invisible, of not only seeing, but seeing meanings."[75]

The concept of the imagination is the central theme of these letters on the Salon of 1859 and is surely its single most important aesthetic and critical contribution. Their author frequently acknowledges his debt to Delacroix for these ideas. In other parts of the essay a variety of individual works are discussed, including Delacroix's salon entries. Once more, the harmonious color, the drawing, and the composition are praised. And above all he delights in those qualities which permit Delacroix to visit the world of dreams—without the use of artificial stimulants, he hastens to assure his readers—and to paint "the *soul* in its golden hours." There can be no doubt of his deep devotion to Delacroix's art nor his profound sense of intellectual obligation to him.

In the century since Baudelaire made his eloquent pronouncements on the genius of Delacroix, many others have honored him. These admirers have often been artists themselves. However, his work has never aroused widespread enthusiasm. Perhaps many people have shared Henry James's exasperation when, as an "English critic of French painting," he tried to encompass Delacroix in his neatly balanced pattern. "So many of his merits have the look of faults, and so many of his faults the look of merits," he wrote in 1868, "that one can hardly

71. *J, W*, p. 288 (Aug. 3, 1855).

72. *Art in Paris*, p. 155.

73. *Ibid.*, p. 159.

74. Gilman, *Baudelaire the Critic*, p. 128 and nn.

75. *Ibid.*, pp. 127–28. See also the discussion of the Baudelairean concept of the imagination on pp. 118–40.

FIGURE 207. Henri Fantin-Latour. *Homage to Delacroix*. 1864.
Oil on canvas. 1.60 × 2.50. Louvre. Photo Agraci.

76. J. L. Sweeney, ed., *The Painter's Eye, Notes and Essays on the Pictorial Arts by Henry James* (Cambridge, Mass.: Harvard University Press, 1956), pp. 39–40. There is a curious echo here of Decamps' praise of Delacroix's "faults" as his "qualities exaggerated."

admire him without fearing that one's taste is getting vitiated, nor disapprove him without fearing that one's judgment is getting superficial and unjust."[76]

Delacroix's *oeuvre* is vast but uneven in quality. For many, the subject matter that was central to his artistic intention now seems irrelevant and distracting. As a result, there is a temptation simply to dismiss it and to regard the works as "form" alone, thereby imposing on them standards that are improper, derived as they are from later and different notions of art. It is true that values are constantly being redefined, but the fact remains that Delacroix was no more an impressionist or a neoimpressionist than Cézanne was a *fauve* or a cubist. The central meaning of his art is not to be found in confusing what he himself accomplished with what he inspired in the art of others.

Yet even those who have felt emancipated from the claims of history and have looked at Delacroix with special eyes—particularly artists—have found him challenging. Françoise Gilot recalls in her *Life with Picasso* that Georges Salles, who was at the time director of the museum, once invited Picasso to conduct a little "experiment" in the galleries of the Louvre. He was to set up some of his

FIGURE 208. Pablo Picasso after Delacroix. *Women of Algiers*. February 13, 1955.
Oil on canvas. 1.14 × 1.46. Collection Mr. and Mrs. Victor W. Ganz, New York.
Photo Museum of Modern Art.

own paintings next to whatever masterpieces he chose. Out of some inexplicable caprice, he decided to confront himself with the attainment of Zurbarán, Courbet, and Delacroix. Although he was satisfied with the results of his comparison with Zurbarán's *St. Bonaventure on His Bier* and Courbet's *Burial at Ornans*, he was noncommittal before *Massacre at Scio* and *Women of Algiers*. Later he admitted that he was annoyed. "That bastard," he declared. "He's really good."[77]

77. See Françoise Gilot and C. Lake, *Life with Picasso* (New York: McGraw-Hill, 1964), p. 203.

Index of Works of Art

Name of artist, if not Delacroix, is given in parentheses. Locations of murals are given in brackets. Page numbers in boldface indicate illustrations in the text.

Index of Authors

Index of Subjects

144, 158–59, 180; English influence on, 51

Soutman, Pieter Claesz, 212, 289; *Hippopotamus Hunt*, 213; *Wolf Hunt*, 217

Spain: as artistic stimulus, 2, 45–46, 115, 188, 193; D's visit to, 113, 115; Peninsular Wars, 102

Spectacles, public: D's love of, 102, 188, 206. *See also* Theater

Stabiae, *Maiden Gathering Flowers*: as D model, 279

Staël, Mme de, 1, 265, 314, 315

Stapfer, Albert: translations of Goethe, 51, 143, 144, 145

Stendhal. *See* Beyle, Marie Henri

Sterne, Laurence, 13–14

Steuben, Charles, *Battle of Poitiers, 732*, 186–87

Stothard, Thomas, 66

Stradan, Jean, 188

Stubbs, George: animal subjects, 59, 204, 206

Swanevelt, Herman van, 313

Synthetism, 278, 334

Taillebourg, Battle of, 185

Talleyrand, Maurice de, 11–12, 28

Talma, François-Joseph, 158, 245; as D patron, 17, 246, 251, 280, 307; as Hamlet, 71, 157, 159

Tardieu Saint-Michel, *Charles-Martel, ou la France délivrée*, 3, 187

Tasso, Torquato, 3, 19, 63, 191

Tastu, Mme Amable, 178

Taylor, Baron: and medievalism, 53, 145, 341

Tellier, *Boissy d'Anglas at the Convention*, 106, 107

Theater: influence on D, 53, 60, 71, 84, 143, 157–58, 173, 280, 300. *See also* Shakespeare, William

Thiers, Adolphe: and D's career, 28, 40, 180–81, 245, 258, 293, 297, 335, 336

Thoré, Théophile: correspondence with D, 59, 121, 145, 245, 263, 292; and D's career, 336–37, 338

Tiepolo, Giovanni Battista, 60; *Way to Calvary*, 238

Timbal, Louis Charles, 292

Tintoretto, Jacopo, 41, 60, 89, 201, 238; *Miracle of St. Mark*, 3, 298

Titian, 60, 239, 288, 298, 325; *Crowning with Thorns*, 242; *Martyrdom of Saint Peter*, 3; *Mocking of Christ*, 196; *Presentation of the Virgin*, 196

Trajan, Emperor, 198–201

Troubadour medievalism: anticlassicism and, 89; interest in, 3–4

Troy, Jean-François de, *Lion Hunt*, 209, 210

Trumbull, John, 109

Turkey: D's desire to visit, 36, 111; war with Greece, 30, 33, 36

Turner, Joseph William Mallord, 59, 330; D's meeting with, 54–55

Universal Exposition of 1855, 82, 229, 287, 343, 344, 347; D's entries, 43, 92, 101, 215

Valéry, Paul, 47

Valmont: D's frescoes at, 196, 245–47; D's visits to, 13, 111, 258

Valmore, Desbordes, 271

Van Dyck, Anthony, 328

Velásquez, Diego, 2, 45

Venetian painting: influence on D, 55, 59–60, 298. *See also* under names of individual painters

Vercingetorix, 178

Vernet, Carle, 204, 206; *Combat between a Mounted Greek Warrier and a Lion*, 209; dandies of, 49

Vernet, Horace, 9, 17, 71, 74, 183, 337, 344; *Arab Chiefs in Council*, 133, 134; *Arab Story Teller*, 134; *Ballad of Lenore*, 173, 174; *Joseph Vernet Tied to a Mast Studying the Effects of a Storm*, 18; *Lion Hunt*, 209, 211; Mazeppa and, 64, 75; *Taking of Smalah*, 340

Verninac, Henriette de, 12, 15; correspondence with D, 16, 28

Verninac, Raymond, 30

Verninac, Raymond de, 12, 15, 29, 111

Veronese, Paolo, 60, 75, 113, 188, 201, 282, 283, 325, 331, 338; *Feast in the House of Levi*, 327; influence of, 45, 55, 59–60; *Marriage at Cana*, 3; *Susanna*, 327

Versailles, 286; Hall of Battles, 185, 186, 187, 259, 313, 335; Hall of Crusades, 188, 335

Vico, Giambattista: influence of, 267, 268

Vignon, Claude, *Death of Seneca*, 274

Vigny, Alfred de, 160

Villot, Frederick, 103, 271, 327, 329, 333; correspondence with D, 114, 245, 246, 258, 265

Vitet, Louis, on *Agony in the Garden*, 79; on *Marino Faliero*, 63; on St. Sulpice murals, 293; on *Sardanapalus*, 92

Voltaire, François, 229, 344

Voutier, Olivier: on Greek wars, 30, 33, 36

Wailly, Gabriele Gustave de, *Ivanhoé*, 174

Wappers, Baron Gustave de, 341

Watteau, Jean Antoine, 88

Weber, Carl Maria von, *Freischütz*, 53

Weber, Max, 226

Weenix, Jan, *Daniel in the Lions' Den*, 224

Wellington, Arthur Wellesley, Duke of, 158, 234

West, Benjamin, 113; *Death on a Pale Horse*, 88; D's interest in, 55, 109

Westall, Richard, 102, 136

Westminster Abbey: as D model, 53, 54, 173

Whistler, James McNeill, 320

Wild animals. *See* Animals, wild

Wilkie, Sir David, *Knox the Puritan Preaching before Mary Stuart*, 54, 55; *Maid of Saragossa*, 102

Williamson, Captain Thomas, *Foreign Field Sports*, 209

Wordsworth, William: influence of *Lyrical Ballads*, 1

Ziégler, Jules-Claude, 322

Zingarelli, Nicola Antonio, *Romeo e Giulietta*, 158

Zurbarán, Francisco de, 115, 312; *St. Bonaventure on His Bier*, 354

THE JOHNS HOPKINS PRESS

Designed by James C. Wageman

Composed in Bembo Series 270 text and display

Printed on 70-lb. Warren Patina II and
bound in Bancroft Natural Finish Buckram
by The Maple Press Company